Picturing Place

PICTURING PLACE

Photography and the Geographical Imagination

Edited by Joan M. Schwartz
and James R. Ryan

I.B. TAURIS

LONDON · NEW YORK

Reprinted in 2009 by I.B.Tauris & Co Ltd
6 Salem Road, London W2 4BU
175 Fifth Avenue, New York NY 10010
www.ibtauris.com

In the United States of America and in Canada distributed by
Palgrave Macmillan, a division of
St Martin's Press, 175 Fifth Avenue, New York NY 10010

First published in 2003 by I.B.Tauris and Co. Ltd. Reprinted 2006
Copyright © selection and editorial matter Joan M. Schwartz and
James R. Ryan 2003

ISBN 978 1 86064 752 9

A full CIP record for this book is available from the British Library
A full CIP record for this book is available from the Library of Congress

Library of Congress catalog card: available

Set in Monotype Baskerville and Univers Black by Ewan Smith, London
Printed and bound in India by Replika Press Pvt. Ltd.

Contents

Figures

Acknowledgements

Picturing Place is concerned with the complex and dynamic alliance between photography and the geographical imagination. The idea for this collection had its origins in Chicago at a conference session organized by Deryck Holdsworth; our editorial collaboration began in Oxford six months later over a lunch arranged by Elizabeth Edwards. To Deryck and Liz, we extend our thanks for lauching this project. We also wish to thank our contributors for willingly, indeed cheerfully, responding to editorial concerns arising from two critical perspectives: the one – photographic, curatorial and historical; the other – geographical, academic and theoretical.

Along the way, colleagues, friends and family helped in numerous ways. In particular, we thank Laurie Beckwith, Richard Brown, Terry Cook, Jill Delaney, Felix Driver, Elizabeth Edwards, John Falconer, Anne Godlewska, Derek Gregory, Marianne Hirsch, Kathleen Stewart Howe, Lynda Jessup, Lilly Koltun, Andrea Kunard, David Livingstone, Heidi Nast, Brian Osborne, Marni Sandweiss, Joanna Sassoon, Sigrid Schulze, Colleen Skidmore and Philip Wolfart, all of whom were generous with their time and thoughtful in their comments. Marta Braun, Jackie Burns, Mikka Gee Conway, Denise Faïfe, Ryan Jensen, Robert Koch, Therese Mulligan, Antonella Pelizzari, Karen Sinsheimer and Ann Thomas all provided invaluable help in tracking down illustrations.

We also extend our appreciation to the National Archives of Canada, the School of Geography and Environment, University of Oxford, and the School of Geography, the Queen's University Belfast, for their institutional support. We are grateful to Tristan Palmer whose enthusiasm launched this project, to Louise Portsmouth who subsequently nurtured it and especially to Denis Cosgrove who lent his support at a critical juncture and to David Stonestreet who carried it through to publication. Linda Scully and Deborah Ryan also deserve our deepest appreciation for their patience and support, good humour and gentle criticism.

We also express our gratitude to the following institutions and individuals for granting permission to reproduce works from their holdings: Magnum Photos; Library of Congress; British Library; George Eastman House/International Museum of Photography and Film; American Antiquarian Society; Transnet Heritage Foundation Library, Johannesburg; MuseumAfrica Photographic Archive, Newtown, Johannes-

burg; Marquand Library of Art and Archaeology, Princeton University; J. Paul Getty Museum; Rheinisches Bildarchiv, Köln; Deutsches Museum, München; National Archives of Canada; National Library of Canada; National Gallery of Canada; Saskatchewan Archives Board; Santa Barbara Museum of Art; Pitt Rivers Museum, University of Oxford; Robert Koch; W. Bruce Lundberg; Michael and Jane Wilson.

Joan M. Schwartz
James R. Ryan

Contributors

Alison Blunt lectures in geography at Queen Mary, University of London, UK. Her research interests span cultural, feminist and postcolonial geographies, and her publications include *Travel, Gender, and Imperialism: Mary Kingsley and West Africa* (1994), *Writing Women and Space: Colonial and Postcolonial Geographies* (edited with Gillian Rose, 1994) and *Dissident Geographies: An Introduction to Radical Ideas and Practice* (co-authored with Jane Wills, 2000). Her current research concentrates on Anglo-Indian women and the spatial politics of home in the fifty years before and after Indian Independence.

M. Christine Boyer is the William R. Kenan Jr Professor of Architecture and Urbanism at the School of Architecture, Princeton University, USA. She is the author of *CyberCities: Visual Perception in the Age of Electronic Communication* (1996), *The City of Collective Memory: Its Historical Imagery and Architectural Entertainments* (1994), *Dreaming the Rational City: The Myth of American City Planning* (1983), and *Manhattan Manners: Architecture and Style 1850–1890* (1985). In addition, she has written many articles and lectured widely on the topic of urbanism in the nineteenth and twentieth centuries. She is currently writing a book, tentatively titled *The City Plans of Modernism* and a series of collected essays entitled *Twice-told Stories: City and Cinema*. She received her PhD and Masters in city planning from MIT and also holds a Masters of Science in computer and information science from the Moore School of Electrical Engineering at the University of Pennsylvania.

Deborah Chambers is Reader in the Sociology of Culture and Communication at Nottingham Trent University, UK. She teaches sociology of the media and has published articles on cultural politics and the media, including public communication, women and suburbanization, and representations of the white family and parenthood in popular culture. She is the author of *Representing the Family* (2001) and is currently co-authoring a book on research methods in Cultural Studies, as well as researching changing social relationships and friendship.

Elizabeth Edwards is Curator of Photographs at the Pitt Rivers Museum, University of Oxford, UK, where she also teaches critical history and theory of still photography

in anthropology and museology with the sub-faculty of anthropology. A historian by training, she has written extensively on the relationship between photography, anthropology and history, especially in the Pacific, and on the relationship between ethnographic photography and contemporary arts practice. She was editor of *Anthropology and Photography, 1860–1920* (1992), and is on the editorial boards of *History of Photography* and *Visual Anthropology Review*. Her most recent book is *Raw Histories: Photography, Anthropology and Museums* (2001).

Jeremy Foster trained as an architect and landscape artist and holds a PhD in Human Geography from Royal Holloway, University of London, UK. He currently teaches landscape architecture at Virginia Tech's College of Architecture & Urban Studies in Alexandria, VA, USA and is preparing a book on landscape, representation and national identity in South Africa.

Derek Gregory is Professor of Geography at the University of British Columbia, Vancouver, Canada. He is author of *Geographical Imaginations* (1994) and *The Colonial Present* (forthcoming), and co-editor (with James Duncan) of *Writes of Passage: Reading Travel Writing* (1999). He is currently working on a full-length study of European and American travellers in Egypt entitled *Dancing on the Pyramids*.

Kathleen Stewart Howe holds a PhD in the history of art from the University of New Mexico. Since 1994, she has served as Curator of Prints and Photographs at the University of New Mexico Art Museum, Albuquerque, USA. In 1996, she was appointed Adjunct Associate Professor in the Department of Art and Art History, and currently serves as co-chair of the UNM Cultural Studies Colloquium. Her publications include *Revealing the Holy Land: The Photographic Exploration of Palestine* (1997), *Excursions along the Nile: The Photographic Discovery of Ancient Egypt* (1993) and *Félix Teynard: Calotypes of Egypt, a Catalogue Raisonné* (1992).

Jens Jäger lectures in history at the University of Hamburg, Germany. Author of *Gesellschaft und Photographie*, a comparison of German and British responses to photography between 1839 and c. 1860, he has published several articles on nineteenth-century photography, and a handbook on photographs as sources for historians, *Photographie: Bilder der Neuzeit* (2000). He is currently doing research for his 'Habilitation' thesis on the emergence of international police cooperation between 1880 and 1933.

William J. Mitchell is Professor of Architecture and Media Arts and Sciences and Dean of the School of Architecture and Planning at the Massachusetts Institute of Technology, Cambridge, USA. Among his publications are *The Reconfigured Eye: Visual Truth in the Post-Photographic Era* (1992), *City of Bits: Place, Space and the Infobahn* (1995) and *E-topia: Urban Life, Jim – But Not As We Know It* (1999). He is a Fellow of the Royal Australian Institute of Architects and a Fellow of the American Academy of Arts and Sciences.

David E. Nye is Professor of American History, Odense University, Denmark. His previous works include *Narratives & Spaces: Technology & the Construction of American Culture* (1998), *Consuming Power: A Social History of American Energies* (1998), *The American Technological Sublime* (1994), *Electrifying America: Social Meanings of New Technology, 1880–1940* (1990) and *Image Worlds: Corporate Identities at General Electric* (1985).

Brian S. Osborne is Professor of Geography at Queen's University, Kingston, Canada. A historical geographer, his research interests have been concerned with the settlement geography of Ontario and Western Canada. Recent publications have addressed the role of art, literature, and the 'culture of communications' in the development of Canadian national identity. He is currently researching monumentalism, commemoration and performance as contributors to the cultivation of social memory and national identity. These matters will be central to his forthcoming volume, *Establishing the Centre, Integrating the Margins: An Historical Geography of Canadian National Identity*.

Maria Antonella Pelizzari is Associate Curator of Photography at the Centre Canadien d'Architecture, Montreal, Canada, where she is currently preparing an exhibition and publication entitled *Monuments of India: Photographs and the Making of History*. She received her PhD from the University of New Mexico, and has written extensively on nineteenth- and twentieth-century photography in *History of Photography, Visual Resources, Afterimage, Photofile, SPOT, Fotologia, A.F.T. Rivista di Storia e Fotografia, Immagine e Cultura, Performing Arts Journal* and *Millennium Film Journal*. She has contributed essays to the exhibition catalogues *America: The New World in Nineteenth-Century Paintings* (1999), and *Alto Adige, Ritratti del Territorio* (1992).

James R. Ryan is Lecturer in Human Geography in the School of Geography, Queen's University Belfast, Northern Ireland. His recent publications include *Picturing Empire: Photography and the Visualization of the British Empire* (1997) and *Cultural Turns / Geographical Turns: Perspectives on Cultural Geography* (2000, co-edited with Ian Cook, David Crouch and Simon Naylor). He has written on the relationship between photography, geography and British imperialism in the Victorian and Edwardian eras.

Joan M. Schwartz is Senior Photography Specialist at the National Archives of Canada, Ottawa. She holds a PhD in Historical Geography from Queen's University, Kingston, where she teaches courses in the history of photography in the Department of Art. Her current research is divided between the role of photographs in the making of early modern Canada, and the role of archives in the construction of social memory.

Introduction: Photography and the Geographical Imagination

Joan M. Schwartz and James R. Ryan

In a multiplicity of ways, Photography has already added, and will increasingly tend to contribute, to the knowledge and happiness of mankind: by its means the aspect of our globe, from the tropics to the poles, – its inhabitants, from the dusky Nubian to the pale Esquimaux, its productions, animal and veget-able, the aspect of its cities, the outline of its mountains, are made familiar to us.

William Lake Price, 1868

§ IN 1839, the geographical imagination acquired a powerful ally. Announcements of two, technologically different but conceptually similar, processes for fixing an image directly from nature using optical–chemical means caused ripples of excitement that began in France and England and quickly spread throughout the Western world. After years of experimentation, Louis Jacques Mandé Daguerre, a Paris stage designer and inventor of the Diorama, had perfected a process that produced a unique image on a silver-coated copper plate. Almost simultaneously, William Henry Fox Talbot, a English gentleman polymath and frustrated amateur artist, announced a positive–negative process on paper that was destined to become the basis of modern photo-graphy. More than one hundred and fifty years later – despite ongoing and unresolved debates over the status of photography as a fine art and over the role of photography in the relationship between vision and modernity,[1] and despite profound changes in imaging technologies – photography remains a powerful tool in our engagement with the world around us. Through photographs, we see, we remember, we imagine: we 'picture place'.

From the beginning, there was an expectation that Daguerre had 'laid the founda-tion of a new order of possibilities'.[2] The unprecedented ability of photographic technologies to fix an image through optical–chemical means, to make detailed and realistic images directly from nature, to make multiple exact copies of objects or drawings, satisfied modernist desires and challenged the applications to which picture-

making had previously been put. Not only likened to, but also used in conjunction with, the telescope and the microscope, photographic technologies expanded human powers of observation and extended the range of observable space. Few pursuits did not find some practical application for photography, and in this enthusiasm for the new medium, there seems to have been little that was not 'susceptible to photographic delineation'.[3] As 'facts of the age and of the hour',[4] photographs were ideally suited to empiricism and the nineteenth-century passion for collecting, classifying and controlling facts, whether in the pursuit of comprehensive knowledge or the conduct of imperial administration.[5] Indeed, as Abigail Solomon-Godeau has so aptly pointed out, in this era of 'taxonomies, inventories, and physiologies', photography 'was understood to be the agent par excellence for listing, knowing, and possessing, as it were, the things of the world'.[6] What is of particular interest here is that the contributions of photography 'to the knowledge and happiness of mankind', as expressed by William Lake Price and many other nineteenth-century practitioners, proponents and critics of photography, were articulated in distinctly geographical terms: through photographs, the world was 'made familiar' and 'brought in intense reality to our very hearths'.[7]

The world 'made familiar' through photographs was changing rapidly under the banner of progress. Industrialization and urbanization, advances in science and technology, improvements in transportation and communication, overseas exploration and imperial expansion, the rise of the middle class and the emergence of the modern nation-state all altered the intellectual, social and political landscape of nineteenth-century Europe and its colonial possessions. Also, beginning in the late eighteenth century and continuing throughout the nineteenth, the geographical imagination was reconfigured as the experience of space and time underwent a profound transformation in the Western world. From the 1840s, the photograph was record, instrument and result of such changes. In particular, the annihilation of space and time was a popular theme that linked photographs to other examples of mechanical genius as an agent of spatial and temporal collapse. 'Space and time have ceased to exist', wrote Théophile Gautier in 1858:

> The propeller creates its vibrating spiral, the paddle-wheel beats the waves, the locomotive pants and grinds in a whirlwind of speed; conversations take place between one shore of an ocean and the other; the electric fluid has taken to carrying the mail; the power of the thunderstorm sends letters coursing along a wire. The sun is a draughtsman who depicts landscapes, human types, monuments; the daguerreotype opens its brass-lidded eye of glass, and a view, a ruin, a group of people, is captured in an instant.[8]

Thus, at a time when steamships, railways and the telegraph made the world physically more accessible, photographs made it visually and conceptually more accessible.

Out of the debates over the nature of the medium, there emerged ideas regarding

the nature of photography and how it could be pressed into the service of science and the fine arts, as well as education and commerce. British, French and American manuals of photographic manipulation described, sometimes in very specific detail, the ways in which the camera was expected to contribute to 'the celerity and extent of the multiform improvements going on in man's condition'.[9] Their arguments carried significant conceptual implications for photography as a way of seeing and knowing the world,[10] defining, in the public mind, what photographs were expected to do, and how people were supposed to react to them. Initial emphasis on the realism and truthfulness of photography effectively masked the subjectivity inherent in the decision of what to record, from what angle and when – contingent, of course, upon the limitations of existing technology – and likewise veiled the power of photography to mediate the human encounter with people and place. Repeated reference in Victorian writing to photography as an instrument of morality and self-improvement flowed from assumptions about the inherent ability of photographs to capture and project feelings, the spirit of place and the character of people, and echoed prevailing enthusiasm for phrenology and other manifestations of the belief in the legibility of appearances. In the failure, or indeed refusal, to acknowledge selectivity and subjectivity in the process of picturing place, in the choice of what was deemed correct, ideal, historical or 'true', the situatedness of human decision-making became naturalized within the practices of photograph production, circulation and consumption, allowing photographs to enter seamlessly into the relationship between observer and material reality. There, they became 'a functioning tool of the geographical imagination', informing and mediating engagement with the physical and human world.[11]

Geography and Photography as 'Ways of Seeing'

Geography has long been an enterprise centred on the visual representation of the world. Yet, in recent years, there has been something of a 'visual turn' in the discipline, notably in cultural and historical geography, nourished in large measure by a broader 'cultural turn' that has characterized much scholarly endeavour in the social sciences and humanities over the last two decades. In this setting, a variety of studies have investigated the 'ways of seeing'[12] that structure and represent geographical practices, languages and ideas. The concept of landscape, for example, has been shown to be a 'way of seeing' that developed in the fifteenth and sixteenth centuries in conjunction with Renaissance techniques of linear perspective and mercantile capitalism.[13] Subsequent work within and beyond geography has amplified the ways in which landscape is shaped by, and carries within it, multiple articulations of cultural memory and identity.[14] Unsurprisingly perhaps, given the visual connotations of the concept of landscape, much of this work has paid particular attention to the *visual* representation of landscape in a range of cultural forms, including painting, map-making, literature, architecture and design.[15] Such interest in delineating the symbolic and material

dimensions of landscape imagery is thus an important part of a broader concern with geographical representation.

Historians of geography and cartography have similarly begun to address the practices and technologies of 'visualization' through which geographical knowledge has been conceived, constructed and communicated.[16] The conventional visual devices and technologies of geography, such as the map, have been scrutinized in the light of questions about perspective, orientation and cultural context. Assumptions as to the accurate, objective nature of cartography have been challenged by studies that have sought to show how maps are a complex and culturally constructed means of representing knowledge.[17] Such work has entailed a greater concern not simply with the history of practices of visual representation, from cartography to painting, but also with how such practices are placed within broader visual regimes and discourses of the 'geographical imagination'.[18]

A further stimulus to work on visual media in geography and beyond has come from the growth of interdisciplinary interest in culture and cultural studies. Reinvigorated fields of human geography have responded to the primacy afforded to issues of cultural representation and cultural politics by developing new approaches to, and understandings of, culture and space.[19] Within this scholarly arena, a number of studies have sought to show how places, cultural identities and social categories of race, gender and class are produced through different media.[20] Others have increasingly focused on the social practices and ideological implications of visual representation in efforts to understand and elucidate the links between vision and modernity, memory and identity.[21] These developing concerns for the practices, politics and poetics of cultural and visual representation have provided fertile ground for a growing interest in one of the most ubiquitous of modern visual media: photography. While many early explorations of geographical imagery focused on the representational practices of cartography and painting, a number of more recent studies have investigated the historical and cultural role played by photography in picturing people and place.[22]

This critical concern with photography in geography is certainly a welcome development, albeit, it may well be argued, a surprisingly late one within a discipline that has long been conceptually and practically dependent upon technologies of the visual. In this respect, historians of geography, as well as cultural and historical geographers, are fortunate in being able to profit from theoretical studies of photography already undertaken in the allied discipline of anthropology,[23] as well as in the history and criticism of art and photography.[24] It is photography as a socially constructed, culturally constituted and historically situated practice, and photographs as visual images, historical documents and material objects that provide the focus of this volume.

The significance of photography in the construction of notions of space and place, landscape and identity may be found at a range of scales, from the sites and sights of popular local urban memory[25] to the image and symbol of the whole earth from

space.[26] However, the meanings of such photographs of local landscapes or global panoramas are neither obvious nor fixed. Studies of the use of photography in the construction of symbolic landscapes of national identity, cultural difference and imperial order show further how the meanings of photographs, though bound up with myriad forms of power, are also continually negotiated.[27] Such studies reveal, despite the abiding authority of the photograph as a vehicle of 'truthful' depiction, the conventional, active and dynamic nature of photographs as visual representations. As Donna Haraway has pointed out:

> The 'eyes' made available in modern technological sciences shatter any idea of passive vision; these prosthetic devices show us that all eyes, including our own organic ones, are active perceptual systems, building in translations and specific ways of seeing, that is, ways of life. There is no unmediated photograph or passive camera obscura in scientific accounts of bodies and machines; there are only highly specific visual possibilities, each with a wonderfully detailed, active, partial way of organizing worlds.[28]

Thus, a range of studies within and beyond geography have begun to address the role of photography, as a distinctive and pervasive form of geographical (broadly defined) image-making, in the construction of landscape and identity. Despite such recent and growing interest, there has been no effort by *geographers* to bring together ideas from this emerging body of interdisciplinary work. Moreover, we can be sure that there is still much to learn about the historical geography of photography and the ways in which photographs, in conjunction with other kinds of images and texts, shape distinctive 'imaginative geographies'. This volume thus arose as an attempt to frame, connect and encourage an exciting and expanding set of debates within and beyond the academic discipline of geography concerning photography and the geographical imagination.

Geographical Imagination and Imaginative Geographies

The advent of photography opened up new worlds to nineteenth-century viewers, enabling them to visualize – with unprecedented accuracy and ease – themselves, their families, their immediate surroundings, their wider communities and the world beyond their doorstep. And, as never before, photographs made the past a palpable part of the present. The historical importance of photography as a new means of collecting and classifying geographical and other forms of knowledge and of communicating them to both popular and elite audiences should not be underestimated. Over the past century and a half, photographs have been used not only 'in a multiplicity of ways', but also in profoundly influential ways to shape modern geographical imaginations. From daguerreotypes to digital images, from picture postcards to magazine illustrations, photographic images have been an integral part of our engagement with the physical and human world. A powerful means of 'picturing

place', both literally and figuratively, they have participated actively in the making and dissemination of geographical knowledge. These same images, now preserved across a range of social spaces, from the pages of family albums to the holdings of national archives, continue to influence our notions of space and place, landscape and identity, history and memory.

This volume seeks to demonstrate how photographs have operated as spatial forms, how they have represented the spaces, places and landscapes within their frame, as well as how different spatial contexts have shaped the practices of photography and the meanings of photographs. At the same time, any attempt to address such questions necessarily involves considering how photographs make 'imaginative geographies'; that is, how photographs shape our perceptions of place.[29] As many of the essays in this volume show, photographic practices – from tourist photography to domestic photography – play a central role in constituting and sustaining both individual and collective notions of landscape and identity. Moreover, photography has long played a central role in giving such social imagery solid purchase as part of the 'real'. Photographs, like other kinds of imagery, have material effects for those individuals and social groupings that fashion and appreciate them. A proper concern with the roles of photography in making 'imaginative geographies' therefore involves blurring the distinction between the real and the imagined. It also involves taking a serious historical and contextual approach to photographic images and practices.

The nature, locus and operations of the geographical imagination have been explored in detail by a number of geographers.[30] David Harvey's well-known use of the term 'geographical imagination' conveys an overarching appreciation of the significance of space, place and landscape in the making and meaning of social and cultural life. As a way of thinking, then, the geographical imagination alerts us to the significance of the spatial in all aspects of social existence. Moreover, as Harvey notes, it enables individuals 'to fashion and use space creatively, and to appreciate the meaning of the spatial forms created by others'.[31] However, for the purposes of this volume, we have interpreted the geographical imagination broadly to be the mechanism by which people come to know the world and situate themselves in space and time. It consists, in essence, of a chain of practices and processes by which geographical information is gathered, geographical facts are ordered and imaginative geographies are constructed. Photography is one of these practices.

Set against this backdrop, the essays in this volume explore some of the relationships between photographic practice and geographical inquiry, between photographic representation and the geographical imagination. The contributors have been drawn from across a spectrum of disciplines; as a consequence, the theoretical and intellectual perspectives that they bring to the subject matter vary. While we have not attempted to set down any unified theoretical or methodological approach to photographic images and practices,[32] the authors share a number of important convictions in their approaches towards photographic representation.

All the authors consider photographs – as well as other kinds of images – as specific material objects worth studying in their own right, both as historical and geographical records and as moments in broader sets of practices and discourses. In this respect the volume responds to earlier calls to take photographs more seriously as primary sources. Raphael Samuel, for example, expressed surprise at how writers are 'content to take photographs on trust and to treat them as transparent reflections of fact'.[33] His call to put quotation marks around historical photographs, to place them as historical utterances of a particular moment in time and place, offers an important challenge. We take as our goal here the subjection of visual imagery to critical, contextual scrutiny, without being reductively iconoclastic in seeking merely to 'smash the aesthetic surface of … images to describe some deeper, more authentic world of social relations'.[34] The book thus works towards a specifically visual historical geography that pays critical attention to the content of the images themselves, as well as to the contexts of their conception, production, dissemination, consumption and preservation.[35] The contributors are alive to the specific spaces of photography, in terms of both the space of particular photographic images and the spaces of photographic practice, reproduction and circulation.

The conviction, expressed so eloquently in 1847 by Joseph Ellis, that 'the object which, photographically pictured, meets our eyes, we have indeed *seen!*'[36] permitted the conflation of reality and its photographic representation. But, as the authors here recognize, optical precision is no guarantee of documentary objectivity: photographs have to be understood as records of visual facts and as sites where those visual facts are invested with, and generate, meaning. Thus photographs are not simply looked at, but are read, deciphered and, therefore, open to a range of interpretations.

To viewers at the dawn of the twenty-first century, photographic images, technologies and practices have become so ubiquitous that they are, for all intents and purposes, invisible. Indeed, as Abigail Solomon-Godeau has observed, photography is 'a medium whose very ubiquity may well have fostered its invisibility as an object of study'.[37] Contributors to this volume have undertaken the important task of making those images, technologies and practices both visible and comprehensible. Sensitive to the responses of contemporary audiences, authors acknowledge that photographs were produced and consumed, commissioned and collected in historically specific and carefully crafted ways, and that many factors combined to frame the ways in which meaning was generated. Photographs cannot be studied in isolation from, but rather must be linked in multiple and complex ways to, other forms of material evidence. Of course, not all photographs survive with recoverable contexts of creation or consumption. Unidentified, unattributed or removed from their original documentary universe or narrative sequence – either permanently or temporarily by institutional preservation practices – photographs often resist efforts to ascertain authorial intent or intended audience, and cannot be made to yield their original messages. Thus, the task of understanding the place of photography in modern visions

of the world – despite, or perhaps because of, the arrival of a new era of digital imaging technology – is a challenge, ever more significant and complex.

In considering the relationship between indexicality and instrumentality, all authors acknowledge and proceed from critiques of the nineteenth-century rhetoric of transparency and truth that governed the taking and viewing of photographs. At the same time, they accept that, despite the claims of accuracy and objectivity made on its behalf, photography has never been an uncontroversial practice of reporting. Indeed, although there is ample evidence that Victorian viewers regarded photographs as empirically objective records, ideal for amassing and ordering facts about the world, there is also much to suggest that the meanings of photographs even in the practice of science were far from straightforward.[38]

Just as we must recognize that nineteenth-century photographs could have different meanings for different viewers in different settings, the contributors here offer their accounts of photographic imagery in the knowledge that they are interpretations: yet more layers of meaning on complex representations. Implicit in this is an argument that cultural representation can be properly explored only in relation to the concrete forms and practices in which meaning is embedded.[39] As such, it is essential to recognize photographs as profoundly *material* objects with their own forms of material culture and history. The materiality of the photograph as an everyday thing is, as Elizabeth Edwards has noted, 'integral to its affective tone as an image'.[40] The making, circulation and consumption of photographs as everyday objects and the everyday spaces in which they are situated, from the newspaper to the family album to the wallet, are thus a central part of how they are made meaningful.

The authors also engage critically with a range of photographic practices to establish a dialogue between the specifics of photographic imagery and other modes of visual and textual representation. They are primarily concerned with photographs not merely as visual reflections of the 'real' world, or solely of the intentions of their maker, but as discrete moments in the production and circulation of cultural meaning, which call into play a range of processes, spaces, actors and audiences.

As David Livingstone has observed, geography has long been 'an enterprise essentially concerned with picturing (or representing) the world'.[41] These essays embrace and examine photographs as one expression – both material and visual – of that picturing impulse.[42] Made practicable at a time when vision and knowledge came to be inextricably linked, the photograph offered a means of observing, describing, studying, ordering, classifying and, thereby, knowing the world. The rhetoric of transparency and truth that came to surround the photograph enabled it to take up a position between observer and material reality. There, photographic facts generated meaning, and gave rise to action. There, 'photographic seeing' became a surrogate for first-hand observation. There, the photograph served as a site where broader ideas about landscape and identity were negotiated. In these ways, geography and photography became partners in picturing place.[43] This book is

dedicated to the proposition that the impact of that partnership has been subtle, but profound.

The Essays

All the essays in this collection are concerned in some way with the role of photography in 'picturing place'. Moreover, all do so from an avowedly historical perspective. While many of the contributions range across long periods of time, with several being concerned with periods in the twentieth century – notably the 1920s, 1930s, and 1950s – the majority focus on the nineteenth century. This reflects our concern to explore some of the key originating practices that set the terms of reference for the ways in which photography has been viewed and practised for much of the last one hundred and fifty years. Many of the essays thus focus on the use of photography in practices of survey, travel, tourism, landscape description, state administration, science, ethnography and family life. Similarly, the essays address key spatial and socio-political themes within the organization of photographic practice in the period, in particular at the levels of nation and empire. However, it is also clear that there are many other applications, scales, practices, subjects and locales that have not been addressed. It is our hope that this volume prompts others to explore such terrain more fully.

The photographic practices and geographical themes identified in this volume have undergone major and continuous cultural, social, economic and technological change since their inception. Now, new electronic and digital forms of photographic imaging and manipulation are changing for ever our most basic cultural definitions and uses of photography.[44] However, it is not the aim of this volume to chart these most recent of transitions or their manifestations in popular culture. Rather, it is chiefly concerned with delineating a historical topography of photography, against which all photographic practices, old and new, have to be placed.

Throughout this collection, we differentiate between 'photography' as the act or technology of taking photographs, 'photographs' as the resultant images, and 'photographic practices' as the constellation of applications of photographic technology to the production of photographic images. This is intended to foreground the distinction between technology and its products, between human acts and their consequences. Furthermore, 'photography' is construed to include all image-making processes by which visible appearances are recorded on a two-dimensional surface through the action of light reflected from objects onto a light-sensitive emulsion. It is also presumed throughout that photography is not only a technology of image making, but also a technology of information transfer. Photography (literally 'light writing'), of course, shares with geography (literally 'earth writing') a root in the Greek *graphos*. Thus, if explicitly photographs are visual images, then implicitly they are also the material residue of an act of communication. The latter notion emphasizes photography as an act of representation or, in reference to its etymological origins, an act

of writing, thus bringing to the fore issues of authorship and authority, authenticity and audience.

The essays focus largely on the nineteenth century as the formative period when applications of photographic technology and habits of photographic seeing were shaped by, and in turn shaped, geographical concerns. During these decades, as ideas about vision and knowledge codified photographic practice, photographs influenced ways of 'doing' geography, and shaped issues of geographical concern. Yet, until recently, critical writing on photography focused almost exclusively on two debates: one, over the nature of photography as an art or a science; the other, over the nature of the photographic image as iconic or indexical. Such bipolar academic attention has failed to acknowledge the continuum of inquiry to which these investigative poles belong. This continuum was aptly described in 1856 by Reverend W. J. Read in a paper delivered to the Manchester Photographic Society as 'photography and the business of life'.[45] This book cannot claim to address such a broad-ranging spectrum of photographic concerns; however, under the rubric of 'photography and the geographical imagination', it explores the ways in which photography as an image-making technology and photographs as visual images – independent of their status as art or science – helped people to know the world and articulate their relationship to it.

Scholars and critics have expressed this notion in a variety of ways. Writing about images more generally, geographer David Lowenthal has observed: 'The lineaments of the world we live in are both seen and shaped in accordance, or by contrast, with images we hold of other worlds – better worlds, past worlds, future worlds. We constantly compare the reality with the fancy. Indeed, without the one we could neither visualize nor conceptualize the other.'[46] Essayist Susan Sontag, in her oft-quoted polemic *On Photography*, claimed that photographic images 'now provide most of the knowledge people have about the look of the past and the reach of the present'.[47] In a similar vein, sociologists Gordon Fyfe and John Law have pointed out that 'depiction, picturing and seeing are ubiquitous features of the process by which most human beings come to know the world as it really *is* for them'.[48] Thus, if the 'geographical imagination' can be conceived broadly to include those practices and processes by which we situate ourselves in space and time, then photography participated in three fundamental ways: in the empirical practices of gathering factual information in visual forms; in the cognitive processes of ordering that information to produce knowledge of places, peoples and events; and in the imaginative processes of visualizing the world beyond our doorstep.

This collection of invited, original and peer-reviewed essays represents an array of scholarly concerns, and responds to editorial perspectives, both academic and curatorial. It also brings a variety of disciplinary approaches: architectural history, American Studies, archival studies, art history, cultural geography, cultural studies, historical geography, history, sociology, visual anthropology. Essays draw upon the photographic records of France, Britain, Germany, Italy, Palestine, Egypt, India, South

Africa, Canada, Australia, the United States and the western Pacific. They examine photographs by amateur, professional and commercial photographers; photographs taken, commissioned, purchased and collected; photographs in government reports, personal albums and corporate archives; photographs produced as art, as record and as data. What binds editors, authors and essays together is a common interdisciplinary concern for the role of photography and photographs in shaping relationships of people to place. Empirically grounded and historically situated, the essays criss-cross the intellectual terrain where writing on photography and writing on landscape and identity converge around issues of representation and space.

Authors explore a range of relationships embedded in photographs: between representation and reality; between representation and expectation; between author and audience; between intention and impact; between content, context and text. They also bring together common nineteenth-century agendas and converging twentieth-century concerns. Individually, each essay is an effort to address the challenge of looking at nineteenth- and early twentieth-century photographs with all the advantages – and disadvantages – of hindsight. Collectively, they aim to secure a place for photographs as primary sources in mainstream research agendas, and, in the process, to stimulate more creative historical analysis and writing through the informed use of photographic sources.

We have grouped the essays into three sections according to the larger 'actions' in which the photographs under consideration participated: 'Picturing Place' (Part I) focuses on the role of photography in the transformation of space on the ground into place in the mind; 'Framing the Nation' (Part II) treats the use of photography in the articulation of national identities; and 'Colonial Encounters' (Part III) considers the application of various photographic practices within colonial-imperial relations. While these titles denote key themes within the story of the role of photography in picturing place, they should not be taken as definitive or exclusive. Indeed, as several authors show, there are significant and multiple continuities between, for example, the use of photography to depict landscapes and its use to promote and sustain a specific sense of national identity. However, it is in exploring the theme of 'photography and the geographical imagination' within these three broadly defined 'actions' that we have tried to transgress photographic discourses and disciplinary boundaries in efforts of wide-ranging contextualization.

The four essays in Part I offer different methodological perspectives on photographic meaning-making in the production of place. In her essay 'La Mission Héliographique: Architectural Photography, Collective Memory and the Patrimony of France, 1851', M. Christine Boyer explores the way in which heritage preservation, collective memory and architectural photography converged in the work of the Mission Héliographique, a state-sponsored project to survey and document the state of France's architectural patrimony. Concentrating on this convergence of mentality and technology, Boyer's contextualization of the Mission Héliographique reveals how

photography was embraced and employed as a key element in the perpetuation of symbolic spaces as places of national identity and collective memory. In a radical departure from previous studies of the work of the *Mission Héliographique*, Boyer shifts attention away from the circulation and viewing of the images to their conception and creation, to show that this project to document the monuments of France's pre-revolutionary past employed photography as a tool of architectural preservation in an effort to achieve and express a new understanding of landscape and identity in France's post-revolutionary present.

Where Boyer confronts the photograph as a tool of preservation, Maria Antonella Pelizzari examines the photograph as a form of travel writing and as a device of memory. Her essay concentrates on three works compiled by travellers to Rome as part of their engagement with place. Pelizzari highlights the temporal and spatial disjunctions between experience and memory, between description and inscription. Her essay is more methodological than geographical, more about the act of looking at photographs than about the experience of visiting Rome. Focusing on the reciprocal relationships between tourist experience, photographic representation and literary description, her essay discusses strategies employed by travellers to construct individual imaginative geographies of Rome with the collaboration of a tourist guide, a personal narration and a romantic novel. Pelizzari emphasizes the idea that nineteenth-century photographs functioned as devices of memory that were employed to evoke the 'real' experience of a visit to Rome. Through an analysis of the written or printed inscriptions accompanying three different bodies of photographs, Pelizzari's essay focuses on intertextuality in the production of photographic meaning in an attempt to detect the visitor's experience in relation to, yet beyond, the photograph. In this study of the parallels between photograph and text, as well as the meanings embedded within and between them, the essay interprets the photograph as a system of orientation that corresponds only partially to the visitor's experience and perception of place. Pelizzari stresses the importance of inserting the photographic component into the existing body of geographical, historical and sociological writing on tourism, cartographic representation, travel writing and literature. In so doing, she points to the tourist encounter with Rome as a photographically mediated experience, formed and focused through the mental maps, the published guidebook and the illustrated novel.

From the interdisciplinary perspective of American Studies, David Nye traces 'the linked evolution of cultural constructions and photographic representations' of the Grand Canyon as a 'quintessentially American space'. Building upon his previous work on the Grand Canyon,[49] Nye offers a series of observations on the 'photographic editing of the landscape' and its relationship to the repeated cultural reinscription of the canyon as: national icon, geological wonder, tourist destination, fragile nature. Acknowledging the influence of changing aesthetic conventions and technological constraints, his essay positions photography against successive imaginative geographies of the canyon and changing attitudes towards nature. Nye suggests a dynamic relation-

ship between landscape meaning and landscape photography, and asks what cultural meanings Americans ascribed to the Grand Canyon, and how photographs recorded and assisted the processes of meaning-making and cultural incorporation. Nye's discussion of the Grand Canyon, its significance as a marker of geological time and its fragility in the face of technological progress, reveals the ways in which photography played a role in articulating, constituting and maintaining its significance as a site judged 'emblematic of the nation'. In the process, he exposes photography as a tool of government ideology of territorial expansion in the American West. In addition, photographs supported the national identification with an Arcadian vision of nature; corporate ideology of the Santa Fe Railroad and other corporate bodies providing tourist services; and environmentalist ideology of wilderness preservation in the wake of the conscious and contested alteration of nature for political and economic gain. Nye's essay also demonstrates that photography must be understood as one of many forms of technology – along with the railway, mass communication, the automobile and hydroelectric power – through which the relationship between the human and physical world has, and continues to be, negotiated.

In 'Family as Place: Family Photograph Albums and the Domestication of Public and Private Space', Deborah Chambers combines historical, autobiographical and interpretive approaches in an effort to achieve a deeper contextual understanding of family photographs. She shows how the private space of the family may be preserved in the private space of the album, and how the family as place may be constituted through a visual dialogue between private and public discourses of space. Just as Pelizzari explores the relationship between written – or printed – word and photographs, Chambers reminds us that a form of intertextuality is equally embedded in the relationship between the visual narratives and oral histories that collide in the family album.[50] From the perspective of sociology and cultural studies, Chambers explores the social and spatial significance of domestic photographic practices in projecting 'the idea and the ideology' of the family. Her essay also raises important questions about the gendered – and, indeed, culturally contingent – nature of those practices and the role of photography in constructing personal memories of identity and belonging, and in shaping imaginative geographies of house and home.

Part II consists of three essays that look at the role of photography in the making of national identity in Britain, Germany, South Africa and Canada. In 'Picturing Nations: Landscape Photography and National Identity in Britain and Germany in the Mid-Nineteenth Century', Jens Jäger looks at the diffusion and reception of photographic images and their contribution in creating these nations' identities. Jäger's examination of the role of photographs of landscapes and monuments in 'symbolizing, strengthening or sustaining the cohesion of a nation', shares concerns with, and carries forward, Boyer's exploration of architecture, photography and collective memory in France. His study of the relationship between landscape and monument photographs and the construction of national identity is concerned specifically with

the way in which landscape images gain ideological significance, and proceeds from obvious differences in the photographic records of Britain and Germany. Jäger shows the important role played by photography in the nineteenth century in the projection of the idea and image of the nation-state; however, his comparison between the reception and function of landscape photography in Britain and Germany demonstrates that photography was not a totalizing practice. The assumptions that grounded the production, circulation and viewing of landscape photographs in Britain were different from those underlying landscape photography in Germany. As Jäger concludes, such differences were not merely a matter of 'lag time' in the popular acceptance of landscape photography. Rather, they lay in complex cultural debates over the ability of landscape photographs to communicate patriotic feelings and moral values.

As alluded to by Jäger, railways played a powerful role in structuring the experience of landscape and in shaping national identity in emerging modern states in the nineteenth and early twentieth centuries. Photographs were an important part of the process. Jeremy Foster, in 'Capturing and Losing the "Lie of the Land": Railway Photography and Colonial Nationalism in Early Twentieth-Century South Africa', considers publicity photographs generated by the South African Railways (SAR) in the early twentieth century. In so doing, he argues for the centrality and instrumentality of photography in the SAR's construction of landscapes symbolic of colonial and national identity. Exploring the 'use of landscape photographs by the SAR to reinforce a fragile vision of White cultural unity', Foster brings together two travel narratives – one constructed by the railway journey itself, the other constructed by the photographic publicity. These narratives are strands of a larger, long-standing relationship between travel and imaginative geographies, between British imperialism and South African nationalism. Focusing on the use of photographs in the SAR Publicity Department's political and economic agenda, Foster reveals how the SAR nurtured a sense of landscape meaning and South African identity. The essay foregrounds issues of corporate authorship and authority, and his concern with the power of photographs to shape ideas about South Africa as a place directs attention to the way in which photographs correspond both to authorial intentions of 'civil servants of the colonial national state' and to the aims of corporate management in their construction of imaginative geographies.

The survival of government and corporate photographic archives, such as that of the SAR, and the availability of the files, reports and publications in which they were disseminated and are now preserved permit investigation of the ways in which the meanings of photographic images were framed by larger documentary contexts to confirm political agendas, communicate corporate ideologies or shape public opinion. In 'Constructing the State, Managing the Corporation, Transforming the Individual: Photography, Immigration and the Canadian National Railways, 1925–30', Brian Osborne considers how photographs created by the Canadian National Railways

(CNR) in conjunction with Canadian government immigration and land settlement schemes represent state efforts to formulate and implement immigration policies, bureaucratic evaluations of cultural difference and corporate agendas to document and monitor the progress of agriculture and colonization. Adopting the concept of the 'gaze' as an analytical device to explore the relationship of images and imaginings, immigrants and immigration, Osborne considers these photographs as expressions of state values, public opinion and immigrant compliance and resistance. Osborne's essay thus connects with the broader theme of the book in its concern for the role of photography in constituting cultural identity and mapping settlement geography. As Osborne's contextualization demonstrates, the power of the dossier photographs to carry out the corporate agenda and construct immigrant identity cannot be understood apart from the immediate context of the CNR archival record and the larger context of Canadian immigration policy.

The essays by Foster and Osborne share common ground where photography and railways intersected – the former in the discourse of tourism, the latter in the discourse of immigration – to shape landscape meaning and cultural identity. This relationship between photography and railways is a seminal one, not simply because railway companies sponsored photography for a variety of purposes, but also because the train and the camera were both products of an industrial age and represented forms of technological power. Both set down particular visual tracks through the landscape that prescribed – and proscribed – particular ways of picturing place. Osborne's essay also suggests interesting resonances between photography of 'native types' in the construction of the cultural/aboriginal Other in Orientalist and imperialist agendas of the nineteenth century on the one hand, and photography of immigrant types in the construction of the cultural/immigrant Other in the early twentieth century on the other.

Part III begins with Derek Gregory's essay 'Emperors of the Gaze: Photographic Practices and Productions of Space in Egypt, 1839–1914'. This is the second of two, longer exercises in contextualization in this volume, the other being Christine Boyer's essay in Part I. However, where Boyer provides an in-depth exploration of the intellectual 'pre-texts' brought to the production and preservation of the photographic records of French architecture by the *Mission Héliographique*, Gregory takes the long view of changing photographic practice in Egypt, tracing its development and complicity in the colonial and cultural encounter, from the obsession with the monumental spaces of ancient Egypt unspoiled by signs of contemporary Arab life to a fixation on native Arab life untainted by signs of European modernity. Gregory draws upon the importance of the visual thematic, the reciprocity of truth, the trajectory from knowing to possessing, the 'scopic regimes of Orientalism' and the camera as a machine for time-space compression. In so doing, he demonstrates the various ways in which photography, as a socially and culturally constituted practice, increasingly permeated the tourist experience of Egypt: photographs were pre-texts of travel,

surrogates for reality, devices of memory; Kodakers and Kodak signs became part of landscape; and the taking, purchasing, collecting and viewing of photographs – all these became part of the experience of place.

Yet, used as both a tool of description and a device of inscription, photography was employed by travellers who carried cameras and by photographers – both amateur and professional – who travelled to produce widely different, even diametrically opposed, imaginative geographies. Along the way, Gregory explores 'photography's early implication in the colonial project in Egypt' and 'the ways in which popular photography came to be spliced into the performances of modern tourism'. His examination of photography as a tool of geographical engagement – from the first landscape views taken by French travellers in the tradition of Napoleon's great *Description de l'Egypte*, to the amateur snapshots taken by British tourists and travel writers – demonstrates how imaginative geographies of Egypt were shaped by, and articulated through, photography, photographs and photographic practices.

Similarly, in her essay 'Mapping a Sacred Geography: Photographic Surveys by the Royal Engineers in the Holy Land, 1864–68', Kathleen Stewart Howe sets out to demonstrate that 'the taking, organizing, collecting and viewing of photographs' was a critical part of British efforts to map the sacred terrain of the Bible. The Royal Engineers' surveys of the Holy Land combined cartographic mission and photographic engagement, religious faith and scientific study. This exercise to recover biblical history and sacred geography was made possible by a consortium of imperial, scientific, religious and philanthropic interests, and made complex by a web of physical, intellectual, spiritual and ideological associations. It employed photography variously as an instrument of exploration, observation, description, inscription and authentication. Although an adjunct to the primary cartographic mission, photography was central to the documentation and promotion of the project, and photographs acted as evidence of scientific pursuits and certificates of British presence. With differing authorial intentions, the survey photographs reached wider audiences through military reports, government documents, scholarly papers, popular publications and commercial sale. Created and used to complete and complement other forms of documentation – text, maps, elevations, plans, plates and scale models – photographs, according to Howe, were recognized, even at the time, to 'embody multiple cultural meanings' that were framed by scriptural pre-texts of viewing and, in turn, became the basis for visualizing the history and geography of the Bible.

The Palestine Surveys discussed by Howe share certain resonances as an imperial, military and scholarly exercise with the Napoleonic survey of Egypt that, as Gregory claims in his essay, forms the underlying tradition of early photography in Egypt. Equally, the notion that the British survey party members were 'at home' in the Holy Land is subsequently echoed and amplified in Alison Blunt's essay 'Home and Empire: Photographs of British Families in the *Lucknow Album*, 1856–57'. Blunt's examination proceeds from the observation that 'the presence of British women and British homes

in Lucknow reflected and reproduced the translation of domestic discourses over imperial space'. It also links to nineteenth-century expectations that photographs were an instrument of 'primal household affection' that, in turn, formed the cornerstone of national unity.[51] Her interrogation of the production and circulation of these photographs is a departure from previous studies that have tended to interpret the images in terms of subsequent events. Blunt's contextualization in pre-'mutiny' Lucknow not only offers a way to understand the uprising of 1857–58 as a crisis of imperial domesticity, but also presents an avenue to explore Anglo-Indian social and spatial relations through accounts of the commissioning, taking, collecting and viewing of photographs. Particularly germane to our concern with photography as a culturally and spatially constituted practice is Blunt's discussion of the power relations enmeshed in photographs of the British elite by an amateur Indian photographer. Her conclusion that analysis of photographs in the *Lucknow Album* disrupts and destabilizes notions of both an imperial and an Indian 'gaze' permits a fuller understanding of the placement and displacement of British families in the imperial and native spaces of Lucknow on the eve of the rebellions. In turn, situated within pre-'mutiny' discourses of imperial domesticity, the *Lucknow Album* emerges as a device for inscribing spaces of home and empire, and serves as a counterpoint for analysing subsequent representations of domestic defilement and imperial heroism.

In a meditation on 'some photographic incidents in the western Pacific', Elizabeth Edwards offers a strategy for looking not *at*, but *through* photographs. She approaches photographs as visual evidence of cultural performances, and looks through them to explore the spatial elements that gave meaning to the participants of cultural encounters. Edwards argues that photographs are 'ambiguously dynamic' and cannot be reduced to signifiers of social forces and relations premised solely on models of alterity, spectacle or surveillance. Bringing together notions of cultural formations, theatres of action, spatial dynamics and dense context, she theorizes photography as part of a wider acting out of roles in the interventionist encounter between colonial and indigenous worlds in the western Pacific. These roles were informed by and enmeshed in exterior forces that framed the negotiation of space. As an ethnohistorian and visual anthropologist, Edwards uses theatricality and spatialization as 'a way of positioning the contexts of the photographs, opening up their historical possibilities'. It is the cultural performance – of which the photographs are agent, evidence and product – that is the focus of her attention. Her concern in this essay is not directly with issues of intention or impact, but rather with photographs as visual conduits to a better understanding of the relationships embedded in them.

Finally, the arguments of the volume are brought to bear on the late twentieth century in '*Wunderkammer* to World Wide Web: Picturing Place in the Post-Photographic Era', an epilogue by William J. Mitchell. Known for his investigations of how we understand, reason about and use images, as well as for his expertise in digital imaging technology, Mitchell casts a retrospective glance over the changing nature of

visual evidence and the production of knowledge, claiming that digital images are 'cultural coinage of a different kind – with different functions and values'. He points out that 'a discontinuous geography of cyberspace … is overlaid on that of physical space' and warns that computer software constructs an 'electronic gaze' that 'mediates all our interactions with digitally encoded visual evidence and inexorably frames our interpretations of it'. In so doing, Mitchell ultimately reveals how the technology of digital imaging has destabilized any remaining authority of photographic truth in relation to the construction of imaginative geographies.

From these explorations of radically different applications of photographic techno-logy emerge common historical threads and theoretical concerns. These include: the role of photographs in the construction of notions of domestic space; the meanings embedded between photographs and their documentary contexts; the reciprocal relationships between photography and travel; the complicity of photography in taxonomic ordering and cultural othering. Also embedded in these essays are a number of lessons in looking at very different kinds of photographs, created under widely different circumstances, to perform widely different functions. Ultimately, these efforts at contextualization reveal how photographs came to be interposed between observer and material reality by foregrounding the nature of their meaning-making in the historical, technological, social, political, economic and cultural circumstances of their creation, circulation and viewing. The essays all point to the fact that the taking and viewing of photographs was an integral, active and influential part of engagement with material reality, helping to construct imaginative geographies, shape collective memory, define cultural difference and sustain power relations based on gender, race, class and colonialism. They suggest that photographs merit closer interrogation as primary sources in mainstream research agendas, not simply for what they are of, or for what they are about, but more importantly, for why they were created, how they functioned and what they were expected to do. To explore the instrumentality of photographs in shaping notions of landscape and identity, we must inquire into the meanings with which they were invested by their authors, and the meanings that they generated in their audiences. This cannot be achieved through narrowly defined analyses of photography-as-art or photography-as-science or photography-as-technology. Rather, to explore photography and the geographical imagination is to understand how photographs were, and continue to be, part of the practices and processes by which people come to know the world and situate themselves in space and time.

PART I
Picturing Place

ONE

La Mission Héliographique: Architectural Photography, Collective Memory and the Patrimony of France, 1851

M. Christine Boyer

§ IN THE summer and autumn of 1851, five men burdened with cumbersome camera equipment undertook arduous missions to five different regions of France. Armed with only sketchy lists of the monuments which they were to photograph, they comprised what we now call the *Mission Héliographique*.[1] By September 1852, some 300 negatives had been deposited in the archive of the Commission des Monuments Historiques without being given a proper showing or a systematic printing. The commissioners drew the following names from an emerging group of architectural photographers: Édouard Baldus, Hippolyte Bayard, Henri Le Secq, Gustave Le Gray and O. Mestral. Relying on inventories drawn up by regional archaeological and restoration societies and supplemented by the inspection tours of Prosper Mérimée, the Inspecteur Général des Monuments Historiques, they sent Baldus to the valleys of the Loire and Rhône, Bayard to Normandy, Le Secq to Champagne and Alsace, and Le Gray, accompanied by Mestral, to the south and west of France.[2]

Launched just twelve years after Louis Jacques Mandé Daguerre's exciting an-nouncement that he had finally been able to capture and fix for all time the images in a *camera obscura* – years in which the aid of photography in creating a visual archive depicting architectural monuments and exotic places obtained much recognition – this innovative mission raises many questions still to be answered. At the very moment when France was beginning to develop a preservation mentality, and its architectural patrimony had only recently been recognized as worthy of study, what did the Com-mission des Monuments Historiques expect to achieve by this mission? How did the idea develop that a people's sense of place and national identity were embodied in its architectural artefacts, and furthermore that these artefacts and monuments should be placed under state protection and be the subject of a state-sponsored photographic survey?

These questions are not easy to answer for they involve two intertwined narrations: one concerns the establishment of a collective memory and the development of visual archives and imaginative geographies; the other involves architectural photography and its technical relation to both the procedures of restoration and the didactic aims of historians. In addition, these two stories are embedded in a larger multilayered dialogue swirling around the role that monuments play in developing the idea of a nation. Let us take up these narrations separately, knowing that a preservation mentality and collective memory are necessarily intertwined with architectural photography and the work of restoration. At the crossroads where these two stories of architectural preservation and architectural photography meet, lie the aspirations and work of the *Mission Héliographique* (Figure 1.1).

Architectural Preservation and the Collective Memory of France

Preserving the patrimony of France At the end of the eighteenth century, as Michel Foucault asserts, 'history' began to make a meticulous examination of things, developing unencumbered spaces in which objects and specimens could be classified and compared. In archives, dictionaries, catalogues and museums, objects and things were arranged and structured in tables, indexes and inventories. 'What came surreptitiously into being between the age of the theatre and that of the catalogue was not the desire for knowledge, but a new way of connecting things both to the eye and to discourse. A new way of making history.'[3] Examples and specimens once collected, then visually analysed, compared and contrasted, would enable the history of their development and the laws governing their evolution to be told. But how did this process of inventory aid architectural preservation and the collective memory of France, and how was this archive of visual information and the writing of this visual history rendered manageable by photography?

In 1794, Abbé Grégoire coined the word vandalism to describe the hostile acts of revolutionaries who smashed and pillaged buildings, sculpture and artefacts associated with the aristocracy, monarchy or church. Since church possessions had been nationalized in 1789, and property from aristocratic and royal households confiscated, the state had the task of safeguarding these artefacts from the wrath of the people. Hence it began, in 1792, to send whatever fragments it deemed worthy of salvaging to different depots throughout France where they were assessed as to their value and potential sale. A Commission des Monuments (renamed Commission Temporaire des Arts in 1793) was formed to inventory and preserve objects of aesthetic interest lest they be overlooked and either sold or destroyed. Although the Commission was able to save a number of buildings from demolition, such as the Porte Saint-Denis and the Château de Chantilly, still much seditious material, items that had feudal, religious or royal connotations, continued to be destroyed. Thus, Grégoire's proclamation held a special meaning: how to relink the people's memory to their own past embedded in mnemonic

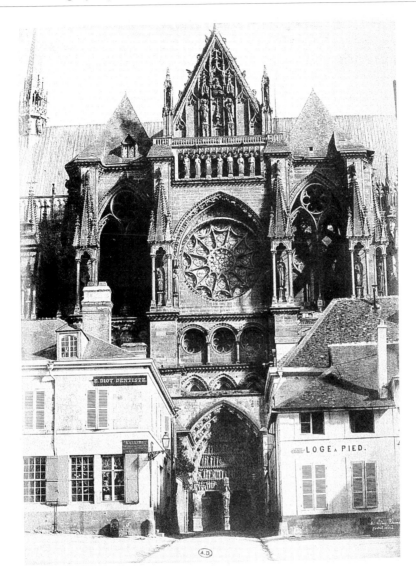

FIGURE 1.1 Henri Le Secq, 'View between houses to the portal of
the Cathedral', Laon, France, 1851. Calotype, 305 × 220 mm.
Courtesy: George Eastman House/International Museum of
Photography and Film.

devices such as monuments or artefacts, and how to reassess this offensive patrimony
so that it might unify the nation. In a series of reports to the Commission, Grégoire
advocated preserving all records and monuments of the past because gazing upon
these objects led to moral improvement. He went even further, calling French Gothic
architecture 'one of the most daring conceptions of the human spirit'.[4] As we shall

see, the Middle Ages and Gothic architecture would be a domain in which a preservation mentality and the collective memory of France would flourish.

Of particular concern was the Abbey of Saint-Denis where kings of France had been buried since the seventh century, for it was brutally sacked for seventy-two hours in August 1793. After this onslaught, cartloads of funerary remnants from fifty-one tombs plus other valuable fragments and sculptures were hauled to the depot at the former convent of the Petits-Augustins on the Left Bank of Paris. A young painter and theatrical devotee, Alexandre Lenoir, received these fragments and many others, sorting them according to artistic worth in the cells of the convent and identifying them as best he could by using illustrations found in antiquarian treatises. His inventory enumerated each object by the arrival date at the warehouse, but his methodology was unique, including descriptive details, compositional materials and dimensions. Quite clearly Lenoir's operation was one of salvage, but he became interested in preserving these objects for pedagogical display, forsaking the traditional mode of listing items by their value or price. If arranged in a didactic order, these objects of French national patrimony might establish a visual history through which the public could stroll and learn to re-evaluate their past. He produced his first catalogue of more than 500 pieces of sculpture and architectural elements in June 1793, turning the former convent into the Musée d'antiquités et monuments français in 1795.[5]

Following the temporal and stylistic theories of Winckelmann, who taught that Greek art developed in a cycle of epochs from birth, development, mature perfection, decadence to rebirth, Lenoir arranged his items in an innovative chronological order revealing the rise, fall and regeneration of French art across the centuries. Between 1796 and 1800, he rebuilt the rooms of the convent for the purpose of exhibiting items from fragments of the tomb of Clovis to artefacts from the late eighteenth century. Each room of the convent contained statuary and sculpture belonging to a given century, theatrically displayed to reflect 'the character, the exact physiognomy of the century that it should represent'.[6] As visitors progressed through the rooms, they advanced in time through the chapters of a three-dimensional book. An introductory room offered a survey of the infancy of art among the Goths, its progress under Louis XII, its perfection under François I and the origin of its decadence under Louis XIV. Lenoir suggested this room be read as a preface: 'if one considers the chronology of past centuries like a book open for instruction, in which one reads the march of events', then the museum became 'a learned school and an encyclopedia where the young will find, word by word, all the degrees of imperfection, perfection, and decadence'.[7] By stressing that these objects belonged to specific historical epochs and stylistic modes, Lenoir was telling the history of France in a unique manner, severing associative links that bound an artefact through its visible features to the *ancien régime*. Even more important than these comparative lessons in visual history was Lenoir's re-evaluation of supposedly 'decadent' art forms opening the way for

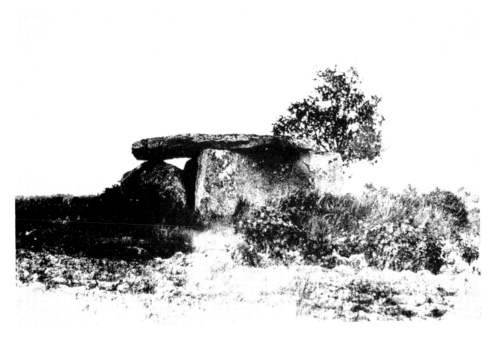

FIGURE 1.2 Gustave Le Gray, 'La Petite Pierre Couverte', a monumental stone
from the Celtic past, Bagneaux, France, 1851. Modern print from original paper
negative, 250 × 342 mm. Musée d'Orsay, Paris. Courtesy: Réunion des Musées
Nationaux/Art Resource, NY.

the rediscovery and reinterpretation of Gothic architecture as the patrimony of
France.[8]

French history, however, was not to be viewed merely as fragments stored in a
museum, no matter how theatrical the display. A diplomat and traveller, Constantin
François Volney, lecturing at the École Normale in 1794, called for a new under-
standing of history based less on archaeological findings and more on what he termed
'*monuments vivants*' or the customs, rites, religions and languages of different people.
He proposed that academies be established to study the history of France for it was
a shame that all attention was focused on the Greco-Roman world leaving one's
homeland to be a foreign country. Following his advice, the Celtic Academy, estab-
lished in 1804 and meeting at Lenoir's museum, would be the first group to study
systematically the history of France. Travel was an essential part of this new field of
study in order to acquire first-hand exposure to the stories, songs, legends and popular
practices across the regions of France. Linking social customs, language, monuments
and places together, Academy member Jacques-Antoine Dulaure began to study the
primitive megaliths located all over France (Figure 1.2). He believed that:

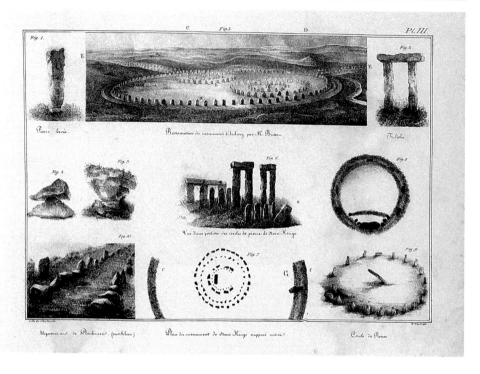

FIGURE 1.3 The objective, outlined by Arcisse de Caumont in *Cours d'Antiquités Monumentales*, was to locate geographically, describe stylistically and classify chronologically all of the monuments of north-west France, from the mute stones of the Celts to the donjons and castles of the Middle Ages. From Arcisse de Caumont, *Cours d'Antiquités Monumentales: Atlas* (Paris: T. Chalopin, Imprimeur-Libraire, 1830–41), Vol. 1, Plate III. Courtesy: Marquand Library of Art and Archeology, Princeton.

[t]he stones or columns that serve as landmarks offered the first repository of human knowledge, and they were the most ancient library of nations, because it was on those columns that all findings in the arts and sciences, laws, great events, political, moral and religious principles, were engraved. Philosophers, scholars, historians, princes, legislators, all came to consult these inscriptions and to draw from them the principles of their doctrine or customs.[9]

Travellers began to search the countryside for stones that spoke the lessons of France. A new monumental territory arose, drawing places and historic events together – an imaginative geography defined by landmarks standing in for national events and allowing the transfer of meaning to place. The tourist re-enacted the memory of these events by following a pre-established itinerary marked on the map, visiting historic sites belonging to a collection that now contained France's architectural and artistic patrimony. If the museum constituted a history book, and the monument or landmark a repository of knowledge, then both offered the viewer a panoramic survey

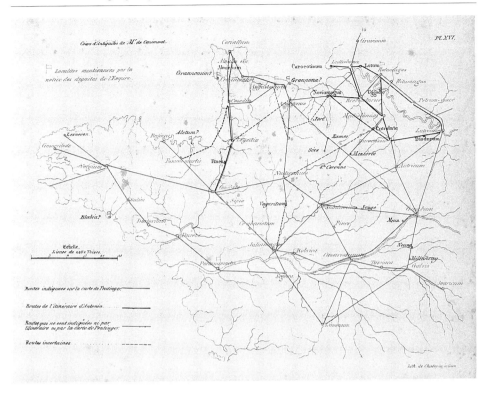

FIGURE 1.4 This map of landmarks, executed by the antiquarian and archaeologist
Arcisse de Caumont between 1830–41, linked specific sites and monuments with grand
and small events and traditions, tying these souvenirs from the glorious past of France to
the collective memory of the nation. From Arcisse de Caumont, *Cours d'Antiquités
Monumentales: Atlas* (Paris: T. Chalopin, Imprimeur-Libraire, 1830–41), Vol. 2, Plate XVI.
Courtesy: Marquand Library of Art and Archeology, Princeton University.

of the nation's collective memory and a condensation of its geographical terrain. A
place on the map of France marked by a megalith, a church, a tomb or a square,
became a place in the history of the nation (Figures 1.3, 1.4).[10]

The rise of a Gothic taste and a preservation mentality Coincident with the
interest in travelling through France to see and meditate on monuments of the past
arose the task of writing a new national history. The mission of historians was shifting,
and the preservation and decipherment of aristocratic documents becoming a
republican affair. The École des Chartes was established in 1821, and the historian
François Guizot encouraged the formation of other national archives and undertook
a massive task of translating many ancient documents into modern French. His thirty-
volume *Collection des mémoires relatifs à l'histoire de France* was published between 1823
and 1835, but his most famous work was the *Histoire de la civilisation en Europe,* depicting

the origins of representative government in Europe.[11] Another advocate of the new history, August Thierry, wrote *Lettres sur l'histoire de France* in 1827. He believed: '[i]f we know that, even in the most difficult times, justice and liberty were never without defenders in the country', then France would have faith in its future. The real France was Gaulish, only usurped by parasitic aristocrats. Now that they were banished, the history of the French people, from the Bretons to the Aquitains, could be resurrected.[12] The writing of history was no longer a matter of political history; rather, it embraced many diverse facts from religious beliefs to philosophical ideas, from private customs to collective memories, from architectural monuments to everyday life. The time was ripe for a systematic re-evaluation in favour of the Middle Ages as the public began to express a widespread taste for Gothic literature, art, manners, dress and furniture which, only twenty years before, had been offensive.[13]

Guizot became a major apologist of the July revolution in 1830 when he was named Ministre de l'Intérieur. He immediately wrote *Rapport présenté au Roi pour fair instituer un inspecteur général des monuments historiques en France* (21 October 1830). Believing that history of art asserted an advantage over general history because it held material objects in its possession and facilitated immediate comprehension of both structural principles and their evolution over time, he consequently argued that the act of inventorying the monuments of France, by type and by date, was not to be undertaken merely to preserve them from ruin and neglect, but to allow the evolution of French civilization to be revealed. Like Grégoire before him, Guizot privileged the Middle Ages, believing it to be the birthplace of the bourgeoisie, the rule of communal rights and responsibilities and the ascension of individual freedoms. He placed the study of the Middle Ages and the conservation of its monuments in alliance, linking the bourgeois monarchy of Louis-Philippe to the people.[14]

As his first Inspecteur-Général of Monuments Historiques, Guizot selected Ludovic Vitet from among the circle of friends surrounding Étienne-Jean Delécluze, the art critic and painter of historic scenes. Delécluze is important to this story as the uncle of Eugène Viollet-le-Duc and a promoter of the daguerreotype. Guizot specified precisely the duties of the Inspecteur-Général. He must be in direct contact with everyone researching the history of every local place in every region of France; he must be a clear advocate to all mayors, priests, private owners and masons responsible for caring for historic buildings; and he must incite local authorities to conserve that which was worthy of being preserved, pointing out the correct procedures to follow so that local awareness guaranteed that not one monument would be lost from ignorance or, the inverse, from excessive conservation. Patrimony was no longer a private affair but was placed under the centralizing control of the state through its various public services and committees, archives and museums. Henceforth, all local initiatives were brought under universal regulation. But of course this was an ideal. How could one man cover all the regions of France and, alone, accomplish the task? Vitet did report in 1831 on a few monuments from his native Normandy and he did follow Guizot's intentions by

listing twenty-one churches as historic monuments, although he failed to rank them chronologically or morphologically, reverting instead to budgetary priorities. Significantly, albeit relatively blandly, so began the listing of historic monuments in France.[15]

Vitet abandoned his job in 1834, and Guizot again returned to Delécluze's friends, this time selecting Prosper Mérimée. Upon taking office, Mérimée promised the archaeologist Arcisse de Caumont: 'I will do my best to plead the cause to the Ministry for "my old monuments".' Mérimée would come to know better than any man in France how many enemies his 'antiquities' had.[16] The Inspecteur-Général held a double role: not only was he to be an administrator overseeing the archival work of the Commission and pleading its cause before various governmental bodies responsible for increasing its stipends, but he was to be a scientific and zealous field recorder as well. Every year Mérimée undertook long and arduous trips to the provinces of France, complaining that his profession was fatiguing without appearing to be and that life in the provinces was horrible and the evenings in uncomfortable taverns terribly long.[17] Each day he examined monuments with care, inspected the ateliers and workshops of restorers, interviewed archaeologists and architects. He established a network of local informants to report directly to him, visited prefects' and mayors' offices to offer directives. After lengthy discussions with locals, he dutifully recorded his findings in detailed correspondence sent back to his ministry, and upon his return to Paris from every field trip he filed lengthy reports.[18]

By September 1837, the new Ministre de l'Intérieur, Montalivet, decided to surround the Inspecteur-Général with a body of specialists, giving birth to the Commission des Monuments Historiques which included members such as the architects Augustin Caristie and Félix Duban, and the antiquarian Baron Taylor. It would become the pole around which a group of young architects would gather as enthusiastic supporters of French architecture from the Middle Ages, desirous of breaking away from the academic tradition narrowly focused on antiquity. Mérimée was preoccupied with the creation of a corps of young architects who would be qualified to undertake restoration work in the provinces and thus remedy the failures of local expertise. He solicited the aid of Charles Questel, Léon Danjoy, Félix Duban and Eugène Viollet-le-Duc, among others. At first the Commission was directed by the Counseiller d'État Jean Vatout, president of the Conseil des Bâtiments civils, with Vitet named Vice-President, and Mérimée Secretary, but it gained some autonomy in 1840 when Vitet was named president. Simultaneously the budget for '*monuments historiques*' grew from 120,000 francs in 1836, to 600,000 in 1848, and 1 million in 1859. In time, the Commission would solidify a preservation mentality, one that included a clearly defined objective – to inventory and preserve historic monuments of France – under an enlightened directorship, with a body of restoration principles worked out in practice and a specially trained group of architects to implement the work.[19] Such a preservation mentality eventually would lead the Commission to consider the use of photography to advance its archival and restoration agenda.

The selection of sites and the *Voyages pittoresques* A taste for the Gothic
had developed; the preservation mentality had been installed; and all the necessary
institutional and budgetary arrangements had been made, but how were the sites that
became 'historic monuments' selected and restored?[20] If Lenoir's museum was a
history book from which lessons could be derived, why not treat architecture in a
similar manner? As Lenoir's vision moved into the field of architectural education, it
became possible to write the history of decadent monuments, i.e. Asiatic or Gothic.
Named conservator of the architectural collection at the École d'architecture in 1803,
Léon Dufourny advocated that architectural history be based on authentic classifica-
tions and types, augmented by the translation of ancient authors, and fortified by
field studies of archaeological ruins. Most importantly, Dufourny believed that France
would be glorified by resuming relations with the architectural monuments of its past
still regarded as decadent. He taught a tripartite history of architecture: the first
traced the cycle of antique architecture through the offsprings of five 'mothers' – the
Asiatic, Egyptian, Greek, Etruscan and Roman; the second cycle studied the deca-
dence of the Romans up to the present time with special emphasis on the various
stages of the Gothic system from the fourth to the fifteenth centuries; while the third
focused on contemporary structures.[21]

In the 1820s, these themes would be reiterated by Jean Nicolas Huyot, professor of
the history of architecture at the École des Beaux-Arts. Like Dufourny, he too divided
his course on the history of architecture into three parts: ancient architecture, Euro-
pean architecture since the Saracen invasion and treatises of the masters. He argued
that the principles that gave rise to societies also gave birth to architecture, principles
that were innate to mankind: 'Monuments instruct us about customs, laws, and
religion. Town buildings inform us about population, commerce, industry. By studying
towns and monuments that survived the hardships of time, we have a precise idea of
societies … since their different stages of childhood, plenitude and decay are marked
on their monuments.'[22]

It was also important to locate or landmark these architectural sites on the visionary
map of the nation as a form of graphic communication; only then would the lessons
of these ruins be transferred from site to memory. The entire nation of France would
become a geographic museum of places, sites, events, language, customs and tradi-
tions. Knowing of Napoleon I's numerous mapping ventures, and searching for a
way to support himself as a painter, Antoine-Ignace Melling proposed to the Emperor
two very ambitious projects in 1811. First he offered to execute 390 paintings, realizing
nine to ten paintings per year, until the whole set created a '*galerie française*'. Three
paintings would be devoted to each of the departments of France: one would depict
the great works of the emperor; the second would be the major city of each depart-
ment; and the third, the place which had made it renowned. The second proposal
elaborated on the first by defining six categories of paintings. He favoured great
public works executed under Napoleon's command: bridges, canals and monuments;

cities founded by Napoleon; imperial palaces and residences; buildings housing public and political institutions; the great monuments and cities memorable for events that had taken place in them. What is striking in these proposals is both the vastness of their architectural themes and the fact that they would require the examination of public works and architectural sites throughout the entire territory of France, noting these places and events as landmarks. But Melling also was suggesting that it was no longer necessary to travel to exotic places in the East to discover sites worthy of interest. Let archaeology remain the province of archaeologists, but allow the painter to become part of the new administrative apparatus of the state and contribute to the consolidation of the empire. Although Melling never acquired the necessary funds or the backing of the Emperor, he nevertheless did focus on one of the regions of France, publishing his *Voyages pittoresques dans les Pyrénées françaises* between 1826 and 1830.[23]

Perhaps the most influential work landmarking the historic sites of France and locating them on the visionary map was the twenty-three-volume *Voyages pittoresques et romantiques dans l'ancienne France* compiled by Isidore Justin Taylor and the writer Charles Nodier. After the two undertook an archaeological excursion to Normandy in 1818, it did not take them long to publish their *souvenirs*: the first volume of *Voyages pittoresques*, dedicated to Haute-Normandie, appeared in 1820. Utilizing an innovative mode of illustration (lithography), Baron Taylor arranged these into a 'voyage picturesque', a publication very much in vogue since the late eighteenth century. Taylor and Nodier had the idea of making a visual record of the monuments and scenery of France, hoping to catalogue all the stones of antiquity, the Middle Ages and the Renaissance. Waiting until the Napoleonic Wars were completed, Taylor and Nodier were politically motivated as well. By rediscovering and documenting France's glorious architectural and colourful historical past, they believed they could reconquer a spiritual empire that war and time had vanquished.

At the time, France was a relatively unexplored country, and so Nodier wrote in the introduction to Volume 1:

> It is not as scholars that we are crisscrossing France, but as travellers curious to find interesting sights and avid for noble memories. Shall I say what inclination, easier to sense than to define, has shaped this journey through the ruins of old France? A certain melancholy disposition of thought, a certain involuntary predilection of the poetic customs and the arts of our ancestors, the sentiment I know not what mysterious correspondence of decay and misfortune between these old structures and the generation which has passed.[24]

Taylor and Nodier also desired to expand the knowledge of little-known regions of France by means of accurate drawings rendered on the spot. Using the best landscape and history painters of the day, artists who specialized in topographical views, by the end of the project in 1878, the architecture and scenic views of nine different provinces were visualized in nearly 3,000 lithographic plates.[25]

By broadening architectural history to consider the ruins of France, proposing a *'galerie française'* or undertaking the *Voyages pittoresques*, these advocates were asserting not only that French architecture was worthy of study, but also that it must be seen in its external surroundings to be fully appreciated. The ruin in its landscape or the building as a coherent ensemble of structures alone aroused emotions and sentiments in the viewer; the context became its legitimate patrimony. The removal of architectural ornaments and fragments from buildings, then placing them inside the walls of a museum where they lay inert as dead stones, would never achieve the same effect as viewing them *tout ensemble*. The same preference for site visits that marked the *Voyages pittoresques* would inform the work of the *Mission Héliographique*, for here, as Michel Foucault remarked, lay the manner in which things were connected both to the eye and to discourse.

Eugène Viollet-le-Duc and the rise of restoration architecture If any of France's architectural patrimony was to be saved, not just remembered in history lessons and *Voyages pittoresques*, restoration architects must arise who were sympathetic to these ruins from the past. Viollet-le-Duc, who would later play a key role in the work of the *Mission Héliographique*, was instrumental in this campaign, but it would not be easy since art and architectural education in France were dominated at this time by Quatremère de Quincy. As the permanent secretary of the Académie des Beaux-Arts, his strict advocacy of neo-classical studies reigned supreme. The state, and consequently Quatremère de Quincy, held absolute control over the education of architects, dictating the number of students, the content of their studies, their scholarships and the winners of the Prix de Rome. The Ministère des Travaux publics and the Ministère des Cultes through the Conseil des Bâtiments Civils, controlled the construction and renovation of all public buildings and churches throughout France, all historic restoration work and even street extension plans. It assigned this work mainly to the select group of Prix de Rome winners. Every significant architect worked for the government, and entry was controlled by ministerial appointments. Nevertheless, Viollet-le-Duc decided not to enter one of the schools or established ateliers, and began his studies by travelling through France witnessing first hand the tormented and flamboyant architecture of the Middle Ages which, once again at the end of the Restoration and the beginning of the July Monarchy, was being attacked by the demolishing ball. Already in 1825, Victor Hugo had added his voice to those proclaiming the sanctity of 'historic monuments' in his first letter *'guerre aux démolisseurs'* for there was not one hour in France that some national monument was not destroyed. Hugo would publish *Le Notre Dame de Paris* in 1831, once more bringing Gothic architecture to popular attention.[26]

Accompanied by his uncle Delécluze, Viollet-le-Duc undertook a three-month pilgrimage in the summer of 1831 to the provinces of Auvergne, Lyonnais, Provence and Languedoc. Thanks to the sale of watercolours from this trip, Viollet-le-Duc

embarked on another voyage in 1832, this time travelling alone to the promised land of mediaeval architecture: Normandy. The following year, during a five-month trip, he visited the châteaux of the Loire Valley, Gascogne, the Basque country, the Pyrénées and Languedoc, returning through the valley of the Rhône. All the while, he sketched and made watercolours of the monuments of France. Conquered by their exquisite and fragile beauty, he became a devoted champion of the Middle Ages. Taylor was impressed by his drawings and would employ Viollet-le-Duc to work on the volumes for *Dauphiné* in 1838, *Languedoc* in 1840, *Picardy* in 1842 and *Champagne* in 1843. He produced a total of 249 drawings between 1837 and 1849.[27]

No doubt Viollet-le-Duc had already seen the first folio volumes of Taylor and Nodier's 'imaginary museum' when he began his travels. And he was probably familiar with efforts being made in the name of France's mediaeval past by the archaeologist Arcisse de Caumont. In 1824, de Caumont published '*Essai sur l'architecture religieux du moyen-âge*', and established the Société des Antiquaires de Normandie in order to publicize its rich inheritance of mediaeval monuments. He would publish his *Cours d'antiquités monumentales* beginning in 1830, noting that not more than fifty people in France were studying the cradle and development of its arts.[28] But archaeological societies in the west and north of France were united in their efforts to convince the state through the Ministère de l'Interieur to intervene against local municipal authorities demolishing precious monuments throughout their regions.[29] They knew that the mission before them was vast, calling on men all over France to reorganize in 1833 under the banner of the Société Française d'archéologie with the aim of studying and conserving national monuments.[30]

It would not take long for Viollet-le-Duc to become interested in architectural restoration. While travelling to Italy in 1836, he was shocked to find Prix de Rome winners spending five long years copying the principles of antique architecture. He was instead interested in imagining what ought to be, not what might have been, in determining how a structure was organized and how it related to its ornamentation. This was knowledge that must be obtained on the site, not from books and treatises in a library.[31] Having no other model to follow, Viollet-le-Duc would develop his theory of restoration by working on monuments. His mission was clear: to cure the weaknesses of Gothic structures in order to give to them historical, formal and structural integrity. All of the parts of a structure were intimately tied together; to change one meant to alter another. Thus, the architect must understand the internal logic of each structure, how each part was related to the whole. He must determine a unity of style controlling the equilibrium of parts. Viollet-le-Duc would eventually define 'Restoration: The word and the thing are modern. To restore a building is to re-establish it in a state which may never have existed.'[32] As Viollet-le-Duc defined it, restoration found its model in the natural sciences. The restoration of a mediaeval structure was comparable to the activity of a palaeontologist reconstituting prehistoric animals. Both knew their objects of study only from fragments and scattered pieces

borrowed from many different specimens or ruins; both reconstructed the whole, adding flesh, muscles, skin and a face to skeletal remains.

Was it Mérimée who appointed Viollet-le-Duc auditor of the Conseil des Bâtiments Civils in 1838 when he was only twenty-four years old, and simultaneously under-inspector of the works of the Hôtel des Archives du Royaume? Did he have any experience when two years later Mérimée charged him with the mission of restoring Vézelay and made him second inspector of the works of Sainte-Chapelle? Mérimée was obviously returning favours to Delécluze, but Viollet-le-Duc was also a young man with exceptional talents. Self-trained, he was one of the few architects not saddled with a Beaux-Arts education, and he was an excellent draftsman and watercolourist. Drawing was the manner in which he envisioned the world, probably one that occupied him each day and would remain his privileged medium. His drawing style was influ-enced by his uncle; a precise linear line-drawer, he was also infused with romanticism, and a penchant for local scenography that he learned from the *Voyages pittoresques.*[33] There was a lot to recommend Viollet-le-Duc as the chief architect promoting a scientific yet romantic view of the Middle Ages. Mérimée would ensure that he did not suffer for work: Viollet-le-Duc was just thirty when he won, along with Jean-Baptiste Lassus, the directorship of the most prestigious restoration workshop in the nation, that of Notre-Dame de Paris. Other missions followed as Viollet-le-Duc was designated supervisory architect on the restoration work of St-Nazaire de Carcassonne in 1845, restoration architect of the controversial workshop at Saint-Denis in 1848 and of the cathedrals of Reims and Amiens in 1849.[34]

Viollet-le-Duc was politically connected, but the coup d'état of Napoleon III in 1848 secured his triumph. That year the Ministère des Cultes reformed the regime directing restoration work on cathedrals, creating a special Commission des Arts et Édifices Religieux. Asked to become a commissioner, Mérimée's dream was fulfilled: he would finally take control of the restoration work on all cathedrals throughout France and so would Viollet-le-Duc. The two drew up a set of guidelines requesting a set of detailed drawings, full historical documentation and an itemized budget for each building being restored. They even urged that daguerreotypes of the principal parts of a structure needing repair be part of each building's dossier. Even though Viollet-le-Duc with his quick eye and trained hand would remain devoted to drawing, he nonetheless viewed photographic documents as essential aids in the work of restoration. They helped to reveal a building's structure, allowing the restorer to see features he had neglected to record or certain traces not perceptible to the naked eye. Afterwards, a photograph became incontestable proof, justifying interventions the restorer had made.[35] In his 1866 *Dictionnaire raisonné de l'architecture*, under the entry 'Restoration', Viollet-le-Duc would write that photography:

> has the advantage of making possible an exact and irrefutable presentation of a
> building in any given state; it provides documentation that can continually be referred

back to, even after the work of restoration has covered over some of the damage that came about as a building was falling into ruin. Photography has also motivated architects to be even more scrupulous in the respect they must accord to the smallest remaining fragment of an ancient disposition; it has enabled them to come to a more exact appreciation of the structure of a building; and it has provided them with a permanent justification for the restoration work they carry out. It is impossible to make too great a use of photography in restoration; very often one discovers on a photographic proof some feature that went unnoticed on the building itself.[36]

Embedded within a preservation mentality and collective memory lies the power of representing the past in the form of images. Not only did the work of restoration involve astute observations, measured drawings and practical judgements, all processes which relied on the training of visualization, but the telling of a nation's history was linked to the picturing of things absent in space and time. Only through imaginative visualization could these things and events be present in memory. As this surveying gaze travelled across the space of the nation, it not only monumentalized landmarks and sites, but it turned them into images or permanent records that could be stored in the imaginative museum of France. Before the photographic survey existed, the principles of photographic perception linked to memory were already in place. Thus, the *Mission Héliographique* would provide not only an organizational tool within the archive, but would assist in the writing of history and the formation of collective memory.

Architectural Photography and the Work of Restoration

Photography and the archive When the Director of the Paris Observatory, Dominique François Jean Arago, reported on 3 July 1839 to the French Chamber of Deputies on Daguerre's photographic process, he stressed that it was an original invention which would not only aid the development of the sciences, but render valuable service to archaeology and the fine arts as well.[37] Had photography been available in 1798 during the French expedition to Egypt, Arago argued:

we would possess today faithful pictorial records of that which the learned world is forever deprived of by the greed of the Arabs and the vandalism of certain travelers.

To copy the millions of hieroglyphics which cover even the exterior of the great monuments of Thebes, Memphis, Karnak, and others would require decades of time and legions of draughtsmen. By daguerreotype one person would suffice to accomplish this immense work successfully. Equip the Egyptian Institute with two or three of Daguerre's apparatus, and before long on several of the large tablets of the celebrated work … innumerable hieroglyphics as they are in reality will replace those which now are invented or designed by approximation. These designs will exce[ed] the works of the most accomplished painters, in fidelity of detail and true reproduction of the local

atmosphere. Since the invention follows the laws of geometry, it will be possible to re-establish with the aid of a small number of given factors the exact size of the highest points of the most inaccessible structures.[38]

Obviously the daguerreotype, Arago suggested, would greatly aid the national work of the Commission des Monuments Historiques. By making available great collections of images for study after the fact, it would thus render a great service to the arts. Although untested, he believed it to be a practical invention: 'Daguerreotype calls for no manipulation which anyone cannot perform. It presumes no knowledge of the art of drawing and demands no special dexterity. When, step by step, a few simple prescribed rules are followed, there is no one who cannot succeed as certainly and as well as can M. Daguerre himself.'[39]

 While it remains debatable whether the daguerreotype involved a practical process or not, from its inception, architecture and photography formed a close alliance, and interest in architectural photography quickly developed.[40] Just three months after Arago's announcement, Frédéric Goupil-Fesquet embarked with the painter Horace Vernet for Alexandria with daguerreotype equipment supplied by the famous Parisian optician Lerebours. En route, he met another daguerreotype enthusiast, Pierre Gustave Gaspard Joly de Lotbinière, who had sailed from Marseilles in September 1839, also equipped by Lerebours. Stopping in Athens, Joly de Lotbinière photographed not only a panoramic view of the city but the Parthenon as well. It was essential to fix an archaeological baseline for these famous ruins for, as he noted, each year they were threatened by a natural catastrophe, or a greedy hand picking up some stone that merely lay on the ground. He echoed the refrains of his compatriots Grégoire, Guizot and Hugo who also feared the threat of time and ignorance destroying the patrimony of France. Both travellers would take many daguerreotypes, some of which would be among the 112 plates published in Lerebours' *Excursions daguerriennes: vues et monuments les plus remarquables du globe* (1841–42). Undertaken at the same time that Viollet-le-Duc obtained his first commissions to restore Vézelay and Saint Chapelle, Lerebours' project produced 1,200 daguerreotypes of the architectural monuments and sites of Europe and their antecedents in the lands of Antiquity. Intended to teach geography to children, these *Excursions* reflected as well an imaginary world of legend and romance.[41] Lerebours was instrumental in the diffusion of daguerreotype images because he believed it took only a few minutes to capture an exact view from anywhere in the world, a view that printers could then use as a model and disseminate in the form of reproductions. In the pages of an illustrated book, between the text and the image, the imagination took flight, giving substance to legends from the Qur'an to the Bible, rendering knowledge about architecture and places not only collectible but palpable and visible.[42] The book, the encyclopaedia, the archive, had met its ultimate ally – the daguerreotype, which could retain for all to see the entire historical setting in which a monument stood, forging a new way of writing and visualizing history.

John Ruskin's stones of memory John Ruskin began to envision architecture and its settings as an integrated spectacle, one that the daguerreotype could greatly enhance. He had learned of Daguerre's innovation in January 1840 and had procured a few images, but it was in 1845 that he made his first comments. Writing to his father from Venice on 7 October 1845, Ruskin proclaimed:

> Daguerreotypes taken by this vivid sunlight are glorious things. It is very nearly the same thing as carrying off the palace itself: every chip of stone and stain is there, and of course there is no mistake about proportions ... It is a noble invention – say what they will of it – and anyone who has worked and blundered and stammered [at drawing] as I have done for four days, and then sees the thing he has been trying to do so long in vain done perfectly and faultlessly in half a minute won't abuse it afterwards.[43]

Ruskin talked about these magical 'sun drawings' able to capture a scene in vivid and sharp detail, and he quickly acquired the necessary equipment.[44] His valet and scribe, 'George' Hobbs, was assigned to the technical and chemical work while Ruskin remained the director, pointing out the views to be 'drawn'. He soon began to compare these views to his own drawings:

> My drawings, [he wrote to a friend in 1846] are truth, too literal perhaps; so says my father, so says not the daguerreotype, for it beats me grievously. I have allied myself with it: ... and have brought away some precious records from Florence. It is certainly the most marvellous invention of the century, given us, I think, just in time to save some evidence from the great public wreckers. As regards art, I wish it had never been discovered, it will make the eye too fastidious to accept mere handling.[45]

Ruskin was just developing an awareness that all over Europe architectural wonders were crumbling into ruins from neglect or being vandalized by unskilled restorers. Clearly he felt the same urgency that prompted the emergence of a French preservation mentality. While in Normandy, preparing *The Seven Lamps of Architecture* in 1848, he sensed he was seeing the last glimpse of a vanishing way of life. As he hastily sketched one side of a building, masons were busily demolishing the other sides. He wrote: 'In twenty years it is plain that not a vestige of Abbeville, or indeed any old French town will be left.'[46] His drawings could not be executed quickly enough, with sufficient detail, nor did time allow sketches to be made of all the endangered monuments. The daguerreotype appeared, at first, to be the ideal solution: it offered a souvenir of the ruin to be carried away in miniature. In the preface to *The Seven Lamps of Architecture*, Ruskin wrote:

> The greatest service which can at present be rendered to architecture, is the careful delineation ... by means of photography. I would particularly desire to direct the attention of amateur photographers to the task: earnestly requiring them to bear in

mind that while a photograph of landscape is merely an amusing toy, one of early architecture is a precious historical document; and that this architecture should be taken, not merely when it presents itself under picturesque general forms, but stone by stone, and sculpture by sculpture; seizing every opportunity afforded by scaffolding to approach it closely and putting the camera in any position that will command the sculpture wholly without regard to the resultant distortions of the vertical lines: such distortion [can] always be allowed for once the details are completely obtained.[47]

Although Ruskin would change his mind about the pictorial value of what he came to call 'sun stains' not 'sun drawings', he remained an advocate of its use for architectural preservation and for creating a photographic archive of cities, monuments and architectural ornaments. Photographic images could frame the discourse, they could speak out for stones that were mute and argue their cause. As memory prompts, their authority was universal and persuasive.

The daguerreotype and restoration At the very moment when Daguerre's photographic process was being discussed, yet before it had been revealed to the public, the Commission des Monuments Historiques began to consider how this discovery might help in the creation of a graphic inventory of the monuments of France. An early supporter of Daguerre, Baron Taylor was asked to comment. His response would be ambivalent. Regrettably, he could not speak in great detail about the daguerreotype. From his personal experience employing artists to work on the *Voyages pittoresques*, he knew that in the provinces designers were rarer than archaeologists; should artists be deployed there, they would be needed to draw. Furthermore, architectural drawings or plans of various buildings all produced on the same scale would be impossible to execute from the small scale of the daguerreotype. There were enormous differences between buildings that an image, no matter how exact, could never measure.[48] On the other hand, Baron Taylor advised, it could aid in the realization of a restorer's design, for it could be taken quickly on the spot, and it would enable parts of a building's restoration work that were suspected of being inaccurate to be recorded. Returned to Paris these documents could advance the argument for better procedures. Since the task of restoration work was immense, the Commission no doubt believed that any record in reduced dimension and portable form such as the daguerreotype should be considered as help. They nevertheless must have recognized as well its limitations compared to large-scale architectural drawings. Although detailed with razor-sharp precision, it offered one-of-a-kind images not printable in any form and of too small a scale for work that must be submitted for government reviews; its very fragility and vibrant tones made it difficult to read and it was absolutely useless in rendering polychrome; plus its chemical procedures encumbered necessary fieldwork.[49]

During the 1840s, a decade wrought with political unrest culminating in the 1848 revolution that overthrew the regime of King Louis-Philippe, the Commission pursued

the restoration of some listed historic properties, Mérimée continued his inspection tours and Viollet-le-Duc began his restoration work on the cathedrals of Paris, Reims and Amiens. Mérimée was particularly interested in Carcassonne, and he visited the site in 1834, 1845 and 1850. Listed in 1840, its restoration began five years later with a special request for extra money to accomplish the task.[50] There appears to be no record of whether or not the Commission advanced its discussion of photography during these troubled years. Between 1840 and 1848, about fifty-six daguerreotypists existed in Paris and itinerant artists with daguerreotype equipment carried on their voyages to exotic spots such as the Levant, India, Egypt, Mexico, America and China.[51] And experimentation advanced on paper negative processes: Hippolyte Bayard, for example, invented his own direct positive photographic prints utilizing paper negatives in 1839 and may have employed it when he photographed several sites and monuments in Paris between 1845 and 1848. There were, by 1850, a good number of photographers using the calotype paper process to record the views and monuments of France.[52]

Never a great admirer of the daguerreotype, Mérimée noted in the summer of 1843 that: 'Duban, whom we have appointed to study the restoration of the Château de Blois, has had some fifty views made. Architecture is always preferable to landscape, but until you have found a way to substitute paper for your metal plates, you will always have a cold tint which doesn't move us.'[53] Nevertheless, by commissioning Hippolyte Bayard to make daguerreotypes of the château, Duban advocated their use as a poignant prompt for preservation, one that established a baseline for restoration. Writing in 1849 of the Royal Portal at Chartres, whose stones were crumbling before his eyes, Duban cried: 'I have seen important parts disappear – fragments of drapery, of hands, and even a whole head. I have daguerreotypes made at different times which give an idea of the rapidity of the problem.'[54]

Although there is no record of the daguerreotypes that Bayard took, nor whether Duban used them to prepare the architectural drawings which he submitted in 1844, once he began the complicated work of restoration, he used more direct means of recording the state of the structure – plaster casts – to serve both as historical records and as models for the stone-carvers.[55] Duban began to work as Mérimée hoped: 'Prohibiting the imagination is the archaeologist's first duty', explained Mérimée. 'Divining must be replaced by scientific analysis which should allow the historical sciences to make the same kind of progress as the natural sciences.'[56]

Viollet-le-Duc showed no such reservations, avidly applying photographs in his restoration work of Notre-Dame de Paris in 1842. In his *Dictionnaire raisonné de l'architecture* (1854), he explained that one could consult a photograph of portals, tympana, voussoirs again and again even when restoration work masked the earlier traces. A photograph revealed more than the naked eye could see; it was an auxiliary to imagination and enabled the archaeologist to restore a structure to a state that may never have existed. Mérimée continued to advocate the opposite view: imagination

should be suppressed in the work of restoration. Known for exaggerating points in an argument, rhetorically inverting the truth, he proclaimed that, won over by the photograph, 'Viollet no longer carries pencils'.[57]

Architectural Patrimony and the Work of the *Mission Héliographique*

The decision to undertake a photographic mission Mérimée was interested in using photography to report, to gather information, to focus on details. He placed it on the side of writing, of recall, of gathering cold and objective facts. The lens of the camera corrected the eye of man; it exposed 'the truth' and saw more details than the naked eye could see. 'One must, as far as possible, make science ocular', or so Michel Foucault wrote, quoting from a scientific treatise of 1797.[58] From all evidence gathered, it appears that the Commission des Monuments Historiques employed the latest invention of photography as an objective reporter: to offer some constants, some laws, some standards. The major reason for the photographic survey was to collect information that would enable the Commission to classify monuments on their list according to need and to programme the steps required to protect the patrimony of France. Mérimée appeared reserved about the use of the daguerreotype for he felt it turned a cold eye on whatever it recorded. He seemed to be a bit more positive about the calotype, its paper negative rival, but his interest in photography was limited to the extent that it might be helpful in arguing the cause of 'his monuments' as he had promised Arcisse de Caumont. The task, however, was daunting, and any aid that could reduce the time it took to draw the stones and ruins must have seemed invaluable. Hence the decision was made in the winter of 1851 to sponsor the photographic missions. Presumably, the photographs were intended to document the progress of restoration activity independent of an architect's report or to provide sufficient information to discern the state of a monument if restoration had not yet begun.

At the same time, the Société Héliographique was formed in Paris in January 1851, with a weekly journal, *La Lumière*, edited by Ernest Lacan. This group of forty eminent scholars, photographers, writers, artists and scientists held its main purpose to be the advancement of technical innovations in the field of photography, seeing that all steps of development were publicized and facilitating the diffusion of photography into many diverse applications. They were the self-proclaimed literary society in which the debates between the merits of photography as a scientific endeavour and the benefits of photography as an artistic expression would be aired, the arguments weighed and the correct judgement made.[59] Among its oldest members was Baron Jean-Baptiste-Louis Gros, who was not only an amateur photographer, having taken views of the Acropolis and its Venetian towers in 1850, but also the author of a pamphlet entitled *Quelques notes sur la Photographie* in which he advocated, among other

things, the replacement of the exact and literal daguerreotype by the rival develop-
ment of soft-hued paper calotypes.

Along with the declaration of intentions and membership list of the Société,
Volume 1 of *La Lumière* carried a report on 9 February 1851 on the Société's member
Gustave Le Gray who had sent the jury of the Salon of 1850–51 nine photographs of
landscapes, portraits and reproductions of works of art. The jury was confused, not
knowing whether to classify them as works of art or science, and so rejected the lot.
They finally determined that photography after all was a graphic art and a form of
copying, hence it belonged in the exhibition space allotted to lithography. This must
not have pleased all of the members of the Société Héliographique, especially the
painters Eugène Delacroix and Léon Cogniet who both stressed the creative nature
of heliography and believed that it held a rich future in the manner in which it could
reproduce images.[60] Delacroix had been an early advocate of photography as an *aide-
mémoire* for artists. He wrote in 1850:

> Many artists have had recourse to the daguerreotype to correct errors of vision: ... but
> to use it properly one needs much experience. A daguerreotype is more than a tracing,
> it is the mirror of the object, certain details almost always neglected in drawings from
> nature, there – in the daguerreotype – characteristically take on a great importance,
> and thus bring the artist into a full understanding of the construction. There, passages
> of light and shade show their true qualities, that is to say they appear with the precise
> degree of solidity or softness – a delicate distinction without which there can be no
> suggestion of relief. However, one should not lose sight of the fact that the daguerreo-
> type should be seen as a translator commissioned to initiate us further into the secrets
> of nature; because in spite of its astonishing reality in certain aspects, it is still only a
> reflection of the real, only a copy, in some ways false just because it is so exact. The
> monstrosities it shows are indeed deservedly shocking although they may literally be
> the deformations present in nature herself; but these imperfections which the machine
> reproduces faithfully, will not offend our eyes when we look at the model without this
> intermediary. The eye corrects, without our being conscious of it. The unfortunate
> discrepancies of literally true perspective are immediately corrected by the eye of the
> intelligent artist: *in painting it is soul which speaks to soul, and not science to science.*[61]

After considerable discussion and review of the usefulness of photography for
archival and artistic work, the Commission des Monuments Historiques finally, on
10 January 1851, asked Henri Le Secq to present some paper negatives for review and
promptly offered him the first photographic mission. Édouard Baldus and O. Mestral
were selected the following week for two other missions, and a subcommittee named
to develop the lists of monuments, the itinerary for each mission and the number and
nature of views. By 28 February, the list of names had been rearranged, perhaps after
a review of different photographers: Baldus, Le Secq and Hippolyte Bayard were to
be sent to Normandy, Midi and to the East, and finally on 9 May the five missions

were complete when Mestral was again retained along with Le Gray.[62] A few months later, on 29 June, *La Lumière* proudly announced that five of its members had just received important missions from the Commission des Monuments Historiques to photograph the beautiful monuments of France menaced with ruin and in urgent need of repair. The following issue, on 6 July, noted that the itineraries given to Le Secq and Bayard covered areas rich with monuments and that their lists contained points of great interest and beauty to archaeologists. So, they proclaimed, not one dissertation on the subject would be as valuable as these photographic studies.[63]

It cannot be determined with certainty who conceived of these photographic voyages, and more importantly why. We have already seen that there was considerable ambivalence among the commissioners over the merits of the daguerreotype in the work of restoration, and various members of the Société Héliographique were advocates for a range of different photographic procedures. In general it can be claimed that the *Mission Héliographique* was a product of its age: a time when the Middle Ages were being re-evaluated as the cradle of the nation while a preservation mentality was being installed. Nor was the Commission des Monuments Historiques the only governmental agency interested in photography: the Ministère de l'Instruction displayed its interest in photography stemming back to 1849, while the Comité des Travaux Historiques recorded their admiration on seeing beautiful photographic representations of the most important historic monuments of the Middle Ages which Viollet-le-Duc submitted for their review on 16 June 1851.[64] Nevertheless, several members of the Société Héliographique may have been instrumental in gathering support from among the commissioners for these photographic missions.

Perhaps it was Comte Léon de Laborde, an adjunct commissioner and a founder of the Société Héliographique, who suggested not only the *Mission Héliographique*, but also the selection of photographers, or at least Le Gray who had taught him the techniques of photography. And he may as well have directed the subcommittee responsible for creating the itineraries, for he had already aided Bayard in his selection of historic sites and architectural views which he photographed in 1849. Charged in March 1851 with making a feasibility study for the creation of the Société's own printing factory, Laborde would have advocated the widest dissemination of the *Mission*'s activity.[65]

It might have been Eugène Durieu who, as director of the Administration des Cultes in 1848, shared with the Commission des Beaux-Arts the financial responsibility for the upkeep of all religious structures in the various communes – the same year restoration work on cathedrals was transferred to Mérimée's control. As a director, moreover, Durieu was a standing member of the Commission des Monuments Historiques, becoming its secretary in April 1850. Thus, it can be supposed that this founding member of the Société Héliographique, who would himself become a well-known photographer of models for painters by 1853, spread a photographic sensibility among the members of the Commission and advocated the adoption of a preservation

mentality that would both speed the work and reduce the cost of restoring the religious structures of France. Just how suggestive Durieu was in the development of the *missions*, however, must remain speculative for he resigned as director of the Administration des Cultes in 1850 and was thus not present on the Commission during the important months leading up to January 1851.[66]

The writer, art critic and journalist Francis Wey was the only one who professed that he was directly responsible for both proposing the *Mission Héliographique* and pressuring the Commission des Beaux-Arts in March 1851 to support the voyages.[67] Wey envisioned that the Commission des Monuments Historiques would become the base for a museum of all that was picturesque and archaeological in France, and he especially championed the positive effects photography would have on painting.[68] But his claim of paternity was made retrospectively in an 1853 article entitled 'Comment le soleil est devenue peintre', in the periodical *Musée des familles*. Furthermore, he stated that the idea of a 'photographic mission' occurred to him in March of 1851, although the Commission des Monuments Historiques was discussing with various photographers their role in January and probably even earlier. In addition, the itineraries that were selected and the dossiers of photographers consulted would have come to the Commission not from Wey but directly from the Commission des Beaux-Arts to which Wey would have had no access. And Wey suggested itineraries which only partially coincided with those the photographers undertook.[69] However, he does seem to have advocated the widest deployment of state funds to sponsor photographic campaigns to record archaeological and artistic finds, and he was avid about architectural photography, stating that even a mediocre photographic view of the portal of Chartres or of Bourges attained a degree of perfection preferable to the most accomplished engraving. Furthermore, *La Lumière* would carry with interest, between 1851 and 1853, his reports on numerous heliographic voyages to diverse countries in which Wey constantly argued the relationship between photography and painting.[70]

The photographic *missions* The outline of each itinerary programmed by the Commission stressed the regions that Mérimée already had visited. And their lists of churches and monuments to be photographed were tied to interventions that were about to be made or had already begun. Once selected and their *missions* outlined, however, the five men were given little instruction besides these lists and the requirement that the list appear at the head of each artist's photographic album.[71] Nor were they told the purpose of their *missions* or how their photographs would be used. Travelling across France in the summer and autumn of 1851, with heavy equipment to carry over long distances, and considering the difficulties of movement in regions where railways were non-existent and public transit was unreliable, the survey work of these photographers was far from comprehensive. Since the commissioners were not all familiar with the regions to be studied nor instructed in the technical aspects of photography, it appears that the photographers were given *carte blanche* to set the

details of their own itineraries and to decide just what structures and from what point of view they would be photographed. Bayard seemed to have been given some detailed instructions about photographing Mont Saint Michel. Baldus's list also had specifications about photographing a particular façade, or the detail of a door, while Le Gray was told to photograph a specific house in Orléans or a portal of an old cemetery.[72]

The first *mission*, given to Baldus, began with Fontainebleau, then to places in Bourgogne, Lyonnais, Dauphiné and sites in Provence. He was to visit thirty-four communes, in fourteen different departments of France. Bayard undertook the second *mission* from Poissy and Mantes, then travelled to Normandy, photographing twelve different places in five departments. Le Secq was assigned the third *mission* to the north-east of France: from Brie-Comte-Robert, he travelled to Champagne, Lorraine and Alsace, surveying twenty-five places in five departments. The fourth *mission*, allotted to Le Gray, began in Orléans, then moved to the valleys of the Loire, Poirou, Charente, Limousin and Angoumois, covering twenty-four places in eight departments. Mestral, undertaking the fifth *mission*, began in Charente, then proceeded to Languedoc, returning through Auvergne, and ending in Nevers and Bourges, recording twenty-six places in fifteen different departments. By the end of the year, 120 different places had been photographed in forty-seven departments; this constituted at least half of the departments of France – nevertheless excluding parts of the centre of France, and Bretagne, Picardie, Artois, Franche-Comté and Corsica.[73]

In the places that had been selected by the Commission, most of the major monuments and many modest monuments were photographed, but there was nothing systematic in the manner in which each photographer studied his areas. Usually two monuments were sufficient for each place, but these were not always the most important ones, e.g. at Rouen, where the Church of St-Ouen but neither the cathedral nor St-Maclou was on the list, and at Montmajour, where the Chapel Saint-Croix was listed but not its celebrated abbey. And of course, since interiors were difficult if not impossible to photograph at the time, the photographers concentrated on exterior façades and sculptural work. Baldus appears not to have photographed some of the sites on his list, while Le Secq seems to have drifted away and photographed structures that were not asked of him, such as traditional habitats in Alsace. So it is difficult to assess how comprehensive the photographers might have been. Certainly they did not deviate from the pictorial conventions and interests of the time. Following the tradition set down by the *Voyages pittoresques*, their work focused predominantly on the religious architecture of the Middle Ages, some monuments from antiquity, and whatever art was to be found from prehistoric times. There were, in addition, a few major monuments from the fifteenth and sixteenth centuries, such as the châteaux of the Loire Valley.[74] In a study of the inventory of 258 proofs and 251 negatives belonging to the *Mission Héliographique*, Anne de Mondenard confirms that the negatives of Bayard are missing, and that Le Gray and Mestral pursued their missions together since all of their proofs and negatives were registered under both of their names. Apparently the

negatives were not delivered to the state until the summer of 1852, except for Bayard who sent nothing. She calculates the total cost of the operation to have been 23,000 francs, comprising 3 per cent of the annual budget of the Commission des Monuments Historiques, not a negligible amount.[75]

Photographs from the *Mission Héliographique* Quite clearly, these artist-photographers did not employ their cameras to record detailed evidence to be used in archival or restoration work. In fact, their photographic work was quite at variance with this task. If they had so intended they would have applied their cameras in a more investigatory manner, photographing at close contact an accumulated, even redundant, series of views divulging details stone by stone. Instead they, like the *Voyages pittoresques* before them, captured a quick study, done on the spot, freezing for all time the ephemeral space of romantic ruins. Since the daguerreotype had limitations with respect to its small size and was not easy to see, label or file, the *Mission Héliographique* lent its support to the paper negative process. Although just why the Commission preferred to employ the softer effects of light and shadow obtained by calotypes over the sharp-edged lines and exquisite details of daguerreotypes was never clearly stated. Its adoption was perhaps due to Le Gray who communicated to the Académie des Sciences in February of 1851 that the use of his chemically treated dry waxed-paper process presented a great advantage because a photographer could operate on paper prepared well in advance of composing the view. Apparently many travellers before leaving on excursions would visit Le Gray's studio, take a few lessons and equip themselves with his dry waxed-paper procedure. It was ideal for fieldwork because it enabled the exposure of dozens of negatives in a single day without having to develop them on the spot. Also Bayard was known to have been experimenting with paper negatives and he too may have influenced the choice.[76]

This choice of the soft-hued calotype enabled the *Mission* photographers to bring imaginative reveries rather than hard cold facts to the surface, and were quite at variance with Mérimée's intention to render the world as information. He preferred to let the monuments speak for themselves, not clouded with expressive gestures. Perhaps this is why the negatives from the *Mission Héliographique* were never printed by the state and, instead, were placed in the *Mission*'s archive, where they remained, almost unknown. Only Le Secq's negatives were printed in any number, but it happened that here and there a photograph that was probably taken by one of the photographers would appear as an architectural illustration, but without attribution to the artist, the *Mission*, or the date. Bayard, the eldest of the photographers, continued to work with albumen glass plates, but his negatives were never submitted and only a few, such as the image of a tower at Caen and the Château de Falaise, can be attributed to his *Mission* work. During Le Gray's *Mission*, Francis Wey reported in *La Lumière* on the dispatches that were returned to Paris and the sublime effects the calotype achieved:

FIGURE 1.5 In this view of Reims Cathedral by Henri Le Secq,
construction scaffolding, encasing the tower at left, almost disappears in
the elaborate decoration of the exterior, and details that would ordinarily
be missed from the ground are here revealed with breathtaking clarity.
Henri Le Secq, 'Tower of Kings, Reims Cathedral', France, 1851. Salt
print, 352 × 260 mm. Courtesy: J. Paul Getty Museum.

Accompanied by M. Mestral, M. Le Gray is working in the regions of the Midi beyond
the Loire toward the Mediterranean: he has not yet returned but has sent precious
dispatches. His plates are enormous; in his studio we have seen those of the château
of Blois, that beautiful and severe page of Renaissance: the effects have been so well

captured that several among them have the strange vigor, powerful relief, and almost fantastic impression of the engravings of Piranesi. Photography has attained a magic feeling that neither drawing nor painting could have reached, especially with regard to Gothic structures. It renders the idea of grandeur, the audacity of proportions that are so striking in the actual presence of these marvels. Whereas engraving aggrandizes the Greek or Roman construction and shrinks those of the Middle Ages, photography, by profusely aerating everything, by softening the swarming details without obliterating the contours, presents to the delighted eye monuments as great as their counterparts in reality, and sometimes even greater. For the old Valois château awakens in our minds the kind of surprise one experiences before the grandest edifices.[77]

An article by Henri de Lacretelle, appearing in *La Lumière*, 20 March 1852, gives evidence that some of the photographs were printed and exhibited if only to the Société Héliographique. Lacretelle declared that he had been completely 'conquered' by the quality of Le Secq's photograph of the cathedral of Reims (Figure 1.5) and he gives evidence that the *Mission*'s work was not just focused on the details of restoration but was inspiration for moral uplift:

> That which we would never discover by our own eyes, he has seen it for us ... One might say that the saint artists of the Middle Ages had foreseen photography ... the entire cathedral is reconstructed, course by course, with marvelous effects of sun, shadow and rain. M. Le Secq makes this cathedral also his own monument.[78]

Not much is known about why these former painters suddenly found themselves intrigued by photography. Almost nothing is known about Mestral, except that he belonged to a group around Le Gray that included Le Secq. All five artists had already experimented with photographing architectural objects, although their major work still lay in the future. Eventually Baldus and Le Secq would build on this experience and pursue careers as architectural photographers. All five were members of the Société Héliographique from its inception in 1851. Bayard was Vice-President and Le Gray played an active role. As painters, Le Gray and Le Secq had worked in Paul Delaroche's atelier, and Delaroche had been instrumental in supporting the state's role in the development of photography since 1839. Evidently Baldus, when a young man in the Prussian army, was known for his talent as a *dessinateur de perspectives*, a good training for an artist who would become interested in architectural photography.

A hint at the photographers' own intentions may be gleaned from the emphasis they placed on art over science. Charles Nègre, a fellow artist from the group around Delaroche and a member of the Société Héliographique, having learned the dry waxed-paper process from Le Gray in September of 1850, wrote a letter to the editor of *La Lumière* the following May which explained:

> We artists who have enthusiastically accepted heliography, this powerful aid that science has given to us, had previously considered our position as quite predetermined, now we

FIGURE 1.6 Édouard Baldus, 'Cloister of Saint-Trophîme', Arles, France, 1851.
Baldus joined together ten different negatives in order to obtain the range of tones
and depth of field he desired in this image. Salt print, 368 × 414 mm. Courtesy:
J. Paul Getty Museum.

find it exciting. Where science ends, art begins. The chemist prepares the sheet of paper,
but the artist directs the lens and guided continually by three beacons in the study of
nature: observation, feeling, and reason, he reproduces effects that make us dream,
simple motifs that move us and sites whose bold and powerful silhouettes astonish and
even frighten us. We have become convinced today that it is less difficult to reproduce
nature than to learn to see her. Before the discoveries of heliography, an artist was
generally considered perfect when he reproduced nature exactly; today, with chemistry
serving this need, we say that the most perfect artist is the one who chooses from nature
with the most taste. Before, we reproduced nature; today, we choose in nature.[79]

Quite clearly the photographers were free to choose their own direction. One of
Baldus's views from his *Mission* work reveals the north gallery of the Cloister of Saint-

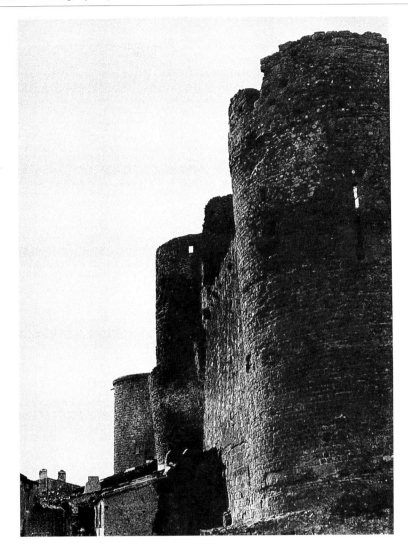

FIGURE 1.7 Gustave Le Gray and O. Mestral, 'Ramparts and corner tower', Carcassonne, France, 1851. Salt print from dry waxed-paper negative, 333 × 235 mm. This photograph may have been the one Wey compared to the engravings of Piranesi. Courtesy: Robert Koch Gallery, San Francisco.

Trophîme in Arles (Figure 1.6). As Malcolm Daniel has observed, this photograph is a typical romantic scene depicted by earlier lithographers of France's patrimony, but Baldus was, in addition, interested in capturing the enormous scale of the cloisters, the literal play of light and shadow and the detail of its sculpture and stones. Unfortunately, his lens could focus on only a portion of the scene while his emulsion could record only a limited range of light and shadow. To achieve the effects of scale

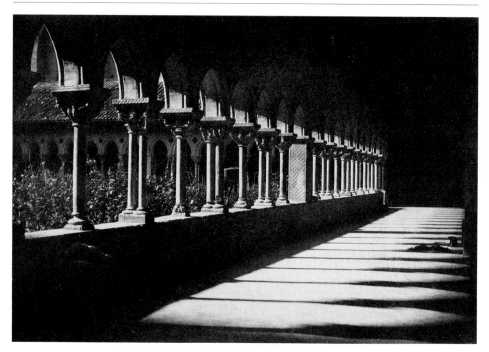

FIGURE 1.8 Gustave Le Gray, 'Cloister of the Abbey Church of Saint-Pierre',
Moissac, France, 1851. Salt print from paper negative, 230 × 345 mm. Le Gray's
taste for sumptuous effects of light and shadow, alternating patches of sharp detail
with voids of darkness, can be seen in this photograph. Musée d'Orsay, Paris.
Courtesy: Réunion des Musées Nationaux/Art Resource, NY.

and detail that he desired, he pieced together ten different negatives, joining them
along the contour lines of columns, cornices and masonry joints, and then retouched
the prints to hide the seams and enhance their tones.[80] This would continue to be
Baldus's style: blending both the picturesque treatment of the scene and the romantic
aura of place with the objectification and details of the architectural monument.[81]
Just as the restorer sought to strip away the surrounding structures that encumbered
a full view of an architectural monument, so Baldus worked in the same spirit –
cutting, pasting, eradicating, until the image of his monument was free from additions
and distractions. His was a search for the particular tones, textures and silhouettes
that characterized an architectural monument.[82]

Le Gray's photographs of the south-west sections of France taken for the *Mission*
reveal the deep melancholy nature of the passage of time. Le Gray photographed
Carcassonne (Figure 1.7) – one of Mérimée's favourite sites – which Viollet-le-Duc
would radically transform in his restoration work. Le Gray was among the earliest
photographers to understand that the camera could be deployed to assemble

artistically constructed compositions. Utilizing the romantic eye of the painter, Le Gray commented in 1854 that:

> It is especially with artists that the camera can achieve its best results; the artist can emphasize or diminish certain details, produce powerful tones of light and dark, or effect sweet softness in the model … It is truly the artist or man of taste who can obtain perfect work with this instrument so capable of rendering an infinite variety of interpretations.[83]

Le Gray modelled the fortifications of Carcassonne in modulating tones of greys, blacks and whites as he chemically manipulated the photographs for poetic effects. He softened many of his monuments with foliage and landscape views, playing with light and shadow until his prints took on the tonalities of colour.[84] Henri de Lacretelle praised Le Gray's 'Abbey of Moissac' (Figure 1.8) in *La Lumière* of 1852, claiming he had obtained 'moonlight effects on the dreaming, silent ruins of the cloister, so true that one expects to see the stones of the tombs rise up by themselves'.[85]

What happened to the *Mission Héliographique*? With so much clamour and excitement swirling around the marvellous effects of photography, so many associative directions down which the imagination could stroll and so promising a future for a scientific instrument that could reduce the architectural heritage of the world to miniaturized form and bring it close enough and with precision allow for detailed inspection, what happened to the photographic documentation of the architectural patrimony of France – the work of the *Mission Héliographique*? There is considerable debate about the 'failure' of the Commission des Monuments Historiques to print or to exhibit the photographs. Weston Naef suggested in 1980 that, since the prints inevitably faded, they disappointed the commissioners who thus decided not to print all of the negatives. Rosalind Krauss also addressed the issue, claiming the failure to print the 300 negatives 'is analogous to a director shooting a film but never having the footage developed, hence never seeing the rushes. How would the result fit into the oeuvre of this director?' André Jammes and Eugenia Parry Janis, in *The Art of French Calotype*, offer a different argument, claiming that the Commission's intention was either to build up an archive for each historic monument – and thus negatives would suffice – or that the photographs presented the structures in too romantic a light, and so could not argue the cause for restoration. They do, however, claim that masons and architects attempting to restore damaged ornamentation would have studied the negatives.[86]

Shelley Rice, in *Parisian Views*, contends that the *Mission Héliographique*'s function was a conservative one: to establish a photographic archive preserving the image of France's vanishing architectural heritage. She claims this created a disjunctive link between a predominantly nostalgic vision and the use of the latest technical invention. Consequently these photographers paradoxically focused on architecture as object at

the very moment the primacy of object-oriented modes of vision were replaced by a more focused look at the visual trace.[87] But, in fact, as has been shown, Viollet-le-Duc was able to use the photographic trace to great effect in his restoration work. Perhaps a better reason why the negatives were not printed in their entirety was the need for architects to focus on large-scale drawings more than on photographs, and this may have been the reason why the dossiers kept on each monument contained numerous drawings and prints, but relatively few photographs. It may not have been readily apparent to the architect's eye trained in drafting skills to see that photography could be the 'handmaiden' of architectural restoration.[88]

Conceivably, the reason why the negatives were never printed is simpler: the *Mission Héliographique* appears to have been a collaborative effort between the Société Héliographique and the Commission des Monuments Historiques, in which the former may have been responsible for printing the paper negative photographs which, in 1851, was an extremely costly and time-consuming endeavour. Louis-Désiré Blanquart-Evrard printed some of the negatives of Le Secq, Baldus and Le Gray. But the commercial failure of his photographic printing shop in Lille was caused by the costly process of preparing paper by hand, before exposing, developing and fixing it. This expensive and time-consuming procedure no doubt prompted the Société Héliographique to desire a printing shop of its own.[89] When its proposed printing factory fell through, it is possible that the lavish expenditure of independently printing the negatives from the *Mission* was prohibitive.

Fortunately, the proofs and negatives of the *Mission Héliographique* remain up to the present in the archive; they are their own testimony to the past. In 1856, Ernest Lacan would write in *La Lumière* that many precious monuments will disappear in time, but thanks to photography they will remain forever in our memory:

> All the debris from another age that are so dear to the archaeologist, the historian, the painter, the poet are reunited through the work of the photographer and rendered immortal. Time, war, terrestrial upheavals can destroy them up to the last stone … they live on in the album of photographs … The great epochs of art have left some cathedrals, palaces, monuments which are some types that are seriously studied for their beauty and their completeness: which is architecture. It was necessary to go to study in their place these celebrated monuments, or to rely on insufficient designs, imperfect, whatever the talent of their author. Today photography gives you their admirable reproductions. No detail escapes it …
>
> The Commission des Monuments Historiques understood the service that photography can render to it, and entrusted to some distinguished photographers its missions. Their views have justified the expense.[90]

By fixing images made at a specific time and place, photography offered a visual record of transient moments that could be measured against future changes. With heightened visuality, it thus inserted itself into the temporal continuum of past, present

and future, as a memory device. Within a few years, photography became a craze, prompting Charles Baudelaire to advise in 1859 that it must 'return to its true duty ... to be the servant of the sciences and arts'; but he, too, could not but admire the manner in which photography preserved the memory of time and place:

> Let photography quickly enrich the traveller's album, and restore to his eyes the precision his memory may lack; let it adorn the library of the naturalist, magnify microscopic insects, even strengthen, with a few facts, the hypotheses of the astronomer; let it, in short, be the secretary and record-keeper of whomsoever needs absolute material accuracy for professional reasons. So far so good. Let it save crumbling ruins from oblivion, books, engravings, and manuscripts, the prey of time, all those precious things, vowed to dissolution, which crave a place in the archives of our memories; in all these things, photography will deserve our thanks and applause. But if once it be allowed to impinge on the sphere of the intangible and the imaginary, on anything that has value solely because man adds something to it from his soul, then woe betide us![91]

Conclusion

In the end, the argument of the success or failure of the *Mission Héliographique* returns to the inextricably combined narrations that used these photographs of historic monuments as both aids to memory and the archive, as both moments of reverie and managerial instruments to classify types and forms of knowledge. The *Mission Héliographique* was a project whose task was to dehistoricize the architectural object and render it in useful and ocular form as well as to landmark and visually record an imaginative geography of the patrimony of France. It is obvious that the beauty and subtlety of the calotypes were far from purely informational. Their magical appearance always revealed antithetical details never subordinated to a more meaningful whole. They lent themselves to anecdote and reverie, shifting attention away from the factual and the precise, opening onto unforeseen horizons and associative memories.

The Commission des Monuments Historiques singled out not only the technical procedures of restoration, but also the new technology of photography to draw attention to its architectural past and establish rapport with the history of a nation. From the storehouse of the museum to the discourse in journals and folios, from the archive of proofs and negatives to the monuments in their atmospheric settings, a preservation mentality was put into play and linked to collective memory. The startling visual effects that arose from photographic images, from a structure in its contemporary surroundings or from stones and paintings in a museum – these were the source not merely of study and analysis, but imaginative projection. Mastering two registers at once, these images were destined for the work of classification, storage and preservation, and simultaneously the opposite, constructing an imaginative geography, a mental map of time, places and events. To fill in the white spaces on the

regional maps of France with stories and images, to clothe it with meaning and establish a way of seeing what one wanted to say and remember about the past and the nation, required both an inventory of sites and monuments, and a keen sense of visualization and insight. The moment when the two registers crossed, the *Mission Héliographique* was born.

TWO

Retracing the Outlines of Rome: Intertextuality and Imaginative Geographies in Nineteenth-Century Photographs

Maria Antonella Pelizzari

Photographic Utterances and the Outlines of Rome

§ IN *Pictures from Italy* (1846), noted author Charles Dickens commented: 'There is, probably, not a famous Picture or Statue in all Italy, but could be easily buried under a mountain of printed paper devoted to dissertations on it.' Against the all-encompassing descriptions he knew from guidebooks and history texts, Dickens claimed that his book was 'a series of faint recollections – mere shadows in the water – of places to which the imaginations of most people are attracted'. The writer's 'recollections' had this virtue: they were 'written on the spot … penned in the fullness of the subject, and with the liveliest impressions of novelty and freshness'.[1] They were not comprehensive or scholarly, but spontaneous.

The early photographers and travellers who visited Italy sought to bring back similarly personal and spontaneous records of their visits. Indeed, it is worth noting that the genesis of photography can be traced to the shores of Lake Como where, in 1833, British traveller William Henry Fox Talbot, frustrated by his inability to sketch the landscape in front of him, was inspired to find a new way to capture his own impressions of those 'lovely shores'.[2] Unlike Sir John Herschel, who moved around the Mediterranean with a portable 'philosophical travelling kit' and even wrote poetry in the borders of his *camera lucida* drawings,[3] Talbot, while admiring the fleeting images of the lakeshore in front of him and commenting on those 'fairy pictures, creations of a moment, and destined as rapidly to fade away', felt incapable of illustrating what he saw.[4] Aware of his own failure at drawing, Talbot sought a mechanical system of representation, which could record those images 'on the spot', with the same immediacy and freshness of Charles Dickens's written notations.

Photography was born from Talbot's sense of inadequacy as an artist when faced with an attractive, foreign scene. The new system of description could potentially

satisfy the need to convey an instantaneous view of an exotic place. If Talbot had initially conceived photography as an aid to travel during his Italian tour, he subsequently identified travel as one of the important applications of his process. In 'Some Account of the Art of Photogenic Drawing' (1839), he wrote that 'to the traveller in distant lands, who is ignorant, as too many unfortunately are, of the art of drawing, this little invention may prove of real service'.[5] Even though he recognized that 'this natural process [did] not produce an effect much resembling the productions of his pencil', he considered part of the traveller's experience the need to devote time 'to the delineation of some interesting locality'.[6] Distance between home and abroad, lack of drawing skills and speed in recording an interesting scene were the factors involved in his use of photography.

No less than writing, sketching and painting, photography came to be an integral part of experiencing and recording impressions of a distant landscape. If, as Dickens seems to suggest, the image of Italy as a place in the nineteenth-century mind was punctuated by a series of individual utterances within the mass-produced description of Italy by the tourist industry, then photographs partook of the same issues of representation. Following the early amateur photographers to Italy, commercial photographic studios, beginning in the 1860s, produced and marketed views in most Italian cities, directing the tourist's gaze to the main monuments, piazzas and panoramic viewpoints. This uniformity became even more regimented after Italy's unification in 1870, with Rome as political capital, when modern districts were built for the industrialized middle class, and many monuments were erected to the heroes of Risorgimento.[7]

Notwithstanding the homogeneous production of tourist photographs by commercial studios such as Alinari, Sommer, Naya and the like,[8] this chapter focuses on three photographic 'utterances' which, like Dickens's *Pictures from Italy*, were idiosyncratic and personal encounters with Rome as a place in the geographical imagination. Looking at photographs as particular representations of a foreign site, my investigation is in line with James Buzard's essay on travel and tourism, in which he questions 'how individual freedom and originality is to be reconciled with the impersonal and standardizing web [of tourism] that contains it'.[9]

I argue that this 'individual freedom' in picturing a fully scripted place such as Rome can be detected, not within the photographs themselves but in the photographers' diaristic notations around the images, in the subtle marks left on the surface of photographs purchased from commercial studios, in the passages carefully transcribed from guidebooks to the pages of photographic albums, in the tourist's imaginary constructions of pre-packaged literary descriptions and in the intertextuality of the narrative.

In his study of travel literature as 'a "transgression" with relation to a given discursive regime',[10] Dennis Porter claims that 'writing' is based on the experience of leaving one's own 'individual mark', thus conveying the impression of actually having

been there while touring a place, or making and purchasing photographs. Through an analysis of the intertextuality of photographic images and written notations, this essay elucidates the role of photography in the tourist experience, as a means of visualizing both the real and the romantic. Words and photographs echo and intensify each other as descriptions of a site. As a consequence, Rome escapes a univocal representation, and, through the process of leaving one's own comment, individual imaginative geographies are constructed.

Specifically, I will investigate the individual utterances embedded in three groups of nineteenth-century photographs of Rome. These involve amateur photographs taken and inscribed by a British traveller; commercially produced photographs purchased and compiled into albums by an anonymous American tourist; and a photographically illustrated novel which resulted from a creative collaboration between book publisher and bookseller, author and audience, photographic fact and literary fiction. I will explore the individual sensibilities at work in these representations, situating such sensibilities against the discursive grain of nineteenth-century tourism in Italy.

Topographical Memory: The Calotypes of C. S. S. Dickins

One British traveller and amateur photographer who visited Italy between November 1856 and March 1857 was Charles Scrase Spencer Dickins. A group of his calotype negatives and matching salted paper prints are now preserved at the International Museum of Photography at George Eastman House in Rochester, New York.[11] Some of this group, representing the manor house, gardens and chapel at Coolhurst, Sussex, in 1854 and 1855, bear the photographer's signature.[12] Another thirty-nine calotype negatives of Rome, two negatives of the Lungarno in Florence taken at the beginning of the tour on 1 November 1856, and thirty-four matching salted paper prints are not signed by the photographer, but exhibit many similarities with the earlier, signed group – the size of the paper (approximately 24 x 30 cm), the type of retouching (waxing and Japanese ink below and on the upper part of the skyline, respectively), the handwriting indicating the date on the negative and giving topographical in-formation on the positive print and mount.

Research into the provenance of these two groups, from the property of the Marquess of Northampton,[13] has led to the original source: the photographer's house at Coolhurst near Horsham, Sussex. The photographer, Charles Scrase Spencer Dickins (1830–84) was the son of Lady Elisabeth Spencer Compton, the sister of the Second Marquess of Northampton, and of Charles Scrase Dickins.[14] He lived on the estate that Lady Elisabeth had inherited from her mother, Lady Mary Compton.[15] His connections with photography were probably stimulated by Lord Northampton, a man of broad interests in science, literature and the fine arts, who was the President of the Royal Society (1838–48) when Talbot read his paper 'Some Account of the Art

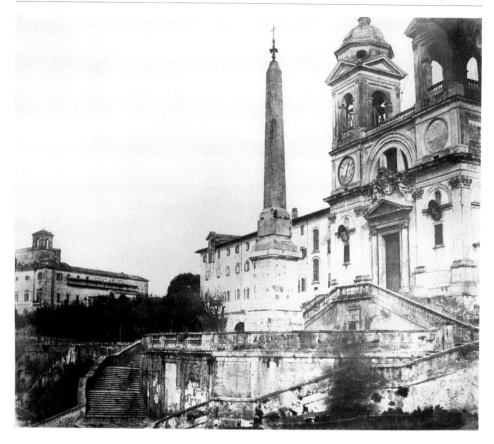

FIGURE 2.1 Charles Scrase Spencer Dickins, 'Church of Trinità dei Monti from the top of the Hotel Europa', Rome, 11 November 1856. Salted paper print, 245 × 288 mm. Courtesy: George Eastman House/International Museum of Photography, 81:3196:0008.

of Photogenic Drawing' on 31 January 1839. At his residence of Castle Ashby, Lord Northampton held scientific gatherings, where early photography was presented and discussed. Sir John Herschel and Talbot corresponded about such events, and, most likely, attended them.[16]

It is possible that Dickins learned the photographic process in his early twenties, within the British milieu which was promoting scientific discoveries. He might have also learned about the process during the years of his college education. Between October 1849 and June 1851, Dickins was enrolled as 'Gentleman Commoner' at Christ Church College in Oxford, reading Greek and Latin authors and taking lessons in Algebra, in the same rooms where, in the 1850s, two British amateur photographers, Charles Lutwidge Dodgson ('Lewis Carroll') and Nevil Story Maskelyne, were, respectively, tutor and science professor.[17] The fact that Dickins travelled to Italy can be

traced to a reference to 'Mr. Dickins and Charlie' in a letter addressed by a friend in Coolhurst to his mother, Lady Elisabeth, who was in Rome with her husband and son.[18] This letter, dated 26 November 1856, suggested locations for 'Charlie's photographical subjects in Rome', noting specifically the Villa Albani and the view from this site.

Dickins's photographs belong to a transitional phase in the history of photography in Italy. As calotypes, from negatives on paper, they are part of the early history of the medium when photography was pursued by a small group of foreign, well-educated travellers and local practitioners in Italy in the 1840s. One of the last British amateurs travelling to Italy with his calotype camera, Dickins, like Talbot, was drawn to record his own impressions, accepting the physical challenges of atmosphere, light and sensibility, different from the ones he had experienced at home at Coolhurst.[19]

Dickins followed the well-worn path of many British travellers on the Grand Tour, stopping in Florence and making Rome his base. His journey, like his photography, was at the cusp between the aristocratic tour and the massive flow of tourism in Italy. Dickins probably travelled on a coach with the family, or he hired a *vetturino* for the journey from Florence to Rome.[20] In Rome, he stayed in the Hotel Europa, by the Piazza di Spagna, in the area of promenades 'most frequented at Rome',[21] not far from the entrance to the city at the Porta del Popolo. Dickins's photographs document this route like a visual diary.

Significantly, Dickins's first photograph in Rome was taken 'from the top of Hotel Europa' on 11 November 1856 (Figure 2.1). From the terrace of his hotel, the British traveller enjoyed a splendid view towards the upper part of the Spanish Steps, with the Church of Trinità dei Monti on the right and, in the distance, the French Academy at Villa Medici. This image suggests his familiarity with, and recollection of, the first two plates in Talbot's *The Pencil of Nature*: one of Queen's College in Oxford, and the other showing a view from the Hotel de Douvres in Paris. Like Talbot in Paris, Dickins in Rome took advantage of the location of his hotel to make the photograph,[22] and, like Talbot in front of Queen's College in Oxford, he structured the composition around architectural masses. He illustrated the interaction between the Spanish Steps and the staircase reaching the Church of Trinità dei Monti, punctuating these architectural volumes with the vertical lines of the obelisk, the church and part of the French Academy in the distance. A month later, he made another photograph from the third floor of the same hotel, opening the view towards the Scala di Spagna and the Villa Medici (Figure 2.2).

Both views are stark representations which frame the buildings inside the urban context, leaving the surrounding life out of the frame. Looking at the Spanish Steps a few years earlier, the writer Charles Dickens had described the colourful spectacle of Italian models sitting on the steps and performing Italian 'types' for the artists' inspiration, resembling living replicas of those painted characters that he had seen in exhibition galleries all around Europe.[23] None of Dickins's early photographs of Rome

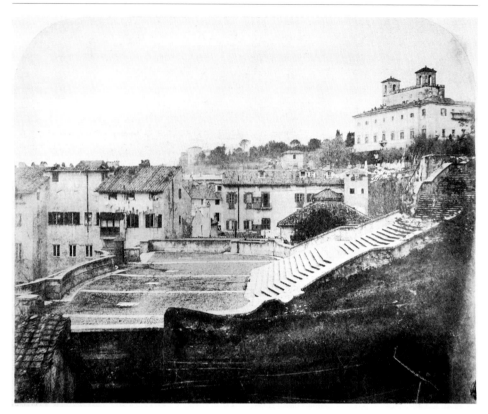

FIGURE 2.2 Charles Scrase Spencer Dickins, 'Upper part of the Scala di
Spagna and the Villa Medici from the third floor of the Hotel Europa', Rome,
17 December 1856. Salted paper print, 236 × 291 mm. Courtesy: George Eastman
House/International Museum of Photography, 81:3196:0011.

records this lively crowd. His particular focus on historic buildings, and the techno-
logical impediments of long exposure and low contrast inherent in the calotype
process, combined to produce an impression of Rome as a ghost city – a classical city
along the banks of the Tiber, presenting to view its Roman ruins, Renaissance palaces
and basilicas.

Apart from his choice of subject matter, the most significant aspect of Dickins's
calotypes lies in the written inscriptions on his negative and positive images. Most likely,
he processed the calotype negatives in Rome, writing on each of them the date and a
brief indication of the site, while he probably printed and mounted the photographs
back home,[24] adding a much more detailed description of the location, occasionally
with the historical information he found in his John Murray's *Handbook for Travellers in
Central Italy*.[25] Thus, he wrote on his photographs twice, as a topographer of his own
memory.

In this way, the photographs served as a way of experiencing and imagining,

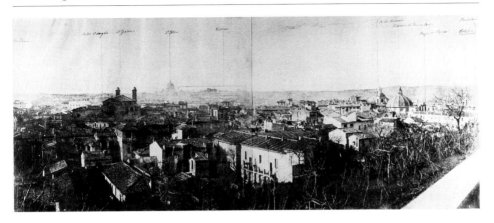

FIGURE 2.3 Charles Scrase Spencer Dickins, 'Panoramic view from the Pincian Hill', Rome, 1856–57. Salted paper print, 209 × 518 mm. Courtesy: George Eastman House/International Museum of Photography, 82:1640:0001.

recording and recalling places in time and space, along with the historical information associated with them. In their factual form, they carried the photographer's own writing, testifying to his use of the guidebook along his walks in Rome, and, back home, as a textual recollection of what he had seen and photographed. Applying this procedure, Dickins followed Talbot's ideas expressed in his Royal Society paper 'Some Account …' in which he declared that the photographs taken, 'when examined afterwards, may furnish [the traveller] with a large body of interesting memorials, and with numerous details which he had not himself time to note down or to de-lineate'.[26] Dickins's photographs were memory traces, to which he added diaristic information, and they also presented detailed views onto which he inserted ink and pencil notations, once he returned to England.

Dickins's two-step inscription of his photographs is particularly relevant in his production of a mounted two-plate panorama, where he added topographical pencil notations indicating the main buildings in the outline of Rome (Figure 2.3).[27] The viewpoint which Dickins chose for his panorama corresponded to the one adopted by Sir John Herschel in 1824. Herschel had condensed the same image, seen through the lens of his *camera lucida*, onto a single sheet of paper, revealing his intention 'to size up [the view], to measure it, and to understand it'.[28] The panorama was taken from the terrace beyond the Villa Medici, on the Pincian Hill, a location not far from the Hotel Europa where he had made his first picture only three days earlier. As the dates on the images suggest, he surveyed the outline of Rome from this panoramic site before recording the buildings and ruins displayed in the city below the hill.

Dickins's descriptive visual and verbal mapping in his panorama, a practice often used by early travelling photographers, indicate the nineteenth-century belief that photography was an accurate system for scientific measuring and encompassing the

world. As current essays on cultural mapping have demonstrated, this topographical attitude was a means to control a territory. The map was 'a particular instrumental form of power',[29] and photography, through its apparent objectivity, contributed to this representation.

In the context of tourism as a particular power structure imposing certain codes and paths to its clients, Dickins accepted the authority of his guidebook in order to orient himself in Rome, choosing the most comfortable hotel and selecting the most conventional and effective panoramic viewpoint from the Pincian Hill. But when we think of Dickins's act of retracing the outlines of Rome from the two-plate photograph to a verbal grid with names of monuments and locations, it becomes apparent that the photograph was for him an incomplete illustration of the view he had seen. With his pencil inscriptions, Dickins layered a diagram over a photograph, suggesting a complementarity between the two systems of description, and diminishing the value of the photograph as a single, universal, spatial representation. Through this process of rewriting, the photograph appears like a text in relation to another text, one reflecting the other like a 'mirror construction'.[30]

In Dickins's descriptive layering, the topographical record was intensified as a personal recollection of having been in Rome through the process of inscription. The actual photograph was a means to his subsequent imagination of the place recorded. In the mirror of his memory, the photographer was able to see what he had seen, remembering it, facing that distant moment from his manor house. Even though Dickins's notations on the photographs were drily factual, and did not convey the poetic flavour of such British draughtsmen as Herschel or, later, John Ruskin, this photographer's imaginative geography of Rome blended scientific accuracy and personal experience, photography and memory, words and images, eliminating the dichotomy between the reality and the representation of Rome.

Guidebook Engagement: The Albums of an Anonymous American Tourist

In 1889, an anonymous American tourist made the Grand Tour of Europe and the Middle East, purchasing commercially available albumen prints en route, and compiling these views into a series of six albums.[31] Unlike Dickins and his family, this tourist visited Italy by train, possibly joining Thomas Cook – 'the Emperor of Tourists' – with his organized tours and 'combined arrangements' on the Continent.[32] Like Dickins, this tourist followed a prescribed path, guided by his/her handbook, and empowered by the greater freedom of movement and transportation. But this travel, and the photographs accompanying it, resulted in a more standardized and carefully organized outline of Rome than Dickins's calotypes produced.

The anonymous American tourist's albums are accompanied by a sixty-three-page manuscript, 'Catalogue of Views', which inventories the six volumes of photographs:

London to Rome, Rome to Pompeii, Pompeii to Berlin, Berlin to Cairo, Egypt and *Palestine*. The first four albums, with a total of 435 photographs, are preserved at George Eastman House; the last two are missing. In the 'Catalogue of Views', each individual photograph is listed with the title, a short description and the reference to the page of the Baedeker.

The tourist might have first purchased the views of the sites visited and subsequently drawn the information about them from the handbook, or, more likely, might have toured with the Baedeker handbook, transcribing into the 'Catalogue' the page numbers of the sites to be visited, and purchasing the photographs corresponding to those pages, like a tourist of our time would purchase souvenir postcards. These albums illustrate the seemingly inescapable 'cycle of pre-texts, itineraries and representations' in the construction of imaginative geographies: 'Pre-texts shaped itineraries, itineraries prescribed photographs, photographs established itineraries.'[33] The cycle becomes particularly evident in the constitution of the albums: most plates refer to the page numbers of the Baedeker for a description of the view, and often the description in the Baedeker is copied around the margins of the photograph.

Detailed information about a building's height, width, depth and date of construction is also offered, in a seemingly perfect command of the styles and language of architecture. St Peter's in Rome is compared in size with Milan Cathedral, St Paul's in London, St Sophia in Constantinople and the Cathedral in Cologne. Through the standardized process of measuring feet and stones, everything becomes familiar. The Eiffel Tower is seen through the filter of the Washington Monument, as St Peter is compared to St Paul. In this album, the tourist's 'experience of difference … mastering otherness and profiting from it'[34] runs through the views of London, Paris, the French and Italian Riviera, Pisa, Rome, Pompeii, Berlin, Egypt and Palestine – places all distant from one another, but homogeneously described, catalogued, packaged and bound together. The Baedeker handbook produced an imaginative geography of Rome which left little room for random wanderings and chance encounters. These pre-packaged descriptions reveal the entrepreneurial tourist strategy, reducing foreign cultures to one orderly grid.

The visits made by this anonymous American tourist were 'acts of confirmation',[35] rather than visits to unfamiliar sites. This sort of behaviour was very similar to the one criticized by Henry Wadsworth Longfellow in his *Outre-mer: A Pilgrimage Beyond the Sea* (1866). In it, he described the tourist as someone who:

> made it a point to see everything which was mentioned in the guide-books; and boasted how much he could accomplish in a day … A Roman aqueduct, a Gothic Cathedral, two or three modern churches, and an ancient ruin or so, were only a breakfast for him. Nothing came amiss; not a stone was left unturned. A city was like a Chinese picture to him, – it had no perspective.[36]

One plate from the 'Second Book' in the set of albums, *From Rome to Pompeii*, is

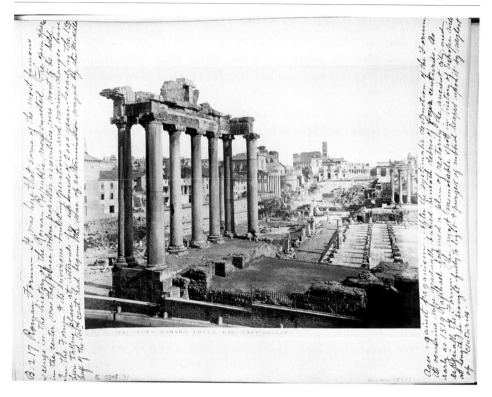

FIGURE 2.4 Unidentified photographer, 'View of the Roman Forum from the
Capitol Hill', Rome, c. 1870s. Albumen print, 204 × 258 mm. Courtesy: George
Eastman House/International Museum of Photography, 86:0308:0031.

particularly revealing of what Longfellow calls 'the city as a Chinese picture with no
perspective'. Space and time are shrunk for this tourist visiting Rome 'with the speed
of thought'.[37] The photograph (Figure 2.4) is framed on both sides with the hand-
written description derived from the Baedeker. But a closer reading of this picture
and text shows that they refer to different moments in time, indicating a slippage
between the visual, intellectual and experiential tracings of the outlines of Rome.

The photograph shows the Roman Forum from the Capitol Hill. It is a standard
view, depicting the Forum between the Capitoline and the Palatine Hills, with the
Temple of Saturn dominating the foreground, the ruins of the Roman Basilica,
the Temple of Castor, and the Sacred Way, leading to the Arch of Titus and the
Colosseum. This photograph, taken in the 1870s, shows the recent excavations of the
Forum, emerging from its earlier condition as 'Campo Vaccino', or cow pasture. There
is no trace of romantic contemplation in this view. Rather, the character of this
photograph reflects the dutiful and disciplined tourist visit, accompanied by a verbal
description of the Forum's past glory and, mainly, of the necessary work of archaeo-

logical excavation and cleaning for the Forum to be 'purged of rubbish'.[38] But, ironically, the 'purge' which the tourist's handwritten text calls for had already occurred when the tourist copied this line onto the page of the album.

The layout of the written inscriptions and photographic images on many pages of these albums reveals the progressive elements of the tourist's photographic experience of the site: the selection and purchase of the view; the ordering and mounting of the view on the album page; and the addition of descriptive notes around the edges of the view, which included copying information about the site from a sometimes outdated Baedeker. The act of transcribing words from the Baedeker into the album attests to the tourist's faith in the guidebook. The juxtaposition of transcription and photograph betrays the difference between representation and reality, between the act of viewing the photograph and the act of experiencing the scene. It also betrays the construction of an imaginative geography which reconciles conflicting details collected on the spot, extracted from the handbook and gathered from the photograph.

Another page presents a temporal disjunction between the photographic view and the verbal text. This view of a terrace around the harbour of Genoa, described in the Baedeker and transcribed into the album, existed at a time prior to the visit of the album compiler. Thus, whereas the description of the Forum in the Baedeker envisages a future transformation which has already taken place in the photograph, the photograph of Genoa harbour becomes a nostalgic representation of what has already passed into history. On another page, the slippage is spatial: the photograph of the graveyard in Pisa is described, below the Baedeker's page number, as the graveyard in Genoa (one Gothic, the other neo-classical architecture). Yet elsewhere, the discrepancy between text and image is visual: a photograph of the empty square in front of the Pantheon is described in the accompanying text transcribed from the Baedeker, as 'generally, a busy scene'. The pages in these albums are sites where the actual, the written and the photographic experiences of place converge, and where the anonymous American tourist's imaginative geography is negotiated in the intertextual space of these slippages. With their seeming truthfulness and realism, the commercial photographs in these albums grant the anonymous tourist an 'authority over imagination',[39] while the tourist's inscriptions reveal that this authority and realism are oftentimes deceptive when compared with the actual experience of visiting the site.

Such discrepancies become even more interesting on those pages where the tourist's text is not derived from the Baedeker, but rather is a personal narration of travel. On one page, below the photograph of the French town of Villefranche, the commentary indicates the presence of 'American gun-boats' on a specific date in February 1889. However, this is clearly not the date when the view was taken, for the photograph shows a quiet little harbour, with no sign of gun-boats. On another page, once again in Rome, the reference to the Baedeker is only a bookish reminder of a personal and succinct description of what tourists experienced when, 'shortly after leaving the city,

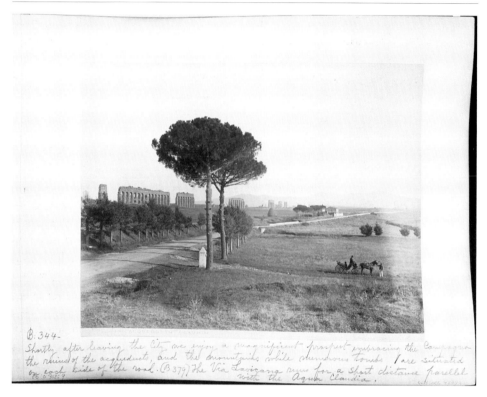

B. 344.
Shortly after leaving the City we enjoy a magnificent prospect embracing the Campagna, the ruins of the acqueducts, and the mountains while numerous tombs [are situated on each side of the road. (B 379) The Via Lavicana runs for a short distance parallel with the Aqua Claudia.
86:0308:9

FIGURE 2.5 Unidentified photographer, 'Claudian Aqueduct', Rome, c. 1870–80.
Albumen print, 263 × 205 mm. Courtesy: George Eastman House/International
Museum of Photography, 86:0308:0009.

[they] enjoy[ed] a magnificent prospect embracing the Campagna, the ruins of the
acqueducts, and the mountains, while numerous tombs [were] situated on each side
of the road'. The photograph (Figure 2.5) shows two Mediterranean pine trees in the
foreground, opening on to the prospect of the Appian Way inside the Campagna, the
ruins of the Claudian Aqueduct and the mountains in the distance. At this mile of
the Appian Way, there is no trace of tombs. Only a horse carriage at the right of the
picture suggests an experience which occurred many miles before.

These aspects of the tourist's visit of Rome support the idea that neither photo-
graphs nor handbooks, no matter how faithful and accurate they attempted to be,
could match first-hand observation of place. Roland Barthes wrote about this concern
in his essay on tourist 'mythology': 'The "Blue" Guide testifies to the futility of all
analytical descriptions, those which reject both explanations and phenomenology: it
answers in fact none of the questions which a modern traveller can ask himself while
crossing a countryside which is real and which exists in time.'[40]

The points of fracture between reality and representation, between word and

image, are indicative of the tourist's travels and responses. The Grand Tour from Europe to Egypt and Palestine was pre-packaged by the tourist industry; the souvenir record was prescribed by the commercially available photographs. This combination was then layered over with memories of the tourist's own experience of place. The album page is the material trace of an imaginative geography, incorporating both cultural discourse and the tourist's individual 'writing'.

Tourist Romance: The Tauchnitz Edition of *The Marble Faun*

My last study of intertextuality of photographs and text concerns the assimilation of a novel into a guidebook. While the previous two studies have suggested the fictitious side of photographs and guidebooks, this third case shows the close relationship between a literary romance and a tourist visit, both accompanied by photographs. In this case, photographs act as evidence of the tourist's imaginary visit/story, thus becoming part of a fabulous perception of Rome through their illustrative power.

Nathaniel Hawthorne's *The Marble Faun*, the story of the American romantic encounter with Rome, was first published in 1860, and then republished eight years later by Tauchnitz with the new title *Transformations: or, The Romance of Monte Beni*.[41] Hawthorne's romance combined the intricate stories of four American characters temporarily living in Rome – Miriam, Hilda, Donatello and Kenyon – with observations taken from his Italian notebooks, thus introducing the facts of a guidebook into the fiction of a novel. *The Marble Faun* soon became a necessary item on the reading list of nineteenth-century American tourists in Italy; in 1879, Henry James declared it to be 'part of the intellectual equipment of the Anglo-Saxon visitor to Rome'.[42] The Tauchnitz edition further popularized this book, rendering it inexpensive and accessible to a large group of international readers and travellers.

Bernhard Tauchnitz was a commercial publisher in Leipzig, who had founded his firm in 1837, establishing its international reputation through the activity of reprinting and distributing large editions of American and British authors on the Continent. Tauchnitz – like Murray, Baedeker and Cook – contributed to the establishment of the tourist market and related romance, cultivating the imperialistic project of conquering the world through the distribution of literary texts. In Tauchnitz's own words: '[I]t gave [him] particular pleasure to promote the literary interest of [his] Anglo-Saxon cousins, by rendering English literature as universally known as possible beyond the limits of the British Empire.'[43]

The Italian tourist industry of booksellers soon joined Tauchnitz's publishing venture, creating custom-made copies with precious binding, and offering tourists the opportunity to illustrate their personal copies by tipping original photographs of the sites described by Hawthorne onto the pages of their books.[44] The purchasers could choose a ready-made package of photographs at the bookseller's, select loose photographs that reminded them of particular episodes of Hawthorne's narration,

or, sometimes, include their own photographs. As a result, no two copies of the photographically illustrated Tauchnitz edition of *The Marble Faun* are alike. The montage of photographs and text substantiated the nature of Hawthorne's text as a hybrid combination of a handbook and a romance, a bestseller written by an American author and a preciously customized book for tourists.

Hawthorne never indicated an interest for the factual information offered by guidebooks and photographs; rather, his work focused on place in the imagination: 'The reality is a failure',[45] he had exclaimed, after visiting St Peter's in Rome, adding that 'there was a better St Peter's in [his] mind'. Similarly for Hawthorne, photographic images were accurate depictions which paled in comparison with the personal images that he, as a writer, sought to conceive of places, people and historical artefacts.

If Hawthorne had a creative interest in photographs, it was primarily for their effect on the mind, as abstract images. Long before his European tour, Hawthorne had investigated the mysterious power of photography in *The House of Seven Gables* (1851),[46] exploring the photographer's special connection with the historical past. Holgrave, the protagonist, was a daguerreotypist who made mirror-images of the present in order to free a house from its bewitching history. In his Italian novel, Hawthorne intended to explore the country's ruined and picturesque landscape as a kind of darkness similar to the one revealed in *The House of Seven Gables*. Like Holgrave, Hawthorne's American characters in Rome were visionaries. They looked at Rome in a dreamful state, and saw spectres, models and 'replicas',[47] rather than the real people. The characters themselves were 'reproduced' as works of art – Hilda as Beatrice Cenci; Donatello as the Faun – and were engaged in activities of representation: Hilda was a copyist of Old Masters paintings, Kenyon a sculptor and 'plagiarist'.

The addition of photographs to the pages of *The Marble Faun* enhanced Hawthorne's thematic concerns, revealing the intricate relationship between romance and realism, invention and photographic authority, in the imaginative geography of Rome in the nineteenth century. As Stephen Rachman has noted, the photographically illustrated edition of *The Marble Faun* 'reflects not only the transformation of romance into guidebook but also how the guidebook makes explicit elements of romance that Hawthorne both recognizes and wants to resist or at least downplay'.[48] The reader of the photographically illustrated edition of *The Marble Faun* was like a 'textual flaneur'[49] in a fictional Rome, following the romantic adventures of four Americans, while looking at the city's historic monuments from the viewpoints prescribed by the standard guidebook of the time.

Thus, we find Hawthorne's characters walking in the footsteps of the British traveller C. S. S. Dickins and the anonymous American tourist, strolling on the Pincian Hill (Figure 2.6), like 'the barbarians from Gaul, Great Britain, and beyond the sea, who have established a peaceful usurpation over whatever [was] enjoyable or memorable in the Eternal City'.[50] And, at another level of 'usurpation', Hawthorne, through

The text and image shown within the figure:

116 ROMANCE OF MONTE BENI.

CHAPTER XII.

A Stroll on the Pincian.

HILDA, after giving the last touches to the picture of Beatrice Cenci, had flown down from her dovecote, late in the afternoon, and gone to the Pincian Hill, in the hope of hearing a strain or two of exhilarating music. There, as it happened, she met the sculptor; for, to say the truth, Kenyon had well noted the fair artist's ordinary way of life, and was accustomed to shape his own movements so as to bring him often within her sphere.

The Pincian Hill is the favourite promenade of the Roman aristocracy. At the present day, however, like most other Roman possessions, it belongs less to the native inhabitants than to the barbarians from Gaul, Great Britain, and beyond the sea, who have established a peaceful usurpation over whatever is enjoyable or memorable in the Eternal City. These foreign guests are indeed ungrateful, if they do not breathe a prayer for Pope Clement, or whatever Holy Father it may have been, who levelled the summit of the mount so skilfully, and bounded it with the parapet of the city wall; who laid out those broad walks and drives, and overhung them with the deepening shade of many kinds of tree; who scattered the flowers of all seasons, and of

FIGURE 2.6 Fratelli Alinari, 'The Fountain of Villa Medici on the Pincian Hill', Rome, c. 1860s. Albumen print, 140 × 100 mm. Hand-tipped into *Transformations: or, The Romance of Monte Beni*, 1868, the Tauchnitz edition of Nathaniel Hawthorne's *The Marble Faun*. Courtesy: George Eastman House/International Museum of Photography.

the addition of photographs to his story, assumed the role of tour operator, co-ordinating marvellous visits to Rome with his novel.

As in the album of the anonymous American tourist, the photographs in the Tauchnitz edition of *The Marble Faun* often diverged from the text, revealing the imaginary elements at work in Hawthorne's novel and in the tourist's experience. Hawthorne was pleased that the photograph of the sculpture included in the book did not correspond to the real Marble Faun, a sculpture in the Capitoline Museum which could not be photographed. Instead, a photograph of the sculpture in the Vatican served as a basis for visualizing Hawthorne's description of the Capitol. Similarly, in one copy examined for this essay, a photograph of a statue in Florence (the Medici Venus) was used to illustrate an episode towards the end of the book, in the Roman Campagna, of the character Kenyon digging up a sculptural fragment and bringing it to light. These images, like the novel for which they supplied visual anchors, were not indexical illustrations of the city of Rome. In them, the visual and the literary, fact and fiction, were mutually dependent, the meaning of one grounding

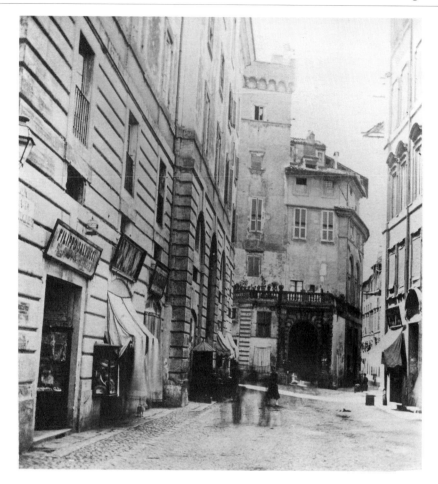

FIGURE 2.7 Unidentified photographer, 'Hilda's Tower', Rome, c. 1870s.
Albumen print, 151 × 100 mm. Hand-tipped into *Transformations: or, The
Romance of Monte Beni*, 1868, the Tauchnitz edition of Nathaniel Hawthorne's
The Marble Faun. Courtesy: American Antiquarian Society, Worcester, MA.

and reinforcing the other. The photographs in the Tauchnitz edition of Hawthorne's
book were to be seen not only as images of the city of Rome, but also as images of
a fabulous historical space.

 This process was particularly clear when the sites of Hawthorne's inventions became
'sacred' spots[51] for the tourist industry, worthy of special attention from the photo-
graphic studios in Rome. One building in particular, Hilda's Tower, the private dwelling
of the American painter and copyist of *The Marble Faun*, became such a site. Because
of its romantic quality, this mediaeval tower in Via Portoghese became an essential
element in the tourist's itinerary, like such renowned buildings as the Colosseum and
the Roman Forum. It was incorporated into the Baedeker of Rome and selected for

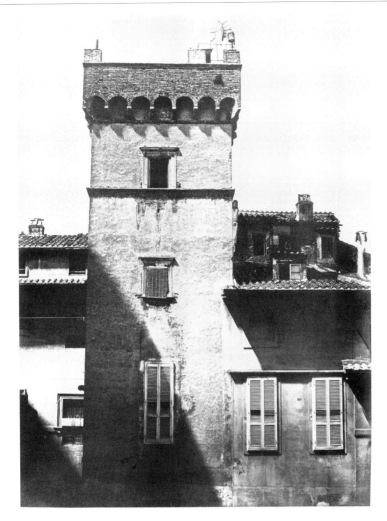

FIGURE 2.8 Robert Macpherson, 'Hilda's Tower', Rome, 1871.
Albumen print, 273 × 378 mm. Courtesy: W. Bruce Lundberg.

inclusion in the Tauchnitz edition of *The Marble Faun* (Figure 2.7). Hawthorne's Rome – the Rome 'in his mind' – had thus become real. Indeed, in 1871, a view of Hilda's Tower was listed as one of the city's important monuments in the sale catalogue of Robert Macpherson, one of the most successful photographers in Rome (Figure 2.8). Through this process, photographs 'seem[ed] to give the confirmation of filmic transparency to a vision that [had] been scripted by romance and romantic aesthetic'.[52]

Whether or not Hawthorne was conscious of the impact of the photographically illustrated edition of his romance, these reproductions expressed the author's own sense of the creative process. With their truthful authority, they invited the reader to wander through the book as through the city, enhancing the memory of this

experience. In Hawthorne's mysterious and romantic Italy, photographs activated a double image, connecting the actual scenes with personal experiences and fantasies, thus shaping the 'mirror construction' in connection with one's memory, in a vision and revision of a foreign space.

Conclusion: Intertextuality and Imaginative Geographies

Like guidebooks, nineteenth-century photographs of Rome oriented most amateur photographers and tourists through the city, leaving them with ephemeral traces of memory. Oftentimes the evidence of these traces is left on the pages of photographic albums and on the surface of the images, suggesting the tourist's personal construction of the city of Rome through intimate and inextricable relationships between words and images.

The examples of three encounters with Rome examined in this essay suggest how photographs as representations imply other representations and systems of writings, such as guidebooks, novels and personal letters. The study of the spatiality of representation, that is 'the multiple sites at which travel writing [and/or photography] takes place',[53] can bring new perspectives to the understanding of nineteenth-century photographs, shedding light on the imaginative effect of these images on individual travellers.

This analysis of two systems of description encourages further contextual studies on the role of photographs in the process of picturing place. The intertextuality of photographs and texts takes different forms, arising from different linkages, and resulting in different slippages – temporal, spatial, documentary. In the process, personal perceptions of place are formed and articulated within pre-packaged texts and photographs, following the guidebook for the choice of effective viewpoints, recollecting the memories of the city back home, purchasing views of Rome and transcribing information into one's own album, wandering through the city guided by a fictional text.

C. S. S. Dickins's imaginative geography of Rome is inscribed between the experience of place and the remembrance of place, between the notations taken during the visit and those after his return home, whereas for the anonymous American tourist, Rome and Italy exist in a temporal and documentary disjunction between the Baedeker description and the view of the scene in the photograph. Finally, the case of the photographic illustration of *The Marble Faun* clarifies the substance of Hawthorne's romantic project and imaginary experience of Rome, in which photographs are symbolic and not indexical signs of the actual sites.

This essay has exposed the gaps between the hegemony of the tourist industry on the one hand, and the traveller's romantic and personal expectations on the other. The utterances left by Dickins, by the anonymous American tourist and by Nathaniel Hawthorne are similar in that they show the role of photography as both fact and

fiction in engagement with place. In the process of writing twice about a city, taking a photograph and compiling photographs inside an album, the 'I' of the tourist constructs its own imaginative geography of Rome, which is neither that of the guidebook nor that of the map but, rather, something that is embedded in the relationships between pre-texts and contexts, expectations and experience, words and photographs.

THREE

Visualizing Eternity: Photographic Constructions of the Grand Canyon

David E. Nye

§ THE GRAND CANYON existed long before human beings came to North America, and although it was inhabited by Native Americans for centuries, it was not known to Anglo-Americans until just before the Civil War. During the period when it was part of the Spanish colonies and later part of Mexico, it was little visited and played no symbolic role in the formation of a national identity. The first Spanish explorers to encounter it, in 1540, had difficulty perceiving its size, and they thought that the river at the bottom was only a few metres wide.[1] For the next three centuries the area was ignored as an impassable, inhospitable barrier to transportation. In striking contrast, shortly after the area was annexed from Mexico by the United States, Anglo-Americans approached the site with an ideology that relocated it within an imaginative geography which already included as icons both Niagara Falls and Yosemite. By the 1870s, a repertoire of cultural attitudes towards nature and conventions of representation had spread widely through society, and such sites were regarded as emblematic of the nation.[2] After being designated the first national park in 1872, Yellowstone's spectacular geysers, hot springs and river valley likewise emerged rapidly as a popular tourist site.

Thus it happened that the practical possibility of representing the Grand Canyon in photographs coincided with the exfoliation of a national symbolic geography that focused on what were termed the 'wonders' of the West. Even had the Canyon been discovered in the ante-bellum era, for practical and political reasons photographs of such a remote location were unlikely, if not impossible.[3] The first Grand Canyon images were not made until the early 1870s, during the expeditions of John Wesley Powell and George Montague Wheeler. Even so, the Grand Canyon, explored immediately after Yellowstone, only slowly became a national icon. In part this was because of its remoteness. Few people saw it until near the end of the nineteenth century. Just

as importantly, however, those who did see it often found the Canyon so immense and complex that they had no aesthetic that easily incorporated it.

Using the cultural perspective of American Studies and treating photography as a crucial part of the construction of nature, this essay will explore why the Canyon was slow to achieve the prominence it has today. It would require a half-century-long process of exploration and interpretation before Americans found a way to see the Canyon that made it as significant as Yellowstone or Niagara. The Grand Canyon eventually would be constructed as a quintessentially American space.[4] Photographic technologies both articulated and constituted this landscape's national significance, and yet it was hardly enough simply to discover the site and photograph it. The Grand Canyon did not become even a national monument until 1908, and it was not declared a national park until 1919, seventy years after the first expedition stumbled upon it. By 1974, however, it was arguably the nation's most popular national park.[5] The present inquiry thus resolves itself into three questions: Why did it take so long for the Grand Canyon to achieve prominence? What shifting cultural meanings did Americans ascribe to it? How did photography record and assist this prolonged process of cultural incorporation?

'This Profitless Locality'

The first American government explorer to enter the Grand Canyon was Joseph Christmas Ives, in 1858. His brief description is worth citing at length, for it suggests the attitude of a practical military man towards such scenery before photographers arrived on the scene more than a decade later:

> The plateau is cut into shreds by these gigantic chasms, and resembles a vast ruin. Belts of country miles in width have been swept away, leaving only isolated mountains standing in the gap. Fissures so profound that the eye cannot penetrate their depths are separated by walls whose thickness one can almost span, and slender spires that seem tottering upon their bases shoot up thousands of feet from the vaults below. The region last explored is, of course, altogether valueless. It can be approached only from the south, and after entering it there is nothing to do but to leave. Ours has been the first, and will doubtless be the last, party of whites to visit this profitless locality. It seems intended by nature that the Colorado river, along the greater portion of its lonely and majestic way, shall be forever unvisited and undisturbed. The country could not support a large population.[6]

In effect, Ives saw two kinds of space, neither of which he called 'grand'. From his primarily utilitarian perspective, it was a 'profitless locality' and 'altogether valueless'. Yet the first part of his description suggests some fascination with the 'fissures so profound', the 'slender spires' and 'gigantic chasms'. When, later, American explorers arrived in the area, they experienced a similar ambivalence. They were searching for

mines, navigable rivers and arable land, but they also recognized the site as being strange and even 'majestic'.[7] Yet eyes trained to admire alpine scenery or verdant river valleys had difficulty seeing either the sublime or the beautiful in this enormous cavity with its fantastic land forms.[8]

In 1872, William Cullen Bryant edited a massive two-volume work, *Picturesque America; or the Land We Live In*, which he called, 'a delineation by pen and pencil of the Mountains, rivers, lakes, forests, waterfalls, shores, cañons, valleys, cities and other picturesque features of our country'.[9] Bryant and his many contributors sought to turn American attention to native landscapes. Bryant's introduction insisted that the United States contained 'a variety of scenery which no other country can boast of', scenery which, he emphasized, offered the artist a vast range of new subjects.[10] Furthermore, Bryant stressed, 'the overland communications lately opened between the Atlantic coast and that of the Pacific' gave Americans 'easy access to scenery of a most remarkable character'. Newly discovered western landscapes appeared in the Bryant volume, not least because such sites were untainted by the fraternal bloodshed of the Civil War. All citizens, North and South, could identify with Yosemite and Yellowstone, which figured prominently in the volume. He even noted that the West had 'enriched our vocabulary with a new word, cañon, as the Spaniards write it, or *canyon*, as it is often spelled by our people', which, significantly, he thought it necessary to define for his readers. 'Canyon', he explained, 'signifies one of those chasms between perpendicular walls or rock – chasms of fearful depth and of length like that of a river.'[11] Bryant did not mention the Grand Canyon by name, for at this time no particular stretch of the river had been designated as *the* canyon. Rather, the whole river north of Black Canyon (near present-day Hoover Dam) was referred to as a single site, and the second volume devoted nine pages to 'The Canyons of the Colorado'. Not only had the Grand Canyon not yet achieved name recognition or a distinct physical location, but the American taste for desert landscape and canyonlands was still undeveloped. Accordingly, Bryant allotted to the Colorado less than half the space given to the eastern landscapes of 'The Susquehanna', 'The Juniata' or 'The Valley of the Housatonic'. As the book's title emphasized, Bryant's ideal landscapes were picturesque. The rugged desert canyons did not fit comfortably within that aesthetic.

The largely eastern audience was also imbued with a taste for the sublime, however, which had been seized upon and institutionalized in earlier images of sites such as Niagara and the Natural Bridge of Virginia.[12] Some of the initial images of the Canyon, not surprisingly, worked out of this sublime tradition. In 1871, Timothy O'Sullivan, the first photographer at the Grand Canyon, made several large plates and stereographs as part of the Wheeler expedition.[13] His images emphasized the enormous scale of the Canyon and showed the comparative insignificance of distant individuals who were nevertheless still in the foreground. O'Sullivan and other photographers[14] were so early on the scene that it was even possible for government expeditions to name mountains after them, including the newly trained photographer Jack Hillers

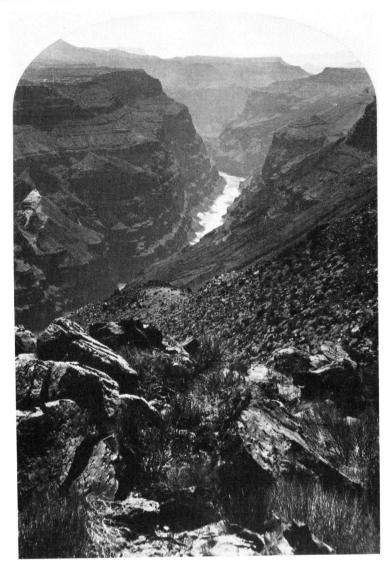

FIGURE 3.1 John K. Hillers, 'The canyon from the foot of Toroweep
Valley', Grand Canyon, Arizona, 1871–74. Courtesy: Library of Congress,
LC-USZ62-94335.

who accompanied Powell on his second trip down the Colorado in 1872.[15] Like
O'Sullivan, Hillers attempted to capture the dramatic geographical scale of the
Canyon (Figure 3.1). These photographers literally went over the ground together with
the first painters. When Thomas Moran visited in 1873, for example, he met Hillers,
who guided him to several views. Moran studied Hillers's work as the basis for his own,
at times depicting scenes he had not witnessed first-hand himself, notably a drawing

of Kanab Cañon that appeared in Bryant's compilation.[16] In short, photographers helped to define the ways in which Americans would see the Grand Canyon – whether in paintings, engravings or photographs – from the moment that Anglo-Americans first became aware of its existence.

The fact that Bryant's volume devotes only nine pages to the entire length of the Colorado, as well as the Green River, indicates that the Grand Canyon *per se* had not yet emerged as an American icon and that the early images did not have as powerful a political and cultural effect as did the first images of Yosemite and Yellowstone. The widespread failure to perceive the Canyon as a sublime object is pointedly demonstrated by J. H. Beadle's more than eight hundred pages on *The Undeveloped West*, written between 1868 and 1873. It contains a description of a descent into the canyon of the Colorado, but the name 'Grand Canyon' does not appear, the river landscape is not the focus and the author describes the hardships of the journey more than the scenery. The lack of attention paid to the Grand Canyon is all the more surprising, considering that Beadle met the photographer of the Powell expedition, E. O. Beaman, and found and used one of Powell's boats to get across the river. Yet Beadle was interested in spectacular landscapes. *The Undeveloped West* described Yosemite and Yellowstone in considerable detail with accompanying engravings.[17] Even a decade later, when Charles Gleed's massive, all-purpose guide, *From River to Sea: A Tourists' and Miners' Guide from the Missouri River to the Pacific Ocean*, appeared touting the scenery along the newly completed Santa Fe Railroad, the Grand Canyon was not mentioned by name, although the canyon country of the Colorado was praised briefly in passing.[18] And again in Gleed's volume, while there are woodcuts of Yellowstone, Yosemite, the Garden of the Gods and many other western scenes, no illustration depicting the Canyon appeared in this volume. Taking the works of Bryant, Beadle and Gleed together, one can conclude that, during the 1870s, Americans still had not perceived the Grand Canyon as an important cultural marker, even though it would seem that they were ideologically prepared to see it as sublime.

Exploring with Photography

What prevented the Grand Canyon from becoming famous as rapidly as Yosemite or Yellowstone? Photographers appeared at each site almost at the moment of discovery, but the Grand Canyon proved harder to depict and more difficult to grasp imaginatively. What were its landmarks? An erupting geyser or a hot spring was comparatively easy to frame, and the waterfalls of the Yellowstone River could be accommodated within the older conceptions of the sublime and the beautiful. But the Grand Canyon was simply too large and too complex to be depicted satisfactorily within a single image, or even a single sequence of images, and it lacked specific, quintessential landmarks like 'Old Faithful' at Yellowstone or 'El Capitain' at Yosemite. Roughly 2,000 square miles in extent, the Canyon contained no central feature. Its

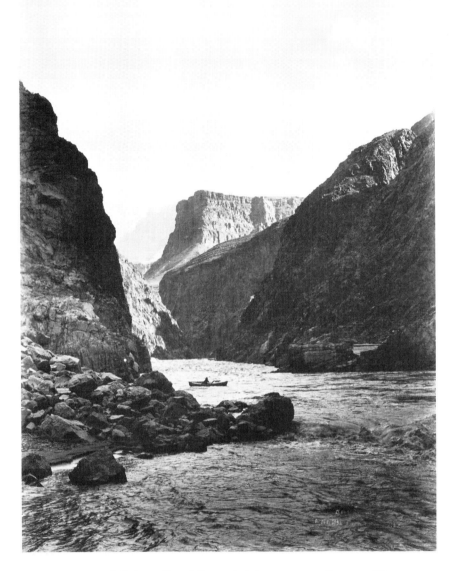

FIGURE 3.2 Kolb Bros, 'Grand Canyon', Arizona, c. 1913. Courtesy: Library
of Congress, LC-USZ62-97100.

rim was invisible from the river, and vice-versa. All photographers faced the problem
of representing the whole on the basis of a selection, but what should they select?
What, if anything, made the Canyon meaningful? Why should a tourist seek it out?
If one saw it, what had one seen?

Most of the photographers who first wrestled with these questions were among the
explorers, and the majority of their images were made at or near the river. While

they showed its size, power and effects, the height and extent of the whole Canyon was impossible to represent from within the confines of the inner gorge. Some photographers, notably Hillers and Kolb, tried to solve this problem by making a vertical view from elevated locations in the inner gorge, showing the river below and the rising amphitheatre of cliffs above (Figure 3.2).[19] This vision was an amplification of what the river explorers saw if they climbed into side canyons. Significantly, they were views looking up, emphasizing the buttes and rock formations that towered above. Such views, which sought to transform the Canyon scenery into mountains, were virtually inaccessible to tourists, who almost invariably looked down and, to their surprise, were unable to see the river from most outlooks. The river voyage through the site was absolutely out of the question. Even as late as 1950, fewer than a hundred people had ever passed through the Grand Canyon in a boat.[20] Even those few who walked down into the gorge only briefly saw the Canyon from one location on the bottom. Thus, there was a disjunction between most of the images made on expeditions, taken on or near the river, and what early tourists were able to see several miles away and 5,000 feet higher up.

This disjunction existed in part because of technical constraints on early Grand Canyon photography. The technology of the 1870s gave photographers no choice but to employ a large, view camera, tripod and heavy glass plates with slow exposure times. To make matters even more difficult, in the first years, before the introduction of the dry plate, photographers had to bring a portable darkroom with them in order to prepare the wet-plate negative immediately prior to exposure and then to wash the plate and fix the image immediately after the exposure, before the collodion dried. This portable darkroom (or darktent), as well as processing chemicals and a supply of clean water, placed extra demands on the expedition as a whole. Frederick S. Dellenbaugh recalled:

> The camera in its strong box was a heavy load to carry up the rocks, but it was nothing compared to the chemical and plate-holder box, which in turn was a featherweight compared to the imitation hand-organ which served for a dark room. This dark box was the special sorrow of the expedition, as it had to be dragged up the heights from 500 to 3000 feet.[21]

The weight of the equipment and the time required to deploy it prior to making an image greatly restricted both the range of movement and the number of photographs that could be made in a day. The temperature extremes of the south-west further increased the difficulties, because in cold weather collodion froze, and in hot weather it 'ran' on the plate. The process, demanding even in a studio, was far more difficult in the rugged and dusty desert terrain.

These technical difficulties were compounded by the steepness and narrowness of all trails out of the Canyon. The steep Bright Angel Trail, with its many switchbacks, still the easiest route down from the south rim, suggests the difficulties early photo-

graphers faced, including many precipices, uneven footing, searing heat and no water. Out of necessity, most images were made near the boats. Carrying nothing more than a light pack with the obligatory food, water and clothing needed for sudden changes in the climate is strenuous; transport and use of a full photographic outfit required at least two men and a mule. Today's hiker has a trail and a map, but the first photographers who boated into the Canyon had no maps, no trails leading upwards and no mules. Furthermore, they faced the time pressures of an expedition pressing downstream before its food supplies ran out. All photographic equipment had to be packed into boats with great care after every stop, so that it could not shift about or fall out, even if the boat capsized, which was by no means unusual. Glass plates could break, muddy water could foul the chemicals and the constant exposure to mist and spray could easily damage a camera. Roll film and hand-held cameras were available by the 1890s, but the images they produced were not of high quality, and, for at least another generation, virtually all serious photographers at the Grand Canyon continued to use large view cameras resting on tripods.[22]

Yet these difficulties created one built-in advantage. It was unthinkable that any early expedition could casually select its photographer. Expedition leaders understood that good photographs were useful when seeking further funding.[23] Making images required, and the leaders of expeditions sought, experienced professionals who could improvise in the field and who knew how to protect glass negatives as they moved across rough terrain. For their part, expedition photographers expected to make a living less from the scanty wages they received than from selling prints, particularly stereographs, after they returned home, and prior acquaintance with the eastern audience provided important information.[24] If expedition photographers sought to make both documents recording their explorations and landscapes that would satisfy a larger audience, scientific record-keeping was the official justification for having photographers along. Yet all the explorers, notably John Wesley Powell, recognized the power of the image to publicize their journeys and most, like Powell, understood the profits to be made from selling reproductions.[25] Stereographs were particularly effective in conveying a vivid three-dimensional sense of the vast landscapes of the West. They helped to make the Grand Canyon, unknown to the public in 1870, nationally known by 1900. Powell himself played a central role in this process. Directed by the Smithsonian to hire a photographer for his 1871 expedition, he employed E. O. Beaman, who made 350 images. Beaman signed a contract with Powell and the chief topographer of the expedition in which they agreed to divide equally the reproduction rights to the stereographs. The following year, Powell bought Beaman's share and long profited from the sales made by the Jarvis Company of Washington, DC.[26] Stereoscopic views of the Grand Canyon were widely disseminated by firms such as the Keystone View Company well into the twentieth century (Figure 3.4).

If photographs were, from the beginning, understood as objects of commerce, they were also essential to authenticate the verbal descriptions of new places. They

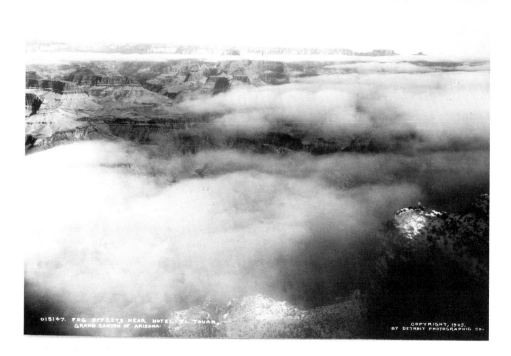

FIGURE 3.3 Detroit Photographic Co., 'Fog effects near Hotel El Tovar', Grand Canyon, Arizona, 1905. Courtesy: Library of Congress, LC-USZ62-99888.

played a role in the creation of the first national park at Yellowstone. The images made by William H. Jackson in 1871 were immediately displayed to the members of Congress, who unanimously passed a bill establishing the park in the following year. (Earlier, Carleton Watkins's images had played a similar role in promoting Yosemite.) In subsequent decades, these images of the hot springs, geysers and waterfalls were generally thought to have accomplished 'a work which no other agency could do and doubtless convinced every one who saw them that the region where such wonders existed should be carefully preserved to the public forever'.[27] In fact, the written report and lectures of the Yellowstone expedition leader, F. V. Hayden, played the decisive role.[28] But the often-repeated tale about the impact of these photographs was enhanced by a naïveté characteristic of the nineteenth century. People thought that 'the photographs were of immense value' precisely because while words could 'exaggerate', the 'camera told the truth; and in this case the truth was far more remarkable than exaggeration'.[29] Photographs were assumed to be accurate representations, which, if anything, understated the case since they were in black and white. In the 1870s, in other words, because photographs were a form of documentation that was taken to

be objective, they were paradoxically seen as an efficacious means of self-promotion. The camera was a strategic device deploying a vision that was all the more powerful because it appeared to be the product of a scientific instrument.

Despite the early availability of Grand Canyon photographs, however, they did not prompt the immediate creation of a national park. Images from the inner gorge failed to represent a view that any tourist could expect to see, even if they did serve to authenticate the heroism of explorers such as Powell, by depicting the spectacular hardships they endured. One example of such an image is that of a frail boat on the turbulent waters of the Colorado, in an angle of the river framed by sheer cliffs (see Figure 3.2). Photographs taken from the water's edge and looking up at monumental scenery preserved the conventions of mountainous landscape. Yet the very hardships depicted in the inaccessible Canyon, if they made for a good story, by definition did not define a tourist site, much less a national icon. Photographs from the rim, in contrast, provided a view that was more accessible to tourists, but one which did not fit into conventional ideas of alpine landscape. From above, the Canyon was a chaotic jumble beneath a disconcertingly flat horizon (see Figures 3.1 and 3.3).

Learning to See Time

Before the Grand Canyon could be considered the equal of Niagara or Yellowstone, three things were necessary: easier access, vigorous promotion and, most importantly, a convincing way for the public to understand the site as a whole. Indeed, the creation of such an interpretative schema was quietly underway from the moment Ives first pushed into the area in 1858. In his expedition was John Newberry, one of the central figures in the development of geology in the United States. Newberry grasped the scientific value of the Canyon as a series of sedimentary beds that exposed to view millions of years of history. His student, Karl Gilbert, returned to the area with the Wheeler expedition. They were the first to realize that, in walking down to the bottom, they walked back towards the origins of the earth. As Stephen Pyne explains, armed with this insight, 'the Colorado River became one of the scientifically great rivers of the world, and its canyon not merely an indescribable and impassable tangle of gorges'.[30] As Newberry put it, the Canyon was the 'most splendid exposure of stratified rocks that there is in the world'.[31]

Geology was still such a relatively new field of study during the 1870s that, among the general public, water erosion was not yet understood to be a major factor in shaping the contours of the earth. Even the leading geologist, Charles Lyell, had believed that the movement of the ocean was more important than streams and rivers, while Georges Cuvier's competing theory argued that catastrophes, such as volcanic eruptions and earthquakes, were the central geological forces. Armed with such ideas, the earliest people to view the Canyon could not imagine that the comparatively small river at the bottom could have created the vast and chaotic landscape. Indeed, even

if they considered this idea, the conventional understanding that the age of the earth might be as little as a few thousand years precluded it. Such erosion would require an enormous period of time, millions of years, perhaps even a billion, more time than they believed the earth had existed. Symptomatically, the first important painting made of the Grand Canyon, Thomas Moran's *The Chasms of the Colorado, 1873–1874*, although it was immediately and enthusiastically purchased by the United States Congress, paid no attention to the sedimentary layers of rocks in the Canyon walls. It could not be read as a representation of the erosive power of water, nor as a representation of the passage of time. Rather, at this early date Moran presented the Canyon as a massive wonder. With considerable (and self-proclaimed) artistic licence, he represented no actual place or point of view, but arranged a composite of impressions on a canvas that converted the actual downward gaze into a look upwards. Moran's Canyon was a strange and remarkable sight, but it was not a massive demonstration of the natural laws everywhere at work in the Grand Canyon.

As in the painting, to those who first saw it, the Canyon was, at best, a magnificent oddity but not yet a scientific exhibit. Only after the geological theory that emphasized the centrality of water erosion to the formation of landscape became accepted among scientists and known to the public, would there be a new way to grasp its meaning. Indeed, the Canyon became the central proof of the fluvial theory,[32] particularly in the work of the geologist Clarence Dutton. His detailed study of its rock formations retained a reverential awe towards the site as a whole, in a government publication that contained alternating chapters on science and landscape. Stephen J. Pyne has argued that Dutton's work was instrumental in establishing the view from the rim as the standard, both for aesthetic appreciation and for scientific observation: 'For Dutton, the scenic cliff and the geological cliff were the same cliff. Both could be understood by similar acts of critical imagination, and one could be trusted to reinforce the meaning of the other.'[33] Yet Pyne is too much the intellectual historian, assuming that the excellence of Dutton's scientific publication in 1882 was almost immediately understood and recognized by a wide audience. Scientists alone do not create national icons; good access to the site and promotion are also required.

The Santa Fe's Canyon

Both promotion and easy access to the Grand Canyon were lacking between 1882 and 1900, and few people – a few thousand at most – actually saw it first-hand. A visit required several days' travel from the nearest railway station and, once the hardy tourist had arrived, there were few facilities. The Santa Fe Railroad remedied this defect in 1901, when it completed a line to within a few hundred yards of the south rim, where it also built the El Tovar hotel (with the Canyon visible from its windows) and began to advertise the site extensively. Just as Niagara Falls was visited far more often after the completion of the Erie Canal, the Grand Canyon became the basis for

a sizeable tourist industry only once the railroad, followed shortly thereafter by the automobile, made it accessible. The railroad's advertising images of the site served as its cultural marker, encouraging the production of similar images or the purchase of postcards and other reproductions. The Santa Fe gave selected painters and photographers free passage on their trains and free accommodation once they arrived. The railroad then purchased images made of the Canyon and mass produced them in pamphlets, calendars and cards, in a promotional effort that lasted for decades.[34] In 1901 alone, the Santa Fe Railroad produced 174,000 copies of *Grand Cañon of Arizona*, 15,000 copies of a pamphlet, *Titan of Chasms: the Grand Canyon of Arizona*, and a smaller run of a 123-page anthology 'of words from many pens' as the subtitle put it, as well as illustrations by painters and photographers.[35] These publications included many images that served as cultural markers for tourists.[36] The Santa Fe was hardly unique in such activities, which had become common practice among railroads during the nineteenth century. Newer corporations, such as General Electric, were also awakening to the usefulness of photography in public relations at precisely the same time.[37] By reproducing paintings by Moran or photographs by Hillers, the Railroad minimized its own promotional role. If the Santa Fe clearly stood to gain from tourism, such images established the value of the tourist experience itself.

The Railroad also built a diorama of the Canyon at the 1901 Pan-American Exposition in Buffalo, and then a larger three-dimensional version at the 1915 Panama-Pacific Exposition in San Francisco. These dioramas further established the downward gaze into the Canyon (rather than its construction as a mountain landscape) as the central experience of the site. In the promotional process, the Santa Fe and its partner, the Fred Harvey Company, also made hotels and other conveniences into subsidiary icons. The text on the back of one postcard read: 'From the wide, comfortable porch of Hermit's Rest, the most recent building erected by the Santa Fe for the convenience and comfort of the traveller at Grand Canyon, a far reaching and most interesting view can be had.' The card depicted not the chasm but the porch. Most cards showed a view, of course, even as the accompanying text insisted that: 'The finest effects at the Grand Canyon are altogether uncommunicable by brush or pen. They give themselves up only to the personal presence ... You cannot paint a silence, nor an emotion, nor a sob.'[38] This text cleverly tells the reader the emotions proper to the site: awe-struck silence or an inarticulate cry. No verbal effusions were necessary. The photographic image itself is thus undercut, as being always inadequate to the immensity and complexity of the scene. The image both represents the experience and is disparaged as being inherently inauthentic. The photograph, no matter how spectacular, was thus positioned as a trace, a marker, a mere taste of a powerful experience that the tourist could only enjoy in person. Therefore, it was appropriate to represent the bench, the porch or the hotel from which the Canyon might be studied. The tourist was assured of enjoying authentic awe in comfort.

Indeed, the need to observe the Canyon for long periods of time also became a

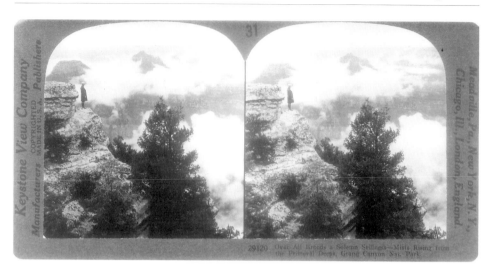

FIGURE 3.4 Keystone View Company, 'Over all broods a solemn stillness – mists rising from the primeval deeps', Grand Canyon National Park, stereoscopic view, c. 1926. Courtesy: Library of Congress, LC-USZ62-99896.

theme of its photographic representation. Once the chasm's general appearance had been established, it became popular to depict it when engulfed with fog, which obscured its depths and made it more mysterious. Thus in 1905 the Detroit Photo- graphic Company sold an image of 'Fog effects near Hotel El Tovar' which provided only glimpses of the by then famous view (Figure 3.3). The Canyon, once it had been deemed important, could be represented as having many moods. One needed to remain in the hotel for days in order to see it in sunshine, storm, lightning, shadow, wind, snow and fog. Its multiplicity became evidence of its ungraspability, suggesting once again the impossibility of full photographic representation. Only a stay at the El Tovar could make good this deficit.

Yet, as the image-making continued, it became clear that even during the early twentieth century there was still no consensus about how to visualize the Canyon. Rather, there were three competing aesthetics, which together served to mystify it more than any single approach could have. One was pragmatic and focused on the Colorado River as a resource; another sought the sublime, concentrating on the powerful contrasts and immense vistas of the region; a third emphasized human experiences against a dramatic backdrop. Every photographer had literally to take a position in the landscape in accord with one of these three, as could be seen during 1923, when an eleven-man expedition sponsored by the United States Geological Survey studied the Colorado looking for dam sites. Three members of the expedition made photographs. The official photographer was Eugene C. LaRue, a hydraulic engineer whose images illustrated the final report: 'LaRue did not like heights and

usually photographed potential dam sites along the river rapids and side streams.'[39] Since he was interested in uninterrupted visual information, he generally used either a wide-angle lens or a panoramic camera on a tripod. In contrast, Emory Kolb, the only person on the expedition who had braved the Colorado before, had made his career as a photographer of the Grand Canyon region (see Figure 3.2), and together with his brother ran a studio at the head of Bright Angel Trail. (Indeed, that studio has itself become a tourist site today.) He emphasized the sublime and, carrying a smaller hand-held camera, 'liked to scale canyon walls and climb out on slick rocks and narrow ledges'.[40] Not surprisingly, Kolb found himself in conflict with the government surveyors and scientists who primarily wanted his services as a guide and boatman.[41] Lewis R. Freeman represented yet a third photographic tradition, that of the journalist. He also worked as a boatman on the expedition with the purpose of reporting the experience for *National Geographic*, where he published an article the following year. His images and reportage emphasized the human experience of the journey, with the spectacular landscape as backdrop. Many of his photographs were made at campsites, providing group portraits that emphasized personal expressions and moods.[42] The expedition imagery exemplified, in microcosm, three aesthetics common to early twentieth-century images of the Grand Canyon. The sharpest distinction must be made between the first and the second of these. Human interest photography could be included along with either the engineering survey or the popular magazine stories in a publication such as *Arizona Highways*.[43]

Entirely new views of the Canyon were also becoming available. In 1919, the Army Air Service, seeking publicity for itself after World War I, began a series of flights across the United States to map air routes for commercial use. On 24 February of that year, a DeHavilland DH-4 bomber flew over the Canyon, and its pilot found that: 'The river was like a pencil. Every wiggle, every shade, every shadow of the giant gorge was visible at once and there is nothing comparable to it.' The following day, a second army plane, carrying a Fox News motion-picture photographer, cruised over the rim and dropped down 2,000 feet for a closer look.[44] Even as the wire services hummed with the public relations story, the next day Grand Canyon was officially made a national park by Congress. The following year, a dare-devil pilot flew within a hundred feet of the Colorado River itself, negotiating the tight confines of the inner canyon.[45] Aerial views of the Canyon became a staple representation by 1923, when an extensive series of photographs was made over the entire length of the Canyon, and several of these were published the following year in the same special issue of *National Geographic* on the Grand Canyon that carried Freeman's human interest story.[46] Taken together, the special issue fragmented the Canyon into a complex series of views, from within the gorge, along some of the side canyons, up on the rim and from the air. The aerial images not only added a new dimension to knowledge of the site, but also became part of a repertoire of visualizations. Collectively, they celebrated the Canyon and announced the human triumph over it.[47]

Yet these four kinds of imagery did not cohere to form one dominant conception of the Canyon. Was it raw material waiting for exploitation as a dam site? An exemplar of the sublime? A challenging environment for camaraderie and adventure? A spectacular aerial view? Or something else? These conflicting perceptions suggest why it is not sufficient to understand the photography of the Canyon by merely charting how it was the object of all of the characteristic styles in photography from 1870 until the present. One could, of course, construct a photographic history of the site that included the exploration images, stereographs, postcards,[48] impressionism,[49] aerial photography, nature photography, ecologically-informed colour photography, celebratory touristic colour photography (Ernst Haas), kitsch, rephotography, postmodernism and, most recently, anthologies of all these images available on the Internet.[50] Using only images for the Grand Canyon, one could construct a reasonably complete art history of landscape photography since 1870. Yet such a sequencing of images would be based on a history external to the site. It would tell us nothing of Grand Canyon's cultural history, and it would not clarify how or why it became a national icon.

The View from the Rim

What did the Canyon mean as a central site in American imaginative geography, and how was this expressed in photographs? In contrast to the explorers, whose travels deep in the gorge were unrepeatable for the tourist, the visitors on the rim understood the site in terms of a sequence of experiences that began with awe at the sudden opening up of an enormous vista. John Muir early noted this awe and disorientation,[51] as did virtually every subsequent commentator. John C. Van Dyke described a typical scene in 1920, when people usually arrived by train:

> In common with the ordinary visitor, upon arrival you hurry up the steps from the station, pass along the front of the hotel, and go out at once to the Rim for a first view. You are impatient of delay in seeing this marvel of the world. Almost before you know it you are at the edge. The great abyss, without hint or warning, opens before your feet. For the moment the earth seems cleft in twain and you are left standing at the brink. As you pause there momentarily the rock platforms down below seem to heave, the buttes sway; even the opposite Rim of the Canyon undulates slightly. The depth yawns to engulf you. Instinctively you shrink back.[52]

This immediate reaction to the sheer scale and complexity of the scene usually then led to an interpretative effort to establish some landmarks that could organize the scene, by learning the names of the most striking formations visible in the distance. Both guidebooks and markers at the site provided this visual information. Many of these names are architectural metaphors, selected by the early white explorers. Muir declared: 'Throughout this vast extent of wild architecture – nature's own capital city – there seem to be no ordinary dwellings.'[53] Since the 1870s, the Canyon has been

described in terms of temples, domes, minarets, towers, walls, pillars, pediments, friezes and the like. Such terminology is pre-geologic, of course, and attempts to understand the site through analogies and comparisons with the man-made. For some tourists, learning these names was a sufficient form of interpretation, but most became intrigued with how water erosion carved the vast canyon. At this point merely looking was not sufficient, and the tourist had to read a guide or hear a short lecture to learn the scientific explanations of the different rock formations. This task was made easier by the fact that each major geological layer had a distinctive colour. What had been a riot of meaningless colour to those who first saw the Canyon became a meaningful sequence. Even if the visitor did not master the details, he or she could quickly grasp the general concepts of sedimentary layers, a gradual rise in the plateau and the eroding counter-force of the Colorado River.

In this geological interpretative tradition, the Canyon was understood as the open book of nature, exposing to view the evolutionary history of the earth, and photographs expressing this view emphasize the effects of erosion and the endless sedimentary layers. The late-nineteenth-century naturalist, John Burroughs, popularized this view, and he is cited in Canyon hiking guides to this day: 'Time, geologic time, looks out at us from the rocks as from no other objects in the landscape. Geological time! How the striking of the great clock, whose hours are millions of years, reverberates out of the abyss of the past!'[54] The tourist rapidly assimilated parts of this interpretative system, acquiring some of the architectural names and gleaning facts about the geological history from maps, trail markers, pamphlets, campfire talks and perhaps a guidebook. What then emerged from this effort was an interpretation of the site as the representation of geological time, stretching back to the origins of life. The view from the rim visualized the sweep of time; the Grand Canyon linked the visitor, and the nation, through billions of years, back to the creation of the earth. This gave meaning to the depth of the Canyon. Instead of a disconcerting inversion of the upward gaze towards an alpine scene, the photograph which showed layer after sedimentary layer stretching down into a vast gulf became the visualization of an almost unimaginable span of eternity.

As Joseph Wood Krutch put it in his classic book on the Canyon: 'I am small and alone in the middle of these great distances, vertical as well as horizontal. But the gulf of time over which I am poised is inconceivably more vast and much more dizzying to peer into.'[55] The Canyon had become more than the proof of a geological theory. The visitor on its rim, admittedly without understanding any of the details or the scientific argument that marshalled them into a proof, gazed towards the origins of the planet. The photograph of the Canyon from the rim represented the Kantian vastness of eternity. Instead of the older, upward gaze towards sublime mountains, expressing what Kant called the 'mathematical sublime', the Canyon epitomized a new form: the temporal sublime. A photograph's inevitable failure to capture the Grand Canyon's plenitude of different views was transformed from a defect into a confirmation of the

Canyon's geological meaning and a proof of human insignificance, often visualized by tiny figures in the foreground. The Canyon had become the spatial correlative of scientific time, and the photographic view from the rim, not from the river or a side canyon, best expressed its cultural meaning.

The Grand Defile Defiled

After about 1960, however, the tourist who sought an undefiled Canyon of vast geologic age increasingly discovered that its physical appearance no longer remained constant. Most obviously after the Glen Canyon Dam was completed upstream in 1963, the water in the Colorado became a controlled flow. The river was no longer warm and red, but cold and green. With sediment impounded behind the dam, erosion slowed down and sand banks were not replenished. Because the gorge was no longer scoured out by high water in the spring, the debris swept down by flash floods from side canyons was not washed away and more permanent vegetation grew close to the main channel. Even as these changes began to be noted, the Grand Canyon itself was repeatedly proposed as a hydroelectric dam site, and legislation to this effect was debated in Congress as late as the mid-1960s, raising a storm of protest from, and indeed stimulating the growth of, the environmental movement. Air pollution from as far away as Los Angeles reduced visibility, making the distant view more like a fuzzy impressionist painting than a vision of infinity. Helicopters and small aeroplanes carried tourists over the Canyon – some 800,000 passengers a year by 1995. The dramatic increases in tourism put more people on the rim and the trails, effectively eliminating the sense of solitude.

Both the rising tide of tourism and environmental threats to the Canyon were of great concern to two of the most important photographers of the 1950s and 1960s, Ansel Adams and Eliot Porter.[56] While the majority of Adams's work was done in California, he did photograph the Grand Canyon in the late 1940s, when he held two Guggenheim fellowships which enabled him to photograph many of the national parks. The most influential landscape photographer (and teacher of photography) for the generation after World War II, Adams reworked the tradition of Carleton Watkins and the early expedition photographers. Like them, he preferred to use large negatives to produce large black and white prints. And while modern film technology gave him the option of making a great many exposures, he rejected this approach to image-making, and insisted on patiently studying a scene and waiting for the right moment to make an exposure when the light and composition appeared to him ideal. What precisely constituted this ideal? In his crisp photographs, the world seems to be new, untouched, luminous, even Edenic. Adams's images, both in the self-consciously old-fashioned manner of their making and in their appearance, appealed on the basis of an apparent fidelity to nature, which is to say, a putative fidelity to what the natural world was like before modern civilization intruded. This vision has proven to be

particularly appealing to the environmental movement, of course, and Adams himself was a passionate environmentalist. Yet, however much Adams seemed to have captured the essence of a scene, while at the same time exhibiting remarkable balance and a sensuous range of textures, his work tended to idealize the natural world, emptying it of human beings, whether Native American or white.[57] Working primarily in black and white, his images emphasized form and light. They intimated that the nature experienced by the first explorers was still recoverable, an intimation seemingly validated in part by using not colour roll film but black and white plates similar to those employed on the early expeditions. The camera was used not merely to reproduce the tourist's experience but to reassure viewers that the site had not changed. This anxiety about preserving the pristine was likewise reflected in the 1960s campaign to protect areas of the nation as wilderness. Indeed, as Richard Grusin has argued in the case of Yellowstone, since 1963 the official policies of national park managers have sought to (re)create 'a reasonable illusion of primitive America'.[58] Thus, Adams's photographic representation and official preservation policy mirrored each other.

In visual terms, 'primitive America' existed in black and white. Because colour photography was not possible until the twentieth century, the wide range of reds, greens, yellows, purples and other strong colours of the Canyon had to be translated into a grey scale. Adams, who is best known for his work in black and white, did make several colour photographs as part of his Guggenheim project, however, several of which were reproduced in *US Camera*, including one of the Grand Canyon.[59] Taken from the South Rim, 'The Grand Canyon at dawn' suggests vastness through a succession of cliffs and buttes that cut horizontally across the frame, receding towards an apparently luminous horizon. This landscape is still in shadow, and so is muted, blurred and almost black and white. But the yellow sandstone cliffs in the foreground are tinged with red by the morning sun, creating a dramatic contrast that increases the sense of depth. Adams's few colour images verge towards black and white composition, while taking the dawn, the moment of beginning, as a central subject. The dawn of one day suggests how the dawn of time may be traced in the sedimentary layers of the Canyon walls.

Eliot Porter, although greatly influenced by Adams early in his career, turned to colour photography almost exclusively and championed its use.[60] This change in technique coincided with rising environmental awareness, as represented in his first book, *In Wilderness is the Preservation of the World*, published, significantly, by the Sierra Club. Its images were accompanied by quotations from Henry David Thoreau. Porter worked extensively along the Colorado, notably in *The Place No One Knows: Glen Canyon on the Colorado*.[61] One of the most influential books ever published by the Sierra Club, it recorded in detail an area soon to be inundated by the new hydroelectric dam which would eventually change the ecology of the Grand Canyon, as already mentioned. Had the spectacular Glen Canyon itself not been just north of the national park, its scenery might have been appreciated sooner and preserved; but, by the time Porter

explored the area and made some of the first (and last) images of the region,[62] it was doomed to inundation. This fact, far from making irrelevant an aesthetic of straight photography that celebrated the natural world before reference to human intervention, lent that aesthetic an ironic force. To use Roland Barthes's terminology, each of Porter's images became in its entirety both 'studium', or mimetic representation, and 'punctum', or a reminder of the death of the object.[63] Porter's book celebrated a landscape whose complete demise had been scheduled. His work appeared the year before Congress answered the rising tide of environmental concern by passing a bill to preserve wilderness areas. As the waters rose to hide the vistas Porter had recorded, his images gained an urgent poignancy. The canyonlands of the Southwest, once indomitable icons of eternity, had become vulnerable and transient, preserved only in photographs.

The use of colour thus coincided with a shift away from the aesthetics that sought to reproduce either the geological antiquity of the site as a visual metaphor for eternity or the Edenic purity of the Canyon at discovery. Partly as an adaptation of Porter's work, an aesthetic developed in some Grand Canyon postcards in which it was increasingly represented by small details. The new colour imagery sought to reveal the beauty in things that were usually overlooked. As one critic noted of Porter's work: 'What is lacking is the obviously spectacular. Rather, what sustains and informs is a sense of revelation– the unveiling of what would otherwise perhaps go unseen.'[64] A popular writer made a similar comment in a *Time/Life* book on the Grand Canyon: 'Within these red walls exist innumerable little worlds, surprising worlds, and hundreds of hidden paradises.'[65] The visualization of this idea was primarily realized through colour photographs by Ernst Haas, a Vienna-born painter turned photographer who had done photographic essays for *Life Magazine*. While the book opens with the expected vistas from high places, there are also many close-ups and tightly-focused images, such as that of a datura plant against an entirely black backdrop, a black-and-white striped snake crawling in grey sand, quaking aspen leaves, etchings made by beetles on tree bark, stretch marks on the trunk of an aspen, a short-horned lizard, a lichen-encrusted rock, a pale-gold scorpion and many shots of flowers and cacti in bloom. Most of these images would lose a great deal of their interest in black and white. In the book as a whole, they serve as counterpoints to the expected views of vast space, emphasizing the many micro-environments and strategies for species survival. These close-ups all remain securely within the world of ordinary vision, and are by no means a form of defamiliarization. Yet if the camera position replicates ordinary vision, human beings are seldom visible within the frame. Ultimately, as with Adams's images of nature, the photographer still seeks to suggest the world as it existed before explorers and tourists. And yet, as with Porter's Glen Canyon images, the natural scenes represented had explicitly become vulnerable.

The logical next step in representation – a more critical awareness of the invasive presence of tourism – emerged by the 1970s. One of Paul Caponigro's two images of

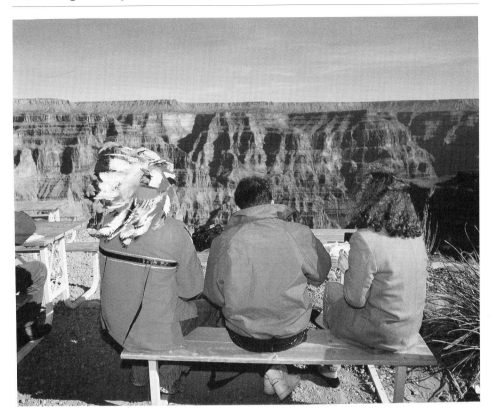

FIGURE 3.5 Martin Parr, 'Grand Canyon', Arizona, USA, 1995.
Courtesy: Magnum Photos.

the Grand Canyon from *The Wise Silence* at first glance appears to be yet another standard view from the rim, but its foreground of white rocks has been worn smooth by the feet of visitors.[66] Their trace, their erosion, contrasts with the vast gulf carved by the Colorado, and so becomes another measure of transience. Caponigro's book took its inspiration from Ralph Waldo Emerson, and began with a quotation from his essay on 'The Oversoul'. In this transcendental vision: 'We live in succession, in division, in parts, in particles. Meantime within man is the soul of the whole; the wise silence, the universal beauty, to which every part and particle is equally related, the Eternal One.'[67] In this aesthetic, humanity merges with the cosmos, and contradictions are superficial, masking underlying harmony and unity. Such a point of view, while it can accommodate the erosion of human feet, cannot so easily incorporate the extremes of human attitudes towards landscape, such as strip-mining or indifference.

Martin Parr's colour photograph, 'Grand Canyon, Arizona, USA, 1995' (Figure 3.5), emphasizes not the natural site but the three people who are looking at it.[68] Their posture suggests not sublime amazement, but rather comfort and relaxation, as

they sit casually on one side of a picnic bench, eating sandwiches. They sit with their backs to the camera, becoming generic figures with no faces or individuality. Despite this anonymity, however, the strongest colours are not those of the Grand Canyon but of their red and blue windbreakers. The most striking object is the imitation Indian feather headdress one of them is wearing, which suggests both a tourist identification with Native Americans and ignorance of the fact that tribes in the Grand Canyon area never wore such regalia. An ironic, postmodern image, it places the viewer outside the sublime image, the utilitarian document, the human interest photograph or the representation of geological time. Indeed, a little more than a century after first being photographed, the Grand Canyon has been so fully appropriated that the gaze bestowed upon it no longer registers a powerful emotion. Absent is the sense of temporal sublimity or the powerful human interest of people sharing a natural wonder in rugged surroundings. The standardized table and bench, fixed to the ground, reminds us that this is an administered space, with mass-produced conveniences. Even the utilitarian impulse seems absent, as this image suggests no desire to reshape or remake the Canyon, but rather acquiescence in accepting the view pre-set by those who installed the table. The three figures lounging with their sandwiches seem as engrossed with eating as with the scenery, and they have the postures of television viewers.

The Sony Corporation suggested the power of the television image to replace the natural scene in a 1992 commercial, which showed a large television set perched near the rim of the Grand Canyon. A small boy runs to it, 'more interested in watching the Canyon's image on TV than taking in the actual landscape'. In the same year, General Electric used the Grand Canyon in an advertisement for the vibrant colours of its commercial lighting system.[69] In each case, technologies are presented as having surpassed nature, just as the synthetic colours in the nylon jackets of the anonymous tourists in Parr's image are brighter than the colours of the Canyon walls. Where the Canyon was once aestheticized, in postmodern times it loses aesthetic value, as the camera refocuses on human beings and the banality of their built environment. The Canyon's geological and environmental meanings have also disappeared from the image. The once sublime spectacle seems no longer to be a source of national pride founded in wonder. And yet the framing of this image gives it a critical edge, asking us not to accept the mass-produced clothing and furniture, the artificial colours or the near indifference to the view.

Conclusion

During a single century, the Grand Canyon moved from the complete obscurity of a 'profitless locality' in 1858 to become one of the most popular national parks and a central iconic site for most Americans. Photographs expressed the shifting aesthetics used to understand the Canyon, and they played a crucial role in publicizing it. Far

from being objective records, they were always cultural constructions, shaped by the desires and expectations of those who made them and looked at them. The first expedition, focused as it was on the utilitarian ends of finding arable land and navigable waters, could only find the region worthless. Some early photographers, imbued with a sense of the sublime, tried to translate the enormous expanse of the Canyon into images that could be set beside those of Niagara, Yosemite and Yellowstone. But the inverted form, the scale and visual complexity of the Grand Canyon to a considerable extent frustrated this attempt, and fifteen years after its discovery, the site was scarcely recognized in some major guidebooks. At the same time, other early images emphasized the view from the banks of the Colorado River. These photographs were able to suggest the difficulty of any descent of the rapids in small wooden boats, and they successfully publicized the bravery and the discoveries of the early explorers. But they did not capture scenes that ordinary tourists were able to see for themselves. The easily available view from the rim became meaningful only when it was incorporated into a modified version of the sublime that transformed the Canyon into the objective correlative of the vastness of geologic time. This reinscription of its cultural meaning depended upon popular acceptance of a new sense of history that pushed back the age of the earth. From a geological point of view, if the Canyon could not be seen all at once, and if its complexity frustrated all attempts at a single, general view, these characteristics, together with its hundreds of square miles of barren rock, tangibly suggested vast erosion during aeons of pre-human history. The Canyon was so much more ancient than the antiquities of Europe that it abolished any sense of American temporal inferiority to the Old World. Indeed, it dwarfed all human accomplishment and all of human existence. Paradoxically, it could therefore become the central symbol of a new nation, one that identified not with civilization but with nature. And given this identification, which had been exteriorized and represented in millions of photographic images of this vast landscape of time, to dam or to pollute the Grand Canyon was to corrupt the soul of the nation itself. To transform it, to change its visualization, was to make it part of that which it was not supposed to be a part: human history. The popular photographic representation of the Canyon, therefore, depicted it as timeless, Edenic and pre-human. It became a form of sacred space, threatened by industrialization, government planning and the sheer press of tourism itself. Thus, the most recent images of the Canyon tend to play off this imputation of perfection, without, however, entirely repudiating it.

FOUR

Family as Place: Family Photograph Albums and the Domestication of Public and Private Space

Deborah Chambers

§ THE FAMILY photograph album is a sophisticated ideological device which is attracting increasing scholarly attention in a variety of disciplines.[1] Public discourses of familial heritage are authenticated and celebrated through this cultural form not only as blood ties, continuity and connection, but also as intimacy, security and spatial belonging. Offering an intriguing insight into the role of photography in reconstructing space as place in her book *On Photography*, Susan Sontag stated: 'As photographs give people an imaginary possession of a past that is unreal, they also help people take possession of space in which they are insecure.'[2] This essay explores some of the ways in which family photograph albums represent ideas about spatial identity and belonging. It inquires into conventions used by compilers of albums to domesticate space. By addressing a particular set of issues and examples within this theme, the essay picks up a small thread within wider discussions of family photography.

The 'domestic space' in which family photography resides is not a fixed or permanent entity but, rather, a cluster of meanings which has been shifting and contested throughout the twentieth century, and negotiated in relation to changing meanings of 'public space'. As such, factors of race, nation and empire, class and gender have been central to the historical process of inscribing meanings about 'the family' and familial space. The role and messages of family photograph albums can be understood as part of these processes.[3] I draw on the theoretical concept of the 'ideology of the separate spheres', developed in part by Leonore Davidoff and Catherine Hall, to argue that family values and meanings are narrated through family albums which constitute a visual dialogue between private and public discourses of space.[4]

A high level of *familiarity* is expected when decoding the subject matter which presumes distinctive modes of viewing. The family album is therefore located in oral interaction. The lack of captions and explanations to guide the viewer through the

visual narrative is typical of this cultural form. Complex, and often contradictory, meanings encoded by the compiler are lost on non-family members. Most family albums are privately owned, and those in archival or library collections often have no supporting documentation. Some repositories and special collections disband the albums and file photographs individually according to subject matter.[5] These challenges can be approached by undertaking an autobiographical study of our own family photograph albums as researchers, and by using an oral history method to excavate the key motives and messages of family albums.

In this way, I draw on three linked sources and approaches. First, I begin by sketching some of the key factors, identified within post-colonial debates and family history, that have contributed to the use of family photography as an 'authentic' witness of the colonization of new, alien space, and as a cultural device for naturalizing hierarchies of gender and race. After making some comments about the composition of the family album as a mode of displaying family photography, I take an auto-biographical approach in the second section to build on the historical points by drawing on the images and meanings of albums produced by my own family in the 1950s. In this way, I aim to offer a self-reflexive dimension and provide some clues about the ambiguous nature of the relationship between personal meanings and images on display.[6] In the third section, I discuss the findings of an oral history research project of the same period, that is, 1950s albums from the Australian suburbs. I comment on the use and meanings of family albums compiled by women who were in their twenties during a crucial period of spatial transition which took place through the rapid suburbanization of Western Sydney.[7] In these ways, the family album is explored as a series of messages about the colonization of familial space as domestic 'place'.

Emphasizing that family photographs are integral to the ideology of the modern family, Pierre Bourdieu said that the practice of photography functions to solemnize and immortalize 'the high points of family life' and to reinforce 'the integration of the family group by reasserting the sense that it has both of itself and of its unity'.[8] Significantly, the family photograph album has evolved as a predominantly feminine cultural form, as a visual medium for family genealogy and storytelling. Echoing Bourdieu, Claire Grey has stated, in a study of related generations of women in her own family albums, that women often take on the role of 'keepers of the past'.[9] While women have been omitted from the public narratives of history, they have been present in private narratives, in the context of compiling albums as celebratory, memorialized and nostalgic representations of parenthood and childhood. The growth and establishment of family photography as a social practice began with the professional recording of 'the family' and later shifted to an amateur social activity in which 'the family' recorded itself. During the early twentieth century, men tended to be the authors rather than the subjects of amateur family photographs, but women were strongly encouraged to participate in this activity by Kodak advertisements of the period aimed specifically at them.

The Role of Family Albums in Representing the White Family, and the 'Public' and 'Private'

The private narratives of family albums have been influenced by national narratives of the nineteenth century in Britain and its colonies. The family, as the 'feminine' realm, played a central role in the metaphoric projections of the imperial modern nation during this period. The Victorian invention of the Royal Family coincided with the rise of photography and provided the ideal and model image of a universal white family for the photographic representation of motherhood as a sign of moral rectitude and father as ruler and protector of wife and children.[10] National bureaucracies gradually took over the social function of the great service families in the nineteenth century, and the family came to act as a metaphor for the naturalizing of hierarchy: the 'national family', the global 'family of nations', the colony as a 'family of black children ruled over by a white father'.[11] Changing aesthetics in photography functioned to erase the presence of First Peoples in colonized nations by representing Native Americans and Australian Aborigines as living anachronisms. In these ways, the nineteenth-century institution of the *white* family became an ideological terrain on which the meanings of nation and race were fought. '[N]ations are frequently figured through the iconography of familial and domestic space', and symbolized as domestic genealogies; for example, the 'Family of Nations', the British and Commonwealth 'Royal Family', as Anne McClintock has shown.[12] The family trope naturalized national hierarchy as a unity of domestic interests. In this way, the Royal Family saw itself as the embodiment of all families, projecting a visual model of patriotism, patriarchy and pedigree.

As a metaphor, the white family came to signify a single genesis narrative for national history, but, as an institution, it was dehistoricized into a symbol and excluded from national power.[13] A hierarchically gendered European middle-class family was centrally a symbol of white imperial nationalism, providing a gendered and racial justification for white male control over colonial space. The conventions of portrait painting among the nobility and merchant classes of Europe acted as a model for the professional recording of the family. Portrait photography exemplified the public and private surveillance of white family lineage as visual spectacle. The nineteenth-century treatment of women as male possessions, and an artistic use of the female form as an expression of 'desiderata and virtues'[14] and an object of beauty, shaped visual discourses of formal portraiture which, in turn, influenced domestic photography.

The nineteenth-century ideology of the 'separate spheres' played an important role in codifying contemporary ideologies of racial and sexual difference.[15] The white middle-class separation of home from work was a social construct and state of mind which led to the public treatment of social space as split between feminine private sphere and masculine public sphere. Despite the fact that many women worked for family-run enterprises, public recognition of their contribution to the public sphere

of work was denied. The domestic sphere became a symbol of 'women's contain-
ment'.[16] This ideology of space culminated in the early-twentieth-century idealization
of motherhood and a white, middle-class sentimentalization of domestic life.[17] The
home came to represent the repository of universal values of morality.

The predecessor of photograph albums was a general 'visual memory album'[18]
containing postcards and other visual memories of outings and events. Within this
format, the desire to link the family with the public world was in evidence from the
nineteenth century through the custom of collecting mass-produced *cartes-de-visite*
portraits of eminent individuals such as royalty, statesmen and clergymen. *Cartes*
portraits were exchanged among family and friends and arranged in personally
compiled, but commercially manufactured, albums with window openings for *carte-*
and cabinet-sized portraits. This visual 'who's who' involved a domestic celebration
of public figures, and a commitment to their public authority. The practice confirmed
that familial identity was formed through family connections to the outside world of
politics, power and pedigree. Some nineteenth-century albums contained a popular
reproduction of a poem that defined the rules of looking:

> Yes, this is my Album but learn
> ere you look,
> That all are expected to add
> to my book,
> You are welcome to quiz it,
> The penalty is
> That you add your own Portrait
> for others to quiz.

The poem was followed by portraits of the Royal Family, Queen Victoria, other
crowned heads of state, politicians and clergymen.[19] In other albums, postcards offered
another cultural framework for shaping discourses of memory associated with space.
The desire to connect one's family to celebrated symbols of nature and 'high culture'
indicates the need to connect the private family to the wider community and to public
institutions which represent national values: the pleasure of the countryside, the
grandeur of public monuments, parades, festivals and the celebration of community.

Early window albums catalogued portrait photographs of family members, famous
people and friends, indicating the family's connection to, and endorsement by, public
institutions. The authors of many early portrait albums are unrecorded and most
photographs were bought from commercial photographers who selected the land-
scapes views and portrait codes. Past anecdotal evidence leads one to suspect that,
within these parameters, the narrators of the albums were almost exclusively women.
Family albums of the 1860s and 1870s consisted of two formats, fulfilling two different
objectives. The first format was a book of pages of stiff cardboard with pre-cut slots
containing professionally produced family portraits. The second consisted of prints

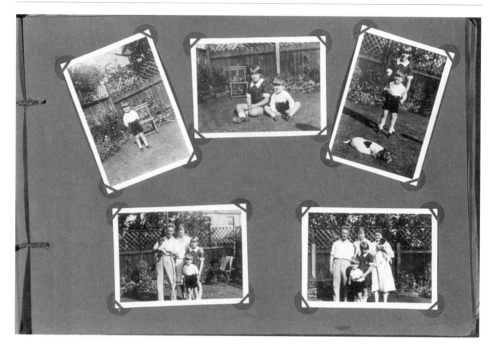

FIGURE 4.1 Chambers family album of the 1930s, East Ham, London, UK.

of differing sizes pasted directly on to blank pages which were custom bound or more often commercially available from stationers or dry goods merchants. The book format for displaying family photographs and memorabilia structured the ideas in the family album through a realist narrative with a chronological ordering of photographs for the telling of a visual story with a beginning, middle and end.

The arrangement of the photographs moved from a single portrait slot per page to the positioning of small photographs of mainly outdoor scenes symmetrically and often informally angled, as exemplified in one of my father's surviving albums of his childhood, from London's East End of the 1930s (Figure 4.1). Albums were conventionally bound with cord ending in two tassels. Some albums contained captioned photos as a visual record of events. By contrast, some were completely devoid of writing, and some contained surprisingly informal, anecdotal and humorous information that would mean nothing to someone outside the family. This feature underlines the function of albums within oral communication, which I turn to below in the oral history study.

Family photographs are seemingly static or unchanging texts when displayed in individual frames around the home, but, when placed in albums, they are sequenced by narratives which structure meanings according to the passage of time and events, or act as visual family trees. The desire for a chronologically and thematically organized narrative was realized through the book format and sequencing of photos. Amateur photography imitates professional photographic codes of realism[20] exemplified by the

highly conformist nature of family albums. Yet the subject matter of family photograph albums typically excluded women's labour in the home and continued to create a spectacle of family lineage and domestic pleasure. The burden of domestic work experienced by women tends to be systematically discounted within the selection of themes for photographic albums, emphasizing the idea of the family home as a 'leisure' unit. This means the pleasurable moments of heightened activity are generally celebrated. Housework has few celebratory qualities, so women collude in its dismissal from family photography's range of themes.

Autobiographical Insights into Family Album Photographs

Family photography became an essential genre and social practice for recording and celebrating the extended family during the transition to industrial modern society at the very moment, during the nineteenth century, when the extended white family form was beginning to disintegrate:

> Photography becomes a rite of family life just when, in the industrial countries of Europe and America, the very institution of the family starts undergoing radical surgery. As that claustrophobic unit, the nuclear family, was being carved out of a much larger family aggregate, photography came along to memorialise, to restate symbolically, the imperilled continuity and vanishing extendedness of family life. Those ghostly traces, photographs, supply the token presence of the dispersed relatives. A family's photograph album is generally about the extended family – and, often is all that remains of it.[21]

The disintegration of the extended family was accelerated by two key trends of urbanization in early-twentieth-century Anglophone societies: increased social and geographical mobility, and increased isolation of individual family units. The term 'mobile privatization' was coined by Raymond Williams to describe these two paradoxical trends.[22] A Victorian domestic ideal, in which the home became used as a symbol of moral rectitude and as a leisure haven for men, was realized in the twentieth-century symbolic segregation of 'masculine cities and feminine suburbs'.[23] The family album became an authentic witness and memorial of the white family's colonization of suburbia. Yet these important social shifts involving mobility, privacy and the breakdown of extended families were profoundly structured by race. The 'white flight' to suburbia was a central component of post-war attempts to create a geographical and cultural distance between white and 'other', indigenous, black and Asian races. Suburbia ensured the reproduction of racial hierarchy and the ethnic privileging of whiteness through a domestication of space as white place. So when the extended family unit was being replaced by a smaller, privatized, geographically and socially mobile family, amateur photography and the family album as a form of display came to the rescue to mythologize a fixed version of it. Family photography records and reinvents something that no longer exists.[24]

FIGURE 4.2 'Wedding Day', East End of London, UK, 1950, from Popkin family album.

FIGURE 4.3 'Father and child and Statue of Liberty', USA, 1956, from Chambers family album.

Using an autobiographical approach, some of these themes can be identified within a study of my own family's albums. Within the constraints of distance posed by time and generation, I can nevertheless make use of my familiarity with the subject matter as an 'insider'. This approach offers insights into the multiple and ambiguous meanings available to viewers. Figure 4.2 is a typical example of the desire to record, and thereby confirm and celebrate, the existence of the extended family at special events such as weddings. The photograph was taken by a professional in 1951 in the East End of London. It was not captioned. My mother was a bridesmaid (left) at her cousin's wedding, two years before she married my father, who is also present elsewhere in the frame. Surrounded by an impressively large number of relatives and friends, the wedding couple were presented as securely embedded in the heart of the extended family, their heterosexual union publicly and visually authenticated by the presence of relatives. My own, autobiographical, interpretation of the image provides only a partial understanding of the complex cluster of relations originally inscribed in the photo. Significantly, I can identify only my parents, one aunt, an uncle and my grandmother in the frame. I do not know the couple being married, and have not met any of my extended family for many years.

These kinds of family photographs are the only remaining proof of the existence of my own extended family. Such photographs fill a void, a sense of absence. For me, the photograph signifies 'imagined community'[25] and evokes a sadness at missed opportunities to get to know these relatives. The social trend towards fragmentation of extended families and isolation of nuclear families from the tight-knit communities of their origin was articulated in this instance by a cultural barrier caused by the social and geographical mobility typical of the 1950s. My father joined the Foreign Office two years after the photograph was taken, married and was then posted abroad as a British diplomat. Photographs became an important mode of communication between my parents and their relatives 'back home', substantiating family ties from a distance.

Despite being in continuous dialogue with public discourses of space, albums remain intended for private consumption among the exclusive group of extended and nuclear family and friends and never for the public domain, for publication. This simultaneously private and yet conformist and rigidly standardized cultural form became a popular medium for more than just the documentation of celebrated domestic events as a photographic diary or record of the nuclear family. It also constituted an Anglo-dominant visual witness of the invasion and colonization, and thereby claiming and domestication, of 'new' spaces by white European families. Family albums consisted of pictorial spectacles and visual memories of the ownership and domestication of unfamiliar, alien space. This theme re-emerges as a central one within the oral history study of family albums, described below.

Scenic backdrops in family albums of the wilderness, holiday resorts and monuments are common themes. An example from my own family's album is shown in

FIGURE 4.4 '1950s suburban home', Washington, DC, 1956, from Chambers family album.

FIGURE 4.5 'Family car in the suburbs', Washington, DC, 1956, from Chambers family album.

Figure 4.3. It is a photograph taken by my mother of my father holding me as a child aboard the *Queen Mary*, crossing the Atlantic to the United States in 1956. My father and I are squeezed into the edge of the frame so that my mother could both capture the family and also position the Statue of Liberty centre-frame. The photograph represents the family's excitement at 'having arrived' in the sense of my family's arrival in the promised land of America, brought about by my father's Foreign Office posting to Washington DC. The famous monument signified 'the American dream' and it seems to me to accentuate my own family's interpretation of familial identity as an achievement in terms of class and national and geographical mobility.

Many families and communities fragmented by geographical migration, whether through past quests to colonize other countries or more recent quests to colonize Western nations' city suburbs, were reconnected through visual narratives of extended kinship. These visual narratives were structured by Western, Anglophone ideas of space, gender and race. The family album represented genealogical and national heritage – it became a social and historical document of lineage and spatial belonging. The ritual of photographing members of the family beside monuments of nation and at national events reveals a familial desire to record the family's involvement in the creation of *domestic* images and meanings of nation. Picturing ideas of belonging to a nation and place were ways in which the album came to represent symbols of imagined community, notions of continuity and connections to the past. By creating images of people in 'special' places, that is, public or ritualized 'places', and at 'special' public or ritualized 'events', the visually selective nature of family photography has given the Western, migrating, colonial and suburban family a visual *raison d'être* by reconnecting the private, domestic refuge with the public domain that invented it.

Other photographs in my family's albums suggest how the evolution of Western consumerism influenced the celebratory theme of possession of consumer items. From the 1930s to the 1950s, the family home and even possession of expensive consumer items such as cars became established as common amateur photographic *mis-en-scène*. This theme echoed earlier rituals of family members posing for photographs, standing by their horses and buggies. I came across many examples of family albums of the 1950s containing photos of the family standing beside the 'family car', or the positioning of the car as a backdrop to family photos of leisure outings. Figures 4.3, 4.4 and 4.5 are examples from my own family's albums, which contain distinctive meanings for my parents about the pictorial celebration of domestic consumption and the familial colonization and domestication of public, 'leisure' space in 1950s American suburbia.

Figure 4.4 captures the family home in the suburbs of Washington, with my mother and me posing on the front doorstep. Figure 4.5 was taken by my mother from the interior of the family home. Father and child standing in front of the family car are framed by the veranda. In Figure 4.6, the mother and child feeding ducks in the park are balanced to one side of the frame with the family clearly visible on the other side, in the background. At a time and place of intense social change, 1950s suburban

FIGURE 4.6 'Mother and child feeding ducks in the park',
Washington, DC, 1957, from Chambers family album.

domesticity was being mapped out and re-presented by family photographs as a secure
space in which the home became a showcase for the consumerist, middle-class, white
nuclear family.[26] These photographs were not only designed for our own nuclear
family album, but were also duplicated for sending copies 'back home' to the extended
family of origin in England, in order to show off the nuclear family's new successful
suburban, consumer lifestyle in the United States. The photographs were not cap-
tioned but each one was dated by the commercial processor on the front of the white
border so as to emphasize the intended use of the image as a visual diary of family
activities and events.

 Most of my own family's albums were destroyed when seawater leaked into the hold
of the ship during a trip to an overseas posting in the early 1970s. We now have no
record of my younger sister growing up, which, understandably, makes her feel 'in-
visible', and it often feels to me as if we have no 'family history'. This is because the
albums in existence, from which some of these pictures are taken, have been compiled
from the copies sent back home to other relatives. Family photographs are often
encoded with peculiarly totemic and commemorative qualities, and given mystical and
talismanic meanings and values. According to Celia Lury, the special status of family
photographs is derived from their potential to capture the 'magical moments' of
intimate contact.[27] To emphasize the cultural significance of family photographs, she

cites Don Slater, who referred to the results of a market research survey in which 39 per cent of respondents claimed their family photos to be the most treasured possessions which 'they would least like to lose'.[28]

The Meanings of 1950s Suburban Family Albums

Some of the themes that emerge in the autobiographical exploration of my own family's albums are echoed within the findings of the oral history project. Within the study of 1950s Australian albums, ten Anglo-Celtic, white women, now aged between sixty and seventy-five, were interviewed about the family albums they had compiled when they were in their twenties in the 1950s. The women album owners were randomly selected from a previous oral history study of women's experiences of suburban development in Western Sydney.[29] We were particularly interested in the ways in which family albums produced during the crucial period of suburbanization were negotiating the spatial changes going on around these families. The sample was not representative but constituted a small-scale, in-depth exploration. It was intended to offer some clues about the range of meanings and values associated with the role, in women's lives, of family albums compiled in the 1950s.

The similarities, rather than the differences, between albums were immediately striking. Subject matter, poses, framing and sequencing were highly standardized. The albums were characterized by rigidly formalized, repetitive sequences and narratives. They contained photographs not only of a narrow range of events, but even of a narrow range of candid and action shots. Upon reflection, these distinctive family album conventions framed meanings specific to each individual family within the private narratives of its albums. Of the ten women, only one was unmarried. All the women interviewed regarded the albums they compiled as artefacts belonging to the whole of their family, with the exception of the unmarried woman whose albums were mostly a record of her holidays with friends. All the married women interpreted their albums as 'a record' or 'diary' of married life and/or of children, emphasizing the album's overwhelming function as 'truthful witness'[30] of familial events. Most albums contained a cross-section of portraits, landscapes and holiday photographs in chronological order. Some, though, were quite remarkable in their deviation from this norm.

Nine out of the ten women interviewed were Australian born. The family album of the one English woman who had moved to Australia as a young married mother consisted of a narration of settlement in the 'new country'. The rest of the albums involved a visual narration of suburban settlement in 1950s Western Sydney.[31] Interestingly, the album owners were divided into two groups in terms of their photographic treatment of their spatial surroundings. The first group consisted of those families who lived in the traditional country towns of New South Wales, in Western Sydney, before these towns were suburbanized. They chose to ignore and deny the spatial

changes around them. Country backdrops were selected when photographing families and friends to avoid images of the encroaching new suburbs. Being proud country-town folk, they did not claim the suburban dream as a positive part of their family's experience: it was seen as an intrusion.

The second group consisted of those families who had moved to the region of Western Sydney during the crucial period of suburban expansion in the 1950s. By contrast, they produced visual celebrations of their arrival in the promised land of suburbia with shots of cars, their homes and next-door neighbours' homes in full view. Many of these albums' photographs showed the move to the suburbs to be a progressive gesture.[32] The poor conditions of the inner city were forsaken for the Australian dream of fresh air, wide open spaces, home and car ownership. Suburbia was pictorially embraced as a utopian dream community. What all album owners and their families had in common, however, was a lack of interaction with members of the rural or urban Aboriginal communities. Spatial and cultural segregation between white and black was severe. Aborigines and Torres Straight Islanders were not treated as citizens at all, and were not enfranchised until the 1960s.

Although photographs were taken regularly by these Anglo-Celtic families, and by the 1950s were not associated simply with special events, a gendered use of the technology could be still be discerned. Wives typically owned a basic, cheap box Brownie, and husbands often owned the more expensive and sophisticated cameras and regarded themselves as the 'experts'. For example, Meg's husband took all the photos in her albums 'because he was a better photographer. He carried the camera!' Similarly, Pam's husband owned a British-made Ensign camera, which she gave him for his twenty-first birthday, followed by a German-made Voigtländer, both roll-film cameras. The latter cost the equivalent of about 100 Australian dollars in the early 1950s: '[A] good camera was a luxury … Well, I always had a camera, but it was only just a Brownie type one, you know – a little plastic one – it wasn't the Box Brownie. So we always had cameras, and on our picnics we always took snapshots you know. I guess it was the men because they had the more complicated cameras.'

The research project was not about the use and meaning of slides, but it was clear that slides were not centrally part of the women's domain. They were popular but not usable in albums. For example, 'hundreds of slides' were customarily taken by Pam's husband in addition to family snaps. They demanded a particular mode of viewing which created a distinctive, cinematic style: at a screen displayed in a darkened room with seated audience. The album owners said that their husbands took respon-sibility for slide shows, setting up the projection equipment and the screen on special occasions when visiting relatives and friends were captive audiences. Slides did not have the talismanic qualities of photographs. Interestingly, they were less tactile, less treasurable and less treasured. When projected, their secret properties were briefly exposed and quickly lost to a 'mass' audience, being viewed by a group rather than intimately by one or two individuals in private.

Despite detectable gender differences in the complexity of camera used, a gradual democratization of camera use was taking place in Western societies in the 1950s; often both wives and husbands took photographs. Four out of the nine married women album owners took their own photographs, while five filled their albums with photographs taken almost exclusively by their husbands. There were examples of albums among the sample which lacked a key member of the family: the father. For example, Pam's husband took the majority of the snaps contained in their family album. Those not taken by her husband were invariably taken by her father-in-law. Pam's husband was, therefore, absent from most outdoor event and holiday photos. These were albums recording only the activities of the mother and children. For her family, the album signified 'wife and children'. The one case where both the photographer and album maker was the husband (Meg's family albums, discussed below), was the most unusual in terms of subject matter. It was an extraordinary visual, chronological document of family residences and family business, and contained few human subjects.

The key purpose of most albums was to act as a record and celebration of children growing up, weddings, friends, relatives, holidays, picnics, Christmas, activities in the garden and scenes around the house. Some albums were interspersed with other memorabilia such as letters, certificates, baby booklets and drawings. The family album was also used to document those natural disasters common to the region: floods and bushfires. Alison compiled her own albums to serve the role of pleasurable memory:

> Yes. I was inspired in doing them by my mother who was, you know, in her eighties, and she'd had them all in boxes all her life. It took me for ever to sort hers out into categories and she loved them, and it was the only thing she ever looked at. She had them beside her chair when she was 88 – and she died at 88 – and everyone that came she said, 'Have you seen these?' They got so sick of those albums. But it gave her a great deal of pleasure. So I thought, well I'll do mine before I'm too old.

Albums were often taken out and looked at as a private and personal activity by the album owners, but more often as a collective family activity at gatherings of more than one generation. They were used as powerful devices for binding family members and generations together. The married women consistently defined their families' albums as a 'record of the children growing up' and as a 'marriage record'. Chronological ordering was regarded as an essential categorizing device. Thus, the humble family album of the 1950s took on the role of turning the experience of parenthood into a spectacle. The experience becomes fixed and transformed into desired memory so that, as Sanders stated, 'the image produces a form of memory that takes an ideological form: the way "one would like to be remembered"'.[33]

Celia made up her own albums, as commercially produced albums were expensive items for her:

110

I made it up myself. Manila folders cut down and, with a four-hole punch, I punched them. The cover of it would have been used to bind up files. It was probably very bad. I probably pinched it from the office in those days … It was a little bit hard to buy albums in the early days and you thought, oh well you could make up your own.

Like most album compilers, Pam arranged the photographers chronologically. She described how and when she arranged her albums:

One winter's evening. Well, not one winter – many winters' evenings, yes … always late doing it. No. Not regularly. I just got the bug every now and again and I'd get the albums out and put a few more in … Yes. I got them all in envelopes and I wrote the date on each envelope of the year and then I just went from there. Started from there and I did it – oh, it was quite systematic.

Pam always wrote on the back of her photos to identify them. All photos were used and only blurred ones were discarded or 'ones that were no good'. When asked how she organized the albums, Pam said:

Well I've organized them as a marriage record actually, of [my husband] Robert's and mine from 1946 to 1965 which are the only black and white ones we have. All the rest are on slides or colour prints. Then I've organized his family, his mother and father's from their marriage through till when he married. And also my own family, from my mother and father's marriage through to when I got married.

The birth of children was a key motivating factor both for taking the photographs and for compiling the albums:

Oh, well, as the children were little, you know, and that goes from 1946 right through the '50s, we took photographs of practically all their happenings and events. Special birthdays and things like that. Picnics always. You'll find lots of picnics in there, and car trips. Oh, if we think the garden looks nice we go out there and take a picture of it. So that's the sort of things we do with the camera.

There was much variation, however, in the purpose of each owner's album. Rather than visually recording the imagined community of the happy family, one compiler used the album to fragment the family unit by breaking it down into its individual members. For example, Jane's albums were unusual in devoting an album to each individual member of the family. The albums of each child begin at birth and end with graduation, represented by the graduation certificate. These albums were given as gifts to each individual child's new family. For Barbara, photograph albums functioned as records of the children growing up. She began arranging the photos in albums when the babies were born. The albums were compiled until the children reached the age of about four, and were then filled erratically and often neglected. Many photos were left in envelopes in bedroom drawers and trunks around the house, and still needed sorting.

When the children grew up, a shift in album subject matter from the celebration of children to the celebration of material possessions and consumption was common. Albums contained photos of the new family car, the house, friends and other relatives. All album owners systematically kept evidence of housework out of their pictures: 'No I was always fussy about having the washing taken off the line before we took any pictures [of the garden].' A large number of album photographs were of the surrounding space that marked out the family's territory. Barbara's family album contained shots of their smallholding on the outskirts of the country town that was rapidly being transformed into suburbia; photographs show their paddock, their horses, garden, the drive, the scenery surrounding the home:

> ... this was in the garden. There was an archway in the driveway – where you drove up – there was an archway. And there was another archway as you went out, but one of the brothers [in-law] who was a school teacher had built at the end of the 30s, he built that.
>
> ... So you've mixed up the years on this page, but you were saying it's for a reason – to keep anything taken around this place, this home – this district really. That's going up the river there.

The recording of public events, and of the family's presence at such events in public spaces, was a strong theme of albums:

> And picture 'G' is the Queen's visit and we are at the Memorial Garden which was opened that day. We went down at about 7 o'clock in the morning and we got a seat. We carried a park bench up to where she was going to be and we sat there and we were about 3 feet away from them [Queen Elizabeth II and the Duke of Edinburgh].

In contrast to the married women's albums, the albums belonging to Celia, who was the only single woman, signified her independence. The subject matter of her albums was holiday trips taken with girlfriends. Clearly, for this narrator, photographs and albums signified leisure: 'Oh, yes! Just to be feeling you're on holiday.' Each album was devoted to a single Australian trip and included postcards of the holiday scenes. She did not keep any family photographs in albums. As an unmarried woman she had full control over the subject matter of the shots. When asked why she compiled the 1950s albums during her early twenties, Celia said: 'Well it's really a record of your holiday, because even if you don't buy photos or the packets [of postcards] – whatever it may be – or the folders, you really haven't got anything to look back on and say "Oh, that was Hobart and so-and so in those early days!"'

Only one woman, Meg, possessed family albums compiled by her husband. These albums turned out to be most unusual so that the gender of the author of the photos as well as the album is significant. In addition to the usual photos of weddings, children growing up, picnics, friends and witness of public events, such as the Queen's visit to Australia in 1954, some albums took the concept of documentation extremely seriously.

Twenty pages of the first album were almost completely devoid of people. It constituted a visual record of all the houses in which Meg and her husband had lived since their marriage. Every room in the house or flat was carefully recorded, often from different angles in strict chronological order: page after page of tidy homes with little to indicate who lived there. Without the benefit of an oral history approach, this collection would have meant absolutely nothing, in respect of 'family', to the outsider. The interview almost ground to a halt at this point. The photos spoke for themselves and yet meant very little to anyone beyond the family:

> Well (photo) 'A' is the bedroom, the bottom of the bed and the dressing-table. And we had like a bay window. 'B' is the bedroom – it shows more. 'C', that is our dining room. That house was old when we went into it. 'D' is, now, that's the spare room. Well, we called it – no – that's my bookcase. So we couldn't get all our bedroom furniture in that bedroom, so 'D' – I'm trying to think. That's our dining room and this was another room that went off the dining room near the … Oh, my God, isn't this dreadful!

At one level, the album was a record of interior domestic space. Meg commented on a series of shots of the same room from several different angles: 'That really is a diary of the kitchen there.' Yet, at another level, this family album was a witness and celebration of family progress within a consumer discourse. The images pictured progression from the small flat, to a small house, then the husband's shop, then the vacant land they had purchased to build the house on, then the completed house, nearby workers' cottages and then the grand finale: the family's new poultry farm. The celebration of the symbol of success culminated in the visual record of the first battery chicken farm in New South Wales, shot from all directions, including an impressive aerial shot. The album contained photographs of the inside of the brand-new shed, hens, the feeding system and egg-packing plant.

This family album is a comment on the modern and the prosperous, albeit pre-organic, phase of Australian farming history. It was a record of the family as a producing as well as consuming unit, but the album typically records images of growth and change as signifiers of material accumulation. Photographed surrounded by countryside, the final large house stands for 'dream home', indicating the ideal Australian lifestyle in an ideal setting: the colonization and domestication of space. Influenced by the estate agents' visual discourses of property as spectacle, the aspirational features of albums as records of achievement are highlighted here. This example of album use for the purposes of documenting each domestic residence is fascinating as an exception to the norm. Albums were rarely used as a loyal document of home space as empty space. Yet that space was always present in the frame, contextualizing and giving meaning to the performances of 'being family'.

The oral history study suggests that family albums play an important role in the struggles over meanings associated with identity, belonging and community. It shows

patterns of social practice which indicate that the recording and interpreting of space through family photograph albums was structured by gender in the 1950s because the type of camera bought, its use for photographing the family, and the collecting and narrating of albums were also distinctively gendered. Modern albums draw on established novelistic and biographical genres from the 1950s as a way of introducing key familial characters and themes. The narratives of albums are tied to cultural myths of collective memory expressed by documenting fulfilment in marriage and parenthood, the innocence and potential of childhood and the realization of familial aspirations through material success.

Family Photograph Albums as Visual Dialogues About and Between Public and Private Spaces

An autobiographical exploration of our own family albums allows us to understand the conventions of this photographic genre and leads us uncover and question the broader patterns of meaning about place and identity that commonly structure family albums more generally. Moreover, because the family album is a crucial part of oral interaction and presumes oral contexts of viewing to decode symbols and actions, an oral history approach offers an entry into the subject. In this example, it has been approached through the experiences of the women compilers and information on gendered strategies of encoding. However, these two methods emphasize agency at the expense of structure. The role of family photograph albums in constructing and representing meanings and values about family and space can be understood only within the wider structures of power which shape the cultural form in the first place, and which circumscribe familial ideas about space and place. Ethnographic approaches therefore need to be grounded within the wider historical contexts of structures of power.

The historical backdrop of Western imperial nations and their colonies uncovers the racialized, gendered and classed structures of power which profoundly influence the role that the family photograph album plays in defining space in Western anglophone nations. Within public preoccupations with national and imperialist needs to make links and connections in terms of lineage, genealogy and belonging, family albums were implicated as powerful devices in rescuing a vision of the family as intrinsically white, extended and patriarchal. By creating photographic images of events, people and places, the visually selective nature of domestic photography traditionally serves the purpose of constructing the family as myth, by capturing a preferred version of family life. These structures set the parameters within which agents create their visual family 'life stories'.

The family photograph album becomes a visual narrative that structures and organizes feelings by fixing meanings of 'family'. Among the white, Anglo-Celtic families of 1950s Western Sydney, photographs were taken by both men and women,

but men typically took possession of more sophisticated cameras, and albums were mainly compiled by women. Albums came to represent a feminine motivation to reunite generations and geographies of isolated and dislocated familial units. Women's involvement in the construction of the family photograph album concerned a visual dialogue between the domestic values that shaped their private lives and the public world which invented these values. The ideological segregation of the public and private was symbolically reconnected through photographs for family albums by using the camera to act as a witness of the family's outings and presence in public spaces and at public events and monuments. The early family album signified the feminine desire to re-historicize the peripheralized and 'private' world of the family, to re-connect it to public history and public space. It represented the feminine motivation to reunite generations and geographies of isolated and dislocated familial units.

 This private yet popular cultural form, as it existed in Western anglophone nations up to the 1950s, may not have subverted dominant structures of power. Nevertheless, it has some transformative potential in the way albums are used to highlight the celebration of spaces occupied by the family, domestic space, as *feminine* space: parent-hood, children and friendships as relationships of community and belonging. While women have been marginal to public narratives, they pose the possibility of symbolic struggles over representation in their role as compilers of their families' albums. The exploratory set of approaches used in this essay offers lessons for future inquiries. The limitations of this kind of study could be usefully addressed through a comparative ethnographic exploration of the parallels and continuities between black indigenous, white and immigrant families in the compilation and use of family photograph albums and other photographic displays. The white family photo album of the 1950s traditionally surveyed and displayed heterosexual, mono-racial familial identities. Its messages are, therefore, as much about absences, fragmentation and exclusion as about presences, unity and belonging.

PART II
Framing the Nation

FIVE

Picturing Nations: Landscape Photography and National Identity in Britain and Germany in the Mid-Nineteenth Century

Jens Jäger

Photography and the Nation

§ A NATION is conceived through symbols and rites, and the diffusion and acceptance of national symbols belong to the process of forming a nation.[1] National iconographies and traditions, whether already existing, invented or emerging, carry the weight of symbolizing, strengthening or sustaining the cohesion of a nation.[2] Most modern nations were 'made' in the nineteenth century, and their making was supported by the popularization and redefinition of all kinds of images and the nationalistic (re)interpretation of landscapes and architectural and honorific monuments. This forms part of a wider movement of national mobilization in Europe. According to the hypothesis of 'imagined communities',[3] the wide circulation of texts helped to enforce the imagination of a nation. The same is true for visual images, including photographs.

The production of images of landscapes and monuments increased substantially during the nineteenth century. Beyond aesthetic developments in the perception of landscapes, images also gained further political or ideological significance. Representations of landscapes and monuments are, of course, not an invention of the nineteenth century, and their traditions pre-date the perception of a country as 'nation' in the modern sense. Perception is, however, culturally determined, and Western nineteenth-century middle-class culture tended towards nationalistic interpretations of literature, art, science, culture and landscape. It was assumed that the physical environment formed the character of its inhabitants, and therefore landscapes and landscape images were frequently seen as representing the essence of national character.

The invention of photography in 1839 provided a new means of producing and disseminating landscape images. Recent scholarly inquiry has shifted attention from the aesthetic aspects of the representation of landscape to the ideological and

discursive power of landscape images.[4] John Taylor has attempted to show which preoccupations and methods photographers representing England in the 1880s shared in constructing a coherent vision of their nation.[5] From a different angle, Joan Schwartz has explored how early travel photographs were a means to construct a specific view of the world catering to Western needs, beliefs and expectations.[6]

At the heart of this essay lies the question of how landscape images gain ideological significance. The focus will be on the contribution of landscape and monument photography to the construction of national identity in Britain and Germany. This is not to establish the British case as a model and to measure the German case against it. Rather, the starting point of this case study is the observation that, compared to the situation in Britain, there is a surprising lack of landscape photography in Germany in the mid-nineteenth century. In German photography collections at Hamburg, Cologne and Munich, landscape photographs taken prior to 1865 are rare,[7] yet, at this time in Britain, landscape photography was certainly prominent. At first, there is no obvious explanation for this. Photography flourished in both countries as in other countries with similarly advanced photographic infrastructures, including Belgium, France and the United States.[8] A comparison between Britain and Germany is instructive because it can be used to highlight the relationship between photography and discourses about nature, national identity, art and science. It is therefore worth exploring the conditions necessary for this type of photography to flourish in practice. A look at the reception of landscape photographs in the nineteenth century reveals if, when and how the new medium was incorporated into the construction of national identity. It also shows which images of landscapes were distributed as representative of a country.

The function of photography to represent a nation by images of (symbolic) landscapes was by no means self-evident. It required a connection between the national movement, a receptive public and an intellectual framework in which landscape photographs were 'read' and generated meaning. This intellectual framework consisted of three key elements: first, objectivity had to be inscribed onto photographs to allow viewers to interpret scenes 'as true representations of nature'.[9] Second, the photographed scene – that is, the landscape itself – had to be embraced as a national symbol; this required a strong connection between certain landscapes on the one hand, and national character and virtue on the other.[10] Third, prevailing aesthetic conventions had to frame the viewing of landscapes and steer the interpretation of landscape photographs in the direction of these associations.

In mid-nineteenth-century Britain, the 'picturesque' facilitated such associations; however, at the same time in Germany, the absence of a landscape aesthetic which effectively linked landscape – and, by extension, landscape photography – with national character might explain the relative weakness of landscape photography as a means of constructing national identity before the founding of the German Empire in 1871. After 1871, the national movement gained a new momentum, and the *Heimatbewegung*

supplied a framework for interpreting landscape in the national sense which previously did not exist.[11] This hypothesis will be elaborated in this essay. First, I shall briefly describe how photography was perceived in both Britain and Germany, followed by a rough outline of the respective national movements in the mid-nineteenth century. To assess the role of landscape images within the national movements, I look at the frameworks for disseminating landscape images. Then the emergence (or lack) of landscape photography in Britain and Germany as a commodity and site of ideology will be explored and compared.

Landscape and Photography: Reception and National Identity

The use of photography to promote the idea of a specific national character of landscapes and monuments was based on the reading of photographic images as true representations of objects and as symbols for a nation. German and British commentators did not differ very much in their interpretation of photography as a means to represent unmediated truth. Robert Cecil, who became British Prime Minister in 1885, wrote in 1864: 'Photographs regarded as evidence of that which they represent, differ in essence from any other species of representation that has ever been attempted. They are free, so far as their outlines are concerned, from the deceptive and therefore vitiating element of human agency.'[12] Not human hands but the divine laws of nature were responsible for the picture.[13] This, it was thought, would have a direct influence on the beholder. The British photographer Francis Frith emphasized the truthfulness of photography and argued: 'It is ... quite impossible that this quality can so obviously and largely pervade a popular art, without exercising the happiest and most important influence, both upon the tastes and the morals of the people.'[14] Although agreeing with the first part of Frith's statement, German commentators were less enthusiastic about the medium's influence upon taste.[15] However, Frith's assertion refers to another important aspect: the reception of photographs was influenced by the contemporary theory of associational psychology and aesthetics, which rested on the assumption that perceived objects excite and stimulate ideas already in the mind of the beholder.[16] Moreover, central to nineteenth-century associationist theory was a strong connection to rural and historical symbolism. The contemporary public did not necessarily view photographs as works of art. Rather, it approached these images with a mixture of scientific and associative scrutiny, often in a religious and historical sense.[17] Photographs, perhaps more than any other type of image, were a source of enlightenment, pleasure and education.

To investigate which chains of associations could be connected to landscapes and monuments first requires an understanding of the respective state of the national movements in Britain and Germany. Mid-nineteenth-century Britain was a unified state with an old monarchy and such well-established institutions as Parliament, although there were significant regional differences in culture and society in and

between England, Scotland and Wales. A distinctive British identity grew slowly in the nineteenth century, never thoroughly eclipsing these regional identities.[18] But, as Linda Colley has asked, what was it Britons thought they were being loyal to?[19]

Colley gives four main elements for the emergence of a British identity between 1707 and 1837: conflicts with a foreign foe, common interests (mainly trade), religion and the continuity of government symbolized by the monarchy and Parliament. But the year 1837 does not mark the end of this long process. Keith Robbins has argued instead that it was another eighty years before a British identity was firmly established, completed by the experience of the Great War, 1914–18.[20] From 1815 until 1854, no major military or any serious commercial conflict demanded loyalty to Britain; the Crimean war (1854–56) occurred thousands of miles away, never threatening the British Isles. Moreover, British trade and industry dominated world markets well into the second half of the century. Robbins has highlighted the importance of the growing acquaintance of an ever-expanding segment of the population with Britain as a whole. Literature, art, maps, the teaching of geography and tourism were seen as the means to disseminate knowledge of Britain to a wider audience. Thus, education and culture became the main theatre of nation-making.[21] 'Britons' were urged and expected to civilize not only the world but themselves as well.[22] These tendencies in art and literature, educational and religious movements tacitly and effectively supported the fabrication of Britain. Photography was seen by the middle classes as an instrument to supply knowledge about Britain's landscapes and monuments. This diffusion of images of 'national shrines' was part of a wider cultural movement that served to create a British identity.

In contrast, mid-nineteenth-century Germany consisted of more than thirty sovereign states, and unification was a major goal that the middle classes wanted to achieve. The middle-class groups, believing in the historical 'mission' of Germany, perceived Germany as a cultural entity. The German 'Volk' shared – it was thought since the eighteenth century – the same language, the same history, the same culture. German encyclopaedias devoted many columns to the definition of 'nation' and they usually emphasized the common cultural, historical and ethnic roots of a nation.[23] The consciousness of the educated classes of belonging to a specific German culture was closely connected with the understanding of German literature, art, music and theatre as determined by national character. Political nationalism began at the turn of the nineteenth century as a movement mostly of educated elites.

Yet, when nationalism emerged as a political movement in Germany, it did not represent the political will of the majority of Germans, nor even of the majority of the middle classes. The endless debates in the revolutionary German Parliament over what should and should not belong to a German state in 1848–49 revealed the problems in finding a common definition of Germany as a political entity. Due to the suppression of opposition in the German states and the surveillance of the public sphere in the decade after 1849, the national movement as a movement of political

organizations was effectively contained.[24] However, suppression of the cultural dimension of nationalism was far more difficult, and these modes of nationalism became increasingly important in the decade after 1849. By this time, the circulation of books, journals, newspapers and printed visual images had increased beyond anything seen in the eighteenth century. Debates on 'national' literature, science and art could therefore influence a larger portion of society than ever before. Thus, the formation of national identity in Germany in the mid-nineteenth century concentrated on the realm of culture. Accordingly, representatives of German culture, such as Friedrich Schiller, Albrecht Dürer, Johannes Gutenberg and Johann Wolfgang v. Goethe, were honoured with public statues commissioned by private enterprise.[25] Despite the fact that conditions for a flourishing landscape and monument photography were conducive, it did not yet emerge.

The Diffusion of Landscape Images

The familiarization of the British and German public with images of 'national' landscape scenery was already well underway before the age of photography. The rapid expansion of the printing industry and the growing importance of landscape painting in the early nineteenth century are well known and need not be repeated here. Genuine art markets emerged in both Britain and Germany[26] in the nineteenth century, and artistic representations of landscapes were popular. The developing illustrated press featured landscape images. Notably, series of landscape engravings or lithographs were produced that were 'national' in scope. J. M. W. Turner's *Picturesque Views in England and Wales*, published between 1826 and 1838,[27] for example, was an enterprise aimed at a nation-wide, albeit comparably well-off, segment of the British middle classes. Illustrated periodicals, among them the *Illustrated London News* founded in 1842, regularly featured engravings of important national sites in Britain.

A similar process occurred in Germany. As in Britain, some illustrated magazines began to publish engravings of landscapes of various German regions, among them the *Pfennig Magazin* and the *Gartenlaube* founded in 1853, the magazine with the largest circulation. In Leipzig in 1836, G. Wiegand began the publication of *Das malerische und romantische Deutschland*, a series of landscape engravings accompanied by texts that emphasized the specific German character of the landscapes.[28] In many German states, similar series were published though usually covering only one state. It seems that the failure of the revolution in 1848–49 halted such national projects, but the publication, *Galerie pittoresker Ansichten des deutschen Vaterlandes und Beschreibung derselben. Ein Hausschatz für Jedermann*[29] in 1856, indicates that there was still an interest in such national projects. Nevertheless, such grand publications were expensive, and only a few people could afford them.

Generally, the representation of landscape was decisively shaped by the arrival of photography.[30] Photographs were seen as exact copies of the features of nature, not

interpretations by an artist and, as such, better suited as proof of the distinct character of a landscape. During the 1850s and 1860s, photographs became cheaper, and an ever-increasing variety of landscape views were on sale. The contemporary beholder was well aware of the difference between an engraving and a photograph, for the latter created a stronger sense of 'being there'; the three-dimensional effect of stereoscopic photographs, introduced in the late 1850s, pushed this development further.

The production of landscape and monument images, especially in Britain, was boosted by the rise of tourism. With the growing railway network and the emergence of travel agencies, travelling ceased to be the prerogative of a few well-off groups. The experience of travelling in large groups created a sense of common interest and feeling. An awareness of the diversity of the country increased.[31] Even before the railway reached a region, amateur and commercial photographers had been there, taking pictures of beautiful and picturesque scenes.[32] Buying pictures of the visited site as souvenirs had long been a common habit of the noble traveller, and this custom spread as mass tourism developed. The photographs could serve, as one commentator noted in *The Athenaeum* in 1853, as a substitute for travel.[33] One was 'tempted to believe that the places themselves are actually before us'.[34] Vicarious travel became as popular as real travel. In a way, the owners of these photographic pictures 'possessed' a part of the land depicted, could claim to 'know' it and, through them, could also claim to display their membership in the nation.[35] Moreover, since the early 1850s dozens of photographic exhibitions featured landscape and monument photography.

By the late 1850s a substantial market for landscape photographs had developed in Britain.[36] In 1855, for example, George Washington Wilson of Aberdeen offered only forty-four, exclusively Scottish, landscape motifs. In 1863, his catalogue included over 400 different landscape photographs from many parts of Britain, thus indicating the enormous growth in this genre.[37] In 1859, Negretti and Zambra from London already had 2,000 domestic and foreign stereoscopic views in stock (of which the majority was British) at prices – between 1 shilling (s) 6 pence (d) and 7s 6d – which large segments of the middle classes could afford.[38]

German photography did not experience this shift of interest until well after 1860. As late as 1860, a correspondent of the *Photographic News* observed that German photography was comparably weak in general, and that 'stereoscopic photography is not yet carried on to the extent it has flourished in France and England'.[39] Hermann Wilhelm Vogel, a chemist and editor of a photographic journal, noted after a visit to the 1862 International Exhibition in London that German photographers devoted themselves almost exclusively to portraiture.[40] The biggest supplier of the German photographic market in 1863 was the 'Stereoscopen Fabrik' C. Eckenrath, Berlin, selling photographs of Germany, Europe, America, India, Japan and China. The stereoscopic views sold at prices between 1 and 17½ (the average being between 7½

and 10) Silbergroschen.[41] These prices were within the reach of the majority of the middle classes.

In Britain, landscape photographs of the United Kingdom and of the British Empire as well as of 'foreign views' were popular. The German market for landscape photographs was smaller, and views of German landscapes comprised only a minority of the images offered. Thus, in the 1850s and 1860s, German customers followed a European trend in embracing travel photographs as evidence of the superiority of Western civilization,[42] but, unlike the British public, failed to demand photographs of their own country.

Britain: The Patriotic Language of the Picturesque

The mere existence of a large market for landscape photography does not indicate, in itself, a 'nationalistic' reading of these images. The popularity of the genre raises questions about which subjects were most marketable, and why. To address this requires consideration of contemporary pictorial conventions, notably the picturesque. However, reference to pictorial conventions alone cannot explain thoroughly why certain types of landscape images dominated the market; the success of picturesque landscape images owed as much to romanticism and antiquarianism as to a specific approach towards photography.

The picturesque, as an aesthetic category, had been very important in England ever since the late eighteenth century.[43] Initially developed as an aesthetic theory for gardening and landscape painting, the idea of the picturesque was extended to the perception and representation of buildings, and even people during the nineteenth century.[44] On principle, 'picturesque' suggested 'pleasing to the eye' and formed an aesthetic category between the beautiful and the sublime. Its main formal elements were roughness, irregularity, a mixture of lights and shades, contrast and diversity, such as are to be found in ancient architecture, rough but not unpleasant nature.[45] The picturesque was, however, more than just a criterion of selection; it was an ideology of perception and interpretation of the environment. To recognize something as picturesque afforded a specific emotional response to the world, as described in associationist theory. It had to be learned, and it required historical and artistic knowledge. The generation of middle- and upper-class photographers, born between 1800 and 1825, had learned this lesson by heart.

The picturesque enhanced the language of visual facts with an acknowledged aesthetic element, crucial for the aesthetic and commercial success of landscape photography. The picturesque allowed photographers to interpret their work in conventional artistic categories and gave them a framework for the selection of subjects. It is important to keep in mind that a picturesque view was not an artist's idealization, but was believed to be a quality of the scene and of the features of the site depicted. Photographers displayed education, artistic feeling and taste when they selected the

best point of view from which to take a picturesque scene.[46] In contrast to gardening and painting, where artists following picturesque principles were 'allowed' to use their imagination to construct picturesque sights,[47] photographers were more circumscribed in their relation to nature. In short, photographers could claim to produce works of art because they could perceive and present nature as such.[48]

The connection between aesthetic elements and ideological qualities made the picturesque an ideal and subtle tool to transmit values. Already, during the Napoleonic Wars, it had become increasingly difficult for the educated observer 'to abstract the formal qualities of landscape features from their social associations'.[49] According to Ann Bermingham, the picturesque in landscape gardening and landscape drawing reflects the political attitude of its adherents and functioned as an argument in favour of the traditional British system, against the constructed and abstract French revolutionary system.[50] This ideological element remained an element of the picturesque. As a way of interpreting landscapes, it slowly reached wider portions of society, but arguably lost its political power as a means to counter the ideas of the French Revolution.[51] However, the language of picturesque arrangements and metaphors entered frequently into social and political discourse in Britain. Benjamin Disraeli's 'Young England'[52] novels, as well as radical publications, contained it.[53]

Much of the popularity of photographs of picturesque views of cathedrals, abbeys and ruins depended upon the rising interest in old architecture and history, and, above all, upon the movement to survey and protect the national heritage.[54] This movement can be described as a process of defining what belonged to the national heritage and what did not. Interest in the heritage of Britain rose steadily from the 1830s and, with it, the wish to communicate it to a wider portion of society. Even the government joined this movement by setting up a select committee to inquire into the state of 'National Monuments'. The decades after 1840 witnessed a sharp rise in the number of architectural and historical societies,[55] some of which commissioned and published photographs.[56] All these private and official organizations claimed to have a higher aim: the 'moral and intellectual improvement for the people'.[57] The sites of national monuments were considered to be a source of reflection on the incidents and accidents of the past. They became catalysts of a British consciousness. For the tourist, photographs kindled reminiscences of the places visited or directed future journeys to points of interest.

However, the reception of photographic images followed existing conventions of representation, of which the picturesque was a very important one. Consequently, not every site merited photographic representation and publication. For example, the reviewer of some photographs, published by Roger Fenton in 1852, wrote in the *Art Journal* that the photograph of Tewkesbury Abbey had been 'degraded by connexion with a mean modern house'. And he regretted that 'objects of large – of national interest, have not been selected'.[58] The products of photographers ought, it was considered, to reflect and relate to 'national interest', at least when it was the intention

to address a wider public. This interest not only focused on architecture, but was also related to the educational value of the images in general.

In December 1852, the first major photographic exhibition in Britain, organized by the Photographic Society of London, opened in the rooms of the Society of Arts, showing portraits, landscapes, travel photographs and scientific images taken mostly by amateur or semi-commercial photographers. In the introduction to the catalogue, Roger Fenton summarized that English photographs showed:

> for the most part, representations of the peaceful village; the unassuming church, among its tombstones and trees; the gnarled oak, standing alone in the forest; intricate mazes of tangled wood, reflected in some dark pool; shocks of corn, drooping with their weight of grain; the quiet stream, with its water-lilies and rustic bridge; the wild upland pass, with its foreground of crumbling rock and purple heather; or the still lake.[59]

Here were the themes of British amateur photographers. Amateurs took photographs of famous as well as lesser-known spots familiar from travel writing, history and literature; and they added sites to this collection. The works of Walter Scott, William Wordsworth and others described landscapes which amateur photographers sought in the countryside. When they photographed such a scene, they often referred to a literary model with a quote from a poem which had been, or could be, read as the inspiration. The albums of the Photographic Club abound in references to poetry.[60] In the *Album for the Year 1855* more than half of the photographs are accompanied by quotes from poets, among them Lord Byron, Walter Scott, P. B. Shelley, William Cowper. Some descriptions supplied background information, for example from *Murray's Handbook of Switzerland*, on the history of a building, tree or site. The photograph thus became a complex instrument of education.

The images of England, Scotland and Wales, and the interpretations proffered in the titles and descriptions were highly selective. They were constructed as an appeal for a 'nationalistic' reading. The public was familiarized with the diversity of Britain, and it was presented, despite regional diversity, as one nation. The character, along with all the values and virtues that stood for Britain's greatness, was inscribed into the landscapes, monuments, cottages, streams and mountains. On the one hand, this vision of Britain was dominated by English concepts; as Stephen Copley and Peter Garside wrote: the 'picturesque "invention" of the region [is] a hegemonic cultural manifestation of the English colonising presence'.[61] On the other hand, there was no particular type of English landscape that was presented as essentially British, for example the south-east of England which later dominated the image of 'British' landscape.[62] These photographs used a common 'language' for a wide variety of landscapes that represented what should be considered as belonging to Britain. A critic, writing in the *Journal of the Photographic Society* in 1858, suggested this resulted in 'mannerism': 'In all probability a picture taken in the Highlands would be treated in

the same manner as one taken in Devonshire.'[63] A picturesque reading and a widespread interest in historic associations combined the diverse representations of landscapes into a vision of Britain as a composition of individual elements that nevertheless formed a union. This was done in most large exhibitions of photographic societies, among them the London Society, in which landscapes of English, Scottish and Welsh scenery were always shown.[64]

Photographs transmitted basic concepts of Britishness to the interested public in the cities and fostered identification with the local and regional scenery. This was an important first step. Many educated amateur photographers understood their work in a way summarized by Robert Hunt in 1848 in the *Art-Union Journal*. He wrote that it was the duty of photography 'to preserve faithful pictures of those "English Shrines" made holy ground to us by the sacred memories which cling to their crumbling walls'.[65] Here it is easy to detect the wish to establish a fixed chain of associations with images of old architecture. This response towards photographs enforced the place of national history as part of collective memory. Equally important was the way in which land-scape photographs were perceived to communicate moral values. Writing about English scenery in *The Sketch Book of Geoffrey Crayon, Gent*, first published in 1820, the American author, Washington Irving, declared:

> England does not abound in grand and sublime prospects, but rather in little home-scenes of rural repose and sheltered quiet. Every antique farm-house and mossgrown cottage is a picture … The great charm, however, of English scenery is the moral feeling that seems to pervade it. It is associated in the mind with ideas of order, of quiet, of sober, well established principles, of hoary usage and reverend custom.[66]

The English amateur photographer, Benjamin Brecknell Turner, used the first sentence of this quote in 1855 as a caption for his photograph 'Bredicot Court' (Figure 5.1), which he submitted to the *Album* of the Photographic Club. Formally, the image combines picturesque aesthetics with historical interest. Bredicot, situated near Worcester, was not only Turner's favourite rural spot for photography, but also the home of his wife's family.[67] He thus produced a multifaceted image which repres-ented his own affection for the countryside and a specific landscape which invited the beholder to read the picturesque image, as the Washington Irving quote suggested, as a stable, safe haven of traditional values.

Photographs acquainted the public with the diversity of British landscapes that were presented as worthy of representation as foreign landscapes renowned for their beauty or picturesque charm. A critic of the first photographic exhibition of the Scottish Photographic Society, in 1857, wrote with satisfaction that many images were on display showing landscape scenes of which 'Britain is peculiar[ly] rich', scenes which, 'instead of wandering in search of them on the Continent, or even at a distance from home in our own Country, every man with a feeling of nature and an eye for art can find within a mile or two of his own home'.[68]

FIGURE 5.1 Benjamin Brecknell Turner, 'Bredicot Court', Worcestershire, April 1852–54, from *The Photographic Album for the Year 1855. Being contributions from the members of the Photographic Club*. Calotype, 207 × 257 mm. Courtesy: British Library, C.43.i.7, pl. 19.

Through photographs, landscapes and views worthy of contemplation were brought within the reach of everyone, opening up the possibility of a collective experience. That was true not only for Scots, but also for every inhabitant of the British Isles. In *A Photographic Tour Among the Abbeys of Yorkshire* by the London photographers Philip H. Delamotte and Joseph Cundall, the editors stressed that few people knew what 'treasures of art or picturesque passages of nature' existed in Britain.[69] The popularization of national monuments, such as Fountains Abbey in Yorkshire, was an important goal for educationalists, nationalists and the government alike (Figure 5.2). Beholding the old abbey ushered in a constant flow of historical associations. Its picturesqueness, like its belonging to the heritage of the whole nation, was never challenged. *A Photographic Tour Among the Abbeys of Yorkshire* was an appeal to people to become acquainted with their own country; the editors suggest that domestic tourism was indeed 'a way of proclaiming who one was'.[70]

FIGURE 5.2 Philip H. Delamotte and Joseph Cundall, 'Fountains
Abbey', from *A Photographic Tour Among the Abbeys of Yorkshire* by Philip H.
Delamotte and Joseph Cundall with descriptive notices by John
Richard Walbran, F.S.A. and William Jones, F.S.A. (London, 1859).
Albumen print from wet collodion negative. Courtesy: British Library,
17e28, pl. 1.

Commenting on the photographs by Turner displayed at the annual exhibition of
the Photographic Society, London, in 1854, the *Art Journal* claimed that they were
'purely, essentially English' and added that those of the Edinburgh photographers
Ross and Thomson 'continue to familiarize us with Scotch scenery'.[71] Thus, in viewing
such photographs, the public could learn what to interpret as essentially English,
Scottish or Welsh. Above all, these landscapes and monuments had something in
common: they were subjected to the same picturesque gaze. The confirmation of
regional identity did not contradict the emergence of the interpretation of these
images as 'British'. However, what exactly 'British' meant remained vague, but it was

successfully superimposed upon a mere 'local' reading. Other photographic series and albums were published combining local images to form representations of British scenery, such as Russell Sedgfield's *Photographic Delineations of Scenery, Architecture and Antiquities of Great Britain and Ireland*[72] in 1855 or Dolamore and Bullock's *Memorials of Remarkable Places; being a Series of Photographic Pictures of British Scenery*, which was published in 1856.[73] The *Memorials* included photographs of Kenilworth Castle, Warwickshire; the Thames Valley; Somerset House, London; and Lydstep Point, Wales. When yet another album by Russell Sedgfield was published in 1859 under the title *Stereographs of English and Welsh Scenery*, the *Art Journal*'s critic acknowledged it to be 'a series of interesting British views … every one of which is of value to the antiquary, the lover of art, or both'.[74] There was, it seems, no distinction between English, Scottish or Welsh views.

There were lessons of history to be learned, especially through viewing photographs that featured ancient buildings. J. T. Brown emphasized in *Photographic Notes* (1858) that, in scrutinizing photographs of old buildings, 'we must in reality examine the progress of various parts of the world towards civilization, and in many cases their relapse into barbarism'.[75] Photographs of architectural monuments, especially ruined abbeys, provided a lesson in how a society could 'relapse into barbarism'. As moral indifference appeared to contemporaries as a great danger, a revival of 'old values', or what were believed to be old values, throughout the nation was seen as the proper measure to stabilize society. To the urban middle class, the countryside represented sobriety, industry, tranquillity and order. The study of images was expected to foster education and self-improvement. To remind people of their common history, culture and interest was thus to support social and national stability.

Moreover, picturesque images not only provided a patriotic translation of a landscape or monument, they also allowed one to inscribe national virtues on the very details of a scene. Fenton spoke of the 'unassuming church, the quiet stream, the gnarled oak'. Here there were no immediate historical lessons to be learned, but the details could be interpreted in a symbolic way. Ancient trees were thus symbols of stability and individuality.[76] Waves and the seashore stood for transitoriness and change. Nature connoted spiritual refreshment.[77] Although industry, urbanization and the progress of science changed the world, there were some stable factors: the countryside, its lifestyle, monuments and old buildings. The assumption that the countryside was free of most of the problems found in the towns was one of the strongest myths in Victorian Britain.[78] The landscapes, as long as they were found on British soil, referred to tradition; they stood for moral improvement. A picturesque landscape thus became a pledge for values suited to protect modern Britain from moral indifference and harmful materialism.

The impact of modernity on the landscape was rarely a subject for photographers, and was even less prominent in public exhibitions. Industrial Britain was not understood as the seat of national character. However, photographers sometimes gave

FIGURE 5.3 W. H. Nicholl, 'Crwmlyn Viaduct', Monmouthshire,
8 August 1854, from *The Photographic Album for the Year 1855. Being contributions
from the members of the Photographic Club*. Albumen print from wet collodion
negative, 211 × 188 mm. Courtesy: British Library, C43i7, pl. 41.

examples of the coexistence of industry and nature. W. H. Nicholl photographed the
railway viaduct of Crwmlyn in Wales[79] which was erected in Monmouthshire, the
Welsh county connecting South Wales with Gloucestershire (Figure 5.3).

Turner's English scenes, Ross and Thomson's Scottish photographs, and images
such as Nicholl's viaduct encouraged members of the public to conceive of themselves
as members of one nation by sharing a set of common experiences and a common
heritage of landscapes and monuments. The picturesque and associative interpretation
of landscapes, with all the references to education and literature, had repercussions
on how certain landscapes and regions were perceived. Photography of Scottish land-

scapes tended towards an image of Scotland as one of a romantic, Celtic Highland civilization.

The impact of photographs was twofold: they were proof of the very existence of the represented scenes, and they reiterated – and thus reinforced – their value as national icons. Photographs brought the land back to the cities, thus reaffirming the link between the two. To reinforce this link, the advocates of landscape photography drew upon the idea that the land formed the national character and that to remind the people of it as vividly as possible would preserve the national character. In representing the sites of national literature and art dear to the educated, photographs wove together the threads of literary, historical and artistic heritage. Thus, as David Lowenthal has observed, 'hills and rivers and woods cease to be merely familiar; they become ideological as site of shrines, battles and birthplaces'.[80] The appeal to preserve and to treasure them was, as well, an appeal to establish them firmly in collective memory. They stood for values to which the English, the Scots and the Welsh could all subscribe.

Germany: Unexposed Nation

Interest in nature and landscape was not a distinctly British phenomenon. Rather, Romanticism had repercussions on the perception of nature and the countryside across all of Europe. In Germany, the national movement discovered the German forest as a national symbol, and the Rhine valley became prominent after the French threat of 1840. The most popular song of this period was '*Die Wacht am Rhein*'. To the liberals Carl v. Rotteck and Carl Welcker, editors of the influential *Staats-lexikon*, the function of art was to foster a sense of the nation. Art itself should become more national, they declared: '[It] needs not only a *Heimat* but a fatherland and a love for the fatherland.'[81] But it was not only liberals who drew on art as an argument for politics and ideology. Some conservatives influenced by romanticism did so as well.[82] The turn to the romantic, historic, symbolic landscape meant a shift away from the ideal and foreign landscape popular among landscape painters.[83] Landscape acquired a deeper meaning as expressing universal moral values and eternal conflicts between human beings and nature. The paintings by Joseph Anton Koch represent this type of landscape imagery: the 'heroic landscape'.[84] In science, the conviction grew that the physical environment was the most important factor in forming national character. The researches of the savant Johann Gottfried Herder (1744–1803) and the geographer Carl Ritter (1779–1859) popularized this theory. Thus the land itself acquired a deeper meaning. The exact representation of a landscape was a site, not merely of aesthetic pleasure, but also of study. Painters such as Koch, Caspar David Friedrich and Carl Gustav Carus were influenced by the notion of environmental determinism. Landscape images therefore had an ideological potential in mid-nineteenth-century Germany. The *Kunstvereine* (art unions), very popular and successful in Germany from

the 1820s onwards, did their share in educating the interested middle-class public. Some enterprising publishers capitalized on the interest in landscapes with their series of engravings mentioned above. There were, it seems, apparently good conditions for the development of landscape and monument photography in Germany. However, the dominant aesthetic discourse rendered this more difficult than in Britain.

In Germany, images of nature were, in general, held to be inferior to those with historic or ideal subjects. The artist copying a beautiful scene in nature did nothing more than copy God's work; the artist did not 'create'.[85] The picturesque – so important to British photography – did not find its way to Germany and, apart from gardening, hardly entered the aesthetic discourse.[86] The German term *pittoresk* was simply used to designate a subject as suited to the artist.

If the meaning of a landscape or monument lay in its features, and not in an artist's interpretation, then photography would have been the appropriate medium to communicate it. In his history of German art, Count Athanasius von Raczynski wrote, in 1841, about the daguerreotype: '[I]t confirms my opinion which I like to introduce to painters of landscapes and architecture: that nature copied with fidelity has a charm which cannot be reached or replaced by poetry, spirit or dexterity.'[87] Two years earlier, a Dr Nürnberger had written in the *Morgenblatt für gebildete Leser* that cathedrals, glaciers, obelisks and the 'picturesque rocks of Scandinavia' would be appropriate subjects for the daguerreotype.[88]

However, Nürnberger and Raczynski belonged to a minority. Until the 1860s, most photographers remained in the cities and rarely went out to take landscapes. The discovery of Germany with the camera was thus slow. The plan of the daguerreotypist, Johann Baptist Isenring, to travel around southern Germany to collect photographic material for a publication including all the 'first-class monuments of older and newer German architecture', was never carried out.[89] Apparently, to most photographers, landscape and monument photography was considered neither interesting nor rewarding. And, as a leisure activity, it was not very popular among the German middle class. Patriotism did not express itself through photographs of local monuments, although some efforts were made in the 1840s.[90]

Even in the 1850s, after numerous technological improvements, landscape photography did not become more popular in Germany. The well-informed correspondent of the *Photographic News* claimed in 1860 that 'the photographic traveler would find more activity prevailing in the exercise of his art on the banks of St. Lawrence than on the Rhine'.[91] It is surprising that interest in landscape and monument photography remained low in comparison to Britain, although the richness in detail and the exactness of the images corresponded with the aesthetic sensibilities of the time.[92] It appears that there was no substantial market for this type of photograph. It was a single and noteworthy event when the photographic firm Wehnert-Beckmann from Leipzig, managed by Bertha Wehnert-Beckmann (1815–1901), opened an exhibition of 600 stereoscopic photographs on their premises in Berlin in 1855.[93] Daguerreotypes

and photographs of Italy, France, England and Germany were on display, stimulating one journalist to write in the *Deutsches Kunstblatt*: 'In fact, one perceives not only the thoughts of the architect but his work with all its history through years and centuries of contingency and realities.'[94] He emphasized the educational benefits of such an exhibition, especially if one already knew something of a building from literature or engravings. It is not known whether these images were for sale, or if this event was organized to promote Wehnert-Beckmann's short-lived venture in Berlin.[95] Such exhibitions, however, were rare events.

In the later 1850s, some journalists began to deplore the lack of regional and national views. There were only a few photographs of 'works of art from our own soil', and the work of the photographer, Leopold Ahrendts, gained a high reputation. Ahrendts had photographed the major buildings of Berlin and its surroundings. The *Deutsche Kunstblatt* hoped in 1856 – one year after the Wehnert-Beckmann exhibition – that Ahrendts would 'direct his activities … to other German cities, so that our most beautiful and distinguished monuments of our native country will shortly lie before us in a collection of excellent photographs, and so that the [work done in] foreign countries will no longer shame us'.[96] Some experts in the art market and some photographers clearly felt the lag between England, France or even Italy and Germany. Yet, in the years immediately after 1856, no substantial change in the photographic market can be detected.

Even the Rhine Valley, with its romantic and patriotic associations, did not attract many photographers. If there were photographs of it, then they were taken by foreign photographers, and foreigners distributed and bought them.[97] Browsing through the advertisements for C. Eckenrath, Berlin, reveals that most of his stock consisted of foreign photographs and that only a small number of German scenes were for sale.[98] Portraits of eminent persons and engravings of landscapes sold nation-wide. But the marketing of landscape photographs seems to have been much more difficult. Given the popularity of photography in general, this is surprising, yet partly explained by three factors: first, the efforts of engravers and publishers who advertised their products in numerous art publications were much more sophisticated, and they operated in an already established market; second, engravings had a better reputation than photographs as works of art; third, the *Kunstvereine* sponsored engraving, but rarely supported photography.[99]

In the individual states of the German Bund, the demand for photographs of regional landscapes or monuments was generally weak. However, at least two exceptions can be identified: the city of Cologne, home of the most famous German building of the nineteenth century, and the kingdom of Saxony, with its own 'national' tradition.[100]

Cologne Cathedral, perhaps *the* national monument in Germany,[101] was popularized by numerous private associations (*Dombau-Vereine*)[102] to support its completion. However, it was not until 1853 that the first photographs of the Cathedral were

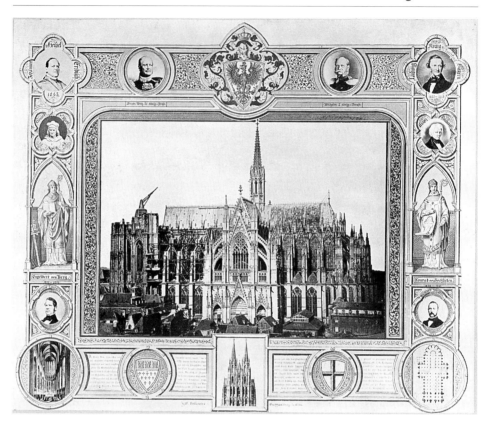

FIGURE 5.4 Friedrich Raps, 'Photographisches Gedenkblatt auf das Dombaufest
am 15 Oktober 1863'. Albumen print from wet collodion negative, 330 × 435 mm.
Courtesy: Rheinisches Bildarchiv, Köln, RBA 222 671.

marketed by the Belgian photographer Franz F. Michiels who worked together with the
publisher F. C. Eisen of Cologne. Everything was done to market the pictures: a local
newspaper, the *Kölnische Zeitung*, published a laudatory article on the pictures in Sep-
tember 1853. Eisen advertised in the nation-wide booktraders' publication *Börsenblatt des
deutschen Buchhandels*. Articles and advertisements in the *Deutsches Kunstblatt* familiarized
the public interested in art with the venture. The images won prizes at exhibitions in
Bruges and Brussels in 1853, and at the Exposition Universelle in Paris in 1855.[103] The
success, however, was partly due to English travel literature: *Murray's Handbook* had an
entry with the address of Eisen's bookshop near the Cathedral.[104] A set of five images
sold in 1853 for 6 Taler 20 Silbergroschen, and a single photograph of the Cathedral
cost 2 Taler, expensive by German standards.[105] In 1855, a second photographer,
Willhelm Horn of Prague, published Germany-wide advertisements for photographs
of the Cathedral at 5 Taler per print, and it took three years before a picture dealer

in Hamburg offered them for sale.[106] In other words: even one of the most popular buildings in Germany, one of its most popular national symbols, did not sell as a photograph. Although the absence of more advertising and the lack of comments in the periodical press are not a very strong argument against the Cathedral as national symbol, it proves that *photographic* images of the Cathedral were indeed not a commodity to be marketed aggressively nation-wide – even more so, because there were many instances when the press commented on portraits of eminent persons which were known (or even celebrated) all over Germany, no matter how often they had previously been photographed and 'published' either as engravings or as photographs. Perhaps the photograph taken in 1863 by the photographer Friedrich Raps (Figure 5.4), and commissioned and distributed by the bookseller J. & W. Boisserée, had more elements which made it attractive to customers. On a single sheet, photograph, engraving and text were combined to commemorate the *Dombaufest*, 1863. The design shows a gothic frame, the vignettes represent men of the past 600 years and especially the last twenty-five years who were important to the project.[107] A short history of the Cathedral is printed around the two coats of arms at the bottom of the picture. The view of the Cathedral was taken from the south, and Raps must have been on the roof of one of the buildings adjacent to it. The combination of photographs and lithographs of eminent persons (among them the Prussian and Bavarian kings) and the reference to the long tradition and history of the Cathedral alongside an exact image of the building as it was in 1863, gave the commemorative picture its strength. Most persons could be identified by the captions, and the whole image is not difficult to decipher as evidence of the importance of the Cathedral and its unifying message.

In the early 1850s, the photographer Hermann Krone produced a series of landscape images of the Sächsische Schweiz near Dresden, which found great popularity in Saxony – as studies for artists.[108] In 1853, a path through the Sächsische Schweiz was completed, and the mountains were now within easy reach for Dresden's citizens. The landscape was renowned for its strange sandstone peaks and wonderful prospects over the valley of the Elbe river. 'Prebischkegel' (Figure 5.5), considered the most interesting place for natural scenery in the entire kingdom, became a favourite destination for tourists. Krone arranged the picture as if he were a successful mountaineer looking down on smaller peaks. The form and structure of the stone are clearly visible and, in the middle distance and background, the view opens on to a valley. Thus, he constructed a view which expressed the domination of the mountains by mankind, and was sublime at the same time. Shortly afterwards, Krone published an album with thirty-six landscape images of the same area, which was exhibited at the *Gewerbeausstellung* in Dresden in 1854 and popularized this landscape further. However, outside Saxony no popular journal, not even the *Photographisches Journal*, mentioned Krone's work.

The middle classes promoted the process of forming the German nation; the same classes promoted photography as well, and had the means to buy photographs. Yet,

FIGURE 5.5 Hermann Krone, 'Prebischkegel', Elbsandsteingebirge,
Saxony, 1853–54. Albumen print from wet collodion negative, 210 × 164
mm. Courtesy: Deutsches Museum München, 06/7727.

photographers and picture dealers rarely offered photographs of Cologne Cathedral
to a nation-wide public; neither did Krone sell or advertise his landscape photographs
outside Saxony. Krone's images were, it seems, quintessentially Saxon, appealing to
tourists from outside Saxony in a similar way that images of the Alps were regarded
as interesting but not symbolic of Germany. Cologne Cathedral was either not really
a symbol of the nation – and to some staunch Protestant north Germans it was not
– or a photograph could not communicate the national lesson. The Cathedral was
indeed ambiguous as a symbol of, and for, the nation, but, no matter if Catholic or
Protestant, *Dombau-Vereine* flourished everywhere. And the most prominent promoter

of the Cathedral was a Protestant, King Friedrich Wilhelm IV of Prussia. What remained was the problem of communicating the national lesson.

The majority of the German public was not prepared to 'read' a photograph of a building (or landscape) as a symbol of nationhood. Partly, this was because most buildings offered were ambivalent as national symbols. However, it was also partly because the factual character of photographs rarely triggered a flow of nationalistic associations. Although the concept of the nation entered painting and aesthetic discourse, it did not affect the perception of photography. Photography remained thought of as a suspect stranger to art, useful only as a tool or sketch. Travel photography only slowly changed this.

It was difficult for the advocates of photography to convince photographers and the public that photographic images excelled in the representation of important buildings or landscapes. Among potential customers, such as the urban middle classes, there was still a considerable number having prejudices against photographs of landscapes for aesthetic reasons, beginning with the lack of colour. The vast majority of photographers was exclusively producing portraits or busy in reproducing works of art, so supply was as weak as demand. No matter how romantic, picturesque or historic a landscape were thought to be, it was not necessarily associated with national values and virtues. Thus, the 'discovery' of Germany took longer than might have been expected. At least photographically, Germany remained unexposed until the last third of the nineteenth century.

Conclusion

From the 1850s, landscape and monument images circulated in larger quantities and reached a wider public than ever before. Interest in architecture, monuments, history, art, literature and science was popular with the middle and upper classes of Europe. Photography was a useful tool for all these fields of interest, and a topic in itself. In a way, photography was an integrative element of European middle-class culture. In this context, photographic images of landscapes and monuments could serve to communicate patriotic and nationalistic ideas if the subjects represented could be deciphered as symbols for the nation. In Britain, photographs were read as such. 'Bredicot Court' stood for stability and tradition which was to be found in country life (Figure 5.1); 'Fountains Abbey' represented an important monument referring to order and disorder, faith and art (Figure 5.2). Both images represented rough and irregular surfaces in a picturesque way, both referred to history and tradition. Modern Britain represented by the railway was reconciled with nature in photographs of railway viaducts spanning romantic dales. All these images were rich in picturesque elements which provided a code to decipher them. Landscapes, no matter if English, Scottish or Welsh, could be read as expressions of certain values which in the end were British. The photographs represented at least what belonged to Britain. Contrasting

Kentish hills with rough Scottish mountains showed the diversity of Britain, but the
ideas associated with them belonged to the same cultural heritage. In 1857 a con-
tributor to *The Athenaeum* described a photograph by Francis Bedford as representing
'solid toryism of old abbeys and old keeps'.[109] The contributor did not describe this
particular building but saw this character in all old abbeys and all old keeps; such
buildings were to be found all over Britain. No matter if, to some people, old abbeys
represented toryism – the ivy-clad monuments became, in themselves, symbols of the
heritage of the nation.

The spiritual heart of Britain lay in the countryside. Power was based in the estates
of 'landed interest'. Photography brought the country to the city, gave the urban
middle classes the possibility of 'owning' precious sights. Many ancient buildings stood
on privately owned land and were not open to the public; photographs made them
accessible. The owners of the estates in which so many of the treasured monuments
lay were thus equally reminded of their duty to preserve them.

The references to the country and to the national heritage within contemporary
photography were not merely a sign of escapism. Political debates referred often to
history, to the values of old times. Photographs of old abbeys, trees, monuments,
castles and valleys could function as a critique of materialism associated with urban
life in modern industrial Britain. The countryside represented a life-style contrasting
the dangers of modernity with the simplicity and stability of 'the country'. Moreover,
the country was the place to experience nature and to refresh body and soul. It was the
cradle of national character and virtue. Again this was not mere escapism or simply
conservative romanticism; it was an appeal to reconcile tradition with progress.[110]
Industrial progress had to be balanced by moral and aesthetic progress. Nature was
the most important teacher in refining taste and knowledge. Writing in 1858, W. Hep-
worth suggested that the aim of photographers was 'to excite in the mind a love for
all that is noble, grand, and beautiful in nature and art'.[111]

In contrast, photographs of the countryside were less a source of ideological
meaning in Germany. Likewise, monument photography remained relatively scarce
despite the fact that the erection of monuments during the second part of the
nineteenth century became quite popular in Germany. The diffusion of images of
landscapes and monuments increased substantially only after the achievement of
national unity in 1871.[112] This paralleled the redefinition of the task of geography as
a science and as a school subject. After the German empire was founded, the study
of geography was seen as a means of fostering patriotism and a love for the fatherland;
it was, at the very least, expected to lead to a 'reassuring recognition of German
specificity'.[113] Before 1871, patriotism focused on the region, the state, not on Germany
as a future nation.[114] The photographs of the Sächsische Schweiz, such as 'Prebisch-
kegel' (Figure 5.5), reveal such a regional connection in presenting to Saxon citizens
one of the most celebrated landscapes of their kingdom. However, such photographs
were rare.

Photographs of persons eminent in the sciences, arts, history and – to a lesser extent – politics, found a receptive public. The German public connected the idea of the nation more exclusively with people and abstract ideas than did the British public. Raps's image of Cologne Cathedral (Figure 5.4) is a case in point, showing the connection between the building and eminent people. Whereas in Britain values and virtues could be communicated through photographs of landscapes and monuments, this was much more difficult in Germany.

The willingness to identify with Germany as a nation was seldom expressed through the creation, circulation and consumption of photographs of landscapes and monuments. In this respect, Germany developed differently from Britain. Several reasons can be posited. First, there was a different infrastructure in which photography was practised in Germany, with far fewer photographic societies, photographic exhibitions and photographic periodicals. Second, tourism was relatively undeveloped in Germany, and if photographers were available, their production was geared to the demand of foreign – usually British – travellers. Third, German photographers were preoccupied with portraiture and the reproduction of works of art, rather than the representation of landscapes. Fourth, the ideological power of photographs required a belief in the ability of the photographic image to transmit a patriotic message; however, only a minority of Germans recognized this power of photographs to disseminate the idea of a nation. In addition, the national movement failed to connect specific landscapes with national ideas and virtues. Thus, if the diffusion of national symbols or images associated with nationhood can be taken as an indicator, then, perhaps, the national movement was weaker in Germany in the 1850s than recent scholarship has assumed. Only later in the nineteenth century did these associations come to be made automatically as German national consciousness was linked to landscape and nature.[115]

It was not simply a time lag in the development of photography which can be called upon to explain the lack of landscape photography in Germany. In Britain, the language of the picturesque was frequently used in national discourse in the mid-nineteenth century. The use of visual elements in this discourse, of which landscape and monument photographs were important parts, gave it a density rare in Germany. German national discourse was predominantly literary, less an artistic and definitely not a photographic one.

To understand the differences in the development of landscape photography in Germany and Britain, it is necessary to locate them in their wider aesthetic and ideological contexts. In the analysis presented here, the different structure of the national movements and the divergent approaches to interpreting landscape images – especially photographic representations of landscapes and monuments – provide a possible interpretation of how nationhood was visualized in mid-nineteenth-century Germany and Britain. The use and dissemination of photographic images mould the relationship between people and place, although they do not determine the precise

outcome of the reception of landscape as national icon, but it would be equally impossible to explain the conception of a nation without reference to images.

Ultimately, photography is not a totalizing technology, applied uniformly in all places and at all times. Rather, photography, as an image-making practice, was determined by specific cultural and social conditions. This is important in explaining differences in, and erasures from, the photographic record, which, in turn, shed considerable light on the role of photography in the geographical imagination and on the relationship between observer and nature, citizen and nation.

SIX

Capturing and Losing the 'Lie of the Land': Railway Photography and Colonial Nationalism in Early Twentieth-Century South Africa

Jeremy Foster

The landscape is not a pre-existing thing in itself. It is made into a landscape, that is, into a humanly meaningful space, by the living which takes place within it.[1]

§ IT IS no accident that photography and railways – perhaps the nineteenth century's two most insidious agents of social spatialization – developed a powerful and durable relationship. Both were new technologies that lent themselves to the projects of modern governance and nation-building.[2] Photography was not only an integral part of the topographical surveys for the construction of new railway lines,[3] but also, once these lines had been built, the ideal means for promoting the development that would ensure economically viable traffic levels on them. Photography's seeming transparency, clarity and precision made it the obvious form of representation for corporations whose power was founded on technology and modernity, while the medium's reproducibility made it the ideal means for engaging the growing middle class's curiosity about, and desire to travel to, places where they were not. Because they both regulated and ordered time and space, railways and photography were also invaluable tools in the creation and definition of new political territories. This was especially true in overseas colonies, where the connections between photography and railways as icons of modernity and metropolitan know-how were repeatedly underscored by photographs that depicted 'trains, stations and dramatic sections of lines as signs of imperial progress and unity'.[4]

In South Africa at the beginning of the twentieth century, this convergence between railways, photography and nation-building was intensified by historical and political circumstances. The South African Railways (and Harbours, after World War I) was

formed by fiat, as part of the constitution which created the Union of South Africa in 1910, by consolidating the former colonial and republican railways into a state-owned corporation. The SAR&H was soon being actively used by the new state as an instrument of nation-building, and quickly came to be known as a 'government within a government'.[5] Not only was the SAR&H the largest employer in the sub-continent,[6] directly or indirectly involved in reconstructing a region that had been laid waste by the 1899–1902 South African War, it was also solely responsible for promoting settlement, investment and tourism in the new country.[7] The Publicity Department, charged with this promotion, was formally set up only in 1919 due to the intervention of World War I, but it swiftly became the predominant commissioner, publisher and purveyor of images of the country. These images took the form of lantern slides, colour art posters, films and, above all, black and white photographs. Taken for use in the SAR&H's own publications,[8] and, as enlargements, in the windows of the SAR&H's publicity offices in South Africa and overseas,[9] these photographs also appeared in foreign magazines and on other national railways.[10] Eventually, the SAR&H's photographs were produced in such quantities that they became the most comprehensive single collection of visual images of the country,[11] used by editors,[12] advertisers and publishers throughout the world, appearing on postcards and even cigarette cards.[13]

Inevitably, the effects of this photographic array transcended those intended by the SAR&H. As the first comprehensive representation of South Africa, occurring during the first decades of the country's existence, this corpus of images became a powerful agent in shaping the nation's view of its territory and its cultural identity. Focusing on the SAR&H's use of landscape photography between 1910 and 1930, I first consider the ideological intentions which underpinned the commissioning and reproduction of these photographs, the kinds of views taken and the ways in which they were discursively used. I will suggest that although white South Africans may, like citizens of other ex-colonies, have felt an overdetermined sense of the connectedness between landscape and national identity, the political situation prevailing in the country at this time also gave rise to a peculiarly intensified version of this imaginary and a concomitant awareness of what photography can and cannot convey. This raises important questions about exactly how photography facilitates 'the transformation of space on the ground into place in the mind', and suggests that this transformation is not a linear, irreversible process, but rather an iterative dialogue between the space of lived experience on the one hand, and the space constructed or suggested by representation on the other. Two particular genres of images used by the SAR&H in the 1920s are used to explore this possibility, and to develop the argument that the ambivalence latent in the use of these photographs helped to construct a unique subjectivity, even at the same time as they were mapping a nation.

This approach to the SAR&H's landscape photography is prompted in part by a lack of detailed archival information about its commissioning, reproduction and use.[14] It is also informed by a desire to expand the kinds of 'evidence' we invoke when we

discuss the relationship between place and identity, as well as the way we construe representation. Much has been made of how, in the modern era, visual imagery in general, and photography in particular, have transformed the geographical imagination.[15] Smoothing out the world's incoherences, aberrations and contradictions, and privileging that which is picturable over that which is not,[16] such imagery – it has been argued – promotes the emergence of an eidolon, or mental map, which can be shared by many. The ability of large groups to inhabit the same subjectivity towards a shared geographical space is dependent on imagery (visual or otherwise) which renders this imaginary space somehow comprehensible to all. Thus, it is argued, the discursive representation of imaginary spaces (or 'places') in some sense creates the community which belongs to them, and representations of place, if not actual representations *of* identity, are, at the very least, powerful agents in constructing that identity.[17]

In the following discussion, I juxtapose this analysis with a parallel one which argues that 'environments are not analogous to images',[18] and sees the provenance of geographical imagination as a form of 'observing without looking'. This analysis locates 'identity' in modes of life and practice that give rise to – rather than result from – particular representations of 'place'.[19] Consequently, 'place' and 'identity' become more than just 'representations', constructs which arise only in specific practices in specific contexts. Engendered by the complete horizon of lived experience (i.e. not exclusively intellectual, social or sensory, but a combination of all of these)[20] unfolding over time, this form of the geographical imagination does not so much harden into *an* imaginative geography as manifest itself as a generalized, qualitative, embodied subjectivity towards (or way of being in) the physical world.[21] This communing with a specific terrain is both practical *and* imaginative, an identification with and an introjection of the self into that terrain through a form of 'body–world dialectic'.[22] It is a form of geographical imagination which cannot be reduced to a mental map, nor can the subjectivity associated with it be read off from images alone. To the extent that it reveals itself at all, it does so in terms of a *bodily disposition towards* the terrain.[23] Similarly, the imaginary 'places' it gives rise to are nothing more (or less) than material homologies of pre-reflective, imaginatively displaced memory and expectation;[24] they come into existence in 'terms of possibilities and histories'.[25] 'Place', in effect, is lived experience reworked through association, metaphor and narrative – a rhetorical re-composition of the circumstantiality of the terrain into the 'typical', 'exemplary', 'anomalous', 'analogous', 'rare', 'accidental' and 'illegitimate'.[26]

Grounded as it is in embodied practice, how does this experiential form of the geographical imagination relate to a discursively constructed one engendered by representation, in which matters of authority, production, reproduction and circulation seem to predominate? Are the imaginative geographies of practice and representation simply different and mutually exclusive ways of conceptualizing the nature of place and identity, or do they exist in some kind of fruitful symbiosis?[27] Answering such questions is bedevilled by the fact that both forms of geographical imagination are

always concurrent and intertwined.[28] It is also complicated by current assumptions about the relationship between the imagination and representation. Today, when representation tends to be understood in primarily projective and instrumental terms, older notions of poetic representation have become all but occluded.[29] In poetic representation, imagination is not just arbitrary 'fantasy' that we project onto the world, but an integral and unavoidable outcome of our intellectual participation in and with it. It implies a re-metaphorization of the image, and a bracketing of concepts such as 'causality' and 'origins'. Considerable allowance is made for the 'unruliness' and multivalence of images – the way they constantly escape the intentions planned for them, and the fact that a substantial portion of their meaning is constructed at the spatial and temporal 'site' of reception, that is, their audience.[30]

In poetic representation, the image is best understood in terms of the philosophical construct of *metaxy*, that is, as a formation or device which stands 'between' the world and the viewer, and not 'for' either.[31] The construct of *metaxy* also helps one come to grips with the paradoxical fact that a 'sense of place' or 'imaginative geography' can, like 'identity', ultimately be referred to only indirectly. A pre-reflective construct deriving from 'life or action', a 'sense of place' is simultaneously unrepresentable and yet accessible only through representation. In this hermeneutic, the place-image becomes not so much a constructor of, or surrogate for, the geographical imagination, as a *prompt* and a *vehicle* for its construction. This means that while photography clearly does have a significant role in the construction of imaginative landscapes and identities, it is perhaps more accurate to describe it as a mediative and refractive one, rather than a decisively constructive one. Photographs are more than 'visible facts'; they are also protean moments of connotation. The 'meaning' that photographs elucidate at the site of the audience encompasses more than just the social, political and economic framework in which that audience lives; ideological intent is only part of what they 'convey' or release. Furthermore, I would argue, it is only when discursively used photographs draw (however indirectly) upon the *lived* dimensions of the experiential 'site' to which they refer, that they acquire the capacity to loosen old responses and create new subjectivities.

Colonial Nationalism and the Limits of Landscape Photography

Perhaps the most traceable form of 'possibilities and histories'[32] is that of the political, and it is here that any exploration of the SAR&H's photography must begin. During the early years of nationhood, the ideological position of the South African state – and, by extension, that of the SAR&H administration – was an ambivalent one. The Union of South Africa had come into existence in 1910 with an idealistic constitution that attempted to overcome the fact that it was, in the words of one historian, 'a state without a nation'.[33] It was also a nation that had been only sporadically mapped,[34] and indeed had not yet acquired definitive boundaries.[35] A contested discourse of

nationhood soon emerged among whites that would co-laterally and systematically strip non-whites of what little political and economic agency they had enjoyed before Union. This contestation was the inheritance of the South African War, which had left the white polity of the sub-continent broadly divided into two groups, identified by the late 1920s with the languages of English and Afrikaans. While both groups saw South Africa as a so-called 'white man's country', they differed on the political character of this imagined nation. Most English-speaking whites saw the future of the country as a 'colonial national' state within a rejuvenated empire based on 'liberty, not force', whereas the core of Afrikaans-speakers envisioned it as a much more separate, autonomous nation, even perhaps a republic entirely outside the British realm of influence. The discourse of South African nationhood from 1902 to 1930 can be broadly described as a struggle between these two (white) positions, with the former initially having the upper hand politically, but being slowly eroded and supplanted by the latter.

The period during which this polarization and contestation played itself out coincided almost exactly with the era of 'New Imperialism'. This was Westminster's attempt to reconstruct the empire as a more or less voluntary commonwealth of economically self-sufficient, English-speaking or English-influenced countries, bound together by trade and cultural interests, with the metropole itself as a kind of guiding partner and cultural hearth. Advocates of 'colonial nationalism' aligned themselves with this 'New Imperial' vision and, during the brief period when the SAR&H first used photography to promote South Africa, dominated the country's political and cultural life. This domination was nowhere more evident than within the SAR&H itself, where the work of the publicity department was controlled by two key 'colonial nationalists': Sir William Hoy, the General Manager of the corporation,[36] and A. H. Tatlow, head of the department. Although British by birth, both Hoy and Tatlow were enthusiastic citizens and promoters of their adopted country.[37]

Relatively little is known about these two figures, but their biographies as well as their public utterances encourage one to make educated guesses about the ideological biases which shaped their use of photography. As administrators of the 'colonial national' state, Hoy and Tatlow's promotional work served not only political and economic but also cultural agendas; like many private European railway companies (only more so), the SAR&H saw itself as a 'maker of history'.[38] At a pragmatic level, the extent and use of the railway system needed to be expanded as quickly as possible, not only to defray the enormous debt burden which the SAR&H had inherited from the pre-Union period,[39] but also to jump-start the agricultural and industrial development which would make the country economically independent of Britain. At a more idealistic level, the SAR&H administration believed that increased passenger traffic throughout the country would help break down the animosities between different sectors of the white population which had been created by the war, and ease the cultural divisions which fed on poverty and a sense of dispossession. Expanded services

would also facilitate tourism, thereby encouraging the cultural ties with the empire and the outside world that were crucial to the realization of a 'white man's country' in a region which was, after all, 6,000 miles from Europe.[40] Photography was actively enlisted by Hoy and Tatlow to serve this multivalent agenda.

This was most tellingly manifested in the *South African Railways and Harbours Magazine*. Edited by Tatlow with assistance from Hoy, the *Magazine* was nominally a monthly corporate journal put out by the Publicity Department. In practice, however, it was the most widely read periodical in South Africa at this time.[41] Although its articles were written by many different authors, the consistency of its editorial tone is such that it is possible to read it as single narrative by a corporate author,[42] a narrative in which an 'eclectic assemblage of rhetoric and metaphor' was used to augment the corporation's technological and administrative authority in the project of nation-building. It carried articles about all aspects of the Union's 'national development', and was copiously illustrated with reproductions of poster art, line drawings and photographs. Indeed, it could be argued that it is in this serial narrative – and not the numerous regional guides and handbooks on various aspects of South African life – that the SAR&H's contribution to the development of a national imaginative geography is the most clearly visible. Thus far, very little archival information has come to light about the goals and inner workings of the Publicity Department.[43] Nevertheless, the *Magazine*, because of its large circulation, strong editorial voice and the way it combined and juxtaposed words and images, provides an alternative perspective from which to read how the SAR&H encouraged members of its intended audience to imagine themselves as citizens of a unified modern nation.

That such citizenship was closely linked to a 'right seeing'[44] of the nation's terrain is underlined by the *Magazine*'s heavy emphasis on photography. Its many photographic reproductions were supplemented by articles promoting the use of photography *per se*. Frequent photographic competitions invited readers to submit photographs for publication, especially ones that depicted 'South African scenic features of general or unusual interest'. Other articles on a photographer's 'adventures', while ostensibly recording one individual's experiences, also subtly suggested how readers themselves should see, perceive and relate to the South African landscape. The subject matter of the photographs used in the *Magazine* was extremely heterogeneous, and the quality varied, especially in the early 1920s; they included photographs taken by in-house photographers (who were never identified)[45] as well as by commercial photographers and readers (who were). Large, artfully composed and lit professional images appear alongside small, blurred images taken by ordinary travellers; images of marshalling yards next to bucolic river scenes. Some images are clearly linked to text, while others are simply presented with minimal comment between articles. The intended relation-ship between pictures and text is frequently unclear, making it difficult to assess which, *pace* Barthes, is parasitic of which.[46]

Within this overall array, it is often hard to discern the intended role of photographs

in the larger editorial narrative. However, one particular conjunction of words and photographs stands out: essays which explicitly pose the question, 'What is a South African?'[47] For the authors of these pieces, the answer to this question was invariably that such a person was someone who lived a particular way of life (thus, 'Europeanism is not the only art of living'),[48] and that this way of life was inextricably grounded in the landscape. Thus, the more untamed this landscape, the more distinctive and authentic the way of life: 'it is in the secluded districts [that the traveller] may sense that elusive and compelling fascination that is essentially South African'.[49] Although these articles were accompanied by photographs of the South African landscape, their texts implicitly suggested that this linkage went beyond mere visual symbolism, into the realm of the experiential: 'Why do South Africans look beyond the things immediately below them? Why do their eyes have that far seeing look? It is because they live in a country of long distances, great spaces filled with clear air.'[50] In South Africa, there was 'a certain freedom of human life, due to the long range, the big view'.[51] 'South Africanism' was not only about freedom of imaginative and bodily movement, however; it also implied a vivid juxtaposition of 'civilization' and 'nature': 'For all the furbelows of modernity, there is in South Africa an ever-present realization of nearness to life in the raw';[52] people 'live near nature, and they get some of its bigness into their beings'.[53]

What is one to make of these articles, in which photographic 'images of the truth' appear alongside text implying that the true character of the landscape cannot be pictured? Are these photographs intended to complement the text they accompany, or do they perform some other kind of function, and if so, what kind of 'truth' are they intended to capture and convey? I would argue that this tension between word and image highlights not only the peculiar way in which the geographical imagination and national identity were entangled in the minds of those who edited these articles, but also their ambivalence towards the uses and effectiveness of photography itself. While the argument that scenic beauty needs 'to be lived to be understood' was to be expected from a corporation trying to encourage travel, this should not obscure how deeply the experiential qualities of the South African landscape were valorized by most whites at this time. Like most landscapes, those of South Africa were culture before they were nature,[54] a metaphorical vision which was as real as the terrain itself.

At the beginning of the century, the dominant vision of southern Africa was one which saw the sub-continent as a physical and experiential frontier to the metropole.[55] Finally incorporated in its entirety as part of British South Africa by the war, the region stood for 'everything that actually existing England, destroyed by the mundane forces of unforgiving modernity, was not'.[56] Central to this vision was the notion that the 'unpopulated' and temperate *interior* had the potential to rejuvenate the 'moral' and physical health of the metropolitan masses, something which was felt to be vitally necessary but impossible to achieve in Britain itself at this time.[57] Here in particular, it was thought, immigrants to South Africa would enjoy a 'classless', rural way of life,

which, because it was free from convention and based on physical exertion and prowess, would promote individuality, resourcefulness and inventiveness.[58] Traceable to the nineteenth-century imaginary of this same interior as an ideal location for recuperating European bodies, this vision had been greatly strengthened by the experiences of tens of thousands of regular British soldiers in the South African War, and subsequently absorbed into, and disseminated by, the Boy Scout movement, itself founded on Baden-Powell's own adventures during that war.[59]

By the time of Union, then, the South African interior had already been culturally appropriated in the metropole as a quintessential imaginary realm: a space containing that which is felt to be lacking or lost, but not 'other' in the true sense. Physically, much of it was precisely the kind of terrain which engaged the metropolitan geographical imagination the most: a landscape which recombined, in a different way and in a remote region 'just off the map', elements of the recognizable world.[60] It was also a terrain whose appeal was grounded in unmediated bodily experience which one might describe as *preceding* the map, the kind that afforded Europeans an exhilarating and reflexive sense of their own agency and 'whiteness'. It was, of course, precisely this liminal vision of South Africa which the SAR&H 'colonial nationalist' administration borrowed and deployed in its own imaginative conflation of national territory and identity in its articles on 'South Africanism'. This conflation would have been further heightened for the substantial proportion of whites who had emigrated from the metropole,[61] and still visited it regularly, as did many functionaries of the 'colonial national' state.[62]

It can be argued, then, that a potent doubling occurred between the vision of the South African landscape, and its predominant representation at this time. Not only were those responsible for photographing this landscape inhabiting a subjectivity which looked in two directions at once – one which, effectively, saw the world as if 'through others' eyes'[63] – but their representations of the landscape were simultaneously directed to domestic *and* international audiences.[64] This doubling placed those responsible for representing South Africa in an ambiguous position. As promoters of the state's agenda of growth, development and nation-building, they were, in a sense, responsible for altering the very ways of life and forms of experience which, at another level, they believed to be the 'birthright' of those claiming citizenship of that nation. This is, of course, a familiar conundrum of modernity,[65] but it was particularly poignant in South Africa, where the landscape needed somehow to be imagined as a space full of possibility for all whites, and yet simultaneously represented as the natural home of a corporeally-replete way of life.[66] The latter imperative would have been especially acute for English-speaking 'colonial nationalists' in a society which increasingly equated identity with language. Even though many of these individuals harboured strong attachments to the country's landscapes, their language threw into question, on a daily basis, their right to describe themselves as 'true South Africans'.[67] Under such circumstances, the need to find a representational medium other than words – which

of course betrayed an allegiance to *a* language – becomes critical, especially if it can capture those aspects of landscape which cannot be raised to words: the experiential and the adjectival.

From this, we can begin to discern the burden which the landscape images used by the SAR&H carried, and why questions about photography's ability to capture and convey the experiential dimension of the South African landscape would have become so important. Such questions were not unique to this time and place, however; they had been latent in the geographical use of photography since the beginning. The nineteenth-century transformation of geography into a quasi-positivist science was not unopposed by those who argued that the truest form of geographical knowledge was not that sustained by pictures of places, or even maps, but that gained from the first-hand encounter with the terrain.[68] Furthermore, as Paul Carter has argued, the representational medium which first threw this problematic into prominence was none other than photography.[69] Many nineteenth-century travellers found the medium's 'accuracy' and capacity to accumulate empirical detail and catalogue minutiae a great leap forward. Others, however, commented on how poorly photography managed to capture the experiential dimensions of a given terrain – its weather, its colours, its sounds, its fragrances, the way its spaces unfolded as one moved through it, or changed in character over the course of a day.[70] Crucially, it was the explorers themselves, not their audience, who were most aware of the way photography obscured this 'lie of the land' that was so different from that of European landscapes.[71] James Ryan has suggested that this 'failure' of photography, at least in the eyes of those who experimented with it, was latent even in that most apparently assured use of the medium, Halford Mackinder's great project to photograph the empire.[72]

This 'failure' of photography's representational power would have been especially vivid for those who controlled the SAR&H's use of photography in the 1920s. The geographical imagination of 'colonial nationalism' owed as much to the embodied aestheticism of the traveller or explorer as it did to the distanced and rationalizing 'gaze' of the scientist, entrepreneur or administrator. (Until well into the 1930s, a lack of reliable maps and statistics meant that a high premium was placed on direct personal observation in the work of pioneer South African geographers).[73] Although photography was the obvious (even, the only possible) medium for the SAR&H to use in its promotion of South Africa, in an important sense, the imaginary which nourished this use was one which had relatively little to do with picturable 'places' or 'features'. It was an imaginary that focused on an aspect of landscape which photography's 'cult of places' tended to obscure.[74] Furthermore, it is easy to see how any ambivalence about photography's capacity to represent the 'atmosphere which is peculiarly South African' might have been sharpened by the fact that the railways themselves seemed to pose a similar threat to the unmediated bodily experience of an expansive, 'unimproved' landscape. Under these circumstances, it becomes plausible that during the 1920s the SAR&H's ostensibly authoritative photographic appropriation of the

country's landscape might well have been marked by the need to find a way of picturing an imaginative topography.[75] In this process, the medium of photography, which in South Africa at least was still a relatively untried mass medium at this time,[76] became the instrument for 'making a trial of'[77] a national 'lie of the land', and at least some of these photographs were taken to see what their subject *would look like when photographed*.

The possibility that SAR&H photography was a multifaceted attempt to picture the hitherto unpicturable is supported by two interlocking facts. The first of these is that, after World War I, perceptions of what photography could and could not convey were in a state of flux. Photography's constitutive dimension was being increasingly recognized; it was becoming evident that the medium not only 'captured' the world, but that it also had the capacity to decipher and discover new aspects of that world.[78] In Europe and North America, the proponents of New Objectivity were using photography's innate poetics to explore the character of everyday objects and landscapes. In parts of the world such as the imperial margins, where technology and modernity tended to take on redemptive ideological overtones, this shift suggested new possibilities for transcending and resolving the perennial colonial preoccupation with the 'gap between the name and the thing'.[79]

The second reason for proposing this is that railways themselves offered a possible resolution to the apparent tension between relational knowledge of travel and photography's 'cult of places'. Any appreciation of the 'lie of the land' is after all created *by* movement and travel; more specifically, different 'lies of the land' are created by different forms of travel, and the SAR&H was, if nothing else, changing the way people moved through the South African landscape at this time. The railways were not only encouraging people to visit places, but also shaping their experiences along the way. No less than journeys by horse or stage-coach, the railway journey included its own set of practices, symbolisms and epiphanies.[80] The train traveller's experience of landscape might have been radically different from that of the explorer, but it was nevertheless an experience which brought inherent pleasures of its own, insights that were directly linked to the sublime character of the South African terrain, yet also new and modern because they were the product of technology.

The 'Empty' Veld, and the View from the Carriage Window

In order to illustrate this argument, I want to return to the photographic array published in the *SAR&H Magazine* during the 1910s and 1920s. Taken primarily to promote tourism and development, these photographs suggest that there was a distinct evolution in landscape subjectivity among white South Africans during this period. Before Union, South African landscape photography, including that used by the SAR&H's predecessors, had tended to be directed by a structure of seeing which celebrated the civilizing influence of colonialism, and served 'work and governance'.[81] Subjects had either been identifiable sights of local interest, objects or features that

FIGURE 6.1 Unidentified photographer, 'Mountain, Wood and Stream
– Scene on the Groote River, near Knysna', published in *SA Railways &*
Harbours Magazine, August 1924, p. 810. Courtesy: Transnet Heritage
Foundation Library, Johannesburg.

could be named and placed or locations of historic events. Occasionally, these images
of treaty-sites, battlefields, birthplaces, public buildings, railway stations, mines,
factories and townscapes were supplemented by photographs depicting highly formu-
laic picturesque scenes, painterly visions of landscape strongly reminiscent of Europe
(Figure 6.1). Although ostensibly quite different, both kinds of images revealed a
'longing for recognizable objects';[82] they reassured a colonial population and made it
possible for them to establish an imaginative foothold in a new country.
 In the 1920s, these 'recognizable objects' began to be supplemented and replaced

FIGURE 6.2 Unidentified photographer, 'The veld', published in *SA Railways &
Harbours Magazine*, July 1925, p. 706. Courtesy: Transnet Heritage Foundation
Library, Johannesburg.

by a new genre of photographs depicting anonymous (that is, unnamed) and un-
peopled regional landscapes, 'unspoilt by the emblems of modernity'.[83] Probably
originally taken for regional guides, and subsequently used in the *Magazine* and other
SAR&H publications, these photographs were often simply captioned as 'the veld'
(Figure 6.2). To describe the South African landscape at this time as 'unpeopled' is of
course highly problematic, given that this was precisely the period during which the
displacement of Africans from the land, brought about by the infamous 1913 Natives
Land Act, was gaining momentum. Yet it remains true that, when seen through eyes
accustomed to the European landscape's complexity and richness of detail, South
Africa did *seem* strikingly empty and unpopulated at this time. To this day, the country's
interior is a terrain vast in scale, poor in physiographical incident, and virtually devoid
of trees. Until well into the twentieth century, the country's tiny rural population was
thinly spread over this landscape, in which farms were necessarily extensive, and signs
of human intervention – for most people, the point of imaginative engagement with
landscape – few and far between. When placed against this reality, the emergence of
photographs that depicted nothing other than the land itself, landscape devoid of
human presence, suggests a significant shift in attitude towards the native terrain.

 There were probably several reasons for this. Not only the physical make-up of the
country but also the immanent structure of seeing shared by its population was
changing, and it was becoming possible to embrace unapologetically the idea that
'there is nothing cameo about South Africa'.[84] For the critical mass of white South
Africans, who with every passing year became less 'colonial' and more 'national', the
mnemonic associations evoked by depictions of intimate, European-scaled places were
weakening. At the same time, the experiential figure–ground relationship between
city and *platteland*[85] had been inverted by the social and economic changes of the

1910s and 1920s;[86] factories, mines and grandiloquent public buildings were no longer remarkable objects standing in isolation in the veld,[87] but the all-too familiar part of white South Africans' lifeworld. This shift in the kinds of scenery depicted by the SAR&H was also probably not unrelated to the fact that the overseas tourists who first began arriving in substantial numbers during the 1920s found that, while South Africa's towns and cities were but pale imitations of their own, the landscape was a 'setting which outshone its stone'.[88]

The emergence of this new genre of landscape views was also, in some measure, a 'product' of photography. In South Africa, as in North America, the depiction of landscapes that were, for all intents and purposes, empty space – what Wolf calls 'the anti-theatrical puzzle [of] a stage without a center'[89] – required a transformation in both 'seeing' and representation. It required images which composed 'empty' land-scapes in such a way that 'the apparently vacant center was revealed as part of a cohesive totality'. This was very much what black and white photography did (and does): emphasizing form and spatial recession, it 'tautened' and condensed spaces which otherwise offered little detail for the naked eye. Compared to alternative forms of landscape representation, photography's polarizing economy of light and shadow (described by one commentator as ideally suited to the sun-struck environment of Southern Africa)[90] rendered the topography of the interior as symptomatic form: clear, uncluttered and legible.

Depicting spaces that had never been photographed or even consciously 'seen' before, these photographs mediated a growing recognition of this landscape's innate relational structure and order, the characteristic accidents of its topography (Figure 6.3). Although these photographs were not particularly striking images, for someone familiar with the region they would have been recognizable as synecdochic fragments of the larger 'lie of the land'. Crucially, the region that benefited the most from this photographic depiction was the interior, the self-same region reified by the metro-politan geographical imagination, and the landscape of 'great spaces filled with clear air',[91] which articles trying to describe the unique quality of South African life implicitly invoked.[92]

Alongside these photographs which attempted to capture the unique relational qualities of the South African landscape, another genre of photo-images appeared in the *Magazine* at this time: the view from the carriage window. Depicting neither landscape nor train, but the effects of juxtaposing the two in a single image, these photographs usually appeared as separate items in the magazine, dissociated from any substantial text. Perhaps more than any other type, these photographs embody the complex interplay of bodily knowledge, representational empiricism and discursive effect at work in SAR&H photography at this time. Like the synecdochic views of the veld, these views from the carriage window at first appear to be 'aberrant', in the sense they seem to have no overt economic or touristic pretext; they depict no reachable *destinations*. It is only when we read them as probative attempts at picturing

FIGURE 6.3 M. Edward and Tromp van Diggelen, 'Rocks, Bush and Beauty:
A secluded hollow about 12 miles from Johannesburg – a few hundred yards off
the Johannesburg–Pretoria Road', published in *SA Railways & Harbours Magazine*,
December 1920, p. 933. Courtesy: Transnet Heritage Foundation Library,
Johannesburg.

a national 'lie of the land', and as representations intended to negotiate the intimations of gain and loss that sustained 'colonial national' subjectivity, that these images become understandable.

The underlying fact behind such photographs was the radical transformation in the experience of national space which the train itself had wrought in a country of South Africa's size. The railway network had brought, for the first time, all parts of the country into a single temporal and spatial frame of reference, and remained, at least until the 1930s, the only viable form of long-distance travel.[93] This regularization of national space was complemented by the way the train window – like the photograph – framed the national terrain primarily as something 'seen', a phenomenon which could be categorized, compared and evaluated at will; in other words, as *landscape*. Removing the individual from direct bodily engagement with it,[94] railway travel turned that terrain into something distanced and panoramic.[95] Not only was this national landscape rendered visible to more people than before, it was done in a regularized way – the physical landscape seen was the same for everyone, every time, determined by the alignment of the line.[96] That this effect was well understood at the time is captured by articles in the *Magazine* which described the train journey as a key to understanding the country, and recounted fictional discussions between travellers about which part of the country was the most 'typically South African'.[97]

This visualization of the country's landscape was also underscored by the fact that much of South Africa's terrain had previously been all but incomprehensible to someone travelling through it because it unfolded too slowly. The train travelling at 30 mph made it possible to grasp, for the first time, the relational qualities of the terrain, which emerged as an integral part of the narrative generated by movement.[98] This newly visible landscape was neither static nor made up of disjunct sites, but organized (or, to borrow Schivelbusch's term, 'choreographed')[99] into spatial presences and emptinesses that were part of one continuous imaginary realm. The observation that '[i]n any 50 miles in Europe, the traveller goes through endless changes of scene, with a fresh landmark at every turn [but in] South Africa, a mere 50 miles hardly takes you from one geological formation to another, let alone to a new type of vegetation or scenery'[100] would, quite simply, have been impossible without this synoptic, unfolding vision.

The photograph of the view from the carriage window attempted to bring into presence some of these effects of train travel on the experience of the landscape. Its most powerful manifestation was the view taken from the compartment of a moving train (see Figure 6.4), or from the footplate of a locomotive. In such images, the landscape is thrice-framed: first by the photograph's border, second by the train window and third by the train itself. The last two function together to concatenate the enclosed, secure compartment with the great sweep of the landscape: the window frames the curving form of the train, which in turn becomes a mediating device which affords the traveller a measure of the otherwise empty landscape.

FIGURE 6.4 Unidentified photographer. This view from the window of a moving
train in the Karoo, the empty, semi-desert heart of South Africa, was originally titled
'Through the "Little Karoo" known as the Aangenaam Valley. In the background are
the Teniquota Mountains of Zwartkops range', c. 1920. Courtesy: MuseumAfrica
Photographic Archive, Newtown, Johannesburg, file ref.916.7.

A significant side effect of this type of photograph was that it emphasized the
furthest visible portion of the landscape. As the blurred foregrounds of these views
from the train suggest, the middle ground and distant horizon are easier to look at
without discomfort from a moving train, because they pass more slowly. The horizon
is precisely that part of the experiential realm where the landscape most character-
istically displays itself as silhouetted figure,[101] and where the African sky – that most
distinctive aspect of the sub-continental 'lie of the land' which so many magazine
writers laboured to describe – began. As one article argues, 'a railway carriage is nearly
the only place where you can see, in perfect comfort, every kind of atmospheric effect
over a broad expanse of changing country'.[102] While photographs would seem to be
ill-equipped to convey such effects,[103] this did not stop the SAR&H from using them.
Photographs in the *Magazine* of mountains seen from a speeding train (Figure 6.5), or
images which try – despite the limitations of black and white reproduction in capturing

September, 1922. S.A. RAILWAYS AND HARBOURS MAGAZINE. 907

S.A. RAILWAYS & HARBOURS.

Tenders for Stores.

Tenders will be received by the Secretary to the Tender Board, South African Railways, Headquarter Offices, Johannesburg, not later than noon on Monday, 4th September, 1922, for the supply of :—

T E A.

Forms of tender, together with full particulars may be obtained from the Railway Stores, Cape Town, Port Elizabeth, East London, Durban, Bloemfontein, the office of the Chief Railway Storekeeper, Park Station Chambers, Johannesburg, and the Town Agents, Johannesburg and Pretoria.

The Administration does not bind itself to accept the lowest or any tender.

W. W. HOY,
General Manager.

Johannesburg,
 5th August, 1922.

ELECTRIFICATION GLENCOE—PIETER-MARITZBURG.

POWER HOUSE EQUIPMENT.

TENDERS are invited for the supply and erection in South Africa of the following plant in connection with the electrification of the above Railways as follows :—

TENDER D.1417—Coal Handling Plant for Power Station.
TENDER D.1418—Ash Handling Plant for Power Station.
TENDER D.1430—Circulating Water Screening Plant for Power Station.

Separate Specifications (blue print) and Forms of Tender for each of the above sections may be obtained at :—

The Office of the High Commissioner for the Union of South Africa, Trafalgar Square, London, W.C. 2, and the Office of the General Manager (Room 67), Johannesburg, on and after Friday, the 28th July, 1922.

The Consulting Engineers, to whom application for any further technical information may be made, are Messrs. Merz & McLellan, 32 Victoria Street, London, S.W. 1. South African tenderers may apply to the General Manager (Room 67), Johannesburg.

Contractors may tender for all or any of the above sections.

The charge for each Specification is Five Guineas for the first copy and Two Guineas each for any further copies. Sums paid for any number of each Specification up to three will be refunded on receipt of bona fide tenders. Sums paid for copies of Specifications beyond three of each will not be refunded.

Sealed Tenders marked "Tender No. D.1417" (as the case may be) are to be addressed to The Secretary, Office of the High Commissioner for the Union of South Africa, Trafalgar Square, London, W.C.2, and lodged in duplicate at his Office in London not later than NOON on WEDNESDAY, the 18th October, 1922.

The Administration does not bind itself to accept the lowest or any Tender.

SNOW ON HEX RIVER MOUNTAINS.
Photographed from passing train.

FIGURE 6.5 Unidentified photographer, 'Snow on the Hex River Mountains. Photographed from passing train', published in *SA Railways & Harbours Magazine*, September 1922, p. 907. Courtesy: Transnet Heritage Foundation Library, Johannesburg.

Photos : *Fred. H. Yeo.*

THREE JOHANNESBURG SUNSETS.

FIGURE 6.6 Fred H. Yeo, 'Three Johannesburg Sunsets', published in *SA Railways & Harbours Magazine*, December 1921, p. 800. Courtesy: Transnet Heritage Foundation Library, Johannesburg.

nuances of light and colour – to depict the distinctive Highveld sunsets are other attempts to depict this new vision of landscape afforded by the train (see Figure 6.6).

Taken together, as an representational array, these various images demonstrate how the SAR&H's 'colonial national' administration used photography to capture an experience of landscape that was simultaneously modern and romantic, and suggest perhaps that 'all the things the old [travel] consciousness experienced as losses became sources of enrichment'.[104] As one article in the *Magazine* argued, 'it is no inconsiderable thing to have an entrancing panorama unrolling itself minute by minute through the glass panels at your window, never so fast as to be obscured, and never so slow as to forfeit the tantalizing element which is so important to artistic pleasure'.[105] Depicting the harnessing of distance by modern technology – that is, photography and railways working in concert – while keeping in play an elusive sense of incompletion, these images encouraged the viewer to imagine the train journey as a trajectory, which somehow brought them into affective alignment with a national landscape.

Conclusion

There can be little doubt that SAR&H landscape photographs played a key role in the collective visualization of a South African national territory. The first comprehensive depiction of this territory, their production and circulation coincided with the country's transformation from a 'frontier of the imagination' into an autonomous modern nation. Their effectiveness in doing this was underpinned by the way in which, like all photographs, they stopped time, and therefore historicized that which they depicted. They gave presence to, and authenticated, that primal locus of collective memory, the 'place' of the nation, and created a baseline against which the progress of this nation could be measured and compared.[106] Equally clear is the reasoning which underpinned this visualization: as a modern, 'factual', reproducible medium, photography was an essential tool for administrators anxious to obliterate sectarian differences and to build a forward-looking, unified modern state based on rational principles. About the inner working of this photography – the hidden currents of imagination and yearning which underpinned its commissioning and reception – it is less easy to be specific. Although these images undoubtedly mediated a shared vision of the nation and a modern way of looking at its landscape, the connotations which they had for most whites would have differed from the ones intended by 'those who concurred in their production'.[107]

Here, one enters the realm of informed speculation. It could, for instance, be argued that photographs of the 'empty' interior, intended to capture the experiential 'lie of the land', might well have unintentionally connoted another 'lie'. Images of 'emptiness' imply 'timelessness', that is, of all or any time. Only artefactual evidence allows the eye to date a landscape precisely, as well as discern to whom it might belong; its absence elides the question of who such a terrain's rightful inheritors might

be. Photographs of the 'timeless veld' would have held equal, if different, appeal to the two subjectivities contesting South African national identity at this time. For wealthy English-speaking land speculators who, by the 1920s, owned large tracts of rural land, images of the empty veld would have invited the play of both entrepreneurial and historical imaginations, becoming representations of space waiting to be filled while recalling the 'hard beauty' of South Africa which so appealed to them. For Afrikaners driven off the land by this capitalization of agriculture, the same images would have recalled a more autonomous and idyllic existence, all the more poignant because it had been lost within living memory. For both white groups, photographs of the empty landscape became vehicles for a complicated form of nostalgia, reminding them what they stood to lose if the territorial claims of a growing African population were recognized.[108]

A different, but equally unifying, kind of elision would have been performed by photographs intended to capture the experience of travelling by train through the South African landscape. Bringing the empty veld and reverie-permeated space of the train compartment into imaginary alignment with each other, these views from the carriage window encouraged a subjectivity halfway between that of the armchair traveller and that of the lone explorer, because it combined traces of both. Celebrating opportunity, mobility and mastery over circumstance, these thrice-framed views mediated and introduced into national discourse an abstracted version of the embodied, sensory encounter with the terrain, and concomitant sense of individual agency, which earlier forms of travel had engendered.

Should we, then, liken the photographic array created by the SAR&H to a map, a seemingly comprehensive representation which pushes away into its prehistory the operations of which it is the result?[109] Or did its effects go further, and rehearse a viewpoint[110] that was also an identity, or a way of being in the world? I would argue for the latter, that these photographs, through an iterative oscillation between ideological intention and experiential resonance, saved and transmitted the sensibility of one group and generation to those who followed, albeit in a transformed version. Their capacity to do so was underpinned by the fact that they were produced and deployed by the same agent that was transforming the spatial practices and experiences which they depicted; they mediated an imaginary symbiosis between the effects of photography and the effects of railways. If the railway journey revealed the landscape's underlying relational structure, photography framed its immensity and emptiness, its material and sensory particularities, and brought it 'closer' to the viewer. The erosion of closeness to the landscape brought about by easier travel through it, allowed images of it to acquire a potency they had not had before.[111]

However, the ultimate power of these images to inscribe as 'uniquely South African' the subjectivity which had informed their production, would seem to rest on the fact that they did not so much define a national *territory* as a national *topography*. The distinction is an important one. Probably the oldest and most 'naïve' form of

geographical representation, the construct of topography, etymologically implies both identity and praxis: *topos* (place) and *graphos* (to draw).[112] It connotes, at the same time, the act of describing a region, *and* the 'lie' of its land, an inclusiveness that emphasizes that the presence of humans in a landscape always already implies the organization of that landscape, just as a description of landscape always already implies the subjectivity which makes that description possible. In this sense, it is cognate with Jonathan Crary's provocative statement that to observe something is, in some way, to 'conform one's actions with it'.[113]

This allows us to see how the imaginative topography created by the SAR&H photographs might also have called into being a particular subjectivity. Commissioned for instrumental reasons, yet marked by the traveller's heightened sense of the 'lie of the land', these images rehearsed the subject-position of 'passing by' an empty and ineffable landscape, even at the same time as they transposed the experiential moments they captured into an imaginary past, the realm of imminent disappearance. Caught between the loss of sensory closeness and the acquisition of mobility and agency, the body-subject they implied was one captivated by what is promised but never quite unveiled in the landscape.

SEVEN

Constructing the State, Managing the Corporation, Transforming the Individual: Photography, Immigration and the Canadian National Railways, 1925–30

Brian S. Osborne

Introduction: Constructed Images, Contested Meanings

§ IN HER novel, *The Diviners*, Margaret Lawrence has her protagonist, Morag, interact with a photograph album. As she engages it, it becomes a set of recollected images captured by her camera, what she calls her 'image-recorder':

> I keep the snapshots not for what they show but for what is hidden in them … All this is crazy, of course, and quite untrue. Or maybe true and maybe not … Looking at the picture and knowing what was hidden in it … I recall looking at the pictures, over and over again, each time imagining I remembered a little more … In my invented memories I always think of my father smiling possibly because he really seldom did. He is smiling in the only picture I have of him, but that was for the camera … I can't remember myself actually being aware of inventing them, but it must have happened so.[1]

For Morag, her personal chronicle of photographed history is a dialogue between the original captured image and the subsequent constructed one. The snapshots become dynamic sites of 'invented memories', 'hidden' experiences, camera-induced posturing, shadowy images, deeply buried truths and guilt about forgetting. Yet, Morag's 'image-recorder', the camera, *always* produces sites of contested meanings that challenge the myth of 'photographic truth'.[2] Her reactions challenge Pierre Bourdieu's claim that the taking and re-viewing of images in the genre of the family album 'presupposes the suspension of all aesthetic judgement' because the 'sacred character of the object and the secularizing relationship between the photographer' serves to 'justify the existence of a picture'.[3] The point is that even if the proposition that 'the camera never lies' is accepted, it must be recognized that it is most often a communicator of nuanced

truths. Also, when we 'take' pictures we are often surprised to find what we have captured, and what we have allowed to escape. To this end, Roland Barthes has reminded us of the 'two ways' of approaching the photograph: 'to subject its spectacle to the civilized code of perfect illusions, or to confront in it the wakening of intractable reality'.[4] While recognizing the challenge posed by 'perfect illusions', it is the search for a further understanding of 'intractable reality' that influences my inquiry here. It is the quest for what Lucy Lippard calls the 'grain of truth in a moment':

> The picture is valued for what it portrays. Losing its modernist identity as an image and its postmodern identity as a reflection, it works in relation to another value system. This notion may make the 'sophisticated' uneasy, since it disregards the common, postmodern perception that a photograph cannot tell the truth. Perhaps it can never tell the whole truth and is often used to tell lies, but there is always at least a grain of truth in a moment that did take place, and it is against that grain that we must test our eyesight.[5]

The problem becomes more acute when attempting historical interrogations of photographs as the 'past is hidden', and entering that one segment of 'liberated space' presented by the photograph requires transcending 'unfamiliar culture and false history, to reach for a physical, tangible, sensuous experience of the image'.[6] That is, the 'reaching out for what finally is absent'.[7]

But how do we do this? In her approach to this essential problem in decoding meanings, Joan Schwartz argues that the photographer is not the only 'person concurring in the formation of the document'.[8] Attention needs also to be directed to the contexts of the initiation, production, immediate reception and subsequent re-viewing of the images. This encourages a plurality of 'ways of seeing'[9] and ways of 'looking'.[10] That is, any photograph constitutes a 'dynamic site' at which many gazes intersect, and it is this intersection of gazes that transforms the photograph into a kaleidoscopic array of multiple meanings.

Indeed, Scott McQuire identifies the complexities and plurality of meaning and the consequent imposition of limits to interpretation: '[M]eaning never resides in one time or place, but traverses a circuit linking the event to the recording apparatus and the scene of viewing. Slippage between the moments of "reality", "representation" and "reception" indicates the potential for immense fluctuations in different readings of the same image.'[11] Henri Lefebvre goes further and warns that 'representational space' – and this is, after all, what a photograph is – constitutes a deceptive and tricky *trompe-l'oeil*, ideal for 'concealing strategic intentions and actions', and best understood as a product of 'complex and extensive webs of meaning'.[12] In a similar vein, James Duncan argues that representations of reality are always 'theory-laden' and challenges protocols of visual interpretation that simply 'open our eyes' and that assume 'an unmediated world that yields its secrets to our gazes'.[13] Rather, he claims, we have to examine 'relations of power' that allow us to 'see how interests play a constitutive role in vision and representation'.[14]

It is in the spirit of searching for the 'hidden truths', 'webs of meaning' and 'relations of power', that I approach a particular set of photographs of immigrants generated by the 'Colonization and Agriculture Department' of the Canadian National Railways (CNR) during the 1925–30 period.[15] The inter-war years in Canada constituted a period in which government, corporations and society at large were constructing new approaches to old problems in the context of a dynamic re-conceptualization of nation-building. Immigration, of course, was a central concern and it is argued here that the CNR immigration photograph-dossiers serve not only as a 'window' into the policy and practice of Canada's 'government railway', but also as a physical manifestation of a complex set of interacting discourses surrounding the concepts of race, ethnicity and nationalism. More particularly, attention will be directed to the tacit, yet active, participation of such photographs in the immigration process and in constituting notions of identity, at the ways in which these photographs expressed government attitudes and shaped public opinion, and the degree to which immigrants were complicit in, or resistant to, this manipulation.

Discursive Contexts: Government Policies and Corporate Agendas

Prior to the adoption of photography by the CNR in its corporate promotional activities and the photograph-dossiers, there was an established history of the use of photography by the Canadian Pacific Railway (CPR) and the immigration branch of the Department of the Interior.[16] Indeed, by the end of World War I, the old-but-new technology of photography was well established throughout Canadian society. The nineteenth century had witnessed the growing popularity of photography as it moved from interesting novelty to ubiquitous medium. The participation of photo-graphy in cultivating the public's visual imagination was advanced by such commercial studios as those of William Notman,[17] and the advent of such illustrated periodicals as the *Canadian Illustrated News* (1869) and *L'Opinion publique* (1870).[18] Raymond Williams has argued that public photography played a crucial transformative role in human communications because of the power of the 'extended' and 'reproducible' image in societies experiencing unprecedented mobility and change. That is, the generation of a 'new social psychology of the image'.[19] Indeed, Raphael Samuel has referred to this increasingly pervasive phenomenon as 'scopophilia', 'the desire to see',[20] that culminated in the photographic journalism of magazines such as *Life* (1936) and *Look* (1937), and the rise of documentary photography.[21]

By this time too, the government of Canada had long made use of photography in surveys and reports generated by such departments as Public Works, Fisheries, Geological Survey, National Parks, War Records Office and the Canadian Con-servation Commission.[22] Also, several of these agencies appreciated that the utility of photographic images transcended mere internal reportage and illustration. Thus, from the 1890s on, the Department of Agriculture and the Department of the Interior

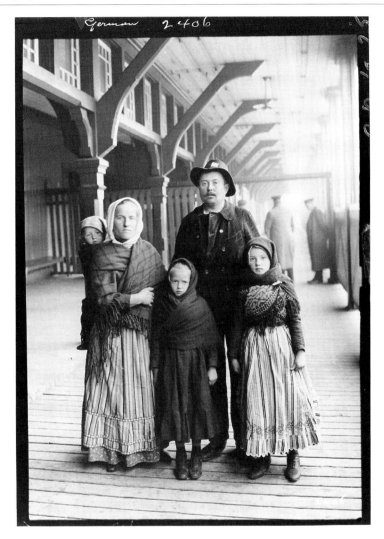

FIGURE 7.1 Imaging new Canadians: William James Topley,
'Germans', Quebec City, 1911. Photograph from glass plate negative
2406, in Album 38, Canada – Department of Mines Collection,
photograph accession 1939-453. Courtesy: National Archives of
Canada, PA-10254.

pioneered the use of 'magic lantern' shows to promote the export of Canadian
produce and to attract potential immigrants.[23] Further, William James Topley, John
Woodruff and other commercial photographers produced a series of choreographed
photographs of the drama of pre-World War I immigration, both for the official
record and for public consumption.[24] More accustomed to the formally posed portraits
created in the confines of their photographic studios, their immigrant compositions

nevertheless serve to transform the mass-immigrant experience of the docks and reception-hall into interpretive vignettes of individual exemplars of race, ethnicity, class and gender, rendered by a selected focus on physiognomy, costume and posture (Figure 7.1). Nevertheless, while reflecting both prevailing scientific attitudes and government policies towards immigration, the primary intention of such photographs was promotional. As pointed out by Greenhill and Birrell: 'The department's photographs had a wide distribution abroad, and it was hoped that Europeans would be encouraged to emigrate by seeing pictures of people similar to themselves at the Immigration Centre, as well as photographs of Canadian scenes – particularly of the western wheat and cattle lands opened up by the railways.'[25]

Following World War I, the newly formed Canadian National Railways embarked on its own system of record-keeping in which the camera served as a tool both of corporate propaganda and documentation. Apart from the usual array of photographs intended to promote both passenger and freight traffic – by inducing immigration and directing settlement and economic development to their territory – others were concerned with nurturing good public relations in a period of growing nativist anti-immigration sentiment. Increasingly, however, there was a growing recognition of the utility of photographic images in the better management of the corporation. The set of some 500 images examined here was created in response to the need to monitor 'Continental' immigration to Canada in the period 1925–30. Nativist and economic concerns prompted an interesting experiment in state–corporate cooperation in immigration, colonization and development.[26] To ensure compliance with government policy, and also to facilitate efficient corporate management of its own activities, the CNR developed a system of immigrant dossiers. These detailed records identified each CNR immigrant by a standardized set of criteria: precise place of origin in Europe; the new location in Canada; date of arrival; the name of the transatlantic carrier; written comments of demographic, economic and cultural information; and, finally, a CNR classification based upon resources and family profile. No mere file of words and numbers, however, each family was also visually tied to the data-set by photographs taken by corporate officers.[27] Collected in albums and organized by province, these visual and statistical profiles were integrated closely into the administration of immigration and settlement business.

An evocative, yet representative, example is provided by the dossier entry for Stefan Waskiewicz (Figure 7.2). Of some significance, Mr Waskiewicz is not represented in the image; only his unidentified wife and two children pose in front of their original shelter and subsequent 'comfortable little house'. Whether or not they 'erected' the latter is open to question as it appears to be already on site to the right of the first image. But apart from the apparently manipulated image of progress and achievement in an unquestionably primitive wilderness setting, a more nuanced story is told by the accompanying biographical profile. Identified by name, village, district, province, nation, ethnicity and religion, details are also provided of the date of arrival in

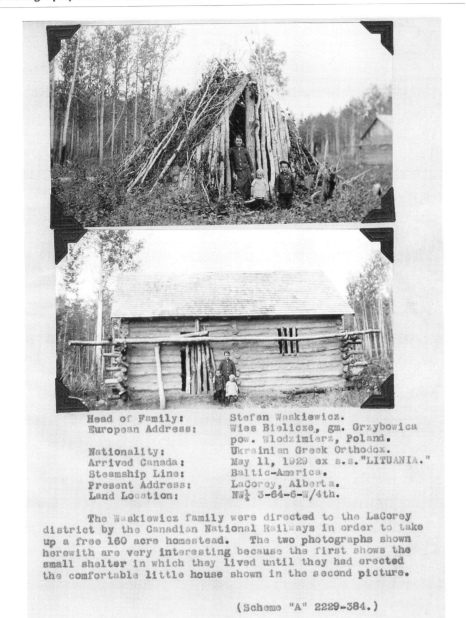

Head of Family: Stefan Waskiewicz.
European Address: Wies Bielicze, gm. Grzybowica
 pow. Wlodzimierz, Poland.
Nationality: Ukrainian Greek Orthodox.
Arrived Canada: May 11, 1929 ex a.s."LITUANIA."
Steamship Line: Baltic-America.
Present Address: LaCorey, Alberta.
Land Location: NW¼ 3-64-6-W/4th.

The Waskiewicz family were directed to the LaCorey
district by the Canadian National Railways in order to take
up a free 160 acre homestead. The two photographs shown
herewith are very interesting because the first shows the
small shelter in which they lived until they had erected
the comfortable little house shown in the second picture.

(Scheme "A" 2229-384.)

FIGURE 7.2 Establishing a home, recording the process: Unidentified photographer, page from CNR photograph-dossier: *Head of Family: Stefan Waskiewicz*, volume for the Province of Alberta. Courtesy: National Archives of Canada, RG30, Vol. 5892.

Canada, the name of the vessel and shipping company, as well as the precise settle-
ment location in the precision of the lot, section, range and meridian of the survey
system. And all of this is tied to prevailing government and corporate policy by the
enigmatic identifier: Scheme 'A' 2229-384.

 These images, words and numbers are but shadowy impressions of the full
explanation of the contemporary context. As Christopher Pinney has put it, '[t]o
raise the possibility of the "picture" is to presuppose a frame'.[28] In this instance, the
'framing' of the image, the text and the very existence of the complete dossier is the
product of several contemporary discourses. Taken together, three of the latter con-
stitute a 'web of meaning' that allows us a better understanding of the generation of
the CNR immigrant photograph-dossiers, and the Canada of the time: nation-build-
ing, immigration policy and corporate strategies. Moreover, it is in the context of
these discourses that the photograph-dossiers functioned explicitly as instruments of
government immigration policy and CNR corporate operations, and implicitly as
rhetorical devices that allow the exposure of hidden subtexts.

Engineering the state The establishment of the CNR as the 'Government Rail-
way'[29] took place in a post-World War I socio-political environment in which the
nation-state was becoming increasingly interventionist and bureaucratic.[30] Thus, in
his 1918 volume, *Industry and Humanity*, future Canadian Prime Minister William Lyon
Mackenzie King outlined what he considered to be the underlying principles of post-
war 'industrial society'.[31] It is a curious intellectual collage replete with references to
forces of darkness and light, good and evil, and scientism. In Mackenzie King's
diagnosis of national health, social malcontents are 'pathological germs'; his prognosis
is that 'the corpuscles of the body politic may combine as effectively to destroy its
pathological germs as, in the human body, white corpuscles combine, and seek to
destroy the germs of disease'.[32] More metaphor than social programme, the tenor of
this statement represents the melding of missionary zeal with objective science in a
search for an ideal society in an increasingly complex industrializing and urbanizing
world. Like so many others in this period, he was convinced that Canada's future
prosperity and progress depended upon a heady concoction of spirituality, social
reform and maximum use of human resources. Such views were grounded in theo-
logical ideas of social redemption, Galtonian theories of eugenics and Keynesian
models of socio-economic planning.

 For many *fin de siècle* social and political reformers, a theologically driven spirituality
alone was insufficient; it had to be accompanied by a commitment to material and
social change informed by theology, psychology and sociology. A veritable crusade
marched forwards under the various banners for 'social gospel', 'moral reform', 'social
redemption' and 'social purity'.[33] The battlefields ranged from the corridors of govern-
ment to the alleys and communities of the nation's urban and rural areas.

 Implicit in all of this righteous zeal for social regeneration was a Darwinian world

of biologically determined levels of achievement. Moreover, if these assumptions accounted for the basic raw material of societies, eugenics provided the means for an interventionist social engineering. Francis Galton's theories of the relationship between the condition of people and biologically determined capabilities were avidly adhered to by many prominent intellectuals and political leaders of the day. Simply put, they advocated the manipulation of social policy and programmes to improve the physical, mental and social qualities of the population.[34] Thus, in March 1914, the *Canadian Journal of Medicine and Surgery* reported on the 'Conference on Race Betterment' that had concerned itself with 'evidence of race deterioration' to check 'the downward trend of mankind' and to seek out 'better race ideals':

> Some of the suggested methods of improvement are frequent medical examination of the well, outdoor life, temperance in diet, biological habits of living, open air schools and playgrounds, the encouragement of rural life, the segregation or sterilization of defectives, the encouragement of eugenic marriages by requiring medical certificates before granting licenses and the establishment of a eugenics registry for the development of a race of human thoroughbreds.[35]

There were others, however, who were more concerned with people's potential for change and advocated the nurturing of the human stock by improving the conditions in which they lived. For Dr Peter H. Bryce, 'euthenics'[36] was the essential counterpart of 'eugenics' with its emphasis upon the improvement of the human condition by producing environments in which individuals and society would thrive. Speaking to the Canadian Purity Education Association in Toronto in 1914, Bryce attacked the degenerative effects of urban and industrial life, profligacy and intemperance, and advocated the therapeutic effects of rural environments and rural ways of life.[37] As chief medical officer and superintendent in the Department of Immigration from 1904 to 1921, Bryce enforced the current immigration policies that required the selection of the strong and the exclusion of the unfit, but he was also an advocate of directing immigrants into rural areas.[38] Indeed, 'back-to-nature' and 'back-to-the-land' movements came to be a clarion call for a whole range of ideological and economic conservatives during this period.[39]

Unplanned and unsupervised distribution of immigrants throughout rural areas could not be expected to produce Bryce's predicted results. It was becoming increasingly evident that unregulated pioneer settlements often degenerated into pockets of rural poverty. In 1909, inspired by Theodore Roosevelt's National Conservation Association in the United States, Canada established its own Commission of Conservation. The CCC's annual reports (1910–19) and its journal, *Conservation of Life* (1914–21), reveal its priorities in conserving forest, fish, water and mineral resources. However, attention was also directed to public health and housing and the optimal development of rural communities. Thomas Adams was the spokesman for the new ethic in settling and developing pioneer districts and argued that 'in the future, science

and clean government must march side by side with enterprise and energy in building up national and individual prosperity'.[40] His pursuit of the science of state-planning leaned heavily on the new tools of surveys, statistics and photography.[41]

The CCC was disbanded in 1921, but others continued to search for a more orderly and 'scientific' approach to pioneer settlement. In 1929, a group of Canadian scholars announced a programme for the 'scientific study of settlement in Canada': to appraise the natural resources of the pioneer regions; to study methods of settlement with a view to avoiding the waste of life and capital that had characterized pioneer settlement in the past; to trace the successive stages of utilization of natural resources and the effects on economic and social institutions.[42] Their aspirations were to 'make some contribution toward the development of economic and social planning in a field where the costs of planless development are peculiarly heavy … The need for the systematic planning and control of settlements, if heavy financial and human costs are to be avoided, is likely to be greater in the future than it has been in the past.'[43] Combining both theoretical and applied research into the pioneer experience, the Canadian Pioneer Problems project stands as a landmark in the development of rational economic, social and regional planning.

For many, therefore, national progress was associated with the planned development of socio-economic infrastructure rather than the biological determinism of eugenics and euthenics.[44] The solution to many social problems was to be pursued by government through an interventionist policy of economic, educational and cultural development that would lead to the 'Canadianization' of the immigrant and the betterment of the Canadian. Further, such concerns for moral reform, philanthropy and pure social pragmatism prompted churches, schools and community organizations to focus on personal hygiene, dress, diet, house-styles and domestic practices. In this way, people's very persons, families, homes and communities were transformed in an orchestrated programme of social reconstruction.[45]

These, therefore, are the subtexts to the images and words of the photograph-dossiers. Read without them, the latter are but raw descriptions of particular people, in lens-fuls of generalized places, and lists of administrative data. But considered in the context of the discourses of state-intervention in nation-building, they became evocative examples of selection, control, surveillance, transformation – all necessary prerequisites for implementing planning and development.

Regulating immigration Faced with a pressing need to populate Canada's west, Clifford Sifton, Minister of the Interior in the Wilfrid Laurier government, oversaw the increase of immigration from 16,835 persons in 1897 to an all-time high of 400,870 in 1913 (see Figure 7.3). Indeed, during this period, some 2.9 million immigrants were introduced to a Canada that had a total population of only 7 million – an increase of some 40 per cent.[46] Following the disruption of World War I, immigration increased from a low of 41,845 in 1918 to a peak of 133,729 in 1923, amounting to a total of

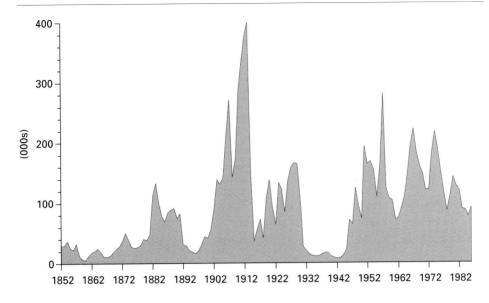

FIGURE 7.3 Canadian immigration, 1852–1982

some 700,000 in the 1918–24 period. A further 800,000 immigrants entered Canada between 1925 and 1930, with 166,783 in 1928 alone. However, a combination of perennial nativist fears, the 'Great Depression', and western droughts rendered a powerful cocktail of economic tension and nativism – 'xeconophobia'[47] – that contributed to the defeat of Mackenzie King's Liberals and the election of R. B. Bennett's anti-immigration Conservative government in 1930. Accordingly, European immigration was virtually terminated, falling to a low of 11,277 in 1935, and amounting to a mere 150,000 persons for the decade of the 1930s.[48]

For eugenicists, unrestricted immigration had posed the greatest threat to the body politic. In the early years following Confederation in 1867, the modest and predominantly British flows were of little concern. Moreover, the ethnic mix of this immigration had shifted as the target of Sifton-Laurier immigration shifted to the peoples of south-central and eastern Europe. Both the amplitude and ethnic constitution of the intake came to be matters of concern to academic theorists and the public alike. Government was urged to re-evaluate immigration policies and practices and to introduce criteria for the effective selection, absorption and assimilation of immigrants.[49]

Predictably, some called for the imposition of immigration restrictions – informed by the science of eugenics – that would admit or exclude immigrants on the basis of objective medical criteria. To this end, attention was first directed to the diagnosis of mental deficiencies which, it was claimed, explained much poverty, unemployment, alcoholism and prostitution.[50] Building on immigration legislation of 1869, 1902 and 1906, the Immigration Act of 1910 identified three categories of exclusions: people classified as mentally defective, diseased and physically infirm. With these restrictions

in place, eugenicists felt secure in the belief that medical inspectors were active in protecting Canada's biological strength and vigour.[51]

However defensible this may have appeared in terms of contemporary views of public health and the national good, what was more insidious was the implicit relationship between eugenics and nativism. This mindset is well demonstrated by J. S. Woodsworth's 1909 classic, *Strangers Within Our Gates*, which was intended to introduce the Canadian people to the 'motley crowd of immigrants' and to 'some of the problems of population with which we must deal in the very near future'.[52] A supportive Introduction by J. W. Sparling warned of the 'the great national danger': 'For *there is a danger and it is national*! Either we must educate and elevate the incoming multitudes or they will drag us and our children down to a lower level. We must see to it that the civilization and ideals of Southeastern Europe are not transplanted to and perpetuated on our virgin soil.'[53] Woodsworth turned to an American fellow-traveller, John R. Commons, for a forthright enunciation of the essential racial and cultural differences in the characteristics of the peoples of the potential source areas:

> A line drawn across the continent of Europe from northeast to southwest, separating the Scandinavian Peninsula, the British Isles, Germany, and France from Russia, Austria-Hungary, Italy, and Turkey, separates countries not only of distinct races but also of distinct civilizations. It separates countries of representative institutions and popular governments from absolute monarchies; it separates lands where education is universal from lands where illiteracy predominates; it separates manufacturing countries, progressive agriculture, and skilled labour from primitive hand industries, backward agriculture, and unskilled labour; it separates an educated thrifty peasantry from a peasantry scarcely a single generation removed from serfdom; it separates Teutonic races from Latin, Slav, Semitic, and Mongolian races.[54]

For many contemporary observers, therefore, the self-evident truth was that people were not all born equal. Indeed, many agreed with Commons that a hierarchy of biologically determined social achievement extended from north-west Europe, down through central and eastern Europe, into the realms of Asia and Africa. Such views fuelled the fears of many Canadians that a polyglot and exotic immigration threatened to erode the Anglo-Canadian hegemony, and promised 'racial degeneration'.[55] In this way, the emotionalism of nativism joined with the science of eugenics in moving Canada closer to a system of national demographic planning and immigration control.

Proponents of these views found a willing ally in high places in Frank Oliver, Clifford Sifton's successor as minister in charge of the Department of the Interior, and responsible for Canada's immigration policies. Concerned that much of the previous immigration threatened to be 'a drag on our civilization and progress', Oliver forcefully challenged some of the assumptions of his predecessor:

We did not go out to that country [the West] simply to produce wheat. We went to build up a nation, a civilization, a social system that we could enjoy, be proud of and transmit to our children; and we resent the idea of having the millstone of this Slav population hung around our necks in our efforts to build up, beautify and improve the country, and so improve the whole of Canada.[56]

No mere nativist rhetoric, Oliver's words were followed by major shifts in immigration policy. The new immigration restrictions reflected an embarrassingly ingenuous, if unambiguous, rationale for selective exclusion. Section 38, Chapter (c) of the Immigration Act of 1910 excluded 'immigrants belonging to any race deemed unsuited to the climatic requirements of Canada'. Immigration was restricted even further by the legislation of 1919 that excluded immigrants of any nationality, race, class or occupation for one of several comprehensive reasons: the 'economic, industrial or other condition temporarily existing in Canada'; or those 'deemed unsuitable having regard to the climatic, industrial, social, educational, labour or other considerations or requirements of Canada'; or 'owing to their peculiar customs, habits, modes of life and methods of holding property'; or again because of their 'probable inability to become readily assimilated or to assume the duties and responsibilities of Canadian citizenship'.[57] In November 1923, J. A. Robb, Dominion Minister of Immigration and Colonization, spoke to the new principles: '[T]he selection of Canada's new settlers must have due regard to physical, industrial and financial fitness and the Dominion's power of absorption.'[58]

Throughout the first half of the twentieth century, those considered to be ideally suited to Canada's 'climate' and the 'responsibilities of Canadian citizenship' were referred to as 'preferred' and were sought out in Great Britain and France, the United States, the Scandinavian countries, Belgium, Holland and Germany. Potential immigrants from certain sections of the former Austro-Hungarian empire – Austria, Czechoslovakia, Hungary, Poland, Romania and parts of Yugoslavia – were classified as 'non-preferred' but were allowed into Canada as farmers with resources, agricultural labourers or domestics. All others – a list that included Albanians, Bulgarians, Chinese, Dalmatians, East Indians, Greeks, Hebrews, Italians, Japanese, Maltese, Negroes, Persians, Portuguese, Spanish, Spanish-Americans, Syrians and Turks – were admitted by 'special permit'. Clearly, these terms represent the implicit implementation of current racist, pseudo-scientific and environmentalist criteria.[59] Moreover, in this search for the 'ideal' population, not only were steps taken to regulate the 'quality' of incomers, but also to cull those who proved to be unwanted. In the period 1903–35, some 62,001 immigrants were deported from Canada, of whom 28,000 were ejected in 1930–35 alone, while the 7,131 deportees in 1933 amounted to a stunning 36 per cent of the intake of that year.[60] The officially stated reasons for deportation, 'medical causes', 'public charge', 'criminality' and 'other civil causes', reflected contemporary biological, social and ideological concerns.[61]

Prevailing biological and anthropological science, together with new political-economic theory, were transformed from ideology, through policy, into practice by new bureaucracies and record-keeping. While government retained control of its system of attracting the 'preferred' and excluding the 'others', by the terms of the Railway Agreement of 1925,[62] the railway corporations were charged with the responsibility for selection, transportation, settling and monitoring the progress of the seemingly oxymoronically labelled 'non-preferred' immigrants. While 'non-preferred' by policy, they were very much wanted by those attempting to settle the outer margins of Canada's west. Apart from being required by government to maintain records of their 'Continental' charges – the descriptor that came to replace the term 'non-preferred' in records if not in mindset – the CNR's photograph-dossiers also served to demonstrate the contribution being made by such immigrant pioneers to the national well-being.

Such corporate pragmatism was accompanied by a growing number of liberal intellectual theorists who argued for a more cosmopolitan view of Canada's future. Thus, J. S. Woodsworth became disgusted by the intellectual posturing of the Ku Klux Klan and other racist and nativist groups in Canada in the inter-war years.[63] He argued for the accommodation of cultural diversity, the provision of social services, the development of a secular culture and the exercise of scientific management. For Woodsworth, the principal threat posed by immigration was 'Balkanization', and he called for the construction of 'a greater Canada which will not be an English Canada or a French Canada but a larger and more inclusive Canada in the building of which all these various people will contribute'.[64] Others shared these more liberal and inclusive views. This was demonstrated by one Denzil G. Ridout, of the United Church's Missionary and Maintenance Fund. His metaphors were romantically picturesque:

> No greater task is before the Canadian people than the co-ordinating of all the racial groups into a blended whole. Just as the individual colours of the spectrum are in themselves beautiful, so all peoples have those things which are to be admired, but it is the harmony of all colours in the glory of the rainbow that stirs the fullest admiration. So it will be as the peoples of all races happily mingle their lives together in this new land that Canadian civilization will become most beautiful.[65]

Nevertheless, a man of his time, Ridout's scientific underpinning was questionable. Immigrants were categorized into 'races': 'Teutonic', 'Slavic', 'Mongolian' or 'Latin'. Moreover, the perspectives, if not the conclusions, of the exclusionist John R. Commons were alive and well, even in the words of an advocate of ethnographic inclusion such as Ridout:

> A traveller from Berlin to Warsaw will soon recognize a difference between the Teutonic and the Slavic races. There is lacking a certain restless, ambitious vivacity in the Slav – but in its place is observed a diligent, ceaseless, plodding persistence. In Teutonic lands the tendency has been towards the increasing use of modern machinery, but in

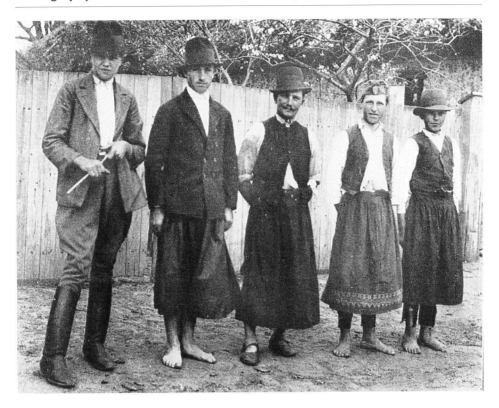

FIGURE 7.4 Unidentified photographer, 'Typical garments of the youth of rural Hungary', from Denzil G. Ridout, 'European Sources of Non-Anglo-Saxons in Canada', *Canadian Geographical Journal*, II, 3 (1931), pp. 201–23.

the Slavic countries, the hand looms are still seen in the homes for spinning the yarn from the hand-combed flax; the men and women in their bare feet are seen working with their hoes on the four or five-acre farms; the small cottages are of the primitive kind, with one or two rooms, mud walls and dirt floors; the women still go to the village streams to wash the clothes and the pots and pans … It seems as though the Slavs, for some reason or another, have lagged a century behind and only in recent years are trying to overtake the march of civilization.[66]

Ridout did not rely solely on florid textual constructions. His article was profusely illustrated with Topley/Woodruff-like compositions (Figure 7.4) which were intended to persuade his Canadian reading public of the benefits that would emanate from a more cosmopolitan view of Continental immigration. Nevertheless, his captions reinforced the condescension of a confident cultural superiority: 'a lassie of German stock'; 'a fine specimen of Bulgarian'; 'sturdy young [Hungarian] woman'; 'this barefoot Ukrainian woman … note the fine needle-work on the sheep-skin jacket'; 'Bulgarian woman … one of the wiry sort'. Despite these somewhat unfortunate

allusions, Ridout's objectives were to endorse an immigration policy that accommodated such diversity:

> These non-Anglo-Saxon peoples have a contribution to make towards the development of this new country. Their best gifts will be available only as all the races and nationalities within the bounds of the Dominion recognize and appreciate the worth of others, and as all work together for the advancement of those things which in the life of a nation will make her truly great.[67]

Such views marked the first steps away from an exclusionary nativism that would eventually lead to a formal model of multiculturalism. Certainly, some of these more progressive views of an ethnically pluralist Canada were to be found among the ranks of those administering the CNR's programme of colonization and agriculture, but the degree to which they were influential must be considered in the light of prevailing corporate policy – and the photograph was to be an integral part of that monitoring process.

Managing the corporation This somewhat unholy combination of racism, eugenics, social redemption, nativism and planning influenced social programmes in general, and immigration in particular. Predictably, because of its direct involvement in national development as an agency of transportation and communication, Canadian National Railways was part of this intellectual milieu. Moreover, as the 'Government Railway', the CNR was particularly well-positioned to sustain connections between the worlds of state and corporation through the promotion of immigration, colonization and agricultural development. Over 34 million acres of unoccupied lands within 15 miles of the CNR's 22,000 miles of track were available for colonization, settlement and development. Accordingly, in 1923, its newly established Department of Colonization and Development mixed national and corporate agendas in a policy statement focused on the development of the national economy – and the agricultural economy in particular – through the attraction of appropriate settlers: 'people of productive capacity'; 'young people of desirable type and character, especially from Great Britain'; those 'qualified to participate in constructive activities and acquire citizenship of distinct value to Canada'; 'immigrants physically fit and anxious to work'. Clearly, this was to be a new era of immigration with a closely monitored selection of newcomers.[68]

These concerns became even more pressing with government's coopting of the two national railway companies into immigration work by the Railways Agreement of 1925. By its terms, the Dominion government authorized the CNR and the CPR to select, transport and settle agriculturalists, agricultural workers and domestic servants from 'non-preferred' countries.[69] This component of the process was directed the way of the railways because of their vested interest in the movement of immigrants along their tracks and the placing of settlers in their territories. However, they were also charged with the responsibility of repatriating any that were not 'absorbed' into

the national economy. Thus, in one fell swoop, government capitulated to the pressures from transport, land and agricultural equipment interests to expand the immigration catchment area, and at the same time handed-off the politically sensitive issue of 'Continental' immigration to non-government agencies.

In anticipation of these developments, the CNR reorganized its colonization branch in 1924 as the 'Department of Colonization, Agriculture, and Natural Resources' and redefined its new policy priorities.[70] While corporate headquarters were located in Montreal, the 'European' office in London, England, administered branch offices in Liverpool, Belfast and Glasgow, as well as Warsaw, Prague, Zagreb, Paris, Antwerp and Rotterdam. CNR 'certificate issuing officers' preselected immigrants according to employment, literacy and health criteria before directing them to Dominion immigration officers who issued visas.

In Canada, the CNR's colonization activity in the east was controlled by the Montreal headquarters with sub-offices at Moncton and Toronto and a 'Port Reception Officer' at Halifax. The western division was administered from 'Room 100' in the CNR's Winnipeg station, with regional sub-offices in Saskatoon, Edmonton and Vancouver.[71] At its peak, some 400 part-time field operatives surveyed settlement possibilities, met immigrants and assisted in locating them, while an additional 2,221 CNR station agents (700 in the Prairies) acted as contacts for new settlers. An ancillary organization, the Canadian National Land Settlement Association (CNLSA), handled negotiations between settlers and property owners, assisted in the purchase of stock and equipment and the land preparation. Through this system, the CNR nurtured close contacts with several ethnic associations in Canada that assisted in the recruitment of suitable immigrants.

Finally, the CNR maintained close ties with several major carriers which came to be referred to as the 'friendly' lines. The CNR's 'British Fleet' consisted of Cunard, Anchor Donaldson and the White Star Line. The 'National Lines' comprised a polyglot fleet of American, French, German, Italian, Norwegian and Polish lines. Together, they cooperated with the CNR both as carriers and recruiters of immigrants to Canada.[72]

During these years, the advocacy of planned settlement became a high priority on the CNR's corporate agenda. Thus, Robert England, field-operative in the CNR's 'Col-and-Ag', was concerned that 'Pioneer communities develop their agriculture largely by trial and error, experiment and imitation stimulated or driven by economic demand, without much regard to research, scientific management or method'. He argued for a new approach 'to reduce for the pioneer the hazards of the supreme gamble of his life'.[73] Accordingly, the CNR developed a system of closely monitored settlement through its CNLSA operatives and its own public relations department. Information was disseminated by means of advertisements in the press, illustrated public lectures, radio, films and widely circulated promotional brochures in which photographs of landscapes of progress and production were prominent. Advisers

were put in place to assist prospective settlers, and prospective farmers were trained by mail-order correspondence courses and experimental farms. Moreover, the CNR increasingly availed itself of the services of the Dominion and Provincial Departments of Agriculture, commercial agricultural organizations, agricultural colleges, livestock breeding societies and farmers' organizations.[74]

It was not simply a matter of economic pragmatics, however. In an era of anti-immigration nativism, both the CPR and the CNR advocated an ethnically pluralistic immigration programme accompanied by initiatives intended to assimilate the new-comers. To this end, the CPR's John Murray Gibbon favoured the metaphors of flower gardens and mosaics, while the CNR's Robert England preferred the rationale of an emerging social science; but they were both committed to the promotion of a culturally diverse immigration – albeit underpinned by the pragmatics of corporate self-interest. Clearly, both corporations were fully aware of the benefits of a strategy that attempted to deflect nativist anti-immigration prejudices, adhere to government interest in western development, and also enhance their corporate balance sheets by increasing passenger and commodity traffic. Thus, the CNR advertised its role in promoting the assimilation of its multiethnic hinterland by a programme of com-petitions dedicated to 'the encouragement of progress towards Canadian Ideals in Home, Community and National Life, in Communities of European Origin in Western Canada'.[75] Ukrainians, Poles, Yugoslavians, Mennonites alike were to be made to conform in terms of dress, diet, domestic arrangements and loyalties. As the landscape of the Prairie West was being transformed from wilderness to farmland, so also the bodies, material culture and mindsets of the immigrants were to be transmuted into 'good Canadians'.[76] Photographs were complicit in that transformation.

Photographic Images: Gazes, Reflections, Constructions

It is these discourses that transform the CNR's photograph-dossiers from mere cor-porate records into Lippard's 'grain of truth in a moment'.[77] The very existence of the documents – let alone their form and content – demonstrate how they are visual-izations of contemporary ideologies and sensitivities and subtle agencies for the reimagining of national and corporate priorities.

The CNR photograph-dossiers came into existence as intentional documents: that is, a device for monitoring their 'non-preferred' immigrant charges. Immigrants' identities are catalogued by photographs, names, locations and dates; their experience is reduced to terse assessments of capital resources, labour and progress (see Figure 7.2). Given this context, it would be easy simply to approach the images as mere visual identifiers embedded in the dossiers. That is, as another piece of ostensibly objective data.

However, despite the intention of bureaucratic objectivity and documentary real-ism, these records can be subjected to the usual protocols of photographic analysis.

They cry out to be interrogated for details of contemporary government policy, corporate practice and prevailing social attitudes. These, together with subtle subtexts, are reflected in the composition, selection and content of the photographs. The words, numbers and opinions bleed into the images; the political, economic and cultural imperatives of the day objectify the human subjects; and the human reaction to their inclusion in a bureaucratic archive provides an emotional tinting. They provoke questions regarding contemporary theories of national identity, national development and the role of immigration in nation-building at this time.

In particular, what runs through this analysis is the role of photography in refining and extending the power of surveillance and, therefore, control. That is, a 'normalizing gaze' that establishes a 'visibility' and thus allows differentiation, judgement classification and, if necessary, punishment.[78] In this way, 'visuality is complicitous in the operation of power' and photography becomes a 'visual strategy' that attempts to establish control over what is being viewed.[79]

Whatever the collusion of influences behind the lens, however, photographers framed the view, arranged the subject, set the scene and, finally, made the exposure to record the image. The prevailing conventions of photography were negotiated by the photographers' awareness of the sensitivities of their patrons, potential viewers and subjects. This having been said, given the particular political and corporate agenda, it may be assumed that a corporate agent dominated the construction of the photographed reality. Indeed, there is documentary evidence of corporate direction, negotiations between photographer and subject, and even of capitulation to the subjects' preferences. Accordingly, the photograph-dossiers reveal three important gazes: the bureaucrat's, the public's and the immigrant's.

The bureaucrat's gaze State and corporate bureaucracies eagerly seized upon the conjuncture of more sophisticated photographic technology and theoretical developments in biological and social sciences. Biometrics, eugenics and racial phenotypes lent themselves to photographic manipulation for the visualizing of putative generalizations of human potentials.[80] In particular, representations of the immigrant reflected underlying racial and ethnographic assumptions. In image after image, Topley, Woodruff and others produced series of images of pre-World War I immigrants as collected 'specimens' that rendered actual individuals as ethnographic–national–'racial' stereotypes.[81] Behind the final image is a never-to-be-recaptured process of observing, selecting, interrogating, isolating and posing. Shiploads of emigrants are processed into immigrants in reception halls, to be represented as proto-Canadians by the photographic representation of carefully selected individuals. While some of Topley's photographs present informally posed family compositions (see Figure 7.1), others display their immigrant-subjects more as scientific specimens arrayed for scrutiny (Figure 7.5). Indeed, in 1910, W. D. Scott, superintendent of immigration, advised J. D. Page, medical superintendent at Quebec, of his photographic needs: 'I want

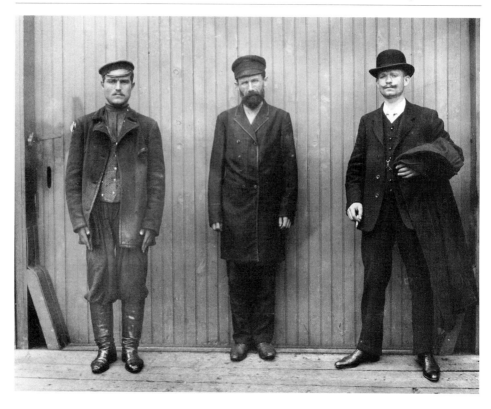

FIGURE 7.5 Immigrants: John Woodruff, 'Pure Russian, Jew, German', 1908. Silver gelatin print in Album 17, *Quebec*, Canada – Department of Mines Collection, photograph accession, 1939-434. Courtesy: National Archives of Canada, C-9798.

[J. Woodruff] to get some good photographs of immigrants while at Quebec … I do not want a line of immigrants of various nationalities with Immigration officers inter-spersed, but what is wanted is individual types taken for the most part singly.'[82] The particular focus of this one official's gaze is here to the fore: the reference to the individual 'type' and 'single' specimen speak to the scientific tropes of the day. As shown in Figure 7.5, the result was a series of individual vignettes arrayed in triple groups in which class, culture, race, nationality, all clash incongruously in the ethnographically loaded comparisons of 'Norwegian/Boscovinian/English' or 'Pure Russian/Jew/German'. Nameless but labelled, they represented assumed 'universal' stereotypes in convincing visualized form. Implicit in the selection and display are the hierarchical enthographics and eugenic taxonomics held by the ilk of Messrs Woods-worth, Bryce and Commons. One particularly energetic vehicle, the *Canadian Courier*, went even further.[83] It rendered a veritable gallery of 'Snapshot Poses of the Polyglot Peoples who are helping to make a New Nation' (Figure 7.6). Arranged in a composite composed out of the masses of individual studies, they were accompanied by captions

SOME TYPES OF THE NEW-COMERS

Snapshot Poses of the Polyglot Peoples who are helping to make a New Nation

FROM PHOTOGRAPHS TAKEN AT QUEBEC AND HALIFAX.

English.	Scotch.	German.	Russian.	Scandinavian.	Icelander.
1908—91,412. Just one of many Types.	1908—2,223. The kind that covers the Earth.	In Ontario, Thousands; in the West, Tens of Thousands.	1908—7,493. An honest plodder, good on the Land.	1908—4,073. Used to come mainly from Minnesota	Thousands of these sturdy people in Manitoba.

United States.	Bukowinian.	Hungarian.	Icelander.	Italian.	Russian Jew.
1909—99,000 Experienced farmers.	From Central Europe. Hates borrowing money.	Best of physique and a good worker.	She'll learn English in a month.	Find him in the Construction Camps.	Not anxious to farm —a dweller in cities.

Poll of the New-Comers

IT is decidedly interesting to note the occupations of the new-comers to Canada. The most striking feature is the great preponderance of farmers among the United States immigrants. Between June 30th, 1903, and March 31st, 1909, a period of five years and nine months, the number of immigrants who landed at ocean ports were 700,391. Of these 187,991 were farmers or farm labourers; 181,397 were general labourers; 175,430 were mechanics; 46,453 were clerks or traders;

18,875 were miners; and 36,803 were domestics. During the same period, the number of immigrants from the United States amounted to 299,603. Of these 198,249 were farmers or farm labourers; 19,476 were general labourers; 12,058 were mechanics; 7,326 were clerks or traders; 3,360 were miners; and only 401 were domestics. Of the British and European immigrants about 27 per cent. were farmers, about 26 per cent. were general labourers, 25 per cent. mechanics, and the other 22 per cent. clerks, miners, domestics or unclassified. Of the United States immigrants, about

67 per cent. were farmers, 7 per cent. were general labourers, 4 per cent. were mechanics and 22 per cent. clerks, miners and unclassified. While only 27 per cent. of the British and continental immigration was agricultural, as against 67 per cent. of the United States, yet the total agricultural immigration is about the same from each source. In this six-year period, the United States farmers and farm labourers are about 11,000 ahead. The pictures shown on this page give some idea of the nationalities who are contributing to the upbuilding of this new dominion.

YEAR	IMMIGRATION INTO CANADA.			TOTALS
1904-'05	65,359 BRIT.	43,652 U.S	37,255 CON	146,266
1905-'06	86,796 BRIT.	57,919 U.S.	44,349 CON.	189,064
1906-'07 9 MOS.	55,791 BRIT.	34,659 U.S. 34,217 CON		124,667
1907-'08	120,182 BRIT.	58,312 U.S.	83,975 CON.	262,469
1908-'09	52,901 BRIT.	59,832 U.S.	34,175 CON	146,908
1909-'10	80,000 BRIT.	99,000 U.S.	25,000 CON	204,000

This Chart has been specially prepared to show the variation in the chief classes of new-comers—British, United States and Continental or European. The figures given here for year ending March 31st, 1910, were estimated ; the latest report gives the correct figures at 208,794.

13

FIGURE 7.6 A taxonomy of immigrants: 'Some Types of the New-Comers. Snapshot Poses of the Polyglot Peoples who are helping to make a New Nation. From Photographs Taken at Quebec and Halifax', *Canadian Courier*, VII, 20 (30 April 1910), p. 13. Courtesy: National Library of Canada, NL-22138.

that encapsulated volumes of contemporary theory in carefully selected textual signi-fiers: Scottish, 'The kind that covers the Earth'; Russian, 'An honest plodder, good on the land'; Bukowinian, 'Hates borrowing money'; Hungarian, 'Best of physique and a good worker'; Italian, 'Find him in Construction Camps'; Russian Jew, 'Not anxious to farm – a dweller in cities'. No doubt, the good Mr Commons would have approved of such stereotypes and, certainly, some of the photographic protocols and ethno-graphic allusions continue into the CNR dossiers.

Indeed, the in-house commentary of Dominion and CNR bureaucrats monitoring immigration in the inter-war years demonstrates that such ethnic stereotyping prevailed well after World War I. Though not accompanied by photographic images of the *Canadian Courier* model, the latter's judgemental stereotyping was still to the fore. Thus, a 1922 report of the CNR's fledgling 'Industrial and Resources Department' declared its assumptions for matching putative ethnic qualities and preferred settlement loca-tions: the United States would provide 'the stamp of men we want west of the Great Lakes'; British Columbia was a 'more congenial habitat for "Britishers" than the prairies':

> The Scandinavian peoples are also a good type for this country, being not only in-dustrious and thrifty, but accustomed to climatic conditions peculiar to the country between Lake Superior and the mountains. Among the Central European races there are also people who would make good settlers here, but we think if it is considered necessary to go there for people, they should be very carefully selected, otherwise we feel certain that Canada would speedily be overrun with small traders of a sort. This is one class that is now clamouring to gain admission.[84]

Another revealing glimpse into the inner workings of the CNR's settlement selection policies is provided by the minutes of a conference of the 'Colonization, Agricultural and Natural Resources Department' held in London 1927. The purpose was to plan for 1928 in the light of the previous year's experience, and it was em-phasized that 'a free expression of opinion by all' was essential.[85] What followed was virtually an omnibus condemnation of Continental immigrants:

> Of those coming from Northern Europe the Germans were the best. Most of the difficulty this season had been with Poles, Hungarians, Czechos [sic] and Yugos [sic]. The three latter were only steamship passengers and not colonists. There were a few Czecho settlements in Western Canada and they were working on construction work as labourers, taking up jobs which should be left for Canadians. They were cunning and worked through foremen to get jobs. In 1926 the Czechos were of the type that drifted into cities. This year most of them were willing to get out and work. The Yugos caused no trouble because they took the first train back east. They did not loaf but went into the Northern Ontario mining districts where employers discharged other men to take them on … It was hard to settle Hungarians as they were no use so far as farm labour is concerned. There were good Hungarians but the greater part would

not go on a farm. Hungarian settlements were of little use for placement as they had large families of their own and were looking for farms for their children.

While the report argued that 'Little trouble was experienced with Ukrainians', it concluded that 'it would become increasingly difficult to place non-preferred people in the West. They must be of the right type.'

The commitment to the attraction of Germans overrode any hesitancy with regard to the 'non-preferred' countries during the years of the Railways' Agreement. Indeed, in 1928, 1,528 families were handled by the CNR's colonization department. Of these, only 259 were 'preferred', thirty-two coming from Germany. But of the 1,269 'non-preferred' families admitted that year, 633 were categorized as 'German non-preferred', a much larger group than the 381 Ukrainians or 225 Poles.[86] Increasingly, therefore, the colonization business throughout Poland, Czechoslovakia and Hungary continued, but with a priority given to this matter of preference for those therein of 'German race'.[87]

If such commentary explicitly records the continued prevalence of ethnic stereo-typing, the photograph-dossiers also display the growing concern for planned settlement. Thus, while there are data on place of origin, ethnicity and religion, much attention is also directed to monitoring the financial resources, economic progress and material setting of the new settlers. Not surprisingly, those charged with the respon-sibility of recording immigrants' progress on their new lands were anxious to ensure that their imagery was appropriate. As ever, immigrants were lined up as if in some scientific experiment, but they were now located in front of their homes, in their fields or next to livestock or equipment. Occasionally a besuited, macintoshed, homburged CNR official invades the image as if to confirm visually the presence of responsible corporate surveillance.

A particularly intriguing item is the identification of each photograph-dossier by letter and number. Thus, Nikolaj Kajokuk of Klevan, Bronyky-Bolyn, Poland, is 'Scheme A-2229-155'; Stefan Leckkobyt of Oryszcze, Horochow, Poland is 'Scheme C-2229-393'. This classification of immigrants from the 'non-preferred' countries referred to financial resources, agriculture experience, marital status and the age and number of children. There were several categories:[88]

Scheme 'X': minimum of $1,000 on arrival at Winnipeg; be fully experienced agri-cultural people; arrive at Winnipeg 15 March – 31 October; need winter provisioning if after 1 August; free to locate anywhere.

Scheme 'A': minimum of $500 on arrival in Winnipeg; be fully experienced agricultural people; mature age with not more than one or two children under six years; arrive at Winnipeg 15 April – 1 September; be prepared to take up pioneer propositions in outlying districts.

Scheme 'B': minimum of $250 on arrival at Winnipeg; be fully experienced agricultural people; mature age with no more than two or three children under twelve years, and

no children under five or six; to be located by CNLSA in outlying districts under pioneer conditions, erect own buildings, and work out for number of years; arrive between 1 May and 1 August.

Scheme 'C': minimum of $100 capital; married couples for 'farm employment'; agriculturalists without previous residence in Canada or the United States; accustomed to manual labour; required to sign an agreement, written in their own language, to accept farm employment under CNLSA direction; located in outlying districts, under pioneer conditions; arrive between 15 March and 15 May.

Scheme 'J': minimum of $100 capital; directed to farm labour; required to sign an agreement, written in their own language, to accept farm employment under CNLSA direction; located in outlying districts, under pioneer conditions; to be between 21 and 40 years old, with no more than three children under 15, and none under three years; parents must take separate employment if necessary; located in outlying districts under pioneer conditions; arrive between 15 March and 15 May.[89]

It was essential, therefore, that the CNR's colonization activities be seen to conform to the national policy, or at least to that of the current political agenda. In this way, individuals were profiled in fine detail in the photographs and biographies, but their personal identities were secondary to the socially and politically loaded categories. And in so doing, the portfolios of images, references and commentary articulate several state and corporate priorities.

TABLE 7.1 Families settled by the CNR under the Railways Agreement

	1926	1927	1928	1929	1930	Total
Purchased lands	–	181	377	425	244	1,227
Rented lands	–	36	62	62	46	213
Homesteads	–	75	136	259	230	700
Farm employment	–	25	108	240	63	436
Settled, no details	–	–	–	–	42	42
Settlement pending	–	45	129	54	248	476
Returned east	–	37	49	41	38	165
In cities	–	11	28	15	8	62
In USA	–	–	2	–	–	2
Returned to Europe	–	–	3	1	1	5
Government families	200	93	–	–	–	293
German refugees	–	–	–	–	33	33
Disappeared	–	82	45	103	62	292
Nominated families	84	117	86	56	–	343
TOTALS	284	702	1,032	1,256	1,015	4,289

Source: NAC, RG30, Vol. 8337, file 3070–31, J. S. McGowan to Dr W. J. Black, 11 December 1930

First, the statistical compilations demonstrated the extent of CNR and CPR coloni-zation activities in the 1925–30 period: they had brought in 10,302 'non-preferred' families with $2.74 million; 4,537 'preferred' families had brought in $3.4 million; some 5.8 million acres of land had been put into production; and, finally, this activity was expected to generate an annual traffic revenue of $7.7 million.[90]

Second, other data identified the numbers of actual settlers, those placed in farm employment, those who had left the land for cities, or others – a problematic category – who had 'returned east' or 'disappeared'.[91] The data shown in Table 7.1, together with the photographs and associated documentation, were evidence of the corporate commitment to the careful surveillance of their 'non-preferred' charges in conformity with the terms of the Railways Agreement. Finally, the system reflected a more professional approach to the planning of colonization to ensure the maximum eco-nomic productivity of corporate territories.

The public gaze The primary reason for the willingness of Mackenzie King's Liberal government to delegate control of the 'Continental' immigration to the CNR and the CPR was that it was a political hot potato. And with the worsening of economic times as the Western world crashed into the Great Depression, that potato got hotter. Thousands of Canadians left the land and moved to towns and cities where they joined the ranks of the unemployed. Though not the predominant element in this group, 'Continental' immigrants were often very visible. Thousands of Canadians raised their voices in protest. For many Canadians, therefore, encouraging immigra-tion at a time of economic stress was not rational, and others even attributed the cause of the latter to the former. Others still espoused more reprehensible arguments regarding the putative ideologies, morals and even biological inferiority of the new-comers. Whatever the reason, the public reaction to the images of the 'Continental' immigrant walking among them in the streets or represented in newspapers and books was a sensitive matter for governments and corporations alike.

The photograph-dossiers were 'internal' documents. In theory, they were not intended to be publicity images such as those of Topley, Woodruff and the *Canadian Courier*. And as such, they did not contribute to the mission of visualizing an evolving national identity or, conversely, the social problem of a threat to national identity. They were intended to be consigned to corporate offices as working documents to be consulted internally as part of the system for monitoring colonization. Nevertheless, internal correspondence between two CNR colonization officials is revealing about sensitivities regarding the cultural representation of their charges, even within the corridors of corporate power. In 1929, F. J. Freer, Superintendent of Land Settlement, wrote to N. S. McGuire, District Superintendent:

> The photographs are generally excellent. We would suggest, however, that in the future it would be a good idea to have the women remove the head shawls before taking the

photographs. Mode of dress is responsible for much of the criticism of newcomers as 'foreigners' and in our photographs it is well to have them look as 'Canadian' as possible.[92]

The response was as revealing of the attitudes of the immigrants as it was of the determination, albeit thwarted, of the officials to conform to corporate preferences. McGuire replies:

> In extenuation of our lack of good judgement in photographing the Continental ladies with their headshawls on, we may say that both Mr. Kirkwood and Mr. Smolyk did everything in their power to do as you have suggested, but the only condition on which they would allow us to take their picture, was in full continental regalia. We are very sorry, therefore, that we were unable to get just what we wanted in this respect.[93]

Indeed, the visual impact of 'Otherness' constantly elicited commentary, the tenor of which highlights the prejudices of the day in official as well as public circles. Consider the views of the CPR's Calgary-based Assistant Superintendent of Colonization:

> With regard to the fifteen Jugos arriving here this morning, I find that their knowledge of German is very limited and fear that we may have trouble with them as we have had in the past. The whole of the trouble here has been caused by Jugos and Czecho Slovaks who are not willing to wait their turn in placement and who are agitated by people of their own nationality to make trouble. These men have been made use of by the labor agitators opposed to immigration here to build up a case against Central Europeans and everybody concerned in bringing them forward.

But (as the complaint goes on to point out) if language and ethnic display were problems, all this was exacerbated by their exotic appearance in public:

> The people of Calgary, as I have already intimated on more than one occasion, are not accustomed to seeing Central Europeans and the sight of them on the street has alarmed many people here and they are willing to believe any complaint no matter how exaggerated. When people get more accustomed to these immigrants in their strange attire and the immigrants have had a chance of proving their worth I do not fear so much trouble but at the present time it is most unwise to send any but Hungarian settlers here.[94]

Then again, the image of a Polish family published in the *Yorktown Enterprise* and *Montreal Star* in 1935 prompted the reaction that 'such publicity at this time is not helpful ... if the sending of pictures of this kind to the West could be avoided it would be a good thing'.[95] The Director of the CNR's Department of Colonization and Agriculture, W. J. Black, shared England's concern, but expressed considerable relief that the feared question on the floor of the House had not materialized: 'Naturally we were quite disturbed by the publication of this picture, expecting that

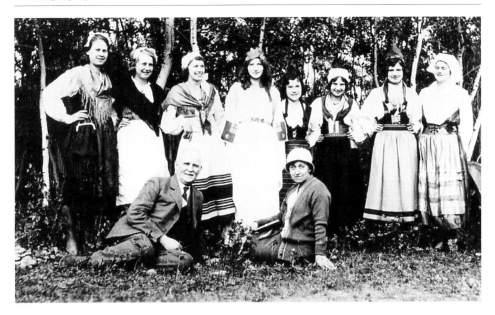

FIGURE 7.7 A progressive view of ethnicity: Unidentified photographer, 'CNR Community Progress Competition Judges (reclining on ground) surrounded by community performers with "Miss Canada" at centre', c. 1930. Courtesy: Saskatchewan Archives Board, Violet McNaughton papers, S B7520.

there would be an incredible reaction through a question [in] the House of Commons, or otherwise, but strange to say nothing has occurred that we know of. Meanwhile there can be no question as to the undesirability of such features appearing.'[96]

Despite these incidents, the CNR's overall corporate interests favoured a more pluralistic cultural policy, even if economic self-interest was to the fore. While required to participate in and administer an essentially exclusionist immigrant policy, its agencies constantly advocated the contribution of its multiethnic settlers to the national development. But even those who were amenable to immigration favoured a neutered and romanticized ethnicity – or else the complete acculturation of the newcomers. This is clearly displayed in the carefully posed scene of 'approved' cultural diversity (Figure 7.7). Two of the CNR 'Community Progress Competition' judges – Walter Murray and Violet McNaughton – are backed by a cast performing in the celebration of cultural difference, albeit acting out a sanitized and glamorized sub-script. Seven ethnically garbed and smiling women are grouped around their model/nemesis, a maidenly 'Miss Canada' draped in pure white, flags and maple leaves. Nowhere were the CNR's corporate-pluralist objectives more to the fore than in the activities of its Community Progress Competitions. But even here they were often represented to a critical public in the acceptable terms of folk dances, egg-painting and exotic crafts.

CANADIAN NATIONAL RAILWAYS

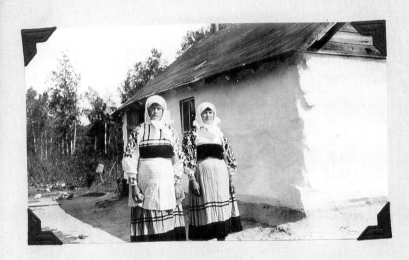

Head of Family:	Jan Klopot-Makarczuk	Sergiej Klopot-Makarczuk
European Address:	O.P.Bugryn, Wies Ilin	O.P.Burgyn, Wies Ilin
	Pow. Rowno, Wolyn	Pow. Rowno, Wolyn,
	Poland.	Poland.
Nationality:	Ukrainian Orthodox	Ukrainian Orthodox.
Arrived Canada:	April 20,1929,ex.s.s.	May 11,1929,ex.s.s.
	FREDERICK VIII	HELLIG OLAV
Steamship Line:	Scandinavian American	Scandinavian American
Present Address:	Stenen, Sask.	Stenen, Sask.
Land Location:	N.W.¼ 16-35-3-W/2nd	N.W.¼ 16-35-3-W/2nd.
	(Scheme A - 2229-160)	(Scheme A - 2229-371)

These two families upon their arrival in Canada were directed
by the Canadian National Railways to the Stenen district in
Saskatchewan where they purchased in partnership a partially im-
proved 160 acre farm for $1200.00, paying $300.00 cash. They
now have 4 horses, a colt, 3 cows and calves, poultry and
machinery. In the above photograph the wives are shown beside
their new home. When visited recently both men were out working
earning good wages.

FIGURE 7.8 Ethnic pride, nativist sensitivity: Unidentified photographer, page
from CNR photograph-dossier: *Head of Family: Jan Klopot-Makarczuk: Sergiej Klopot-
Makarczuk*, volume for the Province of Saskatchewan. Courtesy: National Archives
of Canada, RG30, Vol. 5893.

The immigrant's gaze Little is known of how the immigrants reacted to state regulation, bureaucratic scrutiny and public hostility, but the photographs themselves reveal some clues. Individuals and groups stare out at the camera and, as ever, they constitute enigmatic images. Facial expressions, posture, self-presentation all suggest human reactions to their experience of the processes to which they were being subjected.

The point has already been made that – much to the corporate chagrin – the CNR's colonization agents encountered a determination on the part of some immigrants to present themselves in their old-world context. In several of the photographs, women chose to have themselves recorded in their various costumes (see Figure 7.8). It is unclear whether this was a matter of necessity (their only finery), a matter of customary practice (their usual way of 'dressing up'), or whether it was an act of resistance (a statement of protest).

It was not only an issue of the display of traditional dress; what emerges is a dressing-up, either in response to official direction or personal motivation to impress. The settings are always those of 'improving' homesteads. Too often, the formal, dressy appearance of some belies the vernacular context. For example, the all-so-typical image of the Polish-Ukrainian settlers from St Walburg, Saskatchewan, prompts many questions (Figure 7.9). Did the children always wear those clothes? Did the women perform their farmstead chores with feet so delicately shod? Was the men's hair always so well slicked down? Were the well-dressed teenagers in normal attire or in their best going-to-town outfits? And if not, why were they going to these efforts? These are carefully posed, structured, arranged images – but which side of the lens was responsible and why? Was it a corporate initiative to demonstrate the success of their protégés and their compliance to government directives? Or was it an exercise in preening to display the pride of new immigrants in their personal achievement? And what is to be read into the facial expressions, the postures and the shadow-obscured eyes that stare back at us? Resignation, fear, boredom, docility, stubbornness, flamboyance? Despite the rhetoric of progress and achievement, there are no smiles, only a resigned stare of acceptance of yet another stage in their rites of passage from immigrant to Canadian.

Given the tenor of the times, however, it is not unreasonable to recognize at least a glimmer of fear – or at least suspicion – of the ever-present surveillance with its threat of evaluation, judgement and possible deportation. Lined up to be recorded for the state-corporate documentation, they appear to be striving to conform to the statist, corporate and public preferred image of Canada's recent immigrants. If only I could read it right! If only I could confidently access the 'camera induced unconscious optics' and psychoanalyse the stares and postures.[97] Somewhere in here is buried the 'hidden transcript'[98] of response – if not resistance – to the prevailing processes of 'Othering' and the reaction to an ever-present bureaucracy of assimilation. Subordinate groups have always cultivated complex strategies to exercise their fugitive power to challenge hegemony.[99] Not necessarily overtly confrontational,

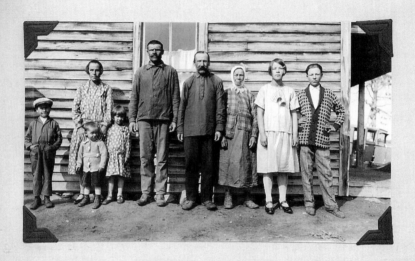

CANADIAN NATIONAL RAILWAYS

Head of Family: Ignaty Zadorozny
European Address: O.P.Boziszcze Pow.Luck,Wolyn,Poland
Nationality: Ukrainian
Arrived Canada: August 11,1928,ex.s.s.CALGARIC
Steamship Line: White Star
Present Address: St. Walburg, Sask.
Land Location: N.E.¼ 25-54-23-W/3rd.

This family were directed by the Land Settlement Association of
the Canadian National Railways to the St. Walburg district, where
friends had been previously settled through the Association.
Zadorozny finally purchased a well i proved 160 acre farm for
$18.00 an acre on the crop payment plan. The farm has 90 acres
under cultivation and has very comfortable buildings. The family
are shown in the above picture standing in front of the house.
Zadorozny is also renting some other land in the district and
has his farm well equipped including 5 horses, 3 cows, 3 calves,
pigs, poultry and a complete line of machinery.

 (Nominated - 2228-1798)

FIGURE 7.9 Immigrants on display and under scrutiny: Unidentified photo-
grapher, page from CNR photograph-dossier: *Head of Family: Ignaty Zadorozny*,
volume for the Province of Saskatchewan. Courtesy: National Archives of
Canada, RG30, Vol. 5893.

resistance can be a subtle, subdued, deceptive strategy of 'refusing to be wiped off the map of history'.[100] To ensure this integrity and survival, acts of 'resistance' and 'transgression' that assert identity can take many forms – even a sullen stare back into the lens of a camera.[101]

Conclusion: Shadows and Mirrors

Much of what has been discussed here is now 'history' in both senses of that term; it has gone. Leaving the grounded reality of Canada's inter-war years' frontier, it exists only in the realm of historical scholarship and abstract theorizing about the power of the photographic image. But is the photographic document a window to the past that reveals shadows of something long gone, or does it reflect an image pertinent today? Faye Ginsburg has suggested that, rather than being a 'window' on reality that allows the enhancement of our powers of observation, the camera – and thus the photograph – is 'a creative tool in the service of a new signifying practice'.[102] James Duncan also argues for an appreciation of the power of a sort of reflected gaze from the apparently obvious past to the more complex present: 'Only when we seriously explore those representations which we find self-evidently false can we begin to question the representations which we find self-evidently true. Only then will our own sites of representation become visible to us.'[103]

There is much evidence to suggest that nativism, xenophobia and government intervention in the social engineering of the state are all but mere shadows now. In 1991, Canada celebrated the centennial of the first Ukrainian immigration to Canada: books were written, conferences called and stamps printed. One image for a commemorative stamp was pulled out of the CNR files because of its exotic characters in a folksy setting, building Canada. A simplistic interpretation would attribute this act to some bureaucratic, committee-appointed designer relying on the efforts of a research assistant. Perhaps this was the mechanical process, but it was initiated, directed and ultimately approved by the contemporary discourses in a pluralist and officially multicultural Canada. It was deliberately selected to celebrate the centenary of Ukrainian immigration to Canada – albeit cropped out of the more polemical context of the CNR photograph-dossier format. It is an image that has since become romanticized and glamorized as an icon of ethnic and populist identity, rendered in the kitsch of roadside vernacular art and municipal pride.

But there is an ugly image in the mirror held up to the 1920s too. Canada at the millennium has strong nativist voices still talking the language of cultural tension, economic pressure, social cohesion and the pragmatics of national unity. Such arguments are often the smokescreen for others of more extreme political orientations. The gazes of nativists and bureaucrats are again being levelled against another group of 'new' Canadians, and they too are gazing back at us. I wonder what they see?

PART III
Colonial Encounters

EIGHT

Emperors of the Gaze: Photographic Practices and Productions of Space in Egypt, 1839–1914

Derek Gregory

'In sight-seeing, as in picture-making, the "point of view" is everything.'
R. Talbot Kelly, *Egypt, Painted and Described*

'Photography itself is hardly immune to the blandishments of Orientalism.'
Linda Nochlin, *The Imaginary Orient*

§ THIS ESSAY is written in the uneven space between two fields. On one side is the continuing critique of Orientalism and, in particular, the ways in which vision and visuality were imbricated in its colonizing gestures. One of the paradoxes of Edward Said's luminous interrogation in *Orientalism* is his emphasis on the connections between power, space and visuality, and yet his stunning oversight of the visual arts themselves. John Mackenzie has revisited Orientalism with an eye to exactly this absence, and yet en route and I think quite unaccountably, he jettisons more or less everything Said has to say about the politics of vision.[1] Art historians have been more scrupulous, and they have been joined by historians of photography to expose the complex visual space within which 'the Orient' was constructed by European and American authors, artists and photographers.[2] On the other side is a body of work that accentuates the centrality of vision and visuality to modern cultures of travel and, in particular, the ways in which 'sight-seeing' has shaped and scripted the routines of modern tourism. It has become almost commonplace to disclose the cultural conventions that structured the 'tourist gaze' and naturalized its organization of the view, establishing hegemonic ways of seeing that at once required and repressed the work involved in their production.[3] But few cultural histories of travel have paid much attention to the ways in which popular photography came to be spliced into the performances of modern tourism.

In this essay, I work in the space between these fields by focusing on European and American photographers who travelled in Egypt between 1839 (when Daguerre's photographic process was first made known) and 1914 (when World War I disrupted Orientalist cultures of travel that had been developed over the course of the long nineteenth century). I depart from the characteristic emphases of many of the studies indicated in the previous paragraph by being as much interested in popular culture as in high culture – a distinction which is constantly undermined throughout the period – and by treating photography not simply as a medium but as a discourse. As I use the term, then, 'photography' comprises agents and instruments, materials and images, conventions and practices, which are articulated through a complex actor-network that, like any such network, threads its way into many others; hence its imbrications in both the visual cultures of Orientalism and the cultures of modern tourism.

In the first section, I consider the formation and development of a photographic tradition concerned with monumental description. Most of the early photographers to visit Egypt were preoccupied with capturing the architectural remains of its ancient civilization and rendering the planes, forms and inscriptions of its temples and tombs. Their work was part of the production of a space of constructed visibility in which 'ancient' Egypt was seen by European and American observers as a monumental space, empty, abstracted and largely outside the spaces of both 'traditional' and 'modern' Egypt. In the second section, I consider the formation and development of another photographic tradition which was concerned with quasi-ethnographic description. Although commercial photographers were closely involved in the production of a space of constructed visibility in which 'traditional' Egypt was made to appear as a gallery of exotic 'types', my own focus is on the part played by ordinary tourists in the production of an overlapping space in which the amateur photography of other people entered into (and increasingly defined) the experience of tourism itself. This was underwritten by a series of technical changes in the practices of photography and modern travel that sustained the conventional image of 'tourists' carrying their 'Kodaks' and hunting for 'snapshots'. As I intend to show, however, their preoccupations continued to be framed by a regime of truth that had been established by their predecessors who sought fidelity among the monuments: one that rendered 'Egypt' as a transparent space that could be fully known by a colonial, colonizing gaze.[4]

Monumental Spaces and (Photo)graphic Authority

The short-lived French occupation of Egypt between 1798 and 1801 was a decisive moment in the formation of a distinctively modern Orientalism, and the practices and representations conducted under its sign continued to invest subsequent visual appropriations of Egypt with much of their meaning. This is not the place to trace through the connections between sketching, painting and photography – important though they were – but I do need to establish how the *Description de l'Égypte* provided a baseline

for later photographic representations of Egypt. For in many respects, I think, European and American photographers were following in the footsteps of Napoleon's soldiers and scholars, and they were, in their way, latter-day 'emperors of the gaze'.

Describing Egypt Napoleon's expeditionary force was accompanied by the Commission des Sciences et des Arts de l'Armée de l'Orient, which was made up of 165 scholars, many of them prominent figures, including engineers, surveyors and cartographers, as well as scientists and artists. Their collective work culminated in the vast *Description de l'Égypte*, which was first published in instalments in Paris between 1810 and 1828. Sales of the first edition were slow; the *livraisons* were expensive and their appearance was denied the fanfare of imperial decree or even advertisement. Even so, the scholars' efforts did not go unremarked. Napoleon gave away dozens of copies of the first *livraisons* to libraries and powerful individuals across Europe, and the second edition, which was prepared between 1820 and 1830, was a strictly commercial proposition, and its publisher went to great pains to keep it in the public eye.[5]

There were three parts to the *Description* – *Antiquités*, *État moderne* and *Histoire naturelle* – but it was the first part that occupied a central place in the public imagination. The cult of 'Egyptomania' identified its object of veneration (and emulation) as 'ancient Egypt'. That this was a *particular* vision of Egypt goes without saying, but it was also a particular *vision* of Egypt: the special significance of the *Description* for my own argument is thus that it valorized a *visual* appropriation of the Orient. There were nine folio volumes of text, ten large volumes of illustrated plates and three huge volumes of an atlas. But it was without doubt the plates that captured the attention of a cultivated public. There were 897 of them, each measuring 70 by 54 cm, and together they made available over 3,000 drawings. Never before had Egypt been rendered to a European audience in such vivid, systematic detail. It was the combination of systematicity and detail – what Said calls a 'discipline of detail' – that also ensured the *Description* its place in the intellectual tradition of Diderot's *Encylopédie* and validated its claims to scientificity.[6] Some of the drawings had to be completed in haste and so were difficult to identify with precision, and some of the conjectural reconstructions of the monuments were fictions in the original sense of the word ('something made'), 'highly stylized simulacra'; but the illustrations were not pure fantasy, and the Introduction to the published volumes insisted that 'the series of plates represents existing objects which can be observed and described in an exact manner, and for that reason, are to be considered as so many positive elements in the study of Egypt'. In fact, several technical innovations had been devised for the reproduction of the plates in the first edition, notably Conté's engraving machine that produced beautiful, intricately detailed results, and the second edition used the original plates to ensure that the illustrations remained of the highest quality. This mode of detailed representation was a way of claiming not only colonial authority, a sense of 'being there' and 'seeing everything' – a sort of 'eagle's-eye view' – but also

colonial legitimacy: an implication that the scholars (and their European audience) were *entitled* to be there and to have the Orient set out thus for their edification. It was as though only the *savants* could 'organize the view', only they were equipped to bring a sense of perspective and composition to the labyrinth of ruins that were thereby marked as a dispersed originary site of a definitively *European* history.[7]

In January 1839 the astronomer François Arago, Secretary to the Académie des Sciences in France, announced that Louis Jacques Mandé Daguerre had perfected a process to fix a clear and detailed image on a polished metal plate. In August of the same year Arago addressed a joint session of the Académie des Sciences and the Académie des Beaux-Arts in Paris, and for the first time the details of the new photographic apparatus were made public. Arago had already received a report from a prominent painter at the École des Beaux-Arts hailing Daguerre's process as one that 'satisfies art's every need': 'M. Daguerre's wonderful discovery', he had written, 'is an immense service to art.'[8] Arago was equally determined to fasten the *scientific* importance of this revolutionary process in the minds of his audience. In order to do so he appealed directly to the *Description de l'Égypte*:

> While these pictures are exhibited to you, everyone will imagine the extraordinary advantages which could have been derived from so exact and rapid a means of reproduction during the expedition to Egypt: everybody will realize that had we had photography in 1798 we would possess today faithful pictorial records of that which the learned world is forever deprived of by the greed of the Arabs and the vandalism of certain travelers.

But all was not lost; it was still possible to construct a photographic record of the remaining ruins and their inscriptions:

> To copy the millions of hieroglyphics which cover even the exterior of the great monuments of Thebes, Memphis, Karnak, and others would require decades of time and legions of draughtsmen. By daguerreotype one person would suffice to accomplish this immense work successfully. Equip the Egyptian Institute with two or three of Daguerre's apparatus, and before long on several of the large tablets of the celebrated work, which had its inception in the expedition to Egypt, innumerable hieroglyphics as they are in reality will replace those which now are invented or designed by approximation.[9]

Arago's enthusiasm was at once understandable and overstated. Exposing daguerreotype plates was a slow and difficult process, and the first successful photographs of hieroglyphs were made only in 1846 by the rival calotype process.[10] But the new photographic machines were, nonetheless, rapidly conscripted to photograph Egypt's ancient temples and tombs. Winter was the season for visiting Egypt, and the first daguerreotypists arrived in late 1839. They included the celebrated artist Horace Vernet and his pupil Frédéric Goupil-Fesquet. After some initial experimentation,

including a presentation to Mohammed 'Ali, Vernet showed little interest in the daguerreotype; Goupil-Fesquet said that he rarely bothered to make even a conventional sketch to record their journey, and that it was as though Vernet had his own daguerreotype lodged in his 'magical' memory. As this metaphor implies, Goupil-Fesquet was caught between veneration for his master and enthusiasm for the new technology. And it was, in fact, Goupil-Fesquet who devoted himself to their *excursions daguerriennes*, much to the amusement of his companions, and with variable results (which seem to have improved once he departed from Daguerre's original instructions). Goupil-Fesquet spent much of his time in and around Cairo with Pierre Joly de Lotbinière, a Swiss-Canadian who had been commissioned by a Paris optician to take daguerreotype views during his travels. To the young Frenchman, his new companion was as much a 'passionate daguerrean' as he was, and when they parted Joly de Lotbinière travelled through Upper Egypt on his own, transporting over 100 lb of photographic equipment by *dahabeah* and donkey.[11]

The early photographers were drawn to Cairo and the Nile valley partly because Egypt had become a fashionable destination for European travellers in the post-war decades, particularly among the bourgeoisie who had reconfigured the aristocratic Grand Tour of the eighteenth century and extended it to the east; a motivation that was often validated by an interest in antiquity which, if not as academic as Arago's, was nevertheless often as serious and as earnest. But there were also sound technical reasons. All travel writers marvelled at the special qualities of Egypt's light, and its brilliance must have been an important consideration for the first photographers. When Goupil-Fesquet lugged his daguerreotype apparatus to the Citadel in Cairo, for example, he found that while his 'mechanical artist worked', he had enough time to stroll around the ruins and seek shade from the sun; and at the Pyramids, a few days later, he discovered that even in full daylight each exposure required at least fifteen minutes.[12] The time was soon reduced, but this limitation shaped subsequent photographic conventions and reinforced the valorization of the monuments as subjects: 'The static mass of architecture was well suited to early daguerreotypes which required long exposure times but which could reproduce every masonry course and architectural detail in perfect perspective.'[13] Calotypes were also pressed into monumental service, and they were soon seen to possess particular advantages for travellers: they were more portable and the plates could be sensitized weeks before use. It seems clear that both the daguerreotype and the calotype allowed for considerable variation and experimentation, so much so that it would be a mistake to posit a single, unifying aesthetic for either of them.[14] Still, I think it possible to identify some basic 'performative' parameters that structured the practices of photographers working within this monumental tradition, and in order to do so I want to consider the work of two photographers, both calotypists, in more detail: Maxime Du Camp, who travelled up the Nile and back with Gustave Flaubert during the winter of 1849–50, and Félix Teynard, who followed a similar itinerary in 1851–52.

Maxime Du Camp and Félix Teynard Du Camp had two closely connected purposes in taking up – briefly, as it turned out – photography. One was pragmatic. In his previous travels, he had wasted 'precious time in drawing the monuments, or views that I wanted to remember'. Sketching was a common accomplishment of the bourgeoisie in the middle of the nineteenth century, but Du Camp complained that he 'drew slowly and in an incorrect manner', and that he subsequently had great difficulty relating his sketches to his notes. He realized that he needed 'a precision instrument to bring back images that would allow me to make exact reconstructions'. It was here that his pragmatism dovetailed with the scientific aspirations of France's leading Egyptologists. Du Camp won the support of the Académie des Inscriptions et Belles Lettres for a *mission* to Egypt – which he was confident would unlock all sorts of doors for him and Flaubert – to secure 'views of the monuments and copies of the inscriptions'. The Académie's scrutinizing committee welcomed the 'uncontestable exactitude' and 'minute fidelity' of Du Camp's 'new companion' (the photographic apparatus not the novelist), and compared it favourably to 'the scattered sketching, the all-too-common habit of travellers of jumping from one monument to another, without having exhausted the study and attention that each one demanded'. What thus attracted the members of the committee to the photographic apparatus was its scientificity: upholding the tradition of the *Description*, it promised to be systematic, disciplined and objective, 'faithfully and sequentially copying the texts claimed for science'. And, equally, Du Camp's other purpose in taking up the camera was thereby to enlist under the banner of empirical science.[15]

As these considerations suggest, Du Camp took his mission seriously, systematically constructing and annotating his photographic archive. At the end of March 1850 Du Camp wrote to Théophile Gautier:

> I have a way of working which is not expeditious. I take photographic prints of each ruin, of each monument, and of any scenery I find interesting. I draw the ground-plan of every temple and make 'squeezes' of all the important bas-reliefs. Add to that notes as detailed as possible, and you will understand that I cannot go very fast.[16]

The difficulties of taking satisfactory photographs taxed Du Camp to the limit. Dismayed by his early results, he changed his technique from the 'dry paper' Le Gray process he had learned in Paris to the 'wet paper' Blanquart-Evrard process he learned from another traveller in Cairo. He was convinced that the speed of this alternative process constituted 'an extraordinary advance over the daguerreotype', but its exacting demands often reduced him to rage and fury. Transporting the equipment was still a major problem. Du Camp packed his glass flasks, crystal bottles and porcelain pans 'like the crown jewels', and had one of his crew carry his heavy camera. The technical demands were no less onerous. Even in the most favourable conditions, each exposure took at least two minutes. Du Camp left many of the basic preparations to his manservant, Sassetti, so that he could devote himself to what he called 'the fatiguing

business of making negatives': it took forty minutes or more to produce the final result. All of this must have made him extraordinarily irritated at his companion's amused condescension. 'Young Du Camp ... is doing quite well', Flaubert wrote to Louis Bouilhet. 'I think we'll have a nice album.'[17]

In fact, Flaubert came to despair of Du Camp's dedication. He was frankly bored by most of the temples and tombs, each one allotted its place in what had already become the standard itinerary, and his irritation at the virtually 'mechanical' system of modern tourism seems to have been compounded by Du Camp's obsession with the mechanical reproduction of its sights.[18] But the difference was not fundamentally one of temperament. The photographic images present a dramatically different impression of the journey to those contained in the travel writings of the two friends. As Elizabeth Anne McCauley remarks: 'Looking at the prints, one would have no idea that these two Frenchmen spent their evenings in the arms of dancing girls, were plagued by fleas and venereal disease, and amused themselves by shooting birds, crocodiles and even dogs.'[19] There was a raw (and on occasion even a refined) sensuality to the composite textual record of their *voyage en Orient* which is purged from the prints. Julia Ballerini speaks of the 'disinterested banality' of the photographs and emphasizes the distance Du Camp assiduously maintained between himself and his subjects. These were primarily the monuments, as his instructions dictated, and only twenty or so out of the 189 negatives Du Camp made in Egypt were not of ancient sites. He focused his attention on Thebes, Philae and Abu Simbel. He placed his architectural subjects squarely front and centre, assuming what Ballerini calls an 'unimaginative middle terrain position' that caused each set of forms 'to exist in its own detached space', so that Du Camp's Egypt, as presented through his photographs, consisted of a series of severe, geometric and abstracted spaces.[20]

Given Flaubert's disdain, it is perhaps not surprising that Du Camp should have so rarely turned the camera on him, and it would have been difficult (if not impossible) and certainly impolitic for Du Camp to have captured their more unrestrained escapades.[21] But his other erasures are more revealing: Du Camp's images remove from the field of vision any trace of the villages that the *fellahin* (the peasants) had constructed inside (and out of) the ruins. At Edfu, Du Camp climbed the pylons to the platform above. 'From this height,' he wrote:

> the eye swoops on the whole ensemble of the temple whose extraordinary dimensions can then be seen easily. *Fellah shanties built on its terraces hide and devour it like leprosy* ... From the top of the pylons, one sees life buzzing in the house imperfectly protected by fragments of mats. The naked children roll around in the dust while their mother is busy with domestic chores and their father smokes crouching in the shadow; in one corner, yellow dirty dogs sleep, their heads stretched onto their paws, some chickens peck at balls of manure and the pigeons fly rapidly toward the square towers covered with clumps of brushwood that are built for them in every Egyptian village, in order to collect their droppings and sell it as a fertilizer to the farmers of the Delta.[22]

Similarly, at Luxor, where Flaubert briefly set aside his ennui at the parade of monu-
ments, the two friends found that 'houses are built among the capitals of columns;
chickens and pigeons perch and nest in great [stone] lotus leaves; walls of bare brick
or mud form the divisions between houses; dogs run barking along the walls'. Flaubert,
who was usually much more interested in a living Egypt than in the remains of
ancient Egypt, was moved to add: 'So stirs a mini-life amid the debris of a life that
was far grander.'[23] Indeed, for exactly this reason, one young traveller suggested that
Luxor was best seen from a distance:

> We went one morning to examine the interior, but all the enthusiasm we could muster
> did not counterbalance the impression left on us by the view of the horribly unclean
> state it is in … [W]ith the exception of a small portion cleared out by a Frenchman,
> who has built his house on the roof, an Arab village with all its appurtenances of
> savage dogs, squalling children, begging women and dirty men &c., &c. are crowded
> within it. Their huts are plastered round the pillars and their buffaloes and asses crouch
> with them under the lofty roofs.[24]

Comparing Du Camp's photographs with passages like these, or – to keep within
a visual register – with David Roberts's sketches and paintings of the same sites, the
emptiness of Du Camp's monumental spaces is striking.[25] The only human figure
who regularly appears in them is a young member of the crew, Hadji-Ishmael, who
was included, so Du Camp explained, to scale the images; but in many of these
photographs even Hadji-Ishmael virtually disappears into the masonry and rubble
(Figure 8.1).[26] It is perfectly true that the vacancy of Du Camp's photographic archive
was accentuated by his publishers, who rejected most of his prints of contemporary
life; but there were, in any case, remarkably few of them, so that this emphasis was
plainly not primarily the product of a commercial decision taken on Du Camp's
return to France.[27] It was as though these monumental landscapes existed on a
different plane to the clutter and cacophony of contemporary Egypt.

A year or so after Du Camp's return, Félix Teynard set out for Egypt with a
similar and even more systematic objective. He was a civil engineer and his intention
was to produce 'a photographic atlas' that would, so he hoped, 'complement' the
Description de l'Égypte. He, too, sought the support of the Académie des Sciences, in
case its members wished him to report 'details about general physical conditions and
topography', but it seems he was unsuccessful. Nevertheless, Teynard was undeterred.
Apart from the crew of his *dahabeah*, he travelled alone, making his preparations in
circumstances as trying as those endured by Du Camp – rocking on a boat, sweating
inside a tent – and on his return published a series of 160 plates. The vast majority
of them (around 130) were of the monuments of ancient Egypt, which Teynard
justified by their archaeological and historical significance: they revealed the condition
of one of the most distant civilizations from the modern world. Although it was
impossible to photograph the interiors of the temples and tombs, he explained that

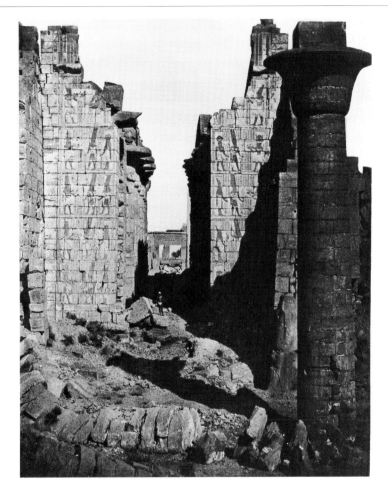

FIGURE 8.1 Egypt monumentalized: Maxime Du Camp, 'Cour des
Bubastites et entrée principale de la salle hypostyle, palais de Karnak,
Thèbes', Figure 37 in *Égypte, Nubie, Palestine et Syrie: Dessins photo-
graphiques recueillis pendant les années 1849, 1850 et 1851*, Vol. 1 (Paris: Gide
et J. Baudry, 1852). Salted paper print, 205 × 161 mm. Courtesy:
National Gallery of Canada, 21569.37.

he had been as systematic as he could. At the more important places, he had taken
a general view of the site, more detailed views of the monuments and then closer
images of the statues. This visual strategy followed the hierarchical organization of
the view deployed by the *Description*, which David Prochaska characterizes as that of
an 'encyclopaedic camera', telescoping downwards 'from panoramic sweeps to micro-
scopic views' and traversing the Nile from south to north.[28]

Teynard preferred oblique views, which accentuated what Kathleen Howe calls 'the
spatial dimensions of the buildings and the physical reality of the site', and she suggests

that he took advantage of the granular quality of the calotype process – the texture of its paper prints – to produce a 'peculiarly sensuous' impression that successfully captured 'the gritty expanses of sand and granite' and the 'roughened surfaces' of the monuments. Howe's reading attributes an aesthetic sensibility to Teynard's project – she describes it as 'an abstracted poetry of light and shadow' – but I also want to insist upon its almost clinical geometricity. As Howe herself concedes, Teynard's plates were, above all, an exploration of the 'intricate anatomy' of architecture; indeed, Ian Jeffrey describes Teynard as 'one of the most severe of all architectural documentarians, [who] rarely turned his attention from the geometries of cut stone'.[29] When he did do so, however, the same geometric imagination, single-mindedly focusing on surfaces and shadows, planes and patterns, was extended to his treatment of landscape. Virtually all of the thirty-odd plates that do not take the monuments as their subject reveal the same geometric abstraction. Teynard presents Egypt as a fractured landscape whose surfaces are heaped with rubble and whose planes are scarred by ravines, its vast skies punctuated by the geometric compositions of palm trees. Only one plate has human figures as its subject; and even these are not local *fellahin* encountered en route but two members of the crew of Teynard's *dahabeah*, part of the apparatus from which he gazed out over this monumental space. The abiding impression of Teynard's Egypt is thus of an anatomy from which all living anatomies have been ruthlessly excised or, as Jeffrey puts it, of 'an austere place apart, an alternative world virtually of his own choosing and making'.[30]

Ancient Egypt, the photographic archive, and the colonial imagination Even in this abbreviated form, these readings of Du Camp and Teynard invite several conclusions about photography's early implication in the colonial project in Egypt. In the first place, photography clearly accentuated the importance of a visual thematic in colonial appropriations. The plates of the *Description* had valorized the visual representation of ancient Egypt to such an extent that, throughout the 1830s and 1840s, most antiquarians seem to have 'uncovered monuments [only in order] to sketch them more completely'.[31] It was common for travel writers to describe their accounts as 'sketches', 'views' or 'glimpses' of Egypt, and several of them employed the *camera lucida* to illustrate their journals; Edward Lane, the author of the canonical *Account of the Manners and Customs of the Modern Egyptians*, first published in 1836, and William Henry Bartlett, author of *The Nile Boat*, published in 1849, were perhaps the most famous to do so. Bartlett, a topographical artist, was (unduly) modest about his text, but he insisted on the importance of his illustrations, 'of which the whole were drawn on the spot'; a statement that sutured originality to authenticity and, in so doing, registered a claim for authority.[32] The advent of photography appeared to redeem such claims in full measure, and the inscriptions on the ruins placed a special premium on its capacity faithfully to capture the visual. Harriet Martineau spoke for countless others when she declared: 'The amount of what one does learn by the eye

is very great – really astonishing in the case of a people whose literature is lost, instead of remaining as an indication of what one is to look for, and a commentary on what one sees. What we do not owe to their turn for engraving and painting!'[33]

By the middle years of the nineteenth century it had become commonplace to invoke photographic metaphors to describe these bas-reliefs. To George Curtis, writing in 1856, a tomb was thus 'a contemporary daguerreotype of old Egyptian life', while to the Reverend Smith the monuments were 'vivid photographs of Egyptian life four thousand years ago'.[34] The parallel was reinforced by the practices of the photographers themselves, so that by 1863 G. A. Hoskins could declare that 'photographic machines have superseded the pencil in delineating the monuments', which remained the principal subjects of most travelling photographers until the closing decades of the nineteenth century.[35] The Reverend Smith's father, who accompanied him to Egypt with his own camera, 'brought away a splendid portfolio of about 140 photographs, comprising views of nearly every temple we saw'; there is no mention of any non-antiquarian subjects.[36] Travellers without cameras continued to sketch and paint, but many of them also purchased photographs of the monuments from dealers. As the century wore on, it became increasingly easy and much less expensive for them to do so.[37] Booksellers often carried photographs, and, by 1898, Baedeker listed three professional photographers in Alexandria, three more in Cairo and one in Luxor, all of whom had prints (and eventually postcards) for sale: 'Good photographs are produced by A[ntonio] Beato at Luxor; but even in Shepheard's and other hotels in Cairo, excellent photographs of Egyptian temples are sold at modest prices.'[38]

In the second place, there was a reciprocity, even a complicity, between the 'truth' of photography and the 'truth' of the ruins themselves. Photography was inscribed within an ideology of realism that reinforced a distinctive regime of truth, which is precisely why the Académie had been so interested in the documentary possibilities of the new medium. 'The mid-nineteenth century was the great period of taxonomies, inventories and physiologies,' Abigail Solomon-Godeau reminds us, 'and photography was understood to be the agent par excellence for listing, knowing, and possessing, as it were, the things of the world.'[39] Photography's truth claims were reinforced by the material density – the facticity and obdurate object-ness – of its monumental subjects: 'the age and monumentality of [its] subjects are easily confused with an unimpeachably august truth'.[40] The architectural archive of ancient Egypt was thus supposed to be transferred intact to a photographic archive. The direct passage between the two was routinely confirmed by the tourist's exclamation: 'Luxor is exactly like its photograph, I should have recognized it anywhere.'[41] Sometimes, to be sure, the relationship was qualified. Hence W. H. Gregory announced his preference for 'the rich, warm tone of [David] Roberts's paintings' over photographs which were, so he said, 'cold abominations'. And yet it was this very coldness, the forensic monochromatic abstraction of photography, that prompted Gregory to commend its documentary

value in recording the inscriptions on the tombs.[42] At other times, the passage between the two was freighted with a studied ambiguity. When Amelia Edwards reached the island of Philae, for example, she found that:

> [Pharoah's Bed] is exactly like the photographs. Still, one is conscious of perceiving a shade of difference too subtle for analysis; like the difference between a familiar face and the reflection of it in a looking-glass. Anyhow, one feels that the real Pharoah's Bed will henceforth displace the photographs in that obscure mental pigeon-hole where until now one has been wont to store the well-known image; and that even the photographs have undergone some kind of change.[43]

This is a complicated passage in which photography both functions as a testimony of presence – of truth and authenticity – inasmuch as Pharoah's Bed 'is exactly like the photographs' and, simultaneously, has its mimetic claims interrupted; the real requires that the photographs undergo 'some kind of change'. For all these hesitations and qualifications, however, the dialectic of anticipation and confirmation between photographic image and monument became a commonplace as tourist itineraries through Egypt were scripted with increasing precision.[44] It had the effect of transferring the architectural archive in Egypt to a photographic archive produced by and, in some substantial sense, *possessed by* the West; of surreptitiously and unconsciously displacing these ancient monuments from their physical sites in Egypt into 'sights' within a European imaginary. The photographic image was thus converted from what Barthes calls a certificate of *presence* produced by the photographer – conferring a sense of authority and hence of veracity – to a certificate of *possession* issued to the viewer.[45]

In the third place, the trajectory from 'knowing' to 'possessing' was more than a metaphorical passage. These photographers effectively reinscribed the imperial gaze of the *Description de l'Égypte* by according a central place to Egypt as a landscape of enduring tombs and temples; a permanent inscription of the origins of what was widely assumed (by Europeans, at any rate) to be a distinctively European history. But there was a difference between the two projects. The French *savants* routinely included themselves in the plates of the *Description* – measuring, surveying, sketching; 'actively looking', as Prochaska puts it[46] – and so emphasized their physical presence among the temples and tombs. But there was no reason for early photographers to establish their credentials in this way. Before commercial photographs became available, the photograph issued its own certificate of presence in a way that was impossible for a sketch or painting. More significant is the fact that so few early photographers took local people as their subjects either. The landscapes depicted by Du Camp and Teynard are largely devoid of human figures.[47] These erasures were in part the product of technical limitations imposed by long exposure times, but Solomon-Godeau claims that this characteristic emptying of places was fully conformable with the ideology of colonialism: 'It is reasonable to assume that such photographic documentation, showing so much of the world to be empty, was unconsciously assimilated to the

justifications for an expanding empire.'[48] Early photographers tacitly represented
Egypt as a vacant space awaiting its (re)possession and reclamation by Europe.

Presence, plenitude and possession In the course of the following decades the
photography of Egypt's monumental landscapes was professionalized and commercial-
ized. This brought photographic images of the temples and tombs into a far wider
circulation than was ever achieved by the expensive *livraisons* and collected editions of
men like Du Camp and Teynard. These later projects took advantage of a series of
technical advances to produce even sharper images that reinforced the primacy of the
visual and shored up its regime of truth. Once the ancient sites were aggressively
cleared of their native occupants by agencies of the state and turned into exhibitions
for passing tourists, the impression of an empty landscape was simultaneously height-
ened and fixed permanently in print.

In effect, the photographic imaginary rendered the remains of Egypt as a trans-
parent space that could be fully 'known' by the colonial gaze. This had been part of
the purpose of the *Description*, of course, and its detailed plates worked with the
accompanying atlas to dissect and articulate the lineaments of those monumental
landscapes.[49] Photography allowed this colonizing autopsy to be taken still further
and it reached its apotheosis during this period with the publication of *Egypt Through
the Stereoscope* in 1905. This consisted of a set of 100 stereoscopic views (around eighty
of them devoted to the antiquities) that was produced by the Keystone View Company
in the USA in association with Underwood and Underwood and explained by – or,
as the fly-leaf of the accompanying text preferred, confirming the intimate association
between photography and tourism, 'conducted by' – James Breasted, who was Pro-
fessor of Egyptology and Oriental History at the University of Chicago.[50] To describe
this project as an apotheosis may seem a strange claim, since the stereoscope had
been perfected much earlier, in the 1850s, and there is an important sense in which,
although it relied on pairs of photographic images, the stereoscope nonetheless
marked a significant departure from the conventions of photography.[51] Even so, the
most vigorous expansion of the market for stereoscopic pairs took place between
1880 and 1914, and I want to suggest that *Egypt Through the Stereoscope* radicalized both
the certificate of presence and the totalizing systematicity of the photographic archive,
thereby extending its colonizing propensities, in two ways.

In the first place, the illusion of depth produced by stereoscopic images dramatically
heightened the viewer's sense of 'being there'. This was particularly significant in an
age when depth was privileged as an index of meaning and used to convey a sort of
'archaeology of truth', and this metaphorical regime played directly into the 'dis-
covery' of ancient Egypt by European and American archaeologists at the turn of
the nineteenth and twentieth centuries.[52] Breasted was himself enthralled by the
medium. 'These superb stereographs', he enthused, 'furnish the traveller, while sitting
in his own room, a vivid prospect as through an open window, looking out upon

scene after scene, from one hundred carefully selected points of view along the Nile.' The stereoscope conveyed 'the sense of substantial reality that these venerable struc- tures are actually rising yonder before the beholder's eye', he declared, and as he became accustomed to its operations so 'it became more and more easy to speak of the prospect revealed in the instrument as one actually spread out before me'.[53] This conceit was positively encouraged by his text, where, at one point, Breasted advised the viewer physically to 'raise the instrument and look upwards' from the base of the Great Pyramid, and at another to lower the instrument towards the floor and look down from the summit: 'Let your eyes run down the precipitous sides nearly 500 feet to the desert below,' he promised, 'and you will be ready to shrink back, I doubt not, at the suggestion of falling.'[54] So complete was the sense of 'being there' that Breasted was able to draw attention to what could *not* be seen as though it, too, were physically present. 'With your eyes within the hood of the instrument,' he advised, 'you must consider carefully the various relations of the prospect before you, the direction in which you are looking, *what lies behind a distant horizon*, what is to the right, left or *behind* you' (my emphases). True to his word, looking down from the Citadel over the city of Cairo, Breasted conjured up a panoramic view of truly continental scope: 'Behind those distant cliffs is the vast expanse of the Sahara, stretching on and on across all north Africa to the far Atlantic, while behind us is the desert interrupted by the Red Sea and extending across Arabia into the heart of Africa.'[55] Practices like these were intimately related to an erotics of vision that was installed at the heart of the colonial imaginary; as Nancy West suggests, it is at least arguable that 'a vision so dependent on material plenitude also creates a desire for optical possession; objects appear so obscenely close, and yet so practically out of one's reach, that they create a frustrated desire for them'.[56]

Secondly, simultaneously confirming and transcending the illusion of presence, the artifice of the stereoscope allowed Breasted to claim that his virtual tour was, in some substantial sense, *superior* to 'being there'. Recalling the 'eagle's-eye view' of the *Description*, it gave the observer access to disciplined and detailed systematicity that was impossible on the ground. By carefully studying each stereoscopic pair, locating the point of view precisely on the maps and plans supplied with the instrument and attending to Breasted's explanations, the viewer 'will have become more familiar with Egypt than most tourists in that country, who usually read so rapidly on the spot and are hurried about at such a rate that they bring home only blurred and confused impressions of what they have seen'.[57] Following his instructions set in motion a geometric triangulation, an enframing, by means of which the viewer was able 'to connect the one hundred points of view into a coherent whole, and into a definite progress through the land in a real and connected tour'.[58] The appeal to an enframed totality – 'a coherent whole' – was the heart of a double illusion. Viewed in isolation, each stereoscopic pair fails to coalesce into what Crary calls a 'homogeneous field'; stereoscopic depth has no unifying order, and its disunified, even 'deranged' visual

field produces 'a localized experience' of separate zones of three-dimensionality in which the eye is led to follow 'a choppy and erratic path into its depth'.[59] But viewing these stereoscopic pairs in sequence, in association with the maps and commentary, produced an enveloping sense of completeness that naturalized the erasure of human subjects from so many of the images. This sense of completeness and of closure was not only an achievement denied to the ordinary tourist; it was also an accomplishment deemed inaccessible to the inhabitants of Egypt. The production of Egypt as such a totality required a visual order, a 'ground-plan', *that had to be brought from the outside, from 'the West', to organize the view.*[60] It would be difficult to find a clearer expression of photography's complicity in the colonizing powers of European modernity.

View-hunting and Snapshots

Cultures of travel were transformed in the second half of the nineteenth century by the rise of tour companies and the growth of organized tourism. Independent travellers continued to stream to Egypt in increasing numbers – by 1861 Emily Beaufort could already complain that 'solitude is difficult to obtain on the now fashionable and crowded Nile'[61] – and on the eve of the opening of the Suez Canal in 1869, the British firms of Henry Gaze and Thomas Cook sent their first parties of 'personally conducted' tourists to Egypt. It is important not to make too rigid a distinction between 'travel' and 'tourism' because the intersections between them were complex and shifting, and marked by contours of class, gender and cultural sensibility in ways that make any simple opposition seriously misleading. In fact, the growth of organized tourism in the closing decades of the nineteenth century overlapped with changes in the expectations and experiences of many nominally independent travellers; the old snobberies died hard, to be sure, but most Europeans and Americans who ventured to Egypt were now willing to admit a far greater importance to entertainment and pleasure: 'Egypt-as-exhibition' licensed more than an earnest study of the monuments.[62] These developments coincided with two recompositions of the photographic imaginary.

First, there was a much greater interest in photographic images of the inhabitants of Egypt. Indeed, by the *fin de siècle*, many commentators claimed that tourists had become increasingly bored by what George Ade called 'the cemetery circuit', the endless round of tombs and temples. Although they continued to troop dutifully through the ancient sites – and to purchase professional photographs and prints of them – Ade was convinced that most tourists found 'their real enjoyment in the bazaars and along the crowded streets [of Cairo], and on the sheer banks of the Nile which stand out as an animated panorama for hundreds of miles'.[63] But this was more than a matter of monument fatigue. It also depended on the activation of the picturesque within a culture of travel now riven by the anxiety of 'belated Orientalism'; by the mounting fear that the tourist had arrived too late and that the 'authentic Orient' had

disappeared under the weight of European modernity. Indeed, Linda Nochlin argues that not only was the picturesque premised on impending destruction, but its sense of imminent loss was projected onto the construction of *cultures* as well as landscapes: 'Only on the brink of destruction, in the course of incipient modification and cultural dilution, are customs, costumes and religious rituals of the dominated finally *seen* as picturesque. Reinterpreted as the precious remnants of disappearing ways of life, they are finally transformed into subjects of delectation.'[64]

Commercial photographers cultivated this new taste for the picturesque as the exotic, and the production of prints and postcards of ethnographic 'types' proliferated.[65] Many of them were staged studio shots, but I think it misleading to suggest that these photographs 'came to provide a simulacrum of the experiences [tourists] avoided', and that images of this kind 'recapitulated street scenes which tourists were convinced were enacted daily in the narrow streets their guides hurried them past'.[66] There is no doubt that the circulation of such images reinforced Orientalist stereotypes – many of them were deliberate fabrications trading on what had become conventional Orientalist iconography, often mixing racism and sexism in a sort of porno-topography[67] – but one must not overlook the extent to which equivalent scenes ('curious', 'bizarre', 'exotic' and 'amusing') were *actively sought out and captured on film by amateur photographers*. In fact, one commentator has suggested that many amateurs 'produced images remarkably similar to those found in commercial photography' precisely because their sense of what constituted a 'good' photograph had been shaped by these widely circulated images.[68]

Secondly, therefore, overlapping with this new quasi-ethnographic sensibility, the photographic imaginary of Egypt was recomposed through the formation of a vernacular tradition of travel photography. This was inaugurated by the introduction of medium-priced, hand-held cameras. The trail was blazed by the Kodak No. 1, which was launched with great fanfare in the summer of 1888. This was a far cry from the elaborate and expensive photographic apparatus of the early decades: it was a small, leather-covered wooden box that weighed 22 oz and cost $25. The photographer simply pressed a button on the side which released the spring and allowed the shutter to drop; a pull of the string recocked the shutter, and another turn of the key advanced the film. When the film was finished, all the photographer had to do was send the camera back to Kodak for processing: 'For ten dollars the film was developed and printed, the camera reloaded with another one-hundred-exposure roll of film, and prints, film and camera were shipped back to the customer.' The promotional copy unwaveringly targeted the mass market: 'You press the button, we do the rest'; 'Photography reduced to three motions: pull the cord; turn the key; press the button'; 'Anybody can use it'. The system was an overnight success. Within a few months, 2,500 of the new cameras had been sold; less than a year after their introduction, sales had reached over 13,000, and the company was processing sixty and seventy rolls of film a day at its plant in Rochester, New York.[69] The verb 'to kodak' and the

noun 'kodaker' quickly passed into general circulation, and tourists soon appeared in
Egypt armed with the new cameras. As early as 1890, Jeremiah Lynch recorded that
when he and his companions had been hauled to the summit of the Great Pyramid
– a rite of passage for all tourists – they immediately 'took photographs by the
"Kodak"'.[70] And barely twenty-five years later, the worldly and weary Sidney Low,
resigned to the 'clients of Cook' thronging the hotels and streets of Cairo, reckoned
that, of their number, 'five out of six carry kodaks and photograph with indis-
criminating assiduity'.[71] Amateur photography had not only come to be identified
with tourism; it now shaped the expectations, practices and experiences of tourism
itself.

Susan Sontag has attributed this coincidence between amateur photography and
organized tourism to the way in which the camera enabled people to 'take possession
of a space in which they are insecure':

> A way of certifying experience, taking photographs is also a way of refusing it – by
> limiting experience to a search for the photogenic, by converting experience into an
> image, a souvenir. Travel becomes a strategy for accumulating photographs. The very
> activity of taking pictures is soothing, and assuages general feelings of disorientation
> that are likely to be exacerbated by travel. Most tourists feel compelled to put the
> camera between themselves and whatever is remarkable that they encounter. Unsure
> of other responses, they take a picture. This gives shape to experience: stop, take a
> photograph, move on.[72]

Seen thus, the camera is a machine for time–space compression; it at once establishes
a separation between photographer and subject and transcends the intervening dis-
tance. Walter Benjamin expressed what I have in mind when he described the urge
'to get hold of an object at very close range *by way of its likeness, its reproduction*'.[73] This
was a common response among tourists visiting Egypt, who went to extraordinary
lengths both to produce and to police boundaries between the observer and the
observed: to enforce the distance and detachment necessary to obtain 'perspective'.
Here, for example, is George Steevens writing about his luxurious voyage up the Nile
on one of Thomas Cook's steamers in 1898:

> A vision of half-barbarous life passes before you all day, and you survey it in the intervals
> of French cooking … Now the solitary palms thicken into groves with a clump or two
> of denser acacias: here is a village. Mud huts pierced by loop-hole windows, rush
> firewood stacked on the roofs, black veils carrying water, young boys, half blue shirt,
> half brown nakedness, paddling in the river. *Rural Egypt at Kodak range – and you sitting
> in a long chair to look at it.*[74]

That last sentence was typical of the late-nineteenth-century culture of Orientalist
travel, conjuring up the security of a modern viewing-platform and the exhibition of
Egypt as a succession of fleeting and exotic images to be captured on film. The

snapshot of 'rural Egypt at Kodak range' took its place in an imaginative geography that represented the Nile voyage as a dream or illusion, and local people as actors in a fantasia staged for an entranced audience of Americans and Europeans.[75] In the course of the nineteenth century it had become commonplace to describe the banks of the Nile as a moving 'panorama' or a 'diorama', but this appeal to a technology of visual illusion, to a fantasy made real or, what amounts to the same thing, to reality turned into a fantasy, had become hackneyed by the 1880s; *until it was invested with new meaning by the hand-held camera.* The audience before a panorama or diorama was physically passive; while the hand-held camera allowed views to be taken in at leisure, as Steevens's contemplation of 'rural Egypt at Kodak range' demonstrates, it also made possible a much more active and even opportunistic participation in the production of the picturesque.

Perspective, predation and the picturesque The search for the picturesque was a *leitmotif* of Oriental tourism long before Kodakers started to track their exotic prey. The commercial photography of Francis Frith, who first travelled to Egypt in 1856, was remarkable for a poetics of place in which the picturesque was of central importance. Not only was he attracted to sites that the ascetic Teynard had deplored precisely because they were picturesque, but Frith's anxiety at their decay also conformed to the dual politics of the picturesque which is predicated on both a fear and a memorialization of the soon-to-be-lost.[76] The picturesque also continued to be a powerful presence in other modes of representation right through the period. Writing in 1877 Amelia Edwards, like many other travellers before her, thought nothing of representing Egypt as a succession of pictures. In Cairo, she declared:

> Every shopfront, every street corner, every turbaned group is a ready-made picture. The old Turk who sets up his cake-stall in the recess of a sculptured doorway; the donkey-boy with his gaily caparisoned ass, waiting for customers; the beggar asleep on the steps of the mosque; the veiled woman filling her water jar at the public fountain – they all look as if they had been put there expressly to be painted.[77]

Similarly, on the Nile, she and her companions became 'spectators of a moving panorama', watching 'the sunny river-side pictures that glide by', as 'the banks unfold an endless succession of charming little subjects, every one of which looks as if it asked to be sketched as it passes'.[78] These seem prosaic enough observations, but they are implicated in a powerful process of enframing. This was captured with precision by Edwards herself at Edfu where, like Du Camp before her, she gazed down from the top of the terrace over the central doorway:

> One looks down into the heart of the town. Hundreds of mud-huts thatched with palm-leaves, hundreds of little courtyards, lie mapped out beneath one's feet; and as the Fellah lives in his yard by day, using his hut merely as a sleeping place at night, one

looks down, like the Diable Boîteau, upon the domestic doings of a roofless world. We see people moving to and fro, unconscious of strange eyes watching them from above – men lounging, smoking, sleeping in shady corners – children playing – infants crawling on all fours – women cooking at clay ovens in the open air – cows and sheep feeding – poultry scratching and pecking – dogs basking in the sun. The huts look more like the lairs of prairie-dogs than the dwellings of human beings. The little mosque with its one dome and stunted minaret, so small, so far below, looks like a clay toy.[79]

It is that sense of a privileged perspective, of seeing without being seen, of achieving a distance which is immediately transcended by the power of the gaze, that is focal to what Timothy Mitchell calls 'the world-as-exhibition'. As it happens, Edwards took no photographs – she confined herself to sketches and watercolours – but the point of view she repeatedly assumed replicates what Mitchell describes as the 'ideal point of view' for the colonizing gaze:

> a position from where, like the authorities in Bentham's Panopticon, one could see and yet not be seen. The photographer, invisible beneath his black cloak as he eyed the world through his camera's gaze, in this respect typified the kind of presence desired by the European in the Middle East, whether as tourist, writer, or indeed colonial power.[80]

If the photographer disappeared under his black cloak, however, his camera had always been prominently visible, and this gave many outdoor compositions an artifice that was as contrived and staged as any studio shot. Indeed, many early photographers had made a great performance out of it all, turning the event of photography into a spectacle in itself. Thus, Flaubert recounted, with evident delight, how he and Du Camp had been supplied with soldiers 'to hold back the crowd when we want to photograph'.[81] The arrival of the hand-held camera radically transformed this state of affairs. For it was now the *camera* and not the photographer that could be made to disappear; if the photographer's garments were capacious enough, a small camera could be concealed about the person.[82] Not for nothing were the new cameras sometimes described as 'detective cameras', and their small size combined with their simplicity and speed of operation to allow amateur photographers to take delight in stealing upon their subjects unawares.

Sontag suggests that this metaphor of predation is written into photographic practice in general: '[T]here is something predatory in the act of taking a picture. To photograph people is to violate them, by seeing them as they never see themselves, by having knowledge of them they can never have; it turns people into objects that can be symbolically possessed.'[83] She continues by suggesting that photography is 'an act of sublimated murder', a claim which may seem unduly fanciful, shockingly excessive; but the metaphor of 'shooting' informed photographic practices in ways that were as powerful as they were profound. Here, for example, is Du Camp explaining how he

induced Hadji-Ishmael to stand still sufficiently long for him to make an exposure: 'I told him that the brass tube of the lens jutting from the camera was a cannon, that would vomit a hail of shot if he had the misfortune to move – a story that immobilized him completely.'[84] Du Camp's figure of speech – which was always much more than a figure of speech – emerged out of an analogical formation that pre-dated the photographic gaze by almost fifty years. It had its origins in William Gilpin's celebration of the cultivated pursuit of the picturesque. 'The pleasures of the chase are universal,' he wrote, 'and shall we suppose it a greater pleasure to the sportsman to pursue a trivial animal than it is to the man of taste to pursue the beauties of nature? to follow her through all her recesses?'[85] The analogy was readily transposed to the new medium. In 1856, George Curtis announced that he had seen 'a man with a callotype [sic], investing Karnak – Nimrod has mounted – tally-ho!'[86] Nimrod was the great hunter in Genesis, and Curtis used it, significantly, as a synonym for the tourist. The imagery was reinforced when, in 1860, 'snapshot' was borrowed from the vocabulary of fox-hunting to describe 'the possibility of securing a picture in a tenth of a second'.[87] And the same imagery was easily returned to traditional media. In 1876, T. G. Appleton described the attempts made by his party to capture the scenery of the Nile from the deck of their *dahabeah*: 'At least one side was always near enough for a landscape effect, and out came our sketch-books, and we shot manfully away, too often, alas! in a Parthian fashion, at the picturesqueness which fled from us.'[88] As Appleton's remark clearly shows, the metaphor was freighted with assumptions about the gendering of the gaze. This was more than an appeal to the 'manliness' of hunting and shooting – a popular sport among male tourists on the Nile for most of the nineteenth century, where many of them brought down whole flocks of birds and lived in the hope of bagging a crocodile – because the classical conception of the picturesque imagined a 'male art of seeing that could complete and correct what a feminized landscape held forth'.[89] This is evident in Gilpin's unconcealed sexualization of 'nature' and the penetration of her 'recesses', but this masculinist presumption was given still freer rein by Orientalist discourses that figured the Orient as feminine.

In an illuminating general discussion of these matters, James Ryan has analysed the photographic capture of a feminized 'nature' with great sensitivity. When he turns to 'culture', however, he confines his remarks to the studio portrayal of ethnographic 'types'.[90] The production of such types is of considerable importance, not least because it continues the systematizing typology of the ethnographic illustrations in the volumes of the *Description* devoted to *l'état moderne* and yet departs from its scientificity by a predilection for staging and even counterfeiting the images. But here I am more interested in the practice of 'view-hunting' in the field, turning the colonizing gaze upon landscapes with figures and, eventually, treating those figures *as* 'the view'.

This assumed a particular significance in Egypt (and elsewhere) where there were strong cultural prescriptions on what could and could not be seen and, above all, on the production and display of visual images of living subjects. Artists and amateur

sketchers had long been aware of this. When Edward Lane visited Cairo in 1827–28, he described the lengths he went to in order to make a sketch in the Kha'n Khalee'leh in Cairo:

> This sketch I made, as it were, by stealth, part one day and part another, from a shop; making use of a very small scrap of paper each time, and holding it in the palm of my hand, so that persons passing by might suppose (if they noticed me) that I was writing; for I wished to avoid being seen in the public places engaged in so *heathenish* an act as *drawing* … I sometimes placed the paper on my knee, and concealed it from all but myself, under my cloak.[91]

In his published *Account of the Manners and Customs of the Modern Egyptians*, Lane was quite explicit: 'The making of images or pictures of anything that has life' was prohibited by the Qur'an and condemned by the Prophet. The visual codes of Islam in relation to figurative art are, in fact, more complex than this allows, but Lane's book remained a *vade mecum* for travellers and tourists throughout the nineteenth and into the twentieth centuries, and many of its injunctions were repeated by subsequent writers and guidebooks.[92] It therefore seems likely that most visitors were well aware of the sensibilities attached to visual representations. M. L. M. Carey's experience was probably typical. Although she and her companions succeeded in persuading the crew of their *dahabeah* to sit for their sketchpads, they found that other likely subjects were much more cautious. Carey recorded meeting a group of Nubian women sitting against a rock, spinning cotton and plaiting date-leaves into large flat baskets: 'The women were much troubled at my appearance, and one of them began to cry when I sat down to sketch the group.'[93] It seems equally likely that most visitors paid little heed to these protocols; on occasion they delighted in turning them to their own account. Less than ten years later, Amelia Edwards turned her sketchpad into a weapon: 'The moment anyone appears on deck, [the *fellahin*] burst into a chorus of "*Backshish!*" There is but one way to get rid of them, and that is to sketch them. The effect is instantaneous. With a good sized block and a pencil, a whole village may be put to flight at a moment's notice.'[94]

These reactions were exacerbated by the presence of the camera. Even in Europe and North America, the hand-held camera enjoyed a tense and, at times, confrontational relationship with the general public:

> While the manufacturers were delighted that 'surreptitious negatives' could now be made 'without attracting the attention of the curious', others wondered whether these 'obnoxious' photographers who were 'annoying' the public were not 'abusing a new found privilege.' In 1902 the *New York Times* complained of the enormous invasion of privacy caused by 'Kodakers lying in wait' to photograph the unsuspecting public.[95]

The same concerns were rarely extended to the inhabitants of Egypt, though, where travellers and tourists had long assumed that every event was a show staged for their

consumption and that, with very few exceptions, they had a natural right to gaze. Funerals, weddings, prayers: all were assumed to be open to the fascinated eyes of European and American spectators. But this was a one-way street. Most tourists would have had little difficulty in identifying with Harriet Martineau earlier in the century, when she had the canvas awning on the side of her *dahabeah* lowered in the morning 'so that the people on shore could not pry', and yet cheerfully confessed how pleasant it was 'to play the spy on them'.[96] Neither would they have found any contradiction in what was, to them, a perfectly natural state of affairs. Photography made a powerful contribution to endorsing such a view. As early as 1892, Hardwicke Rawnsley was recommending 'the little "Kodak" camera' as being 'very useful for instantaneous photographs of figures'.[97] In doing so, he was reproducing a discursive regime wherein the camera was to be held by Europeans and Americans who were to direct its lens at Egyptians. Tourists did, of course, photograph one another, sometimes as individuals and sometimes as groups, usually posed in front of a 'sight'. But such photographs were not of 'figures' in the sense that Rawnsley used the term, and it is to the elaboration of that regime that I now turn.

By 1910, one popular guidebook, published in French, English and German, included a series of 'Hints on photography' for 'persons who, whilst travelling in Egypt with a "Kodak" or similar camera, wish to secure views of the sights visited, the buildings seen, or to take snap-shots of the types of natives they come across, and scenes of life they may witness'.[98] There were few problems in photographing general views or buildings, and the guidebook provided an elaborate script which instructed tourists exactly when and where they should stand in order to obtain the best results. These were called 'special photographs' and corresponded to the stock list of 'sights'. In Cairo, for example, 'the most suitable moment to photograph barges is between two and three o'clock in the afternoon', when the Kasr-el-Nil bridge was opened, and the camera 'operator' was told to stand 'at the northern point of Roda Island'. Similarly, for the Tombs of the Khalifs, photographers were advised that 'negatives taken in the afternoon give greater contrasts and detail', and a 'position should be taken on the alignment between the Kait Bey Mosque and the Sultan Barkouk Mosque'.[99]

But it was accepted that taking 'snap-shots of natives' would be problematic. On the one side, amateurs were warned 'that the natives as a rule, especially the women, have a great dislike of being photographed; this is the case more particularly in Nubia, where, owing to a superstition spread amongst them ever since tourists have been in that country, as soon as they see a photographic apparatus they shriek and run away'. On the other side, however, 'there are no more graceful pictures than the women, young girls and little children of the Nile Valley, carrying on their heads a jar of archaic shape'. Yet, whenever tourists tried to take their photographs, 'their graceful bearings change to a most ordinary attitude, and they veil their faces' and 'the picture, which when first seen was full of and true to life, has at once been changed to one

of the veriest banality'. One possible solution was to offer payment: 'It is true that at times a little *bakshish* will do away with the scruples of these walking models, especially when it is offered by a woman's hand', and the guidebook noted that some children had been 'trained to sit for the traveller, and for whom the business has become very remunerative'. But the guidebook's preferred solution was quite different:

> One must consequently resort to a certain amount of strategy and take them unawares, which is not very difficult … The amateur photographer is advised to find out before-hand the propitious spots on the bank of the Nile where women come daily to fetch their supply of water. Particular note should be made of the position of the sun according to the time of day, and on returning equipped with a camera operate quickly and by surprise. This advice should always be followed.[100]

The recommended strategy was thus one of stealth and surprise: of stalking the prescriptively masculine photographer's desired female quarries as though they were timorous animals at a water-hole. This was fully conformable with an Orientalist imaginary in which the racialization of 'Oriental' subjects was aggravated by their animalization. Less than ten years after the British occupied Egypt, William Fullerton had this to say:

> Cairo begins to impress itself upon you as an English town in which any quantity of novel Oriental sights are kept for the aesthetic satisfaction of the inhabitants, much as the proprietor of a country place keeps a game preserve or deer park for his own amusement and that of those who are so fortunate as to share his hospitality.[101]

This is 'view-hunting' with a vengeance, and its ideology of the bestiary was plainly furthered by the practices of some amateur photographers. It is, I think, telling that, even when local people overcame their reluctance and were willing to pose as subjects for tourists, the vocabulary of the bestiary should have been retained. 'Yet, the Koran notwithstanding,' wrote one visitor of his attempts to photograph Cairene servant girls, 'they are more than willing to be photographed, making absurd *one's preliminary stalking.*'[102]

Let me now develop these remarks by considering the practices of two amateur photographers in more detail. They are both British: the first is Anthony Wilkin, who travelled up the Nile in 1895–96, and the second is Douglas Sladen, who made the first of several visits to Egypt in 1907.

Anthony Wilkin and Douglas Sladen Anthony Wilkin's *On the Nile with a Camera* was a record of his travels illustrated with his own photographs, rather than a hand-book for other amateurs, but it did provide advice and a series of cautionary tales for intending photographers. He used a 'well-worn little hand-camera, a No. 2 Frena', and he introduced his observations in the following way:

Though a large number of tourists pursue the black art [photography] in the Nile valley, comparatively few are lucky enough to preserve tolerable photographs of the places they have visited. The vicissitudes of climate are a sore trial even to the most perfectly constructed of cameras. Dark slides which were impervious to light at home, gape with chinks in Egypt. Glass plates suffer cruelly on sea and land from rough handling and careless packing. Lenses are covered with dust and scratched in the cleaning; spools of film are liable to be torn or fogged. Moreover, amateurs frequently devote their efforts to figure studies, contenting themselves with the purchase of photographs of temples and tombs.[103]

Wilkin thought there were sound reasons for such a preference. He warned that it was (still) extremely difficult to take photographs inside the tombs and temples: 'Photography in these tombs by magnesium light was not satisfactory; in fact with an unsupported hand camera the results are almost certain to be nil.' But he assured his readers that they would be able to purchase perfectly satisfactory prints at Cairo and Luxor. At some sites, however, he complained that the proliferation of commercial photography had placed serious obstacles in the way of the amateur. At Der el-Bahri, for example:

For some reason or other photography was not allowed here; those of us, therefore, who were armed for the fray, were at considerable pains to procure snap-shots. If we thereby did anybody any harm, or anticipated anybody's researches, it was certainly not from the success of the views or from any sinister intention on our part. When apparently puerile restrictions are placed on tourists, it is no wonder if they behave in a manner to justify far more stringent precautions than have yet been taken. If the restrictions are not puerile when they forbid photography what are they, and why do they exist? The reader will remember possibly something of the kind in England – sometimes when nothing but ivy-covered walls are threatened by the camera. Is the real reason to be found in two words – professional monopoly?[104]

Wilkin's indignation is also a claim of injured innocence: what harm could an amateur photographer possibly do that would justify such 'puerile restrictions'?

Equally innocent, so Wilkin implied, was his real passion which was for 'figure studies'. These published snapshots rarely included European tourists. Only four out of 111 photographs in the book showed tourists at all: in two of them they were included as part of a general view of a group of temples; a third showed tourists disembarking for a donkey-ride at Sakkara, while the fourth showed them, waiting at the landing stage at Luxor.[105] Where tourists photographed themselves, it was usually with other tourists and only rarely with local inhabitants, unless they had some nominal proprietary claim over them: 'our' dragoman or 'my' donkey-boy. Wilkin's focus of attention, like most other amateur photographers', was in capturing images of local inhabitants seen as existing in a space apart from, no matter how close to, the

vantage-point occupied by the photographer. Wilkin had been prepared for difficulties in achieving his objective, and reminded his readers:

> There still exists among the majority of the modern Egyptian *fellahin* a very real and deep-seated awe of the 'Evil Eye'. One should avoid any show of interest in, or even kindly feeling towards, young children, as the superstition of their family is liable to be quickly aroused. Much of the surliness complained of by tourists in Egypt is owing to fears for their children's welfare entertained by the parents of these innocent objects of our curiosity.[106]

Wilkin artfully yoked the innocence of the children to what he constructed as the innocence of his pursuit of them, and reinforced this affinity by drawing them into his photographic adventures. At Karnak, for instance, one small boy:

> was so anxious to be of service that I allowed him, not without misgivings, to carry my camera. This he insisted, much against my will, on retaining all day, and was hardly persuaded to allow it out of his hands when it was required for photographic purposes. He waited outside the various tombs while we explored them, surrounded by a crowd of young friends devoured by curiosity not unmingled with fear of the evil eye; and not one of these did he suffer to approach within ten feet on pain of instant chastisement, and at the end of the day he nearly went wild with joy at being allowed a look through the view-finders [sic].[107]

'Looking through the view-finders' was a privileged position; the boy had to wait until the very end of the day before he was allowed, momentarily, to take Wilkin's place behind the lens. Then 'he nearly went wild with joy', which is construed as a natural response to both the magic of the camera and to Wilkin's own harmless indulgence. The reader is invited to assume that, so self-evidently innocent was his quest, Wilkin experienced little or no difficulty in finding willing subjects. At the mosque of Sultan Hassan in Cairo, for example:

> An old but degenerate Mohammedan was delighted to have his photograph taken, but the difficult nature of the illumination has rendered the figure indistinct, and doubtless averted disaster for the law-breaker in a future state of existence. The condemnation by the Prophet of all representations of animate beings is so severe and so far-reaching that I was considerably surprised to find it frequently evaded or ignored … [M]ost of the Arabs I met in Egypt were prepared (always for a consideration) to be photographed at all times and seasons.[108]

It did not seem to matter very much that the photograph at the mosque was far from being a success. Wilkin's anecdote turns on photography as event – rather than on the photograph as record – and is used to say something (rather than show something in any literal sense) about local culture.

Many of the same assumptions reappear with a vengeance in Douglas Sladen's

books on Egypt. He bought his first camera, a Kodak No. 1, while he was in Montreal in 1890: 'a novelty in those days'. On his first trip to Egypt in 1907, he made copious notes, took 'eight hundred photographs, and certainly bought as many more, and as complete a collection of postcards as I could form'.[109] These formed the basis for his first book on *Egypt and the English* (although it included none of his own photographs), but more importantly they also framed the way in which he saw the place and its people on his subsequent visits. To Sladen, Cairo was a 'kodaker's paradise', and in *Oriental Cairo: The City of the Arabian Nights*, he took it upon himself to 'conduct the reader around the sights of the native city'. His tone was relentlessly (hideously, offensively) jocular, and he delighted in portraying what he called 'the humours' of native life. He produced Cairo as a sort of macabre magician's table, in which he cast himself as the magus conjuring up performances of his unwitting subjects as bizarre, fantastic, incredible. Although he evidently prided himself on his literary talents, his camera was an important means of securing the desired theatrical effect. Unlike Sladen's previous books, *Oriental Cairo* was illustrated by sixty-three of his own photographs, taken with a No. 1A folding Kodak camera; no more than six or seven of them took architecture as their subjects, and all the rest focused on the inhabitants of the city.[110] The inclusion of these snapshots enabled Sladen to stage his shows 'before the very eyes' of his audience, to make the incredible materialize in front of them. More, it also enabled Sladen to make his audience complicit in his productions, as he undertook to show the amateur photographer how he, too (Sladen's companion is always presumptively masculine), could realize 'the endless opportunity of securing humorous subjects'.[111]

What Sladen found so comically amusing was the everyday life of ordinary people; but ordinary people performing on a particular stage.[112] His principal subjects were seen as inhabiting another time and space, and like many other tourists and travel writers, Sladen transformed the 'old city' into, at once, 'the medieval city' and 'the city of the Arabian Nights', a conjunction that effectively established the reality, the 'historical truth', of a fantasy world:

> It was as a city which still maintains the atmosphere of the Arabian Nights that Cairo appealed most to me; and while I was there I converted here a gay officer, there a society butterfly into an ardent mosque-hunter or an enthusiastic observer of the medieval life in the Arab city.
>
> The kodak certainly played no small part in the conversion of most of them, for there are few well-off people who go to Egypt without a camera, and they were fascinated with the photographs I took for the production of the illustrations of this book. When my converts were once bitten with the mania for photographing in the Arab city, they generally went there every day, regardless of the bargaining in the bazaars and the fleas of the Market of the Afternoon.[113]

Sladen set out to show 'explicitly where each kind of unspoiled native life is to be

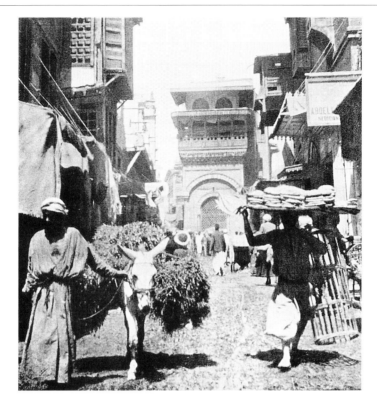

FIGURE 8.2 Egypt exoticized: Donald Sladen, 'The Sûk-en-
Nahassin, the most beautiful, romantic and medieval street in Cairo',
from *Oriental Cairo: the City of the Arabian Nights* (London: Hurst and
Blackett, 1911), p. 4.

found'. 'Unspoiled' meant untouched by modernity, which required him to screen off
modern Cairo and what he called 'the unmedieval and unlovely native life': a couplet
typical for its arrogance and condescension. In places like Ataba-el-Khadra, Sladen
complained, 'instead of spending their lives in doing next to nothing for next to nothing
in a dignified way, everyone is hurrying or touting'. So he hurried the reader – and
the would-be photographer – to the landing stages at Bulak, where he would find 'all
sorts of odd native craft, laden with poor Egyptians with the most kodakable attitudes
and occupations'; to the Sharia Serugiya, 'an unspoiled native street', where, even
though the shops were 'quite uninteresting, they cater for humble native wants', there
was 'plenty for him to photograph among the shoppers'; and to Old Cairo where –
aware of the technical limitations of a hand-held camera – the main street 'is low and
therefore suitable for photography' and, still better, 'it is broken by an occasional
minaret; its shops are thoroughly native and in a state of tumble-down picturesqueness;
and its half-rural, half-river population is engaged in many occupations which are
unfamiliar to the European eye, and prizes to the beholder' (Figure 8.2).[114]

In fact, Sladen often referred to his photographs as 'prizes':

> Cairo is full of prizes for the photographer … I hardly ever went out in the streets without my kodak, and if I was in a hotel when I heard those weird sounds [of a procession] I always flew for my kodak and flew out into the street. And it was seldom that there was not something worth photographing even when one had scores of photographs of palanquins and camel bands.[115]

Here travel has indeed become 'a strategy for accumulating photographs', just as Sontag suggested, but the process of visual accumulation is valorized by its close association with two particular practices of colonial modernity.

On the one side, Sladen's 'prizes' are also surely 'trophies', the spoils of his 'view-hunting'. Here he describes his habitual way of conducting what he called his 'street-to-street visitations of the Arab city':

> I used to stalk down the middle of the street, note-book in hand, with my camera slung round my waist. Ali [Sladen's *dragoman* or interpreter-guide] carried my stick … I went into every mosque that was open, and wherever I saw a house that looked old I sent Ali into its court to see if it had any old architecture, and if there was anything to prevent me going in. I was seldom refused: the permission was generally given cordially.[116]

Sladen's imperial posture – stalking down the middle of the street, a servant carrying his stick, demanding entry to mosques and private houses – was consistent with his treatment of these photographic expeditions as safaris. 'I was never tired of watching the really poor,' he boasted, 'whether I was rambling in the Arab city or in the villages of Upper Egypt. In Asia and in Africa the poor are as natural as animals.' In much the same way, and for much the same reason, he explained that it was better to take one's subjects unawares. At the El-Mas mosque in Cairo, for example, Sladen described how he was able to 'watch the worshippers easily without disturbing them, and they were so pious and wrapt that it was not difficult to photograph them unobserved'.[117] It was even easier to snatch 'snapshots' from the tourist steamer, which had the distinct advantage of the photographer being able to hunt in a pack:

> There is one sight which you see all day and every day on the Nile, and it furnishes the kodaker with some of his best subjects – that is, the drawing of water from it for irrigation by *sakiyas* and *shadûfs* … There was a rush of kodakers for every five-decker *shadûf*. Nile villages and towns were also grateful subjects. They looked like artist's creations for the embellishment of landscapes.[118]

On the other side, Sladen recognized that his 'prizes' had a commercial value: that 'a negative of a pretty savage is worth a small piastre to the artist'.[119] Many of them were thus won in a local economy, where the act of photography had itself become a commodity and where, Sladen seemed to suggest, this modern value-form had proved sufficiently powerful to overcome traditional resistance. 'It is a great advantage

that the poor Egyptian should not mind being kodaked,' Sladen observed, 'though he likes to make money out of it when he can.' He advised his readers that the country-women 'sometimes draw their head-veil closer if you want to photograph them, till they understand that they will get a penny for being immortalised by the camera'.[120] When he left Cairo and travelled up the Nile it was exactly the same. He discovered 'an old woman who lived in a tomb [who] was more like a witch than anything I ever saw ... I thought perhaps that she was waiting for the end of the world, but she was only waiting to make pennies out of being photographed. She had discovered that her hellish appearance had a market value.'[121]

Similarly, the inhabitants of Thebes, 'though they do a little picturesque agriculture, which is also susceptible of being photographed, at a small piastre for each exposure, regard tourists as their real harvest'. And if 'you venture near the Nile you are pestered not only by boatmen but by water-carriers, whose proper function is to fill a water-skin for half a piastre, but who prefer to strike attitudes in the water to earn large piastres from American camera-carriers'.[122]

The new openness of people to the photographic gaze, if this is what it was, had another price, however. 'The *plage* of Luxor,' Sladen complained, 'where the principal shops are situated, is the Egyptian Margate. There is hardly a shop but has its tout entreating you to have kodaks developed or buy films and postcards.' At Aswan, 'if you walked down the front you would think that nearly every shop belonged to the Eastman Company; you get so tired of the word'.[123] And again, at Luxor:

> At the side of every door is a black heart-shaped piece of metal bearing the inscription in letters of gold, '*Kodaks developed*', often adding something about delivering the prints within twenty-four hours ... Every shopman you pass calls out to you to know if you want to buy kodak-films and have any films that need developing; every shopman invites you to inspect his stock of postcards – picture postcards of the scenery and the antiquities of Upper Egypt.[124]

By the opening decades of the twentieth century, Egypt was seen by Sladen and countless others as the site of a fast-disappearing Orient that was being dissolved in the acid-bath of modernity. Its disappearance was heralded by the profusion of Kodak signs that Sladen despaired of bracketing from his own photographs. 'From the windows of the Karnak Hotel', he wrote, 'you get glorious views of the Nile – the undiluted Nile, out of sight of the steamboat wharf and the Kodak signs, with nothing to interfere with your contemplation of the glorious skies of Egypt.'[125] This is – almost – an epiphany, as the amateur photographer comes to bemoan the very signs of colonial modernity that enabled him to produce and possess his own signs of the Orient.

Photography, Travel and the Scopic Regimes of Orientalism

Martin Jay once described vision as 'the master sense of the modern era', but he confined his discussion to European modernity and said nothing of its projections beyond Europe and its aggressive 'mastering' of other cultures and other spaces.[126] The concept of a scopic regime, which Jay borrowed and reworked from Christian Metz, is, nonetheless, capable of clarifying the imbrications of colonialism and modernity. A scopic regime imposes a systematicity on the visual field; a structuring effect on who sees, through the constitution of the viewing subject, and on what is seen, through the production of a space of constructed visibility that allows particular objects to be seen in determinate ways. Such a regime is unlikely to be homogeneous, and the visual practices that it shapes and sanctions are further inflected by different media. In general, scopic regimes are constituted through grids of power, desire and knowledge, and their visual structures and practices enter intimately into the production of imaginative geographies.

In this essay, I have tried to show that the production and circulation of photographs shaped the imaginative geographies of Orientalism and entered into the formation of a colonial imaginary through the production of different kinds of abstract space. The monumental tradition rendered the landscapes of 'ancient' Egypt as a series of planes, severe, geometric, empty of human occupation; a vacant space abstracted from the modern world and awaiting its (re)possession by the forces of European history. The ethnographic tradition was, by definition, disposed towards Egypt as an inhabited space, but it was produced as a space teeming with strange and exotic creatures. In turning their gaze upon human figures constructed as 'types', photographers abstracted these subjects from their own continuing histories and transposed them into a taxonomy where they were exhibited as exemplars of a timeless 'Orient'. This was a colonizing gesture in the most forcible of senses too, because the production of such a 'living tableau of queerness', as Said called it, seemed to require not only preservation and recording – the familiar, anxious response of belated Orientalism – but also the policing and regulation that was made possible by a colonial order.[127]

More than this, photographic representations worked to naturalize the colonizing propensities of Orientalism through archaeologies of truth that rendered Egypt as a series of transparent spaces open to the Occidental gaze. Early daguerreotypes and calotypes were read not so much as traces or copies of the monuments but as virtually direct documents of an ancient past; the passage from the object in front of the lens to the image preserved in the photographic medium was seen as intrinsically 'objective'. The ruins, otherwise incomprehensible and bewildering to ordinary travellers, were stripped of the clutter of villages, *fellahin* and animals that clustered within them, and ordered as geometries, systematic arrangements of planes and surfaces that exposed the enduring structures of an ancient civilization. The ethnographic tradition

derived much of its power from a sort of 'epistemology of the veil' that operated in much the same way: the 'figure studies' composed by commercial and amateur photographers alike were part of a larger Occidental project of 'unveiling' the Orient, in which the capture and fixing of these supposedly representative 'types' would reveal the hidden essence of an otherwise mysterious culture.

These were not only colonizing gestures; they were also profoundly masculinist in their assumptions and their practices, and they entered into the constitution of the tourist as spectator-voyeur, as consumer-collector and, above all, as sovereign-subject. The circumstances under which the early photographers worked shaped their own experiences of travel – their productions were always performances – and, in the course of the nineteenth century, photography entered ever more directly into the performances of tourists. By the turn of the century, photographs helped not only to shape their preconceptions – to condition what they expected to see – but also to script the practice of sightseeing: tourists sought out culturally prescribed 'viewpoints', they participated in a plenary hunt for their own 'snapshots' and they punctuated their travels through Cairo and the Nile valley with an accumulation of photographs to mark their progressive triangulation of the cultural landscape. 'Landscape' is itself 'a way of seeing', however, and, by the early decades of the twentieth century, the landscape of Egypt was shot through with the signs of its seeing – Kodak advertisements, photographic studios, commercial photographers and tourists themselves – that marked its colonization and appropriation by the tourist gaze and its exhibition as a space of constructed visibility.

NINE

Mapping a Sacred Geography: Photographic Surveys by the Royal Engineers in the Holy Land, 1864–68

Kathleen Stewart Howe

> This country of Palestine belongs to you and me, it is essentially ours … It is
> the land towards which we turn as the foundation of our hopes; it is the land
> to which we may look with as true a patriotism as we do this dear old England
> which we love so much.[1]

§ ARCHBISHOP of York William Thomson claimed the Holy Land as a uniquely
British possession at the organizational meeting of the Palestine Exploration Fund on
22 June 1865. Three years later, members of the team surveying the Sinai Peninsula,
an expedition conceived in the spirit of British physical and intellectual possession of
the Holy Land, posed for survey photographer Sergeant James McDonald (Figure
9.1). The group portrait registers the complex associations embodied in the project.
Officers of the Royal Engineers and scholars drawn from Cambridge and Oxford
range themselves on an oriental carpet before a canvas campaign tent. The carpet,
the symbolic field of Orientalism, contains the enterprise. Two camp servants crouch
behind and to the side of the officers and scholars, well off the carpet. Orientalism
is not, after all, a field of endeavour open to natives of the East.[2] Surveying the
East, in this case the birthplace of Western Christianity, united military surveyors,
philologists and biblical scholars in a quasi-military campaign articulated in terms of
the great intellectual project to know the Orient.[3] The taking, organizing, collecting
and viewing of photographs was an integral part of that project.

This essay examines the use of photography in the course of surveys of Jerusalem
and the Sinai Peninsula undertaken by the Royal Engineers in 1864 and 1868 respec-
tively. It explores the intersection of these ordnance surveys and the photographic
record in a particular place in which multiple types of evidence were required. The

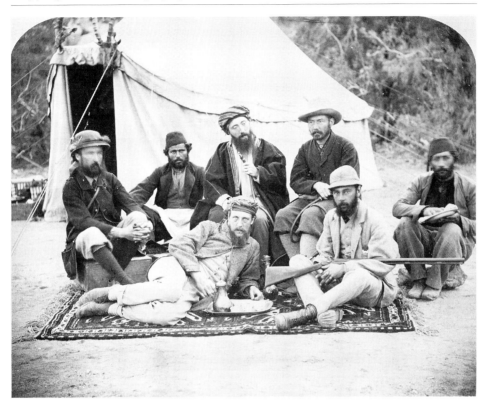

FIGURE 9.1 James McDonald, 'Members of the Sinai Survey', 1868, from
Ordnance Survey of the Peninsula of Sinai. Albumen print, 168 × 215 mm. Collection
of Michael G. Wilson. Courtesy: Santa Barbara Museum of Art.

photograph had essential, if variable, roles in areas of belief, intellectual inquiry and
imperial claim. The production and dissemination of the photographs made during
the course of these surveys reflect these disparate functions.

A Sacred Geography

The region, the Holy Land or Palestine, has long been difficult to define geographic-
ally. For over six centuries, Palestine was simply the western portion of the vast
Ottoman province of Syria. Well after the turn of the century, the 1910 *Encyclopaedia
Britannica* defined it as a nebulous geographical concept based on the name of the
southern coastal strip inhabited by the Philistines in ancient times, the southernmost
part of Syria in which the biblical Hebrews were believed to have lived before the
Exile.[4] Its borders were variously drawn by religious tradition, scholarly research and
competing historical claim. Yet this 'nebulous geographical concept' was the site of
fervent religious certainty, a landscape of belief for Jews, Muslims and Christians.

Determination of the topography of the region, of the name and position of settlements and of their relationship to natural features in the landscape were seen as essential to the interpretation and confirmation of the biblical record. In the nineteenth century, this space, ill-defined yet specific, became an intensely surveyed and mapped geography of religious possession and imperial strategy.[5]

From the end of the eighteenth century and throughout the nineteenth century, Palestine, frequently identified simply as the Holy Land, was the site first of informal, and then of increasingly regularized, geographical exploration and description. The effort to characterize the land, to name and place settlements accurately, to describe natural formations and to associate them with ancient landmarks was usually couched in terms of the search for the 'geography behind history'.[6] The history most writers had in mind was that recorded in the Bible. The author of one of the more popular *travelogues-cum-geographies* of the region, Arthur Penrhyn Stanley, Dean of Westminster and Regius Professor of Ecclesiastical History, Oxford, described the focus of such geographical interest:

> The historical interest of Sacred Geography, though belonging in various degrees to Mesopotamia, Egypt, Asia Minor, Greece and Italy, is, like the Sacred History itself, concentrated on the Peninsula of Sinai and on Palestine. Even in its natural aspect the topography of these two countries has features which would of themselves rivet our attention … But to this singular confirmation we have to add the fact that it has been the scene of the most important events in the history of mankind; and not only so, but that the very fact of this local connection has occasioned a reflux of interest, another stage of history, which intermingles itself with the scenes of the older events, thus producing a tissue of local associations unrivalled in its length and complexity.[7]

Stanley himself added more layers to the 'tissue of local associations'; after this first visit, he escorted the Prince of Wales to the region in 1862,[8] and, in 1865, he became a founding member of the Palestine Exploration Fund, an organization which would come to exert enormous influence on the documentation and examination of the region by the West. As he and others crafted historical (or biblical) geographies of the Holy Land, they inscribed their own history on the area – a history of British scientific and religious imperialism.[9]

The avid interest in biblical sites, which was a hallmark of the nineteenth-century engagement with the region, ordained that the Holy Land would become an essential subject for the newly developed technology for recording images, photography. Indeed, almost immediately after the announcement and description of photographic processes in 1839, photographers were at work in the Holy Land.[10] Daguerre's process was described to the public in August 1839 and, by late November of the same year, Frédéric Goupil-Fesquet was making daguerreotypes in Jerusalem.[11] Even before any official announcements or descriptions of a photographic process, and six months before Goupil-Fesquet made the first successful photographic images in the Holy

Land, the Reverend Alexander Keith attempted to use Englishman William Henry Fox Talbot's paper process in Jerusalem.[12] Keith's unsuccessful attempt in April 1839 must stand as the earliest photographic project in the region.

On a return visit five years later, Keith travelled with his son, George, who daguerreotyped biblical sites. Engravings from the photographs appeared in the 1847 edition of his *Evidence of the Truth of the Christian Religion Derived from the Literal Fulfilment of Prophecy, Particularly as Illustrated by the History of the Jews, and the Discoveries of Modern Travellers*. For Keith, the photograph authenticated both his text and Holy Scripture. The editor's introduction to the 1847 edition cites the earlier attempt and emphasizes that, as the photograph is the incontrovertible evidence of present reality, it also records the trace of ancient events from the biblical past:

> As soon as photography began to take its place among the wonderful arts or inventions of the present day, Keith anticipated a mode of demonstration that could neither be questioned or surpassed; as without the need of any testimony, or the aid of either pen or pencil, the rays of the sun would thus depict what the prophets saw. With this intent, on his first visit to the East [April 1839] he took with him some calotype paper, the mode of preparing which was then secret, but on reaching Syria it was wholly useless … A second visit to Syria [1844], accompanied by one of his sons, Dr. G. S. Keith, Edinburgh, by whom the daguerreotype views were taken, enables him now to adduce said proof; and has led besides to such an enlargement of the evidence from manifold additional facts, as he again hopes may impart that lesson to others with which his own mind has been impressed – a still deeper conviction of the defined precision of the *sure word*.[13]

The writers who minutely described the physical characteristics of the Holy Land in order to relate them to places and incidents in the Bible, and the photographers who recorded those same sites, were engaged in recovering a 'sacred' terrain. The physical reality of place 'confirmed' the events recorded in Scripture. Religious scholarship fused with geographical description to foster an intense, spiritual identification with place, a 'geopiety'.[14]

The link between place and event in the Holy Land imbued an ill-defined portion of Syria with a special resonance for the British. A. P. Stanley pointed out that:

> The passage of the Red Sea – the murmurings at the 'waters of strife' – 'the wilderness' of life – the 'rock of Ages' – Mount Sinai and its terrors – the view from Pisgah – the passage of the Jordan – the rock of Zion, the fountain of Siloa, the shades of Gehenna – the lake of Gennesareth – are well-known instances in which the local features of the Holy Land have naturally become the household imagery of Christendom.[15]

It was considered a matter of course, in mid-nineteenth-century Britain, that a special relationship bound the people of the British Isles to the ancient people and lands of the Bible. From the sixteenth-century division of the English Church from

Rome, through the sway of Cromwell's Reformers, to the evangelical devotions of middle-class Victorian England, the Bible, and especially the Old Testament, served as a template for describing and understanding national history. Noted nineteenth-century scientist and champion of Darwin's theories of evolution and natural selection, Thomas Henry Huxley, thought it a 'great historical fact that this book [the Bible] has been woven into the life of all that is best and noblest in English history, that it has become the national epic of Britain'. Similarly, Matthew Arnold linked 'the genius and history of us English to the genius and history of the Hebrew people'.[16] The surveys of Jerusalem and the Sinai Peninsula, undertaken in the 1860s by the Royal Engineers, mapped British presence on a land over which the British believed they had dominion by right of a spiritual connection intimately tied to their national identity.[17]

The Surveys

The network of military/philanthropic/evangelical/imperial connections which mark the Palestine surveys was present in the first of the surveys by the Royal Engineers, that of Jerusalem in 1864. The survey was the direct result of an article in the *Journal of Sacred Literature*, in which John Whittey called attention to the dreadful quality of Jerusalem's water and the catastrophic effect this had on the health of missionaries and the success of missionary efforts in the old city.[18] In response to the article, a Water Relief Committee was formed with A. P. Stanley as chairman. It was determined that remedial action could be undertaken only after a thorough survey identified the nature of the problem, and a private subscription was launched to raise funds for the survey. The philanthropist, Lady Angela Burdett-Coutts, contributed £500 and pledged that she would not allow the project to collapse for want of money. When further funds were needed mid-way through the survey, Sir Moses Montefiore made a substantial contribution on behalf of the Syrian Improvement Committee. These two major contributors had very different reasons for their involvement. Burdett-Coutts strongly supported the evangelical missionary movement; Montefiore was fiercely interested in improving the situation of the small Jewish population remaining in Jerusalem and in increasing that population.[19] Once funds were secured, the committee requested a detachment of Royal Engineers from Secretary of State for War, Lord Ripon. This would be the pattern for most British surveys in the Holy Land: military personnel drawn from the Corps of Royal Engineers, supported by private funds, engaged in 'neutral', scientific and scholarly research.[20]

Photography and the Royal Engineers The Royal Engineers were the obvious choice to survey the water system. The Engineers were synonymous with competence; they had surveyed throughout the world – Ireland, India, Ceylon, Singapore, Panama, Canada and China. A previous survey of portions of Syria, including Jerusalem,

undertaken in 1840–41 as part of the British military deployment to dislodge the Egyptian Ibrahim Pasha and return the area to the Ottoman Turks, had been made by a small detachment of Royal Engineers (then called Royal Sappers and Miners). Their map of Jerusalem drawn to 1:4800 remained the most accurate until the surveys of the 1860s.[21]

The Engineers had used photography in the field prior to the surveys in the Holy Land. It had been part of the course of training at the Royal Engineers' establishment at Chatham since 1856.[22] In 1860, the Chief Instructor of the Telegraph and Photograph School, Captain Henry Schaw, cited its utility for the following applications:

1. Obtaining exact records of the progress of public works in the course of construction … absolutely truthful representations of the progress of the works.

2. Copying plans and maps, either on the same scale, or reduced, or enlarged …

3. Obtaining minutely accurate pictures of architectural subjects of acknowledged excellence, to assist in designing new works and buildings; or of existing buildings to which additions or alterations are required, to enable the designer to adapt the new work to correspond with the old.

4. Preserving exact details of failures in buildings from defective foundations or other causes, and thus possibly avoiding litigations with contractors after the defects have been made good.

5. Recording the effects of the explosion of gunpowder in different positions.

6. Recording the results of all sorts of experiments in mechanical constructions or new inventions, showing their success or failure and illustrating reports on the subjects.

7. Illustrating the methods of making military bridges, gabions, fascines, etc.

8. Showing the correct positions for soldiers in their various drills, such as rifle drill.

9. In surveying boundaries of different countries, photographs of remarkable natural features of the country, which may either occur in the boundary line or be visible from certain points on it, will tend to fix the position of the line with greater certainty.

10. Obtaining portraits of remarkable persons and costumes of foreigners.[23]

Although Schaw gave priority to the photograph as a template for constructing buildings and machines, and for disciplining human behaviour, he also recognized its utility as an adjunct to the more traditional elements of the survey, the map and the topographical drawing. Most recently, it had proven useful in recording the terrain and peoples encountered by the North American Boundary Survey of 1858–62.[24] In 1860, Captain John Donnelly, RE, argued that 'photographs of a country give a most truthful and accurate idea of it. They would do more to give an accurate idea of any particular position than yards of description'.[25] During the 1860s, photography was incorporated into military campaigns in one or another form, and became an integral part of any comprehensive geographical record.[26]

Ordnance Survey of Jerusalem Captain Charles W. Wilson, recently returned from work on the North American Boundary Survey,[27] commanded the Jerusalem Survey which consisted of himself, Sergeant James McDonald, and four men.[28] They arrived on 2 October 1864 and began a careful street-by-street survey of the city's cisterns, wells and conduits. Sergeant McDonald made photographs at the behest of Colonel Sir Henry James, a member of the Water Relief Committee and Director of the Ordnance Survey Office.[29] 'In addition to requirements of the [Water Relief] Committee I sent out photographic apparatus to enable Srj. McDonald, who is both a very good surveyor and a very good photographer, to take photographs of the most interesting places in and about Jerusalem.'[30]

Not surprisingly, because of the inherent limitations of prevailing technology – the size of the cumbersome view camera and the demands of the wet collodion glass negative process – Wilson did not view photography as the most appropriate recording system for a project in which the primary interest was subterranean systems. In the Introduction to the published account of the survey, Wilson stated: 'Photography was not considered an essential part of the survey; the views were taken at spare moments, and were intended to illustrate as far as possible the masonry of the walls and architectural details of the different buildings.'[31]

McDonald's photographs, although dismissed by Wilson as ancillary notations to the business of the survey, were given a prominent place in the published report. Of the three volumes of *Ordnance Survey of Jerusalem*, one complete volume is devoted to photographs. The published photographs function as a text which states the incontrovertible fact of British presence and prerogative in the ancient city.[32] McDonald photographed members of the detachment in locations where sacred events transpired (Figure 9.2). Their presence can be read as the most common trope of survey photography, the use of the human figure to mark physical scale. They also function as players in a drama in which a historic right (rite) of possession is enacted. Their relaxed postures suggest their sense of being 'at home' in this place which, one might think, would have seemed exotic and foreign. In a very real sense, they were at home. It was a home created by long years of familiarity with Bible stories heard first in the nursery as children, and then from the pulpit as adults.

Survey completed, Wilson and his men set sail for England in May 1865. The scope of Wilson's project exceeded that of the Water Relief Committee's charge. The Committee had asked that the Engineers map the water system, identify areas that had fallen into disrepair and recommend corrective measures. Wilson's contingent produced exquisitely detailed maps of Jerusalem, its water supply and drainage and elevations of the city and surrounding promontories;[33] they mapped the citadel where Turkish troops were garrisoned, noting the number, placement and condition of their artillery;[34] they 'levelled' from the coast at Jaffa to the Dead Sea;[35] and Wilson conducted limited archaeological excavations.[36] Thus, the neutrally conceived survey of the water system evolved to include elements of military intelligence, basic

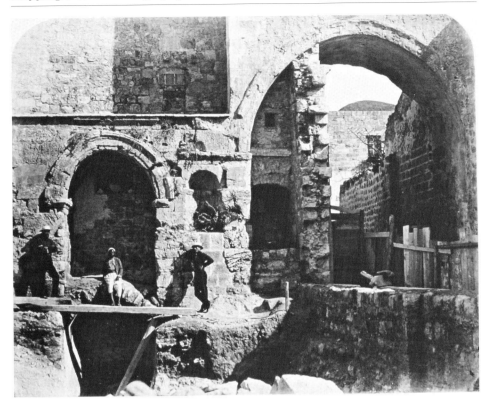

FIGURE 9.2 James McDonald, 'Ecce Homo Arch', 1864, from *Ordnance Survey of Jerusalem*. Albumen print, 194 × 248 mm. Collection of Michael G. Wilson. Courtesy: Santa Barbara Museum of Art.

geographical information and the archaeological investigation of questions related to biblical scholarship.

The results were published later that year as *Ordnance Survey of Jerusalem* in three volumes, one of text, one of maps and a third with eighty-seven photographs. The publication was not the first appearance of the survey photographs. Some had reached England, before the survey team returned, by way of Wilson's field reports. Colonel James recognized the possibilities inherent in photographic evidence to embody multiple cultural meanings. He used the photographs to solicit further aid for the project from Sir Moses Montefiore, a Jewish philanthropist engaged in resettling Eastern European Jewry in Jerusalem. Montefiore noted in his journal that Colonel James had called upon him with a beautiful photograph of the Western Wall which elicited from Montefiore a pledge on behalf of the Syrian Improvement Committee, of which he was the Chairman, for funds to support the completion of the survey.[37] After the survey party's return, individual photographs and maps were available for purchase from the Ordnance Survey Office in Southampton. A scale model of

Jerusalem, constructed from the survey's maps and photographs, went on view at the Survey Office later that year and received a regular stream of visitors.

The success of the 1864 survey was the direct inspiration for the establishment of the Palestine Exploration Fund, a society dedicated to the 'neutral, scientific' study of the Holy Land. Wilson had demonstrated that there were still discoveries to be made in the region if one had a properly equipped and trained investigative force. The prospectus for the organization stated the need for expeditions 'composed of thoroughly competent persons in each branch of research, with perfect command of funds and time, and with all possible appliances and facilities, who should produce a report on Palestine which might be accepted by all parties as a trustworthy and thoroughly satisfactory document'.[38]

Ordnance Survey of the Peninsula of Sinai In 1868, a larger and more complex survey, again supported by private subscription, was organized to map the Sinai Peninsula.[39] Although the size and complexity of the proposed survey were considered beyond the financial capabilities of the fledgling Palestine Exploration Fund, the survey, for which Wilson shared command with Captain H. S. Palmer, was conceived in the spirit of scientific inquiry inspired by the success of the Jerusalem Survey and advocated by the Fund 'to apply the rules of science, which are so well understood by us in other branches, to an investigation into the facts concerning the Holy Land'.[40]

The stated goal of the survey was to resolve contemporary controversies in biblical and philological scholarship – to determine the path of the Exodus, to identify Mount Sinai and to investigate the rock inscriptions in Wadi Mukatteb.

> That there is a great need to carry out such a survey must be manifest to all students of Old Testament history; among the most important and interesting questions which are now subjects of inquiry [are the locations of] the Passage of the Red Sea, the route and encampment of the Israelites, and the identification of the Mountain of the Law-Giving.[41]

This intellectual inquiry was to be informed by two potentially divergent mental habits: an absolute faith in the literal truth of Scripture on the one hand, and the demands of scientific accuracy on the other. As Williams states in his Introduction, subtitled 'On the Exodus and the necessity which existed for having an accurate survey to elucidate its history':

> The most essential element for the investigation of the most various historical questions connected with the Peninsula was a manly unsuspecting trust in the authenticity and authority of the Ancient Records ... [and collecting] such observed phenomena as might enable scholars and philologists to examine the Sacred Text with the advantage – certainly not less important for the elucidation of sacred than of secular history – of an accurate topographical and geographical acquaintance with the country to which the narrative relates.[42]

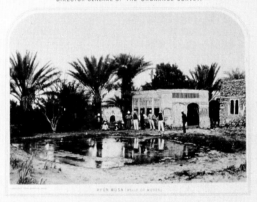

ORDNANCE SURVEY

OF THE

PENINSULA OF SINAI.

MADE WITH THE SANCTION OF

THE RIGHT HON: SIR JOHN PAKINGTON.BART: SECRETARY OF STATE FOR WAR.

BY

Captains C. W. Wilson and H. S. Palmer. R.E.

UNDER THE DIRECTION OF

COLONEL SIR HENRY JAMES. R.E: F.R.S. &c.

DIRECTOR-GENERAL OF THE ORDNANCE SURVEY.

PUBLISHED BY AUTHORITY OF THE LORDS COMMISSIONERS OF HER MAJESTY'S TREASURY.

ORDNANCE SURVEY OFFICE

SOUTHAMPTON.

MDCCCLXIX.

FIGURE 9.3 Title page from *Ordnance Survey of the Peninsula of Sinai*, 1869, with an albumen print, by James McDonald, of the survey party at 'Ayún Músa (Wells of Moses)', hand tipped onto printed title page. Collection of Michael G. Wilson. Courtesy: Santa Barbara Museum of Art.

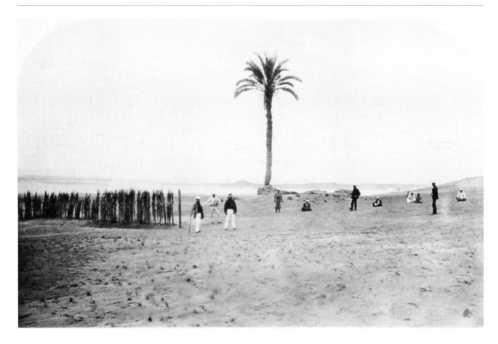

FIGURE 9.4 James McDonald, 'Entering the Desert by Ayún Músa (Wells of Moses)',
1868, from *Ordnance Survey of the Peninsula of Sinai*. Albumen print, 168 × 215 mm.
Collection of Michael G. Wilson. Courtesy: Santa Barbara Museum of Art.

The obvious utility of an accurate survey of the approaches to the Suez Canal, then
under construction by French and Egyptian interests, was not mentioned.

In addition to the Engineers (Captains Wilson and Palmer, Sergeant McDonald,
Corporals Goodwin, Brigley and Malings), the expedition included the biblical scholar
Reverend George Williams who had served as secretary to the subscription fund;
E. H. Palmer (no relation to Captain Palmer), an expert in ancient and contemporary
oriental languages; another biblical scholar, Claude W. Wyatt of Oxford, who also
served as the natural historian for the survey; and Reverend F. W. Holland as geologist.[43]

Photography was expected to play an important role in the mission. Williams lists
it as one of the instruments that would serve up the Sinai to the study of scientists.
He anticipated that the survey would map the important sites of biblical history 'by
subjecting the rugged heights of the Peninsula to the unreasoning though logical tests
of theodolite and land chain, of altitude and azimuth instruments, of the photographic
camera, and the unerring evidence of the pole-star and the sun'.[44] Photography took
its place in the list of scientific instruments because of the pervasive understanding
of it as a neutral tool of observation and investigation, its neutrality assured because
the formation of the photographic image was governed by the rules of optics and
chemistry. The subjects chosen for photography covered a broad range of interests
that represented the range of the Survey's inquiry: 'The photographs, about 300 in

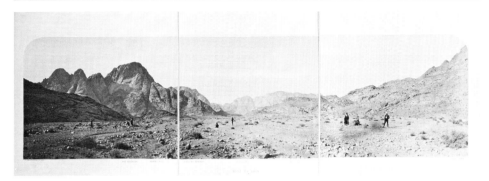

FIGURE 9.5 James McDonald, 'View from Wady Ed-Deir', 1868, from *Ordnance Survey of the Peninsula of Sinai*. Albumen print, 168 × 641 mm. Collection of Michael G. Wilson. Courtesy: Santa Barbara Museum of Art.

number, from various parts of the country ... were selected as to illustrate the natural features of the Penn., its geographical character and scenery, its antiquities and rock-inscriptions, and the appearance and mode of life of its inhabitants.'[45]

A photograph of the party at Ayún Músa, or Wells of Moses, the oasis which by tradition was the place where the Israelites rested before starting across the desert, served as the title page illustration for the published survey (Figure 9.3). The symbolic resonance of a British party following in the footsteps of the Israelites would not have been lost on British readers. This symbolic connection was reinforced by the photo-graph of the survey team as it entered the desert at Ayún Músa (Figure 9.4). The team poses where the last vestiges of water and human habitation emphasize the barren, undifferentiated sweep of the desert. Their indigenous guides and servants are seated in the sand, their passive presence in vivid contradistinction to the emphatic and active postures of the English members of the survey. If, as Edward Said has asserted, 'Imperialism is an act of geographical violence through which virtually every space in the world is explored, charted, and finally brought under control. For the native, the history of his or her colonial servitude is inaugurated by the loss to an outsider of the local place',[46] then, this photograph records the moment at which native people lost the Sinai and the British appropriated it. Their loss is encoded in the active assumption of control by British surveyors even before the mapping cam-paign began and in the assigned passivity of native guides and bearers relegated to a supporting role in their own disenfranchisement.

During the course of the survey, McDonald made several photographic panoramas in the Sinai. In the view from Wadi Ed-Deir (Figure 9.5), the almost overpowering sweep of desert is articulated by the bodies of expedition members. They literally measure an otherwise unknowable space, yet their function as human yardsticks in establishing the scale of the terrain is subverted by the marked disparity in size between the human figures and the landscape. Their presence serves as a counter-

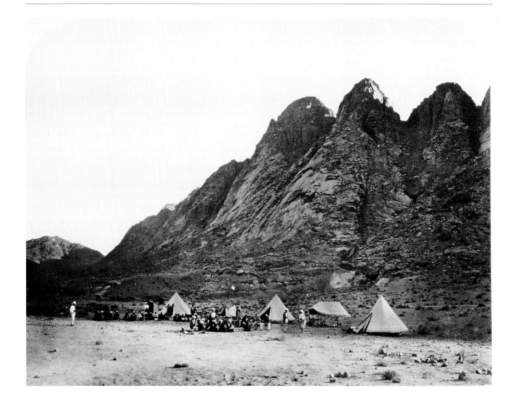

FIGURE 9.6 James McDonald, 'Camp in Wady Ed-Deir', 1868, from *Ordnance Survey of the Peninsula of Sinai.* Albumen print, 168 × 215 mm. Collection of Michael G. Wilson. Courtesy: Santa Barbara Museum of Art.

point to a landscape which reads as almost aggressively empty. The Sinai Peninsula, 'the scene of the most important events in the history of mankind', to use Stanley's description, is immense and empty. The British are the new actors taking their place upon that stage. The three-part photographic panorama is read as a simultaneous representation of continuous space, yet it is in fact sequential. The figures in the right panel moved further into the space for the exposure which produced the centre panel of the panorama, and moved yet further from the camera for the photograph which makes up the left panel. The purportedly simultaneous depiction of space encodes the sequential physical progress of the surveyors as they lay claim to that landscape.

McDonald's photograph of the Engineers' camp in Wadi Ed-Deir encapsulates the control inherent in the British presence in the Sinai (Figure 9.6). At first the tidy encampment seems dwarfed by the mountain peaks behind it, but one comes to see the peaks of the tents as repetitions of the landscape and, ultimately, as a counter-vailing force in this wilderness of rock and sand. A lone British officer, to the left in

the photograph, conducts the disposition of material and native labour at the camp. The photograph orchestrates our understanding of the organizing principle of British control as the introduction of Western systems of regularity.

The findings of the survey were published as *Ordnance Survey of the Peninsula of Sinai* in four volumes which combined the numerous texts, maps, elevations, plans, plates and a volume of photographs. In addition to the 153 photographs included in the official publication of the survey, many of the almost 300 photographs made by McDonald were sold as individual prints or in sets of stereoscopic photographs through the Ordnance Survey Office.[47] Although many of the views published in *Ordnance Survey of the Peninsula of Sinai* were also available as stereo cards, the stereo sets included photographs not found in the publication, such as views of local people in various 'natural' settings – in their villages, before their homes and engaged in everyday domestic activities.[48] This type of photographic production was more closely related to commercial images that dominated the market from the 1860s on, offering the viewer visual possession of, rather than human engagement with, the 'other' peoples of the world.[49] Within the official publication, the Ordnance Survey volumes, the only photographs of native people are those which present them within the context of their service to the survey expedition. Thus, there are photographs of guides, servants and Bedouin tribal groups who assisted in the work of the survey.

The Map, the Model and the Photograph

Colonel Sir Henry James had been the prime force in adding photography to the type of information collected in the course of the Jerusalem Survey. He was directly involved again in defining the objectives of the Sinai mission, and again in expanding the scope of what was recorded and how. He ordered that two-dimensional records – photographs, maps and elevations – be supplemented by the construction of models.

> In drawing up my instructions for the officers in charge, I gave directions for special surveys to be made of Jebel Musa and Jebel Serbal, the two 'rival mountains,' as they have been called, for the honor of being the Mount Sinai of the Bible. I gave directions for these surveys to be carried out with scrupulous care, and in such detail that accurate models of both mountains could be made from them. The model of Jebel Musa was actually made on the ground by Corporal Goodwin, who had been provided with materials for this purpose ... The model of Jebel Serbal was also partly made in Sinai, and completed immediately after the return of the party to Southampton, from the detailed plan of the Survey and a number of photographic views.[50]

Thus, the scale model of Jerusalem, constructed in the Ordnance Survey Office after the 1864 survey, was complemented by models of Jebel Musa and Jebel Serbal, constructed in the field and completed in Southampton from elevations and photographs. Although it was commonplace to construct models of terrain that was the

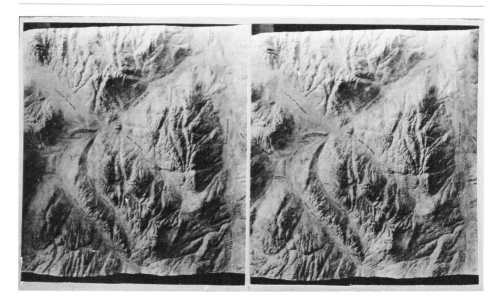

FIGURE 9.7 Unidentified photographer, stereoscopic view of model of Jebal
Musa, 1869. Albumen prints, each 73 × 70 mm. Collection of Michael G. Wilson.
Courtesy: Santa Barbara Museum of Art.

potential site of military engagement or deployment, neither Jebel Musa nor Jebel
Serbal were areas of strategic importance. Rather, the models were three-dimensional
representations of sacred geography. The model of Jebel Musa represented the physical
terrain of the signal event in the Old Testament, the giving of the Law. (The report
of survey team members had identified Musa as the Mount of the Law-giving.) As was
the case with the model of Jerusalem, the models of Jebel Musa and Jebel Serbal
attracted visitors who sought the most tangible representations of sacred place.

Popular interest in experiencing a heightened sense of the physical reality of sacred
geography embodied in the models was also met by stereoscopic photographs of the
models, such as that of Jebel Musa (Figure 9.7). When viewed in a stereoscope, paired
stereoscopic photographs amplified the direct photographic transcription of place
with the sense of standing on the threshold of a fully three-dimensional world. In
effect, the stereoscopic photograph restored the three-dimensional quality of the
physical world to its photographic translation on the flat surface of the print. There
is a curious parallel between the re-creation of a sense of heightened physical reality
in the stereoscopic photograph and the construction of three-dimensional models
based on multiple two-dimensional information sources such as maps and elevations.
Both elicited similar responses as tangible representations of sacred geography.

The Reverend Hugh MacMillan used the stereoscope as a metaphor for the super-
imposition and amplification of the natural and the divine to yield a new reality: 'It
will be found that though truth of God is one, it has two special aspects, as seen in

Nature and Revelation; and that these two aspects, like the two views of a stereoscopic picture, blend together in the stereoscope of our faith into one beautiful and har- monious whole, standing out in clear and glorious perspective.'[51] MacMillan's analogy of a new reality derived from the superimposition and amplification that occurs in the stereoscope can be extended to a consideration of the stereo view of the model of Jebel Musa. In this reading, the stereo card 'blends together' the physical mani- festations of geopiety 'in clear and glorious perspective'.

The stereo view of the model of Jebel Musa is a three-dimensional simulacrum in which photography, cartography and model-making support the persuasive repres- entation of a physical space made significant by geopiety. It and other stereo views were widely circulated and could be found in a range of parlours, from the barely middle class to the royal household, and in Sunday schools. Bible study groups and pious individual readers referred to them as they read and reread Exodus and Deuteronomy, turning to the photographs as confirmation of the physical reality of the story they were reading. They could retrace, in their imaginations, Moses's journey to the place of the law-giving and find in the hyper-reality of the stereoscopic view of the modelled topography of Jebel Musa confirmation of the sacred text and assurance of a uniquely British claim upon this space, which the Engineers had brought back to the people of Great Britain in map, model and photograph. The seamless integration of biblical text with multiple visual references to physical reality reified dominant Christian beliefs and their association with national identity.[52]

Conclusion

Photographs were but one type of information collected during the course of ordnance surveys of Jerusalem and the Sinai. The published reports comprised maps, photo- graphs, elevations and plans of structures; texts described the course of the survey and the techniques employed. Members of the Survey of the Peninsula of Sinai contributed essays on epigraphy, flora, fauna, geology and ethnology; topography was correlated with the route of the Exodus; antiquities were described in relation to biblical history.

These representations of sacred topography separately and collectively derived meaning from their relationship to sacred text. In order for geopiety to function, the visual information of 'the land as it is' had to be anchored to the places where specific incidents in sacred history occurred. Photographic views of Palestine were thus embedded in a web of names with historical or biblical associations. Both surveys presented philological data that tied the photograph to the Bible through language. In Jerusalem, the Reverend Dr Sandreczki, a local missionary, listed the names of sites, streets and structures, and correlated the biblical place name with the Arabic name then in use.[53] Thus anchored, the visual record, and especially the photographs, amplified the fetishistic attachment to place characteristic of geopiety.

Maps and photographic views are both the means by which imperialism manifests its central act, one of 'geographical violence through which virtually every space in the world is explored, charted, and finally brought under control',[54] and the record of that act. In nineteenth-century Palestine, the map and the photograph constituted a source of strategic information; the maps of the region, begun on the two surveys under discussion and carried forward by succeeding surveys, were essential to British military control of Palestine and the subsequent geographic shape of the Palestine Mandate. The insertion of the survey photographs into popular culture through publication and sales reinforced British national identification with the Holy Land and a concomitant national claim. The photographs also recorded the process through which the strategic information of map and photograph was acquired and the foundation of national privilege established.

I extend James Ryan's argument – that photographs made in the course of official or quasi-official government surveys inscribe a set of colonial assumptions in the images produced – to those made by the Royal Engineers in Jerusalem and the Sinai Peninsula.[55] I return to Archbishop Thomson's declaration at the founding of the Palestine Exploration Fund as the articulation of the dominant British assumption regarding the region investigated in the Royal Engineers' Surveys of 1864 and 1868: 'This country of Palestine belongs to you and me, it is essentially ours … It is the land towards which we turn as the foundation of our hopes; it is the land to which we may look with as true a patriotism as we do this dear old England which we love so much.'

The photographs made by the Royal Engineers in the Holy Land encode that possession, whether in the stance taken by expedition members at the holy places in Jerusalem (Figure 9.2), in the sequential penetration of the Sinai (Figures 9.4 and 9.5) or in the integration of map, photograph and elevation in the three-dimensional model and its dissemination as a stereoscopic photograph (Figure 9.7). In each instance, the photographs are graphic articulations of a physical possession, defined and justified by a pervasive geopiety centred on the lands of the Bible; at the same time, they reinforce that attachment to sacred place which is geopiety.

TEN

Home and Empire: Photographs of British Families in the *Lucknow Album,* 1856–57

Alison Blunt

§ WRITING IN his diary on 14 March 1858, the London *Times* correspondent William Howard Russell recorded the destruction that accompanied the British recapture of the city of Lucknow at the end of the Indian rebellion or 'mutiny'.[1] Russell witnessed the immediate aftermath of the conflict at first hand. Describing the scene at the Shah Najaf Imambara, a Muslim tomb in the heart of the city, Russell wrote: 'It is no exaggeration to say the marble pavement is covered two to three inches deep with fragments of broken mirrors and of the chandeliers which once hung from the ceiling; and the men are busy smashing still. This mischief is rude, senseless, and brutal, but no one cares to stop it.'[2]

The following day, Russell was presented with two volumes of photographs that had been taken by Ahmad Ali Khan in 1856 and that came to be known as the *Lucknow Album*.[3] Russell did not record this event in his diary, but a signed inscription at the front of the first of the two volumes reads: 'Head Quarters Camp Dilkoosha Lucknow March 15th 1858. Presented to me by Trevor Wheler.'[4] The two volumes subsequently became separated, and were not reunited until 1975. Volume 1 remained in Russell's family until 1922, when his younger daughter presented it to the Oriental and India Office Collections of the British Library. Volume 2 was exhibited by an antique dealer in London in late 1974, and was purchased by the British Library the following year.[5] There are 149 salt paper prints in Volume 1 and 193 prints in Volume 2, some of which are duplicates. In both volumes, most of the subjects are portraits of Indian and British individuals and groups, although there are also some photographs of buildings in Lucknow and Delhi. The gilt-edged and mounted prints vary in size from 95×73 mm to 170×232 mm and most have hand-written captions. The two volumes are bound in black leather and measure 294×236 mm, with red leather panels on the spines inscribed '*Lucknow Album*, Vol 1' and '*Lucknow Album*, Vol 2'.[6]

Ahmad Ali Khan, the most skilled and prolific photographer in Lucknow before the 'mutiny', took most of the photographs in the *Lucknow Album* at the Husainabad Imambara, where he was employed as a trustee and a steward.[7] Located in the west of the 'native city' of Lucknow, the Husainabad Imambara largely escaped damage and plunder both during and after the 'mutiny' because it was several miles from the conflict that centred on the Lucknow Residency, British cantonments, and along the route of British soldiers advancing from Cawnpore. Before the 'mutiny', many British residents and visitors in Lucknow travelled to the Husainabad Imambara to have their photographs taken by Ahmad Ali Khan. In this essay, I examine photographs of British families in the *Lucknow Album* to explore representations of imperial domesticity before its violent disruption. These photographs provide the most extensive visual record of British families in Lucknow before the 'mutiny'. The content, purpose and circulation of these photographs reveal connections between domesticity and imperialism not only within Lucknow, but also between India and Britain. I also explore the ambivalent position of Ahmad Ali Khan as the photographer of pre-'mutiny' life in Lucknow and the paradoxical representation of British families within the Husainabad Imambara, where they were simultaneously located and yet dislocated in the ornate surroundings of a Muslim tomb. After introducing the Indian 'mutiny' and discourses of imperial domesticity, I seek to embody the gaze, first of Ahmad Ali Khan within the context of early photography in India, and then of his British subjects on themselves. In the latter case, the letters of one of Ahmad Ali Khan's subjects, Henry Polehampton, reveal the social contexts in which the *Lucknow Album* was produced. The essay ends by re-viewing photographs in the *Lucknow Album* by re-placing them in the Husainabad Imambara before the 'mutiny'.

The Indian 'Mutiny'

Events in May 1857 marked the start of what, in imperial terms, came to be known as the 'Indian (or *sepoy*[8]) mutiny' and, in nationalist terms, as the 'First War of Independence'. Detachments of the Bengal army mutinied at Meerut, killing several British officers and setting fire to the cantonment, before marching to Delhi and declaring the Mughal king, Bahadur Shah II, as the reinstated ruler of Hindustan. Over the next year, revolts against the British spread throughout central and northern India, taking place most notably at Delhi, Lucknow and Cawnpore. The 'mutiny' was suppressed by more than 35,000 soldiers sent from Britain by June 1858. There have been many debates about the causes of the 'mutiny', both at the time and since. Imperial histories have tended to focus on the rumour that cartridges for new Enfield rifles had been greased with beef and pork fat, which meant that biting into such cartridges would break the religious faith of both Hindu and Muslim soldiers. Public and parliamentary opinion at the time, however, ranged more widely. Most contemporary debates focused on the organization of the Bengal army and the recent

annexation of the province of Oudh. An estimated 50,000 sepoys were denied many of their landholding privileges and became subject to a new, rigid revenue system when the British deposed the king and forcibly annexed Oudh in 1856.[9]

In Lucknow, the capital of Oudh, disaffection among Indian soldiers heightened from April 1857, culminating in an uprising in cantonments on 1 June. By this time, most of the British population of Lucknow, including more than two hundred women, had moved from their homes in cantonments into the 33-acre Residency compound in the centre of the 'native city'.[10] Following the defeat of the British at the battle of Chinhut on 30 June, the Residency compound was surrounded and besieged for the next five months. In September, an unsuccessful relief provided reinforcements. A second relief of Lucknow in November led to the evacuation of the Residency and the withdrawal of all British troops from the city. Fighting continued until Lucknow was recaptured by the British in March 1858, as documented by William Howard Russell. The siege of Lucknow continued to shape British imperial imaginations for many years following the 'mutiny', with *The Times* stating in 1930 that 'probably no achievement in British history stirs the blood of Englishmen more deeply than the defence of Lucknow'.[11] Indeed, after the recapture of Lucknow in March 1858, the Union flag was lowered from the tower of the Residency House for the first and last time at midnight on 15 August 1947, the date of Indian Independence. This was the only Union flag in the British Empire to fly both day and night and, when it was finally lowered, the *Illustrated London News* reported the event as 'probably the most poignant flag ceremony of the day'.[12]

The significance of the *Lucknow Album* as a unique record of people and places on the eve of the 'mutiny' has come to be inscribed largely in terms of loss and memorialization in view of the siege of the Lucknow Residency which lasted from June to November 1857. The historical significance of photographs in the *Lucknow Album* is inseparably bound to the discursive position from which they are viewed and interpreted. As John Tagg writes: 'What is real is not just the material item but also the discursive system of which the image it bears is part.'[13] For Wheler and Russell, who viewed the *Lucknow Album* both during and immediately after the 'mutiny', the portraits of British officers and their families became particularly significant because of their fate in the year after the photographs had been taken. In literal terms, Wheler and Russell inscribed the *Lucknow Album* as a record of imperial and familial loss and memorialization. Both of them attempted to identify the individuals and locations photographed by Ahmad Ali Khan, and they also appended the fate of many of these individuals during the 'mutiny'. For example, Russell wrote 'siege' below the photographs of Captain and Mrs Germon and Mr and Mrs Cooper to indicate their survival of the siege of Lucknow. In contrast, the photograph of Mr and Mrs Thornhill commemorates a married couple who were 'killed at Setapore', while Lieutenant Green was remembered as 'siege – died' and Mr Jequsira, a Eurasian clerk, 'died of a wound – siege'. Other notes written by Russell after March 1858 record the heroism

of particular individuals during the siege. The portrait of Mr Kavanagh and his daughter Blanche was annotated with the following description: 'This is the gentleman who so nobly volunteered to pass through the city of Lucknow and place at Sir Colin Campbell's disposal the benefit of his local knowledge, which act of daring he performed to the admiration of the whole army.' The captions and annotations added to the *Lucknow Album* commemorate the imperial heroism of those who died during, and those who survived, the siege of Lucknow. The notes added by Wheler and Russell inscribed the *Lucknow Album* as a record of loss or survival, commemorating imperial domesticity in terms of its vulnerability during the 'mutiny'. And yet, while many of the subjects are identified, and their fate during the 'mutiny' is annotated, many other subjects remain unnamed and their fate can only be imagined. There are blank spaces at several points in the two volumes, where the absence of portraits has been noted and decried by William Howard Russell in his captions below: 'Photo stolen out of book in 1859. Lent to _____', 'also stolen out of this place by _____ to whom book was lent by WHR in April 1859', and 'stolen out of book in 1860'. While his proprietary claims led Russell to lament the loss of these photographs, they contrast with the more immediate loss that might have led certain viewers in 1859 and 1860 to remove and keep a personal memorial of loved ones killed during the 'mutiny'.

More recent accounts that refer to the *Lucknow Album* continue to view the photographs taken by Ahmad Ali Khan in terms of the fate of their subjects. According to Ray Desmond: 'It is a poignant record. A number of the men, women and children in the salt print portraits lost their lives in the siege',[14] and John Falconer concurs that: 'While the quality of these small salt prints is very variable, the tragic events which overtook many of the sitters make this a poignant and historically important record.'[15] In his study of seven portraits of army officers in the *Lucknow Album*, John Fraser provides biographical detail that centres on their subsequent involvement in the conflict.[16] In each of these accounts, the photographs taken by Ahmad Ali Khan are viewed primarily in terms of the fate of their subjects in the 'mutiny'. Rather than focus solely on post-'mutiny' representations of the *Lucknow Album*, I will attempt to contextualize the photographs in pre-'mutiny' Lucknow. While it is difficult to view the photographs of British families in the *Lucknow Album* without imagining their fate during the siege of Lucknow, it is also difficult to interpret subsequent events and, in particular, representations of domestic defilement, without examining pre-'mutiny' discourses of imperial domesticity. For the purposes of this essay, the photographs of British families in the *Lucknow Album* provide an important contrast to subsequent representations of the 'mutiny' as a crisis of imperial domesticity.

Discourses of Imperial Domesticity

Discourses of imperial domesticity helped to inscribe spaces of home and empire on household, national and transnational scales. As wives, mothers and consumers, women

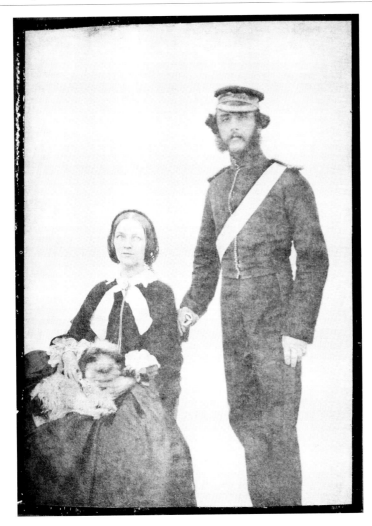

FIGURE 10.1 Ahmad Ali Khan, 'Lieutenant and Mrs Lewin',
Lucknow, 1856–57, from *Lucknow Album*, Vol. 1. Salt paper print,
73 × 101 mm. Oriental and India Office Collections, Photo 269/
1/48a. Courtesy: British Library.

in Victorian Britain performed a range of domestic, national and imperial duties.
Imperial politics were closely tied to domestic discourses at home in Britain, with
domestic reproduction often explicitly linked to national and imperial representations
of racial purity, strength and health.[17] Similarly, the development of imperial cities
such as London, the growth of commodity consumption and the staging of imperial
exhibitions all helped to shape an imperial imagination that not only inscribed 'other'
places, but did so in part by positioning British homes at the heart of Empire.[18] Over

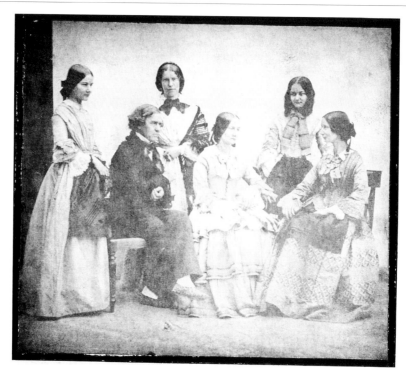

FIGURE 10.2 Ahmad Ali Khan, 'The Ommanney family, Mrs Kirk and
Miss White', Lucknow, 1856–57, from *Lucknow Album*, Vol. 1. Salt paper
print, 97 × 85 mm. Oriental and India Office Collections, Photo 269/1/
46a. Courtesy: British Library.

the course of the nineteenth century, an increasing number of British women travelled
to set up imperial homes with and for their families, either on a permanent basis in
settler colonies such as Canada, Australia and New Zealand, or on a more temporary
basis in places such as India. The presence of British women and British homes in
Lucknow reflected and reproduced the translation of domestic discourses over imperial
space.[19]

The photographs of British families in the *Lucknow Album* portray members of the
official élite. It has been estimated that in the mid-eighteenth century up to 90 per
cent of British men in India were married to Indian or Anglo-Indian women, but that
by the mid-nineteenth century, intermarriage had virtually ceased and an increasing
number of British women travelled to India either once they were married or in
search of a husband.[20] From the 1790s, a range of social, administrative and military
exclusions in racial terms were reflected by domestic anxieties that centred on inter-
marriage and miscegenation. And yet, the regulation of racial, sexual and gendered
conduct through British marriages in India was class specific, and the social and
domestic distance between British rulers and Indian and Anglo-Indian subjects was

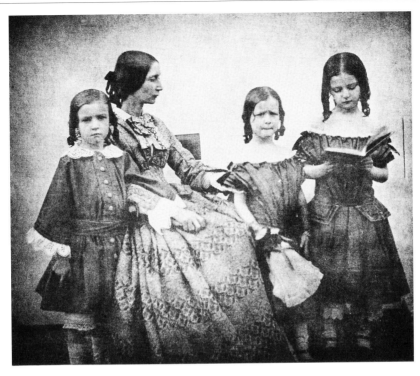

FIGURE 10.3 Ahmad Ali Khan, 'Mrs Kirk and her three daughters', Lucknow, 1856–57, from *Lucknow Album*, Vol. 1. Salt paper print, 97 × 85 mm. Oriental and India Office Collections, Photo 269/1/46b. Courtesy: British Library.

restricted to an official élite.[21] From the 1790s, while the official British élite in India – the 'imperial aristocracy'[22] of army officers and civil servants – was increasingly encouraged to marry British women, military restrictions limited the number of British soldiers able to marry at all.

In the *Lucknow Album*, army officers and their young wives were usually photographed in couples, as shown by the photograph of Lieutenant and Mrs Lewin in Figure 10.1. However, family groups were more likely to feature civil servants and, in several cases, British women outnumbered British men. For example, Figure 10.2 depicts Mr Ommanney, the Judicial Commissioner of Lucknow, his wife, their two unmarried daughters, and Miss White and Mrs Kirk, who were either friends or members of their extended family. In several other photographs, such as Figure 10.3, Mrs Kirk's three young daughters pose with their mother and other female members of the Ommanney family. By including women such as Miss White and Mrs Kirk in a group portrait, the representation of the Ommanneys suggests an extended imperial family. In particular, the inclusion of Miss White suggests that Ommanney family helped to domesticate a woman who, fifty years earlier, might have been perceived as

an 'adventuress' in search of a husband. By the mid-nineteenth century, publications such as the monthly journal the *Calcutta Review* were anxious to distance the current period of domestic progress from the late eighteenth century:

> There are few if any of our readers … who have not heard much and read much on the subject of Female Adventurers, and the Marriage Market, and young ladies going out to India, on what was vulgarly called 'a *spec*.' All this is quite swept away. There are young ladies in every part of India – but the question of what they are doing there may be answered without a reference to the Marriage Mart. In most cases, they are found in our Indian stations, for the same reason that other young ladies may be found in London, or Liverpool, or Exeter – simply because, when in these places, they are in their proper homes. Adventuresses there are none.[23]

The number of British women photographed in family groups by Ahmad Ali Khan reinforced the contested notion that 'India is the home of every girl whose parents are in it; of every married woman'.[24] But soon after the *Calcutta Review* reported improvements in British home-life in India, often embodied by the growing presence of British women, the 'mutiny' threatened imperial domesticity to an unprecedented extent.

In British newspaper reports, parliamentary debates, paintings and drawings, the severity of the threat posed by the 'mutiny' was represented in terms of domestic defilement, which was, in turn, embodied by the fate of British wives, mothers and children.[25] The imperial crisis was represented as a crisis of imperial domesticity, with British families and homes vulnerable and exposed at the heart of the conflict. The destruction of British homes in India was described alongside the fate of British women and children, and both helped to legitimate brutal retaliation. While more than two hundred British women were killed at Cawnpore, most of the British women at Lucknow, 40 miles away, survived the siege. At least eight of the sixty-nine 'ladies' married to officers and officials who were besieged at Lucknow wrote diaries about their experiences, some of which were subsequently published.[26] Just as commentators in Britain represented the severity of the imperial conflict in terms of domestic defilement, the diarists at Lucknow also described the imperial crisis in domestic terms, detailing the desertion of Indian servants and their own unaccustomed servitude. The 'mutiny' provided an enduring legacy that often revolved around the assumed vulnerability of British women far from home and their perceived influence in provoking a greater distancing between rulers and ruled.[27] As Wilfred Scawen Blunt wrote in 1885:

> The Englishwoman in India during the last thirty years has been the cause of half the bitter feelings there between race and race. It was her presence at Cawnpore and Lucknow that pointed the sword of revenge after the Mutiny, and it is her constantly increasing influence now that widens the gulf of ill-feeling and makes amalgamation daily more impossible.[28]

Unlike studies that concentrate on discourses of domestic defilement during the 'mutiny', and their far-reaching implications in the post-'mutiny' reconstruction of British rule in India, this essay explores visual representations of imperial domesticity in Lucknow before the 'mutiny' by focusing on photographs of British families taken by Ahmad Ali Khan at the Husainabad Imambara.

Embodying the Gaze

The photographs taken by Ahmad Ali Khan were brought to the attention of the Photographic Society of Bengal in 1856 at one of its first meetings. Lieutenant Lewin (one of the subjects of Figure 10.1) reported that 'there was a native in the city of Lucknow who took excellent photographic likenesses on glass, which were not however quite clear when transferred to paper'.[29] From the mid-1850s, photography became increasingly important in amateur and professional circles in India. The first daguerreotype studio had been established in Bombay in 1850, and, by 1858, there were six commercial firms in Bombay, six in Calcutta and four in Madras. The first photographic societies in India were founded in Bombay in 1854 and in Calcutta and Madras in 1856. In Britain, future officers at the East India Company's Military Seminary in Surrey were trained in photographic techniques from 1855.[30] The development of official photography took place alongside its amateur and commercial counterparts, recording people and places in India for imperial, military, personal and professional purposes. From the mid-1850s onwards, the imperial state used photography as a tool of control and discipline by providing visual records of categorization and measurement.[31] Influenced by anthropological research, imperial photographers often posed their subjects against blank white screens, grids to enable measurement or in particular landscapes, sometimes holding significant objects to aid identification and classification. The most extensive collection of photographs that sought to record and to classify the population of India was published in eight volumes as *The People of India* from 1868 to 1875. Interpreting *The People of India* in the political context of the aftermath of the 'mutiny', Christopher Pinney writes:

> Preoccupations with origins, purity and the prospect of decay which informed so many earlier and later works were swept away by a concern with political loyalty (or its lack) and an ongoing desire to provide practical clues to the identification of groups which had so recently had the opportunity to demonstrate either their fierce hatred of British rule or their acquiescence.[32]

Unlike such anthropological surveys, post-'mutiny' photographs of the Indian élite represented individuals and family groups against classical backdrops in the form of visiting cards and cabinet cards. As Pinney writes: 'The images are strikingly different from anthropometric photographs, but they are not strikingly different from the self-commissioned images that Europeans collected of themselves.'[33]

Ahmad Ali Khan occupied a complex position as an Indian photographer in imperial Lucknow, photographing British as well as Indian subjects in the Husainabad Imambara before the 'mutiny'. The best-known commercial firm in India was established by Samuel Bourne and Charles Shepherd in Simla. When he visited Calcutta in 1863, Bourne expressed his surprise at the involvement of Indians in photography since its introduction to India more than a decade earlier.[34] Indeed, three Indians had been elected as members of the Council of the Photographic Society of Bombay when it was founded in 1854,[35] and when the Photographic Society of Bengal was established two years later, Indians were appointed to the posts of secretary and treasurer.[36] As Judith Mara Gutman writes: 'Indian photographers had caught the same fever as others around the world.'[37] Gutman goes on to state that the photographs taken by Indians reflected a visual imagination that was different from its Western counterpart: '[Indians] produced a different imagery; different, at least, to Western eyes; the patterns and compositions of Indian photographs had been part of Indian painting for centuries.'[38] Such compositions, she continues, were likely to include 'gigantic' or 'ugly' foreground features and diverse content rather than a single, often isolated, object of the gaze.[39] But just as a singular imperial gaze needs to be destabilized, so too does a singular 'Indian' gaze that is defined purely in terms of its difference from a totalizing Western view. Rather than attempt to substitute an imperial gaze with an Indian gaze, it is important to contextualize the photographer and the subjects and settings of their photographs in time- and place-specific ways.

In some photographs of British family groups in the *Lucknow Album*, such as that of the Ommanney family (Figure 10.2), the edge of a screen is visible, revealing that a plain background has been positioned to conceal what lies beyond. Whether for technical or aesthetic reasons, the effect of such screening is to displace the family groups from their surroundings and to concentrate the gaze on the family itself. In contrast to portraits taken against exotic painted backdrops in the studios of commercial photographers in the metropolis,[40] and the classical painted backdrops in studios in cities such as Calcutta after 1858,[41] the portraits of British families in the *Lucknow Album* were staged against a plain, white background. Unlike the detail that signified imperial power in the metropolis, the photographs taken in the Husainabad Imambara seem placeless, with no indication of whether the subjects are located in Britain or in India except for the name and the genealogy of the *Lucknow Album* itself. The photographs of British families in the *Lucknow Album* fashioned more complex links between domesticity and imperialism than can be translated onto a distinction between home and away, empire and metropolis. Beyond the frame of the photographs and behind the white screen against which British families were positioned, the Husainabad Imambara was excluded from the viewer's gaze. By erasing any reference to their Indian surroundings, such photographs positioned British families in a liminal space between home and away and as simultaneously placed and yet displaced in the Husainabad Imambara.

FIGURE 10.4 Ahmad Ali Khan, 'Postmortem portrait of the daughter of Captain and Mrs Hayes', Lucknow, 1856–57, from *Lucknow Album*, Vol. 2. Salt paper print, 114 × 87 mm. Oriental and India Office Collections, Photo 269/2/76. Courtesy: British Library.

Unlike many later photographs,[42] just one of the photographs of the British in the *Lucknow Album* includes an Indian servant. The only exception (Figure 10.4) is also the only post-mortem photograph included in the two volumes.[43] As shown by Figure 10.4, the recently deceased young daughter of Captain and Mrs Hayes was photographed in the arms of her *ayah*. But the *ayah* herself remains largely invisible and unidentifiable, and she herself, in the form of her white clothes, becomes merely the background against which the young girl is photographed. The imperial power of British families in Lucknow is less tangible than in later photographs that include Indians in subservient and marginal positions. While photographs of British families *with* their Indian servants 'reaffirm the fact that the production of colonial authority is dependent on the ever-present Other on the margins',[44] the photographs in the *Lucknow Album* of British families *without* their servants suggest a more ambivalent representation of British families as imperial rulers. Moreover, Ali Behdad writes that photographs of British families with their Indian servants represent the unconscious desire for self-exoticization held by their British subjects: 'The marginalized natives as photographic props mediate the colonizers' identity as "exotic" – the British colonizers

wanting to look "different" from the British back home in England [sic] – while the colonizer's pensive gaze conveys an unexpected, even violent, flash of uncertainty that undermines his or her self-assured, confident pose.'[45] In contrast, the photographs of British family groups in the *Lucknow Album* display no attempts at self-exoticization and nor do they include 'exotic' referents such as backgrounds and servants that would signify the location of the group far from home and as part of the ruling élite in India. Rather, the photographs in the *Lucknow Album* appear to represent such families as more similar than different to their relations at home in Britain.

The most detailed account of Ahmad Ali Khan's position in pre-'mutiny' Lucknow can be found in letters written by Henry Polehampton between October 1856 and April 1857.[46] Polehampton was the British Chaplain at Lucknow and lived there with his wife Emily. Writing to his mother and brother in Britain, Polehampton described his visits to Ahmad Ali Khan in the Husainabad Imambara. His first attempt to meet the photographer on 4 October 1856 was unsuccessful. Two days later, soon after dawn, he again travelled from cantonments to the Husainabad Imambara, this time accompanied by an interpreter. Referring to Ahmad Ali Khan as the 'Darogha' or 'steward', Polehampton wrote to his mother:

> [He] was not up, and kept me waiting so long, that it would have been derogatory to my dignity (a matter to which one has to attend carefully in India) to stay any longer. So I came away unsuccessful once more. The Darogha is getting bumptious through having so much notice taken of him. He is the only man in the station who does daguerreotypes, and everybody wants them; so he is becoming an important person, and it does not take an Oriental long to find that out. He is a gentleman, and does not take pay; so one has no hold on him.[47]

An imperial relationship of power and subservience between Polehampton and Ahmad Ali Khan was clearly complicated by questions of status and class. The photographs taken by Ahmad Ali Khan were in considerable demand in pre-'mutiny' Lucknow. At the same time, Ahmad Ali Khan refused payment for his photographs and, as a result, acquired the status of a 'gentleman'. In his initial frustration, Polehampton appeared powerless in this relationship, desiring the photographs that only Ahmad Ali Khan could take, and yet resenting his 'bumptious' behaviour and gentlemanly status that undermined any 'hold' that Polehampton could hope to exercise over him. Moreover, Polehampton left the Husainabad Imambara before seeing Ahmad Ali Khan because to wait any longer would have jeopardized his own reputation.

Later that day, however, Polehampton expressed optimism about the likelihood of being photographed by Ahmad Ali Khan when he wrote to his mother that the photographer had sent a Eurasian man to him in search of employment: 'A half-caste man, who knows him, came here to ask me to get him a situation, which I promised to try to do; and charged him at the same time with a letter to the Darogha, which

I hope will prove successful before the mails go out.'[48] By sending an intermediary to Polehampton in cantonments, Ahmad Ali Khan established an indirect contact that ultimately benefited both parties. Not only did the Eurasian acquainted with Ahmad Ali Khan gain Polehampton's help in seeking employment, but Polehampton himself was able to communicate with the photographer without the indignity of travelling to the Husainabad Imambara for a third time.

There are no photographs identified as Henry and Emily Polehampton in the *Lucknow Album* even though, as Polehampton's letters record, Ahmad Ali Khan took photographs of them until as late as April 1857. It is possible that the Polehamptons are one of the unidentified couples who feature in the *Lucknow Album*, but even if this is not the case, Polehampton's correspondence illuminates the social contexts in which the photographs in the *Lucknow Album* were produced, collected, circulated and viewed. The earliest photographs described by Polehampton were taken in December 1856 in the court outside his house in cantonments, seven hours after the death of his baby son. As he wrote to his mother on 7 January 1857:

> I forgot to tell you what most deeply distressed me, after the baby's death, was to find that in my absence Emmie had had her own and my daguerreotype brought her, and had put one of his little hands on one, and one on the other, and the Bible, which her mother gave her, against his breast! It is very sad for her, poor dear little Emmie, to lose her first-born child.[49]

Ahmad Ali Khan took photographs of the baby boy later that day for his grieving parents and for their families in Britain, but copies of these photographs (loosely referred to as 'paper daguerreotypes' by Polehampton) were not sent to Britain until April 1857. As Polehampton explained to his brother Edward:

> Emmie has at last consented to my sending two paper daguerreotypes of our poor little boy. They were taken about seven hours after death. He is lying, you will see, on the sofa, which I had had carried out into the court behind our house … I hardly like to send you these pictures of my poor little boy. I would not but that I like to send anything that may interest you, as I look for the same from you. It makes me sad to think that this picture of my dead child may be the only representative of me that may ever reach England, but who can tell? 'Meliora speramus'.[50]

In his letters to his mother and brother in Britain, Polehampton described the increasing disaffection among sepoys in Lucknow. On 6 April 1857, he wrote: 'Last night, there was a fire in cantonments. Dr Wells, of the 48th's, bungalow was burnt – not *down*, for the walls stand; but the roof was completely burnt off.'[51] The fire destroyed the Wells's home and many of their possessions, including all of their crockery, glass and stores of food, as well as 1,000 rupees. The fire had been provoked by Walter Wells drinking from a medicine bottle in the hospital, rendering it unclean for his Indian patients.[52] The destruction of the Wells's bungalow in cantonments was

a tangible indicator of unrest, and was seen by many, such as Henry Polehampton, as a sign of future conflict in Lucknow. Polehampton reassured his mother: 'Our house is not so likely to catch fire as a bungalow, as it has a flat plaster roof, and very strong brick walls.'[53]

Despite these early indications of unrest in Lucknow, Polehampton wrote to his brother Edward on the day, two weeks after the attack on the Wells's bungalow, that he and Emily had had several portraits taken by Ahmad Ali Khan at the Husainabad Imambara.

> This morning, at six o'clock, I drove Emmie into Lucknow, to be daguerreotyped … The man who takes the likenesses is steward of the place, which is richly endowed. He is a very gentlemanly man, a Mahommedan, and most liberal. He won't take anything for his likenesses. He gives you freely as many as you want, and takes no end of trouble. I have no doubt his chemicals, &c must cost him more than £100 per annum, at the least. This morning I was done with our dog Chloe, at Emmie's special desire. The likeness of me is a profile, the best-tempered looking one I ever saw of myself, and the dog came out very fairly. I will send you a paper impression next mail. I was also done with Emmie. She's the worst sitter in the world, but the Darogha succeeded pretty well. I send you a paper likeness of us, done by him one day last week.[54]

In contrast to the letter in which he complained that Ahmad Ali Khan was becoming 'bumptious', by April 1857 Polehampton described him as a liberal and generous gentleman. Rather than lament the inability to establish a 'hold' over him, Polehampton appears to be grateful for the photographer's skill, care and patience.

For Polehampton, photographs of himself, Emily, their late son and even their dog Chloe helped to maintain an important link between his family and his homes in India and in Britain. Such photographs also helped visually to define a family whose members lived apart in the Empire. These familial and domestic links were not just one-way from India to Britain. On 30 April 1857, in the last letter that he sent from India, Polehampton described to his mother a particularly precious photograph that reminded him vividly of his family in Britain:

> Pray give my kindest love to my dear old Uncle John. I must write to him. I know no one, out of our immediate circle, whom I love better. I often look at the daguerreotype I had done of him, and think of him with affection. I remember St Chad's bells were going for Wednesday morning service as he sat to have it done; and the wind blew his grey hair up, and so it is in the picture.[55]

Later in his letter, Polehampton wrote that 'the Sepoys and natives generally are just now in rather a disagreeable state of feeling towards us'.[56] This unrest culminated in an uprising in cantonments on 1 June 1857. Henry and Emily Polehampton moved with the rest of the British population into the Residency compound, where they lived under siege. Henry Polehampton was hit by shot while he was shaving in the

hospital on 8 July. While he was recovering from this wound, he contracted cholera, and he died on 20 July.

Emily Polehampton, along with other widows, spent the rest of the five-month siege working as a nurse in the hospital. On the day before Lucknow was evacuated in November 1857, she wrote in her diary:

> I burnt all my books, clothing, papers, and letters, – in fact, *all* I had in the world, save a few things, that I kept in our overland box, on the chance of bringing it away. All my husband's sermons that I cared most about I wore in a large pocket round my waist; his gown and surplice, hood and stole, and baby's clothes, I sewed into a pillow; and several small things, likenesses, &c, I put into my carriage-bags.[57]

The photographs taken by Ahmad Ali Khan of the Polehamptons before the 'mutiny' survived the siege of Lucknow and were, with their clothes and her husband's sermons, the only memorials of Henry and their son that Emily Polehampton could take with her when she left India in February 1858.

Emily Polehampton was not alone. On the journey from Lucknow to Calcutta, she befriended another widow, Katherine Bartrum, and her young son, Robert. Little more than a year after the loss of her own son, Emily Polehampton recorded the death of Robert Bartrum in Calcutta on 11 February 1858:

> I washed and dressed him, and laid him upon her bed, and in the morning we gathered roses and other flowers from the garden to lay around him. He had his picture taken as he lay (with buds of orange blossom upon his pillow, and such a sweet smile on his face), by a daguerreotypist, in the middle of the day. The portrait was most successful; the poor little thing lay with its head a little on one side, and he looks as if he were smiling in sleep. The portrait was slightly tinted, to take off the pallor of the effect.[58]

Just as Ahmad Ali Khan had photographed the baby son of Henry and Emily Polehampton soon after his death in Lucknow, a photographer in Calcutta provided the only memorial of Robert Bartrum that his mother could take from India. Such post-mortem portraits, popular both before and after the 'mutiny', were a way of memorializing members of imperial families who lived and died far from home.

Re-viewing Place

The Husainabad Imambara was built in 1837 by Muhammed Ali Shah, who ruled the province of Oudh from 1837 to 1842, and was designed to house his tomb and the tombs of his mother and daughter. By 1842, the endowment totalled almost four million rupees, which were invested in government securities and were used for the upkeep of the Imambara as well as for educational and charitable purposes.[59] Derided by the British *Gazetteer of India* as 'a tawdry building in which the degeneration of intellectual taste is distinctly marked',[60] the Imambara was admired by others. For

example, its opulent interior was described in a guide to Lucknow published by the Baptist Mission Press in 1874:

> the whole interior … is crammed with gigantic chandeliers; candelabra, in crystal, springs from the floor, to the height of twelve feet, branching out in all directions, pier-glasses ten feet high stand against the polished marble walls, the pavement, of porphyry and precious stones, is so highly polished that it is almost dangerous to tread upon it, floor, walls, pillars, all are glittering like glass and reflecting floods of light, so that the mind is bewildered in contemplating such an extraordinary scene, surpassing, by far, the stories of the Arabian Nights, and leaving deep in the shade, any accounts of Oriental luxury or grandeur that have ever been recounted, or even exaggerated, by the most enthusiastic travellers.[61]

In this guide, the Husainabad Imambara is described in fantastical terms of excess, luxury and brilliance, far surpassing the expectations of its grandeur based on other Orientalist accounts.

The Husainabad Imambara was located in the 'native' city of Lucknow, several miles from the cantonments where most of the British population lived before the 'mutiny'. Travelling to be photographed by Ahmad Ali Khan would have been one of the few occasions for British families to enter the 'native' city of Lucknow. Henry Polehampton described his journey from cantonments to the west of Lucknow in a letter to his mother on 4 October 1856:

> I thought Lucknow, as I drove through it the other morning, one of the most beautiful cities I ever saw. The mosques are kept beautifully white, the domes and minarets often gilded. The material is contemptible; only brick, covered with plaster; but the forms of the buildings are good, and they are kept clean outside. At the Imambara end of the city, the streets are very wide, and, thanks to the English, perfectly clean and hard.[62]

Polehampton had previously described the Husainabad Imambara to his mother after his first, unsuccessful visit, and enclosed flowers that he had picked and dried from there:

> The Imambara is a large quadrangle, about the same size as 'Tom Quad.' at Christ Church [Oxford University], surrounded by very beautiful buildings. At the farther end is the King's tomb. It is contained in a large hall, full of all sorts of curiosities. There are many immense chandeliers from England, remarkable only for size; and a wooden horse, from a saddler's shop in Calcutta, is highly prized! With all this, there are some beautiful shrines of silver. The King's tomb is one. It is about eight feet long, and four broad, all silver, as also is his mother's. In the court are tanks of water, something like those at the Crystal Palace; and by the side are creepers trained, and the prettiest creeper is a little red flower, two of which I picked and dried for you, and there they are, not very pretty now.[63]

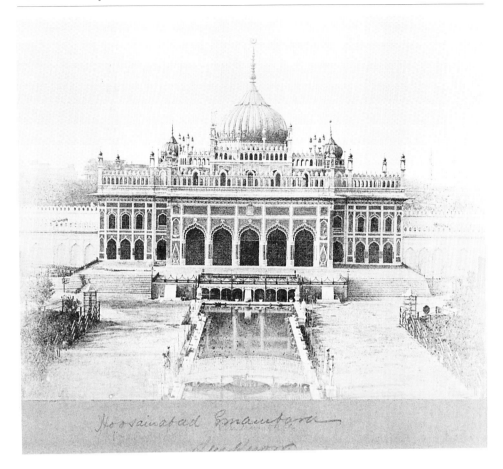

FIGURE 10.5 Ahmad Ali Khan, 'Hoosainabad [sic] Imambara', Lucknow, 1856–
57, from *Lucknow Album*, Vol. 1. Salt paper print, 117 × 78 mm. Oriental and India
Office Collections, Photo 269/1/27. Courtesy: British Library.

Although described in personal correspondence and published guides, the opulence
of the Husainabad Imambara did not feature in Ahmad Ali Khan's portraits of
British families. Nevertheless, in April 1857, Henry Polehampton sent his mother a
photograph of the Husainabad Imambara taken by Ahmad Ali Khan (Figure 10.5).
Although portraits of British families appeared to be placeless, such portraits were
sometimes sent to Britain accompanied by detailed descriptions and photographs
that depicted the exotic surroundings and elaborate interior beyond the white screen.

Conclusions

The two volumes of the *Lucknow Album* provide a unique record of the British and
Indian élites who lived in Lucknow on the eve of the 'mutiny'. In this essay, I have

concentrated on the photographs of British families in the *Lucknow Album* as representations of imperial domesticity before its violent disruption. Ahmad Ali Khan's photographs represented British families to themselves and to their extended families at home in Britain. And yet, taken by an Indian photographer inside the Husainabad Imambara, far removed from the cantonments and civil lines of British imperial domesticity in Lucknow, they are unlike metropolitan attempts to re-create 'exotic' backgrounds for family photographs and unlike later photographs of British families that included their Indian servants. Rather, Ahmad Ali Khan's photographs of British families in the *Lucknow Album* include no tangible referents to an imperial imagination or imperial power. On the eve of the 'mutiny', the photographs of British families in the *Lucknow Album* represented imperial domesticity in familiar ways. The presence of British women as wives, mothers, daughters and friends indicates the number of British women who lived in India before the 'mutiny'. And yet, the photographs of such family groups are strangely placeless, posed against a white screen; there is no attempt at self-exoticization or the domestication of imperial power that posing against Indian backgrounds or with Indian servants might imply. Such photographs were sent to family members in Britain, often accompanied by descriptions and photographs of the Husainabad Imambara where they had been taken. But the ornate surroundings of the Husainabad Imambara remained beyond the frame of family portraits. While the journey from cantonments to be photographed by Ahmad Ali Khan provided one of the few occasions for British families to travel to the 'native' city, their Indian surroundings remain concealed in their photographs. British families were simultaneously placed within, and yet displaced from, the Husainabad Imambara.

Ahmad Ali Khan occupied an ambivalent place in pre-'mutiny' Lucknow. Members of the British élite desired to be photographed and to send copies of such photographs home to Britain, and Ahmad Ali Khan exercised an unparalleled influence over these images of British rulers. As the most skilled photographer in the city, he exercised a powerful influence in representing British families to themselves. The photographs in the *Lucknow Album* not only disrupt a singular, linear notion of imperial power and an imperial photographic gaze, but also destabilize a singular 'Indian' gaze that is defined purely in terms of its difference from a Western view. As Polehampton's letters reveal, Ahmad Ali Khan refused payment for his photographs and came to be viewed by his British subjects as a gentleman. The *Lucknow Album* stands not only as a record of many British and Indian subjects who died soon after, but also stands as a memorial to Ahmad Ali Khan, who, like many of his subjects, died during the 'mutiny'.[64] His skill in the early years of photography in India was known beyond Lucknow, and the two volumes of his photographs that comprise the *Lucknow Album* provide a unique record of visitors and residents in the city just before the 'mutiny'.

ELEVEN

Negotiating Spaces: Some Photographic Incidents in the Western Pacific, 1883–84

Elizabeth Edwards

§ THIS ESSAY is concerned with a series of photographs taken in the Pacific by a Royal Naval officer, Captain W. A. D. Acland. They were taken between 1883 and 1884 when he commanded HMS *Miranda*, a sloop operating out of the Royal Navy's Australia Station at Sydney.[1] While some photographs might be interrogated from the perspective of agency and causality, their forensic detail, their circulation, consumption and impact, this essay focuses specifically on the way in which one might look *through* photographs to allow twenty-first-century eyes more fully to understand and appreciate nineteenth-century performance of space, identity and power in the Pacific. Using photographs 'to think with' can illuminate issues far beyond the forensic content of the images themselves. The constructions and performances with which I am concerned were central elements in the ongoing and increasingly interventionist encounter between colonial and indigenous worlds. The spatiality of social interaction, naturalized, and indeed neutralized, within the realistic appearance of photographs, is inscribed by socio-political relations of which photographs were simultaneously a medium and a product.[2] Vision, and hence its photographic manifestations, can be irrevocably tied to domains of knowledge, arrangements of social space and lines of force and visibility.[3] While this constitutes the cultural formations which made the photographs possible, I shall argue implicitly, however, that the photographs cannot simply be reduced to signifiers of social forces and relations premised solely on models of alterity, nor to models of spectacle and surveillance within a political matrix.[4] Their mechanisms are too complex: they are more ambiguously dynamic.

All photographs are, to a greater or lesser extent, amenable to the kind of analysis presented in this essay, but I shall concentrate here on six photographs, four of the New Hebrides[5] and two taken at Tutuila, Samoa (now American Samoa).[6] While all

Acland's photographs emerge from a clearly articulated contextual base, these six photographs I have chosen seem to me to have a particular density in the webs of significance which Geertz identifies as the site of interpretative activity.[7] It makes them articulate subjects for a case study. They exemplify, in different ways, a full working out of the spatial dynamics within the photograph which are themselves part of (medium) and dependent upon (product) the broader translation of cultural spaces in the Pacific in the late nineteenth century. I shall argue that it is the spatial elements that give meaning to the experience of the participants, give meaning to those concrete spatial elements which form the 'theatre of action' and give shape to cultural performances within them.

The theme of theatre underpins much of my argument. By theatre, I do not mean the embedded formal qualities of drama as a genre, but rather a representation, heightening, containment and projection, a presentation which constitutes a performative or persuasive act directed towards a conscious beholder.[8] Peacock has defined performance as a condensed, distilled and concentrated life, an occasion when energies are intensely focused.[9] Following on from this position, I use the idea of theatre and theatricality in two linked senses. First is an intense sense of presentation and consciousness in the action depicted. This is accentuated by the containments or framing which constitute the photograph itself.[10] Second, I use theatricality in terms of the heightened sign worlds which result from this intensity. As Dening has argued: 'Theatricality is deep in every cultural action ... The theatricality, always present, is intense when the moment being experienced is full of ambivalences.'[11] The ambivalences in Acland's photographs are in the intersecting social spaces which enmesh their making and are embedded in their content.

Theatre is integrally related to spatial forms: it is the arrangement of a narrative within a defined and deliberate space. Spatialization also gives us a way of positioning the contexts of the photographs, opening up their historical possibilities. Context in terms of photographs is often linked to their realism and used to invest them further with authority. Context is presented as something which offers a closure of meaning – the who, what, why, when and where of the making of a photograph and the portrayal of its content. I shall refer to 'functional' or 'originating' context in that this is the context that defines the creation and existence of the photograph, anchoring it as a functional document/object.[12] Context at this level is essential to understanding the photograph as a historical document, and I am drawing on it heavily. However, context is more than a direct explanatory mode. Sperber has argued[13] that an attribution of meaning should not necessarily be directly linked to its causal elements as contextualization in terms of containment or closure of meaning does not necessarily suffice to ensure an adequate rendering of the meaning of what is being 'said'.[14] Context involves more than that which is close to the event. It is a dynamic and dialogical shape of broader discourses which constitute the whole cultural theatre of which the photographs are part. I shall differentiate this as 'dense context'. 'Dense

context' is not necessarily linked to the reality effect of the photograph in a direct way, indeed to the extent that it is not necessarily *apparent* what the photograph is 'of'. Often it is what photographs are *not* 'of' in forensic terms which is suggestive of a counterpoint. 'Dense context' has, literally, a density, opacity and three-dimensional volume.[15] Here, there comes into play an 'awareness that certain phenomena, persons, or events accumulate layer upon layer of meaning, perhaps finding themselves at the crossroads of morphological chains, at the intersection of numerous contexts and action, or at the *nodal point where both contemporary and modern preoccupations reflect and enhance each other* [emphasis added]'.[16] Other contexts, which we may never know fully, were embedded in the complexities of the moment, giving a different shape, lurking within the photographs. The silences of photographs are not necessarily an emptiness but 'the active presence of absent things'.[17] It is after all our own contexts as viewers that enable us to see different points of intersection and different silences.[18] Such configurations form the stage of symbolic action on which the drama of the images' creation and their interpretation is played out. In this sense, 'context' is creative, suggestive and provocative rather than containing in terms of historical meaning.

Space, as I have suggested, is here an essential, provocative element and integral to 'dense context'. Space and place become more than just settings for an action; they are culturally and socially constructed in dynamic practice.[19] Thus, sensitivity to the nuances and possibilities of space and place offers a rich context for the analysis of the photographic incident and its relationships represented in the ongoing encounter of developing colonial agendas in the Pacific. This has relevance not only to geography but also to history and ethnography. To relate concepts of context, as I have just summarized them, to those of space, as they manifest themselves in Acland's photographs, one must first outline briefly notions of a Pacific space as a social production moulded by Europeans. This space of 'restless formation and reformation of [Pacific] geographical landscape'[20] made the photographs possible in physical, political and intellectual terms.

The vastness of the Pacific Ocean had been remarked upon and feared by European seafarers since they first became aware of it in the early sixteenth century. Its multitude of beautiful, scattered and culturally diverse islands formed a framework of place within a vast space which was itself conceptualized in terms of communications. Distance between places, characterized by little-known (to Europeans) currents and winds, supplies of fresh food and water, mapped the space and formed its only coherence. The land on the other hand was perceived increasingly through a series of self-reflective cultural tropes, constructed in the popular imagination as a paradise, the inversion of developing industrialization, alienation and capitalist culture of early modernity.[21]

The age of steam transformed the perception of the Pacific radically. The Pacific became a smaller place in the experience of 'real distance' as communications were no longer hostage to the vagaries of wind and sail. Inexhaustible and apparently

capable of ever-increasing acceleration, ships powered by steam reversed the relations between time, spatial distance (nature) and the technical means for traversing it. Steam deprived nature of its absolute power over the conquest of space, for motion was no longer dependent on the conditions of natural space.[22] As in the case of the railways, the shift was not only in terms of measured distance, but in relationships between peoples and their social spaces.[23] Since the eighteenth century the Pacific had been 'named, renamed with successive acts of possession or sometimes had their native names retained *ex gratia* ... The whole of the Pacific was emplotted in this way by the calendar of saints [San Cristobal], by patronage lines [Admiralty Islands], by accidents of occasion of discovery [Pentecost Island].'[24] By the nineteenth century, the ocean was also being revealed increasingly through scientific investigation and hydrographic survey, especially by Britain and the United States.[25] Space was systematized through relating place to the space of the whole and ultimately to a null point of the coordinate system by which space is ordered, a visibility emanating from the viewpoint of the observer. While one does not wish to argue too reductionist or technologically determined a model here, it is possible to interrogate the emerging European control of space in the Pacific in these terms. In the course of the mid- to late nineteenth century, the Pacific became more closely delineated in spatial terms as the ocean was mapped, depths sounded and plotted, coastlines surveyed and passages charted. Like photographs and their presumed transparent realism, these maps and charts reproduced cultural taxonomic structures as material maps and concrete delineations, fixing both a shape and a name to a place, creating both discourse and order.[26]

The Pacific became a political space and an increasingly contained space as the colonial powers – Great Britain, France, Germany and the United States – sought to enlarge their influence, extending centre–periphery relations. The Pacific became perceived increasingly in the West as a space constituted by political force through which economic, technical and social possibilities, be they conversion or copra, could be realized.[27] Although the heyday of grand-scale *theatrum mundi* of encounter in the Pacific had long passed,[28] the theatre of the micro-event of cross-cultural discourse was still active, and photography – the eye and inscriber of the latter days of *Pax Britannica* – in part created those moments of theatricality in historical terms. The Pacific became delineated by trade and labour needs and by the requirements of the modern navies of the expanding colonial powers which were chained to an elaborate apparatus of fuel depots and repair bases.[29] In sea power, the stress was not on warfare and aggressive colonial intervention, but on 'command of the seas' to serve the interlocking needs of the Navy, commerce and colonial development, especially that of Australia.[30] Much of the Royal Navy's operations out of Australia Station was part of the Admiralty's global policing network of small, cheaply maintained ships. As Rodger has summarized it: '[c]hasing pirates, slavers, and savages, the Navy engaged relentless war on everyone who resisted the sacred liberal virtues of Parliamentary government, scientific progress and free trade.'[31]

Even after the administrative delineation of space with the establishment, in 1877, of the High Commission for the Western Pacific based at Suva in Fiji, the Navy was employed in policing and diplomatic duties over a huge area reaching from Tonga to New Guinea and from Micronesia to New Zealand.[32] One of the principal duties was policing the labour trade whereby labourers were 'recruited' (by means foul or fair) from island Melanesia[33] to work, under an indenture system, on the plantations of Queensland, and to a lesser extent Fiji and other islands.[34] This system was open to serious abuse, both in the way labourers were 'recruited' – which was sometimes little better than kidnap – and in the way in which recruits were treated by the labour boat captains. The Navy also functioned in a diplomatic and quasi-judicial capacity, sorting out reports of massacres and atrocities, white to islander and islander to white, and delivering malefactors to the relevant authorities if possible.[35] The sheer length of time required for communication[36] and the isolated work left senior officers a fair degree of independence and personal discretion in the interpretation of orders. It also meant that more junior, and often relatively inexperienced, officers, perhaps with command of a small gunboat, were forced to make reactive humanitarian and diplomatic decisions of great importance in the field.[37]

I do not want to dwell on an over-extensive review of the Royal Navy in the Pacific here, but it is relevant because all these facets of policy and practice were part of the definition of the Pacific as a place within the colonial perception. Any photographic practice in the Pacific at this period should be seen within the broader cultural ambience of these perceptions. Local social worlds, intersecting or not, cannot be understood in isolation from the 'macro-order of location', territorial identity and sense of place.[38] These form the unifying narratives of Acland's photographs and their cultural patterning, part of the 'dense context' formed by a web of negotiated and contested relationships in the western Pacific.

Captain Acland's Photographs

There are some eighty Pacific photographs in the Acland collection at Oxford.[39] They appear to result from both the 'Island Runs' of October 1883 to January 1884 and April to October 1884, undertaken by Acland as commander of HMS *Miranda*. However, the exact chronology cannot be certain. *Miranda*'s logs[40] show that she visited the various islands of the New Hebrides group more than once on each tour of duty. It is clear from letters to his family that Acland sent photographs home on both tours of duty. The Samoan material comes early in the series and can be dated precisely, the Malakula material late in the series and linked to the investigation of the murder of John Hunt, the site of the massacre appearing in two photographs.[41] This investigation was part of the second tour of duty. Given this, it would appear that the registry order of the negatives approximates the chronological order. It is also possible that visits were conflated in the ordering of the photographs; however, there is a broad

correlation between the sequence of original numbers scratched on the negatives and the list ordering at the time of deposit, which is not in Acland's hand.

Almost half the photographs (thirty-nine) are of the New Hebrides, twelve are of Samoa, and a further four of Banks Islands. There are two of Noumea, New Caledonia, and one of Levuka, Fiji, both ports which *Miranda* visited. The remainder are concerned with life in the Navy, visitors to the ship, views of Sydney harbour and New Zealand landscapes. That the majority of the western Pacific photographs are of the New Hebrides is not surprising given Acland's duties. He spent a considerable amount of time on both his 'Island Runs' involved with problems of the labour trade and the volatile relations between Islanders and settlers, especially in the north of the group in Malakula and nearby islands. The New Hebrides at this period had a fearsome reputation among colonials for violent confrontation and what were seen as 'savage' practices. Both France and Britain had a colonial interest in the group which was not formalized until the establishment of the Condominium in 1906. Thus, it would seem that the diplomatic and policing theatres of action, and the Royal Navy's part in them, formed the broad intentional strategies which shaped the New Hebrides material.

The theme of on-going encounter runs through all Acland's western Pacific photographs. It is not an ethnographic presentation, although they soon became entangled in ethnographic discourse through the contexts of their archiving and their use.[42] When Acland does use the camera 'ethnographically', the nuances are subtly different from those images of on-going encounter and Royal Navy policing which I discuss below. The choice of subject matter in the 'ethnographic' images is consistently 'spectacular' in that the photographs present not an ethnographic quotidian but specific and singular impressive or monumental objects, such as the 'grade' society figures of painted fernwood at Ambrym (Figure 11.1),[43] the slit gongs at Efate or the men's house, *amel*, at Malakula. We have the making of an ethnographic place marked through its objects. The style is more descriptively 'frontal' both in terms of the depth of photographic field and in the posing and arrangement of groups within the frame. The presence of the camera is clearly articulated in the way it reveals its mechanically descriptive purpose, as objects and people are arranged, almost mapped, across the picture plane with little deviation from its horizontal forms. The clear focus is on the object, the people being defined through the object. The colonial contexts and narratives of intersecting spaces, so clear in all Acland's other island photographs, are largely missing. Nevertheless, the very act of photography carries its own set of spatial relations as the subject is placed physically before the apparatus, bringing a further social space into play. There is a pervading sense of unease in the ethnographic images. I do not believe that, at this date, such unease can be reduced merely to an unease with the notion of photography; rather, one could argue that the mood points to intersections which may be outside the photograph but nevertheless resonate within it.

Acland's other photographs articulate more strongly the ongoing encounter and

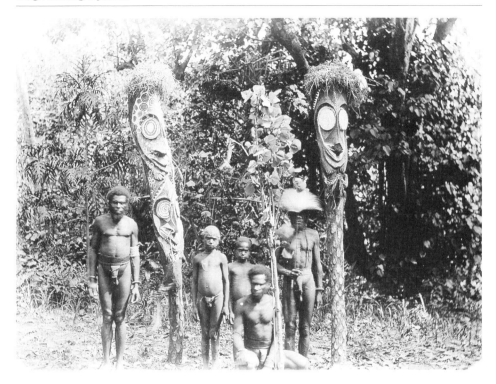

FIGURE 11.1 Captain W. A. D. Acland, 'Fernwood figures', Ambrym, New Hebrides [Vanuatu], 1884? Albumen print from gelatin dry plate negative, 204 × 151 mm. Courtesy: Pitt Rivers Museum, University of Oxford, PRM C.15.2.

negotiation of places, spaces and identities within a changing discourse. However, they too have accrued ethnographic meaning, acquired through the contexts of their preservation. Through divesting them of this ethnographic noise and positioning them within the socio-political spatial dynamic of colonial relations, we can begin to realize their complexity.

On the Beach at Malakula

The majority of the New Hebrides photographs record relations between the indigenous population, the Royal Navy, the mission and traders, precisely the sphere of operations with which the Navy was involved and through which it delineated its perception of the Pacific as a space and as a differentiated geographical region. These were not always easy relationships. From the Navy's point of view they were caught between humanitarian and disciplinary demands. Acland wrote to his family:

> People in England have no idea of the responsible & anxious work we have out here … there are frequent squabbles between traders & natives and some one gets killed,

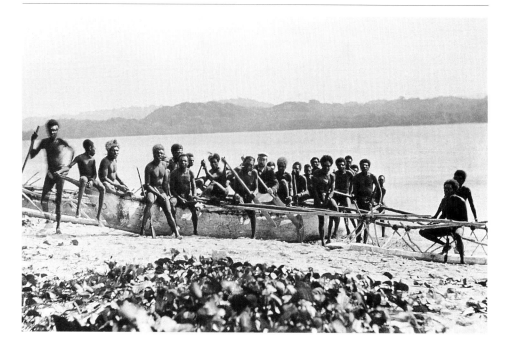

FIGURE 11.2 Captain W. A. D. Acland, 'Beach scene', at Malakula, New Hebrides
[Vanuatu]', 1884? Albumen print from gelatin dry plate negative, 135 × 200 mm.
Courtesy: Pitt Rivers Museum, University of Oxford, PRM C.1.2.29a.

then the natives avenge themselves on a white man, it is then called a massacre & the
Man of War has to go down and engine into the case & sometimes has to punish the
natives by an act of war. Most disagreeable and unsatisfactory work & one which
generally gets the Naval Officer into trouble, either with the Commodore, the Ad-
miralty, Traders or the Aboriginal Protection Society.[44]

In the light of the webs of significance, we can attempt to read through this photo-
graph of rowing the outrigger canoe. The scene on the beach (Figure 11.2) emerges
as a performance through which the potentially volatile situation was worked out;
good humour and camaraderie appear to defuse the situation. Intimacy is suggested
by the close and theatrical containment of both the canoe and the borders of the
photograph frame. A naval lieutenant is 'inserted' into Melanesian physical space of
the outrigger canoe. At one level, this theatricality of action would appear to fracture
Melanesian space – for boats are redolent objects – and make the power relations
visible. Yet, as I have suggested, the absence or silence can be an active presence.
Melanesian space may appear suppressed in the photographs, but it is present in the
social being of the people on their beach, with their perceptions of what is happening.
The relationships between people and place are structured not only on colonial
terms, but within both power relations and the discursive practices of the islanders

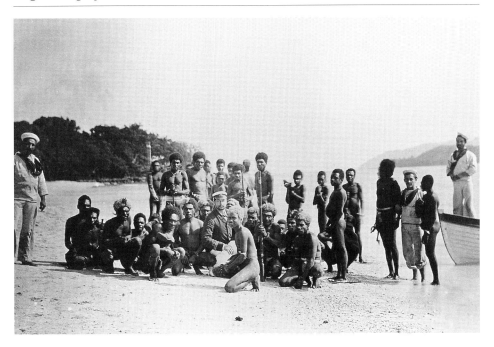

FIGURE 11.3 Captain W. A. D. Acland, 'Beach scene', at Malakula, New Hebrides [Vanuatu]', 1884? Albumen print from gelatin dry plate negative, 135 × 200 mm. Courtesy: Pitt Rivers Museum, University of Oxford, PRM C.1.2.29c.

themselves. Beaches, the boundaries of islands, have major resonances within such constructions of place. Land is important in Melanesian societies, being linked to status through the production of food. Thus geographical 'facts' link people to history and the organization of local knowledge.[45] At the same time, as Hau'ofa has argued so eloquently, Pacific islanders view the island/sea space as a totality comprising not only dry land spaces but also the ocean itself. A 'sea of islands' is very different from the western 'islands in the sea', which drew lines around the dry land and confined islanders to small spaces.[46] Thus Malakulans, through the presence of their own cultural understandings of that space, mark it within the photograph. We are conscious of the possibility of different understanding. Consequently the photographs constitute a working out of contested or intersecting social spaces. Dening's eloquent model[47] of the beach as a space of cultural negotiation in the early years of European–Pacific contact is revealed as equally applicable for the beaches of the 1880s.

Another beach scene, taken at the same time (Figure 11.3), is similarly carefully framed and composed with a depth of grouping. Two naval ratings, forming the left and right frames, contain the group, the one on the right standing in the bow of the ship's boat which projects into the frame. At the water's edge, another seaman stands, arms linked (steadying?) with those of two Melanesians. These two images assume

what Daniels has described as 'high specific gravity', for they appear to 'condense a range of social forces and relations'.[48] They are intensified by the framing of the photograph itself, which stresses its performative relations with the viewer. The central social force here, one can argue, is that of the intersecting social spaces, which are constituted by the expanding colonial domain and the increasingly dominant forces of its specific spatial agendas. These photographs show Melanesian space at the point of negotiation, between space and types of power, between what is close to individuals and those remote and exterior forces, such as the Royal Navy and colonial policy, in which local life is enmeshed.[49] Within the containment of the image, small heightening details, such as the linked arms, and the boots (seaman's boots?) slung around someone's neck, assume a metaphorical and symbolic density for the modern viewer. The careful presentation to the camera has a quiet theatricality with all the self-consciousness that such a *tableau* entails, as both parties project their contesting spaces for the resulting image. On one hand, the 'exact look' of the photograph – traces, inherent in the nature of the medium itself – disguises the gesture, utterance and resonance on which fragile relations, such as those on the beach at Malakula, depended. On the other, those gestures and utterances are made palpably present *through* the photographs if we imagine the theatrical possibilities of the temporarily suspended gesture, the stayed glance, the motionless finger on a forearm.

I do not want to over-read this or suggest that these inscriptions are necessarily intentional visualizations of spaces and the relationships entangled in their making. The photographs should be seen as inscriptions of crossroads, accumulated layers and morphological chains, a working out of the broad cultural and political 'atmosphere' which made them possible, both in empirical or practical terms and in metaphorical terms. At an empirical level, the Mitchell Library album (see note 6) reiterates this position, juxtaposing the photographs of the islands with the colonial progress of HMS *Miranda* over two tours of duty on the 'Island Run'. The narrative positions the images firmly and provides both an 'originating context' and a suggestion of 'dense context', resonating with a broader establishment of the shape of colonial space in the Pacific.

Perhaps the most extraordinary of Acland's New Hebrides photographs is that taken at Ravenga, Efate, described in the negative list simply as 'Ravenga, Vate, New Hebrides',[50] and in the Mitchell Library album as 'Native Hut – Ravinga Island of Vate'. Its composition is surely an intentional *tableau vivant* (Figure 11.4). The double framing of the photograph's edge and, within it, two pairs of palisade stakes forming an entrance, constitute a proscenium arch for the 'action'. Two men stand, posed (by whom?) with guns pointing into the centre of the frame, or is it at each other? Other men look on, two holding steel axes. Behind them a group of women crouch, heads covered, perhaps uncertain of the camera and the action around them. The centre of the image is given a promethean touch by the smoke rising, in front of the protagonists, from earth ovens covered with mats. A thatched hut forms the backdrop while, to the right of the frame, two Melanesians in European dress watch Acland

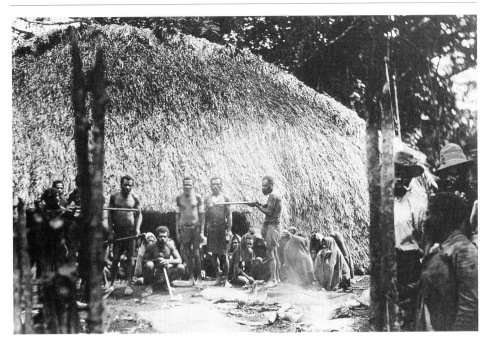

FIGURE 11.4 Captain W. A. D. Acland, '*Tableau vivant*', Ravenga, Efate, New
Hebrides [Vanuatu], 1884? Albumen print from gelatin dry plate negative, 125 × 190
mm. Courtesy: Pitt Rivers Museum, University of Oxford, PRM B.39.1b.

while another watches the action. This group forms the visual link between action
and audience. Acting involves a command of spaces on stage and an ability to project
those spaces into those of the audience. The viewer is thus drawn into the space of
the image through its theatrical presentation.

It has not been possible to establish precisely when the photograph was taken. An
informed guess would be early 1884. Nor do we know at present what the intention
might have been. If placed in the contexts of colonial concerns at the time, one can
conjecture that this image constitutes a theatrical demonstration, a performance, of
the concerns of the Royal Navy in relation to the availability of firearms in the islands,
which was seen by the colonial authorities as an increasingly serious problem.[51] A
number of Acland's photographs from the 'Island Run' include firearms. This not
only reflects the prevalence of firearms but, one can conjecture, that Acland's official
concerns with firearms sensitized his 'seeing' to them. The meaning of this photograph
would seem to lie in the rhetorical relationship between its 'functional and originating
context' and its theatrical spaces of symbolic action, its 'dense context'. The photo-
graphic frame and the actions within it form a symbolic environment in which, one
might argue, the 'truth' of history can be experienced through its expressive, rather
than its realist, forms.[52]

This may appear to have strayed a long way from space/place, but I think not. The plurality of spaces which suffuse these photographs is informed precisely through their 'dense context'. Such spaces are always centred on human agency, amenable to change because their constitution takes place in everyday praxis. Humanized space forms both a medium and outcome of action, both constraining it and enabling it.[53] These photographs represent precisely that. Beaches, like the deck of a ship, as discussed below, are intercultural and transcultural physical spaces, places in which more than one social space is extant.[54] The dominant 'noise' of colonial discourse and the ethnographic 'noise' of archiving may render islander space illegible at first glance, but it is there for anyone with the will and patience to engage with it. Further, photographs, paradoxically, both heighten and suppress. The frame concentrates the eye/mind on a confined physical space of 'exact look', the seductive mechanical realism of the medium which conflates and essentializes space. But it also heightens the 'reality' of moments of space and time through the theatricality of its presentation. Through the very act of dramatizing and making visible, photography inserts the specific moment of *experience*, so central to the construction of space, into the historical consciousness.[55] Further, it makes concrete the construction of social space through experiential response to specific interactions in physical space.

A Palaver at Tutuila

I want to turn now to two Samoan photographs in which these elements of spatial dynamic are most clearly articulated, both at the level of individual event and within the dynamic context of the changing spatial perception of the Pacific outlined above.[56] The 'originating and functional' contextual positioning of these images is very rich. The photographs reify for us one of the micro-events which shaped the social construction of intersecting social spaces and which ultimately shaped the Pacific of the geographical imagination. We know a great deal about them, thanks to the diligence with which Captain Acland reported the proceedings to his commodore in Sydney and to the Admiralty. This allows us to read 'through' the photographs to access structures of space, power and identity, which are only partially visible on the surface. The photographs are a performance, in miniature, of the spatial dynamics which constitute a theatrical playing out of the structures of which they are part and on which they depend. They become self-referential metaphors for the historic moment itself.

On 21 October 1883, HMS *Miranda* was ordered to proceed to Fiji where Acland was to investigate an alleged murder and then cruise the islands, especially the New Hebrides, until the end of the season unless the Acting High Commissioner for the Western Pacific, based at Suva, required any particular action to be taken in the area under his jurisdiction.[57] *Miranda* was thus intended to move around a space defined by British authority. When *Miranda* arrived in Fiji on 4 November, the Acting High Commissioner, Sir George William de Voeux, strengthened Acland's own authority

by giving him the rank of Deputy-Commissioner for the Western Pacific.[58] De Voeux then requested that *Miranda* sail straight for Samoa where the activities of a group of New Zealand adventurers were causing problems although, in fact, by this date, Samoa was increasingly marginal to British interests in their definition of the Pacific, and the Royal Navy had found that countering German influences in Samoa stretched resources unacceptably.[59]

The politics of space and place resonate through the whole unfolding episode and, as I shall suggest, through its photographic traces. When Acland arrived in Samoa he received a request from King Malietoa Laupepa to act on his behalf, with the co-operation of the consuls of the other Great Powers,[60] and intervene in a local dispute which had been giving concern for some time. Samoan internal politics were in ferment and had, through the late 1870s and 1880s, become a tool for international rivalries in colonial ambition. Although Malietoa Laupepa was presented as 'King of Samoa', it was a concept entirely alien to traditional Samoan power structures which were based on the lineages of senior *matai*.[61] The unified sovereign was created by the Great Powers in order to provide a model of authority to which they could relate and thus pursue their own agendas in the Pacific as they related to the geographically strategic Samoan islands.

However, with no warship in Samoan waters, the Great Powers had not been in a position to respond to Malietoa Laupepa's concerns.[62] The dispute involved two rival claimants who had started fighting over the entitlement and succession to the Mauga title on Tutuila. The cause, in itself, was not unusual, nor was its eruption into violence, and it would normally have been seen as an internal Samoan issue.[63] However, what caused particular concern to Malietoa Laupepa was that while one claimant, Mauga Manuma, supported his party, the other, Mauga Lei, was of the opposition party who supported the rival claims of Tamasese, creating a focus for more general-ized opposition to Malietoa Laupepa's kingship. Thus, not only did the situation threaten to escalate into a full-scale civil war, jeopardizing Malietoa Laupepa's own position, but it threatened to destabilize the careful consolidation of a central in-digenous power, orchestrated and supported by the Great Powers.

Any threat to this status quo was clearly a threat to the interests of the Great Powers themselves. Acting on the request of King Malietoa Laupepa and the three consuls of the Great Powers, Acland set sail for Pago Pago, Tutuila, on the evening of 16 November. He was accompanied by the British Consul, Mr W. B. Churchward, the Reverend Charles Phillips of the London Missionary Society, who had agreed to act as interpreter, and two senior representatives of King Malietoa Laupepa – Seumanutafa, 'Governor' of Tuamasaga, the central district of Upolu, and Lauati, reputedly one the finest orators in Samoa, from Malietoa Laupepa's native district of Fa'asalele'aga, Savai'i.[64] Following was the German dispatch ship *Hyäne*, which had just arrived in Samoa, carrying the German Acting Consul, Dr Stuebel.

The intention of the mission was to put a stop to the fighting which threatened to

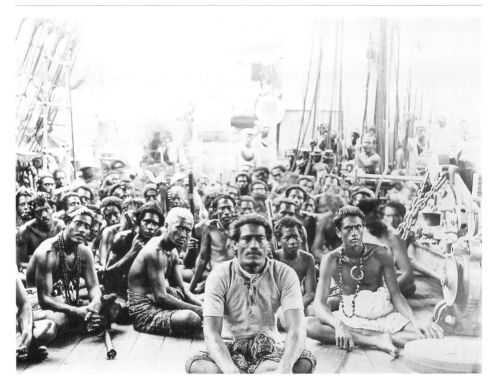

FIGURE 11.5 Captain W. A. D. Acland, 'Mauga Manuma and supporters on the
quarterdeck of HMS *Miranda*', off Pago Pago, Tutuila, Samoa, 18 November 1883.
Albumen print from gelatin dry plate negative, 153 × 208 mm. Courtesy: Pitt Rivers
Museum, University of Oxford, PRM B.36.10a.

engulf the whole of Samoa, not to resolve the argument over the entitlement to the
Mauga title itself, which was purely a Samoan affair. Letters were sent from Acland
and the consuls to both Mauga Lei and Mauga Manuma, requesting their attendance
on HMS *Miranda* at, respectively, 10.30 a.m. and 2 p.m. on 17 November so that the
wishes of King Malietoa Laupepa and the Great Powers could be communicated.[65]
The Maugas duly attended and, after discussion, acceded to demands. Fearing that
neither party would adhere to the peace agreement, Acland recalled both parties on
board HMS *Miranda* the following morning, 18 November, at 10 a.m., for a formal act
of recognition and reconciliation.[66] The parties boarded the ship from opposite sides.
Each party was positioned at corresponding sides of the quarterdeck, the Great Gun
between them.[67] At the head of each party sat its chief, the Maugas, who were
requested to make agreement formally and to give up their firearms. At this point
Acland took two photographs (Figures 11.5 and 11.6).

> The idea struck me that if I could get the fighting men onboard each chief on one side
> of the Quarter Deck and talk to them we might be able to get them to shake hands

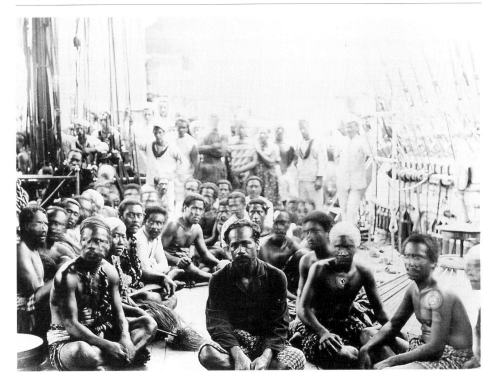

FIGURE 11.6 Captain W. A. D. Acland, 'Mauga Lei and supporters on the
quarterdeck of HMS *Miranda*', off Pago Pago, Tutuila, Samoa, 18 November
1883. Albumen print from gelatin dry plate negative, 150 × 203 mm. Courtesy:
Pitt Rivers Museum, University of Oxford, PRM B.36.10b.

& rub noses & so make the promised peace a little more certain. The two photos. show
the scene on the Qr deck during the palaver. The two chiefs in the middle surrounded
by their followers.[68]

The formal structure of these photographs is similar to many other ships' photo-
graphs. The 'natives' seated on the deck in an organized group are surrounded by
British (or French or German or American) sailors. They are framed by the technical
mastery embodied in the warship, the fighting machine, and in the technical mastery
of the photographic frame. Like so many of Acland's Pacific photographs, they are
photographs of encounter or interaction within an established colonial pattern. Yet
they cannot be dismissed in an essentializing model of social relations because using
the ideas of space to interrogate the images opens up the photographs to a very much
more complex and nuanced reading in 'dense context' which reflects back possibilities
on the more mute and contextually uncertain New Hebrides photographs we con-
sidered above.

What are the spatial elements at work here? What are the intersecting configura-

tions of space, either forensically or metaphorically, in these photographs? First is the space of action, the concrete place, one of 'location', expressed photographically as the authenticating 'this is how it is', that power of the evidential Barthes found so insistent.[69] However, this becomes a second space, one of constraint. Here, location, the framework for the event, is transformed into metaphor through the mobilization of political power.[70] The ship becomes the space of containment or constraint, the zone in which power achieves its concreteness.[71] Integral to this, the elements of logic and design that shape public events, such as Acland's little theatre, are encompassed by the dynamic spatial complexity, instrumental in the construction of social space.[72] The quarterdeck is a deeply cultured and instrumental space, displaying an intensified fragment of the culture of colonial power. However, power by itself is too crude an instrument for measuring all the subtleties that make up the interaction within these photographs, for just as many meanings coexist in one photographic image, so many spaces coexist in one physical space.

To explore this more closely: the two claimants to the Mauga title are seated on *Miranda*'s quarterdeck. This is a space which itself is heavily connotated culturally within the Royal Navy. The quarterdeck was a sacred or non-ordinary space reserved for officers, and within this the space was subject to invisible hierarchical mapping.[73] It was also the site of non-ordinary events, receptions, courts-martial, divine service; in the early days of the Royal Navy the crucifix or shrine was placed on the quarterdeck and acknowledged by those boarding the ship who customarily looked towards the stern (the position of the quarterdeck) and saluted. Its use and shape of significance cannot have been lost on the Maugas and their retinues. They knew well why they were there and the webs of significance which entangled their presence.[74] Within the plural spatial dynamics of colonial negotiation, the photographs become metaphors for the encounter of Mauga Lei, Mauga Manuma, Acland, the consuls and the representatives of King Malietoa Laupepa, each party contained within its own frame, contained within the quarterdeck of a Royal Navy ship, the camera placed somewhere in the middle. Thus the quarterdeck of *Miranda* becomes a point of spatial intersection. To the Great Powers, the ship becomes a microcosm of the authority delineating the Pacific, floated into other authorities. The Maugas have been removed from Tutuila, the site of their own contested powers, to a space in which the spatial concerns of the colonial powers are instrumental. There is a further highly charged intersection spatially represented by the ship, that of the Great Powers and King Malietoa Laupepa. Yet, with the exception of a few naval seamen watching the proceedings from beyond the Maugas and their supporters, the Great Powers appear in the photographs only through their metaphors, the ship and the existence of the photographs themselves. Without the concept of space, these revealing metaphors could not emerge.

However, a point of spatial fracture is in place. Despite the appearance of containment within the space of a British gunboat, there is a Samoan spatial articulation clearly at work, which, rather than being fractured by the spatial expressions of colonial

power we have just discussed, actually asserts its own cultural cohesiveness and fractures (or perhaps subverts) the totality of authoritative space. One could argue that the process of emerging global power is confronted by conscious local configurations of space. Pre-existing socio-political hierarchy in Samoa allots and controls spatial dynamic within precise locales, premised on the space of the socialized body, notably in the village meeting. The claimants to the chiefly title (the Maugas) are seated in the centre; over their right shoulders are their orators, 'talking chiefs' with limed hair and carrying the ceremonial fly-whisk, who spoke for the chiefs and served as chief advisers. Given that these crucial protagonists are in their places – an ethnographically confirmed, spatial arrangement; the other chiefs are in broadly semi-circular array around the Mauga – it is not an unreasonable assumption that the rest of the entourage express hierarchical and kinship relations spatially.[75] Samoan hierarchies, and thus authorities, can be seen, literally performed, on the quarterdeck of HMS *Miranda*.[76] Acland may have been the director, but the actors gave of themselves. Yet, paradoxically, those spaces can be reproduced; as we see here, they are also open to transformation. Like a photograph, appearances may be reproduced, but Samoan social space cannot be replicated precisely for the contexts of social action shift. The contested signification transforms the intersecting spaces and involves different densities of experience.[77] The ship becomes literally the space of negotiation and a negotiated space.

Such a space cannot, however, be separated from temporality. Consequently, something must be said briefly, for it is never far from the surface of this argument.[78] Barthes's description of the illogical conjunction of spatial immediacy and temporal anteriority[79], inherent in the photograph as it fragments time and space, is central here. While my focus has been on space, it should be noted that the two photographs exemplify the process of photographic incision in temporal process: the frenzied temporal processes – of violence and burning, of diplomatic and colonial negotiation, and of manoeuvring in physical space – end in the stillness of the photograph where the nuanced surfaces are drawn in full detail in a way which is uniquely photographic.[80] This apparently static yet insistent inscription can be read as the antithesis of the experience itself. Yet in releasing the viewer from the temporal urgency of the event, the photographs themselves actually create the space for different temporalities to entangle the event and its images. Temporal and spatial processes are integrally active in the production of meaning, but, as suggested in relation to Acland's photographs, temporalities operate at a different scale of discourse when used in conjunction with the spatial.[81] That 'thickness' of description, which started with the cross-reading between the photographs, the Admiralty Office records and theoretical notions of space as an interrogatory model, begins to take shape as 'piled-up structures of inference and implication'[82] which constitute more than a density of simple linear narrative or simple fragment of physical space within the photographic frame. In other words, 'dense context'.

Approaching these two photographs through the rhetorical relation between the 'originating and functional context' and 'dense context' I have just outlined, and interrogating them specifically from the perspective of the social construction of spaces, give us an insight into the spatial dynamics at work. This in turn, as I have suggested, is integral to the delineation of the Pacific as a colonial space in the late nineteenth century. They exist in dialogic relation with one another. The photographs show a set of relations within space, not merely the specifics of physical space, but a cultural space.

Through this recognition of spatial organization re-presented in the photograph, we can come to a greater understanding of the working out of the social processes involved in the construction of a plurality of spaces contained within one image. It is a manifestation of heterogeneous space, relational space which is both concrete and abstract at the same time, where several spaces are temporally coexistent in the same physical space.[83] Further, it is relational in that it mirrors the spatial relations between Samoa and the colonial dynamic in the Pacific which I outlined earlier. The spaces are reified and heightened through the nature of photography itself which, as I have argued, fragments both space and time with intensifying theatrical effect. Photography also draws attention, through its stillness, to the space as one of tension and transition. The spatial patterning of normal social process is projected into the non-ordinary, outside space and time – like theatre. This is the central conundrum of photography, the source of its ambiguity.

In the final analysis, what these photographs do is reify space, making concrete the shift from mental space to social space, from epistemology to practical reality,[84] a heightening process born of the spatial immediacy and temporal stillness that are uniquely inherent to the photographic medium. These two formative elements give an intensity of moment which emphasizes the theatricality of the event, precisely fracturing the processual and instituting an ambiguous plurality of spaces and a tension between temporality of moment and atemporality.

Conclusion

The act of photographing endowed the spatial structuring of 'event' with a perman-ence and theatrically which echoes, at an abstract level, the performance of the event itself. Through a contemplation of spatial figuring, one can reveal the complex structures enacted in a given situation. I have argued a reading through these photo-graphs to the performances of space, identities and power. They are not the only readings, nor are readings mutually exclusive. I have merely chosen to argue for the spatial dynamic in the images and for the construction of space and making of place in which they are enmeshed. This approach might enable us to spatialize the historical narrative, to bring the instrumentality of the spatial dimension of an 'event' and its inscription to the fore, and thus to explore the 'dense contexts' of photographs – the

layering upon layer, the crossroads of morphological chains that I argued at the beginning. Through this, I hope to have reached towards the multiple discourses involved in any fragment held in the form of a photograph. There are other narratives, for instance those clustered around temporalities and the making of history, which are never far beneath the surface of a spatially focused argument. Indeed, they could form equally valid foci for an essay.

Place, as Brenda Croft has argued, 'is an integral part of [these] images even when there is no landscape evident, even when there is "no there there" … Understanding photographs is a process of reaching out for what finally is absent, rather than grasping the presence of new "truths" and disseminating "new" information.'[85] Through my concern with the dialogue between surface and depth which a photograph embodies, I hope to have suggested the way in which the different levels or poles of meaning work and in which, like social drama, the subsidiary subject is really 'a depth world of prophetic, half-glimpsed images and the principal subject, the visible, fully known (or thought to be fully known) at the opposite pole to it, acquires new and surprising contours'.[86] Because the poles are active together, the unknown – the plurality of layers and the metaphors at the intersection of space, place and photography – is brought a little more into the light by the known. I have consciously extended beyond 'grounded' reading to suggest a range of resonances which must inform all more 'contained' readings. For if we do not explore the intellectual possibilities of photographs, but succumb to what Soja has described as 'a myopia that sees only a superficial materiality',[87] we will surely, through privileging surface over depth, be blind to more than half of what photographs have to tell us.

Approaching photographs from a spatial perspective and relating, in turn, the spatial dynamics within them to theatres of context and action, perhaps goes some way to moving photographs away from their essentializing tendencies. Such photographs may not have constructed the colonial space of the Pacific in a direct causal fashion, but they are inherently constituted by, and constitutive of, the space by being what they are – for existing at all. As Geertz has argued,[88] the essential task of theory is to make thick description (or here 'dense context') possible, not to generalize across cases but to generalize *within* them, to make thick description more eloquent and to draw larger conclusions from the small. The photographs comprise a simultaneous presentation of differently constructed and variously perceived spatial worlds and spatial dynamics. I would argue that the photographs on the beach at Malakula or on HMS *Miranda* at Tutuila, in their turn, must be seen as part of a wider acting out of roles in the Pacific, roles which are informed by, and enmeshed in, those exterior forces that negotiate the space of the Pacific at both a macro- and micro-level.

Epilogue

TWELVE

Wunderkammer to World Wide Web: Picturing Place in the Post-Photographic Era

William J. Mitchell

§ FOR AS long as history records, societies have formed their knowledge of past times and distant places by capturing, transporting and displaying evidence of displaced scenes – in particular, visual evidence. The capabilities of the image production, accumulation and distribution systems that were available for this purpose have determined the quantities and perceived levels of reliability of the evidence that has resulted, and hence the cultural, social and legal uses to which this evidence could be put. And there has always been a flip-side, as well; each such technological system has created characteristic opportunities for falsehood and fiction.

To understand these systems adequately, and to assess their changing roles in the production of historic and geographic knowledge, we must look beyond the optical precision and other technical properties of the image formation process. We must consider how *all* aspects of a system – production, reproduction, storage, processing, management, distribution and consumption – combine to create a ground for discursive practice.

For a century and a half, as this volume demonstrates, the system of photography held sway, and has supported a rich variety of practices in a wide range of social spaces. Now, with the development and popularization of digital-imaging technology, the ground is shifting; rules and conditions of visual documentation are rapidly changing once again. Extraordinary new technical and cultural possibilities are emerging and, at the same time, the transformed terrain of visual practices provides a new vantage point from which to look back and put the 150-year history of photographic practice into perspective.

Before Photography

The most ancient of visual evidence collection and display systems is that of the hunter, fisherman, botanist, geologist, relic hoarder and souvenir collector. It depends, first, upon traps, nets, shovels and other devices for physically appropriating actual fragments of distant sites. Then, it requires a physical transportation system – anything from a camel to a lunar lander – to get these fragments back home. Finally, it demands a place to arrange, preserve and display the captured and displaced specimens: a curiosity cabinet, botanical garden, zoo or museum.[1] As Francis Bacon put it in *Gesta Grayorum*, a learned gentleman required a 'goodly huge cabinet, wherein whatsoever the hand of man by exquisite art or engine hath made rare in stuff, form, or motion; whatsoever singularity chance and the shuffle of things hath produced; whatsoever Nature hath wrought in things that want life and may be kept; shall be sorted and included'. And in his 'spacious, wonderful garden' he should keep botanical specimens from the far reaches of the earth, rare beasts and birds, and two lakes for fresh-water and salt-water fish to create 'in small compass a model of universal nature made private'.[2]

These sorts of systems are slow, laborious, expensive and sometimes dangerous to their operators. They produce small quantities of extremely compelling evidence, which we often value highly because of its rarity or uniqueness, and which frequently conveys a sense of the marvellous. We have been willing to spend hundreds of millions of dollars to bring back a few moon rocks, for example. And we would sit up and take notice if an expedition returned with a single actual specimen of a Loch Ness monster or Bigfoot. For those who want to employ these physically-based systems to construct fictions or falsehoods, the trick is to fabricate specimens (such as Piltdown Man's bones) and equip them with false provenances.

Slightly less direct in their operation are systems that make use of contact impressions, such as brass rubbings, plaster casts, fossils, fingerprints, footprints and death masks. Because the processes of creating these impressions are straightforward mechanical ones, providing little opportunity for discretionary intervention, we are generally willing to regard the resulting records as relatively precise and accurate – close approximations to mirror-images of their subjects. The courts take fingerprints and footprints as highly credible evidence. Evolutionary biologists and creationists argue over the fossil record. And at least some of the aura of the original survives the contact-transfer process; it therefore really *matters* whether the Shroud of Turin actually shows a direct impression of the body of Christ.

Less direct again are systems that rely upon projected rather than contact impressions. In Pliny the Elder's mythic account of the origin of drawing, for example, a young Greek woman traced the shadow of her lover's profile.[3] Her hand was guided by the shadow, but it was not mechanically constrained to follow it precisely. There was plenty of room for slips of the hand, error and intentional adjustment, such as

diplomatically taking out the lover's double chin, or flatteringly shaving a little off his prominent nose. Later, it was pretty much the same when artists and topographic draftsmen employed the physiognotrace and the *camera obscura*; you could trust the results only up to a certain point.[4]

Algorithms and 'As Ifs'

Finally, there are systems that operate *as if* they were constructing traces of mechanically projected scenes. Cartographers operate this way when they translate raw survey data into maps. So do architects when they transform on-site measurements of dimensions and locations into plans, elevations and realistic perspective views of existing buildings. Textbook descriptions and diagrams of perspective drawing technique demonstrate how to accomplish this latter task scientifically and precisely, by rigorously following an algorithm based upon the mathematics of perspective projection. (In other words, to put it in modern computational terms, the draftsperson can substitute numerical data and the software of a step-by-step construction procedure for the hardware of an actual optical instrument like a *camera obscura*.) Thus, for instance, Alberti's *On Painting* describes a straightforward, practical algorithm based upon the ideas of a ray running parallel to the ground from the observer's eye, a perpendicular picture plane and a central vanishing point.

The trouble with algorithmic perspective construction is that it is slow and laborious, and does not help you much if you have to deal with inaccessible, curved or moving objects. (Imagine using Alberti's method to draw a flock of birds in flight!) The alternative, when constructed perspective is unfeasible, is to draw freehand; that is, to approximate intuitively the application of a perspective construction algorithm to objective data. The result, if you are good enough, looks as if you had formally constructed the image. This was the procedure mostly followed by the topographic artists who accompanied colonial voyages of discovery – Sydney Parkinson aboard James Cook's *Endeavour* on its voyage to New Zealand and Australia, for example. These artists visually reported back on what they had witnessed, and their credibility depended upon their practised hand–eye skills.

Those 'as ifs' create all sorts of complexities. If you care about the value of the resulting images as evidence about some actual scene, you have to satisfy yourself that the artist's implicit or explicit projection algorithm was mathematically correct. You also need to be sure that the artist followed it without deviation or error. Even more interestingly, of course, you have to allow for the possibility that the scene was fictional rather than actual – that the 'as if' extended to creating arbitrary marks within the visual conventions established by the projection algorithm. A convincingly realistic perspective view of a building, for example, might actually depict an unexecuted project. And a topographic artist might, like Baron Munchausen, be pulling your leg.

The Pencil of Nature Rewrites the Rules

The importance of the photographic process was that it created a greatly enlarged role for mechanized, non-discretionary steps in the image production process, as Fox Talbot famously recognized when he traced a scene at Lake Como, first with the aid of a *camera lucida*, and then with a *camera obscura*, and wondered 'if it were possible to cause these natural images to imprint themselves durably'. Photography left little room for the 'as ifs' of manual image production. The apparatus of lens and picture plane – directly appropriated from the *camera obscura* – reliably mechanized the projection step. Then, the action of projected light on a thin film of emulsion automated, with extraordinary spatial resolution and tonal fidelity, the step of converting the projected image into a permanent visible trace.

Little wonder, then, that the photographic image quickly attained a status as uniquely trusted and valued visual evidence. An image resulted only if some actual scene was in front of the camera (and the lens cap was off). And the photographer's discretion was mostly limited to the steps of selecting (or posing) the scene to be recorded, framing it, adjusting a few process parameters, such as focus and exposure, and choosing the moment to make the exposure. So we entered the era of the photo ID, scientific photography, photographic legal evidence, photodocumentaries and photojournalism. On journeys of exploration and discovery, the camera first supplemented then supplanted the sketchbook.[5] On great public occasions, and at important moments in private and family life, cameras attended.[6]

Opportunities for the deliberate construction of graphic fictions and falsehoods remained; the advertising and movie industries rely on them entirely, after all. However, these were sharply curtailed by comparison with those available to the draftsperson, and they were mostly seen as marginal to an image-making tradition that celebrated, defended and traded upon its capacity to deliver trustworthy evidence. A photographer could attempt to mislead by promulgating falsehoods about the circumstances of exposure – claiming that he was on an unscaled mountain peak, for example, when he was actually on an impressive-looking but negligible foothill. And, to be sure, there were occasional darkroom tricks – surreptitious subversions of the process such as double exposure, double printing, retouching, airbrushing and cut-and-paste. But it seemed transgressive when, for example, Le Corbusier constructed a mythical American landscape by airbrushing classical details out of the photographs of heroically industrial grain elevators illustrating *Vers une architecture*.[7]

The Industrialization of Distribution

As photographically recorded information began to accumulate, and its value was appreciated, established types of collection, organization, preservation and display devices were quickly adapted to deal with it. The scrapbook and the diary were

reborn as the photo album.[8] The library card catalogue transformed into the cabinet for glass lantern slides, then for celluloid 35 mm slides. File cabinets became negative and print archives, and institutions like stock photo houses developed around them. Photographic indexing and retrieval systems, modelled on those for library books, were constructed. Photographic prints were framed and hung on walls, and the photographic equivalents of painting galleries proliferated.

This represented only one part of the photographic accumulation and distribution system, the part most directly borrowed from earlier traditions. Larger-scale, faster distribution was accomplished through halftone screening and printing of photographs, combined with high-speed, mechanized distribution. This gave us photographically illustrated, mass-market newspapers, magazines and books; by the mid-twentieth century, André Malraux could point to a startling new condition – the existence of the world-wide, ubiquitous 'museum without walls'. The tradition of the photographic postcard flourished. And subscriptions to lavishly illustrated colour magazines, such as *National Geographic* and *Life*, allowed any consumer to accumulate a version of 'in small compass a model of universal nature made private'.

An important corollary to this condition was that preservation of the historical and geographic record no longer depended entirely upon saving unique, original artefacts. The existence of numerous, geographically distributed copies guaranteed a form of visual survival, even if the original were to be destroyed; think of all those famous European paintings that were lost in wartime, but live on vigorously in the Malraux virtual museum. And think, as well, of those long-demolished buildings – New York's Pennsylvania Station, for example – that remain familiar to us through the photographic record.[9]

This whole family of technologies for photographic production, processing, repro- duction, accumulation, management and distribution was characteristic of the now- fading machine age. These technologies were chemical and mechanical, rather than electronic. They traded in analog rather than digital information, thus preserving a clear distinction between valuable, first-generation, 'original' images and less valuable, later-generation 'copies'. And they yielded mass-produced physical products, which had to be moved around by means of mechanized transportation systems, rather than intangible data that could be pumped electronically through computer networks.

The Digital Camera

As the technology of silver-based photography was maturing and expanding its cultural role, a formidable successor – electronic digital imaging – was gradually emerging, and would eventually take its place.[10] The first step, in the early nineteenth century (at around the time of early photographic experiments), was the discovery of the photovoltaic effect – that certain substances, such as selenium, would release electrons when struck by light. By the 1880s, Paul Nipkow had filed patents for a

selenium-based, mechanically scanned television camera. And, by the 1920s, experi-mental television transmissions were being conducted, with increasing success, on both sides of the Atlantic.

Television cameras generate analog signals which can be recorded electronically, for example on videotape. The digital era in electronic imaging did not begin until Russell A. Kirsch and his colleagues, working at the US National Bureau of Standards in the 1950s, constructed a mechanical drum scanner and used it to trace variations in intensity over the surfaces of photographs.[11] They converted the resulting photo-multiplier signals into arrays of 176 by 176 binary digits, fed them to a primitive SEAC computer and produced oscilloscope displays. Visual information was thus converted to digital data.

Kirsch's scanner was not a camera, however; it was a slow, cumbersome, delicate piece of laboratory equipment. Practical digital photography awaited the semi-conductor revolution of the 1980s and the possibility of creating sophisticated digital electronic devices that were small, inexpensive, robust and fast. The essential semi-conductor components were CCD arrays, processor chips, compact memory and LCD screens.

The CCD (charge couple device) array is a receptor chip which takes the place of film in a photographic camera or the metallic pick-up element of an old-fashioned video camera. It consists of a grid of tiny photosensitive elements, each of which records the intensity of a single pixel in the scene. CCDs were first used in electronic still cameras in the mid-1980s, and the subsequent development of digital cameras has depended upon the growing capability of semiconductor fabricators to produce dense (and hence high-resolution) CCDs at low cost. Whenever a new generation of CCDs appears, a new generation of digital cameras soon follows. By the late 1990s, good digital cameras for the consumer market were being built around 2-megapixel CCDs, providing colour images of about 1,200 by 1,600 pixels – more than enough for most practical purposes. This represented a decisive crossover point; a growing number of photographers, both amateur and professional, began to put away their film cameras and move to digital as their primary medium.[12]

Since high-resolution CCDs generate large quantities of data, fast processor chips are required, within digital cameras, to manage the data swiftly and effectively. At the very least, these chips need to compress the image data for efficient handling, and to manage the collection of images stored in the camera. Increasingly, they also execute sophisticated image-processing operations that enhance the quality of the raw image captured by the CCD. With a digital camera, the sharpness of the image depends not only upon the quality of the lens and the steadiness of one's hand, but also upon the capabilities of the software.

Some early digital cameras had standard floppy disk drives to record image data, but these proved to be too limited in their storage capacity, too slow and too bulky. Before long, postage-stamp-sized, removable semiconductor memory cards took their

place. These provide the capacity for lengthy photo shoots, and can be plugged into the PCMCIA slots of PCs and printing devices for convenient transfer of images. Meanwhile, in digital video cameras – the close siblings of digital still cameras – digital tape became the standard storage medium.

Finally, miniature LCDs (liquid crystal displays) show exactly what is currently being captured by the CCD, and so perform much the same functions as the through-the-lens viewfinders of 35 mm SLR cameras. They also allow captured images to be replayed and edited.

These capabilities come packaged in many ways. For the nostalgic, they can be wrapped in a box that looks just like a film camera, except that the CCD replaces the film plane. They can be arranged in accordance with the logic of electronic components and their interconnections, rather than that of mirrors and mechanisms, to create some surprising new gadget shapes. They can be embedded in other digital electronic devices, such as laptop computers, personal digital assistants and even cell phones. And they can be hooked up to networked computers to create video-conferencing systems and Webcams. They are shrugging off their ancestry, to look less and less like filmless cameras, just as today's automobiles do not look much like horseless carriages.

Digital Processing

Just as silver-based photography requires a darkroom process for transforming latent images into visible marks on paper, so digital photography needs processes for trans-forming pixel values stored in computer memory into visible displays and prints. These processes are not chemical, but are specified by mathematical functions (expressed as computer algorithms) that map the stored values to intensities in the ranges offered by particular display devices.

Since display devices vary widely in their colour palettes, contrast levels, resolutions and so on, and since algorithms to map pixel values are arbitrary human constructs, there is nothing objective or inevitable about display generation processes. They are closely analogous to musical performances, in which performers interpret symbolic data (that is, scores) as sequences of sounds generated by particular musical instru-ments. Just as performances from the same score may vary widely, so may visible displays from the same pixel values.[13]

Furthermore, with the aid of a computer equipped with suitable software, such as Photoshop, you can intervene to change pixel values arbitrarily. By subtly altering the values of small numbers of pixels, and carefully remaining within the conventions of photorealism, you can retouch a digital image much as you might retouch a photo-graphic negative with a pencil or brush. By altering pixel values more boldly and freely, without necessarily paying attention to the conventions of photorealism, you can 'paint' over a digital image. And, by substituting pixel values extracted from

other digital images, you can construct potentially seamless digital collages. It is a disturbingly slippery slope; there is no clear point at which necessary pre-processing for display or printing becomes discretionary retouching, or at which a trivially retouched image becomes a fictional construction rather than a documentary record.

Thus the technology of digital imaging, by comparison with that of chemical photography, creates a freshly re-enlarged space for arbitrary artistic intervention. It is easy, within this space, to construct not only obvious visual fictions, but also deceptively plausible visual evidence of scenes that do not exist and events that never took place. Even more insidiously, slight and unobtrusive digital adjustment of visual effects can become an effective, and usually undetectable, form of spin-doctoring. Since digitally transformed images may look exactly like plain old photographs, and since we have been slow to relinquish our long-cherished trust in the evidence of such photographs, this condition, though perhaps temporary, has provided numerous tempting opportunities for hi-tech liars and conmen.[14]

In 1994, a sideshow to the O. J. Simpson arrest and trial vividly dramatized the ways in which imaging practices had changed with the transition from chemical to digital, and generated a lively public debate. *Time* and *Newsweek* both published cover portraits of O. J. that were clearly derived from the same Los Angeles Police Department mugshot, complete with identifying serial number.[15] Both looked, at first glance, like unmanipulated photographs. The differences between them were subtle. But, if you put them side by side, it was clear that *Time* assimilated the subject far more closely to the stereotype of the menacing black male than *Newsweek*. How (the discomfited viewers were forced to ask) had this difference come about? Were we being presented with photojournalism or interpretive illustration? Where should the boundaries be drawn? What were now the responsibilities of journalists, art directors and editors? And which of the images, if either, should we take to be that of the 'real' O. J. Simpson?

A couple of years later, the very same magazine covers inadvertently foregrounded another stereotype. Both pictured the parents of the McCaughey sextuplets.[16] *Time* showed the smiling mother with conspicuously uneven teeth. *Newsweek* digitally smoothed them out (as Sir Joshua Reynolds might have done with one of his portrait subjects) in accordance with current, popular ideals of beauty. Once again, there was an outcry.

Scenic beauty may be digitally 'perfected' in similar ways – a cyberspace version of Capability Brown's efforts, in his landscaped parks, to perfect the natural English countryside. Unsightly power poles and litter bins may be excised, and elements may be rearranged within a scene to create a more pleasing composition. In 1982 (very early days for digital imaging), for example, *National Geographic* magazine caused a stir by 'retroactively repositioning' the pyramids at Giza in a cover picture. The cover artist simply pushed the pyramids a few picas closer together to make them look better on the page, but the subsequent revelation of this intervention shook the faith of readers in the capacity of *National Geographic* images to anchor reliably their ideas of

place, and generated a storm of protest. For those who had been taken in, the visual documentation of Egypt – an enterprise begun in photography's earliest decades – would never again seem so securely grounded.[17]

The contentiousness of these cases derived not from the mere fact of artistic intervention, but from the resulting blurring of category boundaries and associated conventions of appropriate usage. When made aware of the interventions, most readers would say that the artists had extended their adjustments beyond the generally accepted boundaries of photographic retouching and pre-press practice, and had entered the territory of interpretive illustration. But they had carefully stayed within the visual conventions of photorealism, and they had not left graphic clues (such as the cut-and-paste discontinuities in a traditional photo collage) to disclose just how far they had gone. Since magazine covers are sometimes used as spaces governed by the conventions of photojournalism, and sometimes operate under the differing rules of hand-crafted interpretive illustration, the context did not tell viewers what to expect. The result was an uneasy ambiguity, and at least a whiff of scandalous deception.

3D Digital Imaging

Digital cameras and related practices directly extend the ancient tradition of perspective image capture – a tradition that began with the manually executed procedures and manually operated perspective machines of the Renaissance, continued with the *camera obscura*, was assimilated to the industrial era with the chemical and mechanical processes of photography, and eventually became electronic in the age of semiconductors. But this is only a small (and early) part of the story of digital imaging. A more radical departure, now emerging, is to create electronic devices that capture three-dimensional digital models of scenes rather than two-dimensional views.[18]

The traditional way to produce accurate three-dimensional models of scenes is to employ surveying equipment to determine dimensions and coordinates, then to record the results in the form of scaled, dimensioned drawings. This, of course, is laborious, slow and error-prone. But now, fortunately, we can use highly automated three-dimensional scanning devices instead.

When NASA does a planetary fly-by, for example, the spacecraft typically employs a radar scanning system to capture a three-dimensional model of the topographic surface. At a much smaller scale, laser scanners can now be used to capture three-dimensional models of sculptures and building façades. Magnetic resonance imaging (MRI) can produce wonderfully detailed three-dimensional models of human anatomy. And there are even clever ways to take collections of digital photographs of a scene, automatically match common points in different views and crunch all the two-dimensional data into a single, consistent three-dimensional digital model.

FIGURE 12.1 Virtual lights and camera: computer-synthesized interior view, from a three-dimensional digital model, of Giuseppe Terragni's unbuilt design for the Danteum. Image by Takehiko Nagakura and Haldane Liew.

Virtual Lights and Cameras

Once you have a three-dimensional digital model produced by any of these means, you can apply standard computer graphics algorithms to produce realistically shaded perspective views from arbitrarily chosen station points. In other words, you can introduce a software 'virtual camera'. When the three-dimensional model is detailed and accurate, and when the image synthesis algorithms are sufficiently sophisticated, the resulting images can be indistinguishable from photographs taken with physical cameras at particular points in the actual scene.

In order to synthesize images from a digital model, it is necessary not only to specify the viewing parameters of the 'virtual camera', but also to introduce 'virtual lights' – much as a cinematographer deploys actual lights around film sets (Figure 12.1). In other words, shading algorithms require, as input, specifications of the locations and spatial and spectral distributions of energy from the light sources to be assumed. With elementary shading algorithms, these specifications may be very simple – describing nothing more than direction and intensity of diffuse light – but with algorithms that produce photorealistic results, these specifications are extensive and must capture numerous nuances and subtleties.

Image synthesis algorithms operate by simulating the physical interaction of light energy with surfaces; in other words, effects of reflection from surfaces and inter-reflection among surfaces in a scene, absorption at surfaces, and transmission and refraction.[19] The physics of all this is classical, well understood and, in principle, presents no difficulties. In practice, however, the necessary computations are complex and time-consuming, so the art of image synthesis has been one of approximating the physics, squeezing the utmost efficiency out of algorithms by means of clever programming tricks, and employing high-powered computing devices to execute the algorithms.

In the 1960s and 1970s, when available computing power was very limited, simple but very approximate shading techniques, such as Gouraud and Phong shading, were employed. In the 1980s and 1990s, the much more sophisticated techniques of ray-tracing and radiosity were able to take advantage of greatly expanded computing power, and were routinely used to produce fully photorealistic results. Extensive 'render farms' – banks of computers executing image synthesis tasks – allowed the shading of complex, detailed scenes that would previously have been impossibly time-consuming and expensive.

The photorealistic virtual camera, in the highly developed form to which it had evolved by the 1990s, subverts the familiar legitimizing narrative of photojournalism and similar practices – that the image-maker was an eyewitness, right there, in the right place at the right time. The 'as ifs' are back, in a startling new way. When the Magellan spacecraft flew by Venus in 1991–92, the realistic fly-by sequence that was produced, back on Earth, from the synthetic aperture radio data, followed a very different path from that of the actual vehicle; it was only *as if* a camera had zoomed among the Venusian mountains at low altitude. And, when a sectioned anatomical view is produced from a MRI scan, it is only *as if* the body had been sliced.

Fictional Topography

From the introduction of virtual cameras into digital models of actual scenes, it is a short step further to introduce them into 3D digital models of wholly imaginary scenes, so providing the means to explore fictional geographies.[20] It is *as if* these geographies actually existed, and had been captured with laser scanners.

During the 1990s, this technique was effectively employed in computer-animated movies, such as the pioneering *Toy Story*, and in 3D computer games such as *Doom*, *Quake*, *Mortal Kombat* and *Myst*, to present complex, detailed, virtual worlds as settings for adventure narratives. Architects employed the same technology predictively, to present possible worlds of the future; if we construct this design, then it *will* be thus.[21] Archaeologists appropriated it to reconstruct lost scenes of the past.[22] And architectural historians even used it to illustrate counterfactuals; if this design had been executed, then the world, today, *would have been* thus (Figures 12.2 and 12.3). An old

FIGURE 12.2 A visual counterfactual: computer-synthesized view of Le
Corbusier's unrealized project for the Palace of the Soviets. Image by Shinsuke
Baba and Takehiko Nagakura, produced by Takehiko Nagakura. (Project not
executed by Le Corbusier; graphic interpretation is the work of the authors.)

principle of visual evidence was thus undermined; optical verisimilitude could no
longer serve as a guarantee that the subject of a scene was more than an entirely
imaginative construction.[23]

As the technology became less expensive, and migrated from research laboratories
and movie studios to inexpensive consumer electronic devices, a whole new space of
scenic and narrative discourse opened up – that of 3D video games. The Sony
PlayStation, Sega Dreamcast and other devices provided astonishing realism com-
bined with rapid action, so allowing game designers to construct extensive fictional
landscapes that could be explored in complex and engaging ways. Players could, for
example, drive virtual taxis through fictional cities (while virtual pedestrians leaped
for their lives), pilot virtual spacecraft through imaginary galaxies and blow away
their enemies, or follow the seductively smooth-shaded, Uzi-toting Lara Croft through
virtual tombs in search of ancient relics.

Through the use of head-mounted stereo displays coupled to position-sensing
devices, these realistic virtual geographies can even be made fully immersive.[24] In
other words, you can move through simulated scenes *as if* they were real surroundings.
Or you can 'drive' simulator vehicles through digitally constructed landscapes: jumbo
jet cockpits hooked up to simulators allow pilots to practise landings at chosen airports,

FIGURE 12.3 Digital completion of an unfinished project: computer-synthesized view of the interior of Le Corbusier's unfinished church at Firminy. Image by Franco Vairani, Xun Chen, Takehiko Nagakura and Hsu-Yuan Kuo, produced by Takehiko Nagakura. (Project not executed by Le Corbusier; graphic interpretation is the work of the authors.)

actual or imaginary; tank interiors and digital battlefield models are used for practice battles in the expected terrain of the encounter; and stationary exercise bicycles can be ridden, just for fun, through fantasy landscapes.[25]

We could once rely on the material differences between images to signal whether we should take them as facts, falsehoods or fictions. Photographs were not *physically* the same as paintings, but this is not the case with digital images. It makes no difference to a display device whether a pixel value was captured by a CCD in a digital camera, computed by an image-synthesis algorithm operating on a three-dimensional model, or arbitrarily chosen by an artist using a digital paint system. A pixel is a pixel is a pixel.

Blending Fact and Fiction

Due to their common foundation upon the mathematics of perspective projection, and their common construction from pixels, the outputs of actual and virtual cameras can be combined seamlessly to construct hybrids of real and imaginary scenes. If an architect wishes to show a future building in its urban setting, for example, the

FIGURE 12.4 Digital combination of the fictional and the actual: computer-synthesized image of Vladimir Tatlin's unrealized St Petersburg tower project (Monument to the Third International) digitally inserted into a photographic image of the present-day city. Image by Andrej Zarzycki, Takehiko Nagakura, Dan Brick and Mark Sich, produced by Takehiko Nagakura.[26]

procedure is to take a digital photograph from the desired viewpoint, synthesize a shaded computer perspective from the same viewpoint and under closely matched lighting conditions, and produce a carefully registered digital collage of the two (see Figure 12.4). Similar procedures are employed in movie special effects, in video productions that combine live actors with virtual sets, and in so-called 'augmented reality' systems that superimpose computed scenes on actual ones in real time.[26]

There are also some more subtle admixtures of captured imagery into computer-synthesized scenes. The common computer graphics technique of texture mapping, for example, makes use of scanned or photographed textures and pictures applied by special software to specified surfaces in a scene – much like wallpaper applied to surfaces in a room. And the photographically recorded or mechanically tracked motion of a real actor may be used to control the motion of an animated character.

Such seamless blending of fact and fiction within a single scene opens the way not only to useful simulations and compelling fictions, but also to some new and insidious

forms of deception. In the CBS News coverage of the 1999/2000 New Year's Eve celebrations in Times Square, for example, a digitally created CBS logo was used to block out a prominent sign sponsored by the rival NBC network. CBS News anchor Dan Rather later called it 'a mistake' that he regretted.[27]

Digital Storage and Reproduction

If digital and virtual cameras had developed in isolation from some crucially complementary technological developments, they would have remained little more than laboratory curiosities, of no greater cultural significance, perhaps, than a new film format. But things turned out differently; these gadgets arrived on the scene at precisely the moment when the cost of digital storage was plummeting, and when high-speed computer networks were providing increasingly effective ways to move large quantities of digital data around.

Let us put this in perspective. A 2-megapixel digital image, with 24 bits of information to store each pixel (the minimum you need for a full-colour image) consumes 6 megabytes of storage unless you compress it in some clever way. With the computers of the 1960s and the 1970s, this was a large quantity of data to handle; you could fit only a handful of such images on disk, and you would have difficulty fitting complete images into RAM for processing and display. In fact, the now-familiar colour raster displays of personal computers did not become feasible until RAM costs dropped sufficiently to allow storage of full-screen colour images. But the inexpensive personal computers of the 1990s routinely had excellent colour display systems, tens of megabytes of RAM, and gigabytes of available disk space. It was no longer a problem to maintain and manage extensive personal libraries of digital images, and collections offered by large organizations could surpass even the most extensive of traditional slide libraries and photo archives.

Given abundant digital memory, copying digital image files is quick, inexpensive and easy – much easier than printing photographs from negatives. There is absolutely no difference, except for the date stamp, between original and copy. And the ease of reproduction destroys rarity value.

In industry and academia, a gradual transformation of audiovisual technology began to unfold as a result of digital storage and reproduction. Where presentations had been made with 35 mm slide projectors or overhead projectors, they were now increasingly made using laptop computers stocked with copies of digital images, presentation software such as Powerpoint, and video projectors. You could shoot an image with your digital camera, electronically transfer it to your laptop computer, edit and sequence it as required, and present it to an audience within minutes. Furthermore, you never found that digital images, unlike slides, had been checked out of the library by somebody else, and you never had to return them when you were finished.

By the late 1980s, Bill Gates had seen what was coming. He began to shake up the museum and photography worlds by buying up digital reproduction rights, acquiring photo archives (including Bettmann), converting images to digital format on an industrial scale, and creating digital image distribution channels. As Y2K dawned, his Corbis Corporation claimed 65 million images, with 2.1 million of those (and growing) in digital format online. And Corbis had plenty of competitors, both institutional and commercial.

Digital Distribution

As demand grew for large-scale distribution of digital images, removable, high-capacity storage media – particularly CD-ROMs – were quickly adapted to the task. CDs have frequently been seen as substitutes for colour-illustrated catalogues and art books, but with the advantages of lower cost per image and greater capacity, and the consequent possibility of comprehensiveness. Thus, a typical art CD of the 1990s – *Rubens and His World*, produced by the city of Antwerp – boasts 1,200 illustrations from seventy-eight collections and forty artists, over thirty QuicktimeVR sequences showing Rubens's own house and collection, and ninety minutes of audiovisual guided tours. Similarly, a CD collection of Frank Lloyd Wright's drawings covers the *entire* vast corpus on a few disks.

Digital high-definition television has also been promoted as a large-scale distribution medium.[28] Here the model is broadcasting rather than print publication. The idea is to store video and image data on large central servers and pump it out to consumers through high-bandwidth digital channels, either wired or wireless. The technical challenge has been to find efficient ways to handle the extremely large quantities of data that are involved. Although there has been a great deal of technical progress, HDTV has disappointed its advocates by proving very slow to catch on.

The clear winner among the competing distribution mechanisms turned out to be the technology of packet-switching, the Internet and the World Wide Web. Like HDTV, the Web eliminates the material substrate of images, and distributes them in completely dematerialized format. Unlike HDTV, it is a highly decentralized rather than a centralized system – one that blurs traditional distinctions between producers and consumers, and reduces the role of gatekeepers such as editors and publishers.

The World Wide Web

The Web is the outcome of a thirty-year technological development that began in the 1960s with the development of packet-switching technology and implementation of the Arpanet, an experimental computer network that hooked up a few computers at universities and research centres.[29] The Arpanet eventually evolved into the Internet, an explosively expanding confederation of networks held together by the TCP/IP

protocol. Then the World Wide Web was implemented on the foundation of the Internet, Web browsers began to appear in the mid-1990s and, before the end of the decade, the Web boom was in full swing.[30] In the more affluent parts of the world, business and home Internet connection – first through slow dial-up links, then through faster cable modem and DSL connections – became commonplace. The digital network became an indispensable new type of urban infrastructure.[31]

Initially, the Web mostly dealt in text and very simple graphics. But as the technology improved, and connections became faster, it became an increasingly graphic environment. Many Websites were organized much like online photo albums; not surprisingly, pornography sites led the way. More ambitious sites, such as those of educational and cultural institutions, provided access to large, searchable graphic databases. Video-conferencing began to migrate from the telephone system to Web-connected PCs. And innumerable Webcams delivered live images, from points scattered around the globe, to anyone who cared to log in; as the clock ticked over to the year 2000, you could track the celebrations around the world, timezone by timezone, on your computer screen.[32]

As the Web became more pervasive during the latter half of the 1990s, as the speed of Web connections increased, and as PCs became more powerful, the guiding metaphor began to shift. Increasingly, Web designers thought of linking 'spaces' rather than 'pages'. And, in some cases, these spaces were three-dimensional rather than two-dimensional.[33] VRML (Virtual Reality Markup Language) emerged to complement HTML, and variations on this idea were used to construct a first generation of three-dimensional virtual places on the Web. Among these were Microsoft's V-Chat, Intel's Moondo, Sony's Cyber Passage Bureau, IBM's Virtual World, Lycos's Point World, AlphaWorld, Worlds Chat, The Realm and Utopia.

These three-dimensional Web spaces may be pre-packaged fictions, they may be collaboratively constructed by their users, or they may be accurate models of actual places for use in navigation, access to online information, and avatar-based interaction. Among the first cities to get such online twins were Los Angeles, Paris and Helsinki.

Web-connected screens – providing windows to electronically mediated spaces of many different kinds – are increasingly pervading our everyday surroundings.[34] There are small, wirelessly connected screens on wearable, pocket and hand-held devices. At the scale of luggage and furniture, there are laptop, desktop, television and wall-mounted screens. Picture frames may have network connections and display downloaded digital images rather than photographs and paintings – providing, for example, a new way to construct and distribute the family album. And many urban spaces, such as Times Square and the Ginza, are now unimaginable without their gigantic video displays.

Increasingly, then, the places we frequent have IP addresses as well as geographic coordinates. Each such place is electronically interconnected to every other, and can potentially function as an image collection, dissemination and reception point. Every

place is potentially visible from everywhere else. A discontinuous geography of cyber-space – woven from random and transitory remote connections, from virtual cameras located within digital models as well as digital cameras pointed at actual scenes, and from fictional as well as actual terrain – is overlaid on that of physical space.

Bits are For Ever, But …

This shift to digital accumulation and distribution systems has important consequences for the permanence and accessibility of the historic and geographic record.[35] Bits are for ever, and can be stored in much greater quantities to create more comprehensive records than ever before, but the physical media on which they are stored are highly perishable – even more so, in many cases, than paper. Furthermore, with progress in digital technology, storage formats and the associated devices quickly become obsolete, so that the information expressed in these formats becomes unreadable. Even if archives have carefully preserved some 1960s data on punch cards, for example, they will have a great deal of difficulty finding a working punch-card reader to extract that data. Worse, there are now vast quantities of digital data stored in obsolete tape and disk formats; much of this will never be readable again.

One strategy for retrieving digital data in obsolete formats is to reconstruct the necessary computing environment. This is a complicated task. First of all, the researcher needs the appropriate application to run the files. Then, to run this applica-tion, the right operating system – probably long obsolete itself – is required. Then, of course, that operating system needs the appropriate hardware on which to run. Since old electronic devices are very difficult to keep in working order (it is now impossible to obtain replacement vacuum tubes for early computers, for example), this hardware often has to be simulated on more modern machines.

Another strategy is to migrate digital data to new formats and devices as they emerge. This is more effective if it is carefully and comprehensively pursued, but it requires institutional commitment to the task, and it is expensive. Serious archives now face the extremely challenging task of developing and executing long-term data-migration strategies.

Perhaps the most effective way to preserve digital data – as many librarians and archivists are realizing – is to 'keep it spinning'. Data permanently stored on Web servers is immediately accessible world-wide, it can quickly be transferred and duplicated to create copies in different locations – thus providing security against redundancy – and it avoids the hardware incompatibility problems that plague re-movable disks and tapes. Despite the continually decreasing cost of online storage, however, server capacity is still a scarce and expensive resource in many contexts, so this strategy is not universally applicable.

Thus, digital storage and distribution systems have created a new economy – more precisely, a political economy – of preservation and access. Librarians, archivists and

other digital gatekeepers must decide what to transfer from older media to digital format (so vastly increasing its accessibility), what digital data to migrate to newer formats and what digital data to keep spinning. Through these choices, the historic and geographic record, including the visual record, is continually constructed and reconstructed.

Digital Image Practices

It had all come together by Y2K. Inexpensive and effective digital sensors and cameras, the computer capacity to store and process vast quantities of graphic data in digital format, sophisticated graphics software, electronic display and printing devices, and global computer networking converged to create an entirely new, globally pervasive, technological system for image production, reproduction, storage, processing, management, distribution and consumption. This created a vast new arena for discursive practice, the characteristics of which were slowly becoming apparent.

The images that we employ to construct our understanding of the world and situate ourselves in it are being captured in far greater quantities than ever before. Hand-held CCD-based cameras, both still and video, continue the long-established practices of photography into the digital era, but transform those practices by making it cheaper to snap the shutter and quicker to see the results. Webcams and video-conferencing installations convert computers into image capture devices and turn the Internet into an increasingly ubiquitous imaging machine – a decentralized, densely present pan-optic instrument. Electronic surveillance cameras in buildings, public spaces and vehicles subject urban space to continuous scrutiny. And imaging satellites endlessly scan the surface of the globe. Through digital imaging, we are electronically constructing an increasingly complete and detailed mirror-earth, in which everything that takes place in physical space is reflected and recorded somewhere in cyberspace.

Visual records produced by these means typically come tagged with textual metadata of various kinds. Digital cameras associate date stamps and serial numbers with the image files that they produce, and may record exposure parameters as well. Some more advanced models incorporate GPS devices, and automatically associate geographic coordinates with images. In the future, they will undoubtedly capture much richer information about the author and the context of image production at the moment of exposure. Furthermore, voice and text annotation opportunities are provided by image management software, and even by some digital cameras, while image database systems require keywords to be chosen and fields to be filled in, and digital watermarks are frequently added to establish ownership and discourage unauthorized copying. All this metadata serves to place digital images in context, much as the location of a photographic negative in a roll of film, or a pencilled annotation on the back of a print does, usually in a far more rudimentary way, for photographic images.

Much of this electronic construction of the new, digital version of the visual record

is automatic. Webcams, surveillance cameras and imaging satellites typically execute their tasks unattended by human operators, under the command of software that encodes generalized strategies and responds to occasional remote commands. Photographs are mostly the outcomes of human *attention* directly paid to scenes, and of explicit *intention* to record, but many digital images are not. They are, therefore, cultural coinage of a different kind, with different functions and values; we can meaningfully ask what such an image tells us, for example, but not what its originator was *trying* to tell us. They are not given credibility by recognition that the photographer was actually *there*, and is prepared to attest to it, but by faith in the mindless, mechanical reliability of a robot-on-the-spot.

Increasingly, digital images – no matter how they originate – end up in electronic storage on Web servers, and thus form parts of an incomprehensibly huge, rapidly expanding, virtual archive of historical and geographic knowledge. None of us can ever hope to become familiar with more than a tiny fraction of this; NASA's online multimedia library alone promises access to over 17 million items. Nor can we take possession, as individual and institutional collectors traditionally have done, by holding images in our albums, library shelves and galleries; we now find what we want by surfing and searching through cyberspace. We might choose to collect relatively small personal caches of images (or digital music performances) in local memory devices, such as personal computers or PDAs, but this is technically indistinguishable from downloading as required, over a fast link, from remote servers. The Web has subverted the collector's credo that you must physically possess something in order to get ready access to it. In physical space, possession may be nine-tenths of the law; in cyberspace, it's having login privileges and remembering your password.

The items in this virtual archive clearly have no rarity value, since they can be replicated instantly, inexpensively and indefinitely. Because the format is digital rather than analog, there is no meaningful difference between original and copy, and there is no degradation of quality with repeated copying. And it is hard to imagine that the sort of aura identified by Walter Benjamin – the mysterious value adhering to an image because it was touched by the brush of Rembrandt, was once latent in the Leica of Cartier-Bresson, or was printed by Edward Weston himself – can propagate through cyberspace. It does not seem likely that traditional practices of image valuation, exhibition, collection and trading can long survive these subversions. Meanwhile, new ones more attuned to the economic principles of cyberspace are emerging; many online image services, for example, provide free digital storage of your pictures and make their money by selling prints on greeting cards, coffee cups, clothing and even biscuits.

Our access to digital images relies entirely upon algorithms embodied as computer software. We need database retrieval software and Web search engines to find what we want, rendering and image-processing software to interpret digital data as visible patches of tone and colour on a picture plane, and display software to physically

produce prints and screen displays. In increasingly many contexts, we employ image recognition and analysis software to classify and sort visual information automatically, and to abstract higher-level knowledge from it. None of this software is neutral, of course; it inescapably manifests the interests, biases and limitations of its authors, and demands rigorous critical scrutiny. Taken together, it adds up to a large and complex intellectual construction that mediates all our interactions with digitally encoded visual evidence and inexorably frames our interpretations of it. We cannot formulate useful conceptions of the veracity, reliability, comprehensiveness or conclusiveness of visual evidence, except in relation to the structure and capabilities of this dynamically evolving intervening system. Software constructs an electronic gaze.

Photographs and printed texts are well-defined, discrete, durable entities that can be identified, catalogued and handled as units, but digital information is inherently fungible and recombinant. Hyperlinks among Web pages challenge familiar conceptions of textual cohesion, completeness and closure. Database reporting software can pull together information from many different locations and present it in new combinations and formats. And image synthesis software may extract data from many different files, stored on different servers, in order to produce rendered scenes. The resulting images are often contingent and transitory constructions, rather than enduring contributions to a corpus of artistic work. Visual patrimony now resides in the accumulated digital data and in the possibilities of the available software tools for selecting, recombining and constructing images from this data, rather than in the set of displayed and printed images physically present at any particular moment.

Since display of a digital image is an actively constructive operation – typically involving search and selection of data, setting various display parameters and applying display algorithms – traditional distinctions between producers and consumers blur. When a viewer adjusts the brightness, contrast or colour balance of a screen image, that viewer is playing much of the role that a photographer once performed by setting camera controls and through darkroom processes. When a visitor to a virtual landscape flies a real-time virtual camera through it, that visitor is taking over some of the functions of a cinematographer or director – the functions that Orson Welles performed in creating the famous fly-through opening of *Touch of Evil*, for example.[36] And when a Web surfer employs a search engine to find and retrieve an image, that Web surfer is not passively consuming pre-formatted content, but actively formulating and pursuing an intellectual enterprise. It is increasingly clear that these shifts in roles will shake to their foundations our conceptions of authorship, originality, scholarly responsibility and intellectual property.

You can see this new technological system and its associated practices as a characteristic social construction of our time, as the consequence of autonomously unfolding technological logic, or as some complex combination of the two. Either way, it is rapidly rising to dominance over the earlier systems of manual image production and of chemical photography; it is penetrating a widening range of social spaces, and it

is opening up unexpected and still largely unexplored new possibilities for reportage, for fiction and for historical and geographic inquiry.

The View from Y2K

Half a millennium ago, Francis Bacon – true to the technologies of his time – thought that a learned (and necessarily highly privileged) person required a well-stocked *wunderkammer* as an instrument for constructing knowledge of the wider world. Half a century ago, as André Malraux pointed out, illustrated books and magazines had provided mass audiences with a powerful new means of doing so. Now, if you want to access 'in small compass a model of universal nature made private', you surf in to yahoo.com.

Notes

Introduction

1. The 'alignment of photography and notions of modernity' is discussed at length by Mary Warner Marien in *Photography and Its Critics: A Cultural History, 1839–1900* (Cambridge: Cambridge University Press, 1997). In it, she observes, 'With the passing of time, photography continued to connote the modern, but the notion of modernity changed' (p. xv).

2. [Joseph Louis] Gay-Lussac, 'The Report of Mr. Gay-Lussac, in the name of a special committee charged to examine the Bill relative to the acquisition of the process invented by Mr. Daguerre to fix the images of the camera obscura, Chamber of Peers, 30 July 1839', reproduced in *An Historical and Descriptive Account of the Various Processes of the Daguerréotype and the Diorama, by Daguerre* (London: McLean, 1839). Souvenir reprint by the American Photographic Historical Society on the 150th Anniversary of Photography, 1989, p. 34.

3. Commonly cited subjects included portraits, landscapes, architecture, buildings, animals, statues, paintings, medals, manuscripts, manufactures, disease, geological specimens, hieroglyphics and public works. Natural history, geography, astronomy, microscopy, architecture, Egyptology, engineering, geology, botany, palaeography, military operations, law and medicine were the fields of study most frequently predicted to benefit from the new technology.

4. [Lady Elizabeth Eastlake], 'Photography', *Quarterly Review*, 101, London, April 1857, reprinted in Beaumont Newhall (ed.), *Photography: Essays and Images. Illustrated Readings in the History of Photography* (New York: Museum of Modern Art, 1980), p. 94.

5. Thomas Richards, *The Imperial Archive: Knowledge and the Fantasy of Empire* (London: Verso, 1993).

6. Abigail Solomon-Godeau, *Photography at the Dock: Essays on Photographic History, Institutions, and Practices* (Minneapolis: University of Minnesota Press, 1991), p. 155.

7. [William] Lake Price, *A Manual of Photographic Manipulation, treating of the practice of the art; and its various applications to Nature*, 2nd edn (London: John Churchill and Sons, 1868) (first published 1858). (Reprint edition, New York: Arno Press, 1973, pp. 1–2.)

8. Théophile Gautier, in *L'Univers Illustré*, 1858, quoted in Michel F. Braive, *The Photograph: A Social History*, trans. David Britt (London: Thames and Hudson, 1966), p. 186.

9. Marcus Aurelius Root, *The Camera and the Pencil: Or the Heliographic Art, its Theory and Practice in all its Various Branches; e.g. Daguerreotypy, Photography, &c.; together with its History in the United States and in Europe; being at once a Theoretical and Practical Treatise, and designed alike, as a Text-book and a Hand-book* (Philadelphia: M. A. Root and J. B. Lippincott, 1864). (Reprint edition, Pawlet, VT: HELIOS, 1971, p. 412.)

10. For a discussion of early critical writing on the nature of photography and its role in the production of social knowledge, see Mary Warner Marien, *Photography and Its Critics*. See also Joan M. Schwartz, '"Records of Simple Truth and Precision": Photography, Archives, and the Illusion of Control', *Archivaria*, 50 (Fall 2000), pp. 1–40.

11. The notion of the photograph as 'a functioning tool of the geographical imagination' is examined from bibliographic, historical, theoretical and empirical perspectives in Joan M. Schwartz, 'Agent of Sight, Site of Agency: The Photograph in the Geographical Imagination', unpublished PhD thesis, Queen's University, Kingston, Canada, 1998.

12. This phrase is most closely associated with the work of John Berger, who used it as the title of his 1972 BBC television series and accompanying book, *Ways of Seeing* (Harmondsworth: Penguin, 1972).

13. Denis Cosgrove, *Social Formation and Symbolic Landscape* (London: Croom Helm, 1984); Denis Cosgrove, 'Prospect, Perspective and the Evolution of the Landscape Idea', *Transactions of the Institute of British Geographers*, NS 10 (1985), pp. 45–62; see also Gina Crandell, *Nature Pictorialized: 'The View' in Landscape History* (Baltimore: Johns Hopkins University Press, 1993).

14. See, for example, Stephen Daniels, *Fields of Vision: Landscape Imagery and National Identity in England and the United States* (Cambridge: Polity Press, 1993); David Matless, *Landscape and Englishness* (London: Reaktion Books, 1998); Simon Schama, *Landscape and Memory* (London: HarperCollins, 1995); Catherine Nash, 'Remapping and Re-naming: New Cartographies of Identity, Gender and Landscape in Ireland', *Feminist Review*, 44 (1993), pp. 37–57; Gillian Rose, 'Geography as a Science of Observation: The Landscape, the Gaze and Masculinity', in Felix Driver and Gillian Rose (eds), *Nature and Science: Essays in the History of Geographical Knowledge* (Cheltenham: Historical Geography Research Series, 1992), pp. 8–18.

15. Denis Cosgrove and Stephen Daniels (eds),

Iconography of Landscape (Cambridge: Cambridge University Press, 1988); Nicholas Alfrey and Stephen Daniels (eds), *Mapping the Landscape: Essays on Art and Cartography* (Nottingham: Nottingham University Art Gallery and Castle Museum, 1990).

16. For a recent review of some of this literature, see Felix Driver, 'Visualizing Geography: A Journey to the Heart of the Discipline', *Progress in Human Geography*, 19, 1, 1995, pp. 123–34.

17. See, for example, J. Brian Harley, 'Maps, Knowledge, and Power', in Denis Cosgrove and Stephen Daniels (eds), *The Iconography of Landscape: Essays on the Symbolic Representation, Design and Use of Past Environments* (Cambridge: Cambridge University Press, 1988), pp. 277–312; J. Brian Harley, 'Deconstructing the Map', in Trevor J. Barnes and James S. Duncan (eds), *Writing Worlds: Discourse, Text and Metaphor in the Representation of Landscape* (London: Routledge, 1992), pp. 231–47; David Turnbull, *Maps are Territories: Science is an Atlas* (Chicago: University of Chicago Press, 1993); Matthew H. Edney, *Mapping an Empire: The Geographical Construction of British India 1765–1843* (Chicago: University of Chicago Press, 1997).

18. Derek Gregory, *Geographical Imaginations* (Oxford: Blackwell, 1994).

19. Ian Cook, David Crouch, Simon Naylor and James R. Ryan (eds), *Cultural Turns/Geographical Turns: Perspectives on Cultural Geography* (Harlow: Pearson Education, 2000); Mike Crang, *Cultural Geography* (London: Routledge, 1998); Pamela Shurmer-Smith and Kevin Hannam, *Worlds of Desire, Realms of Power: A Cultural Geography* (London: Edward Arnold, 1994); Peter Jackson, *Maps of Meaning: An Introduction to Cultural Geography* (London: Unwin Hyman, 1989).

20. See, for example, Kay Anderson and Fay Gale (eds), *Inventing Places: Studies in Cultural Geography* (Melbourne: Longman Cheshire, 1992); Jacqueline Burgess and John R. Gold (eds), *Geography, the Media and Popular Culture* (London: Croom Helm, 1985); James S. Duncan and David Ley (eds), *Place/Culture/Representation* (London: Routledge, 1993); Gillian Rose, 'The Cultural Politics of Place: Local Representation and Oppositional Discourse in Two Films', *Transactions of the Institute of British Geographers*, 19, 1 (1994), pp. 46–60; Leo Zonn (ed.), *Place Images in Media: Portrayal, Experience, and Meaning* (Savage, MD: Rowan & Littlefield, 1990).

21. Scott McQuire, *Visions of Modernity: Representation, Memory, Time and Space in the Age of the Camera* (London: Sage, 1998); Deborah Poole, *Vision, Race, and Modernity: A Visual Economy of the Andean Image World* (Princeton: Princeton University Press, 1997); Kevin Robins, *Into the Image: Culture and Politics in the Field of Vision* (London: Routledge, 1996); Ron Burnett, *Cultures of Vision: Images, Media and the Imaginary* (Bloomington and Indianapolis: Indiana University Press, 1995); Chris Jenks (ed.), *Visual Culture* (London and New York: Routledge, 1995), pp. 1–25; Victor Burgin, *In/Different Spaces: Place and Memory in Visual Culture* (Berkeley, Los Angeles, London: University of California Press, 1996); Celia Lury, *Prosthetic Culture: Photography, Memory and Identity* (London: Routledge, 1998).

22. For an early example, see Joan M. Schwartz, 'The Photographic Record of Pre-Confederation British Columbia', *Archivaria*, 5 (Winter 1977–78), pp. 17–44 (reprinted as 'The Photograph as Historical Record: Early British Columbia', *Journal of American Culture*, 4, 1 (Spring 1981), pp. 65–92). See also Peter Jackson, 'Constructions of Culture, Representations of Race: Edward Curtis's "Way of Seeing"', in Kay Anderson and Fay Gale (eds), *Inventing Places: Studies in Cultural Geography* (London: Longman, 1992), pp. 89–106; Joan M. Schwartz, 'The Geography Lesson: Photographs and the Construction of Imaginative Geographies', *Journal of Historical Geography*, 22, 1 (1996), pp. 16–45; James R. Ryan, 'Picturing People and Places', review article, *Journal of Historical Geography*, 20, 3 (1994), pp. 332–7; Phil Kinsman, 'Landscape, Race and National Identity: The Photography of Ingrid Pollard', *Area*, 27, 4 (1995), pp. 300–10; Phil Kinsman, 'Photography, Geography and Identity: The Landscape Imagery of John Blakemore', *The East Midland Geographer*, 16, 2 (1993), pp. 17–26.

23. A central and useful introductory text in this respect is Elizabeth Edwards (ed.), *Anthropology and Photography, 1860–1920* (London: Yale University Press, 1992); see also Joanna Cohan Scherer (ed.), *Picturing Cultures: Historical Photographs in Anthropological Inquiry*, special issue of *Visual Anthropology*, 3, 2–3 (1990). The most recent contribution to this literature is Elizabeth Edwards, *Raw Histories: Photographs, Anthropology and Museums* (Oxford: Berg, 2001).

24. The literature on the history of photography is extensive. For a useful introduction, see Michel Frizot (ed.), *A New History of Photography* (Cologne: Könemann, 1998) (originally published in French by Bordas, Paris, 1994); Liz Wells (ed.), *Photography: A Critical Introduction* (London: Routledge, 1997); Graham Clarke, *The Photograph* (Oxford: Oxford University Press, 1997); Jean-Claude Lemagny and André Rouillé (eds), *A History of Photography: Social and Cultural Perspectives*, trans. Janet Lloyd (Cambridge: Cambridge University Press, 1987), originally published as *Histoire de la photographie* (Paris: Bordas, 1986); Ian Jeffrey, *Photography: A Concise History* (London: Thames and Hudson, 1981); Gisèle Freund, *Photography and Society* (Boston: David R. Godine, 1980), originally published as *Photographie et Société* (Paris: Éditions du Seuil, 1974).

25. Mike Crang, 'Envisioning Urban Histories: Bristol as Palimpsest, Postcards, and Snapshots', *Environment and Planning A*, 28, 3 (1996), pp. 429–52.

26. Denis Cosgrove, 'Contested Global Visions: One-World, Whole-Earth, and the Apollo Space Photographs', *Annals of the Association of American Geographers*, 84, 2 (1994), pp. 270–94.

27. See John Taylor, *A Dream of England: Landscape, Photography and the Tourist's Imagination* (Manchester: Manchester University Press, 1994); Christopher Pinney, *Camera Indica: The Social Life of Indian Photographs* (London: Reaktion Books, 1997); James R. Ryan, *Picturing Empire: Photography and the Visualization of the British Empire* (London: Reaktion Books, 1997). See also Richard Bolton (ed.), *The Contest of Meaning: Critical*

Histories of Photography (Cambridge, MA: MIT Press, 1989); Solomon-Godeau, *Photography at the Dock*.

28. Donna J. Haraway, *Simians, Cyborgs, and Women: The Reinvention of Nature* (New York: Routledge, 1991), p. 190.

29. The phrase 'imaginative geography' was used originally by Edward Said in his book *Orientalism* (London: Routledge and Kegan Paul, 1978), in which he showed how 'the Orient' was constructed by Europeans as a set of complex and contradictory ideas and images of the East. For a useful introduction to the idea of 'imaginative geography' in contemporary human geography see Felix Driver, 'Imaginative Geographies', in Paul Cloke, Philip Crang and Mark Goodwin (eds), *Introducing Human Geographies* (London: Arnold, 1999), pp. 209–16. See also Derek Gregory, 'Imaginative Geographies', *Progress in Human Geography*, 19, 4 (1995), pp. 447–85.

30. David Harvey, 'Between Space and Time: Reflections on the Geographical Imagination', *Annals of the Association of American Geographers*, 80, 3 (1990), pp. 418–34; David Lowenthal, 'Geography, Experience, and Imagination: Towards a Geographical Epistemology', *Annals of the Association of American Geographers*, 51 (1961), pp. 241–60; Gregory, *Geographical Imaginations*. See also Guy Davenport, *The Geography of the Imagination: Forty Essays by Guy Davenport* (New York: Pantheon, 1992).

31. David Harvey, *Social Justice and the City* (London: Edward Arnold, 1973), cited in Derek Gregory, 'Geographical Imagination', in R. J. Johnston, Derek Gregory and David M. Smith (eds), *The Dictionary of Human Geography* (Oxford: Blackwell, 1994), p. 217.

32. Such an ambition would require a very different kind of enterprise. For more methodological approaches see, for example, Elizabeth Edwards, *Raw Histories*; Joan M. Schwartz, '"We make our tools and our tools make us": Lessons from Photographs for the Practice, Politics, and Poetics of Diplomatics', *Archivaria*, 40 (Fall 1995), pp. 40–74; Gillian Rose, 'Teaching Visualised Geographies: Towards a Methodology for the Interpretation of Visual Materials', *Journal of Geography in Higher Education*, 20, 3 (1996), pp. 281–94; Judith Williamson, *Decoding Advertisements* (London: Marion Boyars, 1978).

33. Raphael Samuel, *Theatres of Memory, Volume 1: Past and Present in Contemporary Culture* (London: Verso, 1994), pp. 329–30.

34. Daniels, *Fields of Vision*, p. 8.

35. For a useful elaboration of the idea of 'visual history', see Roy Porter, 'Seeing the Past', *Past & Present*, 118 (1988), pp. 187–205.

36. [Joseph Ellis], *Photography: A Popular Treatise, designed to convey Correct General Information concerning the discoveries of Niepce, Daguerre, Talbot, and Others, and as preliminary to acquiring a practical acquaintance with the art; by an Amateur. Read before the Literary and Scientific Institution of Brighton, 23rd February 1847* (Brighton: Robert Folthorp, 1847), p. 45.

37. Solomon-Godeau, *Photography at the Dock*, p. xxi.

38. Jennifer Tucker has argued that: 'Nineteenth-century debates in Britain over claims made with photo-

graphs in a variety of settings, from field outposts to the laboratory to the spiritualist seance, suggest that Victorians did not, in fact, accept photographic evidence as unconditionally true and, indeed, that they interpreted facts based on photographs in a variety of different ways.' Jennifer Tucker, 'Photography as Witness, Detective, and Imposter: Visual Representation in Victorian Science', in Bernard Lightman (ed.), *Victorian Science in Context* (Chicago: University of Chicago Press, 1997), pp. 378–408. See also Chrissie Iles and Russell Roberts (eds), *In Visible Light: Photography and Classification in Art, Science and the Everyday*, ex. cat. (Oxford: Museum of Modern Art, 1997).

39. The notion of more or less 'authentic' readings of images also allows for an understanding of the meaning(s) of photographs in historical perspective. See, for example, David N. Livingstone, 'Reproduction, Representation and Authenticity: a Rereading', *Transactions of the Institute of British Geographers*, NS 23, 1 (1998), pp. 13–20.

40. Elizabeth Edwards, 'Photographs as Objects of Memory', in Marius Kwint, Christopher Breward and Jeremy Aynsley (eds), *Material Memories: Design and Evocation* (Oxford: Berg, 1999), pp. 221–36.

41. Livingstone traces 'the centrality of the picture-making impulse' in geographical tradition 'to the reappropriation during the Renaissance of Ptolemy's conception of geography as an enterprise essentially concerned with picturing (or representing) the world'. David N. Livingstone, *The Geographical Tradition: Episodes in the History of a Contested Enterprise* (Oxford: Blackwell, 1992), pp. 98–9.

42. For analyses of such other forms of material expression as mapping, sketching, painting and travel writing, see, for example, Barbara Maria Stafford, *Voyage into Substance: Art, Science, Nature and the Illustrated Travel Account, 1760–1840* (Cambridge, MA: MIT Press, 1984); James Duncan and Derek Gregory (eds), *Writes of Passage: Reading Travel Writing* (London: Routledge, 1999); Bernard Smith, *European Vision and the South Pacific*, 2nd edn (New Haven: Yale University Press, 1985); Denis Cosgrove (ed.), *Mappings* (London: Reaktion, 1999).

43. The notion of geography and photography as partners in picturing place is central to an analysis of the photographic record of mid-nineteenth-century British North America in Joan M. Schwartz, 'Agent of Sight, Site of Agency: The Photograph in the Geographical Imagination'.

44. Martin Lister (ed.), *The Photographic Image in Digital Culture* (London: Routledge, 1995).

45. Rev. W. J. Read, 'On the Applications of Photography', paper read at the 'ordinary Meeting of the [Manchester Photographic] Society held in the Royal Institution, on the Evening of Thursday, March 6th [1856]' and published in *Photographic Notes: Journal of the Photographic Society of Scotland and of the Manchester Photographic Society*, I, 9 (17 August 1856), p. 127.

46. David Lowenthal, 'Introduction', David Lowenthal and Martyn J. Bowden (eds), *Geographies of the Mind: Essays in Historical Geography in Honor of John Kirtland Wright* (New York: Oxford University Press, 1976), p. 3.

47. Susan Sontag, *On Photography* (New York: Dell, 1977), p. 4.

48. Gordon Fyfe and John Law, 'Introduction: On the Invisibility of the Visual', in Gordon Fyfe and John Law (eds), *Picturing Power: Visual Depiction and Social Relations* (London: Routledge, 1988), p. 2.

49. David E. Nye, 'Constructing Nature: Niagara Falls and the Grand Canyon', in *Narratives and Spaces: Technology and the Construction of American Culture* (New York: Columbia University Press, 1997), pp. 13–24.

50. For the most recent articulation of the relationship between orality and photography in family albums, see Martha Langford, *Suspended Conversations: The Afterlife of Memory in Photographic Albums* (Montreal and Kingston: McGill-Queen's University Press, 2001).

51. In *The Camera and the Pencil*, photographer and critic Marcus Aurelius Root stressed the contribution of photographs to 'primal household affection', pointing out that 'the exigencies of life, in most cases, necessitate the dispersion of relatives, born and reared under the same roof, towards various points of the compass, and often to remote distances'. Photography, Root averred, served 'to draw closer, to strengthen and to perpetuate the ties of kindred, of friendship, and of general respect and regard'. Thus, the love of kindred was maintained and nurtured by photographs, and 'A nation is virtuous and united according as the households composing it are well ordered and bound together by mutual regard.' Root's remarks seem particularly prescient in light of Raymond Williams's reflection on the institutional effects of photographic technology: 'The proximate causes of photography are more predominantly scientific and technical, though the intense interest in reproducible images – and especially in images of persons – is almost certainly itself a response to quite new problems of perception and identification within a society characterised by wholly unprecedented mobility and change. To these basic factors were then added the effects of the vast dispersal of families on the generations of emigration, colonisation and urbanisation. Within this dispersal, the cheaply reproducible personal image took on a quite new cultural importance, at the same time that more internal cultural effects, in the new social psychology of the image, were also strengthening.' See Root, *The Camera and the Pencil*, pp. 413–44; Raymond Williams, 'Communications, Technologies and Social Institutions', in Neil Belton, Francis Mulhern and Jenny Taylor (eds), *What I Came to Say: Raymond Williams* (London: Hutchinson Radius, 1990) (first published 1981), p. 185.

1. *La Mission Héliographique*

1. Anne de Mondenard points out that the expression '*mission héliographique*' was first used in reference to these photographic voyages by Bernard Marbot, the conservator of the Bibliothèque nationale in France in 1979. The verbal records of the Commission des Monuments Historiques refer instead to '*missions*' or '*missions pour dessins photographiques*'. The journal of the Société Héliographique, *La Lumière*, used '*missions photographi-*

ques' or '*mission du Comité des monuments historiques*'. Anne de Mondenard, 'La Mission héliographique: mythe et histoire', *Études Photographiques*, 2 (May1997), pp. 61–2.

2. Joel A. Herschman and William W. Clark, *Un Voyage Héliographique à faire: The Mission of 1851*, ex.cat. (New York: Godwin-Ternbach Museum at Queens College, NY, 1981).

3. Michel Foucault, *The Order of Things: An Archaeology of the Human Sciences* (New York: Vintage Press, 1973), p. 131.

4. Anthony Vidler, *The Writing of the Walls* (Princeton: Princeton Architectural Press, 1987), p. 168.

5. Alexandre Lenoir's Musée d'antiquités et monuments français was considered to be a branch of the national museum being set up at the Louvre in the 1790s.

6. Alexandre Lenoir, *Musées des monuments français* (Paris, 1800).Quoted by Vidler, *The Writing of the Walls*, pp. 170, 172–3.

7. Lenoir, *Musées des monuments français*. Quoted by Vidler, *The Writing of the Walls*, p. 170.

8. In 1816, Louis-Philippe terminated Lenoir's Musée des monuments français and turned the buildings of the Petits-Augustins into the École des Beaux-Arts. Stephen Bann, *The Clothing of Cleo* (Cambridge: Cambridge University Press, 1984), pp. 83–92; Francis Haskell, *History and Its Images* (New Haven and London: Yale University Press, 1993), pp. 236–52; Eilean Hooper-Greenhill, *Museums and the Shaping of Knowledge* (New York and London: Routledge, 1992), pp.167–90; Werner Szambien, *Le Musée d'Architecture* (Paris: Picard Éditeur, 1988), pp. 32, 108–9; Vidler, *The Writing of the Walls*, pp. 167–73.

9. Jacques-Antoine Dulaure, *Histoire abrégée des différents cultes* (1825). Quoted by Xavier Costa, 'Mercurial Markers: Interpretation of Architectural Monuments in Early Nineteenth Century France', unpublished PhD dissertation, University of Pennsylvania, 1990, p. 151.

10. Costa, 'Mercurial Markers', pp. 206–14, 219.

11. Jean-Michel Leniaud, *Viollet-le-Duc ou les délires du système* (Paris: Éditions Mengès, 1994), p. 31; and Robert Morrissey, 'Whose House Is It?' in Suzanne Nash (ed.), *Home and Its Dislocation in Nineteenth-Century France* (Albany, NY: SUNY Press, 1993), p. 128, note 11, p. 143.

12. Morrissey, 'Whose House Is It?' p. 129.

13. At the same time that the writing of history was being revised, young architects were challenging the pedagogical philosophy of the French academic tradition. The bedrock of this training lay in the study of antique monuments and the most talented students achieved the Prix de Rome where for five years they developed their skills drawing ruins and making restoration studies. But in the 1820s, Félix Duban, Henri Labrouste and other young architects questioned this requisite archaeological work. There were other monuments to study from other ages and there were other questions to ask about how a building was structurally organized, the materials used, and the effects of light and shadow that its ornamentation cast. They developed a new technique of precise watercolours,

often utilizing the *camera lucida* to sharpen their vision. Rather than search for the abstract ideals of architectural proportion, they wanted to examine architectural surfaces as the embodiment of styles conceived as cultural and tectonic expressions. Barry Bergdoll, 'A Matter of Time: Architects and Photographers in Second Empire France', in Malcolm Daniel, *The Photographs of Édouard Baldus* (New York: Metropolitan Museum of Art, and Montreal: Canadian Centre for Architecture, 1994), pp. 99–119.

14. Louis-Philippe hoped to unify the French by stressing the arts. In 1833 he decided to turn Versailles into a historic museum, with a gallery dedicated to showing through historic paintings that France had been glorious, free and orderly only when it had acted in a unified manner. At the same time, Louis-Philippe modified the programme of exhibition at the Louvre so that it now revealed the role France had held in promoting the arts from Charlemagne to the conquest of Egypt. Leniaud, *Viollet-le-Duc*, pp. 30–2; Jacques Le Goff, *History and Memory* (New York: Columbia University Press, 1992), p. 109.

15. Vitet's Normandy tour covered the departments of Oise, Aisne, Marne and Pas-de-Calais. His list comprised (1) important churches – considerable repairs necessary; (2) important churches – few repairs; (3) middle-ranking churches – important repairs; (4) middle-ranking churches – few repairs. Leniaud, *Viollet-le-Duc*, pp. 33–4.

16. *Prosper Mérimée Exposition organisée pour commémorer le cent cinquantième anniversaire de sa naissance* (Paris: 1953), p. vii.

17. Ibid., p. 41.

18. Ibid.; and David Van Zanten, *Designing Paris: The Architecture of Duban, Labrouste, Duc, and Vaudoyer* (Cambridge, MA: MIT Press, 1987), p. 67.

19. In 1834, the Comité des documents inédits de l'histoire de France was created by the Ministère de l'Instruction publique with the explicit aim of publishing editions of mediaeval texts but also monographs on important monuments. Ludovic Vitet and Daniel Ramée were charged with the study of the cathedral of Noyon while Jean-Baptiste Lassus, Eugène Amaury-Duval and the archaeologist-journalist Adolphe-Napolèon Didron were to document Chartres. The task of this committee was vast and they soon divided into five parts, one of which was the Comité des arts et monuments to which Didron was named secretary in 1835. The goal of this group was three-fold: to create a descriptive and graphic inventory of all the monuments of France, especially those of the middle ages; to publicize archaeological documents useful to the work of conservation; and finally to conserve historic monuments. In all probability the work of this new group would have duplicated the work of the Commission des Monuments Historiques since agenda and committee members overlapped, but its budget was limited and therefore it focused on its mission of inventorying and creating methodological studies. This duplication is still apparent in the French system of preservation which makes a distinction between the

missions which inventory from those which restore. Leniaud, *Viollet-le-Duc*, pp. 37–8; Van Zanten, *Designing Paris*, p. 62.

20. Saint-Denis lay a neglected and deserted ruin until 1806 when Napoleon decided to restore it as a place commemorating former sovereigns of France and preparing it to be his imperial necropolis. Different attempts were made to render it in neo-classical style, but the first steps to preserve it as a mediaeval monument were not taken until François Debert was assigned to be the restoration architect between 1813 and 1846. Although his was an amateur work, Debert did organize the first restoration workshop, assembling a team of architects, glass-makers, painters and masons to carry out the project. Viollet-le-Duc would destroy most of Debert's work when he replaced him as restoration architect in 1846. Leniaud, *Viollet-le-Duc*, pp. 28–9; Jean Antoine Coussin in *Le Gènie de l'architecture* (1822) noted that the Greeks and Romans wrote their histories through architectural monuments, they erected everlasting books. Applying his ideas to Notre Dame in Paris, Coussin called it a 'lofty book of religious instruction, written on all sides'. Costa, 'Mercurial Markers', p. 124.

21. Szambien, *Le Musée d'Architecture*, pp. 59, 73, 112–14.

22. Jean Nicolas Huyot, 'Cours d'histoire de l'architecture à l'école royale' ms. (1830, 1834, 1840). Quoted by Costa, 'Mercurial Markers', p. 166.

23. Szambien, *Le Musée d'Architecture*, pp. 70–2.

24. Isidore Justin Taylor and Charles Nodier, *Voyages pittoresques et romantiques dans l'ancienne France: Normandy*, Vol. 1 (Paris: 1820), p. 4. Quoted by Bonnie L. Grad and Timothy A. Riggs, *Visions of City and Country: Prints and Photographs of Nineteenth-Century France* (Worcester: Worcester Art Museum and the American Federation of Arts, 1982), p. 17.

25. Grad and Riggs, *Visions of City and Country*; André Jammes and Eugenia Parry Janis, *The Art of French Calotype* (Princeton, NJ: Princeton University Press, 1983), pp. 49–51; and Michael Twyman, *Lithography, 1800–1850* (London: Oxford University Press, 1970), pp. 226–53.

In recognition of his attempt to relegitimate the rule of the Bourbons by placing them under the protection of their mediaeval past, Taylor received the title of 'baron' in 1825 upon the publication of the second volume of *Haute-Normandie*. In turn, Nodier was named 'bibliothécaire' of the Arsenal, where he held popular salons. On one such occasion Taylor met the young artist Adrien Dauzats who joined Horace Vernet, L. J. M. Daguerre, Richard P. Bonington and others working on the *Voyages pittoresques*. Dauzats worked in 1827 on the third volume dedicated to *Franche-Comté* and a few years later on the volume of *Auvergne*. After travels with Taylor to Egypt in search of Luxor obelisks, Dauzats continued work on the volumes in France, travelling to Languedoc in 1831 and Picardie in 1835. Adrien Dauzats travelled to Franche-Comté through Lons-Le Saulnier, Nozeroy, Besançon in 1827, and the following year through Auvergne, in Haute-Loire, in Le Puy-de-Dôme and

Cantal. He would execute lithographs of Luxeuil and Monnet-le Château, Clermont, Riom, Ennezat, Bess, etc. Leniaud, *Viollet-le-Duc*, pp. 19–20.

Another landscape painter, François-Alexandre Pernot, undertook the publication of *Voyages pittoresques de L'Écoisse* (1826), and in 1834 began the documentation of the architecture and boulevards of Paris that were just beginning to be transformed by the prefect of the Seine, Rambuteau. Two years later he was employed to produce 500 iconographic drawings of cathedrals all across France by the 'service des Cultes' whose responsibilities included the conservation of cathedrals. He travelled to Aveyron in 1836 and 1839; Normandy in 1839 and again in 1841, Lorraine in 1839, Champagne in 1843, Bourgogne in 1845. Because of his love for mediaeval architecture and his ability to evoke grand historic events associated with places of France, Pernot was named correspondent to the Comité historique des arts et monuments, in 1846. Leniaud, *Viollet-le-Duc*, p. 21.

26. The politician Montalembert would take up Grégoire's legacy and denounce the continued destruction of church properties in 'Lettre sur le vandalism' (1833). Leniaud, *Viollet-le-Duc*, pp. 17, 20.

27. Leniaud, *Viollet-le-Duc*, pp. 20, 22.

28. Auguste Le Prévost, later to be assigned to the Commission des Monuments Historiques, founded the Société libre de L'Eure. The Commission d'Antiquité de la Seine-Infèrieure was also created. Arcisse de Caumont, *Cours d'Antiquités Monumentales*, Vol. 4 (Paris: T. Chalopin, Imprimeur-Libraire, 1830), p. 5.

29. Arcisse de Caumont, *Abécédaire ou rudiment d'archéologie* (Caen: F. Le Blanc-Hardel, 1850).

30. By 1832 a preservation group had been able to save the fifth-century baptistery of Saint-Jean de Poitiers against a municipality's attempt to widen a local road. Other organizations were safeguarding the archaeology of Poitou and Tourraine. In 1834, these preservation groups organized their first national group, La Congrès archéologique de France, in order to establish a fund for architectural restoration work. De Caumont, *Abécédaire*.

31. Leniaud, *Viollet-le-Duc*, p. 24.

32. Laurent Baridon, *L'imaginaire scientifique de Viollet-le-Duc* (Paris: l'Harmattan, 1996, p. 40.

33. Ibid., pp. 125–36.

34. After the architect Charles Robelin completely documented Notre-Dame in Paris, the Ministère des Travaux Publics undertook a pilot restoration project in 1836 on Sainte Chapelle. Although the work was directed by the architect Félix Duban, hardly predisposed towards Gothic architecture, nevertheless he was assisted by Jean-Baptiste Lassus who guaranteed that it would be faithfully and scientifically restored. Viollet-le-Duc joined Lassus on the project. Leniaud, *Viollet-le-Duc*, p. 29.

35. Viollet-le-Duc would henceforth participate in the examination of many different projects of restoration and reconstruction, approving good works and rejecting bad or else substituting his own. Over the next few decades he became the mentor of architects assigned to the Commission des Monuments Historiques. Although never Inspecteur Général des Monuments Historiques, one of his protégés, Émile Boeswillwald, would replace Prosper Mérimée in 1860, the same year Viollet-le-Duc was named member of the Commission. The two were able to transform the mission imagined by Guizot, from a generalist and political organ into a specialist and technical regime controlling all restoration work throughout France. Leniaud, *Viollet-le-Duc*, pp. 78–9.

36. Bergdoll, 'A Matter of Time', pp. 105–6.

37. Dominique François Jean Arago, 'Report', in Alan Trachtenberg (ed.), *Classic Essays on Photography* (New Haven, CT: Leete's Island Books, 1980), pp. 15–25.

38. Ibid., p. 17.

39. Ibid., p. 19.

40. For example, Joseph-Philibert Girault de Prangey's *Monuments arabes de Egypte, de Syrie et d'Asie Mineure* (c. 1841) contained illustrations from daguerreotypes. Prangey was a devotee of the mediaeval architecture of France, having founded in 1834 the Société Archéologique de Langres, and he used the daguerreotype to complement detailed drawings he made of archaeological sites. Larry J. Schaaf, 'Invention and Discovery: First Images', in Ann Thomas (ed.), *Beauty of Another Order: Photography in Science* (New Haven, CT, and London: Yale University Press, 1997), pp. 16–59.

41. Commenting on Maxime Du Camp's 1852 publications of 125 photographic plates from Egypt, Nubia, Palestine and Syria, which he took between 1849 and 1851, Cormenin noted this *excursion daguerrienne* opened new horizons: 'it has unearthed the countries of necropoles and exposes them to us in encyclopaedic form: monuments, landscapes, animals, plants, seen from a bird's eye perspective, are seized in their aspect, their attitude, with the energy of truth and the power of relief. Such tentative efforts should be encouraged, and the government ought to send more travellers to the Pacific who will report on the entire world and enrich our museums through a significant collection' (Louis de Cormenin, 'A propos de Égypte, Nubie, Palestine et Syrie, de Maxime Du Camp', *La Lumière*, 26 June, 1852, p. 104). Quoted by André Rouillé, *La Photographie en France* (Paris: Maccula, 1989), pp. 52–4, quote, p. 125; Joan M. Schwartz, '*The Geography Lesson*: Photographs and the Construction of Imaginative Geographies', *Journal of Historical Geography*, 22, 1 (1996), pp. 16–45.

42. Rouillé, *La Photographie en France*, pp. 51–61.

43. Quoted by Michael Harvey, 'Ruskin and Photography', *Exposure*, 24, 2 (Summer 1986), p. 19.

44. Ruskin stated that his friend Mr Liddel had introduced him, around 1841, to the original experiments of Daguerre. Daguerreotypes had already been introduced to England when Antoine Claudet, the pioneering photographic portraitist, imported some views from France and submitted them to Queen Victoria and Prince Albert in September 1839. Harvey, 'Ruskin and Photography', p. 20.

45. Ibid., p. 21.

46. E. T. Cook and Alexander Wedderburn (eds),

The Works of John Ruskin: Literary Editions (London: George Allen, 1904), Vol. 8, p. xxix, quoted by Costa, 'Mercurial Markers', p. 98.

47. Quoted by Harvey, 'Ruskin and Photography', p. 21. When the first volume of *The Stones of Venice* appeared in 1851, it was accompanied by a folio volume of illustrations from daguerreotypes and calotypes taken in Venice during the winter and spring of 1849–50, and 1851. Although Ruskin failed to continue his photographic record of Venice, he hoped that others would come to aid the preservation of Venice's rich architecture. Under Austrian domination, Ruskin feared that the city might be seriously damaged if war broke out between the Italians and the Austrians.

48. Yvan Christ, Philippe Néagu et al., *La Mission Héliographique: Photographies de 1851* (Paris: Inspection Generale des Musées Classés et Controlé, 1980), pp. 15–16.

49. Herschman and Clark, *Un Voyage Héliographique à faire.*

50. *Prosper Mérimée Exposition.*

51. Jean Sagne, *L'atelier du photographe 1840–1940* (Paris: Presses de la Renaissance, 1984), pp. 19–56.

52. Christ, Néagu et al., *La Mission Héliographique*, p. 11.

53. Bergdoll, 'A Matter of Time', p. 103.

54. Ibid., p. 105.

55. Ibid., pp. 103–4.

56. Ibid.

57. Ibid.

58. Michel Foucault, *The Birth of the Clinic*, trans. A. M. Sheridan Smith (New York: Pantheon, 1973), p. 88.

59. For a complete membership list of the Société Héliographique see Aaron Scharf, *Art and Photography* (London: Penguin Books, 1974), p. 342.

60. Bibliothèque nationale, *Regards sur la photographie en France au XIXe siècle*, ex.cat. (Paris: Berger-Levrault, 1980); Scharf, *Art and Photography*, p. 140.

61. Eugène Delacroix, *Revue des deux mondes* (Paris, 15 September 1850), p. 144. Quoted by Scharf, *Art and Photography*, pp. 119–20.

62. As early as August 1849, the Commission approached Bayard to take six views, the choice to be guided by Delaborde, but no report exists to confirm that the task was implemented. On 17 January 1851, Laborde, Mérimée, Vaudoyer, Lenormand and Courmont were named subcommittee members (Christ, Néagu et al., *La Mission Héliographique*, pp. 16–17). Others have argued that the Commission finally agreed, on 20 February 1851, that there should be three missions: Baldus was offered the first to Normandy, Bayard the second to Midi, and Le Secq was sent to the East. In May of that year, Le Gray was assigned to the fourth mission, and Mestral to the fifth. Malcolm Daniel states that by the end of February all assigned missions were withdrawn and a competition was held for the selection of the five best photographers from among those who had submitted work to the Commission. That is when Baldus, Le Secq and Bayard received their commissions while Mestral and Le Gray were appointed in May. (Daniel, *The Photographs of Édouard Baldus*, p. 22.)

63. de Mondenard, 'La Mission héliographique', pp. 66–9.

64. Ibid., pp. 68–9.

65. Christ, Néagu et al., *La Mission Héliographique*, pp. 21–2.

66. Ibid., pp. 20–1.

67. Wey was interested in the relationship between painting and photography. *La Lumière* published several of Wey's articles on this subject between 1851 and 1853. His claim to the patrimony of the *Mission Héliographique*, however, was published in the *Musée des familles*. A comment should also be made about the symbolic use of the word 'museum' and its association with the documentary mentality, for it denoted an eclectic collection of bric-à-brac rather than a scientific catalogue of precision. There were at least seventy different newspapers, journals and albums published in France from 1806 to 1914 that carried the title *musée* (museum), and the metaphor 'printed museum' referred to an encyclopaedic exhibition devoted to the education of all. In 1833, Jules Janin confessed in the *Musée des familles*' inaugural issue:

> We have sought within a single publication to bring together every newspaper, large and small, every woodcut and copper engraving … to provide a vast and unique collection of things useful, futile, serious, silly, scholarly, … the police, the court of assizes, roads, health, pleasures, theaters, stables, churches, ruins, palaces, hovels, witticisms, caricatures, the rich, the poor, the craftsman, the flirt, the dandy, the gentleman, the poet, the dreamer, the novelist, the historian, who else? This entire crowd of minds, mores, interests, positions and needs, with its mixture of gaiety and sadness, of conflicting moods and opinions will find satisfaction in this collection, this journal, this book, this warehouse, this encyclopedia, this notebook, this museum.

Jules Janin, *Musée des familles, lectures du soir* 1 (1833); quoted and trans. Chantal Georgel, 'The Museum as Metaphor in Nineteenth-Century France,' in Daniel J. Sherman and Irit Rogoff (eds), *Museum Culture: Histories, Discourses, Spectacles* (Minneapolis: University of Minnesota Press, 1994), p. 115. In addition, there were at least sixty-four periodicals called *magasins* or 'department stores' as a synonym for 'museum'; Georgel, 'The Museum as Metaphor', pp. 113, 116.

68. Christ, Néagu et al., *La Mission Héliographique*, pp. 17–20.

69. Wey claimed he would have sent Bayard to Normany, Le Gray and Mestral to Touraine and the Midi, Baldus to Fontainebleau, Bourgogne and Dauphiné, and Le Secq to Champagne, Alsace and Lorraine (Christ, Néagu et al., *La Mission Héliographique*, pp. 17–20).

70. Ibid. pp. 18–20.

71. The 300 paper negatives that comprised the so-called *Mission Héliographique* are located in the photographic archives of the Musée d'Orsay. It was only in 1980 that the historian Philippe Néagu found some negatives in the Photothèque du Patrimoine and identified these as belonging to the *Mission Héliographique*. Anne

de Mondenard compared this inventory with those of the Musée des monuments français and discovered that the first 258 numbers of this list correspond to the images of the *Mission Héliographique*. Furthermore, review of the inventory showed that there were 258 proofs (*épreuves*) and 251 negatives (*négatifs*) submitted by the photographers of the *Mission* (de Mondenard, 'La Mission héliographique', pp. 68–74).

72. Christ, Néagu et al., *La Mission Héliographique*, pp. 23–4.

73. Ibid.

74. Ibid., pp. 23–5.

75. The different numbers between Néagu's 300 and Mondenard's 258 or 251 is the result of counting duplicate prints or negatives as separate or singular entries. Bayard never submitted his work. Le Gray and Mestral submitted their work under both of their names. Furthermore, a comparison of the inventory list of the archive with the lists the photographers were given reveals that some buildings were forgotten while other buildings were favoured and still other structures were added. In addition, the Commission decided to pay the expenses of the photographers as if they had been architects working with the Commission (de Mondenard, 'La Mission héliographique', pp. 74–8).

76. Eugenia Parry Janis, *The Photography of Gustave Le Gray* (Chicago: Art Institute of Chicago and the University of Chicago Press, 1987), pp. 26–7, 29–30, 36; n. 5, p. 155.

77. Francis Wey, 'Des Progrès et de l'avenir de la photographie', *La Lumière* (5 October 1851), pp. 138–9. Quoted by Janis, *The Photography of Gustave Le Gray*, p. 34.

78. Henri de Lacretelle, *La Lumière* (20 March 1852). Quoted in Christ, Néagu et al., *La Mission Héliographique*, p. 5.

79. Charles Nègre, *La Lumière* (May 1850). Quoted by Janis, *The Photography of Gustave Le Gray*, pp. 32–3.

80. Malcolm Daniel indicates where Baldus joined different negatives to produce his photograph of the Cloister of Saint-Trophîme, Arles, 1851 in Figure 3 (Daniel, *The Photographs of Édouard Baldus*, p. 22).

81. Ibid., pp. 21–2, 29, 32.

82. Bergdoll, 'A Matter of Time', p. 108.

83. Le Gray quoted by Donald E. English, *Political Uses of Photography in the Third French Republic 1871–1914* (Ann Arbor, MI: UMI Research Presss, 1984), p. 11.

84. Janis, *The Photography of Gustave Le Gray*, pp. 32, 37, 121.

85. Henri de Lacretelle, *La Lumière* (1852); quoted by Janis, *The Photography of Gustave Le Gray*, p. 38.

86. De Mondenard, 'La Mission héliographique', pp. 70–1. Quoted by Rosalind Krauss, *The Originality of the Avant-Garde and Other Modernist Myths* (Cambridge, MA: MIT Press, 1985), p. 143; Weston Naef, *After Daguerre*, ex. cat. (New York: Metropolitan Museum of Art in association with Berger-Levrault, Paris, 1980); Jammes and Janis, *The Art of French Calotype*.

87. Shelley Rice, *Parisian Views* (Cambridge, MA: MIT Press, 1998), pp. 52–3, 145–6.

88. Only a few decades earlier the mathematician and military engineer Gaspard Monge's 'orthographic system' providing a means to coordinate plane with section and elevation had been considered a 'secret' by the French government. By 1850, the architect's obsession with technical drawings comprised the basis of his art. Tom Porter, *The Architect's Eye* (London: Spon, 1997), pp. 18–19.

89. Shelley Rice claims he printed 100,000 negatives in Rice, *Parisian Views*, p. 46; the figure of 100,000 negatives may be exaggerated.

90. Ernest Lacan, *Esquisses Photographiques à propos de l'Exposition universelle et de la guerre d'Orient*. Quoted in Rouillé, *La Photographie en France*, pp. 130–1.

91. Charles Baudelaire, *Baudelaire: Selected Writings on Art and Artists*, trans. P. E. Charvet (Cambridge: Cambridge University Press, 1972), p. 297.

2. Retracing the Outlines of Rome

I received help and inspiration for this essay from many friends and colleagues: David Wooters, archivist at the George Eastman House, brought to my attention an unidentified group of views of Rome, which I later attributed to C. S. S. Dickins; Joe Struble, assistant archivist in the same collection, located the anonymous American tourist's albums; Mr Fred Spira first showed me, many years ago, the photographic illustration of Hawthorne's *The Marble Faun*. Mr and Mrs Mark Scrase-Dickins in Coolhurst, England, welcomed me, in 1992, to the original house of their ancestor Charles Scrase Spencer Dickins, helping me to find clues for this research. I also wish to thank Rebecca Simmons (George Eastman House), Stephen Rachman and Bruce Lundberg.

1. Charles Dickens, 'Pictures from Italy' (1846), in *American Notes and Pictures from Italy* (New York: Oxford University Press, 1989), pp. 259–60.

2. William Henry Fox Talbot, *The Pencil of Nature* (London: Longman, Brown, Green and Longmans, 1844).

3. See Larry J. Schaaf, *Tracings of Light: Sir John Herschel and the Camera Lucida. Drawings from the Graham Nash Collection* (San Francisco: Friends of Photography, 1990), p. 112.

4. Talbot, *The Pencil of Nature*.

5. William Henry Fox Talbot, 'Some Account of the Art of Photogenic Drawing', *The Athenaeum*, 539 (9 February 1839), p. 11. For similar considerations for the daguerreotype process, see Joan M. Schwartz, '*The Geography Lesson*: Photographs and the Construction of Imaginative Geographies', *Journal of Historical Geography*, 22, 1 (1996), pp. 16–45.

6. Talbot, 'Some Account', p. 11.

7. For the representation of Italy after unification, see my essay 'Bourgeois Spaces and Historical Contexts: Facets of the Italian City in Nineteenth-Century Photography', *Visual Resources*, 12, 1 (1996), pp. 1–18.

8. For an analysis of photography and tourism in Italy and a bibliography on nineteenth-century Italian photography, see my *Nineteenth-Century Italy*, a guest-

edited issue of *History of Photography*, 20, 1 (Spring 1996); Luigi Tomassini, 'Vedere Firenze nell'Ottocento. Immagini e descrizioni della città nell'editoria per il turismo', in *Alle origini della fotografia: un itinerario toscano 1839–1880* (Florence: Alinari, 1989); Andrew Szegedy-Maszak, 'Roman Views', in *Six Exposures: Essays in Celebration of the Opening of the Harrison D. Horblit Collection of Early Photography* (Cambridge, MA: Houghton Library, Harvard University, 1999), pp. 89–106.

9. James Buzard, *The Beaten Track: European Tourism, Literature, and the Ways to 'Culture' 1800–1918* (New York: Oxford University Press, 1983), p. 49.

10. Dennis Porter, *Haunted Journeys: Desire and Transgression in European Travel Writing* (Princeton, NJ: Princeton University Press, 1991), p. 7.

11. Both groups were acquired by George Eastman House in different lots (nos 308 and 314), from the auction house of E. Weil in London (catalogue 14), in 1949. This catalogue mentions that both groups probably came from the property of the Marquess of Northampton. I wish to thank the Marquess of Northampton in Warwick for answering my first letter of inquiry and for directing me to the residents of Coolhurst.

12. Other photographs in the album illustrate sites and residencies in Holmbush, St Leonard's Forest, Harlaxton Manor, Belton Alms House, Ashridge, Gordon Castle and Balcarres (in Scotland). Also included in this group is a portrait autotype of Lord Northampton, dated 1863.

13. For information on C. S. S. Dickins, see also Larry J. Schaaf, *Sun Pictures. Catalogue Four* (New York: Hans P. Kraus Jr, 1987), p. 17.

14. See C. R. Elrington (ed.), *The Victoria History of the Countess of England* (London: University of London Institute of Historical Research/Oxford University Press, 1986), p. 165.

15. See *Dictionary of National Biography*, vol. 14, p. 907.

16. See Larry J. Schaaf, *Out of the Shadows: Herschel, Talbot and the Invention of Photography* (New Haven, CT: Yale University Press, 1992), p. 62.

17. C. S. S. Dickins is listed at Christ Church Oxford in *Alumni Oxoniensis: The Members of the University of Oxford, 1715–1886* (London: Joseph Foster, 1888), Vol. 1, p. 368. I wish to thank Mark Curthoys, archivist at Christ Church Oxford, for answering my letter, and sending me the records of C. S. S. Dickins. Regarding Nevil Story Maskelyne, see Vanda Morton, *Oxford Rebels: The Life and Friends of Nevil Story Maskelyne, 1823–1911* (Gloucester: Alan Sutton, 1987).

18. A series of letters, addressed from Coolhurst to Lady Elisabeth in Rome, reveals that C. S. S. Dickins's party in Italy was composed also of the Third Marquess of Northampton and his wife Minnie (whom he had married on 26 June 1855). Research in the residence at Coolhurst uncovered drawings and watercolours sketched by Lady Elisabeth and the father of C. S. S. Dickins in northern Italy, in Rome and in the Italian South.

19. Regarding the different atmospheric conditions challenging the calotype process in Rome, see Richard W. Thomas, *The Photographic Art Journal*, 3, 6 (June 1852),

pp. 377–80. For the British photographers' travels in Italy, see Robert Lassam and Michael Gray, *The Romantic Era: La Calotipia in Italia* (Florence: Alinari, 1988); Larry J. Schaaf, *Sun Pictures. Catalogue Five: the Reverend Calvert R. Jones* (New York: Hans P. Kraus Jr, 1990).

20. The railway system in Italy was not well developed until the political unification of the country in 1860. The line between Florence and Rome was not active until 1870, when Rome became the capital city of Italy. See Tomassini, 'Vedere Firenze', pp. 13 and 24. For the *vetturini* service, see John Pemble, *The Mediterranean Passion: Victorians and Edwardians in the South* (Oxford: Clarendon Press, 1987), p. 19.

21. Mariana Starke, *Travels on the Continent* (1820). John Murray's *Handbook for Travellers in Central Italy. Part I: Southern Tuscany and Papal States* (London: John Murray, 1843) describes the Hotel Europa and the Hotel de Londres as 'the healthiest situations in Rome', p. 248.

22. See Larry J. Schaaf, introductory volume to *H. Fox Talbot's The Pencil of Nature: Anniversary Facsimile* (New York: Hans P. Kraus Jr, 1989), p. 46, for the explanation of Talbot's view from the Hotel de Douvres, in Paris, in 1843.

23. Dickens, *Pictures from Italy*, p. 379.

24. It was common practice for British calotypists to have their negatives printed in England. See Schaaf, *Sun Pictures. Catalogue Five*, p. 10.

25. Murray's *A Handbook for Travellers ... Part I* contains matching descriptions for Dickins's photographs of the obelisk in Piazza del Popolo (p. 327) and the Church of Santa Maria Maggiore (p. 352).

26. Talbot, 'Some Account,', p. 11.

27. Gerda Peterich identified this view as a work by C. S. S. Dickins in 'Nineteenth-Century Architectural Photographs', *Image*, 7, 10 (December 1958), pp. 224–5.

28. Schaaf, *Tracings of Light*, p. 17. Herschel's *camera lucida* drawing from the Pincio Hill is reproduced as plate 16, p. 63.

29. Anne Godlewska, 'Map, Text and Image. The Mentality of Enlightened Conquerors: A New Look at the *Description de l'Egypte*', *Transactions of the Institute of British Geographers*, NS 20, 1 (1995), p. 7. On issues of mapping and photography see also Gary Sampson, 'Photography and Representation', *Exposure*, 15, 2 (May 1977), pp. 8–11; Ernst Gombrich, 'Mirror and Map: Theories of Pictorial Representation', in *The Image and the Eye: Further Studies in the Psychology of Pictorial Representation* (Ithaca, NY: Cornell University Press, 1982), pp. 172–214.

30. For the notion of 'mirror construction' as 'image reflecting itself', and thus 'reflecting on itself', see Christian Metz, 'Mirror Construction in Fellini's 8½,' in *Film Language: A Semiotics of the Cinema* (1971) (Chicago: University of Chicago Press, 1996), pp. 228–34. Metz's analysis of 'mirror construction' and 'myse-en-abime' is recurrent in art. See Svetlana Alpers, 'The Mapping Impulse in Dutch Art', in *The Art of Describing: Dutch Art in the Seventeenth Century* (Chicago: University of Chicago Press, 1983), pp. 119–68. Alpers's analysis of Vermeer's 'The Art of Painting' arrives at similar conclusions to

Metz, in relationship to a picture within a picture, or a view of Delft within a geographic map, as part of the painter's self-reflexive 'art of describing'.

31. For a study of an American collection of photographs from the Grand Tour, see George Dimock, *Caroline Sturgis Tappan and the Grand Tour: A Collection of 19th-Century Photographs*, ex.cat. (Lenox: Lenox Library Association, 1982). See also Theodore E. Stebbins, Jr (ed.), *The Lure of Italy: American Artists and the Italian Experience, 1760–1914*, ex.cat. (Boston and New York: Museum of Fine Arts and Harry N. Abrams, 1992).

32. See Buzard, *The Beaten Track*, p. 64.

33. Schwartz, '*The Geography Lesson*', p. 31.

34. Dean MacCannell, *The Tourist: A New Theory of the Leisure Class* (1976) (New York: Schocken Books, 1989), p. xv.

35. Schwartz, '*The Geography Lesson*', p. 33.

36. Henry Wadsworth Longfellow, *Outre-mer: A Pilgrimage Beyond the Sea* (Boston and New York: Houghton, Mifflin, 1894), p. 307.

37. Longfellow, *Outre-mer*. Regarding the shrinking of distances due to railway transportation, see Wolfgang Schivelbusch, *Railway Journey: The Industrialization of Time and Space in the 19th Century* (Berkeley: University of California Press, 1977).

38. In 'Forum Romanum/Campo Vaccino', *History of Photography*, 20, 1 (Spring 1996), pp. 25–6, Andrew Szegedy-Maszak discusses the sense of 'duty', rather than 'projective fantasy', involved in the connoisseur's visit to the Roman Forum.

39. Walter Lippmann (1922), cited in Nathan Lyons, 'the outline of its mountains, will be made familiar to us', in *The Great West: Real/Ideal* (Boulder: University of Colorado Press, 1977), n.p.

40. Roland Barthes, 'The Blue Guide', in *Mythologies* (1957) (New York: Noonday Press, 1993), p. 76.

41. See Susan S. Williams, 'Manufacturing Intellectual Equipment: The Tauchnitz Edition of *The Marble Faun*', in Michelle Moylan and Lane Stiles (eds), *Reading Books* (Boston: University of Massachusetts Press, 1996), pp. 117–50.

42. Ibid., p. 118.

43. Ibid., p. 121.

44. Ibid., p. 124. Williams gives the year 1868 as the approximate date of the first photographic illustration of *The Marble Faun*. The main difference between photographically illustrated books and photographic albums in the nineteenth century is that the former were published and commercially distributed, while the latter were compiled by individuals as travel and family records. See Lucien Goldschmidt and Weston Naef, *The Truthful Lens: A Survey of the Photographically Illustrated Book, 1844–1914* (New York: Grolier Club, 1980); Julia Van Haaften, '"Original Sun Pictures": A Check List of the New York Public Library's Holdings of Early Works Illustrated with Photographs, 1844–1900', *Bulletin of the New York Public Library*, 80, 3 (Spring 1977), pp. 355–415.

45. Hawthorne, *The Marble Faun*, p. 99.

46. For an analysis of Hawthorne's relationship to photography, see Carol Schloss, 'Nathaniel Hawthorne

and Daguerreotypy', in *In Visible Light: Photography and the American Writer, 1840–1940* (New York: Oxford University Press, 1987), pp. 25–51; Alan Trachtenberg, 'Photography: The Emergence of a Keyword', in Martha A. Sandweiss (ed.), *Photography in Nineteenth-Century America* (Fort Worth and New York: Amon Carter Museum and Harry N. Abrams, 1991), pp. 16–47.

47. Williams discusses 'replicas' in *The Marble Faun* in 'Manufacturing', pp. 131–6. Regarding the 'replicated experience' in American nineteenth-century photography, see Miles Orvell, 'Photography and the Artifice of Realism', in Alan Trachtenberg and Miles Orvell, *The Real Thing: Imitation and Authenticity in American Culture, 1880–1940* (Chapel Hill and London: University of North Carolina Press, 1989), pp. 73–102.

48. Stephen Rachman, 'Reading Cities: Devotional Seeing in the Nineteenth Century', *American Literary History*, 9, 4 (Winter 1997), p. 665. I thank the author for sharing earlier drafts of this essay with me.

49. Rachman, 'Reading Cities', p. 666.

50. Hawthorne, *The Marble Faun* (1860) (New York: Penguin Classics, 1990), p. 99. Regarding the issue of 'cultural inferiority' towards Italy, see also Pemble, *The Mediterranean Passion*, pp. 60–70.

51. Williams, 'Manufacturing', p. 132. Williams uses MacCannell's term 'sight sacralization' in relation to the touristic value given to specific sites.

52. Rachman, 'Reading Cities', p. 669.

53. James Duncan and Derek Gregory (eds), *Writes of Passage: Reading Travel Writing* (London and New York: Routledge, 1999), p. 3.

3. Visualizing Eternity

1. J. Donald Hughes, *In the House of Stone and Light: A Human History of the Grand Canyon* (Flagstaff, AZ: Grand Canyon Natural History Association, 1978), p. 19.

2. See John F. Sears, *Sacred Places: American Tourist Attractions in the Nineteenth Century* (New York: Oxford University Press, 1989); David Schuyler, 'The Sanctified Landscape: The Hudson River Valley, 1820–1850', in George F. Thompson, *Landscape in America* (Austin, TX: University of Texas, 1995), pp. 93–109.

3. In 1851, 300 whole plate landscape daguerreotypes of the California gold-mines, rivers and San Francisco were exhibited in New York City. Robert Taft, *Photography and the American Scene* (New York: Dover, 1964; 1st edn, 1938), pp. 251–3.

4. Discussed also in David E. Nye, 'Constructing Nature: Niagara Falls and the Grand Canyon', in *Narratives and Spaces: Technology and the Construction of American Culture* (New York: Columbia University Press, 1998), pp. 13–24.

5. 'America's Magnificent Seven', *U.S. News and World Report*, 21 April 1975, pp. 56–7.

6. Joseph C. Ives, *Report upon the Colorado River of the West* (Washington, DC: Government Printing Office, 1861), pp. 109–10 (copy, Special Collections, Leeds University Library). For a similar ambivalence on the part of another early explorer, see Doris Ostrander Dawdy,

George Montague Wheeler: The Man and the Myth (Athens, OH: University of Ohio Press, 1993), p. 9.

7. See Sears, *Sacred Places*, pp. 3–30 and passim; and David E. Nye, *American Technological Sublime* (Cambridge, MA: MIT Press, 1994), pp. 17–26.

8. The aesthetic problems posed by western landscapes were discussed by James Fenimore Cooper who felt that the Rocky Mountains, while they 'possessed many noble views', nevertheless lacked that 'union of art and nature [which] can alone render scenery perfect'. James Fenimore Cooper, 'American and European Scenery Compared', in George W. Curtis (ed.), *Lotos-Eating: A Summer Book* (New York: Harper and Brothers, 1852), pp. 138–9.

9. William Cullen Bryant, *Picturesque America; or the Land We Live In* (New York: Appleton, 1872).

10. Ibid., p. iii.

11. Ibid., pp. iii–iv.

12. Barbara Novak, *Nature and Culture: American Landscape and Painting, 1825–1875* (New York: Oxford University Press, 1980), pp. 34–44, passim. See also Sears, *Sacred Places*, passim.

13. Estelle Jussim and Elizabeth Lindquist-Cock, *Landscape as Photograph* (New Haven, CT: Yale University Press, 1985), p. 56.

14. Alan Trachtenberg, *Reading American Photographs: Images as History, Mathew Brady to Walker Evans* (New York: Hill and Wang, 1989), pp. 119–63.

15. John K. Hillers, *'Photographed All the Best Scenery': Jack Hillers's Diary of the Powell Expeditions, 1871–1875*, Don D. Fowler (Salt Lake City, UT: University of Utah Press, 1972).

16. Bryant, *Picturesque America*, Vol. 2, p. 510: 'The picture drawn by the artist of a pinnacle in one of the angles of the Kanab is from a photograph taken by Mr. Hillers.'

17. J. H. Beadle, *The Undeveloped West; or Five Years in the Territories: Being a Complete History of That Vast Region between the Mississippi and the Pacific* (New York: Arno Press, 1973; 1st edn, Philadelphia, 1873), pp. 631–3.

18. Chas. S. Gleed (ed.), *From River to Sea: A Tourists' and Miners' Guide from the Missouri River to the Pacific Ocean* (Chicago: Rand, McNally, 1882).

19. See, for example, Hillers's 'The Grand Canyon, from North Side near Foot of Toroweap Valley' as reproduced by Frederick S. Dellenbaugh in *A Canyon Voyage: The Narrative of the Second Powell Expedition* (Tucson, AZ: University of Arizona Press, 1991), halftone facing p. 254.

20. Hughes, *In the House of Stone and Light*, p. 114.

21. Dellenbaugh, *A Canyon Voyage*, p. 58.

22. Speed and mobility long remained limited on the rim as well. In c. 1906 the Detroit Publishing Company sent a cameraman to make images along the Grand View Trail; he used 8 x 10-inch glass negatives. Five years later, when Alvin Langdon Coburn photographed the Grand Canyon he used a 3¾ x 4½-inch reflex camera and hauled his equipment to the bottom on mules (Alvin Langdon Coburn, *Alvin Langdon Coburn, Photographer: An Autobiography*, ed. Helmut and Alison Gernsheim, New York: F. A. Praeger, 1965, p. 84). Library of Congress, Photographic Collections, Detroit Publishing Co. view of hanging rock: LC-D4-19252 and reproduction no. LC-D4-19252 DLC. View from in front of hotel: call no. LC-D4-19250; reproduction no. LC-D4-19250 DLC. There were other images in this series, for example a view from the head of the Grand View Trail, LC-D4-19248, reproduction no. LC-D4-19248 DLC, Detroit Publishing Co., no. 50503. This is a photomechanical colour photochrome print: LOT 3888, no. 2 (H) (original) det 4a31593.

23. Trachtenberg, *Reading American Photographs*, p. 131.

24. See Richard N. Masteller, 'Western Views in Eastern Parlors: The Contribution of the Stereograph Photographer to the Conquest of the West', *Prospects*, 6 (1981), pp. 55–71.

25. Taft, *Photography and the American Scene*, p. 308.

26. Joni Louise Kinsey, *Thomas Moran and the Surveying of the American West* (Washington, DC: Smithsonian Institution Press, 1992), pp. 101–2.

27. Cited in Taft, *Photography and the American Scene*, p. 302.

28. Howard Bossen, 'A Tall Tale Retold: The Influence of the Photographs of William Henry Jackson on the Passage of the Yellowstone Park Act of 1872', *Studies in Visual Communication*, 8 (Winter 1982), pp. 98–109.

29. Taft, *Photography and the American Scene*, p. 302.

30. Stephen J. Pyne, *How the Canyon Became Grand* (New York: Viking, 1998), p. 49.

31. Cited ibid., p. 48.

32. Michael Smith, *Pacific Vistas: California Scientists and the Environment, 1850–1915* (New Haven, CT: Yale University Press, 1987), p. 74.

33. Stephen J. Pyne, *Dutton's Point: An Intellectual History of the Grand Canyon* (Grand Canyon Natural History Association, Monograph no. 5), 1982, p. 34. Clarence E. Dutton, *Tertiary History of the Grand Cañon District* (Washington, DC: US Government Printing Office, 1882, reprinted by Peregrine Smith, 1977).

34. Marta Weigle and Barbara A. Babcock, '"To Experience the Real Grand Canyon": Santa Fe/Fred Harvey Panopticism', in Marta Weigle and Barbara A. Babcock (eds), *The Great Southwest of the Fred Harvey Company and the Santa Fe Railways* (Phoenix, AZ: The Heard Museum, 1996), pp. 13–19.

35. Charles A. Higgins, *Grand Cañon of Arizona* (Chicago: Passenger Department of the Santa Fe Route, 1901). Passenger Department of the Santa Fe Railroad, *The Grand Canyon of Arizona; being a book of words from many pens, about the Grand Canyon of the Colorado River in Arizona* (Chicago, 1902). See also *Grand Canyon Outings* (Chicago: Atchison, Topeka, and Santa Fe Railroad Company, c. 1922), p. 46.

36. Alfred Runte, *Trains of Discovery: Western Railroads and the National Parks* (Flagstaff, AZ: Northland Press, 1984).

37. See David E. Nye, *Image Worlds: Corporate Identities at General Electric* (Cambridge, MA: MIT Press, 1985).

38. Peter Bacon Hales, 'American Views and the Romance of Modernization', in Martha A. Sandweiss (ed.), *Photography in Nineteenth-Century America* (Fort Worth and New York: Amon Carter Museum and Harry N. Abrams, 1991), pp. 237–8.

39. Donald L. Baars and Rex C. Buchanan, *The Canyon Revisited: A Rephotography of the Grand Canyon* (Salt Lake City, UT: University of Utah Press, 1994), p. 8.

40. Ibid., p. 8.

41. Ibid., p. 4.

42. *National Geographic Magazine*, 46 (July 1924), pp. 36–7 and passim.

43. These three aesthetics could also be adapted to film. The Kolb brothers took the first moving images, of their own boat trip down the river, emphasizing the sublimity of the landscape. The film is deposited at the University of Northern Arizona, Flagstaff. A Ford Motor Company film (1916, 1920) more in the tourist mode began with a map of the Colorado River plateau illustrating the sedimentary layers which the river had cut through. It then showed tourists on horseback descending Bright Angel Trail to the Phantom Ranch. Mayfield Bray (ed.), *Guide to the Ford Film Collection in the National Archives* (Washington, DC: National Archives, 1970), p. 21.

44. Ronald L. Warren, 'Aviation at Grand Canyon: A 75-Year History', *Journal of Arizona History* 36, 2 (Summer 1995), pp. 151–2.

45. Ibid., p. 154.

46. *National Geographic Magazine*, 46 (July 1924), pp. 62–8.

47. The view from the air was not yet standard tourist fare. There were few paying customers in the 1920s, and attempts to establish a commercial air service failed financially until 1931, when the demand for excursions had increased enough that Grand Canyon Airlines began regular flights. This company entered into a contract with the two park concessionaires, Fred Harvey Company and Utah Parks Company, granting them a percentage of sales in exchange for exclusive rights to provide air transport inside the park. Park superintendent M. R. Tillotson approved the arrangement. Hughes, *In the House of Stone and Light*, p. 100; Warren, 'Aviation at Grand Canyon', p. 161.

48. Hales describes how western photographers found their sales drop after the introduction of postcards into the mails in the 1890s, and how they subsequently sold reproduction rights to large companies that could market nationally. Hales, 'American Views', pp. 236–8.

49. Coburn, *Alvin Langdon Coburn*, p. 84.

50. Postmodern sensibilities are also suggested by the contrast between stereoscopic images and those available at several Internet sites. There are both official and unofficial home pages for the Canyon, as well as images available through the website of the Library of Congress. See: National Park Service homepage: http://www.nps.gov/grca/index.html

There is also a trip planner home page devoted to the Grand Canyon at: http://www.thecanyon.com/nps/tripplanner/index.html

Grand Canyon Association home page: http://www.thecanyon.com/gca/

Library of Congress: http://lcweb2.loc.gov/ammem/consrvbibquery.html

51. John Muir, 'The Grand Canyon', in Paul Schul-lery (ed.), *The Grand Canyon: Early Impressions* (Boulder, CO: Colorado Associated University Press, 1981), p. 79.

52. John C. Van Dyke, *The Grand Canyon of the Colorado: Recurrent Studies in Impressions and Appearances*, Foreword by Peter Wild (Salt Lake City, UT: University of Utah, 1992; 1st edn, New York: Charles Scribner's Sons, 1920), p. 1.

53. Muir, 'The Grand Canyon', p. 77.

54. Cited in Stewart Aitchison, *A Naturalist's Guide to Hiking the Grand Canyon* (Englewood Cliffs, NJ: Prentice Hall, 1985), p. 20.

55. Joseph Wood Krutch, *The Grand Canyon* (Tucson, AZ: University of Arizona Press, 1989; 1st edn, New York: William Sloane Associates, 1958), p. 35.

56. Eliot Porter, *The Grand Canyon* (New York: ARTNews, 1992).

57. See, for example, the following famous images: 'Clearing Winter Storm, Yosemite National Park, California, 1944', 'Mount Williamson, Sierra Nevada from Owens Valley, California, 1944', 'Sand Dunes, Oceano, California, 1950', and 'Sand Dunes, Sunrise, Death Valley National Monument, California, 1948', all reproduced in the widely distributed Peter Turner, *American Images: Photography 1945–1980* (New York, 1985), pp. 24–7.

58. Richard Grusin, 'Representing Yellowstone: Photography, Loss, and Fidelity to Nature', *Configurations*, 3 (1995), pp. 417–18.

59. *US Camera* (1949), p. 206.

60. See the interview with Porter in Paul Hill and Thomas Cooper (eds), *Dialogue with Photography* (New York: Farrar, Strauss, Giroux, 1979), p. 241.

61. In 1956 David Brower and the Sierra Club were lobbying to prevent certain dams from being built further up the Colorado River, and they agreed to a political compromise that permitted the Glen Canyon dam to be built. They did so without any first-hand knowledge of the Glen Canyon area, an ignorance that they later much regretted. Eliot Porter, *The Place No One Knows: Glen Canyon on the Colorado* (San Francisco: Sierra Club, 1963).

62. Philip L. Fradkin, *A River No More: The Colorado River and the West* (Tucson, AZ: University of Arizona Press, 1984), pp. 196–7.

63. Roland Barthes, *Camera Lucida: Reflections on Photography* (New York: Hill and Wang, 1981), passim.

64. Kenneth Poli, cited in *Contemporary Photographers* (New York: Macmillan, 1982), p. 605.

65. Ann and Myron Sutton, *The Wilderness World of the Grand Canyon*, cited in Robert Wallace et al. (eds), *The Grand Canyon* (Alexandria: Time/Life Books, 1973), p. 84.

66. Paul Caponigro, *The Wise Silence* (Boston: New York Graphic Society and George Eastman House, 1983), p. 129. The other image shows a huge rock mass in the right upper corner that seems about to fall into the diagonal cleft in the cliff wall which affords a view of the cliffs and buttes of the Canyon beyond. Here there is no sign of humanity.

67. Caponigro, *The Wise Silence*, frontispiece.

68. *Magnum Landscape* (London, 1996), p. 14.

69. Fara Warner, 'The Place to be This Year', *Brandweek*, 33, 45 (1995).

4. Family as Place

1. Seminal works include Pierre Bourdieu, *Photography: A Middle Brow Art*, trans. Shaun Whiteside (Stanford, CA: Stanford University Press, 1990); Julia Hirsch, *Family Photographs: Content, Meaning and Effect* (New York: Oxford University Press, 1981); Marianne Hirsch, *Family Frames: Photography, Narrative and Postmemory* (Cambridge, MA: Harvard University Press, 1997); Annette Kuhn, *Family Secrets* (London: Verso, 1995); Jo Spence and Patricia Holland (eds), *Family Snaps: The Meanings of Domestic Photography* (London: Virago, 1991). PhDs are now being written on the subject; see, for example, Geoffrey Wilson Poister, 'A Cross-cultural Study of Family Photo Albums', unpublished PhD dissertation, Syracuse University, 1998.

2. Susan Sontag, *On Photography* (London: Penguin, 1977), pp. 8–9.

3. For debates about the politics of space and the gendered and sexualized nature of spatial relations, see, for example, Linda McDowell and Joanne P. Sharp (eds), *Space, Gender, Knowledge: Feminist Readings* (London: Arnold, 1997); David Bell and Gill Valentine (eds), *Mapping Desire: Geographies of Sexualities* (London: Routledge, 1995).

4. Leonore Davidoff and Catherine Hall, *Family Fortunes: Men and Women of the English Middle Class 1780–1850* (London: Routledge, 1994; 1st edn 1987).

5. Marion F. Motz, 'Visual Autobiography: Photographic Albums of Turn-of-the-century Midwestern Women', *American Quarterly*, 41 (March 1989), pp. 63–92; p. 66.

6. For examples of the use of autobiography in the analysis of family photography, see M. Hirsch, *Family Frames*; Kuhn, *Family Secrets*; Jo Spence, *Putting Myself in the Picture: A Political, Personal and Photographic Autobiography* (London: Virago, 1991). For discussions about the need for a more self-reflexive, autobiographical approach to the study of culture within the interpretative tradition in anthropology, and in cultural studies, feminism and oral history, see, for example, Clifford Geertz, *The Interpretation of Cultures* (New York: Basic Books, 1973); James Clifford, 'Introduction: Partial Truths', in James Clifford and George E. Marcus (eds), *Writing Culture: The Poetics and Politics of Ethnography* (Berkeley and Los Angeles: University of California Press, 1986), pp. 1–26; Elspeth Probyn, *Sexing the Self: Gendered Positions in Cultural Studies* (London: Routledge, 1993); Ronald J. Grele, 'Movement Without Aim: Methodological and Theoretical Problems in Oral History', in Robert Perks and Alistair Thomson (eds), *The Oral History Reader* (London: Routledge, 1998).

7. 'The Family Photograph Album' research project was conducted with Carol Liston at the Women's Research Centre, and assisted by summer research scholar Louise Denoon and research assistant Robyn Arrowsmith. The project was funded by a seed grant from the University of Western Sydney, Nepean,

1992. One-hour taped discussions were held with ten women album owners, aged sixty and over, who were in their early twenties during the 1950s. The names of the women quoted from have been changed. The album photographs reproduced in this essay as examples have been drawn from albums belonging to my own family. In the interests of confidentiality, I have avoided publishing photographs of the album owners interviewed.

8. Bourdieu, *Photography*, p. 19.

9. Claire Grey, 'Theories of Relativity', in Spence and Holland (eds), *Family Snaps*, p. 107.

10. Eric Hobsbawm and Terence Ranger (eds), *The Invention of Tradition* (Cambridge: Cambridge University Press, 1983); see also James R. Ryan, *Picturing Empire: Photography and the Visualization of the British Empire* (London: Reaktion Books, 1997).

11. Anne McClintock, *Imperial Leather: Race, Gender and Sexuality in the Colonial Context* (London: Routledge, 1995), p. 357.

12. Ibid., p. 357.

13. Ibid., p. 358.

14. See Marina Warner, *Monuments and Maidens: The Allegory of the Female Form* (London: Picador, 1985).

15. Davidoff and Hall, *Family Fortunes*.

16. Ibid., p. 451.

17. Ibid.

18. Alan Self, 'The Family Album: Means and Results', in *Leisure in the Twentieth Century: History of Design*, Second Conference on Twentieth Century Design History (London: Design Council Publications, 1977), p. 34.

19. I am grateful to Joan Schwartz for providing me with the information about these *cartes-de-visite* and for identifying their significance to the theme of this essay.

20. John Berger, *About Looking* (London: Writers and Readers Publishing Cooperative, 1980).

21. Sontag, *On Photography*, pp. 8–9.

22. Raymond Williams, *Television, Technology and Cultural Form* (London: Fontana, 1976).

23. See Anne Game and Rosemary Pringle, 'Sexuality and the Suburban Dream', *Australian and New Zealand Journal of Sociology*, 15, 2 (July 1979), pp. 4–15, p. 4.

24. Noel Sanders, 'Family Snaps: Images, Ideology and the Family', *Occasional Papers in Media Studies*, 8, Faculty of Humanities and Social Sciences, New South Wales Institute of Technology (1980), p. 4.

25. Benedict Anderson, *Imagined Communities: Reflections on the Origins and Spread of Nationalism* (London: Verso, 1993).

26. See Lynne Spigel, 'From Theatre to Space Ship: Metaphors of Suburban Domesticity', in Roger Silverstone (ed.), *Visions of Suburbia* (London: Routledge, 1997), pp. 217–39.

27. Celia Lury, *Prosthetic Culture: Photography, Memory and Identity* (London and New York: Routledge, 1998), p. 81.

28. Don Slater, 'Domestic Photography and Digital Culture', in Martin Lister (ed.), *The Photographic Image in Digital Culture* (New York and London: Routledge, 1995), pp. 129–47.

29. 'The Western Sydney Women's Oral History Project: From Farms to Freeways' was conducted with Carol Liston and Chris Wieneke, and assisted by summer research scholar Larissay Banberry, at the Women's Research Centre, University of Western Sydney, Nepean. The project was funded by an Australian Research Council Small Grant, 1991. For an account of the study, see Deborah Chambers, 'A Stake in the Country: Women's Experiences of Suburban Development', in Silverstone (ed.), *Visions of Suburbia*.

30. Berger, *About Looking*.

31. See Chambers, 'A Stake in the Country'.

32. Ibid., pp. 89–90.

33. Sanders, 'Family Snaps', p. 145.

5. Picturing Nations

1. Karl W. Deutsch, *Nationsbildung – Nationalstaat – Interpretation* (Düsseldorf: Bertelsmann Universitätsverlag, 1972), p. 29.

2. Much has been written in recent years about the role and history of symbols in national movements. Hans-Ulrich Wehler, *Deutsche Gesellschaftsgeschichte, Vol 3. Von der Deutschen Doppelrevolution bis zum Beginn des Ersten Weltkriegs 1849–1914* (München: C. H. Beck, 1995), pp. 1459–61 provides a useful bibliography on this topic. See also Denis Cosgrove and Stephen Daniels (eds), *The Iconography of Landscape: Essays on the Symbolic Representation, Design, and Use of Past Environments* (Cambridge: Cambridge University Press, 1988); Eric J. Hobsbawm, *Nations and Nationalism Since 1780* (Cambridge: Cambridge University Press, 1991); Dieter Langewiesche, 'Reich, Nation und Staat in der jüngeren deutschen Geschichte', *Historische Zeitschrift*, 254 (1992), pp. 341–81. Tradition is used here in the sense of Eric Hobsbawm, 'Introduction: Inventing Traditions', in Eric Hobsbawm and Terence Ranger (eds), *The Invention of Tradition* (Cambridge: Cambridge University Press, 1983), pp. 1–2.

3. Benedict Anderson, *Imagined Communities: Reflections on the Origin and Spread of Nationalism* (London: Verso, 1983).

4. Landscape, according to a recent definition by W. J. T. Mitchell, can be defined 'as a process by which social and subjective identities are formed'. W. J. T. Mitchell, 'Introduction', in W. J. T. Mitchell (ed.), *Landscape and Power* (Chicago: University of Chicago Press, 1994), p. 1.

5. John Taylor, *A Dream of England: Landscape, Photography and the Tourist's Imagination* (Manchester: Manchester University Press, 1994). Taylor investigates post-1880 *English* landscape photography, emphasizing the differences between England, Scotland and Wales.

6. Joan M. Schwartz, '*The Geography Lesson*: Photographs and the Construction of Imaginative Geographies', *Journal of Historical Geography*, 22, 1 (1996), pp. 16–45.

7. This is the result of researches in the following museums: Museum für Kunst und Gewerbe, Hamburg; Agfa Photo Historama, Köln; Deutsches Museum München, Photomuseum im Münchner Stadtmuseum,

München; and Kupferstichkabinett Dresden, Dresden. Though there are photographs of landscapes and cityscapes, their number is much smaller than the number in British museums.

8. Joan M. Schwartz's discussion (in '*The Geography Lesson*') of the British and French cases would support this. M. Christine Boyer explores the efforts of the French government to employ photography for the creation of collective identity in the early 1850s in the present volume. In Belgium, the government commissioned the photographic conservation of national monuments in 'the spirit of national patrimony', cf. Christine De Naeyer, 'Belgian Landscape through the Eyes of Photographic Commissions', in '*Darkness and Light*': *Proceedings of the ESHP Symposium Oslo 1994* (Oslo: National Institute for Historical Photography, 1995), pp. 59–66. There is a large and varied literature on the nature and role of landscape photography in the USA in the nineteenth century. See, for example, Martha A. Sandweiss, 'Undecisive Moments: The Narrative Tradition in Western Photography', in Martha A. Sandweiss (ed.), *Photography in Nineteenth-Century America* (Fort Worth and New York: Amon Carter Museum and Harry N. Abrams, 1991); also Joel Snyder, 'Territorial Photography', in Mitchell (ed.), *Landscape and Power*, pp. 175–201.

9. For a further discussion of the way photography was debated in the middle of the nineteenth century, see Jens Jäger, 'Discourses of Photography in Mid-Victorian Britain', *History of Photography*, 19, 4 (Winter 1995), pp. 316–22.

10. This is notably the case with English landscape. As David Lowenthal has noted: 'Nowhere else is landscape so freighted as legacy. Nowhere else does the very term suggest not just scenery and genre de vie, but quintessentially national virtues.' David Lowenthal, 'European and English Landscapes as National Symbols', in David Hooson (ed.), *Geography and National Identity* (Oxford: Blackwell, 1994), p. 20.

11. Alon Confino, *The Nation as a Local Metaphor: Wuerttemberg, Imperial Germany, and National Memory, 1871–1918* (Chapel Hill, NC: University of North Carolina Press, 1997).

12. Robert Cecil, 'Photography', *Quarterly Review*, 116 (1864), p. 483.

13. This was emphasized frequently: '[I]t not only ensures *perfect fidelity* of likeness where it is most essential, and where it is hardly attainable by the most practised and patient hand and eye, but also gives us the *minutest details* – those which are *imperceptible* to the naked eye' (italics in the original). *The Penny Cyclopaedia of the Society for the Diffusion of Useful Knowledge*, Vol. 17 (London, 1840), p. 113.

14. Francis Frith, 'The Art of Photography', *Photographic Journal*, 6 (1859), p. 71.

15. A. R. v. Perger, 'Ueber Photographie', *Allgemeine Zeitung*, 18 August 1859, p. 3755, for example, mentioned educational benefits and photography's entertaining power but did not wonder about its moral influence.

16. J. A. Schmiechen, 'The Victorians, the Historians, and the Idea of Modernism', *American History Review*, 93 (1988), pp. 302–3.

17. Schmiechen, 'The Victorians', pp. 287–316; see also: Francis D. Klingender, *Art and the Industrial Revolution* (London: Mackay, 1968).

18. Keith Robbins, *Nineteenth-Century Britain: England, Scotland, and Wales. The Making of a Nation* (Oxford: Oxford University Press, 1989), p. 3.

19. Linda Colley, *Britons: Forging the Nation, 1707–1837* (New Haven, CT: Yale University Press, 1992), p. 1.

20. Robbins, *Nineteenth-Century Britain*, pp. 183–5.

21. This is not a phenomenon exclusively to be found in the nineteenth century as shown by Richard Helgerson, *Forms of Nationhood: The Elizabethan Writing of England* (Chicago: University of Chicago Press, 1992).

22. The colonies provided a source of pride and identification to British citizens. The contribution of colonial photography to the development of British national consciousness is very important and cannot be elaborated here. On this topic see Part III of the present volume and especially James R. Ryan, *Picturing Empire: Photography and the Visualization of the British Empire* (London: Reaktion Books, 1997).

23. See, for example, Krünitz, *Encyclopädie*, Vol. 101 (Berlin, 1806), pp. 393–414.

24. Wehler, *Deutsche Gesellschaftsgeschichte*, Vol. 3, pp. 230–1.

25. Thomas Nipperdey, *Deutsche Geschichte 1800–1866. Bürgerwelt und starker Staat*, 5th edn (München: C. H. Beck, 1991), pp. 305–6. In recent years the literature on national monuments has increased substantially. For a comprehensive guide see Charlotte Tacke, *Denkmal im sozialen Raum. Nationale Symbole in Deutschland und Frankreich im 19. Jahrhundert* (Göttingen: Vandenhoek and Ruprecht, 1995).

26. Robin Lenman, 'Painters, Patronage and the Art Market in Germany, 1850–1914', *Past and Present*, 123 (1989), pp. 109–40.

27. Elizabeth Helsinger, 'Turner and the Representation of England', in Mitchell (ed.), *Landscape and Power*, pp. 103–26.

28. G. Wiegand (publ.), *Das malerische und romantische Deutschland* (Leipzig, 1836 ff). Initially planned to include ten parts, the first edition was by 1842 extended to fourteen parts covering nearly all German regions. A second edition was printed in 1847.

29. *Galerie pittoresker Ansichten des deutschen Vaterlandes und Beschreibung derselben. Ein Hausschatz für Jedermann* (Leipzig, 1856–59).

30. This is evident in the early use of daguerreotypes as the basis for engravings, e.g. N. M. P. Lerebours, *Excursions daguerriennes: vues et monuments les plus remarquables du globe* (Paris, 1840–44).

31. See Robbins, *Nineteenth-Century Britain*, pp. 21–8.

32. Roger Taylor, *George Washington Wilson: Artist and Photographer, 1823–1893* (Aberdeen: Aberdeen University Press, 1982). The discovery of Cornwall is a good example. Before Cornwall was connected to the railway network in 1859, photographs of Cornish landscapes and monuments were taken and published by John W. Gouch from Bristol. See Charles Thomas, *Views and Likenesses: Early Photographers and Their Work in Cornwall and the Isles of Scilly, 1839–1870* (Truro: Royal Institution of Cornwall, 1988), p. 57.

33. See Schwartz, '*The Geography Lesson*'.

34. Anon, 'The Photographic Exhibition', *The Athenaeum* (30 April 1853), p. 535. Similar comments in many periodicals of the time described the merits of photography in the same way.

35. Helsinger, 'Turner', p. 106.

36. We have no information on the editions of landscape photographs. Some portraits were sold in huge quantities; the print dealers Marion and Co. sold 70,000 *cartes-de-visite* portraits of Prince Albert a couple of weeks after his death. Helmut Gernsheim, *Geschichte der Photographie. Die ersten Hundert Jahre* (Frankfurt/M., Berlin, Wien: Propyläen Verlag, 1983), p. 361.

37. Taylor, *George Washington Wilson*, p. 64.

38. Negretti and Zambra, *Descriptive Catalogue of Stereoscopes and Stereoscopic Views* (London: Negretti and Zambra, 1859). The figures for 'Views on paper' are English: 418; English and Welsh: 333; Scottish: 57; Welsh: 42; and Irish: 100.

39. Anon, 'Foreign Correspondence', *Photographic News*, 4 (1860), p. 200.

40. Hermann Wilhelm Vogel, *Die Photographie auf der Londoner Weltausstellung des Jahres 1862* (Braunschweig, 1863), pp. 64–5. Professor Friedrich Heeren of Hannover, Juror for Class XIV (Photography), observed the same phenomenon and added that landscape photography was especially cultivated in England. See *Amtlicher Bericht über die Industrie- und Kunst-Ausstellung zu London im Jahre 1862 erstattet nach Beschluß der Kommissarien der Deutschen Zollvereins-Regierungen*, 3 vols (Berlin, 1863–65), Heft VI, 14. Klasse Photographische Apparate und Photographien, pp. 451–76.

41. From an advertisement of *Kölnische Zeitung*, 29 November 1863, reproduced in: Werner Neite, 'Der Verkauf photographischer Bilder in den frühen Jahren der Photographie', in Bodo v. Dewitz and Reinhard Matz (eds), *Silber und Salz: Zur Frühzeit der Photographie im deutschen Sprachraum 1839–1860* (Köln and Heidelberg: Edition Braus, 1989), pp. 558–9. Eckenrath boasted that he owned the biggest stock of photographs in Germany. He supplied landscapes, portraits and reproductions of works of art.

42. See Schwartz, '*The Geography Lesson*', p. 31.

43. A definition of the picturesque is notoriously difficult because it is *per se* an open category. For a short definition of the picturesque see: Joseph Rosenblum in 'The Picturesque', Laura Dabundo (ed.), *Encyclopedia of Romanticism, 1780s-1830s* (New York: Routledge, 1992), pp. 455–7; see also Christopher Hussey and Luigi Salerno, 'The Picturesque', *Encyclopaedia of World Art*, Vol. 11, 2, rev. edn (New York, 1972), pp. 341–2. For a discussion of the picturesque as an aesthetic category, see Eckhard Lobsien, 'Landschaft als Zeichen. Zur Semiotik des Schönen, Erhabenen und Pittoresken', M. Smuda (ed.), *Landschaft* (Frankfurt/M.: Suhrkamp, 1986), pp. 159–77. For a comprehensive discussion of the picturesque as ideological category, see Stephen Copley and Peter Garside (eds), *The Politics of the Picturesque: Literature, Landscape and Aesthetics Since 1770* (Cambridge: Cambridge University Press, 1995).

44. Hussey and Salerno, 'The Picturesque'.

45. Lobsien, 'Landschaft als Zeichen', pp. 168–77.

46. In contrast to many learned societies, photographic societies accepted women as members. The Photographic Society of London advertised in *The Athenaeum* (1853), p. 152, that 'Ladies may become members'.

47. See Stephen Daniels, 'The Political Iconography of Woodland in later Georgian England', in Denis Cosgrove and Stephen Daniels (eds), *The Iconography of Landscape: Essays on the Symbolic Representation, Design and Use of Past Environments* (Cambridge: Cambridge University Press, 1988), pp. 43–82.

48. Lobsien, 'Landschaft als Zeichen', p. 172.

49. Daniels, 'Political Iconography', p. 57.

50. Ann Bermingham, 'System, Order, and Abstraction: The Politics of English Landscape Drawing around 1795', in Mitchell (ed.), *Landscape and Power*, pp. 77–101.

51. Daniels, 'Political Iconography', argues that the picturesque lost its political power in the Victorian era. The argument is based on the fact that the theoretical debate came to a close in the 1820s.

52. Benjamin Disraeli, *Sybil, or the Two Nations* (London, 1845) and Disraeli's novels: *Coningsby, or The New Generation* (London, 1845); and *Tancred, or The New Crusade* (London, 1847).

53. For example, Anon, 'The Monk of Tintern: A Tale of the Twelfth Century', *National. A Library for the People* 1, 1 (1839), pp. 4–6. Pencil'em [Pseud.], 'Fine Art', *The Union: A Monthly Record of Moral, Social and Educational Progress* 1, 2 (1842), pp. 47–52. For a fuller discussion of the radicals' use of the picturesque see Anne Janowitz, 'The Chartist Picturesque', in Copley and Garside, *The Politics of the Picturesque*, pp. 261–81.

54. Grace Seiberling, *Amateurs, Photography, and the Mid-Victorian Imagination* (Chicago: University of Chicago Press, 1986), pp. 47–9.

55. The oldest was the Society of Antiquaries established in 1717. Between 1839 and 1860, local and regional societies sprang up including the Architectural Society of Oxford (1839), the Architectural Society of the County of York (1842) and the Archaeological Society of Surrey (1854).

56. For example, the Cambrian Archaeological Association. [Fanny Price] Gwynne, *The Tenby Souvenir, Illustrated with 24 Photographic Views of the Scenery and Antiquities of the Neighbourhood* (London, 1862).

57. *Report from the Select Committee Appointed to Inquire into the Present State of the National Monuments and Works of Art in Westminster Abbey, in St. Pauls Cathedral, and in other Public Edifices, to Consider the Best Means for their Protection, and for Affording Facilities to the Public for their Inspection, as a Means of Moral and Intellectual Improvement for the People*, Parliamentary Papers, 1841, Vol. 6.

58. Anon, 'Photographic Publications', *Art Journal* (1852), p. 374. In the same article Maxime du Camp's work *Egypte, Nubie, Palestine et Syrie* […] (Paris, 1852) was praised. The reviewer of the *Illustrated London News* shared this view and suggested to the publisher that he select more interesting subjects such as 'our cathedrals, abbeys, and castles'. 'Literature: The Photographic

Album – Bogue', *Illustrated London News*, Supplement (30 October 1852), p. 363.

59. Roger Fenton, 'On the Present Position and Future Prospects of the Art of Photography', Society of Arts, *A Catalogue of an Exhibition of Recent Specimens of Photography Exhibited at the House of the Society of Arts*, rev. edn (London, 1852), pp. 4–5.

60. *The Photographic Album for the Year 1855. Being Contributions from the Members of the Photographic Club* (London, 1855). Every photograph is accompanied by exposure time, process, photographer, title and explanatory description.

61. Copley and Garside (eds), *The Politics of the Picturesque*, pp. 6–7.

62. Alun Hawkins, 'The Discovery of Rural England', in Robert Colls and Philip Dodd (eds), *Englishness, Politics and Culture, 1880–1920* (London: Croom Helm, 1986), p. 62.

63. Anon, 'The Exhibition', *Journal of the Photographic Society* (May 1858), p. 209.

64. Irish landscapes were shown just as frequently. The way in which Ireland was photographed and the images which were presented deserve a far more detailed analysis, which is outside the scope of this chapter.

65. Robert Hunt, 'The Applications of Science to the Fine and Useful Arts', *Art Union Journal* (1848), p. 133.

66. Cited in Mark Haworth-Booth, 'Benjamin Brecknell Turner: Photographic Views from Nature', in Mike Weaver (ed.), *British Photography in the Nineteenth Century: The Fine Art Tradition* (Cambridge: Cambridge University Press, 1989), p. 89. Full quote in: Washington Irving, *The Sketch Book of Geoffrey Crayon, Gent* (London: Dent, 1968), p. 60. The chapter's title is 'Rural life in England'. Irving (1783–1859) was a very popular author in the USA and in Britain. He visited Europe and England several times for longer periods. A second edition of the *Sketch Book* was published in 1848.

67. Seiberling, *Amateurs*, p. 147.

68. Anon, 'Photographic Society of Scotland First Exhibition', *Photographic Notes*, 2 (1857), p. 24.

69. Philip H. Delamotte and Joseph Cundall, *A Photographic Tour Among the Abbeys of Yorkshire, with Descriptive Notices by John Richard Walbran, F.A., and William Jones, F.A.* (London, 1859), p. 1.

70. Colley, *Britons*, p. 173.

71. Anon, 'The Exhibition of the Photographic Society', *Art Journal* (1854), pp. 48–50, esp. p. 49.

72. Russell Sedgfield, *Photographic Delineations of Scenery, Architecture and Antiquities of Great Britain and Ireland* (London: S. Highley, 1854–55).

73. Dolamore and Bullock [publ.], *Memorials of Remarkable Places; being a Series of Photographic Pictures of British Scenery* (London: Dolamore and Bullock, 1856 [?]).

74. Anon., *Art Journal* (1859), p. 126.

75. J. T. Brown, 'On the Application of Photography to Art and Art Purposes but more especially to Architecture', *Photographic Notes* 3 (1858), pp. 18–19. Brown thought that representations of Gothic archi-

tecture especially would lead the 'thoughts from earth and worldly matters' (p. 19).

76. Carolyn Bloore and Grace Seiberling, *A Vision Exchanged* (London: Victoria and Albert Museum, 1985), pp. 6–7. See also Seiberling, *Amateurs*, p. 57.

77. See Christopher Titterington, 'John Dillwyn Llewelyn: Instantaneity and Transcience', in Weaver (ed.), *British Photography in the Nineteenth Century*, pp. 65–78. For the notion of nature refreshing the mind, see Roger Taylor, 'Darkness and Light: Approaching Victorian Landscape', in *'Darkness and Light': Proceedings*, pp. 19–28.

78. For a fuller discussion see Michael Bunce, *The Countryside Ideal: Anglo-American Images of Landscape* (London and New York: Routledge, 1994).

79. W. H. Nicholl, 'Crymlyn Viaduct', 1854, *The Photographic Album for the Year 1855*, no. 41.

80. Lowenthal, 'European and English Landscapes', p. 17.

81. 'Kunst', in Carl v. Rotteck and Carl Welcker (eds), *Staats-Lexikon oder Encyklopädie der Staatswissenschaften*, Vol. 9 (Altona, 1840), p. 593 (my trans.).

82. Nipperdey, *Deutsche Geschichte 1800–1866*, p. 317.

83. Timothy F. Mitchell, *Art and Science in German Landscape Painting, 1770–1840* (Oxford: Clarendon, 1993).

84. The relationship between early landscape photography and landscape painting in Germany has yet to be researched and deserves a more comprehensive discussion.

85. Helmut Börsch-Supan, *Die Deutsche Malerei von Anton Graff bis Hans von Marées 1760–1870* (München: C. H. Beck, 1988), p. 320.

86. Ibid., p. 326.

87. Athanasius Graf v. Raczynski, *Geschichte der neueren deutschen Kunst*, 3 vols (Berlin, 1836–1841), Vol. 3, p. 419 (my trans.).

88. Dr Nürnberger, 'Noch einige Bemerkungen über Daguerre's Erfindung', *Morgenblatt für gebildete Leser*, 71 (23 March 1839), p. 282. Nürnberger (1779–1848), a scientist, took a special interest in astronomy and stressed the use of photography for astronomical research.

89. See *St. Galler Zeitung*, 7 April 1841, cited in Joachim Siener, *Von der maskierten Schlittenfahrt zum Hof-Photographen. Die Photographie in Stuttgart 1839–1900* (Stuttgart: Cantz, 1989), p. 47.

90. Daguerreotypes of urban monuments were taken in the 1840s in Berlin, Cologne, Bremen and Marburg. Wilhelm Dost and Erich Stenger, *Die Daguerreotypie in Berlin 1839–1860* (Berlin: Bredow, 1922), p. 27; Werner Neite, 'Die Photographie in Köln 1839–1870', *Jahrbuch des Kölnischen Geschichtsvereins 46* (Köln, 1975), p. 111; H. Goergens and A. Löhr, *Bilder für Alle, Bremer Photographie im 19. Jahrhundert* (Bremen: Focke Museum, 1985); Kurt Meschede, *Marburger Frühphotographien* (Marburg: Trautvetter und Fischer, 1977).

91. Anon, 'Foreign Correspondence', *Photographic News*, 4 (1860), p. 200.

92. Ursula Peters, *Stilgeschichte der Fotografie in Deutschland, 1839–1900* (Köln: DuMont, 1979), p. 100.

93. On Bertha Wehnert-Beckmann, see Claudia Gabriele Philipp, 'Bertha Wehnert-Beckmann – eine Frau der ersten Stunde. Mit Fragen und Anmerkungen zur Photographiegeschichtsschreibung', in Dewitz and Matz (eds), *Silber und Salz*, pp. 214–35.

94. 'E', 'Genüsse der Stereoskopie bei Wehnert-Beckmann, Unter den Linden 23', *Deutsches Kunstblatt*, 6 (1855), pp. 204–5 (my trans.).

95. Dost and Stenger, *Die Daguerreotypie in Berlin, 1839–1860*, have no entry for Wehnert-Beckmann in their directory.

96. Anon, 'Photographie. Die Arbeiten von Leopold Ahrendts und Ph. Graff', *Deutsches Kunstblatt*, 7 (1856), p. 325 (my trans.).

97. See Negretti and Zambra, *Descriptive Catalogue*. The French photographer Clouzard sold 132 motifs to Negretti and Zambra. The company had 566 'German' motifs in stock.

98. Neite, 'Der Verkauf photographischer Bilder', pp. 558–9.

99. Joachim Großmann, 'Künstler und Kunstvereine im Preußen des Vormärz (1815–1848)', in Peter Gerlach (ed.), *Vom realen Nutzen idealer Bilder. Kunstmarkt und Kunstvereine* (Aachen: Alano, 1994), pp. 100–11. In 1858, the Kunstverein Hamburg raffled a photograph, see Jens Jäger, 'Der Hamburger Künstlerverein und die frühe Photographie', *Jahrbuch des Museums für Kunst und Gewerbe Hamburg*, Neue Folge, Vol. 14, 1995 (Hamburg: Museum für Kunst und Gewerbe, 1997), p. 40.

100. Saxony was the most industrialized region of the German Bund. Technically advanced and comparably rich, it was also the most urbanized German state.

101. Thomas Nipperdey, 'Der Kölner Dom als Nationaldenkmal', Otto Dann (ed.), *Religion – Kunst – Vaterland. Der Kölner Dom im 19. Jahrhundert* (Köln: Bachem, 1983), pp. 109–20.

102. *Dombau-Vereine* were founded in many German cities and attracted members from all social classes.

103. Neite, *Der Verkauf photographischer Bilder*, p. 555.

104. Ibid., pp. 553–4. Neite concludes that most of Eisen's business was directed towards foreign travellers and tourists.

105. Ibid., p. 556.

106. *Photographisches Journal*, 3 (1855), p. 16; and Neite, 'Die Photographie in Köln', p. 121.

107. The vignettes show (clockwise from upper left) Archbishop Johannes v. Geissel, 1796–1864, (in whose regency construction of the cathedral was resumed); Friedrich Wilhelm IV, King of Prussia, 1840–61; the Prussian Eagle; Wilhelm I, King of Prussia, 1861–88, Ludwig I, King of Bavaria, 1825–1848 (who supported the construction); Sulpiz Boisserée (who initiated the completion of the cathedral); Archbishop Konrad I (1238–61); Richard Vorgrel (from 1861 architect in charge); plan of the cathedral; a coat of arms; front view of the cathedral as if completed; a coat of arms; the central nave of the cathedral; Ernst Zwirner (1802–1861, architect in charge from 1833–61); Archbishop Engelbert I (1216–25); Gerard v. Riehl (the first architect of the cathedral).

108. Anon, *Achter Hauptbericht über das Wirken des*

Gewerbe-Vereins zu Dresden in den Geschäftsjahren 1850 bis 1854 (Dresden, 1854), p. 37. On Krone see: Wolfgang Hesse and Timm Starl (eds), *Photographie und Apperatur: der Photopionier Hermann Krone. Bildkultur und Phototechnik im 19. Jahrhundert* (Marburg: Jonas, 1998).

109. *The Athenaeum*, 14 February 1857, p. 218. The photograph 'Baptistry, Canterbury Cathedral' was published in *The Sunbeam*, Part I, edited by Philip Henry Delamotte.

110. The countryside (nature) remained an important source of spiritual refreshment during the nineteenth and twentieth centuries. For a discussion of the complex relationship between the country and the city, between modernity and traditionalism after World War I see: Frank Trentmann, 'Civilisation and its Discontents: English Neo-Romanticism and the Transformation of Anti-Modernism in Twentieth-Century Western Culture', *Journal of Contemporary History*, 29 (1994), pp. 583–625.

111. W. Hepworth, 'An Historical Sketch of the Photographic Art – Its Present Influences and Prospective Development, Applications and Uses', *The Liverpool and Manchester Photographic Journal*, 3 (1858), p. 35.

112. Kirsten Belgum, 'Displaying the Nation: A View of Nineteenth-Century Monuments through a Popular Magazine', *Central European History*, 26, 4 (1993), pp. 457–74.

113. Gerhard Sandner, 'In Search of Identity: German Landscape and Nationalism 1871-1910', in Hooson (ed.), *Geography and National Identity*, pp. 71–91, esp. p. 81.

114. Nipperdey, *Deutsche Geschichte 1800–1866*, pp. 306–7.

115. Thomas Nipperdey, *Deutsche Geschichte 1866–1918, Bd. 2, Machtstaat vor der Demokratie* (München: C. H. Beck, 1992), p. 598.

6. Capturing and Losing the 'Lie of the Land'

1. J. Hillis Miller, *Topographies* (Stanford, CA: University of California Press, 1995), p. 21.

2. The contemporaneous emergence of railways and nation-building occurred in Germany in the 1850s, Belgium in the 1830s, and Italy in the 1860s (see Nicholas Faith, *The World the Railways Made* [London: Bodley Head, 1990]), and in the USA from 1830 to 1860 (see Leo Marx, 'The Railroad in the Landscape: An Iconological Reading of a Theme in American Art', in Susan Danly and Leo Marx, [eds], *The Railroad in American Art: Representations of Technological Change* [Cambridge, MA: MIT Press, 1990], p. 186).

3. Often, as in North America, the use of photography to plan railroad construction became inseparable from the photographic survey of 'unoccupied' land. See Edward Buscombe, 'Inventing Monument Valley: 19th Century Landscape Photography and the Western Film', in Patrice Petro (ed.), *Fugitive Images: From Photography to Video* (Bloomington, IN: University of Indiana Press, 1995).

4. James R. Ryan, 'Visualizing Imperial Geography: Halford Mackinder and the Colonial Office

Visual Instruction Committee, 1902–11', *Ecumene*, 1, 2 (1994), p. 166.

5. Personal communication, Eric Conradie, Chief Archivist, Transnet Heritage Museum Johannesburg, February 1997. Without Eric's generosity in sharing with me his enormous knowledge about the SAR&H, this essay could not have been written.

6. As a result, its policies had often had widespread social and economic consequences. On this, see the work of Gordon H. Pirie, especially 'Racial Segregation on South African Trains, 1910–1927: Entrenchment and Resistance', *South African Historical Journal*, 20 (1988), and 'White Railway Labour in South Africa, 1873–1924', in Robert Morrell (ed.), *White but Poor: Essays on the History of Poor Whites in Southern Africa, 1880–1940* (Pretoria: UNISA Press, 1992).

7. On a similar relationship between the promotion of railway traffic and colonial nation-building, see E. J. Hart, *The Selling of Canada: The Canadian Pacific Railway and the Beginnings of Canadian Tourism* (Banff: Altitude Press, 1983).

8. These included regional guides, as well as booklets on investment, farming, travel, game reserves, history and various forms of recreation, printed in runs of up to 30,000. Sometimes the same photographs were used several times, albeit differently captioned and cropped.

9. Overseas promotion began in 1921 with establishment of a dedicated publicity bureau and full-time agent in London, followed five years later by the same arrangement in New York.

10. In Great Britain, Austria, Norway and Germany. Posters advertising South Africa also appeared in the London Underground (*Railways Administration General Manager's Annual Report* [hereafter, *GMAR*], 1926–27).

11. By 1921, the publicity department archive already comprised some 20,000 negatives, and in 1928 its photographers were still adding around '3,000 new negatives' each year (*GMAR*, 1928–29).

12. For instance, during the Prince of Wales's visit to South Africa in 1925, the publicity department dispatched on average 1,000 photographs a week to journals and newspapers in the USA (*GMAR*, 1924–25). The photographic section's annual 'output' rose from 4,500 in 1926 to 14,000 in 1929 (*GMAR*, 1926–27 and 1929–30).

13. In 1927, the Imperial Tobacco Co. printed seventy-two 'South African Scenes' on the backs of cards included in over 4 million cigarette packs, which were distributed internationally (*GMAR*, 1927–28).

14. A lack made all the more remarkable by the fact that it occurred under the auspices of the type of corporation normally renowned for its obsessive bureaucracy and meticulous documentation of its own history. See George Revill, 'Working the System: Journeys through Corporate Culture in the "Railway Age",' *Environment and Planning D: Society and Space*, 12 (1994), p. 708.

15. See, for instance, Joan M. Schwartz, 'The Geography Lesson: Photographs and the Construction of Imaginative Geographies', *Journal of Historical Geography*, 22, 1 (1996), pp. 16–45.

16. John Taylor, *A Dream of England: Landscape, Photography and the Tourist's Imagination* (Manchester: Manchester University Press, 1994), p. 18.

17. See, for instance, Stephen Daniels, *Fields of Vision: Landscape Imagery and National Identity in England and United States* (Princeton, NJ: Princeton University Press, 1990).

18. Rob Shields, *Places on the Margin: Alternative Geographies of Modernity* (London: Routledge, 1996), p. 13.

19. See, for instance, Angela Martin, 'The Practice of Identity and an Irish Sense of Place', *Gender, Place and Culture*, 4, 1 (1997); and Steve Pile and Nigel Thrift (eds), *Mapping the Subject: Geographies of Cultural Transformation* (London: Routledge, 1995).

20. The most radical proponent of this 'carnal subjectivity' is Maurice Merleau-Ponty. See *The Phenomenology of Perception* (London: Routledge, 1961).

21. Martin, 'The Practice of Identity', p. 92.

22. The term is Merleau-Ponty's.

23. See Tony Hiss, *The Experience of Place* (New York: Knopf, 1991).

24. See Donald Kunze, *Thought and Place: The Architecture of Eternal Place in the Philosophy of Giambattista Vico* (New York: Lang, 1987).

25. See, for instance: David Leatherbarrow; *The Roots of Architectural Invention: Site, Enclosure, Materials* (Cambridge: Cambridge University Press, 1993), pp. 33–41; and Christopher Tilley, *A Phenomenology of Landscape: Places, Paths and Monuments* (London: Berg, 1994).

26. See Michel De Certeau, *The Practice of Everyday Life*, trans. Stephen Rendall (Berkeley: University of California Press, 1984).

27. For a wider-ranging and more thorough discussion of this question than there is room for here, see Shields, *Places on the Margin*, pp. 3–28.

28. This is of course the nub of the so-called 'hermeneutic circle', that is, the fact that visual representations are simultaneously the products of the culture in which they occur, and constitutive of that culture. See Patrick Wright, 'Schama's Country', *Modern Painters* (Spring 1995), p. 14. Linked to this is the difficulty in the modern era of separating the changes which affect our lives from the changes in the way we represent them; see Pierre Nora, 'General Introduction: Between Memory and History', in Lawrence D. Kritzman (ed.), *The Realms of Memory: Rethinking the French Past*, Vol. 1 (New York: Columbia University Press, 1996), p. 2.

29. On the evolution of ideas about the representational connotations of physical form, see Dalibor Vesely, 'Architecture and the Conflict of Representation', *AA Files*, 8 (1985), pp. 21–38, and 'Architecture and the Poetics of Representation', *Diadalos*, 25 (1987), pp. 24–36.

30. Donald Kunze, 'Architecture as a Site of Reception: Cuisine, Frontality and the Infrathin', *Chora*, 1 (Montreal: McGill University Press, 1995), p. 86.

31. See Peter Bishop, 'Rhetoric, Memory and Power: Depth Psychology and Postmodern Geography', *Environment and Planning D: Society and Space*, 10 (1992), p. 16.

32. Leatherbarrow, *The Roots of Architectural Invention*; and Tilley, *A Phenomenology of Landscape*.

33. See William Beinart, *Twentieth-Century South Africa* (Cape Town and Oxford: Oxford University Press, 1994).

34. At the time of Union, maps of the region were based on a highly uneven collage of farm diagrams, mining plats, railway surveys, and military intelligence maps, and little detailed topographical or hydrological information was available for large parts of the country. See Elri Liebenberg, 'Mapping British South Africa: The Case of G.S.G.S. 2230', *Imago Mundi*, 49 (1997), pp. 132.

35. The constitution left open the possibility that a yet greater British South Africa might emerge, in which the original four provinces would be joined to the British Protectorates, Rhodesia and even the mandated South West Africa. This vision faded in the 1920s.

36. General Manager of the SAR&H from its inception until 1928, and founder of the South African Publicity Association, Hoy was an influential figure in South Africa at this time. Knighted in 1916, he accompanied Botha and Smuts to the Versailles Peace Conference in 1919, and represented South Africa at the Imperial Conference in London in 1924. See 'Sir William Hoy: A Great South African', *SAR&H Magazine* (hereafter, *Magazine*) (October 1926), and 'Forty Years of Railway Service in South Africa: The Career of Sir William Hoy, K.C.B.', *Magazine* (March 1930). Strong parallels can be drawn between Hoy and Sir William van Horne, general manager of the Canadian Pacific Railways from 1882 onwards. See Hart, *The Selling of Canada*, 1983.

37. These figureheads reflected a general trend: most of the first-generation engineering and administrative staff of South African railways had been recruited from systems in Europe or elsewhere in the empire.

38. On this phenomenon in Britain, see Revill, 'Working the System', p. 710.

39. Over 80 per cent of the Cape Colony's overseas debt at the outbreak of the South African War derived from railway investment. See Peter Henshaw, 'The Key to South Africa: Delagoa Bay and the Origins of the South African War, *Journal of Southern African Studies*, 24, 3 (September 1998), p. 534. See also Kenneth Wilburn, 'Engines of Empire and Independence: Railways in South Africa, 1863–1916', in C. Davis and K. Wilburn (eds), *Railway Imperialism* (Westport, CT: Greenwood Press, 1991).

40. Thus: 'If the British Commonwealth is to endure, its anchors must dig deep into the sympathies and understanding of the men and women at home and overseas ... Scattered as we are about the seven seas, at great distances from one another, swift and easy communication is vital to the spiritual unity of the Empire.' See Violet Markham, 'The South African Riviera', *Magazine* (March 1925).

41. Personal communication, Eric Conradie, February 1997.

42. On the concept of 'corporate authorship', see Sheila Hones, '"Everything Hastens Where It Belongs": Nature and Narrative Structure in *The Atlantic Monthly*, 1880–84', *Japanese Journal of American Studies*, 8 (1997), p. 36.

43. Other than its annual budgets. Eric Conradie has found 'absolutely no records' of the Publicity and Travel Department's photographers or how it allocated and kept track of photographic tasks, and notes that its photographs were mostly undated (letter to author, 31 July 1996). This absence of information is corroborated by Gordon Pirie of the University of Salford, who has also extensively researched the early days of the SAR&H.

44. On the concept of visual education as a means of building a sense of citizenship in Britain at this time, see David Matless, 'Regional Surveys and Local Knowledges: The Geographical Imagination in Britain, 1918–39', *Transactions of the Institute of British Geographers*, NS 17 (1992), and '"The Art of Right Living": Landscape and Citizenship, 1918–39', in Pile and Thrift (eds), *Mapping the Subject*.

45. Records show that only four photographers were employed by the SAR&H to cover the entire country. See 'Summary of Staff', *SAR&H Estimates*, 1926–27, Union Government (UG) 10–26. This probably accounts for the frequent use of photographs taken by non-SAR&H staff at this time.

46. See Roland Barthes, *Barthes: Selected Writings*, ed. Susan Sontag (London: Jonathan Cape, 1982), p. 204.

47. For instance, B. Bennion, 'The Call of South Africa', *Magazine* (December 1923); W. L. Speight, 'The True Land of Hope and Glory', *Magazine* (July 1925); and Fred Bell, 'South Africa and the Lure of the Sun', *Magazine* (February 1928).

48. 'South Africa through American Spectacles', *Magazine* (May 1926), p. 634.

49. Speight, 'The True Land of Hope and Glory', p. 705.

50. 'Introduction', in *The Picturesque Eastern Transvaal: Barberton, Carolina & Lake Chrissie* (Johannesburg: SAR&H Publicity Dept, 1928).

51. Bennion, 'The Call of South Africa', p. 1187.

52. Bell, 'South Africa and the Lure of the Sun', p. 61.

53. Bennion, 'The Call of South Africa', p. 1188.

54. Simon Schama, *Landscape and Memory* (London: HarperCollins, 1995), p. 61.

55. Bill Schwarz has discussed this imaginary thoroughly in an unpublished paper, 'The Romance of the Veld', given at the Lothian Foundation Conference on the Round Table Movement, London House, March 1996.

56. Schwarz, 'The Romance of the Veld', p. 10.

57. See Jeremy Foster, 'John Buchan's Hesperides: Biography, Rhetoric and the Aesthetics of Bodily Experience on the Highveld, 1901–1903', *Ecumene*, 5, 3 (1998).

58. One of the most influential promoters of this imaginary was the writer (and, later, statesman) John Buchan, who lived and worked in the country after the South African War. Of his experiences in the South African interior, Buchan wrote: 'Fine scenery is too often witnessed by men when living the common life of civilization … (b)ut on the veld there is bare living and hard riding, so that a man becomes thin and hard

and very much alive, the dross of ease is purged away, and the body and mind regain the keen temper which is their birthright'. John Buchan, *The Africa Colony: Studies in Reconstruction* (London: Blackwell, 1903), p. 129.

59. See Robert MacDonald, *Sons of Empire: The Frontier and the Boys Scouts Movement, 1890–1918* (Toronto: University of Toronto Press, 1993).

60. Richard Philips, *Mapping Men and Empire: A Geography of Adventure* (London: Routledge, 1997), p. 13. The heart of the South African interior, the Highveld, is an elevated temperate grassland which in parts resembles the upland margins of metropolitan Britain; see Foster, 'John Buchan's Hesperides', p. 329.

61. At this time more than 20 per cent of the white population in South Africa had been born overseas. From 1891 to 1904, the white population in the country nearly doubled, and three-quarters of this growth was due to immigration. Beinart, *Twentieth-Century South Africa*, p. 71.

62. This effect is captured by the argument of the eminent geographer-explorer Frances Younghusband, that 'people who live in the same place are unable to see its full beauty'. 'Natural Beauty and Geographical Science', *Geographical Journal*, 56 (1920).

63. It is no accident that Hoy's constant refrain, every time he returned to South Africa, was 'how little Europeans knew of South Africa'.

64. In 1925, Hoy headed off a motion at the SA Publicity Association's conference that domestic and overseas publicity be separated, saying that the two were too closely related.

65. What Marshall Berman describes as the realization that to have designs on something is to take the first steps in destroying it. See his *All That is Solid Melts into Air: The Experience of Modernity* (New York: Simon and Schuster, 1982), p. 53.

66. A precedent for the use of photography to record vanishing ways of life had been set in Britain in the 1880s and 1890s by photographers Emerson and Sutcliffe. See Ian Jeffrey, *Photography: A Concise History* (London: Thames and Hudson, 1996), pp. 67–72. For a discussion of the persistence of nostalgia in 'imperialist' representations of places and ways of life, and the way it renders more aggressive practices innocent, see Renato Rosaldo, 'Imperial Nostalgia', *Representations*, 26 (Spring 1989), pp. 107–22.

67. By comparison, and as one would expect, the Afrikaans language expresses a long, inherently topographical history of inhabiting landscapes unique to the sub-continent, and includes many words which quite simply have no direct equivalent in English.

68. Frances Younghusband's election to the presidency of the RGS in 1920 suggests that this debate was still in play at this time. For a precis of Younghusband's ideas, see his 'Natural Beauty and Geographical Science'.

69. See Paul Carter, *Living in a New Country* (London: Faber and Faber, 1992), p. 34.

70. Carter, *Living in a New Country*. A recent version of this is James Corner's argument that 'Landscape experience is received in moments, glances and ac-

cidental detours, kinesthetically unfolding through rambling and habitual encounters over time … The subject in the landscape is a fully enveloped and integral part of spatial, temporal and material relations'. 'Representation and Landscape: Drawing and Making in the Landscape Medium', in *Word and Image*, 8, 3 (July–September 1992), p. 251.

71. See David Lowenthal and Hugh Prince, 'The English Landscape', *Geographical Review*, 54, 3 (1963).

72. Ryan, 'Visualizing Imperial Geography', pp. 170–1. Ryan records that this 'failure' became yet more poignant with the arrival of cinematography, which threatened to further 'debauch the imagination by relieving the spectator of all effort'.

73. W. S. Barnard, 'Encountering Adamastor: Early 20th Century South African Regional Geographies and their Writers', Department of Geography, University of Stellenbosch, 1998.

74. As Daniel Wolf has observed, 'if the time it takes to cross space is a way by which we define it, then to arrive at a view of space "in no time" is to have denied its reality'. *The American Space: Meaning in 20th Century Landscape Photography* (Middletown, CT: Wesleyan University Press, 1983), p. 9.

75. An early article on the promotion of South Africa emphasized that, instead of providing 'a detailed catalogue of places', the SAR&H needed to convey 'as far as possible what one sees and feels and thinks when travelling in this country'. 'Making South Africa Known to Settlers and Tourists', *Magazine* (January 1920), p. 9.

76. Although a few expensive albums of hand-tipped prints had been published in the 1880s and 1890s, it was not until after the South African War that inexpensive images of the country, in the form of photojournalism and postcards, became widely available. See Karel Schoeman, 'The Post Card Collection of the South African Library', *Quarterly Bulletin of the South African Library*, 41, 4 (June/July 1987).

77. The etymological origin of the word 'experience'. See Edward Casey, *Getting Back into Place: Toward a Renewed Understanding of the Place-World* (Bloomington: University of Indiana Press, 1993), p. 30.

78. It is interesting to juxtapose this historical shift and Susan Sontag's observation that 'photographers only started worrying about what they knew, and what kind of knowledge of a deeper sense a photograph supplied, after photography was accepted as an art'. *On Photography* (London: Penguin Books, 1979), p. 126.

79. Carter, *Living in a New Country*, p. 7.

80. As Michel De Certeau argues: 'Surveys of routes miss what was: the act itself of passing by. The operation of [moving through the landscape] is transformed into points that draw a totalizing and reversible line on the map … Itself visible, it has the effect of making invisible the operation which made it possible.' *The Practice of Everyday Life*, p. 97.

81. Joan M. Schwartz, '"We make our tools and our tools make us": Lessons from Photographs for the Practice, Politics, and Poetics of Diplomatics', *Archivaria*, 40 (Fall 1995), p. 44.

82. Carter, *Living in a New Country*, p. 45.

83. 'Introduction' in 'The Picturesque Eastern Transvaal'.

84. Guy Gardner, 'Round in Three Thousand', *Magazine* (December 1926), p. 1949.

85. A traditional Afrikaans word for undeveloped rural areas.

86. South Africa experienced exponential industrial growth during World War I, due to import substitution and increased overseas demand for South African agricultural products.

87. Nicholas Monti has suggested that it was specifically during early colonial periods that 'the spread of cities, notable new buildings and other indicators of civil pride' became favoured subjects of commercial photography, because they appealed both to visiting travellers and settlers wishing to affirm their status in the metropole. Nicholas Monti, *Africa Then: Photographs, 1840–1918* (London: Thames and Hudson, 1987), p. 125.

88. Speight, 'Land of Hope and Glory', p. 704. A 1929 newspaper article reporting the impressions of a recent tour group argued: 'American tourists are not very much interested in South Africa's cities – they can see the finest cities in the world in the States, but they realize that South Africa has something unique to offer them. They are primarily interested in the scenery of this country, and the wilder it is the better.' *Eastern Province Herald*, Port Elizabeth, 21 February 1929.

89. Wolf, *The American Space*, p. 7.

90. Emanoel Lee, *To The Bitter End: A Photographic History of the Boer War, 1899–1902* (London: Penguin Books, 1985), p. 12.

91. See footnote 43.

92. It is precisely this elevated, open landscape which, to this day, South Africans usually imagine when they use that quintessential descriptor of indigenous, non-urban landscape, 'veld'.

93. Even in the late 1920s, all weather-roads only extended some 30 or 40 miles beyond the city limits of Johannesburg and Pretoria.

94. As would have been the case when using animal-drawn transport. On this topic see, for instance, Jessica Dubow, 'Rites of Passage: Travel and the Materiality of Vision at the Cape of Good Hope', in Barbara Bender and Margot Winer (eds), *Contested Landscapes: Movement, Exile and Place* (Oxford: Berg, 2001).

95. Wolfgang Schivelbusch, *The Railway Journey: The Industrialization of Time and Space in the 19th Century* (New York: Berg, 1986), p. 61.

96. Everyone travelling in the same class, that is. Seating provision and window area would eventually have been different for whites and Africans. It is worth noting that the SAR&H administration fought government and public pressure to equate class with race in their trains, but failed in this during the 1920s.

97. See, for instance, 'From the Carriage Window: Scenic Pageantry Beside the Line', *Magazine* (October 1930), pp. 1445–8.

98. 'The motion of the train shrank space, and thus displayed in immediate succession objects and pieces of scenery that in their original spatiality belonged in separate realms.' Schivelbusch, *The Railway Journey*, pp. 59–60.

99. Ibid., p. 60.

100. Gardner, 'Round in Three Thousand', p. 1949.

101. Landscape-as-horizon is landscape reduced to its most elemental expression, probably the original prompt for classical genius loci, and the implied corelative of literary prosopopoeia.

102. 'R.A.W.', 'Travelling by Train: Veldside Vignettes in Variety', *Magazine* (July 1929), p. 1147.

103. See footnote 71.

104. Schivelbusch, *The Railway Journey*, p. 59.

105. 'R.A.W.', 'Travelling by Train', p. 1146.

106. Schwartz, '*The Geography Lesson*', p. 31.

107. Schwartz, 'We make our tools', p. 47.

108. For this insight, I am indebted to an unpublished conference paper by David Bunn, entitled 'To the Valley Below: Good Shepherds, Game Wardens and the Uses of Settler Landscape Prospect', c. 1994.

109. De Certeau, *The Practice of Everyday Life*, p. 121.

110. According to Alexandre Chemetoff, simultaneously 'a vantage point, something to be looked at, an opinion, and a way of considering a problem'. See 'Des Paysages', *Architecture d'Aujourd'hui*, 303 (February 1997), p. 52.

111. Schivelbusch, *The Railway Journey*, p. 63.

112. Hillis Miller, *Topographies*, p. 252.

113. Jonathan Crary, *Techniques of the Observer: On Vision and Modernity in the Nineteenth Century* (Cambridge, MA: MIT Press, 1990), p. 6.

7. Photography and the Canadian National Railways

Dr Susan Wurtele, Trent University, served initially as research assistant and latterly co-researcher in several aspects of this research. A version of this paper was first presented as 'Corporate and State Images of Immigration: The Canadian National Railways in Western Canada' at the annual meeting of the Association of American Geographers, Chicago, March 1995. Mr Bob Oliver provided me with a critical reading and valuable references. But I am most indebted to the two editors of this volume for provocative suggestions and commentary. Finally, I am grateful for the financial support from the Social Sciences and Humanities Research Council of Canada and the School of Graduate Studies and Research, Queen's University.

1. Margaret Lawrence, *The Diviners* (New York: Knopf, 1974), pp. 6–19.

2. John Tagg, 'The Currency of the Photograph', in Victor Burgin (ed.), *Thinking Photography* (London: Macmillan, 1982), pp. 110–14.

3. Pierre Bourdieu, *Photography: A Middle-brow Art* (Cambridge: Polity Press, 1990), p. 90.

4. Roland Barthes, *Camera Lucida: Reflections on Photography* (New York: Hill and Wang, 1981), p. 119.

5. Lucy Lippard, *Partial Recall: Photographs of Native North Americans* (New York: The New Press, 1992), p. 23.

6. Ibid., p. 17.

7. Ibid., p. 20.

8. Joan M. Schwartz, '"We make our tools and our tools make us": Lessons from Photographs for the

Practice, Politics, and Poetics of Diplomatics', *Archivaria*, 40 (Fall, 1995), p. 47.

9. John Berger, *Ways of Seeing* (London: Penguin Books, 1972).

10. Catherine Lutz and Jane L. Collins, *Reading National Geographic* (Chicago: University of Chicago Press, 1993), p. 187.

11. Scott McQuire, *Visions of Modernity: Representation, Memory, Time, and Space in the Age of the Cinema* (London: Sage, 1998), p. 59.

12. Henri Lefebvre, *The Production of Space*, trans. D. Nicholson-Smith (Oxford: Blackwell, 1991; 1st edn, 1971), p. 143.

13. James Duncan, 'Sites of Representation: Place, Time and the Discourse of the Other', in James Duncan and David Ley (eds), *Place / Culture / Representation* (London and New York: Routledge, 1993), pp. 39–56.

14. Ibid., p. 39.

15. The photograph-dossiers survive in multiple copies in the National Archives of Canada: see Canadian National Railways Collection, Photograph Accessions 1965–023 and 1967–131; also T. P. Devlin Papers, RG30, Vols 5892 and 5893. Each album begins with the statement: 'The following pages contain photographs and particulars concerning a few of the large number of European families settled on land in the PROVINCE OF … by the LAND SETTLEMENT ASSOCIATION of the CANADIAN NATIONAL RAILWAYS, 1927–28, 1929–1930.' There are separate volumes for each of the provinces of Manitoba, Saskatchewan and Alberta.

16. Susan Wurtele, 'Introduction to the Collections of the Department of the Interior', unpublished report, National Archives of Canada, Documentary Art and Photography, 1990.

17. Roger Hall, Gordon Dodds and Stanley Triggs, *The World of William Notman: The Nineteenth Century through a Master Lens* (Toronto: McClelland and Stewart, 1993); Stanley G. Triggs, *William Notman: The Stamp of a Studio* (Toronto: Art Gallery of Ontario/Coach House Press, 1985).

18. Jim Burant, 'The Visual World in the Victorian Age', *Archivaria*, 19 (Winter 1984–85), pp. 110–21; Terresa McIntosh, 'W. A. Leggo and G. E. Desbarats: Canadian Pioneers in Photomechanical Reproduction', in Joan M. Schwartz (ed.), *Canadian Photography*, special issue of *History of Photography*, 20, 2 (1996), pp. 146–9.

19. Raymond Williams, 'Communications, Technologies and Social Institutions', in Neil Belton et al. (eds), *What I Came to Say: Raymond Williams* (London: Hutchinson Radius, 1990), p. 185.

20. Raphael Samuel, *Theatres of Memory. Volume I: Past and Present in Contemporary Culture* (London: Verso, 1994), pp. 364–77.

21. Maurice Berger, *How Art Becomes History: Essays on Art, Society, and Culture in Post-New Deal America* (New York: HarperCollins, 1992), p. 3.

22. Schwartz, 'We make our tools', p. 47; Schwartz (ed.), *Canadian Photography*, pp. 166–8; David Wood, 'Picturing Conservation in Canada: The Commission of 1909–1921', *Archivaria*, 37 (1994), pp. 64–74.

23. Ellen Scheinberg and Melissa K. Rombout, 'Projecting Images of the Nation: The Immigration Program and its Use of Lantern Slides', *The Archivist*, 111 (1996), pp. 13–24; H. Gordon Skilling, *Canadian Representation Abroad: From Agency to Embassy* (Toronto: Ryerson Press, 1945); Wurtele, 'Introduction to the Collections of the Department of the Interior'.

24. Claude Minotto, 'Le centre d'immigration de Québec (1908–1910), seuil de l'Amérique', *Archives*, 9, 1 (1977), pp. 11–17. Woodruff joined the topographical surveys branch of the Department of the Interior in 1891, became chief photographer in 1909, and travelled extensively in Canada to acquire his images to be used in promoting immigration. Topley was a commercial photographer commissioned by the government. See *Reflections on a Capital: 12 Ottawa Photographers* (Ottawa: Public Archives of Canada, 1970). Interestingly, Greenhill and Birrell differentiate between the 'excellent' work of Topley and Woodruff's 'more ordinary photographs', the former's *oeuvre* having received more attention both for its documentary and its aesthetic qualities. Ralph Greenhill and Andrew Birrell, *Canadian Photography, 1839–1920* (Toronto: Coach House Press, 1979).

25. Greenhill and Birrell, *Canadian Photography*, pp. 144–5.

26. Brian S. Osborne, '"Non-preferred" People: Inter-war Ukrainian Immigration to Canada', in L. Luciuk and S. Hryniuk (eds), *Canada's Ukrainians: Negotiating and Identity* (Toronto: University of Toronto Press, 1991); Brian S. Osborne and S. Wurtele, 'Canada's Other Railway: The Canadian National Railway and National Development', *Great Plains Quarterly*, 20, 2 (1995), pp. 1–24.

27. To date, my survey of RG30 has not uncovered the implementation of the photographic system, nor has the identity of the actual photographers been determined. The latter, therefore, may have been locally commissioned professionals rather than CNR field-operatives.

28. Christopher Pinney, 'Future Travel: Anthropology and Cultural Distance in an Age of Virtual Reality; or, A Past Seen from a Possible Future', *Visual Anthropology Review*, 8, 1 (1992), pp. 38–55.

29. The Canadian government's amalgamation of several struggling railway companies into the Canadian National Railways in 1919–23 was one of the earliest acts of state intervention into the corporate affairs of the country. See G. R. Stevens, *Canadian National Railways, Volume 1: Sixty Years of Trial and Error, 1836–1896* (Toronto: Clarke Irwin, 1960); G. R. Stevens, *Canadian National Railways, Volume 2: Towards the Inevitable, 1896–1922* (Toronto: Clarke Irwin, 1962); Donald MacKay, *The People's Railway: A History of Canadian National* (Vancouver: Douglas and McIntyre, 1992).

30. Adam J. Podgorecki, Jon Alexander and Rob Shields, *Social Engineering: The Technics of Change* (Ottawa: Carleton University Press, 1996).

31. William Lyon Mackenzie King, *Industry and Humanity: A Study in the Principles Underlying Industrial Reconstruction* (Toronto: Thomas Allen, 1918). As Member of Parliament, Minister of Labour, Leader of the Liberal Party, and Prime Minister of Canada, Mackenzie King bulks large in the political culture of the period 1906–62.

32. Mackenzie King, *Industry and Humanity*, p. 17. Indeed, Mackenzie King prefaces his study with an epigram from Louis Pasteur: 'Science will have tried, by obeying the law of Humanity, to extend the frontiers of Life.'

33. Ramsay Cook, *The Regenerators: Social Criticism in Late Victorian English Canada* (Toronto: University of Toronto Press, 1985); Marlene Shore, *The Science of Social Redemption: McGill, the Chicago School, and the Origins of Social Research in Canada* (Toronto: University of Toronto Press, 1987); Mariana Valverde, *The Age of Light, Soap, and Water: Moral Reform in English Canada, 1885–1925* (Toronto: McClelland and Stewart, 1991); Allen Mills, *Fool for Christ: The Political Thought of J. S. Woodsworth* (Toronto: University of Toronto Press, 1991).

34. Angus McLaren, *Our Own Master Race: Eugenics in Canada, 1885–1945* (Toronto: McClelland and Stewart, 1990).

35. 'National Conference on Race Betterment', *Canadian Journal of Medicine and Surgery*, 35, 3 (1914), pp. 160–1.

36. Bryce referred to 'euthenics' in his advocacy of the power of a beneficent Nature.

37. Peter H. Bryce, 'Ethical Problems Underlying the Social Evil', *Canadian Journal of Medicine and Surgery*, 35, 3 (1914), pp. 211–23; see also Peter H. Bryce, *The Illumination of Joseph Keeler, or On to the Land* (Boston: AJPH, 1915).

38. McLaren, *Our Own Master Race*, p. 52.

39. George E. Altmeyer, 'Three Ideas of Nature in Canada', *Journal of Canadian Studies*, 11 (1976), pp. 21–36.

40. Thomas Adams, *Rural Planning and Development* (Ottawa: Commission of Conservation Canada, 1917), p. 1.

41. Michel F. Girard, *L'écologisme retrouvé: Essor et déclin de la Commission de la conservation du Canada* (Ottawa: Les Presses de l'Université d'Ottawa, 1994); Wood, 'Picturing Conservation'.

42. The initiative stemmed from Isaiah Bowman who, in 1928, with support from the Rockefeller Foundation, the Social Science Research Council and the American Geographical Society, had established a programme of pioneer studies. It produced three important volumes: Isaiah Bowman, *The Pioneer Fringe* (New York: American Geographical Society, 1931); W. L. G. Joerg (ed.), *Pioneer Settlement: Cooperative Studies by Twenty-six Authors* (New York: American Geographical Society, 1932); and Isaiah Bowman (ed.), *Limits of Land Settlement: A Report on Present-Day Possibilities* (New York: Council on Foreign Relations, 1937). The Canadian team of geologists, geographers, soil experts, economists, historians and sociologists combined to produce eight volumes in the *Canadian Frontiers of Settlement* series. For more, see Shore, *The Science of Social Redemption*, pp. 162–94.

43. W. A. Mackintosh, *Prairie Settlement: The Geo-*

graphical Setting (Toronto: MacMillan of Canada, 1934), p. xv.

44. McLaren, *Our Own Master Race*, p. 64.

45. Susan Wurtele, 'Assimilation Through Domestic Transformation: Saskatchewan's Masonic Scholarship Project', *The Canadian Geographer*, 38, 2 (1994), pp. 122–33.

46. F. H. Lacey (ed.), *Historical Statistics of Canada* (Ottawa: Statistics Canada 1983), Series A350.

47. Terence Corcoran, 'Xeconophobia versus Free Immigration', *Globe and Mail*, 27 October 1990, p. B4.

48. Valerie Knowles, *Strangers at Our Gates: Canadian Immigration and Immigration Policy, 1540–1990* (Toronto: Dundurn Press, 1992), pp. 75–117; Freda Hawkins, *Critical Years in Immigration: Canada and Australia Compared* (Montreal: McGill-Queen's Press, 1989), pp. 3–30.

49. Osborne, '"Non-Preferred" People'; for more on popular attitudes to immigration, see Howard Palmer, *Patterns of Prejudice: A History of Nativism in Alberta* (Toronto: McClelland and Stewart, 1982); Howard Palmer, *Immigration and the Rise of Multiculturalism* (Toronto: Copp Clark, 1975); Knowles, *Strangers at Our Gates*.

50. McLaren, *Our Own Master Race*, p. 51.

51. Ibid., p. 56.

52. J. S. Woodsworth, *Strangers Within Our Gates: Or Coming Canadians* (Toronto: University of Toronto, 1972; 1st edn, 1909), p. 9.

53. Quoted in ibid., p. 8.

54. Quoted in ibid., p. 164.

55. In 1924, the Social Service Congress of Canada warned of the 'eugenic effects' of an immigration of 'stock' that had demonstrated its failure to 'hold its own in the stern competition in the motherland' and which would add to 'our national burden of pauperism, vice, crime and insanity'. Quoted in McLaren, *Our Own Master Race*, p. 46.

56. Hawkins, *Critical Years*, p. 8.

57. Ibid. pp. 16–17.

58. Quoted in Myron Gulka-Tiechko, 'Inter-War Ukrainian Immigration to Canada, 1919–1939', unpublished MA thesis, Department of History, University of Manitoba, 1983, p. 25.

59. Irving Abella and Harold Troper, *None is Too Many: Canada and the Jews of Europe, 1933–1948* (Toronto: Lester and Orpen Denys, 1983); Economic Council of Canada, *New Faces in the Crowd: Economic and Social Impacts of Immigration* (Ottawa: University of Ottawa Press, 1988); Knowles, *Strangers at Our Gates*.

60. Barbara Roberts, *Whence They Came: Deportation from Canada, 1900–1935* (Ottawa: University of Ottawa Press, 1988), p. 38; see also Donald Avery, *Dangerous Foreigners: European Immigrant Workers and Labour Radicalism in Canada, 1896–1932* (Toronto: McClelland and Stewart, 1979).

61. Roberts, *Whence They Came*, p. 43. Ironically, the popular fear of the 'non-preferred' continued in the face of the evidence that the British 'preferred' consistently provided the largest proportion of the deportees, amounting to 10,364 of the 14,579 deported in the 1929–32 period. Robert England, *The Colonization of*

Western Canada: A Study of Contemporary Land Settlement 1896–1934 (London: P.S. King and Son, 1936), pp. 86–87.

62. Knowles, *Strangers at Our Gates*, pp. 107–8.

63. Mills, *Fool for Christ*, p. 231.

64. Ibid., p. 233.

65. Denzil G. Ridout, 'European Sources of Non-Anglo-Saxons in Canada', *Canadian Geographical Journal*, 1931, 2, 3 (1931), pp. 201–23.

66. Ibid., pp. 203–4.

67. Ibid., p. 223.

68. NAC, RG30, 'Annual Report of the Canadian National Railway System for the year ended 31 December 1923'.

69. Knowles, *Strangers at Our Gates*, pp. 107–8; Osborne, 'One of the Preferred'. By 1929, the terminology if not the underlying philosophy of immigration was being sanitized. Henceforth, north-western Europe was to be used for the 'so-called preferred' countries; central Europe was to be used for the 'former non-preferred'; all other European states were henceforth Southern Europe while the Near East was to be used for that part of Asia adjoining Europe. NAC, RG30, Vol. 5625, J. S. McGowan, interdepartmental memorandum, 23 November 1929.

70. NAC, RG30, Vol. 8329, 'Survey of the Department of Colonization and Agriculture, 4 April 1955'; other details of CNR's colonization operations are derived from the testimony of Dr W. J. Black, Director of CNR's Department of Colonization, Agriculture and Natural Resources, before the House of Commons, Select Committee on Agriculture and Colonization, Immigration Inquiry, 21 March 1928; see also Osborne and Wurtele, 'The Other Railway', 1995.

71. Initially, CNR also operated offices in the United States at Boston, St Paul and Seattle.

72. NAC, RG30 Vol. 3081, f. 600, 'Committee on Transatlantic Steamship Services, September 1927'.

73. England, *The Colonization of Western Canada*, p. 165.

74. The Depression stimulated increased government intervention through such programmes as the Dominion-Provincial Land Settlement Scheme, the Dominion-Provincial Training Farms Plan and the 'Back to the Land' movement.

75. England, *The Colonization of Western Canada*, p. 183; Wurtele, 'Assimilation Through Domestic Transformation'. For more on CPR festivals which were intended to demonstrate the positive contribution of immigrants to Canada, see Maria Tippett, *Making Culture: English-Canadian Institutions and the Arts Before the Massey Commission* (Toronto: University of Toronto Press, 1990), pp. 19–20, 56–7.

76. Osborne, 'One of the Non-Preferred'; Wurtele, 'Assimilation Through Domestic Transformation'; similarly, prior to the formation of the Canadian Radio Broadcasting Commission in 1933, the CNR's own radio station broadcast concerts, poetry readings and a historical drama series, 'The Romance of Canada', to 'encourage Canadian national consciousness' among listeners. Tippett, *Making Culture*, p. 50.

77. Lippard, *Partial Recall*, p. 23.

78. Lutz and Collins, *Reading National Geographic*, p. 192.

79. Phil Macnaghten and John Urry, *Contested Natures* (London: Sage, 1998), p. 121.

80. Galton's use of composite photographs is discussed in Martin Kemp, '"A Perfect and Faithful Record": Mind and Body in Medical Photography before 1900', in Ann Thomas (ed.), *Beauty of Another Order: Photography in Science* (New Haven, CT: Yale University Press, in association with National Gallery of Canada, Ottawa, 1997), pp. 120–49. For more on phrenology and anthropometric photography, see Elizabeth Edwards, 'Photographic "Types": The Pursuit of Method', *Visual Anthropology*, 3, 2–3 (1990), pp. 235–58; Elizabeth Edwards (ed.), *Anthropology and Photography, 1860–1920* (New Haven, CT: Yale University Press, 1992); and Elizabeth Edwards, 'Ordering Others: Photography, Anthropologies and Taxonomies', in Chrissie Iles and Russell Roberts (eds), *In Visible Light: Photography and Classification in Art, Science and the Everyday*, ex.cat. (Oxford: Museum of Modern Art, 1997), pp. 54–68. See also, Allan Sekula, 'The Body and the Archive', *October*, 39 (1986), pp. 3–65; McQuire, *Visions of Modernity*, pp. 44–5; Duncan, 'Sites of Representation'.

81. Minotto, 'Le centre d'immigration'.

82. NAC, RG76, Vol. 48, f. 696173, W. D. Scott, Superintendent of Immigration, to J. D. Page, Medical Superintendent, 29 June 1910.

83. *Canadian Courier: A National Weekly* was a particularly energetic agent for immigration, publishing a barrage of articles with such titles as 'Canada's Best Immigrants', 'The Invasion of Canada', 'British Immigration to Canada', 'The Canadian Northern Railway System'. The Autumn 1911 edition was to present a complete description, 'pictorially and otherwise', of the 'resources and progress' of Canada. The CNRS were offered 60,000 copies, the Superintendent of Emigration another 20,000 copies. NAC, RG76, Vol. 48, ff. 608821–2.

84. NAC, RG30 Vol. 5568, 'CNR, Grand Trunk Pacific Railway, Fourth Annual Report, Industrial and Resources Department', January 1923. It is possible that this allusion to 'small traders' is coded language for Jews. Certainly, a communication from the CNR's Warsaw office was more explicit: 'The nominee assured the agent of the H.A.L. [Holland American Lines] that he had accepted the Baptist faith, and considered he was therefore eligible. If a ruling could be obtained that such a family were eligible I am satisfied there would be a tremendous number of Jews converted to the Baptist faith.' NAC, RG30, Vol. 5647, f. 9025–1, 'Warsaw Office Report on Activities, 1929'.

85. NAC, RG30, Vol. 5611, 'Minutes of the London Conference, 1927'.

86. NAC, RG30, Vol. 5571, 'CNLSA Report for 1928'.

87. By 1933 this preference had became even more pronounced and CNR's Director of Colonization and Agriculture, Dr W. J. Black, instructed his staff that 'outside the countries originally listed as preferred we should not take anybody excepting those of German race'. NAC, RG30, Vol. 8337, 28 November 1933.

88. NAC, RG30, Vol. 8400, f. 3885–12.

89. There were several other schemes: 'L' and 'M' for German Lutherans; 'T' for German Baptists; 'P' and 'K' German Catholics; 'S' families with less than $50 capital proceeding forward to employment with friends and relatives.

90. NAC, RG30, Vol. 8337, f. 3070–31, 1 October 1930, 'Presidents of CPR and CNR to W. S. Gordon, Minister of Immigration and Colonization'.

91. NAC, RG30, Vol. 8337, f. 3070–31, 'J. S. McGowan to Dr W. J. Black', 11 December 1930.

92. NAC, RG30, Vol. 5608, f. 11101, 1 December 1928, F. J. Freer, Superintendent of Land Settlement to N. S. McGuire, District Superintendent, Department of Colonization.

93. NAC, RG30 Volume 5608, f. 11101, 5 December 1928, N. S. McGuire, District Superintendent, Department of Colonization, to F. J. Freer, Superintendent of Land Settlement.

94. Glenbow, Canadian Pacific Collection, memo from the Assistant Superintendent of Colonization, Calgary, Alberta, to Mr Van Scoy, 8 June 1927.

95. NAC, RG30, Vol. 8337, 21 March 1935, Robert England, Western Manager, Colonization and Agriculture, to W. J. Black, Director.

96. NAC, RG30, Vol. 8337, 27 March 1935, Director Black to Robert England, Western Manager, Colonization and Agriculture.

97. Walter Benjamin, 'The Work of Art in the Age of Mechanical Reproduction', in Hannah Arendt (ed.), *Illuminations*, trans. Harry Zohn (New York: Shocken Books, 1968), p. 237.

98. James C. Scott, *Weapons of the Weak: Everyday Forms of Peasant Resistance* (New Haven, CT: Yale University Press, 1985); James C. Scott, *Domination and the Arts of Resistance: Hidden Transcripts* (New Haven, CT: Yale University Press, 1990).

99. Scott, *Weapons of the Weak*.

100. Steve Pile and Michael Keith (eds), *Geographies of Resistance* (New York: Routledge, 1997), p. xi.

101. Tim Cresswell, *In Place/Out of Place: Geography, Ideology, and Transgression* (Minneapolis: University of Minnesota Press, 1996), p. 22.

102. Faye Ginsburg, 'Indigenous Media: Faustian Contract or Global Village?', *Cultural Anthropology*, 6, 1 (1991), pp. 92–112.

103. Duncan, 'Sites of Representation', p. 54.

8. Emperors of the Gaze

Preliminary versions of this essay were presented to the Annual Conference of the Royal Geographical Society with the Institute of British Geographers in Glasgow, Scotland, and at 'Representing Egypt: An Interdisciplinary Symposium' at Carleton University Art Gallery, Ottawa, Canada. I am grateful to Joan Schwartz and James Ryan for their patience, encouragement and advice, without which I would never

have completed this essay, and to Dan Hiebert for reading an early draft with a critical and typically constructive eye.

1. Edward Said, *Orientalism: Western Conceptions of the Orient* (London: Penguin Books, 1995; 1st edn, 1978); John Mackenzie, *Orientalism: History, Theory and the Arts* (Manchester: Manchester University Press, 1995). I develop these remarks in Derek Gregory, 'Orientalism Re-viewed', *History Workshop Journal*, 44 (1997), pp. 269–78.

2. There were, of course, several 'Orients', but studies of particular relevance to this essay include Nissan Perez, *Focus East: Early Photography in the Near East, 1839–1885* (New York: Harry N. Abrams, 1988); Sarah Graham-Brown, *Images of Women: The Portrayal of Women in Photography of the Middle East 1860–1950* (London: Quartet Books, 1988); and Kathleen Stewart Howe, *Excursions Along the Nile: The Photographic Discovery of Ancient Egypt* (Santa Barbara: Santa Barbara Museum of Art, 1993). See also Deborah Bull and Donald Lorimer, *Up the Nile: A Photographic Excursion. Egypt, 1839–1898* (New York: Clarkson Potter, 1979).

3. See, for example, Judith Adler, 'Origins of Sightseeing', *Annals of Tourism Research*, 16 (1989), pp. 7–29; John Urry, *The Tourist Gaze* (London: Sage, 1990).

4. I have taken the concept of a 'space of constructed visibility' from John Rajchman, 'Foucault's Art of Seeing', in his *Philosophical Events: Essays of the 8os* (New York: Columbia University Press, 1991), pp. 68–102; I have developed its implications for cultures of travel and tourism in Derek Gregory, 'Scripting Egypt: Orientalism and Cultures of Travel', in James Duncan and Derek Gregory (eds), *Writes of Passage: Reading Travel Writing* (London and New York: Routledge, 1999), pp. 114–50, and in 'Colonial Nostalgia: Orientalism and Cultures of Travel', in my *The Colonial Present* (Oxford, UK and Cambridge MA: Blackwell, forthcoming).

5. Henry Laurens, Charles Gillispie, Jean-Claude Golvin and Claude Traunecker, *L'expédition d'Égypte 1798–1801* (Paris: Armand Colin, 1990); Fernand Beaucour, Yves Laissus and Chantal Orgogozo, *The Discovery of Egypt* (Paris: Flammarion, 1990); Laure Murat and Nicolas Weill, *L'expédition d'Égypte: le rêve oriental de Bonaparte* (Paris: Gallimard, 1998). On the publishing history of the *Description* see Michael Albin, 'Napoleon's *Description de l'Égypte*, Problems of Corporate Authorship', *Publishing History*, 8 (1980), pp. 65–85.

6. Edward Said, *The World, the Text and the Critic* (London: Faber, 1984), p. 223; the phrase derives from Michel Foucault, *Discipline and Punish* (London: Penguin Book, 1979), and I have explored its intersections with vision, visuality and colonial power in Derek Gregory, 'Imaginative Geographies', *Progress in Human Geography*, 19, 4 (1995), pp. 447–85.

7. Said, *Orientalism*, pp. 40–3, 80–7; on the 'organization of the view' in general, see Timothy Mitchell, *Colonising Egypt* (Cambridge: Cambridge University Press, 1988), and on the *savants'* particular 'organization of the view' see David Prochaska, 'Art of Colonialism, Colonialism of Art: the *Description de l'Égypte* (1809–1828)', *L'esprit créateur*, 34 (1994), pp. 69–91.

8. Daguerre was supposedly so intimidated by the intensity of public interest and the size of the crowd that he was unable to speak for himself: I have taken these details from Janet Buerger, *French Daguerreotypes* (Chicago: University of Chicago Press, 1989), pp. 4–7.

9. 'Report of the Commission of the Chamber of Deputies … Presented by M. Arago … on July 3, 1839', reproduced in Josef Maria Eder, *History of Photography*, trans. Edward Epstean (New York: Dover, 1978), pp. 234–5.

10. The calotype process – originally called the 'talbotype' after its inventor, William Henry Fox Talbot – produced paper negatives and so, unlike the daguerreotype which had to be reproduced through engraving and lithography, allowed multiple direct copies to be produced as salted paper prints. The first photographic reproductions of hieroglyphs appeared in Samuel Birch, *The Talbotype Applied to Egyptian Hieroglyphics* (London: 1846), but ten years later they were still sufficiently uncommon for W. H. Gregory to call for the British government to 'send forth a competent staff of photographers to take proofs of all inscriptions and cultures which can be reached'. Not only would the antiquarian have 'a certain basis on which to work which would not, as in the case of copies, be exposed to the imputation of incorrectness' – Gregory was convinced of 'the incontrovertible accuracy of the photograph' – but such a record 'would be accessible to every student of archaeology at home, whose health or occupations precluded his visiting the originals, scattered as they are through Egypt, Nubia and the Arabian deserts'. See his *Egypt in 1855 and 1856* (London: privately printed by John Russell Smith, 1859), Vol. II, p. 28.

11. Frédéric Goupil-Fesquet, *Voyage d'Horace Vernet en Orient* (Paris: Challamel, 1843), pp. 33–4, 107, 116. In both cases the original plates have been lost. Some images by Goupil-Fesquet and Joly de Lotbinière appeared in Lerebours's *Excursions daguerriennes* as lithographs, and some of Joly de Lotbinière's were also used as the basis for the colour lithographs in Hector Horeau's *Panorama d'Égypte et de Nubie* (1841). See Perez, *Focus East*, p. 169; Joan M. Schwartz, 'The Geography Lesson: Photographs and the Construction of Imaginative Geographies', *Journal of Historical Geography*, 22, 1 (1996), pp. 16–45, esp. pp. 21–2.

12. Goupil-Fesquet, *Voyage d'Horace Vernet en Orient*, pp. 107, 125.

13. Howe, *Excursions Along the Nile*, p. 24.

14. For some cautions on 'the art of the calotype', see Abigail Solomon-Godeau, *Photography at the Dock: Essays on Photographic History, Institutions and Practices* (Minneapolis, MN: University of Minnesota Press, 1991), p. 14.

15. I have taken these details from Elizabeth Anne McCauley, 'The Photographic Adventures of Maxime Du Camp', *Library Chronicle of the University of Texas at Austin*, 19 (1982), pp. 19–51; quotations from pp. 22, 24. I note that the French for 'lens' is *objectif*.

16. Maxime Du Camp, *Souvenirs littéraires* (Paris: Hachette, 1882), Vol. I, p. 484. 'Squeezes' remained the usual means of making impressions of the bas-reliefs,

and here Jean-Jacques Ampère (who visited Egypt in 1844) describes the process and explains its superiority over the daguerreotype:

> With a sheet of paper, a glass of water and a brush, in a few minutes one takes the impression of an inscription or a bas-relief; it's a sort of portable printing which makes it possible to make multiple copies of any original that can't be removed. No transcription, no sketch can equal this mechanical reproduction. The eye and the hand of the copyist can tire or make mistakes; but making squeezes [*estampage*] is not liable to distractions or errors. Thanks to it, one carries away the object itself cast accurately and securely. Squeeze-paper and the camera lucida are the two instruments needed to make an exact and easy reproduction of the monuments. The daguerreotype appears to have marvellous claims to speed; in fact, it is rarely easy to use. We are taking one of those instruments with us, however, but I am told that it will not be as useful as it seems it ought to be. J. J. Ampère, *Voyage en Égypte et en Nubie* (Paris: Lévy, 1868), pp. 2–3.

17. Du Camp, *Souvenirs littéraires*, pp. 423–4; Francis Steegmuller (ed.), *Flaubert in Egypt: A Sensibility on Tour* (Chicago: Academy Chicago, 1979), pp. 101–2, 130. Perhaps this explains Du Camp's studied omission of any mention of Flaubert from his own account of their voyage: for an accessible version, see Michel Dewachter and Daniel Oster (eds), *Un voyageur en Égypte vers 1850: 'Le Nil' de Maxime du Camp* (Paris: Sand/Conti, 1987).

18. Steegmuller (ed.), *Flaubert in Egypt*, p. 142.

19. McCauley, 'Photographic Adventures', p. 26. See also Dewachter and Oster (eds), *Un voyageur en Égypte*; Gustave Flaubert, *Voyage en Égypte*, ed. Pierre-Marc de Biasi (Paris: Grasset, 1991); Antoine Naaman (ed.), *Les lettres d'Égypte de Gustave Flaubert* (Paris: Nizet, 1965). I have provided a discussion in Derek Gregory, 'Between the Book and the Lamp: Imaginative Geographies of Egypt, 1849–50', *Transactions of the Institute of British Geographers*, 20 (1995), pp. 29–57.

20. Julia Ballerini, 'Photography Conscripted: Horace Vernet, Gerard de Nerval and Maxime du Camp in Egypt', unpublished PhD dissertation, City University of New York, 1987, pp. 124, 252.

21. Flaubert told his mother that he never allowed himself to be photographed, but he recorded posing for Du Camp at two sites: one, on top of the Great Pyramid, where he appears only as a tiny unrecognizable figure, and the other, in Arab dress, walking in the garden of the Hôtel du Nil in Cairo. There is one other image of a man in European dress, pointing at an inscription with his walking stick, which some scholars have claimed to be Flaubert.

22. Du Camp, in Dewachter and Oster (eds), *Un voyageur en Égypte*, pp. 173–4 (my emphasis).

23. Steegmuller (ed.), *Flaubert in Egypt*, p. 165.

24. A daughter of Japhet, *Wanderings in the Land of Ham* (London: Longman Brown, 1858), pp. 117–18.

25. For a modern edition of David Roberts's paintings, see *Yesterday and Today in Egypt: Lithographs and Diaries by David Roberts R.A.* (Cairo: American University in Cairo Press, 1996; New York: Stewart, Tabori and Chang, 1996).

26. For an extended – and, in places, I think fanciful – reading of Du Camp's incorporation of Hadji-Ishmael, see Ballerini, 'Photography conscripted'; Ballerini subsequently reworked her argument in her '"La maison démolie": Photographs of Egypt by Maxime Du Camp 1849–1850', in Suzanne Nash (ed.), *Home and Its Dislocations in Nineteenth-Century France* (New York: SUNY Press, 1993), pp. 103–23, and in 'The In/visibility of Hadji-Ishmael: Maxime Du Camp's 1850 Photographs of Egypt', in Kathleen Adler and Marcia Pointon (eds), *The Body Imaged: The Human Form and Visual Culture since the Renaissance* (Cambridge: Cambridge University Press, 1993), pp. 147–60.

27. Howe, *Excursions Along the Nile*, pp. 27, 45n; Du Camp's photographs were gathered together as *Égypte, Nubie, Palestine et Syrie* (Paris: Gide et Baudry, 1852).

28. Prochaska, 'Art of Colonialism'.

29. Félix Teynard, *Égypte et Nubie* (Paris: Goupil, 1858); Kathleen Stewart Howe, *Félix Teynard: Calotypes of Egypt* (New York: Hans P. Kraus, 1992); Ian Jeffrey, *Photography: A Concise History* (New York: Oxford University Press, 1981), p. 17.

30. Howe, *Félix Teynard*, pp. 140, 144, 146, 148; Jeffrey, *Photography*, p. 17.

31. Jason Thompson, *Sir Gardner Wilkinson and His Contemporaries* (Austin: University of Texas Press, 1992), p. 87.

32. William Bartlett, *The Nile Boat, or Glimpses of the Land of Egypt* (London: Arthur Hall, Virtue; New York: Harper, 1849), p. iii; for an account of his life and work, see Alexander Ross, *William Henry Bartlett: Artist, Author and Traveller* (Toronto: University of Toronto Press, 1973). Despite its name, the *camera lucida* was not a photographic precursor; it was developed in 1831 as an aid to drawing and used prisms or mirrors to project an image of an object on to a plane surface so that it could be traced.

33. Harriet Martineau, *Eastern Life, Present and Past* (London: Edward Moxon; Philadelphia: Lea and Blanchard, 1848), p. 227.

34. George Curtis, *Nile Notes of a Howadji* (New York: Harper, 1856), p. 304; Reverend Alfred Smith, *Attractions of the Nile and Its Banks* (London: John Murray, 1868), Vol. II, p. 184.

35. G. A. Hoskins, *A Winter in Upper and Lower Egypt* (London: Hurst and Blackett, 1863), p. 105.

36. Smith, *Attractions of the Nile*, Vol. II, pp. 185–6.

37. Even so, prices fluctuated with demand. George Buckham and his party visited Egypt in March, at the very end of the season, and they 'spent some hours in … procuring photographs of Egyptian places visited' only to find that they had to pay 'the highest prices, especially when, as now, the stock of photographic views is limited': George Buckham, *Notes from the Journal of a Tourist* (New York: Gavin Houston, 1890), p. 255.

38. Karl Baedeker (ed.), *Egypt: A Handbook for Travellers* (Leipzig: Baedeker, 1898), p. 226. Beato had had a studio in Cairo in 1860–61, but by 1862 he had moved to Luxor where he continued his work until 1905: see

Colin Osman, 'Antonio Beato, Photographer of the Nile', *History of Photography*, 14, 2 (1990), pp. 101–11. Julian Arnold was full of praise for Beato: 'His collection is far the best on the Nile', Arnold declared, and while it was possible to purchase views of temples and tombs in Cairo, 'if travellers desire to have really fine specimens of the river scenes, and not merely ordinary reproductions from bad negatives, they cannot do better than obtain them from Mr Beato' who, so Arnold said, had 'virtually made a panorama of the valley'. See Julian Arnold, *Palms and Temples: Four Months' Voyage Upon the Nile* (London: Tinsley, 1882), p. 265.

39. Solomon-Godeau, *Photography at the Dock*, p. 155. Cf. Michael Taussig's view that colonial photography was 'emblematic', its function 'to verify the existence of the scientific attitude as much as the existence of that which was photographed': *Mimesis and Alterity: A Particular History of the Senses* (London and New York: Routledge, 1993), p. 199. For a discussion of photography's 'realism', see Don Slater, 'Photography and Modern Vision: The Spectacle of "Natural Magic"', in Chris Jenks (ed.), *Visual Culture* (London: Routledge, 1995), pp. 218–37.

40. Maria Morris Hamburg, 'Extending the Grand Tour', in Liz Heron and Val Williams (eds), *Illuminations: Women Writing on Photography from the 1850s to the Present* (Durham: Duke University Press, 1996), pp. 33–7; quotation is from p. 35. That this was a distinctive – in other words, a highly *particular* – regime of truth needs to emphasized. As Hamburg goes on to remark: 'Although these photographs constituted a growing museum without walls, the supposedly faithful "documents" that composed it were rife with subjective impressions and inflections of European culture – so much so that it would be fair to say that the archaeology and geography of the photographers' imaginations had the upper hand on objective science.'

41. Norma Lorimer, *By the Waters of Egypt* (London: Methuen, 1909), p. 210, quoting her daughter.

42. W. H. Gregory, *Egypt in 1855 and 1856*, Vol. I, p. 358.

43. Amelia Edwards, *A Thousand Miles up the Nile* (London: Longmans Green; New York: Scribner, Welford and Armstrong, 1877; 2nd edn, 1888), p. 208.

44. D. Gregory, 'Scripting Egypt', pp. 134–5; cf. Schwartz, '*The Geography Lesson*', pp. 31–2.

45. Roland Barthes, *Camera Lucida: Reflections on Photography* (New York: Hill and Wang, 1981; 1st edn, 1980), p. 15. In much the same way Said describes the Napoleonic desire to annex Egypt as 'a department of French learning' as symptomatic of the Orientalist impulse 'to transmute living reality into the stuff of texts, to possess (or think one possesses) actuality because nothing in the Orient seems to resist one's power'. *Orientalism*, pp. 83–6.

46. Prochaska, 'Art of Colonialism'.

47. There were exceptions: Graham-Brown, *Images of Women*, p. 36, reproduces a photograph of an Egyptian washerwoman taken by Pierre Trémaux in the late 1840s, and Howe, *Excursions Along the Nile*, p. 29, draws attention to the work of Ernest Benecke in the

early 1850s, which included an unusually wide range of human subjects. But these are indeed exceptions, and the early photographic archive of Egypt is dominated by the monumental tradition.

48. Solomon-Godeau, *Photography at the Dock*, p. 159.

49. Anne Godlewska, 'The Napoleonic Survey of Egypt', *Cartographica*, 25 , 1 & 2 (Spring/Summer 1988) Monograph 38–9; 'Map, Text and Image: Representing the Mentality of Enlightened Conquerors', *Transactions of the Institute of British Geographers*, 20 (1995), pp. 5–28.

50. James H. Breasted, *Egypt Through the Stereoscope: A Journey Through the Land of the Pharaohs* (Meadville, PA: Keystone View Co., 1905).

51. William Darrah, *The World of Stereographs* (Gettysburg, PA: William Darrah, 1977); on the disjuncture between photography and the stereoscope see Jonathan Crary, *Techniques of the Observer: On Vision and Modernity in the Nineteenth Century* (Cambridge, MA: MIT Press, 1990), pp. 116–36.

52. Cf. Jean Vercoutter, *The Search for Ancient Egypt* (New York: Harry N. Abrams, 1992); Brian Fagan, *Rape of the Nile: Tomb Robbers, Tourists and Archaeologists in Egypt* (Wakefield, RI: Moyer Bell, 1992).

53. Breasted, *Egypt Through the Stereoscope*, pp. 11–12, 13–14.

54. Ibid., pp. 115, 126.

55. Ibid., pp. 48, 57.

56. Nancy West, 'Fantasy, Photography and the Marketplace: Oliver Wendell Holmes and the Stereoscope', *Nineteenth-Century Contexts*, 19 (1996), pp. 231–58; quotation at p. 245. In a geopolitical sense the British 'desire' for Egypt had been satisfied by the military occupation of 1882, and the imaginative geographies (re)produced by many British tourists at the *fin de siècle* are imbued with a strong and self-confident sense of possession. But for the French it was quite otherwise, and in so far as there was a distinctive metaphysics of loss and memory shaping their *fin-de-siècle* response to 'the Orient', one wonders how this affected their photographic appropriations of its landscapes and people: cf. Said, *Orientalism*, pp. 169–70.

57. Breasted, *Egypt Through the Stereoscope*, p. 50. Breasted's remark was part of a much more general snobbery about organized tourism in general and Cook's tours in particular: I discuss the historical curve of these reactions in 'Colonial Nostalgia'.

58. Breasted, *Egypt Through the Stereoscope*, p. 48.

59. Crary, *Techniques of the Observer*, pp. 125–6.

60. Cf. Mitchell, *Colonising Egypt*.

61. Emily Beaufort, *Egyptian Sepulchres and Syrian Shrines* (London: Longman, Green, 1861), Vol. I, p. vii.

62. See James Buzard, *The Beaten Track: European Tourism, Literature and the Ways to 'Culture' 1800–1918* (Oxford: Clarendon Press, 1993); D. Gregory, 'Colonial Nostalgia'.

63. George Ade, *In Pastures New* (New York: McClure and Phillips, 1906), pp. 148, 185; for a fuller discussion, see D. Gregory, 'Scripting Egypt'.

64. Linda Nochlin, 'The Imaginary Orient', in her *The Politics of Vision: Essays on Nineteenth-Century Art and Society* (New York: Harper and Row, 1989), pp. 33–59,

quotation at p. 50; see also Ali Behdad, *Belated Travelers: Orientalism in the Age of Colonial Dissolution* (Durham, NC: Duke University Press, 1994).

65. Graham-Brown, *Images of Women*, pp. 39–54.

66. Howe, *Excursions Along the Nile*, p. 41.

67. For a general discussion see Irvin Schlick, *The Erotic Margin: Sexuality and Spatiality in Alterist Discourse* (London: Verso, 1999).

68. Graham-Brown, *Images of Women*, pp. 51–2. By the end of the nineteenth century they were also circulating as postcards and as photographic plates in books.

69. Douglas Collins, *The Story of Kodak* (New York: Harry N. Abrams, 1990), pp. 55–6, 59, 65.

70. Jeremiah Lynch, *Egyptian Sketches* (London: Edward Arnold; New York: Scribner and Welford, 1890), p. 64. As one commentator indicated, using a hand-held camera of one's own had a distinctive advantage over recourse to some commercial photographers: 'There are others who come to be photographed *with the Pyramids*, in order to prove to any doubting person at home that they have really been there, but alas! how many of these have been deceived by the pseudo-photographer, whose outfit has consisted of an empty cigar-box, a black cloth and a specious manner. After having posed with the neck stiff and the body uncomfortable, and having given his address and a sovereign, he is surprised to hear a few days later that he has quite spoilt the picture by having moved.' See A.B. de Guerville, *New Egypt* (London: Heinemann; New York: Dutton, 1906), p. 85.

71. Sidney Low, *Egypt in Transition* (London: Smith, Elder, 1914), p. 145. Low was, of course, reinscribing the deeply sedimented distinction between 'travellers' and 'tourists': cf. Buzard, *The Beaten Track*.

72. Susan Sontag, *On Photography* (London: Penguin Books, 1979), pp. 9–10. Ballerini, 'La Maison démolie', p. 121 attributes something of the sort to Du Camp, for whom photography afforded 'a provision of reassurance implicit in any scenario that structures anxiety'; but I am not persuaded by her argument, not least because so much of Du Camp's 'anxiety', if that is what it was, seems to have been provoked *by* the exacting and unfamiliar demands of photography.

73. Walter Benjamin, 'The Work of Art in the Age of Mechanical Reproduction', reprinted in *Illuminations*, ed. Hannah Arendt (New York: Schocken, 1969), pp. 217–51; quotation at p. 223 (my emphasis). It was, of course, this sense of plenitude and possession which was focal to the ideology of the stereoscope.

74. G. W. Steevens, *Egypt in 1898* (London: Blackwood), p. 215 (my emphasis).

75. See D. Gregory, 'Scripting Egypt' and 'Colonial Nostalgia'.

76. Francis Frith, *Egypt and Palestine Photographed and Described* (London: James Virtue, 1858–60); Jeffrey, *Photography*, pp. 34–5. It is also important to notice that Frith included people in his landscapes as something other than staffage figures; as Jeffrey remarks, 'his Egypt is an Egypt of habitable spaces rather than of flattened fragments'.

77. Edwards, *A Thousand Miles up the Nile*, p. 3.

78. Ibid., pp. 72, 98. Only once does Edwards call this imagery into question: 'It is all so picturesque, indeed, so biblical, so poetical, that one is almost in danger of forgetting that the places are something more than beautiful backgrounds, and that the people are not merely appropriate figures placed there for the delight of sketchers, but are made of living flesh and blood, and moved by hopes, and fears, and sorrows, like our own.' Edwards, *A Thousand Miles up the Nile*, p. 201.

But the assumption of 'the Orient' arranged expressly for its audience carried the day, and was carried over into the capture of photographic subjects: 'I often wonder if there is a special crew [on the steamboat], kept to do nothing but say their prayers,' remarked Norma Lorimer, 'for there is always a group of black-skinned Soudanese in white drawers on their knees in the bows of the boat. Perhaps Thomas Cook and Son recognise how valuable they are for "off days" on the Nile, for tourists to kodak.' See Lorimer, *Waters of Egypt*, p. 31.

79. Edwards, *A Thousand Miles up the Nile*, p. 405. This visual strategy reappears in several different forms. Most revealing of all are Edwards's successive stagings of Siût. As she approaches the town from the Nile it looks 'more like an air-drawn mirage than a piece of the world we live in' (p. 98); but then, on shore and wandering through its streets, 'our mirage turns to sordid reality, and Siût, which from afar off looked like the capital of Dreamland, resolves itself into a big mud town as ugly and ordinary as its fellows' (p. 101). Only when she climbs the mountain above the town is the imaginary order reimposed: 'Seen from within the great doorway of the second grotto, it looks like a framed picture … [and] Siût, bathed in the splendour of the morning sun, looks as fairy-like as ever' (pp. 104–5). This strategy was especially common in Orientalist readings of Cairo, as I show in 'Rumours of Cairo: The City of the Arabian Nights and Paris-on-the-Nile' (forthcoming).

80. Mitchell, *Colonising Egypt*, p. 306.

81. Steegmuller (ed.), *Flaubert in Egypt*, p. 30. In her discussion of Goupil-Fesquet, Ballerini makes much the same point: 'The interest of the photograph resides in the spectacle surrounding its process. Like many of the earliest photographic projects, it is the performance that is often important, not the rather dull pictures that often resulted from such performances.' Ballerini, 'Photography Conscripted,' p. 100.

82. Collins, *The Story of Kodak*, p. 54.

83. Sontag, *On Photography*, pp. 14–15.

84. Steegmuller (ed.), *Flaubert in Egypt*, pp. 101–2. It is scarcely surprising, then, that Hadji-Ishmael never adopted 'the assured, appropriating stance assumed by Westerners at foreign sites: that pervasive pose of the bent knee and the foot against the monument that accents hundreds of travel images'. Ballerini, 'Photography Conscripted', p. 287. At least one other party of photographers preferred to use a mannequin rather than a live model as a staffage figure, which they dressed

à l'européene. They professed amusement at the reaction of the crew of their *dahabeah*, who (so they claimed) were first frightened but then came to treat the model as though it were a real person; in the end, however, they confessed that, even to the photographers, he seemed to be 'a man like any other: he lives in photography'. See Henry Cammas and André Lefèvre, *La vallée du Nil: impressions et photographes* (Paris: 1862), pp. 185–6.

85. William Gilpin, *Three Essays: On Picturesque Beauty, on Picturesque Travel, and on the Art of Sketching Landscapes* (London: Blamire, 1792), p. 48. Cf. Nochlin, 'Imaginary Orient', p. 50: 'The picturesque is pursued throughout the nineteenth century like a form of peculiarly elusive wild-life, requiring increasingly skillful tracking as the delicate prey – an endangered species – disappears farther and farther into the hinterlands.'

86. Curtis, *Nile Notes*, p. 337. Francis Frith was at Karnak in the same year, and he used a parallel image to describe his photographic activities; he had been told that it was 'idle' to attempt to photograph the Great Hall, but he said he 'brought up [his] artillery boldly, and fired away right and left'.

87. The term was first used by Herschel writing in the *Photographic News*, 13 May 1860, when he described the 'possibility of making a photograph, as it were by a snap-shot'.

88. T. G. Appleton, *A Nile Journal* (Boston, MA: Roberts, 1876), pp. 13–14.

89. Buzard, *The Beaten Track*, p. 16; cf. Elizabeth Bohls, 'Landscape Aesthetics and the Paradox of the Feminine Picturesque', in *Women Travel Writers and the Language of Aesthetics 1716–1818* (Cambridge: Cambridge University Press, 1995), pp. 66–107.

90. James R. Ryan, 'Hunting with the Camera', in his *Picturing Empire: Photography and the Visualization of the British Empire* (London: Reaktion, 1997), pp. 99–139. See also Suren Lalvani, *Photography, Vision and the Production of Modern Bodies* (Albany, NY: SUNY Press, 1996), pp. 69–81.

91. Edward W. Lane, *Draft of Description of Egypt*, Bodleian Library, Oxford: MS Eng misc d 234, f. 71.

92. So too were its detailed sketches, over one-third of which nevertheless depicted human subjects; the 1895 edition even included posed studio photographs. See Edward W. Lane, *An Account of the Manners and Customs of the Modern Egyptians* (London: Knight, 1836), pp. 95–6.

93. M. L. M. Carey, *Four Months in a Dahabeeh* (London: Booth, 1863), p. 272.

94. Edwards, *A Thousand Miles up the Nile*, p. 360.

95. Sarah Greenough, 'The Curious Contagion of the Camera', in Sarah Greenough, Joel Snyder, David Travis and Colin Westerbeck, *On the Art of Fixing a Shadow: One Hundred And Fifty Years of Photography* (Chicago: Art Institute of Chicago, 1989), p. 139.

96. Martineau, *Eastern Life*, p. 41.

97. Hardwicke Rawnsley, *Notes for the Nile* (1892) p. xi.

98. *Egypt and How to See It* (London: Ballantyne, 1910; Paris: Hachette, 1910; Hannover and Leipzig: Adolf Sponholtz, 1910), p. 153.

99. Ibid., pp. 155–6. That said, there were formidable problems in composing street scenes: 'The gate and the mosque, together with the constant pressure of traffic, make a most fascinating picture, but unfortunately it is one almost impossible to photograph. I remember clambering with infinite toil upon a huge stone window-ledge just over the spot where condemned criminals were wont to be garroted in the brave days of old, intent on securing a picture of the old gate, the red Mosque behind, the stream of passing traffic below, and the soaring minaret above – but all in vain. It was a dismal failure. In no city are street scenes more difficult to photograph than in Cairo, where the upper air is so brilliant and the lower levels so shrouded in shadow.' Philip Marden, *Egyptian Days* (London: Unwin, 1912), p. 58.

Many photographers were also troubled by the impossibility of rendering the colours that were widely held to mark 'the Orient' as exotic. Gabriel Charmes had long since recognized that 'an exquisite work' would be produced by transferring what he called 'living pictures' – the street life of Cairo – 'to the canvas by a photographic process'; but, he asked, how was it possible to transfer, 'even with the most magical brush, the marvellous brilliancy of the colours under the reflections of a powerful light?'. Gabriel Charmes, *Five Months at Cairo and in Lower Egypt* (London: Bentley, 1883; 1st edn, Paris, 1880), p.76. That 'magical brush' did not appear until the introduction of Kodachrome film just before World War II.

100. *Egypt and How to See It*, pp. 153–4.

101. William Fullerton, *In Cairo* (London: Macmillan, 1891), pp. 6–7.

102. Harry Franck, *The Fringe of the Moslem World* (New York: Grosset and Dunlap, 1928), p. 11 (my emphasis).

103. Anthony Wilkin, *On the Nile with a Camera* (London: Unwin, 1896), p. 1 (my emphasis).

104. Ibid., pp. 124–5.

105. There were also two photographs of the Thomas Cook steamer on which Wilkin travelled, *SS Rameses*.

106. Wilkin, *On the Nile with a Camera*, p. 9 (my emphasis).

107. Ibid., pp. 117–18.

108. Ibid., p. 9.

109. Douglas Sladen, *Twenty Years of My Life* (London: Constable, 1914), pp. 36, 224. It would be easy to portray Sladen as a minor Colonel Blimp, given the attitudes and actions I am about to describe, but he was a more complex figure than the caricature suggests. Sladen was born in England in 1856; he was educated at Cheltenham ('the most prominent boy of my time'), took a First in History at Oxford, and in the early 1880s was appointed to the Chair of Modern History at the University of Melbourne (his uncle was Premier of Victoria). He returned to London in 1884, writing regularly for magazines and newspapers, and in 1897 established the model for *Who's Who*. Thereafter, he notes: 'I proceeded to spend my life in delicious travels in Europe, Asia and Africa, writing my travel books and novels, and in enjoying the gay Bohemian life of the 'nineties with which I was to be intimately con-

nected.' It is entirely consistent with his sense of self that he should also have written two autobiographies: in addition to *Twenty Years*, see Douglas Sladen, *My Long Life: Anecdotes and Adventures* (London: Hutchinson, 1939).

110. Douglas Sladen, *Oriental Cairo: The City of the Arabian Nights* (London: Hurst and Blackett, 1911), pp. vii, 2. Sladen included a section devoted to 'Artist's Bits in Cairo, with directions on how to find them', whose object was to assist not only painters but also 'the great army of kodakers'. This was a personal selection of mosques, meshrabiya-work and 'Mameluke houses', and it is significant that these architectural subjects should appear as an Appendix whereas the body of the text is largely given over to the pursuit of human subjects.

111. Ibid., pp. 10, 45. It is difficult to determine if amateur photographers were in fact predominantly men, but travel writings by women during this period seem to make much less of the performance of photography. An exception is Minnie Ross's extraordinary account of her trip up the Nile on a tourist-steamer, where the narrative is steadily overwhelmed by her obsessive quest for 'antiquities' and trinkets; no sooner has she bought one, than her attention moves on to the next. She treats her photographs in much the same way. For example: 'I think I got a good snap there, and another of two women just coming from the river'; or again: 'I jumped up just now to snap a native pump arrangement we were passing, a shadoof, and I hope it was near enough to show.' Recalling Sontag's remark, for Ross travel is a strategy for accumulating souvenirs and snapshots, both of which are conceived as trophies. See Minnie Ross, *Around the Mediterranean* (New York: Grafton, 1906), pp. 113, 117.

112. The theatrical metaphor is Sladen's own; in an earlier book, he had identified five 'stages', sites in Cairo where 'native life' was supposedly best displayed. See Douglas Sladen, *Egypt and the English* (London: Hurst and Blackett, 1908).

113. Sladen, *Oriental Cairo*, p. 4; for a detailed discussion of the imaginative transformation of Cairo into 'the medieval city' and 'the city of the Arabian Nights', see D. Gregory, 'Scripting Egypt' and 'Rumours of Cairo'.

114. Sladen, *Oriental Cairo*, pp. 10, 35, 64, 83, 142–3.

115. Ibid., p. 251.

116. Ibid., p. 88.

117. Ibid., pp. 44, 176. Sladen claimed that it was not always necessary to go to such lengths: 'The Egyptian … is quite large-minded about allowing infidels who are interested to watch the Moslem processions and ceremonials and even to photograph them,' he wrote, and promptly attributed this to the fact that 'the Egyptian has a real appreciation of foreigners being intelligently interested in the ancient customs and monuments of his country' (p. 245).

118. Douglas Sladen, *Queer Things About Egypt* (London: Hurst and Blackett, 1910), pp. 392, 394.

119. Sladen, *Oriental Cairo*, p. 140.

120. Sladen, *Queer Things About Egypt*, pp. 40, 143.

121. Ibid., pp. 364–5.

122. Ibid., pp. 402, 408. The jibe at American tour-ists was based in part on typical British chauvinism and in part on Sladen's pride in his bargaining powers.

123. Ibid., pp. 304, 353.

124. Ibid., p. 409.

125. Ibid., p. 410.

126. Martin Jay, 'Scopic Regimes of Modernity', in Hal Foster (ed.), *Vision and Visuality* (Seattle, WA: Bay Press, 1988), pp. 3–23. Jay's discussion is silent about the ways in which gender and sexuality inflect 'the master sense'; these considerations are treated – in a philosophical rather than historical register – in his *Downcast Eyes: The Denigration of Vision in Twentieth-Century French Thought* (Berkeley, CA: University of California Press, 1993).

127. Said, *Orientalism*, p. 103.

9. Mapping a Sacred Geography

I would like to thank Joan Schwartz for her close reading and careful editing of this manuscript; it is a better essay for her probing questions. An early version of this chapter was presented at the November 1998 Cultural Studies Colloquium at the University of New Mexico and benefited from the thoughtful critique of my colleagues for which I thank them. As with any research project, the debts one owes are too numerous to list, but I would especially like to thank Shimon Gibson at the Palestine Exploration Fund in London, and the curators and librarians at the Royal Engineers Barracks at Brompton, for their assistance. As always, Michael and Jane Wilson have been gracious in allowing research in, and reproductions from, their collection. This essay evolved from the exhibition and catalogue, *Revealing the Holy Land: The Photographic Exploration of Palestine* (Santa Barbara: Santa Barbara Museum of Art, 1997).

1. William Thomson, Archbishop of York, opening address to the organizational meeting of the Palestine Exploration Fund, 22 June 1865, cited in V. D. Lipman, 'The Origins of the Palestine Exploration Fund', *Palestine Exploration Quarterly*, 120 (1988), p. 51.

2. See Edward Said, *Orientalism* (New York: Random House, 1978).

3. This essay deals only with the two missions which surveyed Jerusalem and the Sinai Peninsula in 1864 and 1868 and the photographs made during the course of those surveys by Sergeant James McDonald. Surveys commanded by other officers of the Royal Engineers worked throughout the region. H. S. Palmer mapped the northern and eastern sections of the Sinai. Horatio Herbert Kitchener and Claude Conder mapped Western Palestine, and eventually the Negev. The maps of Palestine produced in this burst of activity were used by General Allenby in World War I and eventually became the basis upon which the boundaries of the Palestine Mandate were determined. See Yehoshua Ben-Arieh, 'The Geographical Exploration of the Holy Land', *Palestine Exploration Quarterly* (July–December 1972), pp. 81–92. See also my *Revealing the Holy Land: The Photographic Exploration of Palestine* (Santa Barbara: Santa Barbara Museum of Art, 1997).

4. *Encyclopaedia Britannica*, 11th edn (1910–11), Vol. 20, p. 600. The difficulty in defining and delimiting Palestine as a geographic entity was faced by the British at the end of World War I, the beginning of the Palestine Mandate. See Gideon Biger, *An Empire in the Holy Land: Historical Geography of the British Administration in Palestine, 1917–1929* (New York and Jerusalem: St Martin's Press, 1996), pp. 39–42.

5. On mapping surveys undertaken in Palestine in the nineteenth century, see Yolande Jones, 'British Military Surveys of Palestine and Syria 1840–1841', *Cartographic Journal*, 10, 1 (1973), pp. 29–41; Ben-Arieh, 'The Geographical Exploration of the Holy Land'; and I. W. J. Hopkins, 'Nineteenth-Century Maps of Palestine: Dual Purpose Historical Evidence', *Imago Mundi*, 22 (1968), pp. 30–6. For connections between the role of geographers in mapping new territories and the rise of modern, imperial states, see Anne Godlewska, 'Napoleon's Geographers (1797–1815): Imperialists and Soldiers of Modernity', in Anne Godlewska and Neil Smith (eds), *Geography and Empire* (Oxford: Blackwell, 1994), pp. 31–53.

6. Robin Butlin described the concept of historical geography in the nineteenth and early twentieth centuries: 'In essence, the type of historical geography advocated and practised was the geographical context of historical events, principally although not exclusively the historical contexts of ancient civilizations ... what Darby calls "the geography behind history".' He indicated that the key figures practising this form of historical geography in the nineteenth century were primarily clerical academics from the Oxford colleges, citing A. P. Stanley as an example. Robin Butlin, 'George Adam Smith and the Historical Geography of the Holy Land: Contents, Contexts and Connections', *Journal of Historical Geography*, 14, 4 (1988), p. 392.

7. Arthur Penrhyn Stanley, *Sinai and Palestine in Connection with Their History* (London: John Murray, 1860), p. xii.

8. The group accompanying the Prince of Wales included the photographer Francis Bedford. The photographs of the trip were published in *Egypt, Sinai and Jerusalem* (London: Day and Son, 1863).

9. Robin Butlin parsed the theological and cultural assumptions behind these travelogues and the tradition of historical geographies in the Holy Land in 'George Adam Smith and the Historical Geography of the Holy Land', pp. 392–6. For a historical perspective of nineteenth-century historical geography as practised in the Holy Land, see also Butlin's 'Ideological Contexts and the Reconstruction of Biblical Landscapes in the Seventeenth and Early Eighteenth Centuries: Dr. Edward Wells and the Historical Geography of the Holy Land', *Ideology and Landscape in Historical Perspective: Essays on the Meaning of Some Places in the Past* (Cambridge: Cambridge University Press, 1992). For a discussion of European geographic surveys, Yehoshua Ben-Arieh, 'Nineteenth-century Historical Geographies of the Holy Land', *Journal of Historical Geography*, 15, 1 (1989), pp. 69–79; in addition to his 'The Geographical Exploration of the Holy Land'.

10. For an overview of the application of photography to the Holy Land, see Yeshayahu Nir, *The Bible and the Image: The History of Photography in the Holy Land, 1839–1899* (Philadelphia: University of Pennsylvania Press, 1985); Nissan Perez, *Focus East: Early Photography in the Near East, 1839–1885* (New York: Harry N. Abrams, 1988); and Eyal Onne, *The Photographic Heritage of the Holy Land, 1839–1914* (Manchester: Manchester Polytechnic, 1980). My *Revealing the Holy Land* discusses the photographic context in which McDonald and the Royal Engineers worked in 1864 and 1868.

11. Frédéric Goupil-Fesquet travelled to the Middle East with his teacher, the Orientalist artist Horace Vernet. Their trip was motivated by the desire to gather visual material for their paintings, and they added daguerreotype equipment to the standard sketchbooks of the artist. At the same time, Swiss-born French-Canadian seigneur, Pierre Joly de Lotbinière, was also in the region making daguerreotypes. A few of the daguerreotypes made by Goupil-Fesquet and by Joly de Lotbinière were reproduced as engravings in Nicolas M. P. Lerebours, *Excursions daguerriennes: vues et monuments les plus remarquables du globe* (Paris: 1840–44).

12. For the earliest practitioners of photography in Jerusalem, see Nir, *The Bible and the Image*, pp. 29–44.

13. Alexander Keith, *Evidence of the Truth of the Christian Religion Derived from the Literal Fulfilment of Prophecy; Particularly as Illustrated by the History of the Jews, and the Discoveries of Modern Travellers*, 36th edn (Edinburgh: W. Whyte, 1847), p. 8. The italics are the author's.

14. The concept of geopiety, first proposed by John Kirtland Wright, is used by John Davis to describe the importance of place in nineteenth-century religious sensibilities in the United States. See John Kirtland Wright, 'Notes on Early American Geopiety', *Human Nature in Geography* (Cambridge, MA: Harvard University Press, 1966), pp. 250–85; and John Davis, *The Landscape of Belief: Encountering the Holy Land in Nineteenth-century American Art and Culture* (Princeton, NJ: Princeton University Press, 1996), p. 83. For a discussion of a generalized spiritual attachment to place and its implications, see Yi-Fu Tuan, 'Geopiety: A Theme in Man's Attachment to Nature and Place', in David Lowenthal and Martyn J. Bowden (eds), *Geographies of the Mind: Essays in Historical Geosophy in Honor of John Kirtland Wright* (New York: Oxford University Press, 1976), pp. 11–39.

15. Stanley, *Sinai and Palestine*, p. xxv.

16. Barbara Tuchman, *Bible and Sword: England and Palestine from the Bronze Age to Balfour* (New York: Ballantine Books, 1984), traces British interest in the Holy Land to long-standing traditions that identified the earliest Britons as descendants of Noah's grandson Gomer, converted to Christianity by Joseph of Arimathea (the source of the legend of the Holy Grail), and connected to the Phoenicians of biblical times through trade. The long-standing traditional connection was reinforced and extended in the eighteenth and nineteenth centuries to encompass political and cultural forms. She cites Huxley and Arnold in the context of this pervasive cultural identification.

17. The connection between attachment to the Bible as a template for understanding national events and the explorations carried out in Palestine was recognized by Walter Besant, Secretary of the Palestine Exploration Fund. Speaking in 1885, after the first twenty years of the Fund's activities in the Holy Land, Besant recognized that the sense of national identity which promoted the establishment of an agency such as the Fund no longer existed: 'We have ceased, for instance, in a large measure, to hear sermons on the teachings of certain episodes in the Old Testament. Those who applied every episode in the life of David, say, to the conduct of our daily life are gone; the expounders of prophecy are nearly all gone. Were we to begin, today, the Survey of the Holy Land, we should have a very much smaller support, in proportion to our wealth and numbers, than we had in the year 1865.' Cited in Naomi Shepherd, *The Zealous Intruders: From Napoleon to the Dawn of Zionism – The Explorers, Archaeologists, Artists, Tourist, Pilgrims and Visionaries Who Opened Palestine to the West* (San Francisco: Harper and Row, 1987), p. 226.

18. British Consul James Finn testified to the consequence for the indigenous population. The hospital recently established for the Jews in Jerusalem by the London Society for the Advancement of Christianity among the Jews recorded a staggering 5,000 visits in 1856 when the Jewish population of the city numbered 9,000.

19. Despite the subscription, the commander of the survey, Charles W. Wilson, reported that he personally spent £300 for field expenses. Colonel Sir Henry James, then Director of the Ordnance Survey Office at Southampton, bore the cost of the photographic component of the survey. I wish to thank Shimon Gibson at the Palestine Exploration Fund for bringing to my attention the correspondence between Wilson and James on the subject of financial support for photographic materials.

20. Although the focus of this essay is the two ordnance surveys of 1864 and 1868, the pattern holds true for other, later, surveys in the region in which personnel of the Royal Engineers were deployed. For discussion of the connections between imperial ambition, military presence and archaeological investigations, see Neil Silberman, *Digging for God and Country: Exploration, Archaeology, and the Secret Struggle for the Holy Land, 1799–1917* (New York: Alfred A. Knopf, 1982). A more general account of the motives and agendas of travellers in the region may be found in Shepherd, *Zealous Intruders*. An interesting nodal point in the tangled web of cartographic survey, archaeological investigation and the operations of British intelligence in the region occurs with the career of T. E. Lawrence, known as Lawrence of Arabia, who worked with a detachment of Engineers mapping the Wilderness of Zin, or the Negev. Later he worked with British intelligence to mobilize the desert tribes against the Germans in World War I. See Rupert Chapman III and Shimon Gibson, 'A Note on T. E. Lawrence as Photographer in the Wilderness of Zin', *Palestine Exploration Quarterly*, 128 (1996), p. 15.

21. Jones, 'British Military Surveys of Palestine and Syria 1840–1841'.

22. For the Royal Engineers' use of photography, see John Falconer, 'Photography and the Royal Engineers', *Photographic Collector*, 2, 3 (Autumn 1981), pp. 33–64; Andrew Birrell, 'Survey Photography in British Columbia, 1858–1900', in Joan M. Schwartz (ed.), *The Past in Focus: Photography and British Columbia, 1858–1914*, a special issue of *BC Studies*, 52 (Winter 1981–82), pp. 39–44; and James R. Ryan, *Picturing Empire: Photography and the Visualization of the British Empire* (Chicago: University of Chicago Press, 1997), pp. 78–83.

23. Henry Schaw, 'Notes on Photography (Papers on subjects connected with the duties of the Corps of Royal Engineers)' 1860, cited in Falconer, 'Photography and the Royal Engineers', p. 38.

24. Birrell, 'Survey Photography in British Columbia, 1858–1900', pp. 41–8.

25. Cited in Ryan, *Picturing Empire*, pp. 78–9.

26. For analysis of the Royal Engineers' use of photography in the Abyssinian Campaign and the implications for photography's use in geographical study, see ibid., pp. 73–98.

27. Captain Wilson (then Lieutenant) served as Secretary on that Survey. Falconer speculates that he may have been directly involved in obtaining ethnographic portraits of native peoples encountered on the western portion of the 49th Parallel Survey. Certainly Wilson's journal notes that he directed men in his command in the making of photographs. Falconer, 'Photography and the Royal Engineers', p. 51.

28. Charles William Wilson (1836–1905) held many posts, among them Director General of the Ordnance Survey (1886–93); Director, Topographical Department of the War Office (1870); Assistant Quartermaster-General, Intelligence (1873–76). He retired with the rank of Major General. For Wilson's involvement in the North American Boundary Survey 1858–62, see Andrew Birrell, 'Classic Survey Photos of the Early West', *Canadian Geographical Journal*, 19, 4 (October 1975), pp. 12–19.

29. James was keenly interested in the application of photography to the mission of the Ordnance Survey Office, especially as a means to reproduce maps rapidly. Under his direction, the Ordnance Survey developed photo-zincography, a printing technique which combined photography and offset lithography. The importance of James's project to geographical pursuits is indicated by the presence of Sir Roderick Murchison, President of the Royal Geographical Society, on the committee that reviewed the process. In addition to its use in reproducing maps, James applied the process to create a photo-zincograph facsimile of the Middlesex portion of the Doomsday Book in 1861. James, 'Photo-zincography as Applied at Ordnance Survey Office', *Professional Papers of the Corps of Royal Engineers*, 10 (1861), p. 129.

30. Major General Sir Henry James, 'Preface', *Ordnance Survey of Jerusalem* (London: Authority of the Lords Commissioners of Her Majesty's Treasury, 1865), p. 1.

31. Wilson, 'Introduction', *Ordnance Survey of Jerusalem*, p. 18.

32. Wilson's statement that the views were taken at spare moments as illustrations of building types and masonry detail is contradicted by the significant position the photographs occupy in the published survey report. One might speculate that Wilson's evaluation was that of a field officer with experience in the use of photography in the field – at the very least, he had seen the process used during the North American Boundary Survey. Thus Wilson's view may be seen as the pragmatic assessment of an engineer assigned to survey water channels. The prominence given the photographs in the published survey is indicative of Colonel James's interests in photography and in the broader implications of survey work in the Holy Land. James was a member of the Water Relief Committee and a founding member of the Palestine Exploration Fund.

33. The map volume of Wilson's *Ordnance Survey of Jerusalem* contained maps of Jerusalem drawn to 1:2500 (the British survey team of 1840–41 had mapped Jerusalem at 1:4800); the environs of the city at 1:10,000; the Temple Mount 1:5000; the Holy Sepulchre and the Dome of the Rock 1:200; and maps and plans of several important structures such as the Citadel, the Church of St Anne, David's Tomb, the Armenian cathedral, the Church of the Flagellation, and the Dome of the Ascension on the Mount of Olives. Also included were plans based on excavation at the Tower of Tancred and the support of the subterranean cistern that became known as Wilson's Arch.

34. The survey team of 1840–41 did not enter the Citadel, or *Haram*, in deference to their Turkish allies.

35. Although previous travellers had measured the elevation of the Dead Sea, Wilson obtained a more accurate elevation. The project had the added benefit of allowing him to remove himself and his men from Jerusalem during the fever season.

36. Wilson's findings prompted a mission to Jerusalem the following year, the first financed by the newly formed Palestine Exploration Fund. Commanded by Captain Warren and again composed of men from the Royal Engineers, it concentrated on continuing and expanding archaeological excavations near the city wall.

37. The photograph Montefiore describes was not made by McDonald or one of his assistants, but by Peter Bergheim, a converted Jew who was one of the first local resident photographers in Jerusalem. Three of Bergheim's photographs were reproduced in the *Ordnance Survey of Jerusalem*, all of them of the Western Wall, the so-called Wailing Wall of the Jews. It seems likely that, as a local, his presence would have been judged less intrusive in this holy spot. One might speculate as to whether this particular view had been requested by James as an inducement to Montefiore's interest in and financial support of the project. The Survey was under-funded and the initial funds were exhausted while the team was still in Jerusalem. In fact, Captain Wilson had to draw on his own funds to bring the project to completion.

38. George Grove, draft of the prospectus for the association, cited in Lipman, 'The Origins of the Palestine Exploration Fund', p. 49.

39. As with the 1864 Survey of Jerusalem, a subscription fund was established. The Reverend George Williams of Cambridge acted as Secretary, and Sir John Herschel, Sir Roderick Murchison of the Royal Geographical Society and Colonel Sir Henry James were trustees. (Williams also accompanied the Survey.) The fund raised £2,338 with grants from Cambridge, Oxford, the Royal Society and the Royal Geographical Society, as well as from individuals such as Lady Burdett-Coutts who again made a significant contribution.

40. Grove, draft of prospectus, in Lipman, 'The Origins of the Palestine Exploration Fund', p. 45.

41. George Williams, 'Introduction', *Ordnance Survey of the Peninsula of Sinai* (London: Authority of the Lords Commissioners of Her Majesty's Treasury, 1869), p. 8.

42. Ibid., p. 6.

43. Members of the survey team contributed to the final publication: Captain Palmer wrote the chapters, 'Descriptive Geography', 'An Account of the Special and Geographic Survey' and 'Topographical Notes', and compiled a table of latitude, longitude and altitudes as an appendix; E. H. Palmer contributed Chapter 3, 'Bedawin and Their Traditions', Chapter 6, 'Mohammaden History of the Exodus', and the appendix, 'Nomenclature'. Reverend Holland wrote Chapter 8, 'Geological Notes'; Wyatt was responsible for Chapter 11, 'Zoology', which included 'Notes on Mammals and Avifauna, and List of Coleoptera'. Captain Wilson wrote Chapter 5, 'Notes on the Position of Mount Sinai and the Route Followed by the Israelites after Crossing the Red Sea', and Parts 2 and 3 of Chapter 7, 'Archaeology, Primitive Remains, and Monastic and Premonastic Remains'. Samuel Birch, noted Egyptologist and papyrologist at the British Library, wrote the first part of the chapter, 'Egyptian Remains'. The chapter on botany was written by the pre-eminent British botanist Joseph Hooker, based on notes and collections made by Wyatt.

44. Williams, 'Introduction', p. 6.

45. Captain Palmer, 'Account of the Special and Geographic Surveys', *Ordnance Survey of the Peninsula of Sinai*, p. 37.

46. Edward Said, 'Yeats and Decolonization', in Terry Eagleton, Frederic Jameson and Edward Said (eds), *Nationalism, Colonialism, and Literature* (Minneapolis: University of Minnesota Press, 1990), p. 77.

47. Certainly the sets of stereoscopic photographs and single photographic views were produced and offered for sale by the Ordnance Survey Office, thus making them an 'official' publication. I use the term 'official' publication here to reference the multi-volume set published as *Ordnance Survey of the Peninsula of Sinai* and intended for use in government offices and research libraries, and by scholars and contributors to the Fund. The published volumes stood as the official record of the Survey's findings and their interpretation by the Office of the Ordnance Survey.

48. For a discussion of the power of photography and the stereoscopic photograph in the acquisition and display of imaginative geographies, see Joan M. Schwartz, 'The Geography Lesson: Photographs and the Construction of Imaginative Geographies', Journal of Historical Geography, 22, 1 (1996), pp. 16–45. I discuss the absence of local populations in official survey photographs and their reappearance in commercial tourist views in my Excursions Along the Nile.

49. It should be noted that the North American Boundary Commission Survey, in which Wilson took part, included photographs of indigenous people. Falconer ('Photography and the Royal Engineers') suggests that the ethnographic portraits made during the survey may have been made under Wilson's direction.

50. James, 'Preface', p. 3.

51. Hugh MacMillan, Bible Teachings in Nature (New York: D. Appleton, 1867), cited in Davis, Encountering the Holy Land, p. 75.

52. Davis describes a more ambitious model of the region, the 170-feet scale model of central Palestine built at Chautauqua, New York. The model became the site for the enactment of pilgrimage journeys. In this case, the overlay of simulacrum, geopietistic attachment to the space of the Holy Land and the re-enactment of biblical events blurred the distinction between physical geography and imaginative geography. Visitors referred to their experience of the model as if they had visited the Holy Land. Davis, Encountering the Holy Land, pp. 89–92.

53. In addition to the list of place names gathered by members of the Sinai survey, E. H. Palmer transcribed the inscriptions found on rocks in Wadi Mukatteb, and wrote a lengthy essay on them. Prior to Palmer's work it had been believed that the inscriptions dated to the time of the Exodus and were in a form termed Sinaitic script.

54. See Said, 'Yeats and Decolonization', p. 77.

55. James R. Ryan, 'Imperial Landscapes: Photography, Geography and British Overseas Exploration, 1858–1872', in Morag Bell, Robin Butlin and Michael Heffernan (eds), Geography and Imperialism, 1820–1940 (Manchester: Manchester University Press, 1995), pp. 53–79.

10. Home and Empire

1. William H. Russell, My Diary in India, in the Year 1858–1859, 2 vols (London: Routledge, Warne and Routledge, 1860). I refer to events of 1857–58 as a 'mutiny' because I am examining imperial representations of British families in India. See Christopher Hibbert, The Great Mutiny: India 1857 (London: Penguin Books, 1978) for further discussion of these events.

2. Russell, My Diary in India, p. 324. The looting of Lucknow reached its peak with British soldiers helping themselves to 'shawls, rich tapestry, gold and silver brocade, caskets of jewels, arms, splendid dresses. The men are wild with fury and lust of gold – literally drunk with plunder' (ibid., p. 330). But by the following day, Russell recorded that 'plundering is stopped by order' and, by 16 March, sentries stood guard over the few valuable items that remained intact amid the destruction. Also see Veena Talwar Oldenburg, The Making of Colonial Lucknow (Delhi: Oxford University Press, 1989).

3. The Lucknow Album is held at the Oriental and India Office Collections of the British Library, reference Photo 269 1/2.

4. Wheler was a captain in the Indian Army and part of the forces that recaptured Lucknow in 1858. It remains unclear how he had come to acquire the album, but the presence of a bookplate in his name suggests that he was likely to have been in possession of it before the plundering of Lucknow on 14 March. It is possible that Wheler himself had compiled the Lucknow Album from photographs gathered in Lucknow after the siege.

5. Volume 2 was displayed as part of a photographic exhibition held by the antique dealer Howard Ricketts at his shop in New Bond Street. As the exhibition catalogue and an article in The Times attest, Volume 2 of the Lucknow Album was regarded as the most significant exhibit. The British Library was given first option to purchase it with a view to reuniting it with Volume 1. From notes and cuttings held in an uncatalogued file on 'Mutiny Material' held in the Prints Room, Oriental and India Office Collections, British Library.

6. Collections Handlist, Oriental and India Office Collections, British Library. Because the photographs have faded over time, a facsimile album was made in 1975.

7. Edward Hilton, The Tourists' Guide to Lucknow, 9th edn (London: Murray, 1916).

8. The term 'sepoy' refers to private soldiers in the infantry.

9. Thomas Metcalf, The Aftermath of Revolt: India 1857–1870 (Princeton, NJ: Princeton University Press, 1965); and John Pemble, The Raj, the Indian Mutiny and the Kingdom of Oudh 1801–1859 (London: Harvester Press, 1977).

10. MacLeod Innes, Lucknow and Oude in the Mutiny: A Narrative and a Study (London: A. D. Innes and Co., 1895). Estimates of the numbers under siege vary. Innes states that there were 3,000 people under siege, of whom 1,392 were Indian and 1,608 were British and others of European descent. Innes also estimates that there were 1,720 combatants and 1,280 non-combatants. For more on diaries written by British women during the siege of Lucknow see Alison Blunt, 'Spatial Stories Under Siege: British Women Writing from Lucknow in 1857', Gender, Place and Culture, 7, 3 (September 2000), pp. 229–46.

11. The Times, 18 February 1930.

12. Illustrated London News (no date), from the Mutiny Scrap Book, School of Oriental and African Studies, University of London, MS 380484.

13. John Tagg, The Burden of Representation: Essays on Photographies and Histories (London: Macmillan, 1988), p. 4.

14. Ray Desmond, *Victorian India in Focus: A Selection of Early Photographs in the India Office Library and Records* (London: Her Majesty's Stationery Office, 1982), p. 65.

15. John Falconer, 'Photography in Nineteenth Century India', in Christopher Bayly (ed.), *The Raj: India and the British, 1600–1947* (London: National Portrait Gallery Publications, 1990), pp. 264–77, p. 276.

16. John Fraser, 'Some Pre-Mutiny Photograph Portraits', *Journal of the Society for Army Historical Research*, 58 (1980), pp. 134–47. As Fraser writes, Ahmad Ali Khan's photographs 'constitute a unique record of people who were living in, or just visiting, Lucknow in the year or so before the Mutiny. He photographed many of the British people who were to be involved in the Mutiny and he photographed some of the future Indian rebel leaders, and so his photographs provide a fascinating record for the student of the Indian Mutiny' (p. 134).

17. Anna Davin, 'Imperialism and Motherhood', *History Workshop Journal*, 5 (1978), pp. 9–65.

18. Thomas Richards, *The Commodity Culture of Victorian Britain: Advertising and Spectacle, 1851–1914* (London: Verso, 1990); and Jane Jacobs, *Edge of Empire: Postcolonialism and the City* (London: Routledge, 1996).

19. Alison Blunt, 'Imperial Geographies of Home: British Domesticity in India, 1886–1925', *Transactions of the Institute of British Geographers*, 24, 4 (December 1999), pp. 421–40.

20. Kenneth Ballhatchet, *Race, Sex and Class under the Raj: Imperial Attitudes and Policies and their Critics, 1793–1905* (London: Weidenfeld and Nicolson, 1980).

21. Ronald Hyam, *Empire and Sexuality: The British Experience* (Manchester: Manchester University Press, 1990).

22. Benedict Anderson, *Imagined Communities: Reflections on the Origin and Spread of Nationalism* (London: Verso, 1991).

23. 'The English in India – Our Social Morality', *Calcutta Review* (1844), pp. 290–336, p. 321.

24. 'Married Life in India', *Calcutta Review* (1845), pp. 394–417, p. 404.

25. Alison Blunt, 'Embodying War: British Women and Domestic Defilement in the Indian "Mutiny", 1857–8', *Journal of Historical Geography*, 26, 3 (July 2000), pp. 403–28.

26. See Jane Robinson, *Angels of Albion: Women of the Indian Mutiny* (London: Viking, 1996); Jenny Sharpe, *Allegories of Empire: The Figure of Woman in the Colonial Text* (Minneapolis: University of Minnesota Press, 1993); and Penelope Tuson, 'Mutiny Narratives and the Imperial Feminine: European Women's Accounts of the Rebellion in India in 1857', *Women's Studies International Forum*, 21 (1998), pp. 291–303, for further discussion of these diaries and other representations of imperial domesticity under threat during the 'mutiny'.

27. See A. Blunt, 'Imperial Geographies of Home' for further discussion.

28. Wilfred Scawen Blunt, *Ideas about India* (London: Kegan Paul, Trench and Co., 1885), p. 47.

29. Ray Desmond, 'Photography in Victorian India', *Journal of the Royal Society of Arts* (1985), pp. 48–61, 57.

30. Ray Desmond, 'Photography in India during the Nineteenth Century', *India Office Library and Records Report* (1974), pp. 5–36.

31. Christopher Pinney, *Camera Indica: The Social Life of Indian Photographs* (London: Reaktion, 1997).

32. Ibid., p. 34. Also see Sara Suleri, *The Rhetoric of English India* (Chicago: University of Chicago Press, 1992), for further discussion.

33. Pinney, *Camera Indica*, p. 72.

34. Desmond, 'Photography in India' and James R. Ryan, *Picturing Empire: Photography and the Visualization of the British Empire* (London: Reaktion, 1997).

35. Ray Desmond, '19th Century Indian Photographers in India', *History of Photography*, 1, 4 (October 1977), pp. 313–17.

36. Desmond, 'Photography in Victorian India'.

37. Judith M. Gutman, 'Through Indian Eyes', in Liz Heron and Val Williams (eds), *Illuminations: Women Writing on Photography from the 1850s to the Present* (London: I.B.Tauris, 1996), pp. 427–34, p. 428.

38. Ibid., p. 428.

39. Ibid.

40. See, for example, Anne McClintock's discussion of imperial photography in the metropolis, where she writes: 'People, most often women, were posed before artificial backdrops, often exotic and incongruously out of keeping with the sitter's world, but expressive nonetheless of fantasies of imperial control over space, landscape and interior.' For McClintock, both the photographic studio and the photographs taken within it confounded and yet repeated distinctions between domesticity and imperialism, private and public space. Anne McClintock, *Imperial Leather: Race, Gender and Sexuality in the Colonial Contest* (New York: Routledge, 1995), p. 125.

41. Pinney, *Camera Indica*.

42. See, for example, Ali Behdad's discussion of the imperial photographs that illustrate the 1987 Oxford edition of Rudyard Kipling's short stories. Ali Behdad, *Belated Travelers: Orientalism in the Age of Colonial Dissolution* (Durham, NC: Duke University Press, 1994).

43. Although there is only one post-mortem photograph in the *Lucknow Album*, Ahmad Ali Khan did take others. Henry Polehampton's descriptions of his son's post-mortem photographs are discussed below.

44. Behdad, *Belated Travelers*, p. 75.

45. Ibid.

46. Edward Polehampton and Thomas Polehampton (eds), *A Memoir, Letters and Diary of the Rev. Henry S. Polehampton* (London: Richard Bentley, 1858).

47. Ibid., pp. 141–2.

48. Ibid., p. 142.

49. Ibid., pp. 169–70.

50. Ibid., p. 226.

51. Ibid., p. 220.

52. As described in Frances Wells's letters to her father in Britain. Bernars Papers, Centre of South Asian Studies, University of Cambridge.

53. Polehampton, *A Memoir, Letters and Diary*, p. 220.

54. Ibid., pp. 224–5.

55. Ibid., p. 228.

56. Ibid., p. 229.

57. Ibid., p. 348.

58. Ibid., p. 376. Also see Katherine Bartrum, *A Widow's Reminiscences of the Siege of Lucknow* (London: James Nesbit, 1858).

59. Hilton, *The Tourists' Guide to Lucknow*, p. 68.

60. Ibid., p. 31.

61. *The Lucknow Album* (Calcutta: Baptist Mission Press, 1874), pp. 52–3. This book shares the title of the two volumes of photographs discussed in this essay but is entirely separate. Produced sixteen years after the *Lucknow Album* of photographs was given to William Howard Russell, it is unsurprising that the book makes no mention of its namesake.

62. Polehampton, *A Memoir, Letters and Diary*, p. 141.

63. Ibid., pp. 140–1.

64. After the British suppression of the 'mutiny', a number of local people who were entitled to receive stipends from the Hosiniabad Imambara endowment were unable to gain their money and complained to the government. A subsequent inquiry discovered that during the 'mutiny', Ahmad Ali Khan, the other trustee, and the agent of the Hosiniabad Imambara had disappeared, that many of its valuable contents had been plundered, and that the government securities that comprised the endowment had been taken from the safe. Further inquiries found that Ahmad Ali Khan had died during the 'mutiny'. The other trustee surrendered himself, and the agent made a deposition on his deathbed. Both trustees were tried in a hearing that lasted for longer than a year, in which Ahmad Ali Khan was represented by his son. This hearing learnt that at the beginning of the 'mutiny', the agent assumed the post of Prime Minister in the Rebel Durbar, dispossessed and deposed the trustees, and assumed sole control over the endowment. As a result of this hearing, Ahmad Ali Khan and the other trustee of the Hosiniabad Imambara were pardoned under the Governor-General's amnesty. See Desmond, 'Photography in Victorian India'; Oldenburg, *The Making of Colonial Lucknow*; and *The Lucknow Album*, for further discussion.

11. Negotiating Spaces

I should like to thank Joan Schwartz, James Ryan and my colleague, Chris Gosden, for their close reading and constructive debate over the various drafts of this essay, and Andrew Lambert for guiding my understanding of nineteenth-century Naval strategy in the Pacific. For an extended discussion of the Samoan photographs, see E. Edwards, *Raw Histories: Photographs, Anthropology and Museums* (Oxford: Berg, 2001), pp. 107–29.

1. HMS *Miranda* was an Osprey Class sloop built at Devonport, UK, and launched in September 1879. She was of composite construction (teak and iron), had a displacement of 1,130 tons, was 170 ft long by 36 ft wide and carried a complement of 140 officers and ratings. She was powered by sail (barque-rigged) and a single screw compound engine made by Napiers of Glasgow. Thus HMS *Miranda* was a relatively new ship

when Acland took over her command. This class of ship was designed for handiness and speed, essential for the detached cruising that made up the policing duties undertaken by the Royal Navy in the Pacific. However, in light of the available marine technology, such ships were poor steamers, and carried antiquated armaments such as *Miranda*'s two main 7-inch muzzle-loading guns. Antony Preston and John Major, *Send a Gunboat! A Study of the Gunboat and its Role in British Policy 1854–1904* (London: Longmans, 1967), pp. 220–1.

2. Edward Soja, *Postmodern Geographies: The Reassertion of Space in Critical Social Theory* (London: Verso, 1989), pp. 6–7.

3. Suren Lalvani, *Photography, Vision and the Production of Modern Bodies* (Albany, NY: SUNY, 1996), pp. 2–3.

4. For example, Alan Sekula, 'The Body and the Archive', *October*, 39 (1986), pp. 3–64; and Malek Alloula, *The Colonial Harem* (Minneapolis: University of Minnesota Press, 1986).

5. I am using the colonial name New Hebrides throughout rather than the correct name, Vanuatu, first because this is the name that Acland used and, second, because naming is intrinsic to the spatial discourse in the Pacific of which Acland's photographs are part.

6. Negatives and prints for most of the Acland material from the Pacific are in the Photographic Collections of the Pitt Rivers Museum, University of Oxford, UK (hereafter, PRM). There is an album, 'New Hebrides and Other Views' in the Mitchell Library, Sydney (ML Q988.6/N) which includes some of these images, along with others concerned with the Royal Navy or settler society in Australia. There is another album in National Library of Australia (Album 460) which is concerned with the 1884 tour of duty and comprises mainly Norfolk Island material, but which includes some commercially produced photographs as well. I am grateful to Sylvia Carr, Alan Davies, Roslyn Poignant and Max Quanchi for supplying me with this information and for answering my detailed questions concerning these albums which I have been unable to examine personally.

7. Clifford Geertz, *The Interpretation of Culture* (London: Fontana, 1993; 1st edn, 1973), p. 5.

8. Michael Fried, *Theatricality and Absorption: Painting and the Beholder in the Age of Diderot* (Berkeley: University of California Press, 1980).

9. James Peacock, 'An Ethnography of the Sacred and Profane in Performance', in Richard Schechner and Willa Appel (eds), *By Means of Performance* (Cambridge: Cambridge University Press, 1990), p. 208.

10. This goes beyond what might be technologically determined. See Edwards, *Raw Histories*, pp. 17–21.

11. Greg Dening, *Performances* (Melbourne: Melbourne University Press, 1996), p. 109.

12. Joan M. Schwartz, '"We make our tools and our tools make us": Lessons from Photographs for the Practice, Politics, and Poetics of Diplomatics', *Archivaria*, 40 (Fall 1995), pp. 51–2.

13. Dan Sperber, 'Interpreting and Explaining Cultural Representation', in G. Pálsson (ed.), *Beyond*

Boundaries: Understanding Translation and Anthropological Discourse (Oxford: Berg, 1993), p. 173.

14. U. Wikan, 'Beyond the Words: The Power of Resonance', in Pálsson (ed.), *Beyond Boundaries*, p. 193.

15. This notion of 'dense context' is something akin to Geertz's notion of 'thick description' (*Interpretation of Culture*, pp. 6–10) and Stephen Daniels's idea of 'specific gravity'. *Fields of Vision: Landscape Imagery and National Identity in England and the United States* (Cambridge: Cambridge University Press, 1993), pp. 244–5.

16. Florike Egmond and Peter Mason, 'A Horse Called Belisarius', *History Workshop Journal*, 47 (1999), p. 249.

17. Paul Valéry quoted in Dening, *Performances*, p. 116.

18. Norman Bryson, 'Art in Context', in Ralph Cohen (ed.), *Studies in Historical Change* (Charlottesville: University of Virginia Press, 1992), p. 40.

19. Margaret Rodman, 'Empowering Place: Multi-locality and Multivocality', *American Anthropologist*, 94 (1992), p. 643.

20. Soja, *Postmodern Geographies*, p. 11.

21. There is a massive literature on this subject; see for instance Bernard Smith, *European Vision and the South Pacific*, 2nd edn (London and New Haven, CT: Yale University Press, 1985) and references therein; E. Barkan and R. Bush (eds), *Prehistories of the Future* (Stanford, CA: Stanford University Press, 1996); and Alison Nordström, 'Early Photography in Samoa: Marketing Stereotypes of Paradise', *History of Photography*, 15, 4 (1991), pp. 272–86.

22. W. Schivelbusch, *The Railway Journey: The Industrialisation of Time and Space in the 19th Century* (Leamington Spa: Berg, 1986; 1st edn, 1977), pp. 10–11.

23. Stephen Kern, *The Culture of Space and Time 1880–1918* (Cambridge, MA: Harvard University Press, 1983), p. 221.

24. Greg Dening, 'The Theatricality of Observing and being Observed: Eighteenth-Century "Europe" "discovers" the ? Century "Pacific"', in Stuart B. Schwartz (ed.), *Implicit Understandings: Observing, Reporting, and Reflecting on Encounters between Europeans and Other Peoples in the Early Modern Period* (Cambridge: Cambridge University Press, 1994), p. 476.

25. Susan Schlee, *A History of Oceanography: The Edge of an Unfamiliar World* (London: Hale, 1975).

26. Denis Wood and John Fels, *The Power of Maps* (London: Routledge, 1992), pp. 17–18.

27. Henri Lefebvre, *The Production of Space*, trans. D. Nicholson-Smith (Oxford: Blackwell, 1991; 1st edn, 1974), pp. 280–81.

28. For various perspectives on this see S.B. Schwartz (ed.), *Implicit Understandings*.

29. W. Millis, *The Future of Sea Power in the Pacific*, World Affairs Pamphlet 9 (New York: Foreign Policy Association 1935), p. 5.

30. Ibid., p. 8.

31. N. A. M. Rodger, 'The Dark Ages of the Admiralty, 1869–1885. Pt. II and III', *Mariner's Mirror*, 62, 1 (1976).

32. John Bach, *The Australia Station: A History of the Royal Navy in the Southwest Pacific 1823–1913* (Kensington, NSW: New South Wales University Press, 1986).

33. The concept of Melanesia is itself of European making.

34. There were very substantial movements of populations through this system during the second half of the nineteenth century. Various measures were taken to control it, both in humane terms and to counter the problems encountered by local island subsistence economies through the departure of young men to the plantations.

35. On the tours of duty when these photographs were taken Acland dealt with cases precisely along these lines, investigating reports of kidnap of labourers, labour vessels flying false colours and instances of violence and murder between indigenous peoples and white settlers. Public Record Office, Kew (hereafter, PRO), ADM. 1/6705.

36. Despite the fact that Australia and London had been linked by telegraphic communication in 1872. Bach, *The Australia Station*, p. 3.

37. Ibid., pp. 3–5.

38. John Agnew and James Duncan (eds), *The Power of Place: Bringing Together the Geographical and Sociological Imaginations* (Boston: Unwin Hyman, 1989), p. 2.

39. The dry gelatin whole-plate negatives survive but are in a very fragile condition. However, there were clearly more which have as yet not been located, if they survive, as there are some prints in the Sydney albums for which there are no negatives in Oxford. The prints in Oxford are albumen prints made in 1886 when the collection was given to the Pitt Rivers Museum. Significantly, only those deemed 'ethnographic' were printed. Acland probably learned photography as a lieutenant at Greenwich Royal College where various suitable technical skills were taught to young and rising officers. The photographs discussed here are competently and carefully produced; they are not first attempts. Yet a letter from his sister Sarah Angelina (Angie) hints that Acland's photography was a relatively recent enthusiasm: 'We have enjoyed your photographs too immensely they are very interesting indeed. What a gain it is that you have learnt [photography].' Bodleian Library (hereafter Bod. Lib.), University of Oxford, Acland Ms, d107, f85–85v. Angie Acland to Capt. Acland, 20 February 1884. Miss Acland herself took up photography in 1892 with great success and developed an interest in colour photography when it was in its infancy.

40. PRO. ADM 53/14620. 'Island Run' was the Royal Navy colloquial name for the tour of duty taking in the western Pacific, literally a run up through the islands, Sydney, New Zealand, Norfolk Island and north-northwest to New Caledonia, Vanuatu, Fiji and over to Samoa in the east.

41. Pitt Rivers Museum original negative nos 98–99.

42. A few of Acland's photographs of New Hebrides and Banks Island are found illustrating books of popular anthropology. The photograph of the group on the beach (Figure 11.2) discussed here appeared as

Figure 15 in A. H. Keane, *The World's People* (1908) captioned 'Natives of Mabekula [sic], New Hebrides. Full blooded Melanesians, noted wood carvers and boat-builders.' Another Acland photograph in the same volume is Figure 17, 'Women of Mota Island, Banks Archipelago: the Natives of Mota are Christians and wear European clothes.' A different photograph taken on the same occasion (PRM C1.2.29c) appears in *Living Races of Mankind* ([1901?]:40) as does a cropped version of 'A Group of Natives, Pentecost Island' (page 41) (PRM B39.12b). However, a full examination of the afterlife of Acland's photographs is beyond the scope of this essay.

43. Briefly, Ambrym men progressed in seniority through a series of *mage* 'grades' achieved through the rituals of status acquisition and the secret secular rites of *luan* and *bato*. The transitions were marked by material markers of status, including the erection near the dance ground of fernwood figures painted with stylized human features. See Mary Patterson, 'Mastering the Arts' and references therein in J. Bonnemaison et. al, *The Arts of Vanuatu* (Bathurst: Crawford House Publishing, 1996), p. 254.

44. Bod. Lib. Acland Ms. d40.f.133. Sydney, 11 October 1883.

45. Lamont Lindstrom, *Knowledge and Power in a South Pacific Society* (Washington, DC: Smithsonian Institution Press, 1990), pp. 51, 71.

46. Epeli Hau'ofa, 'Our Sea of Islands', *Contemporary Pacific*, 6, 1 (1994), pp. 152–3.

47. Greg Dening, *Islands and Beaches: Discourses on a Silent Land, Marquesas, 1774–1880* (Honolulu: University of Hawaii Press, 1980).

48. Daniels, *Fields of Vision*, pp. 244–5.

49. V. Berdoulay, 'Place, Meaning and Discourse in French Language Geography', in Agnew and Duncan (eds), *The Power of Place*, p. 129; Rodman, 'Empowering Place'.

50. PRM B39.1b; Negative 79.

51. At the time this photograph was made, the Pacific Island Labour Act 1880 (amended) was in place to forbid British traders and labourer recruiters (who sometimes paid labourers off in firearms and ammunition) from supplying firearms and ammunition to Islanders. This legislation, which came into force in July 1884, was resisted by British labour recruiters who argued that it put them at serious disadvantage in recruiting labour, given that rival colonial powers, especially the Germans, had placed no such restrictions upon their nationals. For instance, in November 1885 it was complained the Germans had paid off two shiploads of labourers from the New Hebrides and Solomon Islands with rifles and ammunition. D. Munro and S. Firth, 'German Labour Policy and the Partition of the Western Pacific', *Journal of Pacific History*, 25, 1 (1990), p. 94.

52. Dening, *Performances*, p. 101.

53. Chris Tilley, *The Phenomenology of Landscape: Places, Paths and Monuments* (Oxford: Berg, 1994), p. 10.

54. Dening, *Islands and Beaches*; David Tomas, 'Transcultural Space', *Visual Anthropology*, 9, 2 (1993), pp. 60–78.

55. It is the specific moment of experience which is so often lacking in historical *writing*.

56. I have explored these two photographs in the different context of visuality and cultural biography in 'Visuality and History', in C. Blanton (ed.), *Picturing Paradise: Colonial Photography of Samoa, 1875–1925*, ex. cat. (Daytona Beach, FL, 1995). Another version appeared in J. Engelhard and P. Mesenhöller (eds), *Bilder aus dem Paradies* (Marburg: Jonas Verlag, 1995). For a revised and expanded version, see Edwards, *Raw Histories*.

57. The numerous sources for this event in the papers of the Admiralty Office are most accessible in their printed and collated *Proceedings* form, *Cruise of H.M.S. Miranda: Fiji and Samoa, October to November 1883*. PRO, ADM 122/143.

58. This procedure was not uncommon during the classic period of British marine diplomacy in the Pacific.

59. Bach, *The Australia Station*, p. 104. Nevertheless, Samoa had become a site of tension for rivalries between colonial powers, and Britain could not afford destabilization in the region which would threaten its trade and labour supplies. The situation was stabilized at the Berlin Conference in 1889, but in 1899 colonial interests in Samoa were finally resolved, Samoa being divided between Germany and the United States, with Britain relinquishing its interests. After that, except for the fascination with Robert Louis Stevenson, Samoa largely slipped from British consciousness. The British need for coaling and port facilities was answered in the development of Suva in Fiji and an increasing interest in Tonga which became a British protectorate with independent sovereign in 1900.

60. The colonial powers struggling for control of Samoa were the United States, Germany and Great Britain, collectively known there as the 'Great Powers'.

61. *Matai* were heads of clans and lineages, and were pivotal in the local power structure.

62. William B. Churchward, *My Consulate in Samoa: A Record of Four Years' Sojourn in the Navigator Islands* (London: 1887), p. 337.

63. The Mauga *matai* (head of lineage) title was being disputed between the *tama tane* and *tama fafine* kinship connections; for an explanation of the significance of this see Gilson, *Samoa 1830–1900: The Politics of a Multi-cultural Community* (Melbourne: Melbourne University Press, 1970), pp. 35–9. Mauga Lei was the *tama fafine* claimant, being a son of the sister of the deceased Mauga title-holder. Mauga Manuma was the *tama tane* claimant, being the son of the deceased Mauga and his testamentary heir. Churchward, *My Consulate*, p. 336.

64. Churchward, *My Consulate*, p. 340.

65. King Malietoa Laupepa's demands were that the Mauga claimants stop fighting, that they should be brought to Mulinu'u for one year's exile and that if they refused to obey Captain Acland they should each be fined $1,500. PRO, ADM.122/13.

66. Churchward, *My Consulate*, p. 343; PRO, ADM. 22/13.

67. Churchward, *My Consulate*, pp. 343–4.

68. Bod. Lib. Acland Ms. d55.f2v. Acland to W. H. Smith, 28 January 1884. Prints of the two photographs discussed in this essay were clearly enclosed with the letter; these have since disappeared. W. H. Smith, founder of the chain of newsagents in Britain, soon after became Acland's father-in-law. Smith was also a prominent Conservative politician and served as First Lord of the Admiralty 1877–80 in Disraeli's second administration. It is Smith who is immortalized satirically in Gilbert and Sullivan's light opera *H.M.S. Pinafore* as the First Lord who 'stayed close to his desk, and never went to sea, and now he is the ruler of the Queen's Navy'. Rodger, 'The Dark Ages of the Admiralty', p. 39n.

69. Roland Barthes, *Camera Lucida*, trans. Richard Howard (London: Fontana, 1984), p. 89.

70. Victor Turner, *Dramas, Fields and Metaphors: Symbolic Action in Human Society* (London and Ithaca, NY: Cornell University Press, 1974), p. 17.

71. Lefebvre, *The Production of Space*, p. 281.

72. D. Handelman, *Models and Mirrors: Towards an Anthropology of Public Event* (Cambridge: Cambridge University Press, 1990), pp. 10–17. It constitutes a sequential organization, goal-directed activity that conveys to participants a version of social order. An extended consideration of the meeting between the Maugas on HMS *Miranda* in the light of Handelman's analysis of public event is beyond the scope of this essay, but elements none the less remain pertinent to the consideration of both photography and spatiality.

73. For instance, the commander walked on the leeward side, out of the wind, while other officers were on the windward side, in the prevailing winds. Many of such ritual configurations of space had a pragmatic basis in the operational and navigational demands of sail but survived as cultural spaces into the age of steam and beyond.

74. The Admiralty Office papers note a number of incidents when this tool of marine diplomacy was resisted because of the spatial and thus political dislocations it represented and the diminution of the Samoans' own powers. This was fully understood by the Samoans. For instance, in a notable case, the chiefs of Atua, who were at the time in violent conflict with the people of Falifa, stated that they were afraid to come on board the British warship HMS *Danae*. The incident culminated in the British burning the village of Lufi Lufi. PRO, ADM.122/13:118–19. Capt. Child-Purves to Commodore Crawford, 29 May 1880.

75. D. Holmes, *Samoan Village* (New York: Holt Winston and Rinehart, 1974), pp. 25–6.

76. It is difficult to be precise about the details as each village and/or title tends to have its own structural peculiarities of spatial configuration on such occasions of debate (Holmes, *Samoan Village*, p. 26). Only a detailed study of the spatial expressions of the Mauga title of Tutuila itself could resolve this and this is beyond the scope of this essay, not to mention my expertise. However, the arrangement coheres to a broad spatial patterning so that it is possible to make general statements here that are sufficiently substantiated to uphold the thrust of my argument.

77. As Tilley has argued, socially produced space combines the cognitive, physical and emotional. *Phenomenology of Landscape*, p. 10.

78. There is massive literature on the relationship between space and time from many perspectives; see, for instance, J. Fabian, *Time and the Other* (New York: Columbia University Press, 1983); John Bender and David E. Wellbery (eds), *Chronotypes: The Construction of Time* (Stanford, CA: Stanford University Press, 1991); and Christopher Gosden, *Social Being and Time* (Oxford: Blackwell, 1994), pp. 78–80, and the extensive references cited in these works.

79. Roland Barthes, 'The Rhetoric of Image', in *Image, Music, Text*, trans. Stephen Heath (London: Fontana, 1977), p. 44.

80. Referenced by imposed, structured time in imposed, structured space – the Maugas were to be on the quarterdeck of the ship at 10 o'clock in the morning.

81. Soja, *Postmodern Geographies*, p. 24. As Eduardo Cadava has argued in relation to Walter Benjamin's photographic allegory of history, '[The photograph] interrupts history and opens up another possibility of history, one that spaces time and temporalises space.' *Words of Light* (Princeton, NJ: Princeton University Press, 1997), p. 61.

82. Geertz, *Interpretation of Culture*, p. 7.

83. Doreen Massey, 'New Directions in Space', in Derek Gregory and John Urry (eds), *Social Relations and Spatial Structures* (London: Macmillan, 1985), pp. 15–17.

84. Lefebvre, *The Production of Space*, p. 4.

85. Brenda Croft, 'Laying Ghosts to Rest', in *Portraits of Oceania*, ex. cat. (Sydney: Art Gallery of New South Wales, 1997), p. 8.

86. Turner, *Dramas, Fields and Metaphors*, p. 51.

87. Soja, *Postmodern Geographies*, p. 7.

88. Geertz, *Interpretation of Culture*, pp. 26, 28.

12. Epilogue

1. On the tradition of cabinets of curiosities at its height, see Joy Kenseth, 'A World of Wonders in One Closet Shut', in Joy Kenseth (ed.), *The Age of the Marvelous* (Hanover, NH: Hood Museum of Art), 1991, pp. 81–102.

2. Francis Bacon, 'The Second Counsellor, advising the Study of Philosophy', in *Gesta Grayorum* (1600). Reprinted in James Spedding, Robert Leslie Ellis and Douglas Denon Heath (eds), *The Works of Francis Bacon, 1857–74*, Vol. VIII. *Gesta Grayorum* was a contribution to Christmas revels at Gray's Inn. In this short entertainment, six counsellors offer advice, on various subjects, to an elected 'Prince of Purpoole'.

3. Pliny the Elder, *Natural History*, XXXV.

4. On mechanical perspective devices, see Martin Kemp, *The Science of Art: Optical Themes in Western Art from Brunelleschi to Seurat* (New Haven, CT: Yale University Press, 1990).

5. On the early history of the travel photograph and its uses, see Joan M. Schwartz, '*The Geography Lesson*: Photographs and the Construction of Imaginative Geo-

graphies', *Journal of Historical Geography*, 22, 1 (1996), pp. 16–45.

6. Deborah Chambers, 'Family as Place: Family Photograph Albums and the Domestication of Public and Private Space', this volume, ch. 4.

7. Le Corbusier, *Vers une architecture* (Paris: Editions Cres, 1923). Translated as *Towards a New Architecture* (London: Architectural Press, 1927).

8. Maria Antonella Pelizzari, 'Retracing the Outlines of Rome: Intertextuality and Imaginative Geographies in Nineteenth-Century Photographs', and Alison Blunt, 'Home and Empire: Photographs of British Families in the *Lucknow Album, 1856–57*', this volume, chs 2 and 10.

9. The value of photography as a tool for the preservation of architectural patrimony was recognized very early. See, for example, M. Christine Boyer, '*La Mission Héliographique*: Architectural Photography, Collective Memory and the Patrimony of France, 1851', this volume, ch. 1.

10. A useful summary of the prehistory and history of video and digital imaging is provided in Brian Winston, 'The Vital Spark and Fugitive Pictures', Part II of *Media Technology and Society: From the Telegraph to the Internet* (London: Routledge, 1998), pp. 65–143.

11. R. A. Kirsch, L. Cahn, C. Ray and G. H. Urban, 'Experiments in Processing Pictorial Information with a Digital Computer', *Proceedings of the Eastern Joint Computer Conference* (New York: Institute of Radio Engineers, 1958), pp. 221–9.

12. Sailing boats did not disappear with the advent of steam power, horses were not eliminated by the internal combustion engine, and painting was not entirely swept away by photography; but the roles of the older means shifted, and they were, in many ways, marginalized. We can expect the same of chemical photography and digital imaging. The economic interest of film and camera suppliers in preserving the value of their huge investments in the older technology, and the momentum of the widespread practices of chemical photography, will keep film around for quite a while. And there will be niches – such as the production of very high resolution images in very large formats – where film may well remain superior. But chemical photography is a very mature technology that is not going to improve much, while the development of CCD photography will be driven by Moore's Law and the explosive growth of digital networking, so the advantages of digital over chemical will grow.

13. On score and performance see Nelson Goodman, *Languages of Art* (Indianapolis, IN: Hackett, 1976). On the relationship of this distinction to digital data and its graphic display, see William J. Mitchell, 'Picture This. Build That. Algorithms, Machines, and Architectural Performance', *Harvard Design Magazine* (Fall 1998), pp. 8–11.

14. For examples see William J. Mitchell, *The Reconfigured Eye: Visual Truth in the Post-Photographic Era* (Cambridge, MA: MIT Press, 1992); and 'When is Seeing Believing', *Scientific American* (February 1994, pp. 44–9). On related concerns of geographers, see

John Pickles (ed.), *Ground Truth: The Social Implications of Geographic Information Systems* (New York: Guilford Press, 1995).

15. *Time*, 27 June 1994; *Newsweek*, 27 June 1994.

16. *Time*, 1 December 1997; *Newsweek*, 1 December 1997.

17. Derek Gregory, 'Emperors of the Gaze: Photographic Practices and Productions of Space in Egypt, 1839–1914', this volume, ch. 8.

18. V. Michael Bove, Jr, 'Multimedia Based on Object Models: Some Whys and Hows', *IBM Systems Journal*, 35, 3–4 (1996), pp. 337–48. In many ways, these three-dimensional imaging technologies are digital extensions of the old idea of stereoscopic photography.

19. For a comprehensive summary of these techniques, see James D. Foley, Andries van Dam, Steven K. Feiner and John F. Hughes, *Computer Graphics: Principles and Practice*, 2nd edn (Reading, MA: Addison-Wesley, 1995).

20. On the design of three-dimensional virtual environments, see Peter Anders, *Envisioning Cyberspace: Designing 3-D Electronic Spaces* (New York: McGraw-Hill, 1998).

21. For examples see B. J. Novitski, *Rendering Real and Imagined Buildings: The Art of Computer Modeling from the Palace of Kublai Khan to Le Corbusier's Villas* (Rockport, ME: Rockport Publishers, 1999).

22. See, for example, Maurizio Forte and Alberto Siliotti, *Virtual Archaeology: Re-Creating Ancient Worlds* (New York: Harry N. Abrams, 1996).

23. In films, it became harder and harder to distinguish virtual sets and characters from real ones. The difference in verisimilitude is dramatic if you compare an early computer-animated film such as Disney's *Tron* (1982) with a later production such as Pixar's *A Bug's Life* (1997).

24. This idea is older than many people imagine. For a description of the first working head-mounted display see Ivan E. Sutherland, 'A Head-Mounted Three-Dimensional Display', *Proceedings of the Fall Joint Computer Conference* (Washington, DC: Thompson Books, 1968).

25. See, for example, Mitsubishi Electric Research Laboratory's 'Diamond Park' (www.MERL.com/projects/dp/index.html), in which cyclists can explore a detailed, mile-square virtual landscape. For some additional explorations of the artistic uses of immersive virtual reality technology, see Mary Anne Moser and Douglas MacLeod, *Immersed in Technology: Art and Virtual Environments* (Cambridge, MA: MIT Press, 1996).

26. R. T. Azuma, 'A Survey of Augmented Reality', *Presence*, 6, 4 (1977), pp. 355–80.

27. Bill Carter, 'CBS is Divided Over the Use of False Images in Broadcasts', *New York Times*, 13 January 2000, pp. C1 and C2.

28. Joel Brinkley, *Defining Vision: The Battle for the Future of Television* (New York: Harcourt Brace, 1997).

29. For a comprehensive account of these developments, see Janet Abbate, *Inventing the Internet* (Cambridge, MA: MIT Press, 1999).

30. Tim Berners-Lee, *Weaving the Web* (San Francisco,

CA: HarperSanFrancisco, 1999).

31. William J. Mitchell, *E-topia: Urban Life, Jim – But Not As We Know It* (Cambridge, MA: MIT Press, 1999).

32. Among the prominent Webcam sites were www. Y2Kcams.com and www.earthcam.com. You could surf in to the first of the millennium, in the Kingdom of Tonga, at www.forthenews.com. And you could peek at Times Square (if the overloaded servers would let you in) at www.timessquare2000.com.

33. William J. Mitchell, 'Replacing Place', in Peter Lunenfeld (ed.), *The Digital Dialectic: New Essays on New Media* (Cambridge, MA: MIT Press, 1999), pp. 112–27.

34. William J. Mitchell, 'Telematics Takes Command', in *E-topia*, pp. 30–41.

35. On digital versus traditional libraries, museums and galleries, see William J. Mitchell and Oliver Strimpel, 'There and Not There', in Peter J. Denning and Robert M. Metcalfe (eds), *Beyond Calculation: The Next Fifty Years of Computing* (New York: Springer-Verlag, 1997), pp. 245–58.

36. In the photographic era, theorists could sustain a comfortable distinction between directorial (before exposure) and darkroom (after exposure) manipulation of image content, but this is no longer possible.

Index